5000 Years of the
Art of India

5000 Years of the Art of India

Mario Bussagli
Professor, University of Rome

Calembus Sivaramamurti
Director, The National Museum of New Delhi

Harry N. Abrams, Inc., New York

Chapters 1-3, 5, 8, 9, 11, 12
translated by
Anna Maria Brainerd

Designed by Studio Smeets
Produced by Joes Oerlemans -
Smeets Lithographers

Standard Book Number:
8109-0118-8
Library of Congress Catalogue
Card Number: 78-133846

All rights reserved. No part of
the contents of this book may
be reproduced without the
written permission of the
publishers, Harry N. Abrams,
Incorporated, New York
World rights Smeets, Weert,
Holland

Printed and bound in
the Netherlands

Contents

1. Introduction

by Mario Bussagli

The world renown of some of India's monuments does not mean that Indian art is really known and appreciated outside the limited circle of its scholars. Even in modern culture it does not enjoy a popularity comparable to that of other non-European figurative traditions, despite the interest aroused by certain similarities to Hellenistic Roman Classicism (in the so-called Gandharan school), especially apparent to Western scholars, and by particular associations with European Renaissance art. Consequently, speculative research into figurative phenomena and comparative studies of aesthetics and iconology often disregard this gigantic production which developed throughout the Indian subcontinent over more than four thousand years. In the general view of art history, scholars tend to overlook the highly original manifestations, so rich in independent creations, tendencies, and trends, and to ignore the problems and solutions that are peculiar to India's art. Widespread knowledge of this art would, if nothing else, afford a term of comparison, a useful and unique parameter to help form tentative judgments and verify theories concerning that fundamentally important activity of man: art. The neglect is grave also because the art of India is an exact reflection of the essence of its civilization, which is so hard to define despite its marked characteristics and so fruitful in the fields of philosophy, linguistics, poetry, and the theater.

Originating in a world imbued with deep religious feeling, Indian art developed along two main lines: one that was Indian proper and, with the waning of Buddhism, became 'Hindu,' that is, traditionalistic and anti-Islamic; and another created by Muslim thought and mentality transplanted to Indian soil. In the latter line, which is the lesser, belong the eclecticism of the Mogul school and the syntheses of the Indo-Muslim schools. The reactionary schools of Rajput and Maratha, which were well aware of the Islamic figurative experience but firmly opposed to the aesthetic principles of their religious and political adversaries, are also included in this group. The richer and more active main line is both extremely consistent, notwithstanding variations, and varied, despite the persistence of certain figurative characteristics that survived even the worst social and political upsets.

Indian art proper appears to have been constantly faced with the problem of giving shape to abstruse metaphysical concepts on which, in the cultural and social atmosphere of India, all the other human values depended—and to a certain extent still do. Based on a vision of life in which the divine and the human were continuously and variously intermixed, many of the sacred images created by this art tended to become diagrammatical and readily intelligible only to the initiates who possessed the key to their interpretation. This is another reason why the art of India is little known and seldom referred to in speculative discussion.

The difficulties of approach that Western scholars encountered in trying to familiarize themselves with its complex and diverse religious symbolism almost obscured the efforts of the anonymous artists to harmonize and humanize their creations. In other words, the aesthetic achievements were overlooked in an attempt to discover why Durga* might have ten arms, Siva five faces and four arms, and Brahma four heads and as many arms; why the Buddha was sometimes represented with an Apollo-like face, whereas, later, a Bodhisattva was depicted with four heads, another holding a sword, and yet another the stem of a blue lotus flower. At this stage of investigation, advanced by comparison with the childlike curiosity that the exotic strangeness of some of the images had previously aroused, the Indian artistic expression was considered to be mainly illustrative of the sacred texts. The gradual unveiling of the concepts of the sovereignty of the universe and the multiplicity of powers and the deciphering of the various, often macabre-looking symbols fully satisfied those early researchers. The sacred images, however, were neither sheerly celebrative figures nor mere objects of adoration. Study of the Indian techniques of meditation had demonstrated that revelation of the god's appearance could result only from profound, mystical concentration. The psychic process by which this concentration, stimulated by yoga, was achieved is called dhyana in Sanskrit. The same word was used to indicate the representations of both the Hindu and the Buddhist divinities; so the work of art was thought to be at once the result of a hallucinatory intuition and a means of reaching a further stage of mystical insight. Concentration on a sacred image merged the meditator's spirit with the object of his meditation and, therefore, with the divinity and the metaphysical values for which it stood. This second stage, known as samadhi, clearly indicated that the function of the image was basically to facilitate and direct the psychic process aimed at approaching the divine. The texts describe in great detail the countenances of the gods and the images representing them, so that the sufficiently well-prepared believer might reach a more advanced stage of ecstasy. The image gradually faded away, opening the way to the meditator's perception of the absolute and immutable values that require neither symbols nor images.

Along these lines of thinking, Indian iconography took a most unusual course, pursuing aims that are completely alien to the rationalizing mentality of the majority of mankind. Even when it was a matter of representing human Teachers, such as the Buddha or the Jain Mahavira, the artists relied mainly on yoga, especially on those who, having succeeded in envisaging the divinity, could provide them with a description

*Diacritical marks for transliterations of Sanskrit and other Indic names and terms are shown in the List of Indic Proper Names and Words (pp. 314ff.).

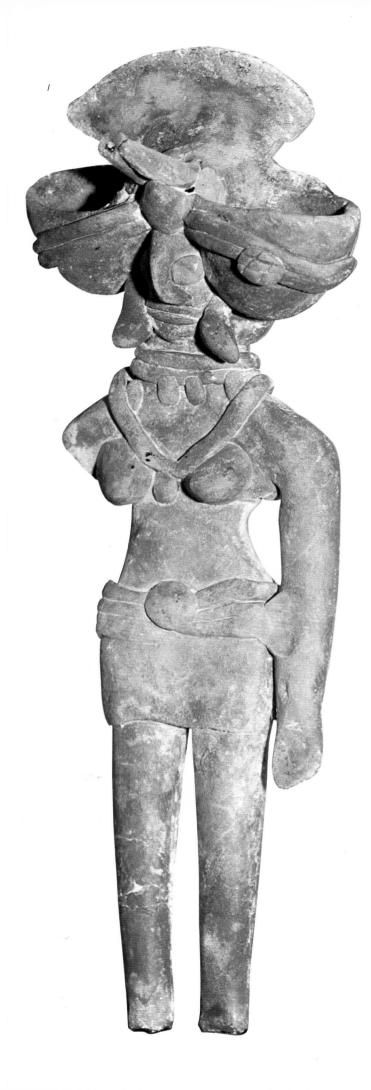

of it. The reason for this approach was that, although after Enlightenment his body remained anatomically the same as before, the Enlightenment of the Buddha had transformed him into a superior being since, through his intuition of the truth, he had been able to understand the Law and disclose it to mankind. He had been born to fulfill this mission and, consequently, was himself the Law. Unequal to the task of rendering the spiritual essence of the Buddha, early Buddhist art resorted to certain symbols that had already been accepted and used in the Vedic period and, owing to a centuries-old convention, expressed the absolute and universal principle. In the eyes of the believers the human personality of the Buddha disappeared or, better, became one with the Law he preached. Later, Buddhist speculation insisted on these concepts that the artists of the early schools had already perceived. Subhuti, the most outstanding supporter of the theory based on the Prajna (Buddhist gnosis), finally stated that all but Enlightenment is illusory and unreal, while other dialectic schools, such as that of the sharp commentator and exegete Nagarjuna, distinguished between the Buddha's life and physical appearance and his actual substance and considered the latter infinite, calling it Dharmakaya (body consisting of the Law). Meanwhile, artistic symbols, narrative episodes such as the Measurement of the Buddha's Body, and particular compositional elements forming a link between the two concepts, for instance, walls painted over with images of the Buddha (see fig. 21), were paving the way to a further step that consisted in conceiving even the body of the Buddha (Rupakaya) as limitless as space and, therefore, shapeless and

1. Female figurine of terra-cotta, with an elaborate hairdress. Probably a representation of the Great Goddess; perhaps a votive or a cult image. From Harappa, beginning of the second millennium B.C.

2. Naked dancer in repose. Bronze statuette. From Mohenjo-daro, first half of the second millennium B.C. National Museum, New Delhi About 5½ inches tall, the figurine represents a Negroid type. The artist had full mastery of foreshortening and body torsion. The attitude of the left arm and shoulder is proof of the distance separating Indus Valley art from the conventional figurative schemes of all other archaic art.

3. Mutilated male torso of red sandstone. From Harappa. Art of the Indus Valley, before the middle of the second millennium B.C. National Museum, New Delhi The realism of the accurately rendered anatomical structure in Indian art is little known, except for very rare works of special significance. However, the anatomical rendering of this minute figure (less than 3 inches tall) is so perfect that it has been thought to be a Greek work or one in the Greek style that somehow found its way into the protohistoric strata. This supposition, in itself not impossible, is very unlikely considering that the arms of the torso must have been mobile and that the two hollows at the ends of the shoulders unquestionably demonstrate a taste and conception alien to the Classical world.

capable of containing all shapes. Thus, the appearance of the Teacher was turned into a symbol, and though carefully studied in every detail and accurately represented like that of all other divinities, it was but the minor expression of infinitely more complex spiritual values, which were only accidentally acquiring material, and sometimes human, shape in works of art. The artists were doing no more than offering the minds of the faithful a means or 'support' by which to reach beyond iconography and iconology toward intuitive values that involved complicated psychic processes, for instance, that of yoga, as was said before.

Obviously, an unfathomable gulf separates the Indian cult images from those of other religions. They appear to be more like instruments of magic than works of art. At the beginning of the present century this consideration, though it accounted for many curious aspects of Indian art, greatly puzzled the scholars. The critics kept their distance from such baffling depictions, especially since the mystico-religious atmosphere from which the images sprang had imposed extremely rigid and precise rules on the artists. Poses, symbols, proportions, colors—all were firmly established in keeping with the typically Indian inclination toward the treatise and the system, so that there seems to have been very little latitude for the creative genius of the artists. Unfavorably impressed with an art that seemed to be chained to textual descriptions and iconometry, the critics regarded it, at best, as the outcome of a very particular ritual performed according to extremely complicated techniques, which alone were instrumental to the 'functional'—that is, to the mystical—quality of the representation.

Actually, even though it is exceedingly difficult to appraise these works apart from the religious values attached to them and apart from their main purpose of forming a link between the human and the divine, these aspects do not constitute all there is to Indian art. Indian society, with its unique way of associating the divine and the human, is clearly reflected in the narrative compositions, in the ornamentation, and in all that speaks directly to the mind of the beholder and does not involve magic or meditation, though it may have an edifying undertone. In this manner the human element preserves its weight and the artistic creations remain indissolubly bound to the real life that inspired them in so many different ways. Some works even seem to have been prompted by purely aesthetic motivations. Furthermore, this religious art, bent on educating and edifying, was forced to seek the appreciation of the widest possible public. And in this respect Indian art is truly 'popular,' not only because it sprang from a common religious experience and reproduced a world in which all—the nobles as well as the common people—believed but also because it strove to find an all-intelligible language to express the myths, hopes, and fears of a great many different peoples held together by a common civilization but politically and socially fragmented into innumerable communities. This popular quality also shows in many subjects associated with folk fables, anecdotes, and tales, for instance, in the Jatakas, stories narrating the previous lives of the Buddha—all of which sometimes interpret, in the edifying manner of the new religion, older popular motifs originally unrelated to this sphere.

2

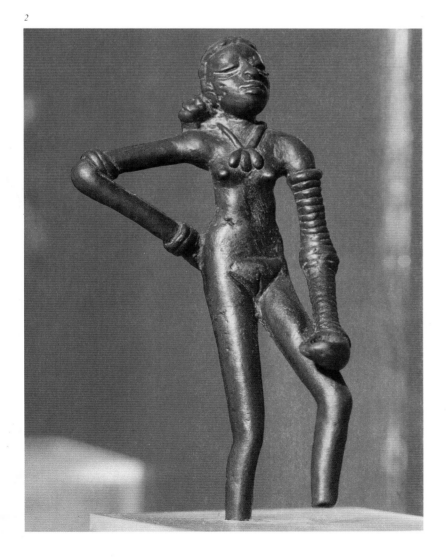

3

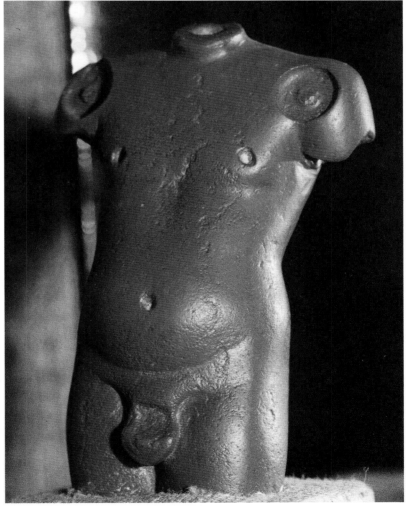

4. Stylized female figure of terra-cotta. The date is debatable. Perhaps of the Maurya period, about the third century B.C. National Museum, New Delhi
The figure probably represents the Great Goddess and is a symbol of fertility. Although it belongs to a very old iconographic manner, this terra-cotta shows innovative, autonomous, and isolated tendencies.

5. Male head, of stone. Perhaps of the Maurya period, third century B.C. or (according to some authorities) first century B.C. The type is markedly characterized, showing traits that depart somewhat from those usual in Indian art—notably the mouth, the large empty eyes, and the short, stout neck.

6. Royal personage with insignia represented as a winged being. On a support of the rail from the Bharhut stupa. End of the second century B.C. or first half of the first century A.D. Indian Museum, Calcutta
The insignia may be sacred in nature, with religious and royal values. On the staff, below the insignia, is a capital of a style found at Persepolis.

4

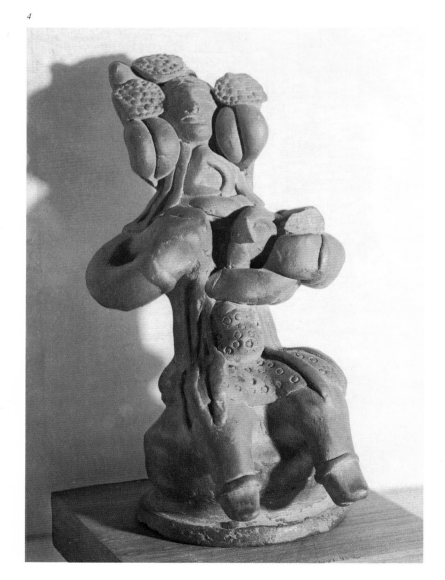

5

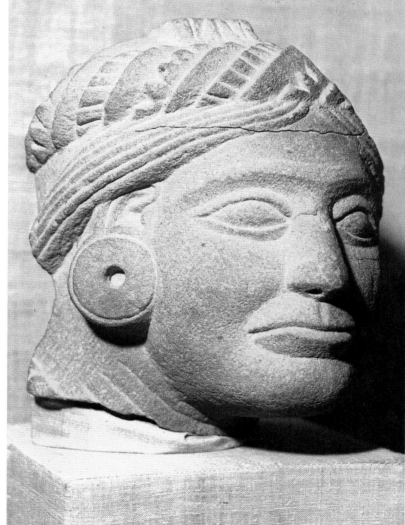

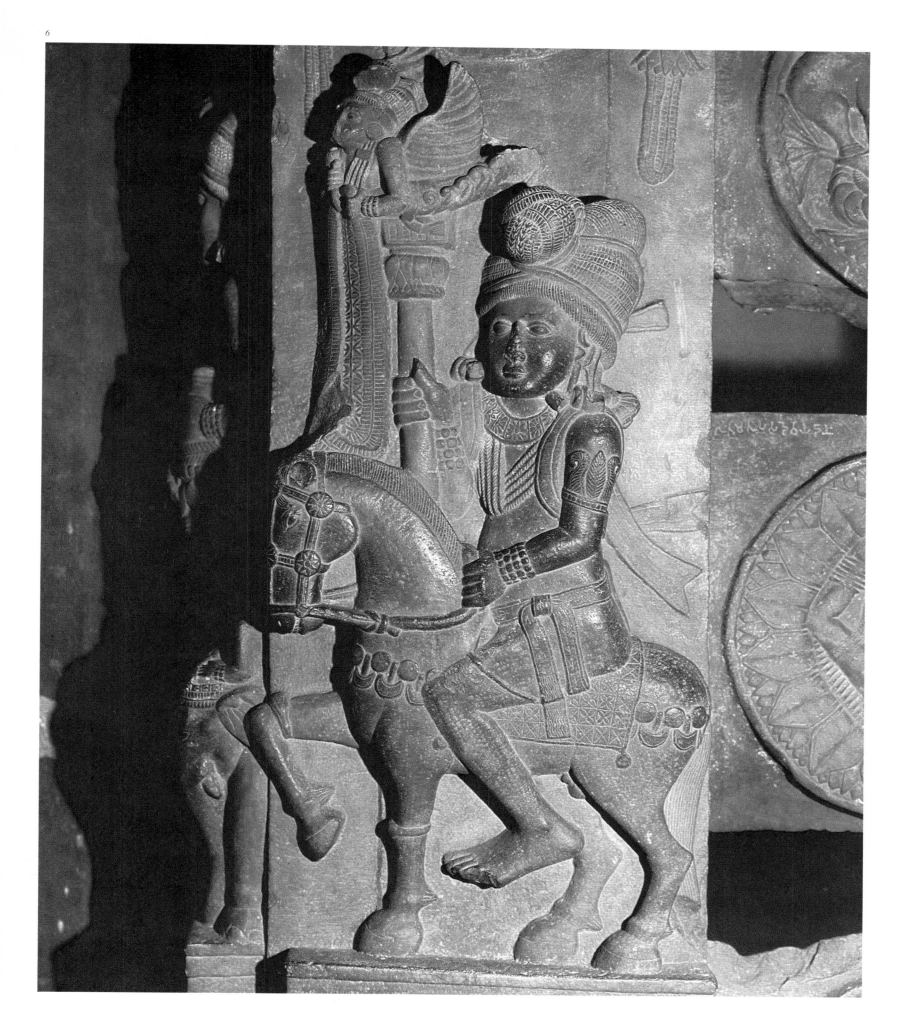

For all these reasons, non-Muslim Indian art was, above all, the prerogative of independent craftsmen, workshops, and guilds: an anonymous art which aimed to produce timeless works whose authors did not count. The silpin was not concerned with asserting his personality or pursuing fame. ('Silpin' is a word I prefer to render as 'artist,' unlike others who have chosen the term 'artificer' to distinguish such a worker from the modern Western artist especially, for the silpin had neither the same cultural interests nor the same background, and also from the artisan to whom he was infinitely superior in creative inventiveness.) Many silpins regarded themselves as mere tools of that, to them, really personified divinity who used them in much the same way that they did their implements. By remaining anonymous, the silpin conformed to that general pursuit of depersonification and renunciation of individuality which was directed toward the attainment of the Absolute, the

Infinite Eternal, and which for centuries constituted the aspiration and anguish of the religious soul of India. Others were incorporated in guilds (sreni), rigidly organized bodies that were so powerful economically and politically as to be feared even by the kings and the religious orders. The outstanding personality of an artist enrolled in a guild or school no longer shone as an individual light but was reflected in the works of the whole group. However, even in the uniformity of the schools, workshops, and groups of itinerant artists it is possible to discern the gigantic shadows of forgotten or unknown personalities. It could have happened only in India that the name of the maker of the Bodhisattva with the blue lotus flower at Ajanta was obliterated. Actually, the whole complex of cave temples at Ajanta was forgotten for centuries, only to be accidentally rediscovered by a group of British officers out on a hunting expedition. And only in India could it have

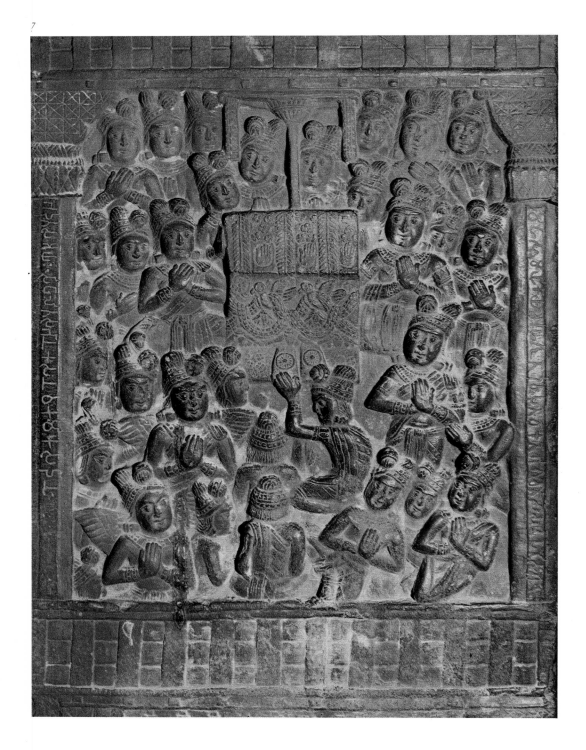

7

7. The worship of the Buddha, whose presence is suggested by the empty throne (markedly stylized) and by the footprints at the sides of the Wheel of the Law. Stone panel from the Bharhut stupa. End of the second century B.C. *or first half of the first century* A.D. *Indian Museum, Calcutta Note the members of the crowd depicted at different angles (there are even figures turning their backs); the composition departs from the frontal scheme of the archaic type and creates an effect of depth. The lateral inscription in Kharoshthi characters exalts the Buddha and the Law.*

8. Detail of the back of the eastern gateway of the Great Stupa at Sanchi (cf. fig. 72)
The sculptors' ability to depict animals is apparent in these buffaloes and elephants; they testify that the Buddha's Law obtains for all forms of life.

been possible for the name of the conceiver and executor of the Kailasa at Ellora to disappear into oblivion; the Kailasa, a superb architectural and sculptural representation of the dreads of anguished men and of the most intricate theology ever known (see figs. 289–291), expresses awesome symbolic myths in the language of an art truly unrestricted in imagination and, therefore, great. It took the impact of Islamic thought and the spread of the partly industrialized production of miniatures to enable Indian art to emerge from that nearly total anonymity. From before the Mogul period, there have come down to us only the names of a few minor artists active in the northwestern area of the peninsula, where contacts with Iran and Hellenistic Greek infiltrations contributed to a development of the figural arts along lines much closer to those of Western Classicism.

On the other hand, India never knew that myth of man as center of the

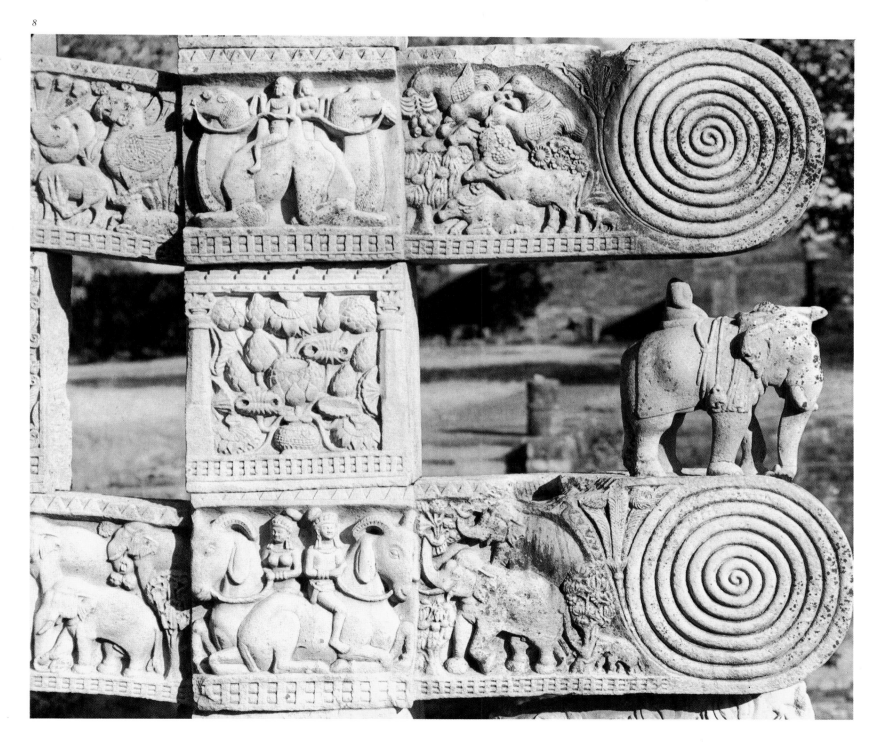

9. *The offering of gifts to a young king. Ornamental medallion of limestone from the large stupa at Amaravati. Second half of the second century* A.D. *Government Museum, Madras*
The king sits on a throne with one leg bent and resting on the seat, surrounded by his harem, his courtesans, and his riches (note on the right the horse, a prized possession of Indian kings). Under the throne is the Vidusaka, the court jester. The circular shape of the medallion has been exploited by adapting to it the disposition of the figures in a manner reminiscent of, but far superior to, the European Romanesque style.

9

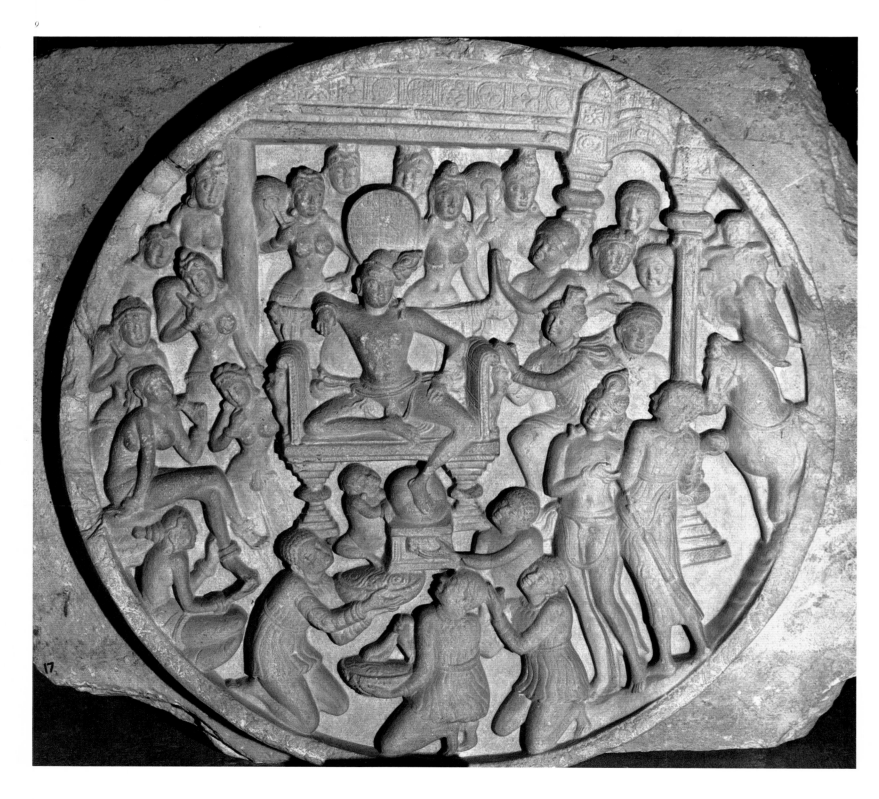

14

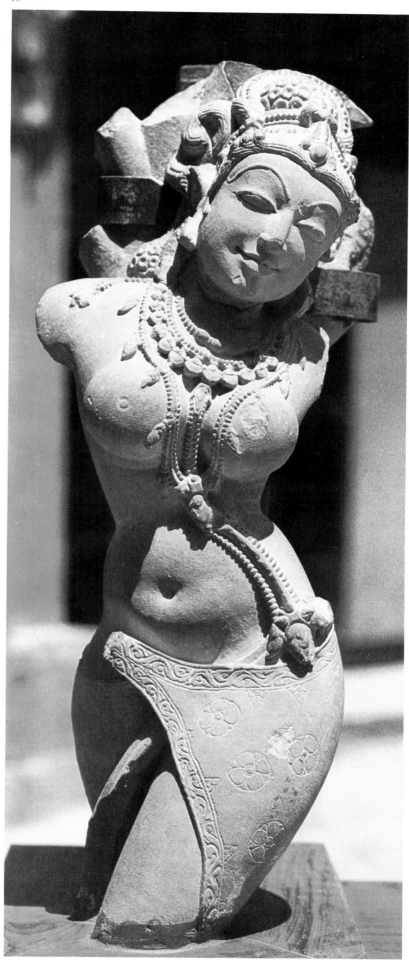

10. *Vrikshaka (wood nymph).*
From Gyaraspur, eighth to ninth
century A.D. *Archaeological*
Museum, the Fort, Gwalior
(Madhya Pradesh)
The statue, now unfortunately
only a fragment, represents a
salabhanjika, a female figure
grasping a branch of a sal tree
while arching her body in triple
torsion and in triple flexion, a
pose also depicted on the sides of
the gateway, or torana, at
Gyaraspur. The anatomy is care-
fully studied, and the face has an
intense expression, a rather rare
occurrence in Indian art. That
this image was more than a mere
ornamental figure is indicated by
its high quality. It is one of the
finest Indian interpretations of
the feminine form.

universe—a concept that was overturned in the West only with the progressive trends prevailing at the beginning of the twentieth century. Wittingly or unwittingly, the Indian artists adhered to a vision of life and the world in which man was not the supremely important being that ruled over nature but was, rather, a part of it. The Indian saw himself as submerged in nature and overwhelmed by it. Above all, he felt akin to all forms of life indiscriminately: to the most perfected as well as to the most humble. Because of this feeling for nature, the artists liked to set tales and episodes in natural surroundings; and as a consequence of their extraordinary sense of kinship with all living beings, their mastery in depicting all sorts of species undoubtedly makes them the most remarkable idealizers of animal life (for example, figs. 8, 49, 374, and 378). However, they would have had neither this interest nor this very particular ability had not the cosmic vision shared by many faiths of India put human and animal life on the same plane. The concept of continuous rebirth not only ties all the living to the 'wheel of life' but practically equates them all to man; for an animal may be a man or a woman in one of its future lives, and a man may have been an animal or even an insect in a previous life and may be one again in his next. It is therefore quite understandable that to the Indian mind all forms of life are on a level, even though only man has come close to liberation and the absolute, having reached the uppermost step, whence worthy conduct will bring him to the supreme sphere denied even to the gods (deva), who must descend to the human level to attain salvation. The only opposition to this conception came from the materialistically inclined trends in Indian philosophy—proof that it was very deeply rooted and widespread. No wonder that from the very start Indian artists strove to render the secret stream of life flowing not only in man but in every living being.

As to the human image, artists were mainly concerned with expressing its predominant moods. Sentiments and qualities, whether good or bad, were studied and at times rendered by means other than those typical of figurative art. The pose of the body and the gesture of the hands (mudra, meaning seal; see fig. 19), derived from the language of the dance, clearly convey to all who know their significance the mood of the image. This is another important consequence of the unity that characterizes Indian culture: that blending together of literature, theater, dance, religion, techniques of meditation, usages, fashions, and attitudes. The figural arts, drawing freely from this cultural background, at the same time pursued aesthetic values. Often the artists successfully brought to life symbolically posed hands (see fig. 206) and impressed elongated hands—vaguely reminiscent of Gothic painting and of the Sienese school in particular—with the mystic impulse of the soul. This idealization of symbolic gestures can be found also in the treatment of the entire figure, in which case reality is transposed to a higher, almost abstract plane.

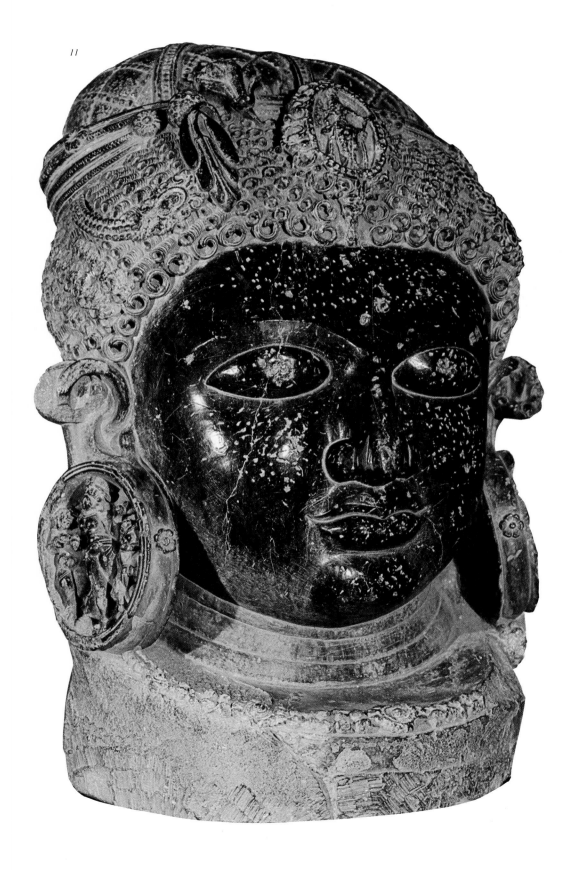

11

11. *Colossal head of Siva. Bluish-gray schist. From Kalyanapura (Rajasthan), seventh to eighth century* A.D. *Victoria Hall Museum, Udaipur (Rajasthan) The head is characterized by a complicated coiffure with, fastened at the center, a medallion depicting in relief the figure of a woman. The large disk earrings also bear images of female figures, flanked by their handmaidens.*

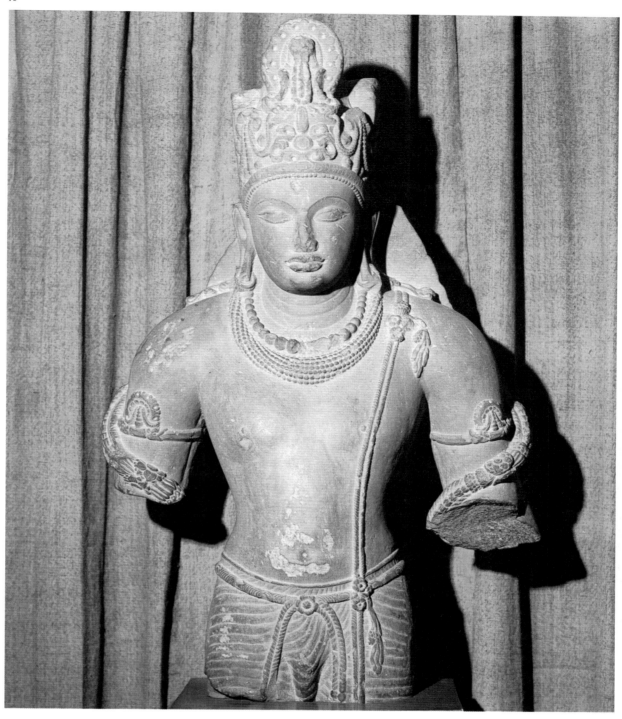

12. Vishnu with crown and royal jewels. Sculptural fragment. Gupta period, fifth century A.D. National Museum, New Delhi

The male figure has the so-called leonine aspect: broad chest, slim waist, solid flesh, and free movement (see figs. 9 and 39); but no attempt at the anatomical rendering of the masses, tensions, and muscular contractions is apparent. The female figure, instead, with enormous bust and rounded hips (see figs. 1, 2, 32, and 34), adheres to the requirements of a very old canon of feminine beauty, absolutely alien to the traditional taste of the Aryan peoples. In both, the resulting idealization is a reelaboration and transposition of real life, in which movement becomes free, well-balanced, and full of vitality—perfectly in keeping with reality and yet infinitely far from it. The artists endeavored to epitomize all possible types of a certain category of subjects in a figure that had all the essential characteristics of the chosen category. The acuteness of the analysis, performed both perceptually and spiritually, demonstrates that the artists must have made a vast selection and studied a great many subjects before concentrating on certain traits and emphasizing them, the better to render the essence of the category represented. This process of idealization explains more clearly than any commentary the original meaning of the word rupa, namely, 'form,' which was first 'prestige' and later became 'beauty.'

Obviously, in accordance with this approach based on the flow and essence of life, the greatest stress was laid on rendering the movements of the bodies—at once the manifestation and the rhythm of life. In this respect, the entire evolution of India's figurative art is rooted in really ancient traditions and achievements. The best works of the Indus Valley civilization, dating from the second half of the third millennium, are proof not only of a perfect ability to represent in detail the anatomical

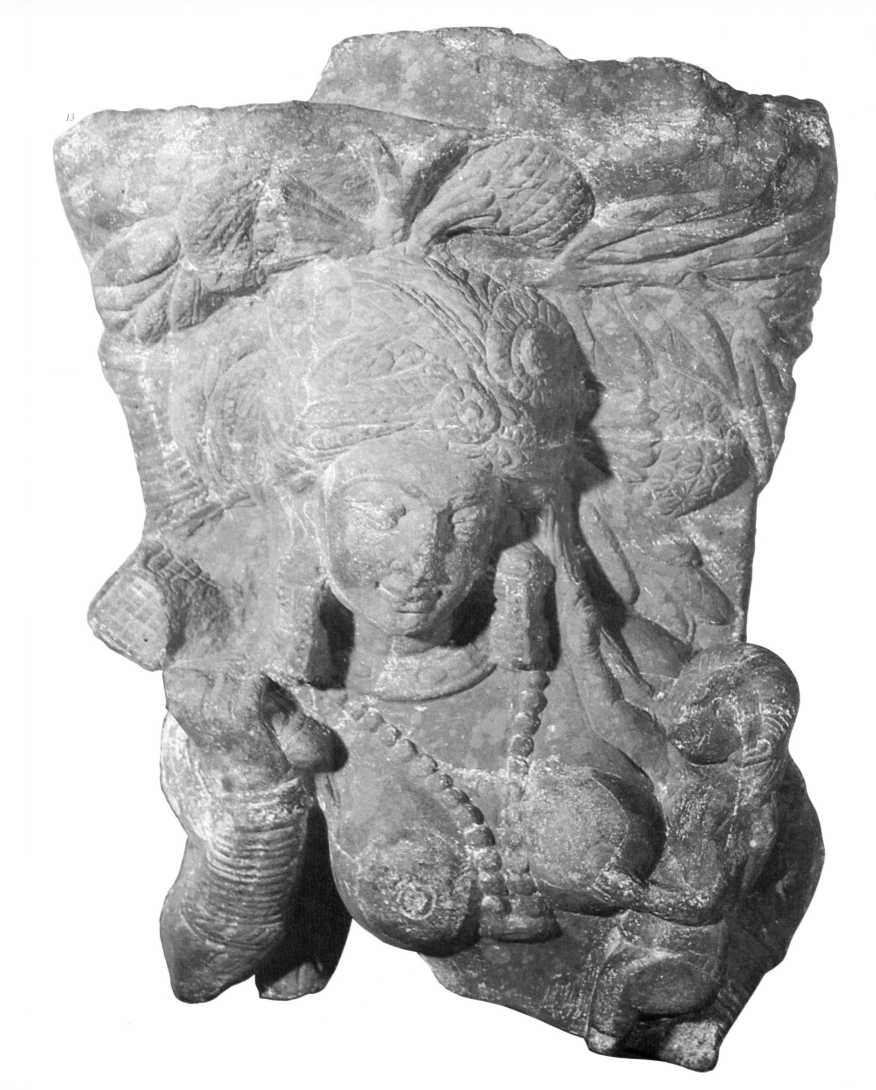

13. *Woman under an asoka tree,*
holding a child and amusing him
by shaking a rattle. Fragmentary
group in red sandstone. School of
Mathura, third century A.D.
Archaeological Museum, Mathura

14

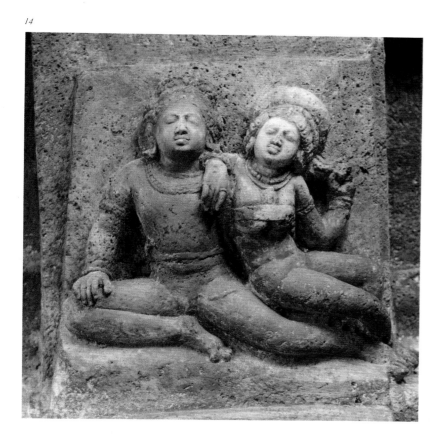

14. *Pair of presumably divine*
'flying' figures. Decorative panel
in Cave 16 at Ajanta (Deccan).
Second half of the fifth century
A.D. *(470–80?)*
The panel testifies to the high
quality of the sculptural decora-
tion of rock-hewn monuments. It
served as a corbel linking the
pillars of the portal and the false
beams of the ceiling.

15. *Fantastic animal with lion's*
body and ram's horns and two
human figures armed with swords.
Pinkish yellow Chunar sandstone.
Fragmentary architectural deco-
ration from Sarnath, fifth century
A.D. *National Museum, New*
Delhi

15

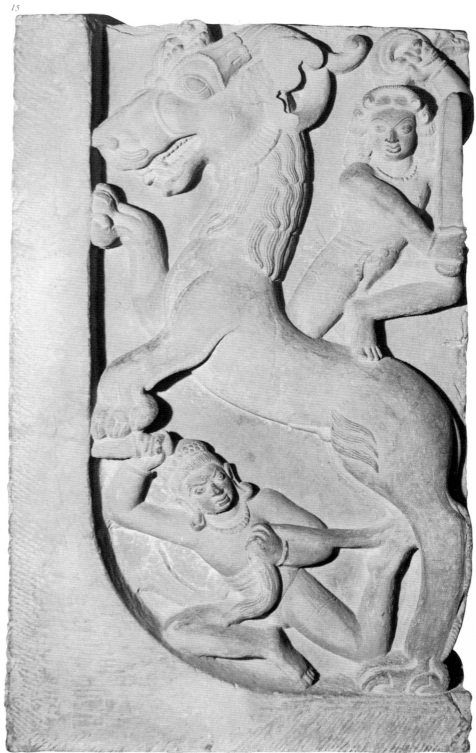

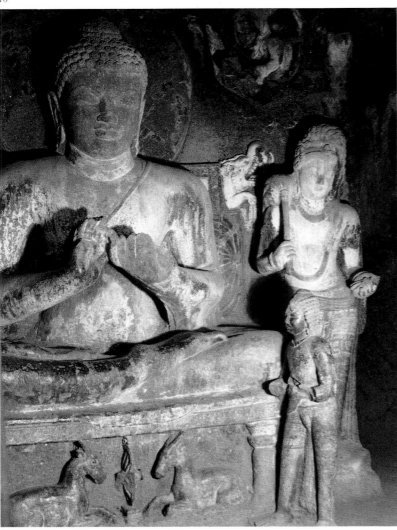

16. The Buddha's first sermon in the Deer Park at Benares. Sculpture in the central chapel of Cave 17 at Ajanta. End of the fifth century A.D.
The subject is indicated by the pose of the Buddha's hands and by the two deer facing each other on either side of the Wheel of the Law on the front of the throne. The back of the throne is decorated with fantastic animals. Two divine attendants, one on either side of the throne, and two human listeners (smaller in size) complete the composition. This illustration shows only two of the four figures flanking the Buddha.

17. Returning to Kapilavastu, the Buddha receives alms from his wife and son. Painting in Cave 17 at Ajanta. End of the fifth century A.D.
The symbolic aggrandizement of the Buddha's figure in comparison to the others is characteristic. The scene represents the Teacher's first encounter with his family after his renunciation of worldly life, and the alms signify his family's acceptance of his choice and their acknowledgement of his great moral stature.

structure of human and animal bodies (see figs. 46 and 47)—an ability that, as has been said, was not to have an immediate echo in the history of Euro-Asiatic art—but, also, of a total freedom from the frontal and parallel schemes typical of the very early art. The few better-preserved sculptures of human figures at Mohenjo-daro and Harappa testify to such mastery in the use of foreshortening as a means of rendering movement that, in a way, they can be classed with the far removed and much later sculptures of Greece (see figs. 2 and 3).

But the artistic production of India failed to exercise an influence despite commercial and cultural contacts with Mesopotamia. Sumerian art continued to express the supreme values through immobility and made its influence felt on contemporaneous Indian art. This acceptance of a foreign pattern did not, however, diminish the importance of the veritably Indian representations. On the contrary, there is ground to believe that a gray stone torso from Mohenjo-daro, mutilated and acephalous, represented a tricephalous, ithyphallic god in the act of dancing. If the reconstruction is correct, this is an instance of an *ante litteram* dance of Siva, which explains why the proto-Indian artist chose to render in immobile stone an instant-long pause between two contrary movements, thus anticipating by fifteen or twenty centuries the canon of Myron. From the time of the above-mentioned Mohenjo-daro torso to that of the magnificent thirteenth- and fourteenth-century bronzes (see figs. 34 and 35), the dance of the gods expressed a divine rhythm governing the rise and fall of the universes. It exalted the life-flow oscillating be-

tween the two opposite poles of creation and destruction, and emphasized its absolute, immobile, and intangible value. Rather than being abstract and detached, Indian thought was steeped in the flow of life. It admitted the transitoriness of individual lives, but, beyond and above them, it perceived an unchanging and undifferentiated principle that animated all lives and was the life of the universe itself. In the light of this thinking, the chaotic movement of some sculptural compositions acquires a different significance: it is the exaltation of life and nature. So great was the strength and spread of this conception that when it came to narrating the life of the Buddha, with its religious content that rejected all wordly things, the hymn to life broke through. At the Great Stupa at Sanchi, also, the overlapping human, animal, and vegetal shapes create a lively movement (see fig. 8), and the anonymous artists took visible pleasure in emphasizing the fleshy and supple grace of the dryads, or yakshis, carved on the sides of the large portals. This pursuit of movement and life unified events scattered over a period of time in a single scene. Occasionally it emerges in unexpected details of scenes pervaded with supernatural stillness. It is also the motive behind the dense decoration of the huge medieval temples—at Khajuraho (see figs. 243–245), as well as at Konarak (see figs. 36–38 and 238), Srirangam (see fig. 329), and Kanchipuram—crowded with supple female bodies, erotic scenes, and colossal figures. The rhythm of dancing is ever present, even in bodies that seem to be still but are actually gracefully bent in the so-called three-bend pose (tribhanga) that is also derived from

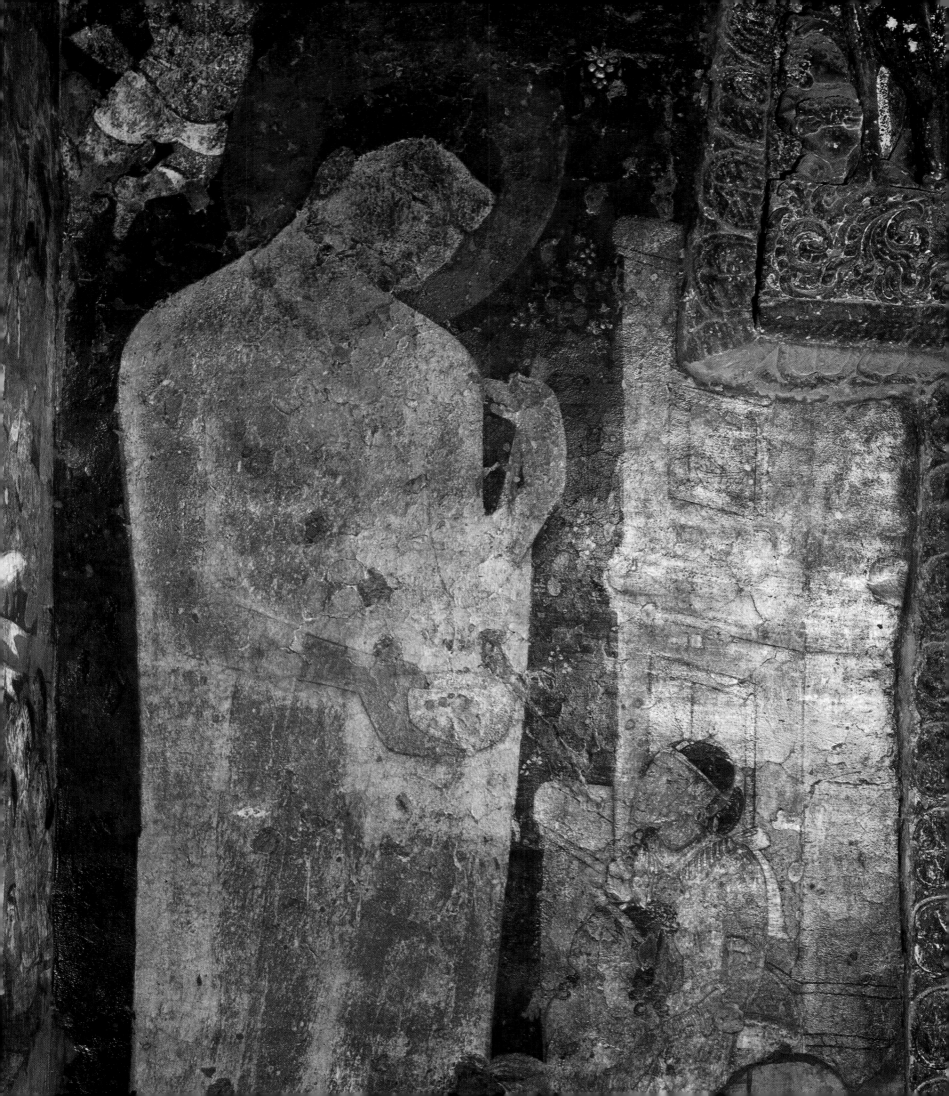

the dance (see fig. 34). The dancing rhythm, unimitative of nature, was thought to express the vital energy of the universe and was symbolically exemplified by Siva Nataraja, lord of dance (see figs. 27 and 29), and by Vishnu weaving a rhythm on the ocean waves as a prelude to his new creation. Thus late Buddhism, also, made use of the rhythm of the dance to confer new significance on its fierce divinities.

However, perhaps through foreign influence, Indian art produced, in addition, static figures. The representations of the meditating Buddha (see figs. 163 and 165) and of the Jain Mahavira were inspired by yoga and sprang directly from it; but the steles of Gandhara (see fig. 91), the strictly frontal images appearing throughout the Indian sculptural production, and certain images in the round, rich in volumes but still rigidly fixed, constitute the other face of India's artistic creation. There is, in fact, a canon of immobility that the texts refer to as samapada-sthanaka (a standing position with legs straight), implying security and

lack of outside stimuli, which also had a following. Close observation reveals, however, that after the very early examples the truly Indian artists absorbed and slightly modified this type by introducing sinuous lines, for instance, in the drapery of the Buddha's images (see fig. 90), or by softening the contours in a manner clearly suggested by the suppleness of plants—a demonstration that they were hardly appreciative of rigid shapes and, instead, often drew inspiration from the vegetal world, and especially from lianas, to represent the volumes and curves of the human body.

Thus, Indian art reacted to every foreign suggestion by adapting it to its understanding, taste, and sensitivity. This ability accounts for its extraordinary unity, which never failed even in the variety of the styles and at the inevitable times of arrest or regression. If one wished, one could trace the history of Indian art along the line of its successive reactions to the major foreign influences. Sumerian art, the art of

18

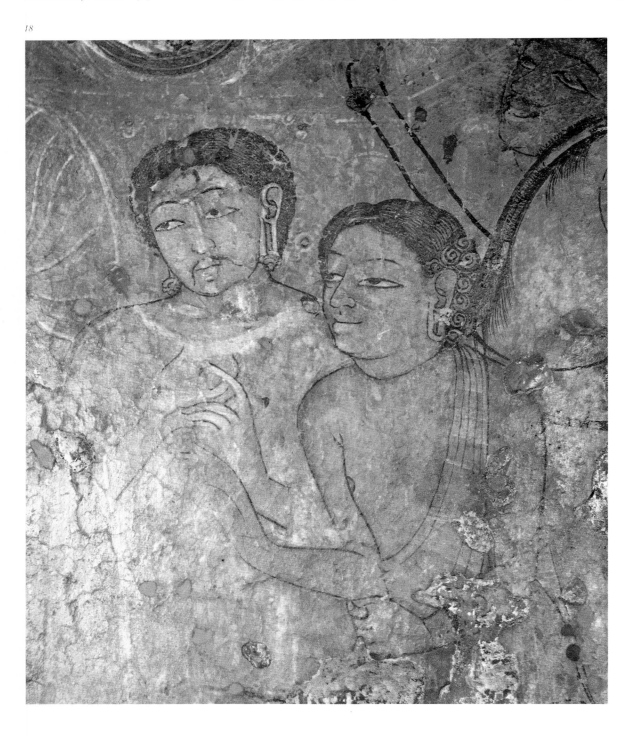

18. *Two figures near a quadriga (only partly visible). They exemplify the multitude of minor figures that populate the mural paintings of Ajanta. End of the fifth century* A.D.
These two figures are unmistakably Indian youths and form part of a vast composition of uncertain meaning on the left side of Cave 17. In the same cave are depicted a Persian ambassador with his retinue and other images of foreigners.

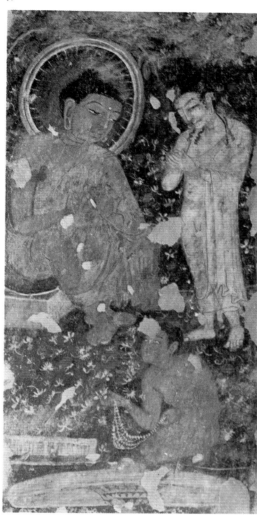

19. The Buddha explaining the
Law to Yasa, the first lay member
of the Buddhist community.
Detail of a large painting in Cave
10 at Ajanta. End of the fifth
century A.D.
Yasa, in white clothes as befits a
layman and with an elaborate hair-
dress, is devoutly listening to the
words of the Teacher. The
Buddha's hands are posed in the
preaching mudra and his head is
surrounded by a rayed nimbus.
In the foreground is the figure of a
monk. The background is blan-
keted with stylized floral motifs.

20. Head of the Buddha in stucco, with traces of polychromy. Provenance uncertain. Third to fourth century A.D. National Museum, Karachi
This head represents one of the clearest derivatives of the Classical Apollonian image created by the school of Gandhara in its first phase. The Greek profile and the oval face are retained, even though the bulge of the eyeballs (characteristic of exophthalmia) is undoubtedly not Classical, nor is the recession of the hairline on the forehead. The image expresses the concentration of the Buddha, his detachment from the world, and the intense life that animates him.

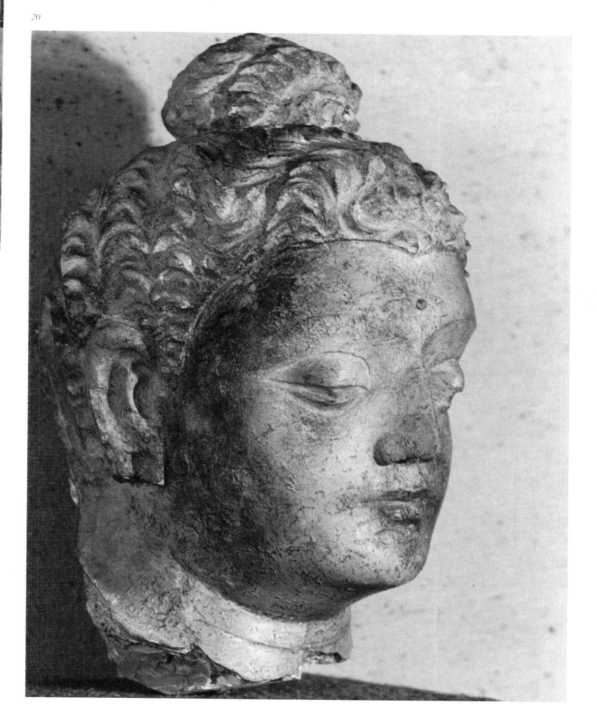

21. *The Buddha sitting on a lotus
throne with two attendants on
either side. Detail of a mural
painting in Cave 2 at Ajanta. End
of the sixth century or beginning
of the seventh century* A.D.
*The motif, endlessly repeated on a
wall, indicates that the space is
pervaded with the essence of the
Buddha. This symbolic and orna-
mental composition is excellent
artisan work and dates from the
period of the best Vakataka
painting.*

21

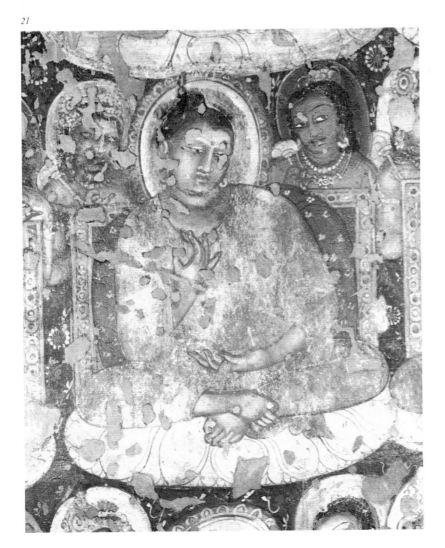

24

Achaemenid Persia, the Hellenism of Alexander and his successors, the forming of a Graeco-Roman Buddhist school in northwestern India, the Dravido-Alexandrian synthesis, which in the Roman period occasionally showed up in the southern production, Parthian and, later, Sassanian influences—none altered the local genius. It was to remain untouched also by the early Muslim influences, which sometimes generated vehement isolationism and at other times syncretisms and new tendencies that were, however, dominated by the Indian taste. All foreign techniques and suggestions were assimilated and transformed, so that India's great art seems to have sprung miraculously from the earth itself and to have reproduced the hidden forms of it that human will cannot change.

Tradition and religious background are partly responsible for these reactions to outside influences and for the essential unity in the evolution of Indian art. Above all, however, it was the spiritual attitude of the whole Indian people, their very essence, that established the constant taste and in general the characteristics to which generations of artists instinctively conformed. The establishment of figurative formulas did not result in an impoverishment of art, for the formulas evolved with the changing taste, techniques, and social structures. Most important among the general characteristics are the pursuit of movement, the impulse toward all manifestations of life, and the symbolic exaltation of the dance. All of these have already been examined briefly, and it need only be added that despite the appeal of all forms of life—human, animal, and vegetal—to the Indian mind it was the human body that created and described the rhythm of the dance. Consequently, the human image is predominant, and even though the artists equated it to animal figures and vegetal motifs, they favored it both as a subject and as an ornamental motif. The erotic couple (mithuna), with the large male and fertile female, appears constantly from early times as a recurrent decorative element separating the principal scenes in Buddhist

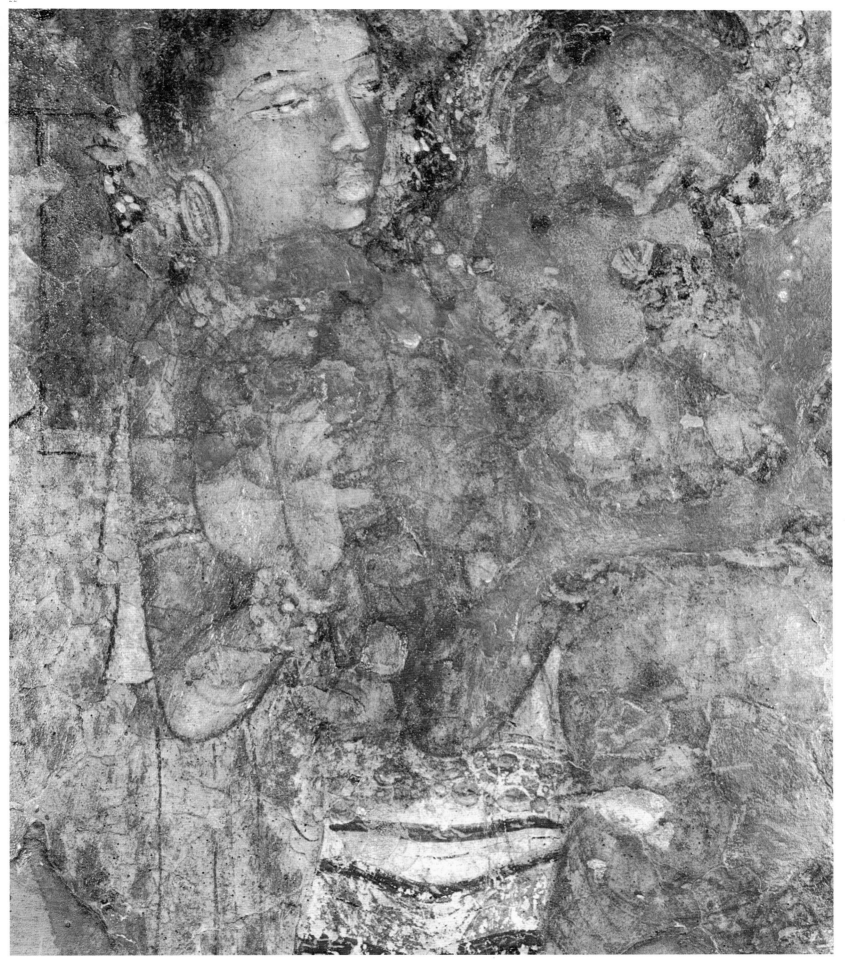

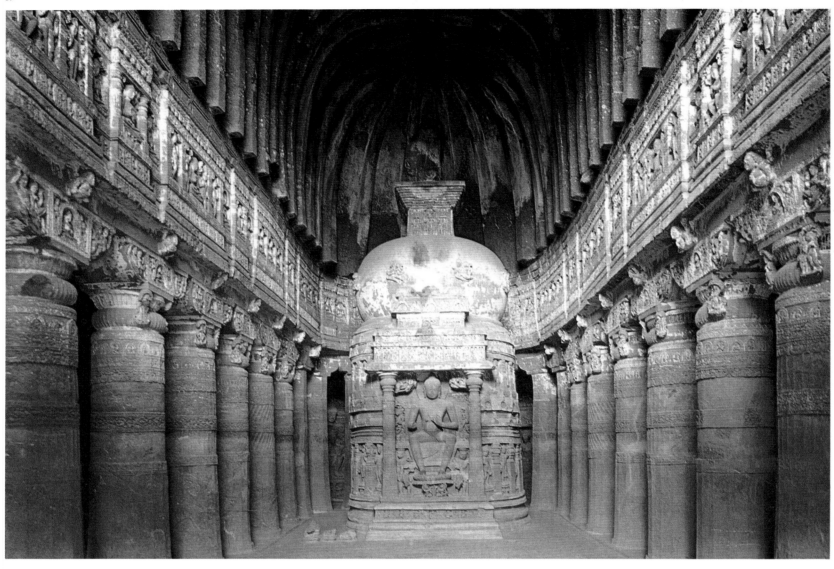

monuments and filling the empty spaces on the crowded walls of the large medieval temples (see fig. 36). Owing to this concept, and also because reincarnation as man was the closest stage to 'freedom' from the deceitful reality of the world and, consequently, the last and necessary step to reunification with the essence of the universe itself, man indirectly resumed his station as the sovereign being.

On the other hand, Indian aesthetic doctrines always distinguished the creations of man from those of nature. Sankuka tells us that the images made by the artists imitate reality so that they may be recognizable but, in themselves, are neither real nor false, being mere images that antedate any judgment of the real or unreal and are hence extraneous to the world of nature from which the artist draws his intuition and observation.

Incredible as it may seem, Indian thought had actually been developing coherent and systematic aesthetic doctrines as well as ample speculation on the problem of artistic creation since the last centuries before our era. It may be added that the problem, long undetected by all other civilizations, which made only empirical criticism of works of art and analysis of techniques, was first dealt with acutely but desultorily until, in about the ninth or tenth century, it was fully recognized, especially in relation to literature and the theater. The figural arts provided clear but isolated and occasional examples. Yet one of the earliest texts, the *Dhammasamgani*, a work dating from the third or second century B.C.

and therefore coeval with the full growth of the great 'aniconic' Buddhist schools such as Bharhut and Sanchi, and the *Atthasalini*, a fifth-century work by Buddhagosha, the most important exegete of Singhalese Buddhism in Pali, base their accurate analyses of the activity of the human spirit and of creative intelligence largely on examples from painting. Buddhagosha remarked that desires were hidden from the conscious mind, ready to become transformed into conscious will and, therefore, into action. In a painter's spirit the creative impulse, consisting first of the desire and then of the will to create forms and of the intuition of what was to be represented, was translated into a work in which the content was provided by the image perceived, while the material form was attained through technique and harmonious lines and colors. The unresting spirit, however, received new impressions in the act of creating and altered its original intuition partly without knowing. The work of art was a direct reflection of the creative activity of the spirit and, though also material, was, above all, spiritual. The Buddhist exegete identified it with the creative attitude of the intuition, of which its form was but an accidental 'translation.' The desire to create—in other words, the creative impulse that chose the colors and lines of the material representation—accounted for the apparent antithesis between the ever-active spirit and the fixity of the created work. Consequently, the entire work was the complete and tangible translation of

23. *Interior of Cave 26 at Ajanta. First half of the seventh century* A.D.
The elaborate false stupa of the apse is carved with the image of a Buddha sitting in European fashion on a 'lion throne,' a symbol of universal sovereignty, while Nagas (snakes, earth spirits) hold the lotus corolla that serves as a footrest. Overblown and heavy as it is, the composition is powerful.

24. *Temple 5 at Mahabalipuram, in the shape of a processional chariot (ratha), without wheels, with an elephant statue at the side. Beginning of the seventh century* A.D.
This temple is known as Saha-deva. Note the guardian lions supporting the entrance pillars.

25. *Vajradhara (?). Mutilated bust of a female divinity with three heads. Gahadavala style, eleventh century* A.D. *National Museum, New Delhi*

24

25

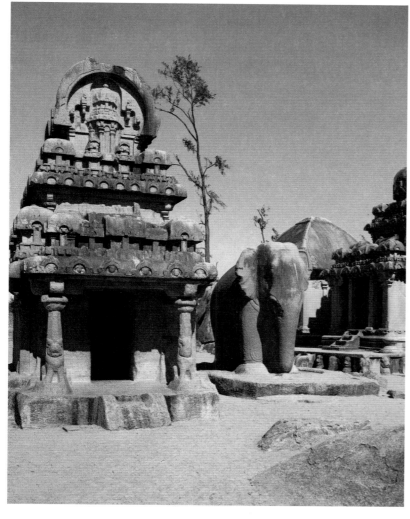

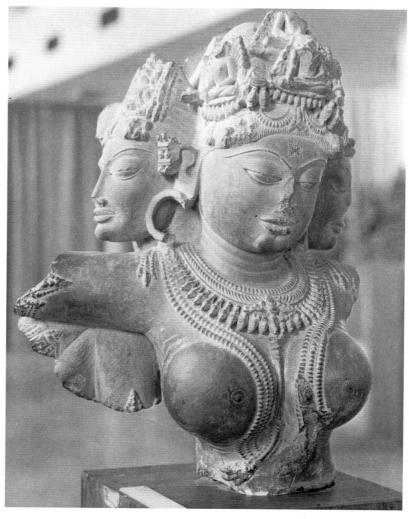

the image perceived by the artist: the semblance of an inner condition that actually constituted the work of art. Thus Buddhagosha thought that any means apt to stir an intuition or inner image, including mysticism-inducing yoga, was a valid and permissible source of artistic inspiration. The *Sukranitisara*, a Hindu text by the politician and philosopher Sukracarya, also dating from the fifth century of our era, states that a depiction of the divinity—all other subjects are considered unreligious by this author—is valuable in proportion to the completeness and perfection of the contemplation that inspires it. Only after intuition has envisaged the image in every detail is it possible to reproduce it. At the preliminary stage, artist and image-to-be are one from the mystical point of view, but the real manifestation of art occurs only after the form perceived has materialized in a concrete and perfect image.

26. Two gazelles in repose. Detail of the large rock-carved composition The Descent of Ganga, *the goddess of the Ganges, at Mahabalipuram. Beginning of the seventh century* A.D.
This detail, an incidental, small part of the left panel, shows the sensitivity of the Indian artists, even those inclined toward fantastic representations and religious symbols, in the depiction of animal life.

26

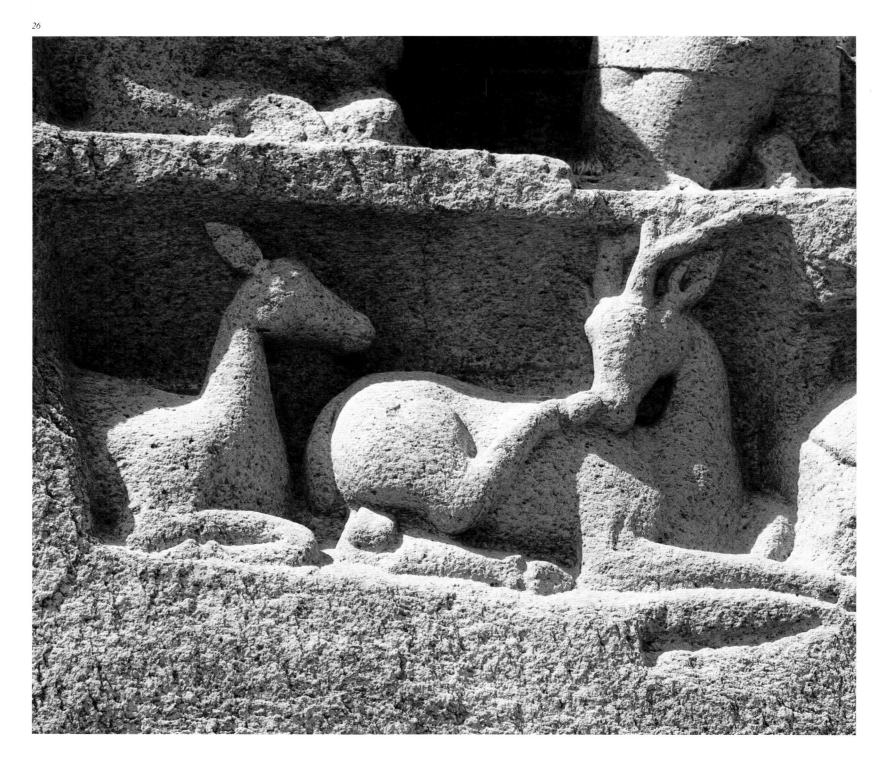

Thus, to Sukracarya, the original intuition became secondary to the actual realization, and he regarded the work itself as different from and superior to the inspiration or intuition behind it. Other texts, such as the *Silparatna* and the *Pancaratna*, elaborate the same concept, stressing the artist's ability in representation. Perfect perception of an image was not enough; it had to be perfectly rendered. Whereas any believer could conjure up wonderful images of the divinity in his meditations, it took exceptional ability to transform the shape seen in one's inner eye into a tangible work of art, which alone had value: hence the concept or, better, the consciousness of the instability of all rigid canons, no matter how well perfected, to codify ever-changing Beauty. While trying to clarify the mystery of beauty through the investigation of proportions, weights, and measures, Sankharacarya had a vision of Beauty personified in a shape that violated all canons and rules. The wise philosopher saw the truth and said: "O goddess, these rules and schemes are not meant for you. My pedantic observations serve only for the cult images. For infinite are the shapes you take, O Beautiful, and no rule can define them" (quoted from S. N. Das Gupta, *L'intimo aspetto dell'antica arte indiana*, Rome, 1936).

These ever-true words are basic to the understanding of Indian art. They show that artists and philosophers were perfectly aware of the artifice of certain rules and, therefore, were able to break them; hence the great systems of Dandin and Bhatta Lollata, of Sri Sankuka and Bhatta Nayaka, concerning rasa, namely, that condition of consciousness which is the 'sap' and 'flavor' of the feeling expressed in the work of art and the true objective of aesthetic investigation.

27. Siva dancing before his bride, Parvati. Carved panel in Cave 21 (Ramesvara) at Ellora
The six-armed god with all his attributes, including the cobra, is in a dancing pose different from those in which he is generally represented as Nataraja. Behind Siva's enormous figure a hardly visible skeleton suggests the destructive aspect of the god. It is death personified.

27

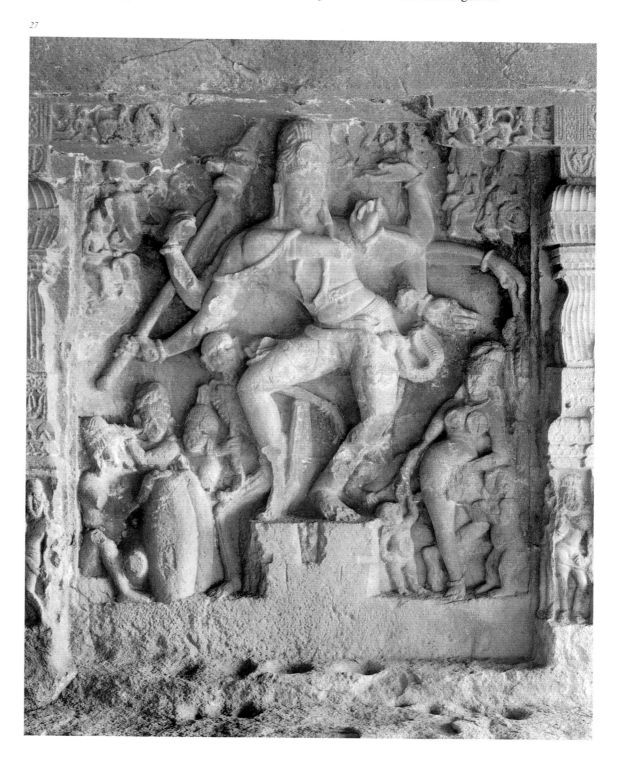

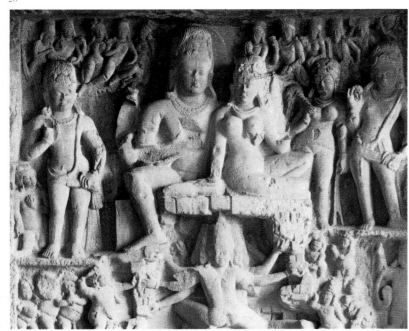

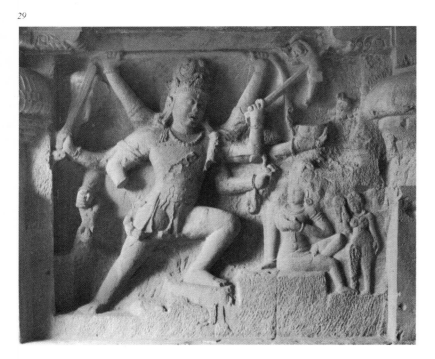

29

29. The eight-armed Siva dancing before his bride, Parvati, on an elephant hide and showing all his tremendous power. Side panel in Cave 29 (Dhumar Lena) at Ellora. Seventh century A.D.

28. The demon Ravana shaking the Kailasa (the cosmic mountain where the gods dwell) from the bowels of the earth. Principal panel of Cave 29 (Dhumar Lena) at Ellora. Seventh century A.D. The large divine couple sitting on the mountain, which is rendered in the shape of a throne, is unaware of the danger. Cave 29 is the largest of the Ellora group.

30. Small monolithic shrine (mandapa) in Cave 33 (Indra Sabha) at Ellora. Seventh century A.D. The overall structure is in the shape of a polygonal cross, lightened by the moldings.

Dandin and others regarded rasa as an ordinary mood or feeling intensified by the combination of various elements: in drama, for instance, by the plot, the text, the acting, the scenography, the actors, and so on. To Sankuka it was a feeling felt and imitated without reference to reality, that is, purely abstractly. To Bhatta Nayaka, as R. Gnoli points out in his book *The Aesthetic Experience According to Abhinavagupta* (Rome, 1956), rasa is a pleasure unrelated to everyday life—a pleasure experienced in a generalized, universal manner, regardless of time and space. According to Bhatta Nayaka, the aesthetic enjoyment is such that it can even temporarily break the samsara, that is, the chain of causes and effects on which the wheel of nativity and mortality depends. In this sense, rasa is pleasure, bliss, repose. Consequently, aesthetic consciousness is not a means but an end and, being similar to the mystical experience, is also an enlightened, autonomous condition. Abhinavagupta regarded pure enjoyment as the ultimate aim of art and thought that aesthetic fulfillment could purify those who felt it to the extent of raising their spirits to cosmic consciousness, that is, to consciousness of present, past, and future mankind. As is evident, Indian speculation on artistic phenomena was extremely advanced. In some respects, it anticipated the most current achievements of Western thought; in others, it makes one wonder what possible different evolutions toward abstraction the figurative art of India could have had, since, according to its aesthetic doctrines, the artists worked from a mental prototype, elaborating reality as they wished. But, in point of fact, the art of India could never conceive other than natural forms. It lacked the urge to create absolute shapes that were truly outside the realms of perception and reason. Steeped in the flow of life, it remained anchored to it, using paranormal means of inspiration only in so far as they clarified the entangled thinking on the problem of being. What it perceived beyond natural forms and the flow of life was without form. Like all other religious art, however, it was expected to give shape to the formless; this is why it remained bound to nature, which it considered the illusory mirror of the ineffable essence but, also, the only possible source from which to draw in the attempt to approach the supreme, immobile, and immutable truth: the mysterious and eternal divinity dispensing life and death.

The language that the Indian artists created to convey their intuitions reveals their tireless effort to make works that would really bring man closer to the inexpressible truth. Seen through modern eyes and in the light of the most recent developments of the figurative arts, the efforts of the Indian artists are surprising both for ambitiousness and for results. For there can be no question that, if they did not achieve the divine, they certainly succeeded in rendering the universal life of the cosmos, which is a manifest and tangible aspect of the divine.

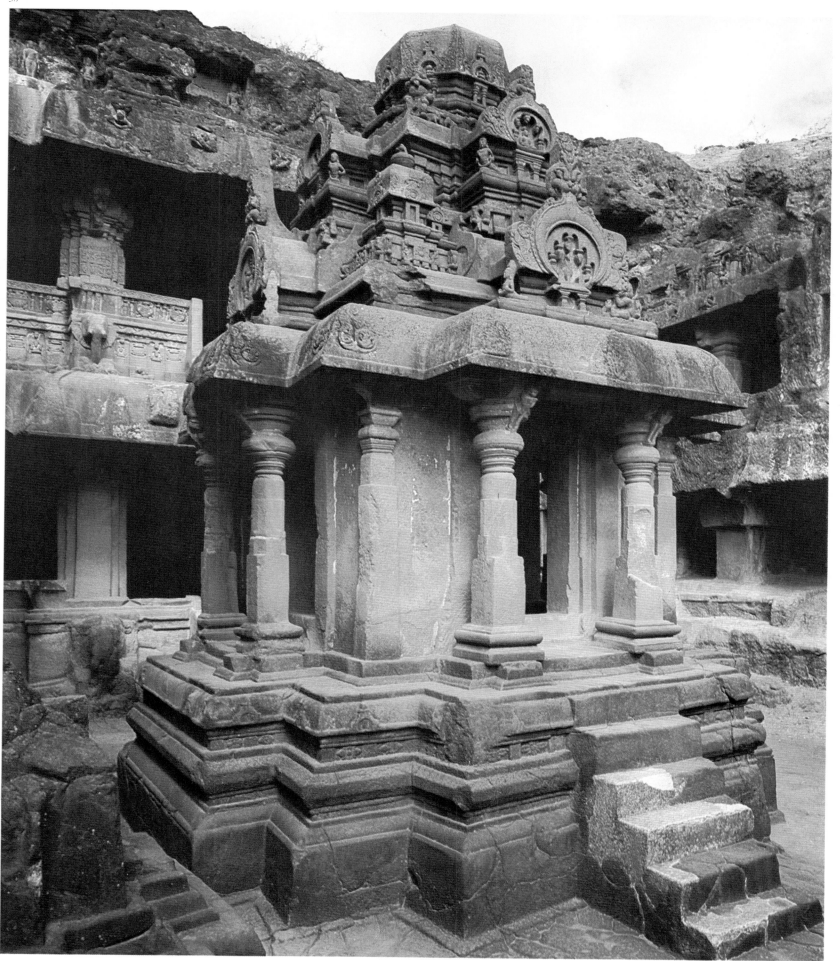

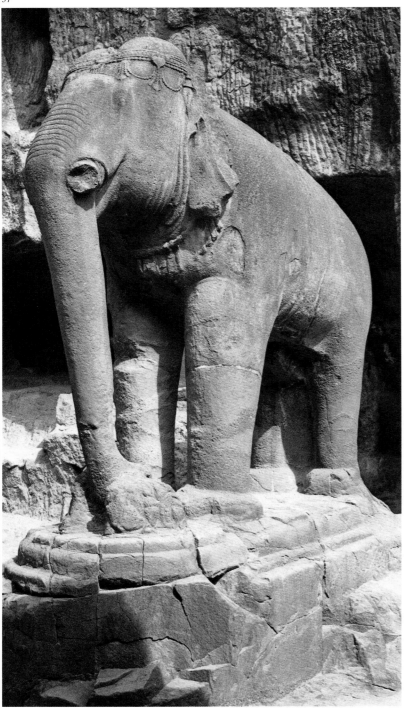

31. Isolated elephant in the courtyard of Cave 33 (Indra Sabha) at Ellora. A.D. 750–850 The monumental complex at Ellora, and especially the Kaila-sanatha temple, are characterized by the presence of innumerable elephant images, sometimes used as caryatids.

Indian thought not only elaborated complex speculation on the evolution of art, it established also a hierarchy of artistic activities where painting, poetry, theater, and dance are foremost. Architecture, sculpture, and the minor arts were theoretically relegated to artisan rank. However, since most of the paintings are lost, today's major figurative masterpieces from India are the product of the latter category. Singularly tied to the culture and social structure of the Indian world, its architecture has absolute validity as a great art form. The major temples, whether freestanding or rock hewn, are often masterpieces rich in originality (for instance, those in the shape of chariots), in ingenious solutions, and in studied effects.

The temples with curvilinear roofs (sikhara) and pyramidal stepped roofs (vimana) imitated the divine dwellings. Standing on sites chosen in special magic rites and charged with symbolic values, they were often gigantic in size. The largest ones were surrounded by monumental complexes so vast as to form actual religious cities—for instance, Khajuraho in Central India (see figs. 243–245), Bhubanesvar in Orissa (see fig. 235), Madura in the southeast. The Buddhist cave complex of Ajanta is, instead, a marvelous example of that rock-hewn architecture which solved the problems of statics through the cohesion of the rock but originated others, starting with indoor light and light effects (see figs. 126–136). In these curious structures, there is a complete reversal of the architectural approach. Space-delimiting perimetrical walls are nonexistent and the facade is unimportant; what counts is only the cutout inside space divided by the false ribs of the false vaults and the false pillars carved out of the rock to create spatial effects.

The Buddhist or Jain stupa is a solid structure with no inside space save for the closed and inaccessible niche where the relics of the Buddha or of the Mahavira or, for lack of these, the holy objects and texts that quicken the stupa, conferring magic power on it, are preserved. Symbolically, to the faithful who circumambulate it in the appropriate state of meditation, the stupa is at once tomb, cenotaph, representation of the universe, magic site, and structure facilitating the achievement of truth. It is the representation of the cosmos as seen from the outside; a kind of 'negative' of the universe, for the full dome representing the sky is inaccessible from the inside and shaped in accordance with a vision outside space and time. Rather than being a feat of architecture, it is a 'constructed' sculpture, just as the cave temples are pure space carved out of the rock. Conceptions of the kind could occur only in India where the predominant religious symbolism could assume artistically valid forms that were born of a characteristic sensitivity far removed from the ordinary functional, social, and spiritual considerations that dictated the architecture of the other contemporaneous civilizations.

Yet India's typical monuments—rock-hewn temples and cliff carvings—spread throughout most of Asia following the expansion of Indian religions: Buddhism especially, but also Hinduism. The shapes India created gave rise to others: the tower-pagodas of China; the mountain stupa at Borobudur in Java; sacred cities such as Angkor Vat; the bell-shaped stupas of Laos and Thailand; the towers with the large, enigmatic, smiling faces of late Khmer art (see fig. 185); and the entrance vestibules in the shape of small temples *(sezisnat)*, Javanese in style.

The diffusion of Indian figurative art was always very extensive, sometimes much more so than India's cultural and religious influence, as if it had been echoed by the neighboring civilizations and had thus been passed on to others farther removed. Therefore, it is not surprising that features reminiscent of Indian art are found in northern Asia; in the West, to which they came through Persia; and in Madagascar as well as along the coasts and in the inland of eastern Africa. These are, however,

32. Maternity scene. Architectural fragment (individual panel). Black basalt. Pala, eleventh century A.D. *National Museum, New Delhi*
The large recumbent female figure with a baby at her breast, attended by a servant, may allude either to the birth of Krishna (Devaki with Krishna) or to that of Siva in one of his aspects. Above are new divinities, including the Navagrahas (the planets and stars), Ganesa (the god of wisdom with an elephant's head), Karttikeya (the god of war), and a lingam, a phallic symbol alluding to fertility.

32

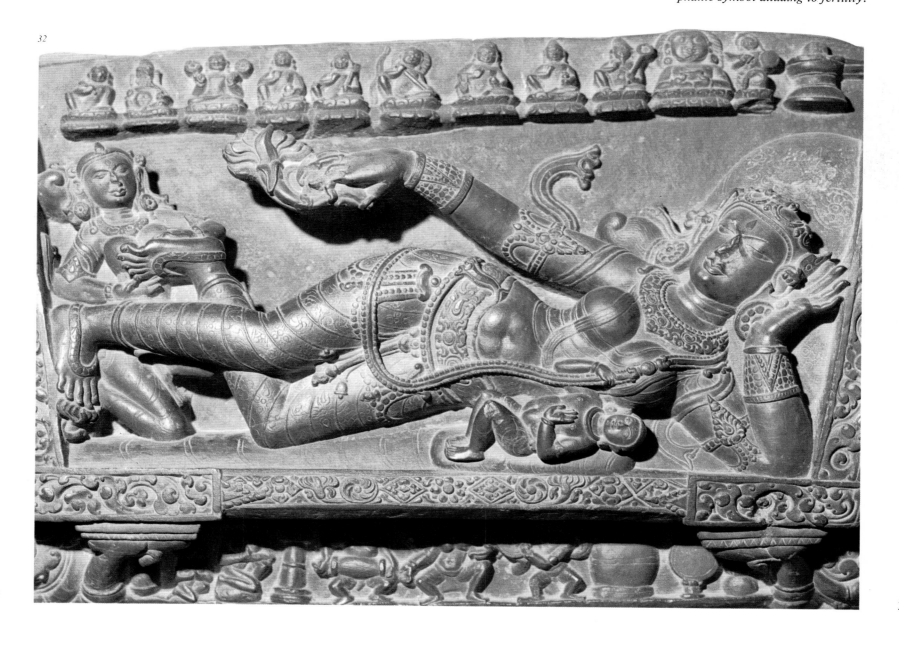

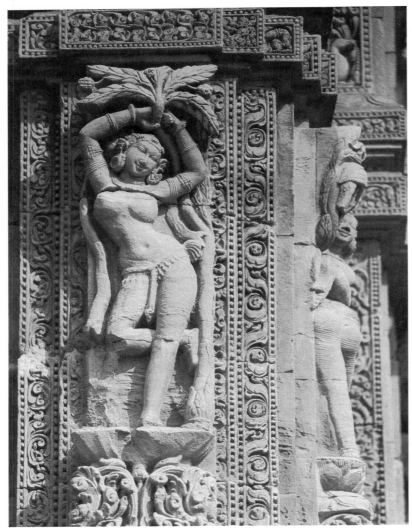

33. *Ornamental figure of a woman
holding a branch in her hands.
Detail of the exterior decoration of
the sikhara temple known as the
temple of the Rajarani at Bhuba-
nesvar. Twelfth century* A.D.
*A classical motif of Indian art,
such a figure is used almost ex-
clusively for decoration. Its name,
salabhanjika, refers to the ancient
girls' game of picking flowers
from the sal and asoka trees for
the weaving of garlands, but later*
*became a strictly figurative term.
Starting from the second century*
A.D., *the motif was transformed.*

famous Supreme Buddhas evolved from reflections on the artists'
depictions of the historical Buddha performing miracles and of the
quiescent Buddha, unshakable and unshaken, like the pivot of the
universe itself.

Understandably, the impact of the Muslim aesthetic currents on a world
so consistent and closed created a deep crisis.

The Muslim conquerors, descending from the north into the vast plains,
were not in a position to appreciate the strange many-headed and many-
armed images, or the dance rhythm, or even the huge temples crowded
with images. Above all, the erotic symbols and the couples bound in the
strangest carnal conjunctions offended the sensitivity of the Muslims,
who shunned human representations and animal depictions, and who
sought to express the infinite variety of divine creation only through the
arabesque and through fantastic, abstract decoration; hence the violent
persecutions, the massacres, and the genocides. No matter how violent
the impact, however, Indian civilization could not be extinguished. It
withdrew, leaving the Rajput and the warrior tribes of the peninsula to
contend with the invaders for better or for worse. Islam, which had
subjected and absorbed so many civilizations, could never have the
better of Hindu India. Only under the rule of the Mogul emperors—the
third of the great Indian empires to rule over a large part of the pe-
ninsula—was there an attempt at coexistence and synthesis. The Mogul
emperors, with the exception of Aurangzeb, were open to spiritual sug-
gestions from India, the Christian West, and, of course, Islam; so
Mogul Indian society and art in particular show contradictory aspects
and attitudes unconceivable outside India.

Islamic culture came to India charged with the complex figurative
experience that had matured in Persia, and the taste of the new rulers,
even before the Mogul emperors, had developed from that of Iran.
This is why early Muslim buildings (of the thirteenth and fourteenth
centuries) are clearly seen to be derived from Persian taste and tech-
niques (see figs. 342–344), while in Sind, in Gujarat (where Jain bankers
and merchants still controlled the local economy), and in Kathiawar,
local craftsmen raised religious and civic buildings for the Muslim
rulers, using as raw materials the remains of the Hindu and Jain temples
that had been razed to the ground by order of the iconoclastic new
lords. Thus, the Indo-Islamic style originated from circumstances
rather than from aesthetic ambition. Its principal characteristic is that
the exteriors adhere to the canons of Persian Islam (see figs. 347 and
349), despite wider use of corbeled domes and horseshoe arches, while
the many-pillared interiors are decidedly Indian (see fig. 348). The real
fusion that gave rise to an original style came only with the Mogul rule
(see fig. 350).

secondary, questionable features, which are ornamental and schematic
rather than stylistic and iconographical, and the support of their
testimony is not needed to appreciate the expansion and vitality of
Indian art. Its diffusion over Central Asia is proof enough, especially
if we consider its traces on the art of the caravan towns of the Tarim
Basin, where it merged with Classical and Iranian currents and origi-
nated extremely interesting and beautiful local developments. These
stylistic contributions would not perhaps have been so welcome had
they not come with the new religion, which, strangely, was able to take
root in social structures completely unrelated to the cosmic and reli-
gious views of India. Buddhist thought, which originated in opposition
to the stagnant Brahmanic and Vedic currents, eventually became an
ecumenical, missionary religion that was embraced by most of Asia.
The concessions that Buddhism had to make to acquire supernational
acceptance are reflected in iconography and style. Similarly, progressing
beyond the boundaries of the huge peninsula, Indian art accepted,
absorbed, and modified foreign suggestions. Between the edifying cul-
tural and narrative cult images and the religious speculation there was
for centuries a constant interchange, so that the works of art suggested
new clues to the exegetes of Buddhist and Hindu thought, and the new
clues and reflections in turn gave rise to new artistic compositions and
more complex iconography. In this respect Indian art developed in
embryo a 'civilization of the image,' owing to the fact that it was di-
rected to all believers regardless of class, merit, or preparation. It is
very significant that the images of the meditating Buddha and the

34. *Parvati. Bronze statuette. Chola, probably twelfth or thirteenth century* A.D. *National Museum, New Delhi*
The goddess is in the left-hand three-bend pose. The proportions of the body, slightly different from those established in iconometry, make the representation very lively and extremely significant of the bronze production of southern India.

35. *Royal personage with markedly characterized facial features. Bronze statuette. Chola, fourteenth century* A.D. *National Museum, New Delhi*

34

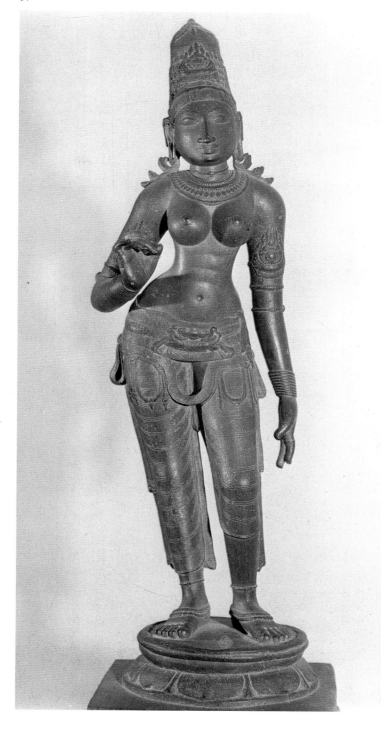

35

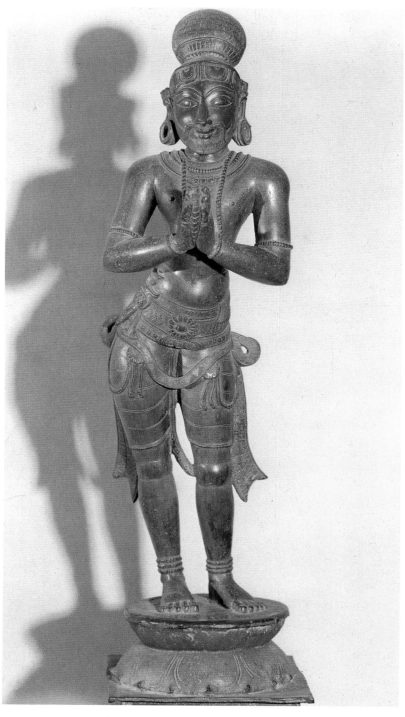

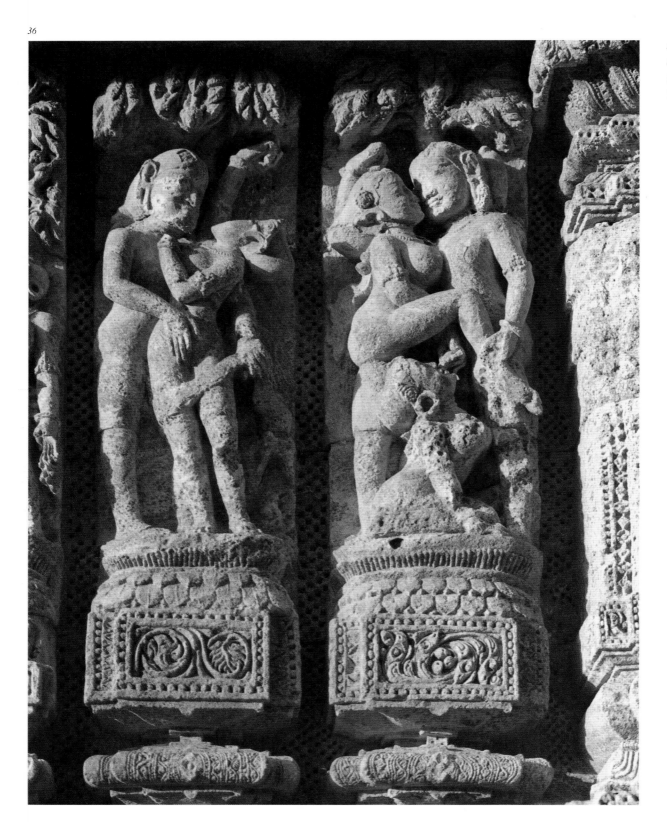

36. Detail of the erotic scenes adorning the central platform of the Sun temple at Konarak. Thirteenth century A.D.

Although still essentially Persian in taste, the Mogul style was largely Indian, showed traces of Turkish influence, and echoed European art, especially in the perspective and relief effects of miniatures (see figs. 366, 368, and 371). Miniature painting developed enormously in the Mogul period and became one of the best and most widespread forms of art, even though it was executed in specialized and partly industrialized workshops by many different artists, some of whom did the designs, some the coloring, and some the faces. A significant symptom of the great change that took place at that time is the fact that art was no longer anonymous. The court records bear the names of such famous miniaturists as Basawan, Daswanth, Mir Sayyid 'Ali, Abd al-Shamad, Miskina, and Abu'l Hasan. A practical administrative necessity impelled the artists to make sure that the attributions were correct and that each was credited with the part he had contributed to the making of the miniatures or album paintings. This, however, was not the only reason for their interest. The Islamic regard for personality also had something to do with it. Some of these painters acquired great fame and prestige, and the modern critic will have no difficulty in realizing that the reputation they enjoyed was far from undeserved, despite the tendency to industrialization, with teamwork and serial production. Mogul miniature painting is a veritably independent facet of Indian painting, even though for a long time Western scholars stubbornly continued to consider it a sort of Indo-Iranic hybrid.

The European element which shows in some artists' copies after Dürer or after Italian artists whose works they had seen in prints or reproductions, surprising as it may seem, is still but a negligible aspect, for the scientific perspectives in landscape paintings, the modified palette, and the different visual approach did not really change the essential characteristics of Indian taste. Furthermore, the study of Western perspective was never carried beyond the stage of a mere formal enrichment, of a novel experience that never went very deep, for the schools of miniature painting that flourished from the sixteenth to the eighteenth century (see figs. 40 and 385) and in some cases down to the first half of the nineteenth century always reverted to traditional rather than foreign solutions. These were studied, understood, and finally rejected as being unsuitable to the aims and taste of Indian painting.

Nevertheless, the Western element is important for certain reactions that it stimulated, which are extremely interesting from the historico-critical viewpoint. For instance, the Rajput school of miniature painting (see fig. 393), coeval with the Mogul school, represents a pictorial tendency that is opposed to the court academicism of the Mogul painters because it reacted to both Islamic and Western elements. The Rajput school, which was divided into two main trends (see figs. 380 and 394), those of Rajputana (Rajasthani) and Himalaya (Pahari), was in fact the resurgence and reaction of the village artists against the academic, stagnant court production, not only that of the imperial court but also that of the courts of the dignitaries and minor sovereigns who were vassals of the emperors. That is why in the infinite variety of its styles it had always a freshness and vivacity which Mogul art never again attained after the period of the great emperors. On the other hand, the Rajput and the southern Deccan currents, as well as the Indo-Muslim tendencies, could avail themselves of a great many models, ranging from the simple, popular forms that survived in the pictorial tradition of the smaller towns—almost a village art—to those of the great and truly Indian pictorial tradition. Besides, they could draw from the Islamic and Mogul innovations that had been accepted and assimilated by a different but still truly Indian taste. For this reason some of the miniatures of the Indo-Muslim schools may seem to be provincial variants of the Mogul style, but most of them are the antithesis of works by the imperial painters in design, palette, and even subject.

This difference or, better, contrast so evident in painting is not equally apparent in architecture because of the lesser importance of the Rajput and Maratha architecture in the ambience of Indian art. Agra (see figs. 347–352), Delhi, Lahore—all the great centers of the Mogul empire reveal the emperors' wish to create religious and secular buildings worthy of their power and of the splendor of their courts. Elsewhere, instead, functional considerations prevailed, and in the south—at Bijapur, Golconda, and Gulbarga—massive, less refined monuments were built with enormous bulb-shaped or ribbed domes which may have been the world's largest but which certainly had none of the lightness and elegance attributed by general agreement to the best architectural works of the Mogul period. The whole of Muslim and Hindu India is symbolized by the Taj Mahall in Agra (see figs. 359–365).

The most widely known of the Mogul monuments, the Taj Mahall is the marble memorial built by the Emperor Shah Jahan in honor of his favorite wife, who died in childbirth in 1631. This architectural gem combines Persian, Indian, and Turkish elements and, in its general structure as well as in its inlay decoration, also Western, especially Venetian, elements. Geronimo Veroneo, a Venetian architect who worked on it, transfused inspirations from the villas of the Veneto into the Taj Mahall's perspective effects and the relationship between its structural masses and the huge anterior gardens, while in its marble inlay he exhibited some of his ability as a goldsmith. A Frenchman, a Turk, and some Indian artists collaborated with him, but probably the real author of this marble dream, of this unique wonder in Eastern and Western art, was Shah Jahan himself, who never recovered from the loss of his beloved and remained on the throne, unable to smile and prematurely white, only so that he might complete the monument that would remind the world forever of his lost love.

With the slow decadence of the empire and the increasing foreign domination, first of the East India Company and then of Great Britain, India lost confidence in its artistic ability. At the beginning of the nineteenth century, the Mogul, Indo-Muslim, and Hindu traditions were only half alive. The prestige of the Western figurative techniques

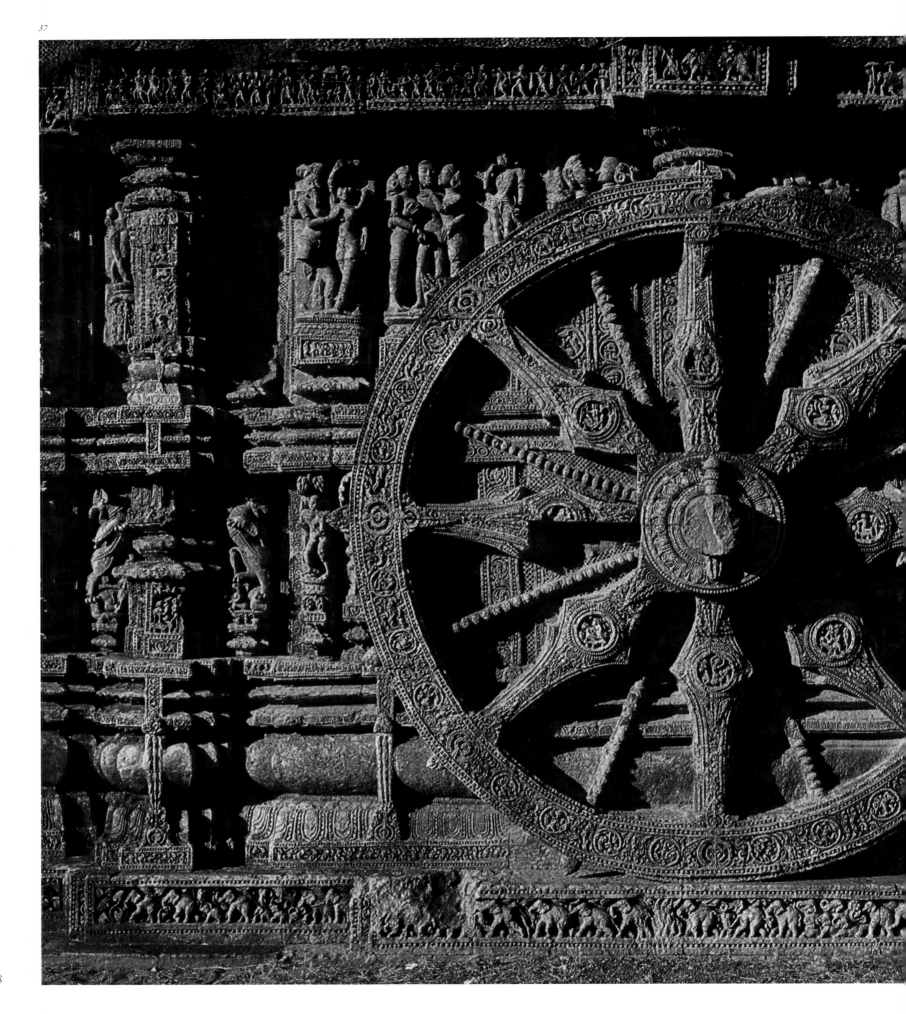

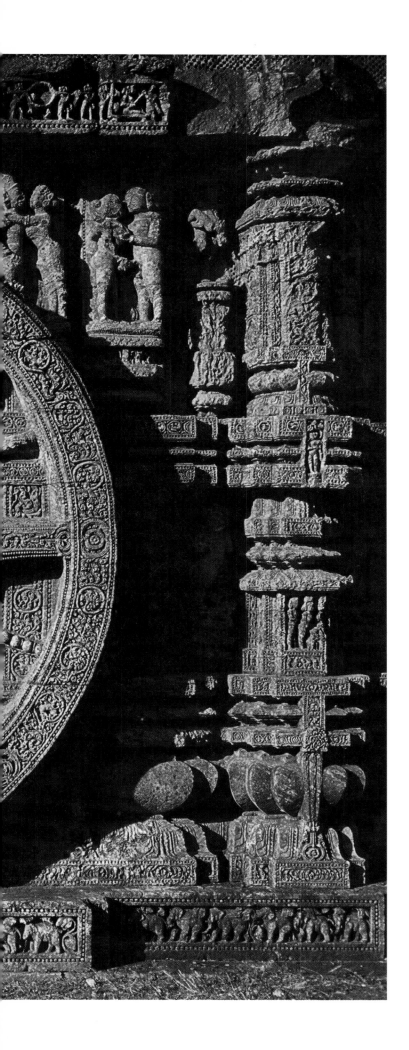

37. *Detail of the south side of the platform supporting the large ruined sikhara, or spire, that belonged to the Sun temple at Konarak. On this platform stood the central construction, over 210 feet high, which imitated the Sun's chariot and was surrounded by twelve wheels, each about 30 feet in diameter. The entire construction was in the form of a processional chariot. Thirteenth century* A.D.
The sculptural decoration consists mainly of erotic couples in very vivid and obvious poses (for example, fig. 36). For this reason the Konarak Sun temple has been nicknamed 'the Black Pagoda.'

38. *Side view of one of the horses on the south side of the Sun temple at Konarak. Thirteenth century* A.D.

38

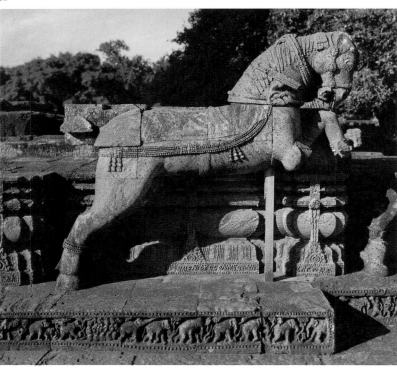

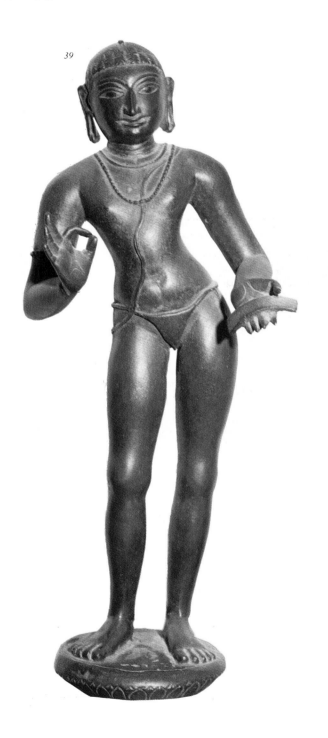

39

was overwhelming, as was England's superiority in the military field, in science, and in technology. Besides, there was the need to adapt Indian art to the strictly conservative taste of the foreign residents. At that point, however, the echo of the deep impression that Japanese block prints had made on the progressive artistic milieus and particularly on the best French painters reached freedom-seeking India, and the modern phase of Indian art began. Through the work of Rabindranath Tagore and all the other enlightened minds who felt more heavily than others the burden of foreign rule, the artists attempted to revert to the glorious traditions of the past. First they drew from the Mogul pictorial tradition as being the closest in time and, in a sense, the one that was still alive. They also felt that the perspective, color, and design of the Mogul miniatures could supplement the teaching that the Japanese block prints had given Westerners and help them free themselves completely from the classicistic and academic approach.

A mere revival of an old-fashioned tradition, however, was impossible. The attempt was bold but also ineffectual, because it took no account of the widespread spiritual ferment that was brewing in the West. Hence it failed, and so also did the second attempt, which consisted in reviving the forms created by the anonymous painters of Ajanta and of the murals adorning the walls of the medieval temples that were then thought to be the sole examples of the truly Indian tradition. Lacking the religious impulse and the symbolic values of the old, misinterpreted forms, this effort amounted to a momentary experiment, which was soon abandoned to seek an artistic expression that would suit the social and political developments of this enormous country driving toward inevitable freedom. From the West, new approaches and tendencies kept reaching India. Still seeking independent expression, especially through the work of great artists such as Jamini Roy, present-day India is fully participating in the contemporary trends, facing problems and evaluations for which its millenniums-old experience may seem to be worthless, save for its historicocritical value.

It is possible that, once it has been able to establish clearly the new requirements of the perpetually evolving peoples that form the two large nations of the Indian Union and Pakistan, Indian genius will once more offer mankind new forms and new stylistic and iconographic values, as it did for thousands of years in every field of figural art. In order that this may happen, however, fresh, lively sources of inspiration must take the place of fading religious values, especially among the better educated. Or another possibility is for Indian religiousness to take up new, vital, and world-acceptable aspects that can be translated into art. And this is perhaps the more likely alternative.

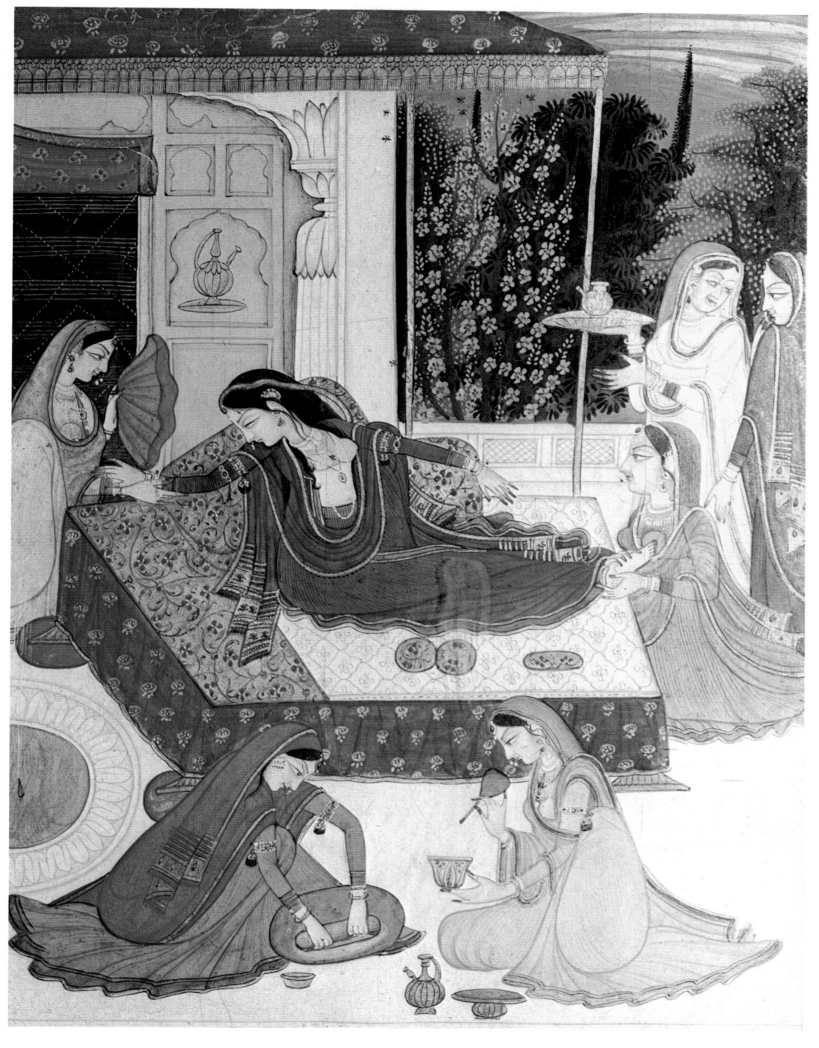

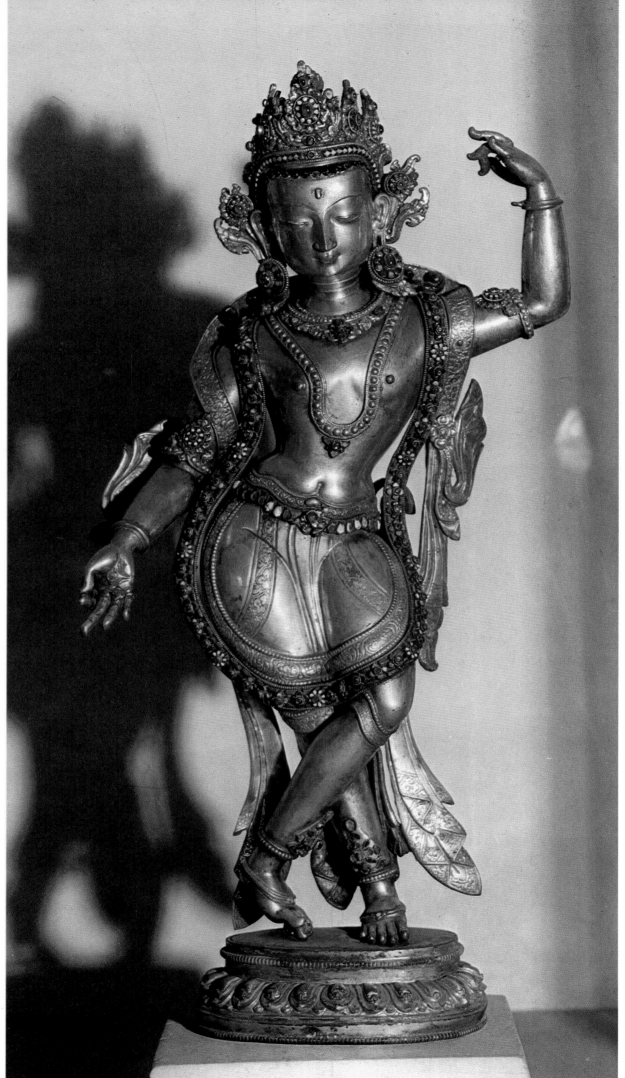

41. *Tara. Gilded statuette set with turquoise and semiprecious stones. Nepalese, eighteenth century* A.D. *Prince of Wales Museum of Western India, Bombay*
The crowned, bejeweled goddess is in the act of dancing. Whether white or green in complexion, Tara is probably the first Buddhist goddess that is not linked with other religions. Although it is possible that two historical personages, the two wives (one Chinese and one Indian) of a Tibetan king, Srong-tsan Gampo (A.D. *629–650), contributed to her definitive form, the cult of Tara is certainly much older. She is the woman's 'flavor' that helps one through life to the Absolute, dispelling physical and metaphysical fears and permitting one to satisfy all one's desires.*

2. Early Indian Civilization

by Mario Bussagli

Evidence of the first phases of human existence is to be found throughout the Indian subcontinent, now politically divided into two large states: the Indian Union and the Republic of Pakistan. The early presence of man in this geographic area, which was then different in shape, extension, configuration, and climate, is demonstrated by roughly made stone handicrafts of a type which seems characteristic of the so-called Soan (or Sohan) culture of the Asian world, a culture which lasted for several hundred thousand years. The manufacturers of these objects, tools fashioned of pebbles smoothed down by the rolling waters of rivers, were probably anthropoid beings similar to the Javanese *Pithecanthropus* or perhaps to the Peking *Sinanthropus*. It is certain that the northern Indian regions, which even then were no longer submerged, bear traces of four glaciations synchronous with the European and American glaciations, whereas in the southern regions rainy seasons must have alternated with periods of extreme drought, causing the modern geographic physiognomy of those parts. This climatic difference accounts for the fact that, while the northern cultures (for example, those of Kashmir) have the characteristic alpine-glacial aspect that is well known in Europe, in the Madras area there developed a well-defined and fairly evolved autonomous culture undoubtedly related to the so-called Oldowan culture, typical of East Africa (L. S. B. Leakey, in *Nature*, CCII, 1964, pp. 7 ff.; Leakey et al., *ibid.*, pp. 5–7). In the course of time, there also developed in India a remarkable variety of prehistoric cultures probably associated with different humanoid or human types, and the manufacturing processes for the products in stone became better and more refined. In some cases remarkably large human groups covering fairly extensive geographic areas remained fixed in the lithic production until a very late date. For this reason, it is better not to venture an opinion, despite the existence of arms and tools similar to those of the European Chellean and Acheulean cultures and the possibility of identifying phases of the Levalloisian tradition in the upper Godavari, at Tirapalli, in the Singrauli Basin, along the Narbada, and in other southern parts where the alternate recurrence of rain and drought is very pronounced. To draw definite inferences from apparent analogies with foreign cultures when there are no proofs—first of all, radiocarbon tests—to support them is unjustifiable. On the other hand, art historians have not so far found elements of great interest in these very early phases of human life on the Indian soil. The few remaining traces of prehistoric paintings are hard to date and probably very late. The cliff carvings, despite the opinion prevailing only a few decades ago, are late, often dating from the end of the pre-Gupta period and therefore from a fully historic age. Of no great figural value are the drawings, schematic in type (not to say 'stylized' in relation to such rough works), made on rocks with hematite (ferric oxide), sometimes heightened with other colors—light green and yellow and brownish red. Their dating depends on apparent associations with Mesolithic and proto-Neolithic objects and is debatable since it cannot be satisfactorily proved. According to the research of various scholars, between the Paleolithic and the Neolithic ages mankind disappeared completely from Indian territory as a consequence of disease and pestilence resulting from violent climatic changes. Unquestionably, there was a substantial decrease in the already scarce demographic density, so that the microlithic culture (characterized by stone products of diminutive proportions) must have been introduced by a series of migrations passing through Baluchistan from unknown areas. These migrations are supposed to have repopulated the Indian territory and introduced the Mesolithic phase. It is a fact that the Indian microliths, analogous to and perhaps contemporaneous with the European ones, bear a particular resemblance to the Syrian and African products of the same kind, whereas they differ greatly from the so-called sand microliths to be found from Chinese Sinkiang in Central Asia to Manchuria and the borders of the Gobi. This suggests the possibility that the repopulating migrations may have come from the west.

Thus we come to the earliest protohistoric cultures organized into villages, acquainted with agriculture and ceramics, sometimes capable of vast trade, and living a life which was the direct and necessary premise to present-day civilization. These cultures, which developed in the fourth millennium B.C. (late by comparison with Egypt, which had already evolved a protodynastic structure, and with the oldest Mesopotamian and Iranian cultures), covered an extensive region of the northwest and stretched out into the area where the first great Indian civilization, known for its two large metropolises, Mohenjo-daro and Harappa, was to bloom. In their attainments, these protohistoric cultures always interacted with those of Iranian derivation and the autonomous local currents that the former had given rise to and that consisted in highly refined artistic works, such as elegantly shaped vases with marvelous paintings on them (see figs. 42–44), which in many cases can rightly be called Indian. Lack of cohesion and fragmentation into a multitude of small centers made these early cultures into a sort of protohistoric 'Greece.' The scattered larger villages developed independent cultures, but, as was the case in Greece, they were joined in a kind of interterritorial unity which made their bearers conscious of their cultural characterization and collective originality fostered by trade and contacts. No sense of challenge to the 'barbarian' strangers—whoever they may have been—is apparent because there was no isolationism. In the west of India, different but related cultures bear witness to the existence

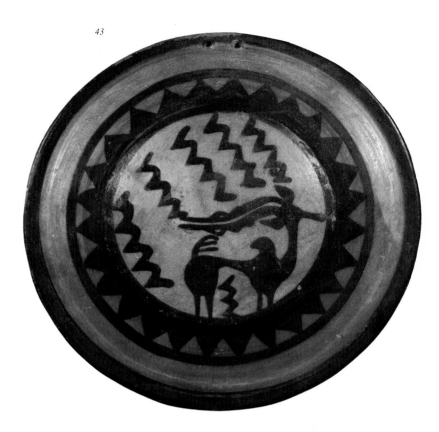

43. *Plate with two holes in the border and painted decoration on the inside surface. Red slipped terra-cotta with black paintings. From Harappa, third millennium* B.C. *National Museum, New Delhi*
In the middle is a highly stylized figure of a stag with abstract decorative motifs providing an effect of space.

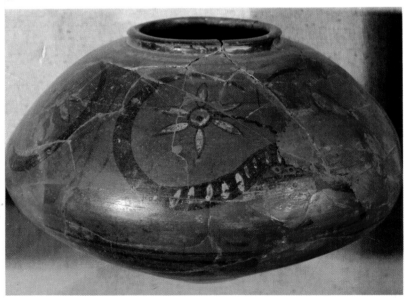

42. *Biconical vase. Slipped terra-cotta. From Kot-Diji, first half of the third millennium* B.C. *National Museum, Karachi*
On the dark red background are represented bull or buffalo heads with large curved horns forming an ornamental motif. Six-petaled white flowers are joined to the animal heads, which are represented frontally. This is a rather rare figural convention at such an early epoch.

of human groups less active and perhaps not so well organized but still advanced enough to belong to the same evolutional level. The culture of Rana Ghundai, which a number of scholars, among them D. H. Gordon (*The Prehistoric Background of Indian Culture*, Bombay, 1958), include in the larger denomination of Loralai, descends in five subsequent phases down to the first millennium B.C. At first this culture had remarkable analogies with that of Hassuna, the greatest of the Mesopotamian protohistoric cultures, but later it drew closer and closer to the production of Tepe Hissar, a large Neolithic center in the Iranian highlands south of the Caspian Sea. The most often recurrent images on pots from Rana Ghundai are those of humped bulls whose crescent-like horns are represented frontally although the animal is in profile. Series of parallel lines frame or enhance the figures. The subject is unquestionably Indian: its highly stylized treatment is unrelated to the Iranian production and constitutes a group bypassed in the subsequent evolution of Indian art.

Another very old culture, that of Quetta, shows links with the Iranian production both in its geometric motifs and in the chalice-shaped pottery. However, blotchlike—and often radial—decorations are proof of a different color vision. From the Mesopotamian world it borrowed the 'step-pinnacle' motif.

Amri, a large center in the vicinity of the Indus Valley, favored chessboard motifs, concentric ellipses, and other geometric patterns without, however, neglecting the stylized animal figures whose bodies were rendered in a marked pointillism or in strokes particularly suited to the emphasis of characteristic attributes, such as the lion's mane.

The other coeval culture, that of Nal Nundara in Baluchistan, shows a more realistic trend in its figural production with a vast repertory of animal figures and a few geometric motifs; it was probably the outcome of an infiltration of new peoples. Some of the Nal motifs were to pass unaltered into the ceramic production of the Indus civilization, both at Harappa and at Mohenjo-daro. The most refined stylizations, however,

are those of the pottery painting of the Kulli culture that flourished in South Baluchistan. Here, again, the humped bull *(Bos indicus)* is the predominant motif appearing in the compositions, flanked by goats. The main figures are enormously elongated, colored in blotches, and surrounded by stylized plant motifs suggestive of landscapes. The elongation may be an influence of the highly stylized 'running' dogs which occur so frequently in the earliest pottery painting of Susa and, therefore, may be of Western origin. However, in the Kulli ware the animals are presented in landscapes, obviously because they were regarded as images derived from a complex reality rather than as abstract motifs. Furthermore, the blotchlike coloring, which makes the paintings seem heavy and static, shows that the foreign influence, if any, must have been greatly reelaborated by the unknown artists of Kulli. It is not unlikely that the keen observation that characterizes all the early great art of India, and was supported by the religious thinking, traced its roots directly to the creations of the Kulli ceramists. On the other hand, this culture cannot be measured by the same criteria that are used for the other similar cultures since, for all its ignorance of writing and lack of ability to create towns proper, it was unquestionably very complex, technically advanced, and sensitive to spiritual problems. Its bearers must have been widely traveled people and able merchants since their particular, unmistakable products of both stone and bone found their way to the West, reaching such distant regions as Mesopotamia and even Syria. In the cultures of Amri, Kulli, and Nal Nundara—the last

in its later phases was influenced by both the former—a metal production appears which dates at least partly from the Neolithic age.

The great period of the northwestern cultures had no echo beyond the Indus or in Kashmir, although places in western Central India, such as Jorwe, Nasik, Rangpur Navda Toli, and others, had a typical ceramic production, sometimes decorated with paintings, that very closely resembles the Iranian production of the third millennium B.C. in shape, ornamentation, and style. The analogy is probably the result of a direct Western influence, a very important element in the study of Indo-Iranian relations antedating the beginning of historical times.

We do not know what the social organization of the large northern villages was like, but it must have been very complex if it allowed the contemporaneous development of agriculture and trade, fishing and sailing, crafts and cult. We do not even know whether these villages were confederated or simply linked together by coexistence, alliances, friendships, and enmity. The fact remains that neither the bearers of the local cultures of Baluchistan nor those of other neighboring protohistoric cultures were able to make the transition from the associated—though not so well balanced as it may be thought—life of the village to the less unitary life of the city fractioned into innumerable specializations. Yet various elements existed to facilitate the transformation, starting with the common religious beliefs based on the cult of the Great Goddess (see fig. 1), which extended over an area of more than a hundred thousand square miles; the extent and variety of trade; and, finally, the

44

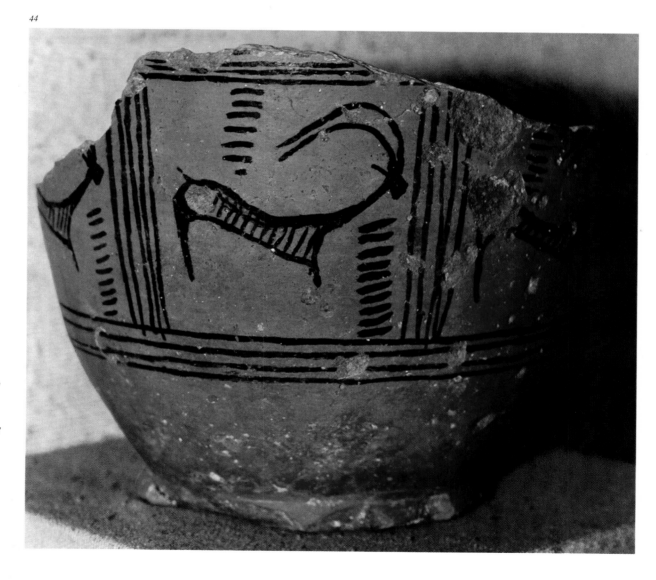

44. *Fragment of a red terra-cotta vase. From Mohenjo-daro, third millennium* B.C. *National Museum, Karachi*
The black decoration on the slip consists of stylized goatlike figures (ibexes), framed within panels and completed with strokes suggestive of space. The body also is depicted in strokes showing the different colors of the hide and following the figural tradition of Kulli.

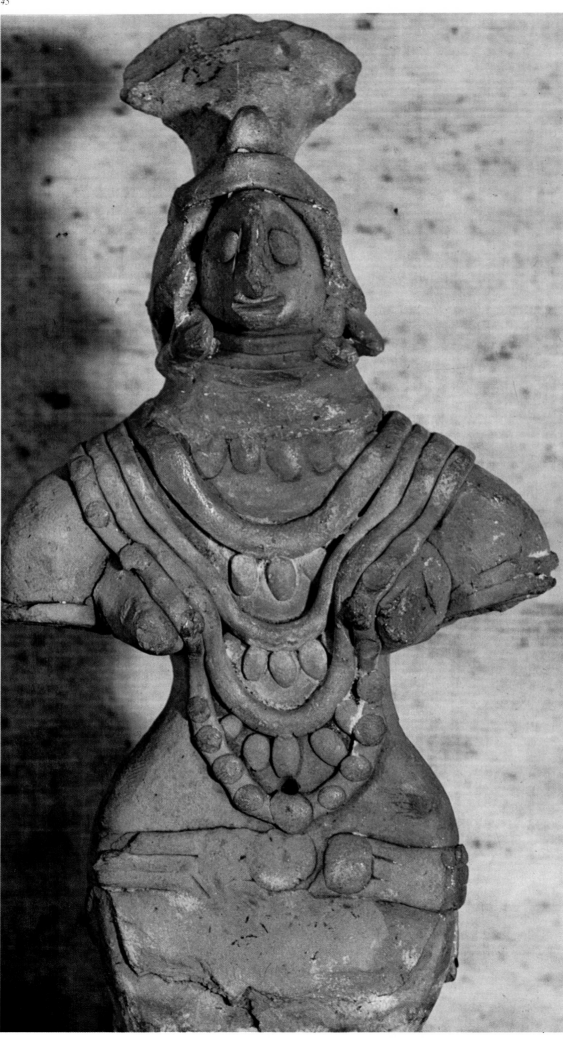

45. Female figure. Gray terracotta with traces of polychromy. From Mohenjo-daro, third millennium B.C. *National Museum, Karachi*
The highly stylized figure, characterized by a tall headdress, a rich series of necklaces, some around the neck and some pendent, and a girdle, may suggest a mother goddess and is probably a figurine of the household cult.

46. Male bust of calcareous marble. From Mohenjo-daro, third millennium B.C. *National Museum, Karachi*
Unquestionably a priest, as is demonstrated by the cloak covered with sacred trefoils, which must have been finished with inlays, probably of semiprecious stones. The subject may even have been a king-priest. With its elongated face and fluent, stylized beard, its slit eyes and thick, sensuous lips, the work may recall the statuary of Sumer, though it is basically an original creation.

sameness in the level of the various cultures. Obviously, what was lacking was the drive; for, by comparison with Egypt of the Pharaohs and the governmental structures of Sumer and Akkad, the society of Baluchistan appears unquestionably less united and not so inclined toward the formation of complex organisms.

The transition was made almost naturally in a notably different ambience by human groups culturally linked to those of Baluchistan. The city was created by a riverain civilization with characteristics markedly different from those of any other in Asia or Europe. Probably it grew in successive stages. Kot-Diji, the recently discovered oldest center, seems to represent an evolutionary stage midway between the cultures of the north and the Indus Valley civilization. The pottery of Kot-Diji (see fig. 42) is earlier than that of the Indus civilization; it shows strong similarities to that of Baluchistan and may be dated about 2800–2700 B.C. The city has a large citadel rising above the houses, encircled by thick defensive walls of unbaked bricks and uncut stone. About four hundred years after it was founded, Kot-Diji was razed to the ground in warfare. Obviously, the passage from 'culture' to civilization proper took place by degrees. There is no need to refer to the Mesopotamian influence to explain the existence of the large metropolises, especially since the plan of the Indus Valley cities is different from that of any other contemporaneous center. It is more likely that environmental difficulties and economic reasons caused certain social groups—traders, warriors, etc.—to prevail and, thanks to their acquired wealth, to effect the rapid transformation.

The Indus Valley civilization had two main centers, namely, the northern metropolis uncovered near the village of Harappa and the southern metropolis lying halfway down the river and called by the modern name of Mohenjo-daro (the hill of the dead); these were accompanied by a multitude of smaller towns, by the town of Chanhu-daro, and by a port which now lies inland because of the alterations that have taken place along the coast. This port, Lothal, about 220 yards long by 40 yards wide, was provided with large brick dry docks, dams, and loading facilities at different levels. In area, this civilization covered all the valley of the Indus up to the source and, at the sea end, extended widely along the coasts, reaching out toward the Iranian regions. Meerut and the peninsula of Kathiawar were within its boundaries. Its economy relied on cotton production and control of the waters. Trade was enormously developed. In direct contact with Mesopotamia and Egypt, it imported jadeite from Central Asia, lapis lazuli from the Himalayan regions and the area that is now called Afghanistan, and gold from Mysore. Its mixed population included alpine European types, Austronesian people, and perhaps Mongol minorities. The fact that Brahui, a Dravidian language which is also to be found in Iranian territory, is spoken there today may be imputed to a very old migration from the south, responsible for the ethnic characteristics of the Indus Valley people. On the other hand, the pictographic writing found on the innumerable seals (see figs. 49 and 50)—perhaps amulets, sacred tesserae, or even mere signs of proprietorship—is very similar to that of Easter Island, despite the gap in time and distance. Consisting of 240 different signs, it was deciphered in 1969/70. With the assistance of computers, Finnish and Russian scholars have identified the language of the Indus writing as proto-Dravidian (i.e., as a southern language).

Thorough examination of the finds suggests that the Indus Valley civilization—also called Harappan—must have been the product of a rationalistic and commercial society, highly organized and stratified into classes which must have corresponded to the different ethnic groups forming it. That it was a highly planned society is demonstrated by the

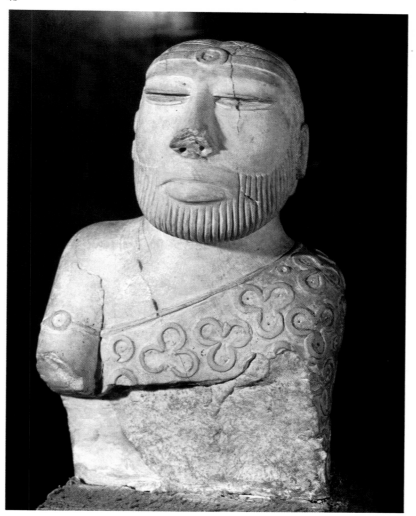

design of both major and minor towns; these are grid-shaped with the main thoroughfares crossing at right angles and the side streets also intersecting in the same manner and refreshment stations for the caravans in transit located at the busiest crossroads on the farthest outskirts. The citadels with their thick walls standing on man-made flats of beaten earth must have been the seats of the civic and religious powers. The absence of religious buildings proper and the presence of large public baths which could have served for religious rites have suggested a special cult of water both as a ceremonial medium and as a symbol of the divine essence. From the technological viewpoint, the civilization of the Indus Valley, with the exception of Kot-Diji, appears to have been a complex and highly developed but static creation, to judge from the few variations that its history offers. At the inception, it was probably Chalcolithic but soon became Aeneolithic. Its high technical standard, undoubtedly superior to that of Mesopotamia, is apparent from the clever and practical system of drainage built to collect the refuse liquids of the houses and carry them to the main sewers. The brick houses do not display much aesthetic care but are highly functional. They consist of two or three stories in which sloping brick corbeled vaults take the place of arches, and the whole architectural structure conforms to criteria of practicality. Brick is everywhere, to such an extent that the gradual deforestation resulting not only from the need to feed the brick and metal furnaces but from a change in the course of the river may have contributed to the end of this civilization. Chance finds of structures from the Harappan civilization, which were

not understood and were soon forgotten, enabled the British engineers building the northern railways to strengthen the track ballast with bricks from a remote world of whose existence they were unaware and the importance of which they did not even suspect, though the quantities that they were using might have suggested a productivity infinitely superior to that of any other archaic civilization.

To judge from the available data, the figural production of the Indus Valley civilization was never bent on the grandiose, nor did it ever seek spectacular effects through the size of its works, which, on the other hand, show remarkable diversity of aesthetic quality.

Religiousness was frequent and deeply felt, as is demonstrated by the innumerable figurines of the Magna Mater, the Great Goddess (see fig. 1), which link the world of Harappa and Mohenjo-daro as well as that of the smaller towns and villages to the peoples of the north. Confirmation of the spread of religious feeling comes also from various seals, such as one with the figure interpreted as a proto-Siva or, according to recent research, possibly as a female divinity, and others of female beings with apparently symbolical associations with the vegetal and

animal worlds, to say nothing of the figures of fantastic or 'masked' animals (see fig. 49a) that often occur in the Eastern world to express a vast gamut of symbolic values and, above all, the indistinct and the chaotic from which spring order and life. However, the men of the Indus Valley civilization chose not to associate the gods that they adored with their group existence as the Western civilizations did, assuming, instead, that the destruction of a town or people occurred with the death of the god that presided over it. Even though horribly gloomy nightmares haunted those men and women exposed to the perils of a luxuriant nature, the whims of the river, the hardships of collective work, the risks of the interminable caravan trails and unsafe river navigation, along the Indus the concept of the divine was identified with the life of the universe itself. Consequently, it was supinely accepted when it turned malicious and destructive and extolled when it granted riches, livelihood, and pleasures. This is why the art of the Harappan civilization as it appears in its diminutive sculptures is the only prehistoric art that pursued realism, foreshortening, and the illusion of natural movement, a completely different matter from the whirling

47

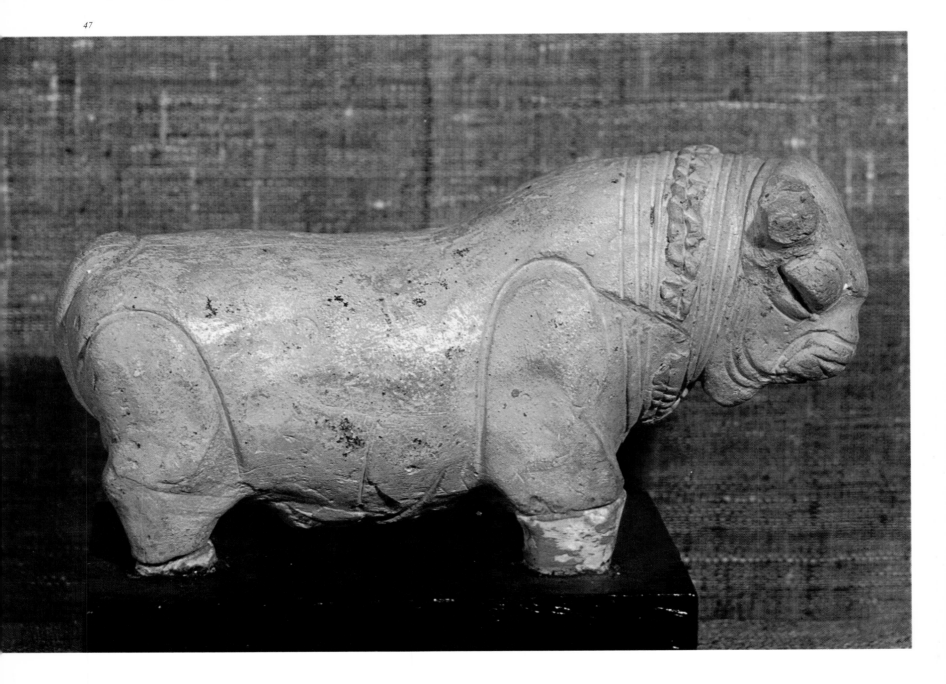

movements of figures shown turning on their own axes and possibly suggested by the use of the potter's wheel. Whereas the Egyptians and the Mesopotamians rejected these values, the artists of the Indus Valley pursued them with gusto, studied them tenaciously, and through them demonstrated their acceptance of reality, life, and the world. Proof of this attitude is a bronze statuette of a girl dancer at rest (fig. 2), dressed only in her jewels, which, despite marked stylization, shows perfect knowledge of the human body in its attitude of rest. Merged into space so that it is effective from all angles, its Negroid features are no less well rendered than are its necessary foreshortenings. The figure, by the way, was cast in an alloy of copper similar to the bronze of Sumer, whereas for other objects arsenic alloys were used. The same vision that created the dancer was the guideline for a male dancer's torso, acephalous and lacking the arms and parts of the legs. This gray stone statue, which perhaps represents a tricephalous, ithyphallic god, was made mobile with articulations and pulling devices. The artist who carved it was not only perfectly acquainted with the subject of the human body and its anatomical structure but was also a master of foreshortening. This

ability bespeaks a figural richness that is absolutely unique at such an early epoch and the more appreciable in so far as it was backed by a figural vision largely based on a religious attitude unlike any other of the time. Another torso (fig. 3), powerful despite its minute proportions, represents in red sandstone a naked man and shows such a deep knowledge of anatomy that many have doubted that it is a product of the Harappan civilization. Actually, it reveals such a profound desire to adhere to reality without idealizing it—though transforming it into a universal value—that there is no reason to question the attribution. Its adipose, sagging abdominal muscles testify not only to the artist's attentive pursuit of realism but also to the subject's identification with a human type characteristic of the earliest peoples of India. Proto-Indian sculpture, therefore, achieved the illusionary technique of foreshortening and the figural knowledge of human anatomy long before Greece did. It is also possible, however, that both the proto-Indian and the Greek achievements were attained along the same lines.

Yet, despite inventiveness and the richness of its illusionary devices, the art of the Indus Valley received the influence of Sumer. Evidence of

47. *Fragment of a terra-cotta bull. From Mohenjo-daro, third millennium* B.C. *National Museum, New Delhi*
The short-muzzled animal with thick, creased dewlap has an ornament around its neck. Executed with extraordinary realism, it is one of the best works of the Indus Valley potters.

48. *Small head of red terra-cotta. From Harappa, third millennium* B.C. *National Museum, Karachi*
From a figurine connected with the cult of the mother goddess. Despite stylization, thick coiling braids and a peculiar—probably symbolic—headdress can still be clearly detected. The eyes are superimposed disks.

48

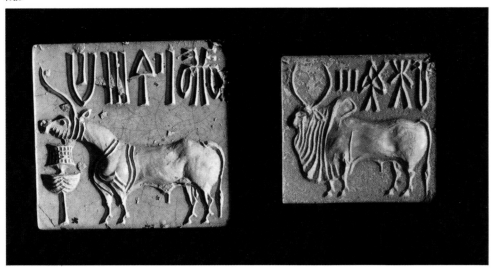

49ab

49. Seal with a 'unicorn' and ritual objects (a). Another with a humped bull and pictographic writing (b). From Mohenjo-daro, third millennium B.C. National Museum, Karachi
The seal representing the big humped bull with crescent horns and thick, heavy dewlap (b) is one of the most striking artistic creations of the Indus Valley civilization. The other, bearing an imaginary animal with a single horn (a), is probably a symbolic figure associated with particular rites. Note the suggestion of a saddlecloth. The two objects under the animal's muzzle are also related to some unknown rite, perhaps connected with purification and water. Maybe they provided the exact meaning of the symbolic composition.

50. Four steatite seals from Mohenjo-daro. Third millennium B.C. National Museum, Karachi
The largest seal (a) represents a goddess among the leaves of an asvattha tree. The hairdress is suggestive of a lunar divinity. In the foreground a similar figure in adoration seems to be dragging a bull-like being with a half-human head and zigzag horns to be sacrificed. Seven attendants in characteristic costumes follow. A 'unicorn' with a saddlecloth (b), a man on a bench in a yoga posture (c), and a creature with three heads (d)—a bull's, a 'unicorn's,' and a 'goat's,' respectively—are represented on the other three seals.

50ac

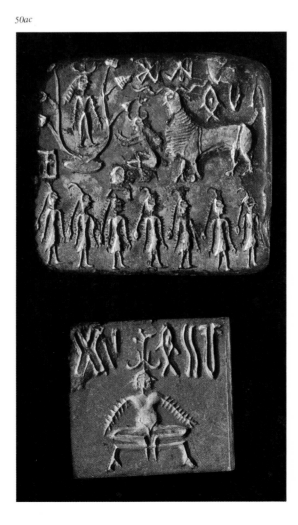

50bd

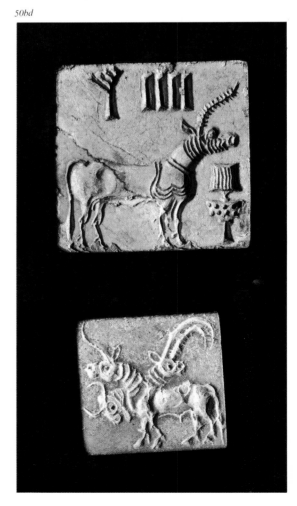

50

51. Miniature draw cart with a female figure. From Mohenjo-daro, third millennium B.C. National Museum, Karachi Probably a terra-cotta votive object or else—though this possibility is less likely—a toy. It consists of the body of a cart, on the front edge of which a nude female figure is squatting, and of two zebus and the two wheels of the cart, each about 1⁵/₈ inches in diameter.

52. Figurine of red terra-cotta. From Mohenjo-daro, third or second millennium B.C. National Museum, Karachi The figure represents a human being with pronounced bosom and male sexual organs clearly visible, despite breakage. It is probably an androgynous being, a figure connected with the orgiastic rites typical of the Indus civilization, according to the Mahabharata *and the* Vedas.

52

this is a bust of a man with markedly Sumerian facial characteristics and a hairdress that resembles the helmet of Meskalamdug, wearing a cloak decorated with inlaid trefoils (fig. 46). This figure and other such works show that there was an acceptance of foreign traditions and an interest in strange types. Obviously, a long habit of communication and trade made the people of the Indus very flexible in their tastes and able to appreciate foreign figural trends. On the other hand, since at least eight seals of the Harappan civilization have been found in connection with sure or probable Sargonid archaeological strata, exchange with Mesopotamia must have been twofold. In fact, a close look tells us that the best works of the Indus people were the steatite seals (see figs. 49, 50, and 57). The figures depicted on them of humped bulls, treated with thorough knowledge of anatomy and of the effects that can be obtained from bas-relief, those of the urus ox (the so-called unicorns), and other realistic animals, whether 'masked' or not, are at the root of that animal art in which India has excelled at all times. And it is important to note that the symbols before the humped bull (fig. 49b) and the 'masked' animal (fig. 49a), with its fake trunk of woven ropes and a tiger's skin on its back, have precedents in the pottery paintings of Kulli. Whether the symbols represent a sacred manger or implements associated with the purification and aspersion rites of the sixteen different qualities of water (as in much later Indian rituals for royal consecrations), the Harappan civilization and the cultures of Baluchistan were certainly linked in religious thought. In historical times India derived some of its main religious motifs from the Indus civilization—the cults of Siva and Kali, of the tree divinities, of certain sacred trees (the pipal, the *Ficus religiosa,* and the neem or nim, that is, acacia), of some animals (the cobra, the bull, etc.), and even of sexual symbols alluding to human and animal fecundity, the fertility of the earth, and the flow of life.

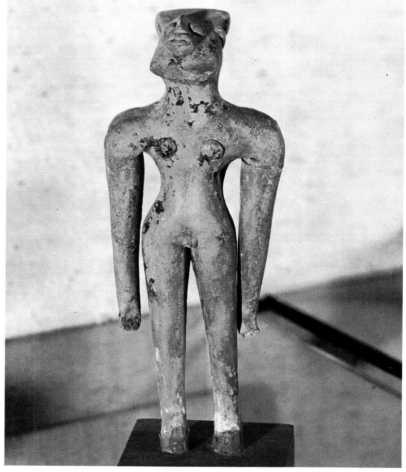

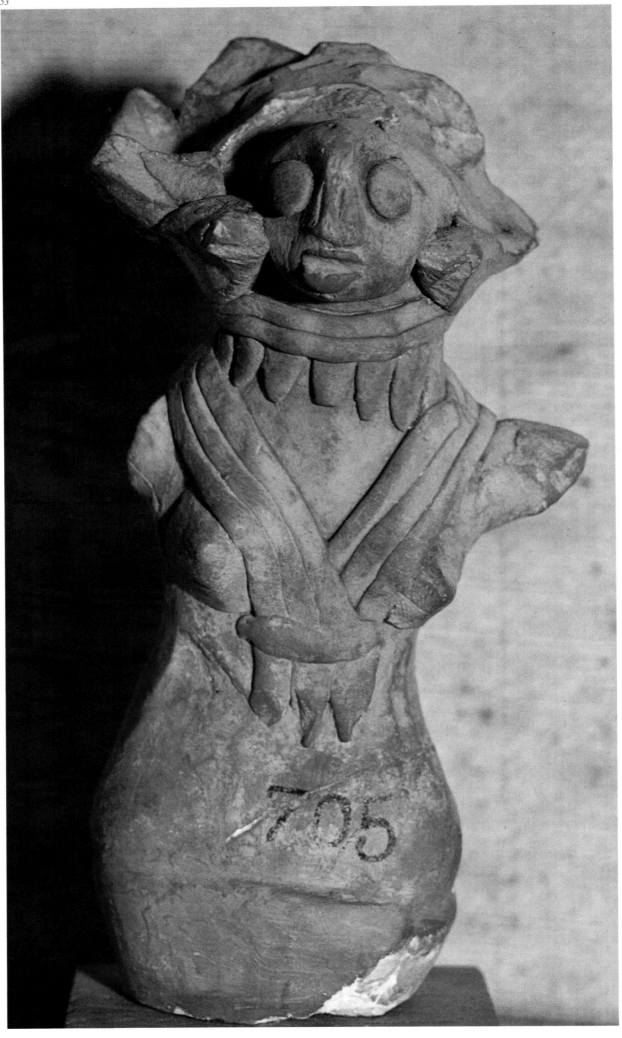

53. Female figure with both round-the-neck and scarflike, pendent necklaces. From Harappa, third millennium B.C. National Museum, Karachi

As to the minor arts, artisan industrial production was certainly uncommonly advanced; of lesser importance was ceramics—in black and red or in blue and white—with designs of four-petaled flowers and intersecting circles typical of the products of Tell Halaf. Despite the preference for geometric ornamental motifs (see figs. 43 and 44), the shapes of the vases occasionally reveal a similarity to the wares of Baluchistan, though on the whole they are original. Prevalence of a rough, monochrome ware confirms the decline of ceramics. In the field of goldwork (fig. 58), of which there are very few examples, the artists of the Indus paralleled all the other specialists of the epoch. Gold and silver were widely worked; both the lapping technique and the Classical lost-wax (cire-perdue) process were known, and semiprecious stones, with a preference for agate, were extensively used (see figs. 58 and 59).

The end of the Harappan civilization was brought about by a series of environmental alterations. Gradual but substantial deforestation caused a profound transformation in the flow of waters, which already constituted a menace to the organized life of the industrious Harappan people. A stratigraphic study of Mohenjo-daro shows that the city was seven times destroyed by floods caused by the steady rising of the river's bed, the changing profile of the banks, as well as the excessive human activity which, by impoverishing the woods, caused the waters to flow faster toward the valley. The society of the Indus must have been unique if it managed to survive in such a threatened area. Endowed with extraordinary faculties for recovery, it must have resorted to them under the firm and inflexible guidance of its rulers. Then came a slackening of energy and discipline. With irrigation canals and artificial embankments no longer adequately maintained, desert and marshy lands started gnawing at the tilled ground. Human dangers in the form of hostile peoples were nonexistent, nor were there precise frontiers, for the people of the Harappan civilization were practically isolated and safe

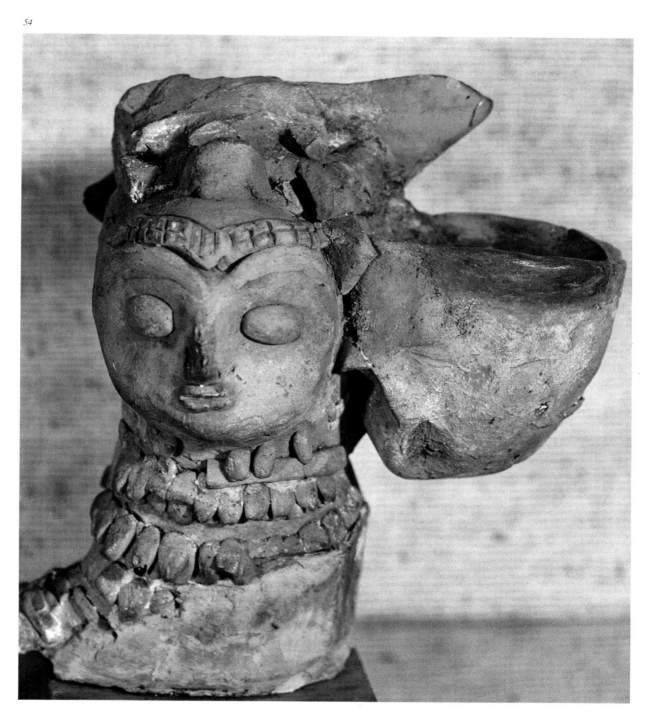

54. Fine small female head of terra-cotta. From Mohenjo-daro, third millennium B.C. National Museum, Karachi
The head, adorned with a three-string necklace, wore a now fragmental headdress, within which is a small hollow, probably a perfume-burner.

and even the metropolises, though partly protected by citadels, had no peripheral walls, despite the fact that they were the focal points of existence, economy, and civilization. How long was this period of decadence? For how long did the people of Mohenjo-daro, Harappa, Chanhu-daro, and Lothal carry on their tremendous battle against the environment? If the long chronology is adopted, the Indus civilization lasted little over a thousand years, remaining almost unaltered and bound "to the immutable traditionalism of the temple rather than to the wordy volubility of the court" (S. Piggott, *Prehistoric India*, Harmondsworth, Middlesex, 1950).

This lack of evolution over such a long period of time is puzzling and, indeed, improbable. It contrasts with the explosive energy needed to create metropolises such as Mohenjo-daro and Harappa, port facilities such as those of Lothal, and the enormously extensive network of canals and dams which ensured the irrigation and safety of the vast cultivated areas. Above all, mental stagnation is contradictory to the willpower and energy that it must have taken to build the large metropolises which the river destroyed. It is therefore possible that the successive strata cover a much shorter period of time than a millennium and that immobility is only a deceitful appearance, especially since the backing up of the Arabian Sea may have occurred over a few decades, for there is no

evidence that towns were moved away or special measures taken to forestall the consequences, though they were no doubt extremely serious to the numerous human settlements on and by the sea. On the other hand, it appears certain that man dealt the final blow at least to Mohenjo-daro where hurriedly built fortifications and traces of fire and massacre are unmistakably evident. The destroyers of this civilization were unable to inherit or continue it, and a few surviving groups remained only on the Kathiawar Peninsula. Despite many gaps and uncertainties, the only likely supposition is that the people who brought to an end the already decadent Harappan civilization were the Aryans. The struggles that the *Rigveda* relates extol the Aryan victories over the dark-skinned Dasyus and the destruction of the pur, the fortified cities that Indra, the war god of the Aryans, crushed by the hundreds with his deadly club. These, apparently, were the struggles that the Aryans undertook against the remaining forces of the Harappan civilization, even though the physical portrait of the stubborn defenders of Indian soil is dissimilar from that of the proto-Mediterranean type which became predominant over the bearers of the languishing proto-Indian civilization. On the other hand, though the *Rigveda* deals very spitefully with the Dasyus (the name has the root das, to devastate), it admits that they were very rich in gold reserves and cattle, and were

55

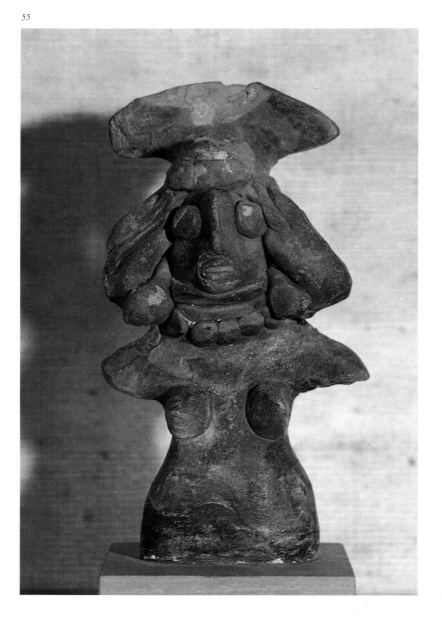

55. Female figure of blackish terra-cotta. From Mohenjo-daro, third millennium B.C. National Museum, Karachi
This figure has a somewhat similar headdress to that of figure 48.

unitarily organized into real confederations of warrior peoples with citadels and fortified villages and towns which they defended steadfastly and with courage from the attacks of the enemy. It is very likely that the Aryan invasion came from two directions, with one southbound branch stopping on the verge of the Saurashtra (Kathiawar) Peninsula, while the other branch traveled north to, and perhaps beyond, Harappa. The presence of these two Aryan infiltrations was the seed of discord that caused the new lords of India, now divided into Panduids and Kuruids (the lunar and the solar stocks), to fight each other in that violent clash which is so humanely described in the distichs of the *Mahabharata*. Still, in a few cases the invaders and the autochthonous people coexisted. The so-called cemetery H at Harappa, uncovered in 1946, may be such an instance. It must not be forgotten, however, that the culture of the so-called Aryans is everywhere extremely unclear, even though it is possible that the Jhukar culture was Indo-European (at least this is the opinion of R. von Heine Geldern, in *Man*, LVI, 1956, pp. 136–40, and W. A. Fairservis, Jr., in *Man*, LVIII, 1958), and that the so-called painted gray ware also was Indo-European, a possibility which could once more bring into question the identity of those who destroyed the large cities of the Harappan civilization in the northeastern areas, as will be mentioned later.

56. Acephalous, squatting woman. Alabaster. From Mohenjo-daro, third millennium B.C. National Museum, Karachi
This fragmentary figure belongs in a category that does not come up to the best creations of Indus Valley art but is superior to the terra-cotta production. Alabaster, which was little used, indicates that the work was regarded as valuable by the culture that produced it.

56

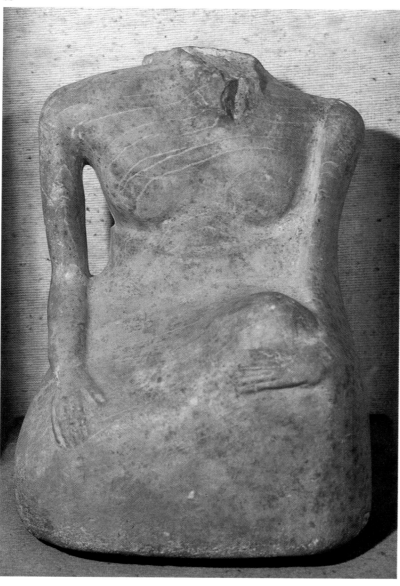

57

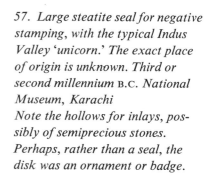

57. Large steatite seal for negative stamping, with the typical Indus Valley 'unicorn.' The exact place of origin is unknown. Third or second millennium B.C. National Museum, Karachi
Note the hollows for inlays, possibly of semiprecious stones. Perhaps, rather than a seal, the disk was an ornament or badge.

58. Jewels from Harappa. Third millennium B.C. *National Museum, New Delhi*
The necklace of gold, semiprecious stones, and vitreous paste; the gold bracelet; the double-coil ornament; and the setting of the red, cone-shaped stone with the central hinge are characteristic. As is evident, jewelry-making was very advanced.

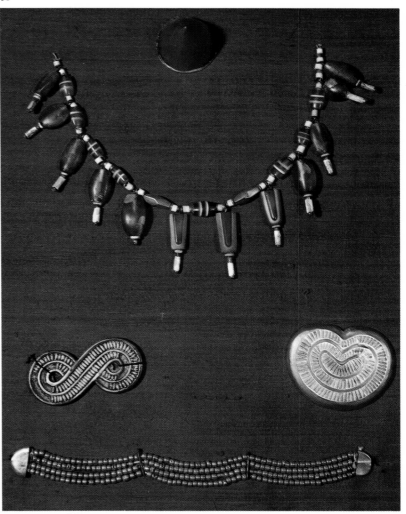

The Indus Valley civilization is not the only Indian cultural manifestation of the protohistoric phase. Mundigak, an Afghan center of great archaeological interest, in contrast with the Neolithic cultures of the Zhob, shows a particular local adaptation of the architectural structures characteristic of the Harappan civilization—especially the silos—indicative of a hard to define but very interesting dependence that testifies to the unexpected persistence of certain technical and formal aspects of the Indus Valley civilization outside the confines of its expansion.

In the upper valley of the Ganges also there developed, with alternatives of greater or lesser vitality, a consistent culture with unmistakably Indian traits. Whether it was an Indo-European culture or not, its beginnings were certainly much earlier than those of the Harappan civilization, by which it was influenced in the techniques of metalwork and in the typical painted gray ware. From the artistic standpoint, the ornamental motifs of this ceramic ware reveal a remarkable figural sensitivity, apparent also in the shapes of the vases. Some seemingly anthropoid images of unascertained use (perhaps ornaments) made out of copperplate also bear witness to an extraordinary skill in the stylization of the figures. Various almost identical examples come from Bisauli, Fatehgarh, and Sheorajpur. It is not impossible that the first suggestion for these stylized figures came from Iran. In fact, considering that to a small extent the Ganges culture thrust out into the area of expansion of the Harappan civilization, it is probable that its bearers may have more or less directly contributed to the end of the Indus Valley civilization even though they were not Aryans, a possibility that I hinted at above.

At this point, after mentioning the presence in southern India especially of Megalithic cultures not unlike the Western ones and those of the rest of Asia and after adding that, again in the south of the large peninsula, there is evidence of lingering cultural traits or, better, stubborn persistence of the earliest technical and organizational stages, we may consider our short survey of protohistoric India completed.

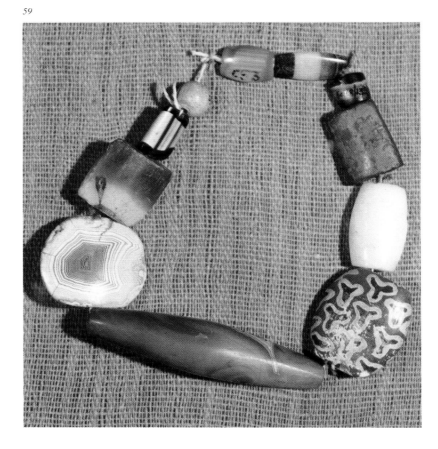

59. Series of pierced pieces for jewelry of jade, semiprecious stones, terra-cotta, thin enamel (with trefoil motif), and bronze. From Mohenjo-daro, third millennium B.C. *National Museum, New Delhi*
Different techniques put together for comparison.

3. India of the Mauryas

by Mario Bussagli

Because they were seminomadic peoples in a frenetic phase of expansion and movement, the invading Aryans did not build any lasting structures. Accustomed to using timber, they maintained this preference in their new territories also and ignored the technical and organizational experience of pre-Aryan India. For this reason and because of an inborn tendency, the artistic activity of the Indo-Europeans on Indian soil is almost exclusively limited to poetic literature. Firmly settled in the region of the five rivers (Panjab), the Aryans continued their expansion, originating the so-called Vedic civilization named after a well-known collection of literary works, the Vedas (meaning knowledge). The Vedas consist of three long religious and liturgic poems with the addition of a fourth that is esoteric in character and amounts to a collection of magic formulas. Apart from literature, hardly anything is left of the Vedic civilization, although it stamped the Indian world with a completely different religious character. It is quite likely that during this phase the concept of tirtha (meaning sacred site, that is, characteristic rocks, isolated blocks of stone, and any natural or artificial expanse of water) influenced the growth—however limited—of an activity whose purpose was the better definition of the area and its sacred characteristics. Thus was created the original seed from which later developed the significantly poetic quality of Indian figural art. To make them stand out better, sacred trees were circumscribed and isolated, rocks were cut to a more regular shape and sometimes squared off, and waters were hedged in or consecrated in parts. However, though these phenomena may be deduced from the literary stratifications of the Vedas, there is no figural evidence to support them. Bloch's old theory maintained, probably with good reason, that some of the Bihar tumuli belonged to the Vedic period and were tombs, smasana, built for famous people according to the Vedic ritual. In this case, a figure of a woman embossed in gold plate could represent the goddess (Prithivi) to whose custody the human spoils were entrusted. The date, however, is uncertain, and Bloch's suggestion of the eighth century B.C. seems too early. Consequently, though an evolutional continuity is apparent from the designs on the shards—especially on those of hard red ware—and an insistence on the shape of the pottery is also evident, to find a monument that can be dated with some measure of assurance we must reach down to the middle of the first millennium B.C. The rough, cyclopic walls around Rajagriha (today's Rajgir), the large city of King Bimbisara of Magadha, famous in the history of Buddhism, are in all likelihood from that period.

The use of stone is exceptional, probably due to the existence of this material close at hand. In any case, it was limited solely to defensive structures, so that the contradiction of the Vedas and other related texts in which there is mention of large cities, sculptural and pictorial works, and plenty of figural activity seems the more striking. The only possible explanation is that the relevant passages of the Vedas were much later or even subsequent interpolations, unless archaeologists have always been so luckless as never to have struck the right spots.

Apart from the continuing presence of fictile figurines representing the Great Goddess (see fig. 4), the artistic activity of India begins with the Mauryas, the dynasty that created the first national Indian empire on the models furnished by both the Persian empire of the Achaemenids, which at the time of its greatest expansion bordered on the Indus, and of Alexander the Great, who led his troops into India specifically to restore the Persian imperial rule, which now also included the Graeco-Macedonian world. Alexander's undertaking, dictated by a wish to avenge Greece, achieved the unification of the then civilized world by bringing both the Graeco-Mediterranean areas and the Persian territories under his domination. Alexander even dreamed of extending the confines of his empire farther when he realized that across the Indus there lived other peoples and empires whose level of civilization was appreciable. As soon as Alexander started back on his westbound way, India reacted with an anti-Greek revolt which led to the foundation of the empire of the Mauryas. As a consequence of this transformation, a great many Persian suggestions both in governmental organization and in the figural arts were accepted, almost as if the Persian culture, strengthened by the contributions of Greece, was spreading belatedly. In fact, whereas the scarce traces of the Achaemenid rule in northwestern India have an archaeological and epigraphic character rather than an artistic interest, the official and formal aspect of the Mauryan art is clearly derived from that of Persia. The ruins of the large Mauryan palace at Pataliputra leave no doubt of their derivation from the similar buildings of Persepolis, which were begun under Darius and completed under the rule of Artaxerxes I. A hall thick with columns resembling the 'hundred-column hall' which served the Achaemenid rulers as a magic center as well as an audience chamber is obvious proof of this analogy. On the other hand, Megasthenes, the Graeco-Seleucid ambassador to the court of the Mauryan sovereigns, says in his description of this palace that the fortifications were of very hard wood, a fact that excavations have confirmed. So, apparently, the evolutional line of the Mauryan architecture must have followed both foreign suggestions and the traditional Indo-European trend with its characteristic preference for timber, which, however, can be found also in Persia, where the use of stone was limited to works of a sacred nature, whereas the royal quarters both at Susa and at Persepolis were built of timber. Anyway, apart from a few minor works, the art of the Mauryan period centers on a series of isolated pillars crowned with bell-shaped capitals, often topped by animal protomas. These pillars, known as lats or stambhas, symbolically represented the world's axis or, better, indicated the magico-religious nature of the places where they were erected. The

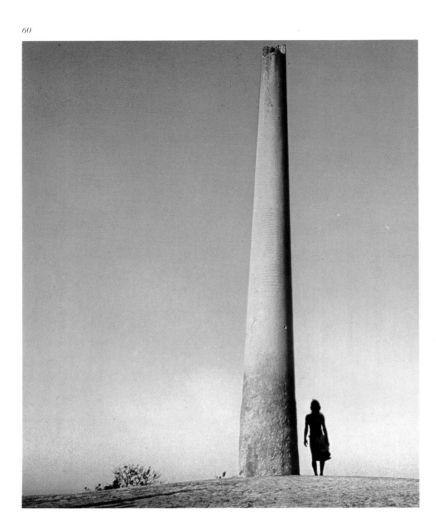

60

60. *The Topra Asoka pillar*

61. *Detail of the pillar in figure 60. An edict of Asoka is inscribed on the stem of the pillar, with, at the base, the later rendering in the Devanagari alphabet.*

61

correspondence between the capitals of these pillars and those of Persepolis is precise and complete except for a slight flare at the base of the Mauryan type. They were unquestionably developed from wooden models which contributed not only to the achievement of the final form but to the maturing of the Indian reaction to the foreign influence discernible in the more demanding stone examples. That there was a process of assimilation is apparent from the fact that the Mauryan architecture used the pillar and capital as an isolated structure, a thing apart from the general context, and a symbolic and ornamental element. The polish on the stone, obtained by rubbing, must be of Greek inspiration. The ornamentation is composite, for while the lion protomas topping the pillar at Sarnath—which has now become the symbol of the Indian Union—are treated in the Persian manner, the humped bull on the pillar from Rampurva, the elephant on that of Sankisa, and the horse of Rummindei are all in the Indian manner with that typical enthusiasm and love which the Indian artists were always to show for animal images. Other animal figures, magnificent for their vitality and forcefulness, adorn the abaci of some of these capitals, which are otherwise decorated with the Assyrian palmette. The sculptural effectiveness of every detail, to be found also in the minor figures of the period, is proof that Mauryan India could count on exceptionally skilled artisans strongly reactive to any foreign influence which they were capable of assimilating and modifying to their taste and mentality.

The capital of the Persepolitan type, in more or less pure form, was used in India until the Gupta period; this shows how deeply it was assimilated. In fact, the cushion capital (amalaka) characteristic of southern India is almost certainly a gradual adaptation and alteration

of the Persepolitan capital. Once India had assimilated and mastered these foreign influences, conferring on them a new value and a particular balance in keeping with its own figural taste, it continued to modify and elaborate on them for centuries, reaching unexpected solutions that were often in contrast with the original creations.

It is almost certain that the stambhas known as the 'pillars of Asoka' (see figs. 60–62) were erected by this sovereign as magic signs connected with his political thought, which, though inspired by Buddhism, differed from it in being more practical. It has been speculated that these stambhas may have been built by his predecessors and that Asoka may have used them for the promulgation of his edicts. The poor quality of the writing, in jarring contrast with the accurate finish of the pillars and capitals, supports this supposition (see fig. 61). However, the fact that many of the capitals are topped by and adorned with the Wheel of the Law, the stamp of the Buddhist-inspired political and social order desired by Asoka, makes an earlier origin for these pillars unlikely. Consequently, these splendid creations that mark the beginning of the great period of Indian art can be dated about the middle of the third century B.C.

In any case, Asoka must not be credited only with the erection of these pillars, which, in technical terms, are dharmachakrastambhas proper (pillars of the Wheel of the Law, in which the law is the political and social order instituted by Asoka, who made a distinction between his own law and the Buddhist Law which he called saddharma, meaning the Good Law). In his infinite tolerance, he also sponsored, or at least permitted, the creation of non-Buddhist temples, such as those on the Barabar hills, which bear inscriptions corresponding to the second year

*62. The Mirath Asoka pillar and
later buildings*

of his rule, and the cave temple of Karna Kauphar, which bears the date of the nineteenth year of his reign. The so-called temple of Sudama dedicated to Vishnu at Barabar has a rectangular plan, a false barrel vault, and a single, low side entrance in the shape of an elongated trapezoid. The apse of the temple consists of a semicircular cell depicting the protoma of a hut, inserted into and projecting out of the temple. It is not impossible that earlier funerary structures may have influenced these works which mark the beginning of a long series of rock-hewn temples and structures based on a kind of reversed architecture. The walls of these constructions are often polished by a technique which closely resembles that used for the pillars and capitals. The cave of Lomas Rishi seems to have had at the entrance a kudu, that is, a false arch in the shape of a horseshoe, which was to become a very frequent feature of Indian art even during the medieval period. Apart from the decoration of the architrave, which may be later, the whole structure of Lomas Rishi, with its characteristic oval cell, is unquestionably very ancient.

There is also minor statuary of the Mauryan period. It consists mainly of stone figures, heavy in their portrait-type compositions but very interesting for a number of reasons, among them that, despite the un-Indian heaviness and dull symmetry in the faces, they have a vigor and a sort of monumentality that are in blatant contrast with their small size (see figs. 5 and 63). A great many terra-cottas from Pataliputra, Golakpur in Bihar, and other places are generally dated to the Mauryan period, even though for some of these works a later date is more likely. In fact, they show little of that power of expression that the stone works assuredly datable to the time are rich in. Furthermore, the stylization of

the stone faces, which is sometimes extremely pronounced and skillfully rendered in its simplicity, is virtually unique in the whole of Indian art, and the different medium is not reason enough to account for the stylistic difference in the terra-cottas.

Now that we have examined the artistic activity that accompanied the blooming of the first national Indian empire, to conclude this survey it seems appropriate to ask ourselves a recapitulatory question: To what extent does the art of the Mauryan period belong in the general evolution of Indian figural art? The answer is not an easy one, even though the Mauryan phase is considered by most scholars to be an initial stage from which originated a remarkable series of stylistic, architectural, and figural elements that were later to recur throughout Buddhist and Hindu Indian art. Obvious confirmations for this theory are not lacking and, if research takes into account the so-called directional symbolism associated with the animal figures on the abaci of the capitals, we can observe, as Benjamin Rowland does (in his book *The Art and Architecture of India, Buddhist, Hindu, Jain,* Baltimore, 1959, pp. 40–44), that related or analogous symbolism can be found in Indian art and even in the art of Farther India (Magna India as it might be called after the Greek precedent, namely, Southeast Asia) until a very late date. However, it must not be overlooked that, whereas the religious, symbolic, and magic thought of India had already acquired an advanced and precise aspect, having overcome crises and contrasts, dissentions over the formulation of doctrines, and contradictory interpretations of the commentaries, the same was not true of the figural arts. Emerging from what seems so far to be a blank that prevents us from establishing what its precedents were, Mauryan art appears to have been an inter-

pretation of the Iranian-Achaemenid experience enriched by the Greek contributions; this interpretation may involve simply the technique (if the polishing of the pillars and caves was really dictated by the foreign influence), instead of a style springing from the pursuit of clarity and brightness recurrent in the Indian figural evolution. Mauryan art is an art that bears a lot of seeds which were to bloom in later epochs—on completely different levels, however. The expression of an extremely centralized political and religious power, it often sought effects which were later to be either neglected or exaggerated beyond recognition. Though decidedly Indian in spirit, the art of the Mauryas is, above all, the first attempt to create in durable forms sculptural, architectural, and symbolic values suited to the Indian thought and taste. It made use of strange experiences that became valuable only in so far as they were promptly reelaborated and permitted the Mauryan artists to find new formulas obviously dictated by the social milieu in which they were active. Just as the empire of the Mauryas, the first national empire of India and the first successful attempt at the political unification of Indian territory, was destined to have no direct consequence, so also the art of this empire remained an isolated expression in the complex evolution of the figural art of India. As has already been said, this does not imply that the experience of the Mauryan artists did not offer their successors strong foundations and fruitful ideas that were to be extremely important in the centuries to come.

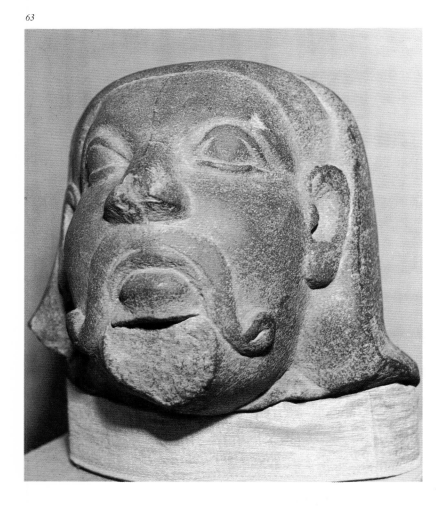

63

63. Head of a man. Stone sculpture. Mauryan period, end of the reign of Asoka or later. National Museum, New Delhi The head is strongly characterized and stylized.

4. The Archaic Schools (Bharhut, Sanchi, etc.)

by Calembus Sivaramamurti

When Pushyamitra, the ambitious commander-in-chief of the Mauryas, slew the weak and indolent Brihadratha, the last Mauryan ruler, the reign of the Sungas began. Simultaneously with the weakening of the Mauryas, the large empire extending over the Indian subcontinent was broken up. The contemporaries who ruled in the Deccan were the early Satavahanas, and in the east the powerful Cheta dynasty asserted itself. Of this last, Kharavela, the mighty emperor, is known from his own inscription to have brought back to his realm, as an art trophy, a famous sculpture of a Tirthankara, earlier carried away by the Mauryas from Kalinga. (On the Hathi Gumpha inscription of Kharavela, see K. P. Jayaswal and R. D. Banerji, eds., in *Epigraphica Indica*, XX, part VI, 1932, pp. 71–89, especially p. 88.)

Like Caesar and Napoleon, later great warrior connoisseurs, here we have a king who gave equal attention to the arts of war and to the arts of peace. He arranged music, dance, and drama for the entertainment of his people. He created and appreciated works of art. To him we owe the famous caves Rani Gumpha, Ananta Gumpha, Manchapuri Gumpha, Ganesa Gumpha, and others at Udayagiri and Khandagiri in the vicinity of Bhubanesvar in Orissa.

The continuity with Mauryan tradition may be observed in an arch over the doorway of the facade of a cave in Udayagiri recalling the identical one in the Lomas Rishi cave. The delightful animal study at Udayagiri affirms the natural skill of the early Indian sculptor in depicting animal form and movement (see also p. 76), a capacity that has survived through the ages. The lotus, the swan, the elephant, and the deer—not to mention feminine charm—are among the favorite themes of the Indian sculptor, who has excelled in their representation.

The rock-cut caves follow the style of wooden buildings with a series of cells and pillared verandas; the entrances to the cells have lintels decorated with a pattern of toranas. The pillar brackets are ornamented with floral designs, human riders on griffins, and loving couples (dampati). The double-storied galleries are early instances of the multistoried mansions mentioned in the literature of the period.

As Kharavela, a contemporary of Pushyamitra Sunga, was a devoted Jain, the subject matter of the carvings in the caves is from Jain mythology. The long series of friezes in these caves in many cases still await identification. Among the well-known ones is the representation of the story of Udayana and Vasavadatta, popular alike in Brahmanical, Jain, and Buddhist legend. The proficiency of the charming prince in playing the lyre, how he taught the charming princess of Ujjain to play the instrument, and how he eloped with her and reached his capital, Kausambi, is a popular theme in early art (see also p. 67). The depiction at Udayagiri is among the most interesting.

In the rock-cut caves the early forms of Surya, Sri Lakshmi, and Chaitya-vriksha may be seen on the doorway lintels; the full complement of the early Indian orchestra is also depicted. The hunting scenes in the Rani Gumpha cave (see fig. 64) are portrayed with a rare exuberance and enthusiasm.

Only fragments of the rail and a single gateway (torana) from the stupa at Bharhut have survived (see figs. 7 and 66–69). An inscription on one of the pillars of the gateway at Bharhut mentions its construction during the reign of the Sungas in the second century B.C. The stupa must once have been a treasure house of Jatakas and Avadanas recounting the Buddha's life in his previous births, when he qualified himself by his good deeds to become the Supremely Enlightened One; a series of incidents from his life as Siddhartha also appeared on the rail around the stupa, one of the most important in early India. Yet even these fragments provide the most eloquent picture of life, culture, and civilization in India of the second century B.C. India owes the preservation of this portion of the magnificent rail and torana to Sir Alexander Cunningham, who not only discovered them but also brought them all the way from a distant hamlet in Madhya Pradesh to Calcutta, to be preserved in the Indian Museum.

All his life the Buddha preached an attitude of love, and it was a tragedy that there was a quarrel over his relics, for the possession of which there were so many disputes that it required the exhortation of a Brahman, Kaundinya, to effect a compromise. The best-known depiction of this scene is of the Rail period from Amaravati. In a recent find, however, a long Bharhut coping piece acquired by the National Museum in New Delhi (fig. 69), another magnificent depiction of the identical scene with an orchestra providing music as part of the funeral ceremonies has been brought to light.

The recently discovered panel from Bharhut depicting the division of the relics of the Buddha and the ceremonies accompanying his funeral is very close to the scene at Amaravati and virtually inspired it. A similar parallel between Bharhut sculpture and sculpture from Amaravati occurs in the episodes of the *Vidhurapandita Jataka*. It is interesting indeed to find that the Bharhut sculptors, the earlier artists, anticipated the work of the sculptors at Amaravati, who later depicted identical subjects.

The long coping of the stone rail from Bharhut has a never-ending meandering creeper, or kalpavalli, issuing from the mouth of a celestial elephant, with Jataka scenes in the meanders as well as a variety of garments, jewelry, wine cups, and toilet articles. It is a pictorial commentary on Kalidasa's description in the *Meghaduta* of a single celestial plant that provides a wide range of feminine ornament and toiletry: ekas sute sakalam abalamandanam kalpavrikshah.

No other monument in India, except the rail from Amaravati, has provided such a wealth of scenes from the Jatakas, as well as scenes from the life of the Buddha, as the rail from Bharhut. The short, but significant, labels in Brahmi characters provide identifications of the

61

64. Hunting episode from a Jain story. Frieze at Rani Gumpha, Khandagiri-Udayagiri (Orissa). Cheta, second century B.C.

64

65

65. The dream of Maya: Bodhi-sattva entering her womb as an elephant. Medallion on a rail pillar from Bharhut (Madhya Pradesh). Sunga, second century B.C. *Indian Museum, Calcutta*

66. The Naga Elapatra and his retinue worshiping the Buddha, shown symbolically by an empty seat under the tree. Panel from a rail pillar from Bharhut. Sunga, second century B.C. *Indian Museum, Calcutta*

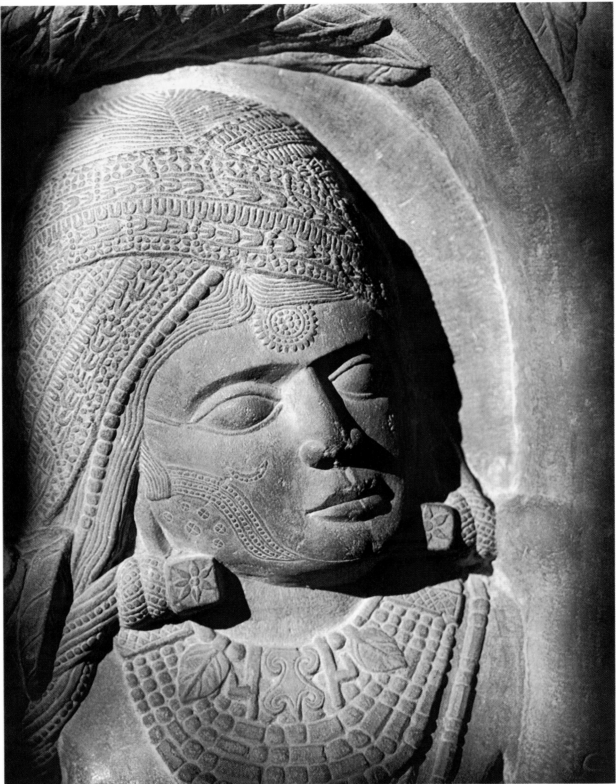

67. Close-up of Chulakoka Yakshi. On a rail pillar from Bharhut. Sunga, second century B.C. *Indian Museum, Calcutta Note the peculiar ornaments such as the ear coil, or karnavesha- tana, and necklace of alternating plaques and beads, or phalakahara, described in the* Arthasastra *and other early texts, and the plaited hair dressed with gold ornaments.*

68. *Loving couples (dampati).*
Panel from a rail pillar from
Bharhut. Sunga, second century
B.C. *Indian Museum, Calcutta*
The characteristic costume and
jewelry of the Sunga period as
well as the frontality typical of
this early stage of the development
of sculptural technique are well
represented.

69. *Division of the relics of the*
Buddha and his funeral rites,
accompanied by music and dance.
Panel from the coping of the rail
from Bharhut. Sunga, second
century B.C. *National Museum,*
New Delhi
This is a fine depiction of the
transportation of the relics in
reliquaries by the recipients and
of a musical performance, a
forerunner of the famous identical
scene from Amaravati of the
mid-second century A.D.

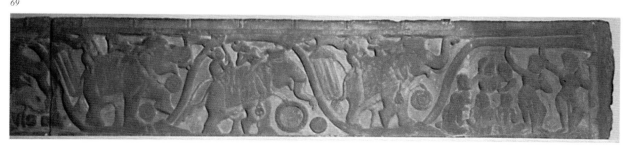

figures in the Jatakas to be compared with the names in the texts themselves, which they usually follow. Some of the scenes from the life of the Buddha are similarly labeled.

Already at Bharhut the concept of the previous Buddhas—Vipasyin, Visvabhuh, Krakuchanda, Kanakamuni, and Kasyapa with their respective bodhi trees—is represented. The almost life-size carvings of innumerable godlings, for example, the yakshas, yakshis, Nagas, and Devatas popularly worshiped by the folk and incorporated into Buddhist literature, thought, and concept as devoted followers of the Buddha and his dharma, are especially noteworthy for several minute details of early iconography. Such folk deities as yakshas and Nagas are depicted, with their names inscribed, in the life-size carvings of the beautiful goddess of luck Sirima-Devata, Chulakoka (fig. 67), Yaksha Kubera, and Yakshi Sudarsana, among others.

70

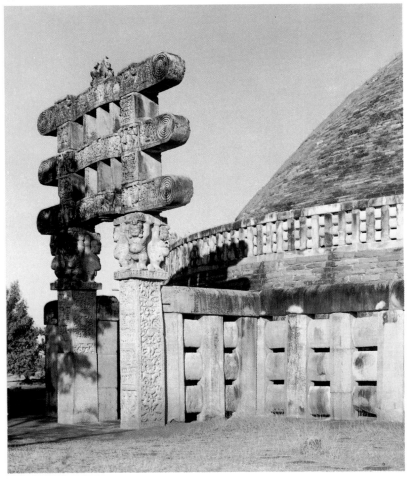

70. Western gateway (torana),
with part of the rail and the stupa
in the background, at Sanchi
(Madhya Pradesh). Satavahana,
second–first century B.C.
Note the yakshas as supporters
of the architraves.

The earliest sculptural version of the Jataka stories is found at Bharhut. A sculptor could here be at once humorous, as in the depiction of the *Aramadusaka Jataka* and the *Kukkuta Jataka* and quite grave and philosophic, as in the representation of the *Mahadeva Jataka* or *Mahajanaka Jataka* (see also pp. 74-76). Scenes from the life of the Buddha, in spite of the fact that the master is represented only symbolically (fig. 66), are shown very effectively. The scene of the presentation of Jetavana at Bharhut has never been excelled. Equally impressive is the Buddha's descent after preaching to his mother in heaven; one foot on the top of the ladder and the other down below suggest the celestial and the terrestrial ground he has trodden.

The attribution of almost human feelings to animals and the moral pointed by every fable depicted at Bharhut are noteworthy features of the representations there. Rare nobility, even in an animal, is the trait on which emphasis is placed in such stories as the *Chhaddanta Jataka* and the *Mahakapi Jataka*. The story of Vessantara, the generous prince, is depicted at Bharhut, as in most other Buddhist monuments.

It should be observed, however, that in spite of the sculptors' lack of knowledge of the correct rendering of human anatomy, figures like those of Sirima-Devata and Chulakoka (fig. 67) in this naive, early indigenous art have great decorative charm.

The sculptures of Bharhut are characterized by frontality and a certain lack of knowledge of modeling and, as has been said, of the rendering of human anatomy; nevertheless, this does not detract from the aesthetic quality of the figures and the compositions. Although a naive primitiveness is revealed, greater technical skill and perfection are apparent a couple of centuries later when an indigenous Indian art is at its best.

Sculptures from Kausambi, Mathura, and other places, for example, Mehrauli near Delhi and Banganga near Kurukshetra, have yielded interesting examples closely related to the Bharhut group.

In archaic times the sculptor not only presented narrative episodes effectively but often introduced suggestions for enhancing the value of such depictions. He was adept at indicating both the time when a scene occurs and its mood. That Kalidasa learns through the mouth of the yaksha that his separated beloved, already sad during the day is disconsolate by night, is effectively conveyed in a feminine figure from a coping from near Banaras: she is shown with her head buried in her arms, which entwine her knees, the very picture of grief, beside a lamp suggestive of night and darkness and sorrow. In the case of Maya's dream (fig. 65) the lamp immediately signifies night, and thereby the dream Maya experiences. A complete orchestra not only illustrates the rich accompaniment of music for the dance, but also the mirth and gaiety of an occasion, for instance, the festival of the worship of the turban of Siddhartha, labeled Charidamaha.

At Bodhgaya the portrayal of Anathapindika's presentation of Jetavana is less effectively shown than at Bharhut, though the turbaned Surya in a chariot drawn by four horses exemplifies the early iconography well. The most effective work here, however, is in such delightful carvings as that of the lovely damsel in the motif of Dohada, climbing a tree to create unseasonal efflorescence by kicking the trunk while her lover guides her foot to help her and gets a knock on the head from her heel. This carving is a translation into sculpture of Kalidasa's description, in the *Malavikagnimitra* (III, 12), of the two who welcome the foot of the lovely damsel, the asoka tree, so that it may blossom out of season, and the lover caught dallying with another sweetheart: akusumitam asokam dohadapekshaya va vinamitasirasam va kantam ardraparadham.

Although the quality of sculpture at Bodhgaya shows a slight advance

over what can be seen at Bharhut, two centuries passed before the first traces of progress were discernible.

The utmost perfection in modeling was attempted with success in the soft medium of clay. Among the most remarkable Sunga terra-cottas is a medallion, in the Allahabad Museum, showing Udayana eloping with Vasavadatta on an elephant, while an attendant empties a bag of gold for the pursuing soldiers to stop and pick up. The most elaborate of Sunga terra-cottas, however, is the large one in the Ashmolean Museum at Oxford with an elaborate hairdress for the feminine figure. Mathura, Kausambi, Bhita, and other places have yielded rich examples of Sunga terra-cottas.

The early Satavahanas, who ruled the whole of the Deccan and the south from their capital at Pratishthana, were responsible for the decoration of caves in western India like those at Bhaja, Karla, Kondane,

71. Eastern gateway (front) at Sanchi. Satavahana, second–first century B.C.
Scenes from the life of the Buddha; the adoration of the Tree, the Wheel, and the Stupa; winged lions; Sri Lakshmi bathed by elephants; etc.

71

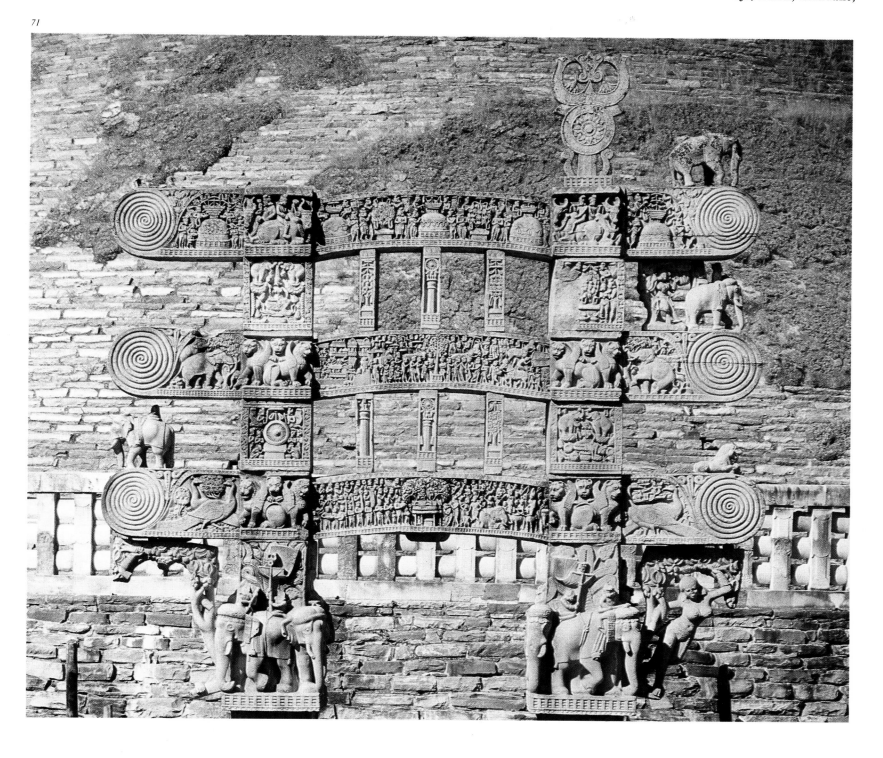

Bedsa, and others. An inscription in the Nanaghat cave mentions the powerful early king Satakarni. The eastern gateway at Sanchi has an inscription mentioning the ivory carvers of Vidisa as the artisans who created the magnificent reliefs on these toranas, or arched gateways (figs. 70–76). That this work was done during the time of the early Satakarni is also recorded. The existence of a guild of ivory carvers at so early a date in Vidisa proves the corporate feeling among artisans and craftsmen in ancient India.

The translation into stone of the delicate work of the ivory carver at once suggests the versatility of the early Indian artist. This adaptability is supported, if not corroborated, by the inscription on the dwarf yaksha from Pitalkhora now preserved in the National Museum in New Delhi (fig. 77), for the inscription in early characters proclaims that the figure is the work of a goldsmith, Kanhadasa. A goldsmith and an ivory carver could chisel stone with the same dexterity.

The torana is seen at its best at Sanchi, where the sculptor concentrated on the arched gateway, leaving the railing bare, unlike the example at Bharhut, where the railing was fully carved on both sides. The sculpture at Sanchi exhibits not only the delicacy of the ivory carver but also the method of the scroll painter. In the *Dutavakya* of Bhasa, a dramatist of the third to second century B.C., the pata (painting on a canvas roll) is introduced unfurled to show a picture, in this case Draupadi's pulling of the garment off a body in court (chiraharana). Yet another instance is the disclosing of the news of the death of the Buddha to Ajatasatru by unfurling a canvas depicting scenes from the life of the Master, including his demise; an example of this type is on the walls of a stupa at Qyzyl in Turkistan (see H. Zimmer, *The Art of Indian Asia*, Bollingen Series XXXIX, New York, 1955, I, p. 203). A common representation in ancient and medieval India is the Yamapata, a scroll depicting Yama, mounted on his fearful buffalo, ordaining reward in heaven and punishments in hell for good and evil doers; while rushing to his father's deathbed Harshavardhana witnesses such a scene and regards it as an ill omen. The long narration of Jataka tales and scenes from the life of the Buddha on three architraves at Sanchi almost as on a scroll suggests a greater length still furled in the spirals at the terminals (see fig. 75). It may also be interpreted as the curled tendrils of the wish-fulfilling

72

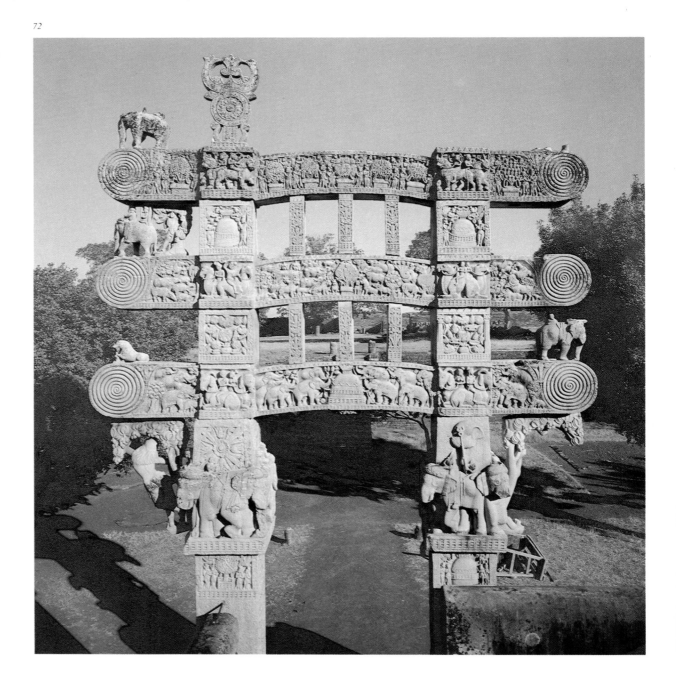

72. *Eastern gateway (back) at Sanchi. Satavahana, second–first century* B.C.
Scenes from the life of the Buddha; the adoration of the Tree, the Wheel, and the Stupa; winged lions; etc.

73. *Yaksha devotee or a portrait of a royal donor on a jamb of the eastern gateway at Sanchi. Sata-vahana, second–first century* B.C.

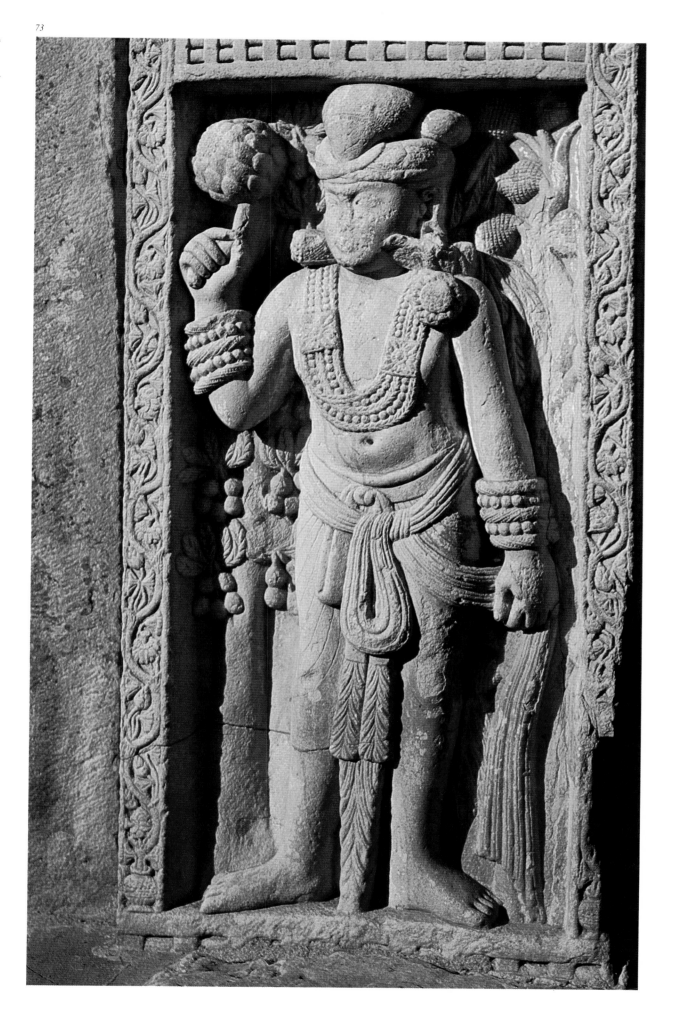

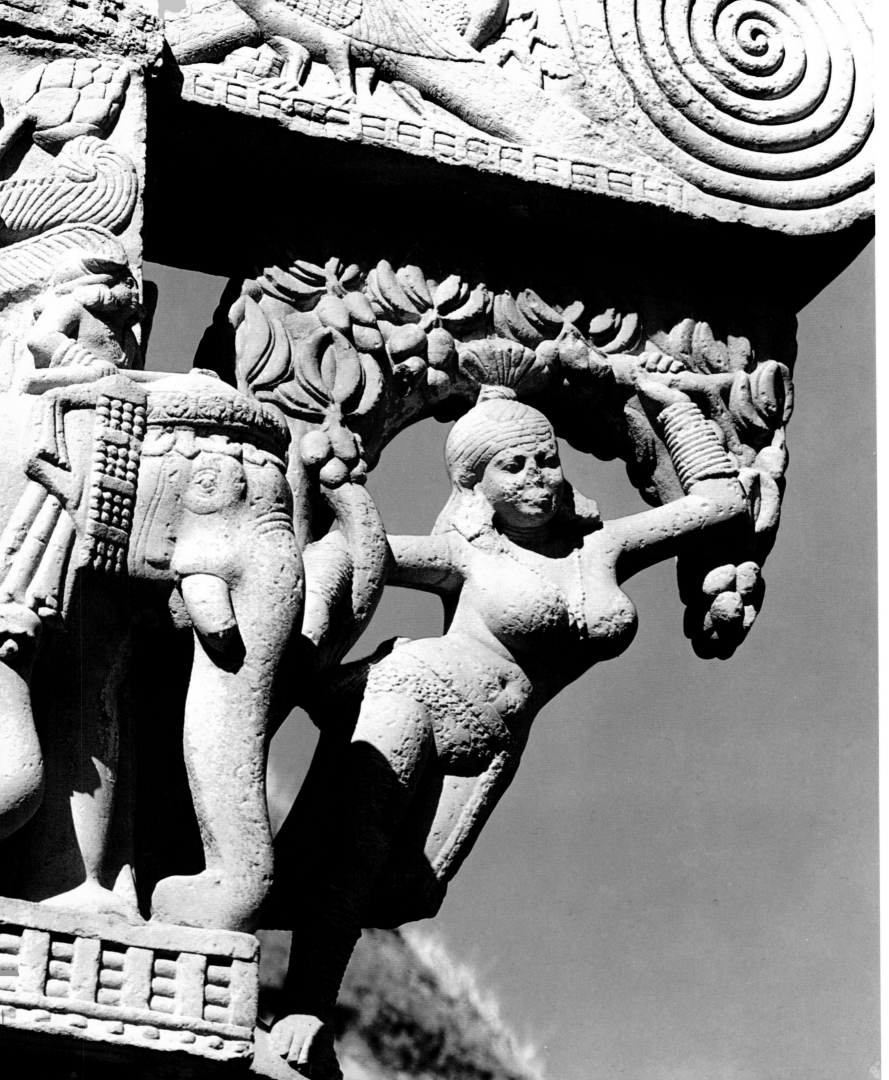

74. *Close-up of a yakshi, or dryad (salabhanjika). Bracket figure on the eastern gateway at Sanchi. Satavahana, second–first century* B.C.

75. *Terminals of architraves of the western gateway with carved panels illustrating Jataka scenes at Sanchi. Satavahana, second–first century* B.C.

creeper, or kalpavalli, yielding all the desires of feminine grace, a motif most frequent at Bharhut, Sanchi, and Amaravati. Even the unevolved and completely natural makara, or monster resembling a crocodile, on the torana at Bharhut has its tail curled up, a spiral of great auspiciousness, signifying as it did at that date the mystic syllable Om or Pranava.

The toranas at the cardinal points of the Sanchi stupa give the best idea of the grandeur of the monument. The northern and eastern gateways of Sanchi are a treasure house of Buddhist legend and vividly present a picture of life in the land over two thousand years ago.

The touching stories of the generous-hearted Prince Vessantara, who gave away all that he was asked for; of Chhaddanta, the six-tusked elephant, who willingly bestowed his tusks on the cruel hunter; and of Sama, the only son and support of his aged blind parents, and other Jataka stories and scenes from the life of the Buddha such as the Maradharshana, or his temptation by Mara, his conversion of the Jatilas, the presentation to him of honey by a monkey at Vaisali, his descent by a jeweled ladder at Sankisa, and so forth are tellingly depicted at Sanchi. Yaksha guardians of the gateways, large in scale, recall similar ones from Bharhut. At Sanchi occurs the motif of the yaksha with a lotus issuing from his navel, a motif that survived for several centuries with splendid examples in Gupta art. It may be that

71

76

*76. The adoration of the Buddha.
Panel on a jamb of the western
gateway at Sanchi. Satavahana,
second–first century* B.C.

some of these yakshas are portraits of royal donors (see fig. 73). On either side of the northern and eastern gateways, under the volutes of the architraves, a lovely nymph is shown standing in graceful flexion under a sal tree full of flowers. The famous one from the eastern gateway (fig. 74) certainly recalls the description of Asvaghosha in *Buddhacharita* (V, 52), his poem narrating the life of the Buddha. The poet compares lovely damsels who bend over window sills to peep into the street to watch a bridal procession to the damsel gracefully flexed under the flower-laden sal tree: avalambya gavakshaparsvam anya rachita torana-salabhanjikeva. The term for the motif, torana-salabhanjika, gateway with the sal-tree maiden, is indeed significant.

At Sanchi, where there is a definite advance in sculptural technique and treatment over that of Bharhut, variations in date, style, and iconography are easily observed. Thus, while Indra at Bhaja still wears a turban, in his earliest representation at Sanchi, fifty to seventy-five years later, he assumes the crown. But, generally speaking, the proportions of the figures at Sanchi are still heavy. It is very much later at Amaravati and Nagarjunakonda that the figures assume light and graceful contours. However, one cannot but be deeply impressed by the dexterity of the Sanchi sculptors in modeling, even at this stage; exquisite examples of their skill are the feminine torsos now in the museums at Sanchi and in Boston.

At Sanchi itself, however, in the very early second-century phase, the primitive style is easily observed. Motifs often represented include the adoration of the Wheel, the Tree, and the Stupa (figs. 71 and 72); the first is especially noteworthy as it places the Wheel above four lions facing the quarters, crowning the pillar and the Sunga column. This is a proof of the validity of the theory that the Mauryan capital at Sarnath originally bore the Dharmachakra, or Wheel of the Law, on top, which is now broken, but some fragments of it were recovered during excavations at the site.

Among the most noteworthy of early Satavahana creations are the large panels at Bhaja showing Indra on his elephant Airavata, moving in his pleasance Chaitraratha, and the Sun-god, Surya, in a chariot drawn by four horses, dispelling darkness, personified as a giant groaning under the weight of the solar car.

At Karla, a site of somewhat later date, greater maturity and an advance in technical skill can be noted in the carvings. Crowning the pillars are pairs of lovers (dampati) riding magnificent pairs of elephants, forming an imposing colonnade. On the facade of the chaitya (shrine) at Karla are the famous loving couples, or dampati, that are so well known (figs. 78 and 79). They are hefty figures recalling Titian's heavy-bodied feminine beauties. How closely knit was the vast empire of the Satavahanas, and how widespread throughout the realm were the ideals of the age in art, is illustrated by the figure of a woman in adoration at Karla, which comes very close to an almost similar figure from Amaravati, the eastern capital of the Satavahanas at the mouth of the Krishna.

In this part of the empire of the Satavahanas, the early phase is well represented in panels such as those from Jaggayyapeta and in carvings of the first phase from Amaravati. A very famous one from Amaravati, which is inscribed, is the figure of Yaksha Chandramukha, described in the label as residing in a bakula tree. This figure is also interesting as pointing to the early worship of the yakshas in the Krishna Valley as in the north. The occurrence of Yaksha Kubera and Suchiloma or Supavasa or Yakshi Sudarsana at Bharhut and of Chandramukha in the Krishna region proves the similarity of notions in folk worship all over the land. Absorption of these popular deities into Buddhism as devotees of the Buddha demonstrates this eclectic tendency of the Buddhist faith.

77. *Yaksha carrying a bowl for offerings, at Pitalkhora (western India). Satavahana, second century* B.C.
An inscription on the hand gives the name of the sculptor who fashioned the figure, Kanhadasa, a goldsmith.

There are other figures of yakshas and yakshis standing on imaginary animals such as a horse or elephant with hindquarters in the form of fish (minavaji, Matanganakkra).

Jaggayyapeta is the provenance of some most interesting sculptures in low relief in the early primitive style. Of these the panel representing Mandhata is the most important. Here is presented an ideal emperor, who in his desire to save his people the trouble of producing corn, weaving cloth, or earning money caused by his own merit a rain of corn, clothes, and gold. It is this last that is specially represented at Jaggayyapeta. The punch-marked variety of coins, square-shaped, dropping from heaven in streams when the emperor raised his hand, is very vividly represented. Around him are the famous Seven Jewels of his office: the queen, the prince, the minister, the elephant, the horse, the gem, and the wheel.

The sculpture at Jaggayyapeta recalls the delicacy of ivory work. We have only to think of the ivory carving from Ter, also of the early Satavahana period, to understand how an adept in one medium could work well in another.

The early sculpture of Siva at Gudimallam, depicting him as the Sacrificer, Yajamana, with the sacrificial vessel (ajyapatra), the sacrificial goat (pasu), and the staff (danda), and with the tied-up matted hair suggestive of a turban (ushnisha), represents the Yajurvedic concept of Siva as Ushnishin Kapardin and Kalagni-Rudra against a sacrificial post.

At Ajanta, Caves 9 and 10 are noteworthy not only for their early paintings but also for the sculptures they contain, and in particular Cave 10 for the inscription in Brahmi letters of the second century B.C. that mentions Katahadi of the Vasishtha family as the donor of the place.

In Cave 10 the worship of the bodhi tree, the *Sama Jataka*, and the *Chhaddanta Jataka* are very graphically depicted, though unfortunately mutilated. The touching story of Sama, who lovingly looked after his blind parents and was still thinking of them even when mortally wounded, is surpassed only by the more popular story of the noble six-tusked elephant that willingly gave away his tusks to the wicked hunter who wounded him fatally. The treatment of the painted figures, both human and animal, recalls sculptural representation, the color adding charm to the contours.

The early phase of Satavahana sculpture is well represented in the caves of western India. The Nanaghat cave, which gives a splendid account of the power and opulence of the great Satakarni, who performed sacrifices and gave away rich gifts that bespeak the magnitude of his resources, originally contained invaluable royal portraits, now lost but for portions of turbans and jewelry, elaborately carved, which are almost all that is left of the personages mentioned by name in the inscribed labels, which are intact. These, however, arouse curiosity for a glimpse of the features of the royal personages that have forever disappeared, owing to vandalism and the ravages of time.

It is thus very clear that at Bharhut, Sanchi, and the early caves of western India and at Udayagiri in Orissa, we have a visual representation of life in the earliest historical phase in India. At Bharhut the simple life of the Rishis and Rishi-Kumaras in the forest, where the Upanishads and the Aranyakas were taught, of which we have so many touching references both in Vedic literature and in the epics, is shown in the scene of Dighatapas instructing his pupils. The simple decoration of a house or a couch with palm prints in saffron or sandalwood paste as an auspicious mark is also shown at Bharhut. Likewise of great interest is the resemblance of the chariot to its counterpart in other

parts of the known world—Greece, Rome, Egypt, and Assyria. The modes in which garments are worn, with many folds (satavallika), curved like an elephant's trunk (hastisaundika), or in a fishtail (Machchhavalaka), all have their pictorial representation. In addition, there are numerous types of ornaments and jewels closely answering the descriptions in the *Arthasastra* (see fig. 67). The richness of the turban was indicative of the rank of the wearer, whether a prince, a nobleman, a merchant, or a commoner. A woman tying an elaborate turban, the granaries in a country house in a scene from the *Ghata Jataka*, a scene of acrobats on a Bharhut pillar now in the Allahabad Museum, and other similar representations serve as a mirror of daily life over twenty-five hundred years ago.

The carving of a feminine horseback rider with a Garuda banner in her hand is as essential in understanding the importance of royal emblems as is the kamandalu, or water vessel, in the scene of the presentation of Jetavana to the Buddha by Anathapindika by suggesting graphically the significance of presenting gifts. A carving of a standing warrior against an upright shows that he wore a tunic to cover his torso like a Kanchuki, or chamberlain, while even the prince was usually dressed only in two pieces of cloth, the lower and the upper garments, antariya and uttariya.

Though the fragments of the rail and a single torana from Bharhut and portions of the rail from Bodhgaya are the only surviving remains of monuments of the Sunga period, the sculptural panels here suggest the types of structures that existed. These corroborate literary descriptions. It is at Bharhut that we have the earliest representations corresponding to the motifs decorating the palace of Ravana as described in detail in the *Ramayana*. The kutagara, a spacious mansion like a sabha actually labeled 'Sudharma devasabha'; the Vriksha Chaitya, the multistoried shrine around the sacred tree that is worshiped (the typical shrine around the Chaitya Vriksha is seen in sculpture for the first time at Bharhut); the separate circular cell, or gandhakuti, of the Buddha in the vicinity of the monastery, or vihara, in Jetavana; the hut of leaves, or parnasala, contrasted with the magnificent palace and assembly halls of India, definitely labeled 'Vaijayanta Prasada,' the term used for the mansion of India; the hut, parnakuti or sala, for the hermit; and the simple wagon-roofed house of the villager are all types of buildings depicted in Sunga sculpture.

The multistoried buildings like the mansions in Lanka, described in the *Sundarakanda* as sapta bhauma, or seven-storied, and ashta bhauma, or eight-storied, are actually seen in caves excavated in the rock on two levels at Khandagiri and Udayagiri in Orissa.

It is at Sanchi, however, that we get more elaborate representation of Valmiki's graphic descriptions in the *Ramayana*. Here is the city wall with the moat laden with lotuses; city gateways with elaborate fortification and roofing in the styles of hut and hall, or kuta and sala.

In an impressive scene carved at Sanchi, a prince marches along the royal highway and issues through the city gateway, watched curiously by damsels who pack the balconies of multistoried mansions. A balcony (valabhika, often ivory-decorated) may be seen on the topmost floor, cool and lightly roofed, in the dream of Maya (fig. 65). In the western Indian caves such as those at Bhaja the arched facade, which is elaborate, suggests an advance over the simpler type at Guntupalli near Bezwada, which still conforms to the Mauryan type in the Barabar hills near Bodhgaya. The trelliswork of the windows and the pierced lithic screens in the caves suggest the jalavatayanas and gavakshas described in the *Ramayana*.

In the earliest phase at Amaravati not only were the Vriksha Chaitya and

78. Detail of a female figure from a donor couple (dampati) at the right of the right-hand entrance of the facade of the chaitya (shrine) at Karla (western India). Satavahana, first century A.D.

the multistoried building suggested in carved panels but the simplest and the earliest form of the stupa was also shown there. The structure was low, without elaborate arrangement of a platform all round and without projections at the cardinal points. In place of the later decorative medallions it had nagadanta pegs at regular intervals within reach of the hand of the devotee to permit the placement of wreaths all around the stupa. The harmika, or balcony above the dome, was absent. The simple railing around the stupa, if present, was of wood. As in the case of every other architectural part, it is this wooden prototype that was later copied in stone, and such parts were specially carved, even in the caves where they served no structural purpose except to prove their origin. It is therefore interesting that wooden rafters used as decoration in western Indian rock-cut caves were recently discovered at Bedsa.

When one considers the sculptors' knowledge of literature, their technical skill, and their methods of delineation in this early phase, it cannot be denied that already there is a full realization of all that is essential in pictorial art for making the composition as effective in visual art as in poetry.

At Bharhut the attitude of the yakshis entwining their legs around tree trunks, seeming almost to kick them to make the trees blossom out of season in artificial efflorescence, a motif known as Dohada, and a human hand issuing from a clump of trees to offer food and water, suggesting the hospitality of kindly wood spirits, the Vanadevatas, recall popular notions of the day freely voiced in literature of that time. Gajalakshmi, standing on a lotus, holding lotuses, and bathed by elephants, is represented for the first time on the torana at Bharhut. The motif of the woman on a pillar, the frieze of geese (a subject already treated in Mauryan sculpture and repeated here), fantastic animals such as elephants with hindquarters in the form of fish, and the similar horse and bull, are all as described in the *Ramayana*. The term Ihamriga (imaginary animal) occurring in the *Ramayana* denotes motifs created entirely from imagination with no corresponding example in nature.

The sense of humor cannot be underestimated when we consider such panels at Bharhut as that of the *Aramadusaka Jataka*, where the wise old monkey pulls up plants to judge the size of the roots in order to assess the amount of water required for each one, to avoid waste. An equally amusing panel shows the monkey as a dentist, engaging an elephant tied to a rope to extract a giant's tooth. In the graphic representation of the *Chammasataka Jataka* a fool watches a butting ram approaching him with its horns lowered, taking this as a sign of respect until, hit by the animal's horns, his tremendous fall brings him back to reality.

The *Kukkuta Jataka* is in an equally humorous vein, where we cannot help laughing at the coaxing cat that cannot prevail on the bird, perched beyond his reach, to come down to serve as his breakfast.

In a philosophic strain, the *Mahajanaka Jataka*, suggesting a mood of peace (santa rasa), is effectively depicted. In this story a king learned a lesson of peace in loneliness while watching a smith straightening an

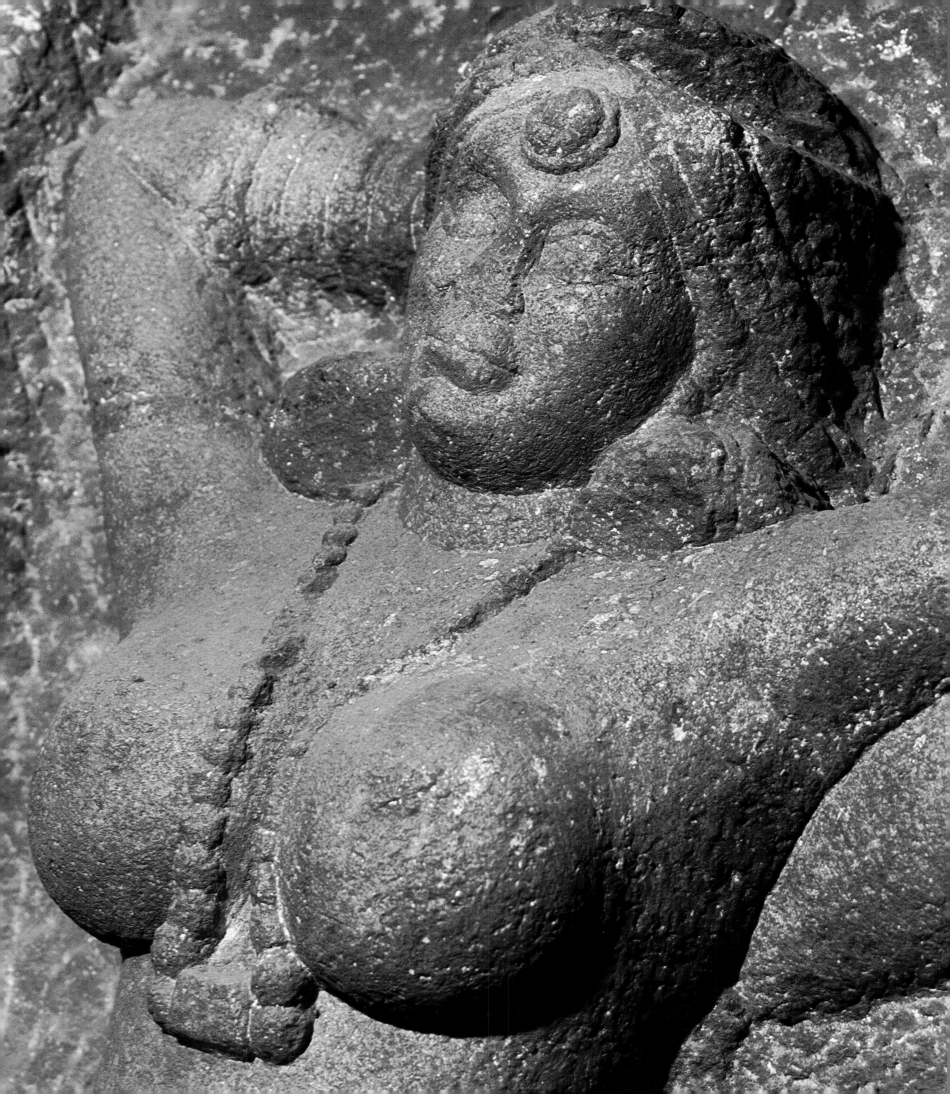

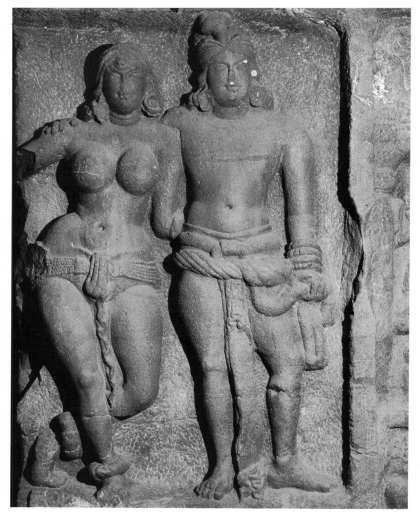

79. *Donor couple (dampati) at
the right of the left-hand entrance
of the facade of the chaitya
at Karla. Satavahana, first
century* A.D.

arrow by checking it with one eye closed; thereupon the king renounced kingdom and queen, to be a lonely hermit. The *Mugapakka Jataka* is another instance of the Bodhisattva's choosing a life of renunciation rather than that of princely estate and pretending to be ignorant only to avoid royal status. In the *Sujata Jataka*, again in a philosophic strain, the wise son criticizes his father for his lament over a dead animal.

The beautiful figure of the goddess Sirima-Devata and Chulakoka (fig. 67) and, in particular the damsel playing the vina, on a rail pillar from Bharhut show how much at ease the sculptor has been when depicting the feeling of love (sringara rasa) through feminine charm. The painting of designs with sweet-smelling kasturi on the sandalwood-smeared body by the lover is another instance of suggestion of the sentiment of love. The *Nigrodhamiga Jataka*, the *Mahakapi Jataka*, and, more effectively, the *Chhaddanta Jataka*, in each of which an animal willingly and easily offers his life as a pure sacrifice for the good of others, cannot but evoke the sentiment of pity (karuna).

At Sanchi, the sentiment of love is effectively represented in panels showing a comely damsel with companions around her as she adorns herself, mirror in hand, or in scenes of lovers, seated under a kalpa tree on the bank of the heavenly stream, enjoying a cup of wine, with the toilet box close to the damsel, to be used as necessity arises.

Love of a lower order, tirjyagatarati, is portrayed in the cooing of birds on a housetop, as at Bharhut, or in the tender attention of a female elephant to its mate in a lotus pool, as represented at Udayagiri in Orissa. Here the sculptor, a keen student of literature, has followed Kalidasa's description in depicting the noble bull elephant graciously receiving lotus stalks lovingly offered by the female. A pleasant chat with a parrot is as much a favorite pastime of a lovely damsel, as depicted in sculpture at Udayagiri, as is the guarding of a doorway by a hefty woman in the attitude of an Amazon. The damsel talking to the parrot in a love pastime, or sringara-cheshta, is a counterpart to the scene verbally pictured by Kalidasa in the forlorn yakshi's conversation with the parrot in the *Meghaduta*.

The heroic sentiment is clear in the battle for the relics at Bharhut (fig. 69) and other similar scenes. The sentiments of aversion and fear, bhibhatsa and bhayanaka, are aroused in such panels as the Maradharshana, the temptation of the Buddha by Mara, at Sanchi, where, large and imposing in bodily contour, Mara looks the very image of personified evil.

The spirit of wonder, adbhuta, also is clearly seen at Sanchi in the panels of the monkey offering honey to the Buddha and the Buddha floating on the waters watched by the amazed Jatilas.

5. The Art of Gandhara

by Mario Bussagli

The geographical area stretching approximately from the upper Indus Valley to the present course of the Amu Darya fell under the Hellenistic cultural expansion, not only as an effect of Alexander's conquest but also as a result of the survival of scattered and circumscribed Greek kingdoms (Graeco-Bactrian in the north and Indo-Greek in the south), which proudly preserved Greek culture for a long time, becoming a sort of Hellenizing filter to the nomadic peoples, who, in a manner not always very clear, later came in touch with the Indian world and civilization. Until a few decades ago the spread of Greek culture over vast Asian territories following Alexander's conquests was considered a temporary, irrelevant phenomenon, even though unexpected, long-lasting, and all but insignificant traces of Hellenization kept emerging here and there. In this general neglect, the only exception which fascinated scholars for its unmistakable characteristics and which was therefore carefully studied for over a century was the so-called art of Gandhara—a figural trend inspired by Buddhism and lasting for about a millennium (from the first century B.C. to the end of the eighth century or to the beginning of the ninth century of our era, if considered down to its very last manifestations). This art derives its rather conventional name from an old region, rich in monuments and works of art, that is thought to have been its cradle. Its obvious links with the Classical, Hellenistic, and Roman worlds, confirmed by successive archaeological finds, made it, in the eyes of the specialists, the farthest eastern propagation of Classicism, and critics referred to it as 'the semi-Classical art of Gandhara,' 'Graeco-Buddhist art,' and 'Graeco-Roman–Buddhist art.' The adaptation of forms, images, stylistic details and decorative motifs from Classical Western art to exotic subjects such as the Buddhist legends, the episodes of both the historical and the previous lives of the Buddha, and his miracles had excited the interest of Western scholars from the second half of the nineteenth century. Gandharan work, with its obvious—in fact, striking—Classical component appealed to the traditional taste of the West, whereas other Indian work, despite its frequent grandeur and often obscure religious symbolism, was not equally appreciated. In the first half of the twentieth century, when Western culture at all levels began to depart from Classicism to seek new values under the impulse of the new artistic experiences and of the exhaustion of the old ones, judgment of Gandharan art underwent a profound change and the enthusiasm of researchers slackened considerably. The Classical component came to be regarded as an insufficiently assimilated foreign influence and the works of Gandhara as spurious artisan products that failed to reach the supreme peak of art. In 1930, however, with the discovery of the stuccos of Taxila (see fig. 96) and Hadda (see figs. 98 and 99) a more objective evaluation began

to be established. It was admitted that the art of Gandhara not only had created true masterpieces, especially in the field of sculpture, but also had not passed from Classical to anti-Classical; in other words, that the Hellenistic component, fostered by trade with Rome, was not a mere initial thrust that had yielded in time to local forms (by a sort of gradual Indianization): it was, instead, a much more vital element that had kept reappearing in obvious manifestations whenever historical (and social) conditions allowed. Today, there is absolute certainty that, despite the contrast between the coexisting classicistic forms, free, illusionary, and often 'impressionistic' (or, rather, 'sketchy') and the anti-Classical, rigidly frontal, and paratatic patterns of Gandharan art, the Gandharan stuccos are actually the last lively manifestation of Hellenistic Roman Classicism. When both the more refined art and the provincial art of Rome turned away from illusionistic representations after the revitalization of the unsuppressable Italic background by virtue of the imperial mystics and the triumph of Christianity (a prelude to the 'late antique' and the schools of Ravenna and Byzantium), it was in Gandharan art alone that the illusionary forms of Hellenism fully survived. In fact, it was at that time that these illusionistic forms, already modified by the Italo-Roman and Eastern Roman currents, became adapted to the Buddhist mystical theory of 'light,' extolling the Buddha also in terms of his universal sovereignty and identifying him with the essence of the universe through symbols—which sometimes turned into stylistic elements—and the choice of special subjects and types.

The art of Gandhara was not, however, an isolated occurrence. Though it stands out as a distinct phenomenon, clearer and more complex than others of the kind, it formed part of an uninterrupted stream extending from Egypt to the western borders of the Chinese territory proper. Since the studies of Daniel Schlumberger ('Descendants non-méditerranéens de l'art grec,' *Syria*, XXXVII, 1960, pp. 131–66, 253–319), the manifestations of this flux east of the Syrian and more deeply Romanized area are defined as 'Asian' or, better, as 'non-Mediterranean' Hellenism. The historical and artistic importance of the Eastern Hellenistic or Hellenized schools is not inferior to that of the various Western currents—including all the Roman schools. Between the two Hellenized areas there were, no doubt, exchanges and contacts. In short, from the western borders of the Syrian Desert throughout the Iranian Plateau, from the slopes of the Caucasus to the territories lying between the present courses of the Amu Darya and the Syr Darya, to eastern Afghanistan and the northwestern regions of the Iranian peninsula, the Hellenized area of the East continued, with greater variety of forms and stylistic interpretations, the Hellenistic Roman figural tradi-

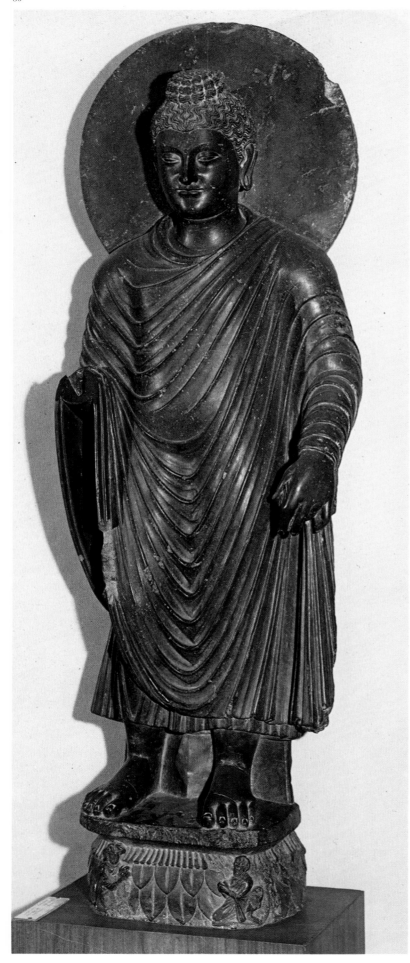

80. Standing Buddha with nimbus. Black calcareous marble. Second or third century A.D. National Museum, New Delhi
The figure, which lacks the right hand, is one of the most 'Classical' produced by the Gandharan school. The stylized forms, the praying figures at the rounded corners of the lotus-flower *pedestal, and the slightly stiff drapery are more typical of the third than of the second century.*

tion. The differing intensity and depth of the Classical influence resulted in different manifestations, all of which, however, arose from the common Hellenistic background. Throughout this area there occur the same encounters, the same solutions to identical difficulties, and the same desire to adapt the foreign contribution to the unsuppressable requirements of the local taste. The Nabataean and Palmyran currents, the earliest sculptural production of Mathura, the colossal and markedly Classical creations of the Commagenes, the sculpture of Daghestan, the works of Chorezm (on the lower course of the Amu Darya), the art of Gandhara, and even that of regions beyond it, all testify to the immense figural richness carried by the Hellenistic wave, particularly with respect to the foreshortening, perspective, anatomical accuracy, and volume of the images.

Hellenism bore, above all, on town planning and sculpture (including the work in stucco and terra-cotta, goldwork, and seal making). The architecture and whatever little is left of the painting show a rather restrained acceptance of suggestions of Classical inspiration, both in technique and in iconography and style, because they conformed more closely to the local taste and requirements.

Transformed and sometimes distorted, the Hellenistic influence, often strengthened by Roman contributions, is still recognizable and points to the fact that the first real integration of Europe and Asia, manifest in the figural arts, occurred as a consequence of the Graeco-Macedonian expansion and of the transition from Classicism proper to Hellenism. Whether directly or not, however, the Hellenistic and Roman diffusions reached far beyond the lands dominated by Alexander. The triumph of Buddhism and the trade activity between the Mediterranean and the Far East helped the spread of Gandharan art even to southern Central Asia (where merchant civilizations gravitated around the transcontinental route of silk and gold with its main centers in the oases of the Taklamakan Desert), which appears at first to have been Hellenized as far as the borders of the Chinese empire. In this unexpected and in some ways unpredictable stream, which has only recently become apparent, the thousands of known and studied Gandharan works were like a lone light, of little use toward clarification and comparison.

The historical and chronological uncertainties about Gandharan art; the difficulty of identifying the exact origin of its Classical component, which seemed in turn Hellenistic, Graeco-Parthian, and Roman; even the fact that it was erroneously thought to be a single and isolated phenomenon enshrouded in apparently insoluble problems was not encouraging to scholars, who nevertheless sensed its interest and importance. Chiefly because of the echoes it evoked in the iconography of Buddhist Asia, the spread of its characteristic stylistic motifs, and the influence it exercised on the Central Asian settlements and on some of the southern Central Indian schools—which in turn influenced southeastern Asia—this phenomenon, mistakenly thought to have been more

81. *Large female figure with markedly Classical elements in the face and drapery. From Mathura, about the second century* A.D. *Archaeological Museum, Mathura*

This large statue of bluish Gandharan schist was found at Mathura. A work already remarkable for the elegant solutions of the drapery (note the 'knot' over the left leg, almost up at the waist), its interest is heightened by its stylistic merits. It has been suggested that the figure may be a portrait of Kambujika, the wife of the kshatrapa (independent satrap) Rajnvula, but it may also be a Hariti, protectress of children.

82. *Acephalous statuette of the semi-Classical type. Probably a Graeco-Iranian victory goddess. Green phyllite, traces of gilt on the chest. From the Dharmarajika stupa, Taxila. As the date, the first century of our era is suggested. Taxila Museum*

The markedly Classical drapery, which is also strongly reminiscent of Parthian sculpture (Hatra and Dura-Europos), leaves the left leg uncovered. Round the ankle of this leg is a thick ring. A fine example of composite and yet unitary style.

82

81

mysterious than it actually was, has never failed to arouse interest. The Gandharan experience was unanimously considered fundamental to the figural evolution of the whole of the Buddhist world as far away as China, Korea, and Japan; consequently, it could not be neglected. On the other hand, these difficulties stimulated the scholars, and the wealth of iconographic, stylistic, and chronological problems—many of which appear insoluble to this day—fascinated them. This is why Gandharan art (we choose to use this conventional name because it does not lend itself to misinterpretations) has always been, in the eyes of archaeologists and art historians, a charming episode of human activity, a source of endless curiosity, and above all, an especially valuable parameter for all who are concerned with Classical art. With good reason, Bernard Berenson, in one of his most controversial books *(The Arch of Constantine, or The Decline of Form,* London, 1954), blamed many scholars and lovers of Classical art for their peculiar whim of neglecting the whole of the Gandharan phenomenon, which should have been valued, if for no other reason, as unquestionable proof of a figural trend in the Classical taste, and of remarkable importance, at the farthest end of Alexander's dominions.

The historical origin of the encounter between the Classical world and Buddhism has roots that sink deep in the past. The eastern stretches of present-day Afghanistan and western Pakistan were exposed to constant interaction with the cultures and civilizations of the Iranian and Mesopotamian areas since very remote times. Furthermore, this territory was a stage for phenomena that had a vital influence on the historical and cultural development of huge areas. The Indo-European hordes that were to create the Indian civilization proper passed through this region in successive waves, and Iranian populations, of Scythian and perhaps Sarmatian stock also, which later founded empires important not only to the history of Asia but to that of Europe as well, settled there. Linked to the Mediterranean by commercial exchange that flowed partly along the transcontinental caravan routes and partly along the monsoon routes, these empires had a brisk trade even with northern Europe, as is attested by the finding of Asian coins in archaeological sites on the Baltic coast where the amber route passed.

It must be remembered that this Asian region, which was the meeting place of both India and Iran and nomadic and sedentary peoples, was a border area coveted by many. The Assyrians fought over it in their anxiety to raise a barrier against the invading nomads, and the Persian empire of the Achaemenids annexed it in order to secure a firm and

83

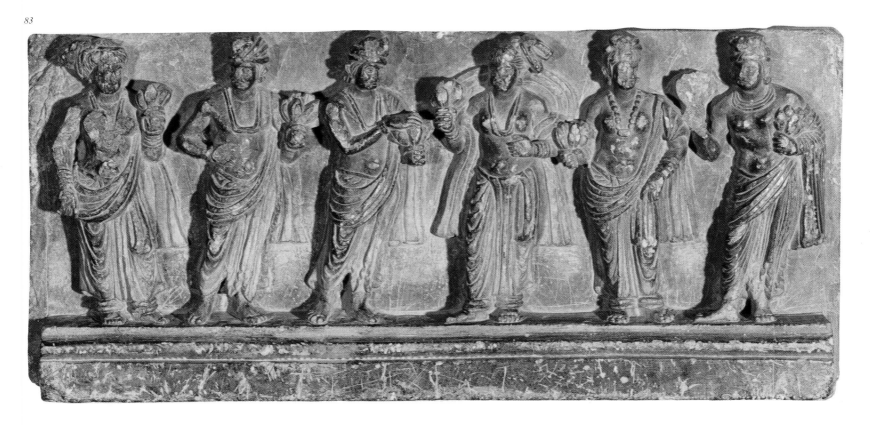

83. Group of donors. Panel of bluish schist. Second or third century A.D. National Museum, Karachi
The panel represents three men and three women offering flowers to the Buddha. Dressed in rich clothes, they must be of princely rank. The panel is one of the best of its kind. The type of costumes, reminiscent of Iran both in the cut and in the drapery, makes the second century the more likely date.

84. *The Buddha worn by ascetic tests. From Sikri, third century* A.D. *Central Museum, Lahore*
For seven years the would-be Buddha tried the hardest ascetic experiences in order to find the way to salvation. In this work he is represented in the ultimate state of consumption before giving up the ascetic way, which had proved fruitless. The rendering of the emaciated body, though unrealistic, is extraordinarily effective. Despite the Greek inspiration, the piece shows various Indian elements, such as the two networks of veins on the ribs, and is proof that the artists of Gandhara could equal and even sometimes outdo their masters.

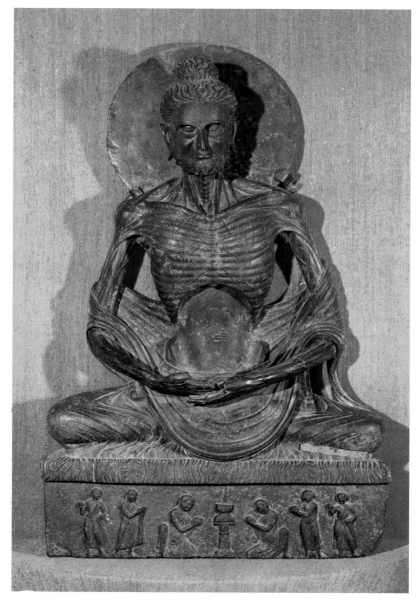

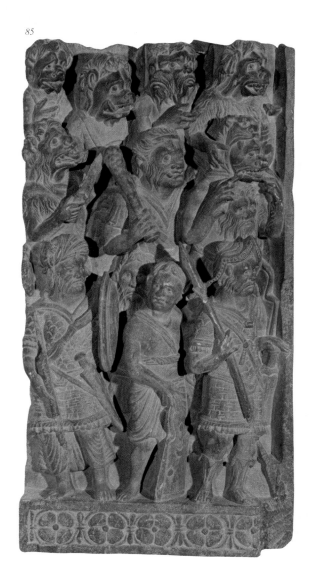

85. *The demons of Mara's army. Panel. Second or third century* A.D. *Central Museum, Lahore*
This group in schist, well known for its expressive force, unmistakably proves that both the conception and the iconography of the demoniacal in the Gandharan culture were very similar to those of the European Gothic style. It also confirms the theory of Wilhelm Worringer, who, in his study of Hellenism and the Gothic style (Form in Gothic, 1927), traces the source of the latter back to the seemingly forgotten Hellenistic background. The panel, which gives a comprehensive picture of the arms and military customs of the Kushan epoch, offers a great many stylistic details, especially in its light effects and in some iconographic elements; the last are exceedingly interesting for their magic value. The faces on the abdomens, the tusked and monkey-faced demons, those that breathe flames, the being with two heads and three eyes, another with a lion's scalp (a Classical reminiscence), the demons carrying shields with ghosts' faces and magic signs are separate elements of a vein of magic which was obliterated by the success of Buddhism.

clear-cut borderline that would stem the advance of the barbarian hordes heading toward the cultivated areas and the southern trade arteries. The impact of the Graeco-Macedonian forces that swept away the Achaemenian empire in 330 B.C., erasing the Persian giant, did not stop with the enemy's final defeat, but proceeded eastward. Alexander's original idea of avenging Greece on its traditional enemy developed into the ambitious project of building a Graeco-Iranian empire, vaster and more glorious than the solely Iranian one that had dissolved in the sacrilegious fire of Persepolis. Thus, Alexander brought back to the banks of the Oxus (Amu Darya) and of the Indus the domination of the no-longer Iranian but Hellenized West. Through this project—later disrupted by the fatigue and rebellion of his army—the area where the Gandharan school was to flourish became a part of the Hellenistic world. The fact that the Achaemenian monarchs had exiled to Bactria (a kind of 'Siberia' of the time) the rebellious Greek subjects of Asia Minor paved the way, to a degree difficult to evaluate, for the subsequent intense Hellenization that took place under Alexander's successors: the Seleucids first, then the Graeco-Bactrians and the Indo-Greeks. The history of the area where Gandharan art was to bloom became very complicated. Perhaps after Alexander's example, the national Indian empire of the Mauryas first originated from anti-Greek guerrilla warfare conducted by Chandragupta Maurya, its eventual founder. The clash of Mauryan and Seleucid forces started the slow decline of the Hellenistic political power and kindled the revival of India, but Greek remained the official language of the Mauryan emperors. Under Asoka, the third and greatest sovereign of the dynasty, Greek was also used to compile the edicts that explained to his Hellenized

subjects the dharma—that is, the ethical and political law of Asoka derived from Buddhism, which was different from the Buddhist Good Law in so far as the latter had no political implications. The translation of the edicts from Magadhi into Greek shows how much care and knowledge were put into rendering in a completely foreign language the complicated philosophical terminology based on Buddhism and pertaining to the dharma.

The history of the Indo-Greek kingdoms is essentially associated with the decline of the Mauryan empire. An isolated remnant of Hellenism deeply impregnated with Hellenistic culture became an independent state owing to the audacity of Diodotos I, a Bactrian satrap, who shook off his bondage to the Seleucid empire and thus became separated from the political framework of the Classical world. The Graeco-Bactrian rule gravitated northward toward Central Asia and the newly laid-out silk route, whereas the kingdom of the Indo-Greeks, which became independent soon afterward and was hostile to the Graeco-Bactrians, descended southward to the plains stretching from the Indus to the Ganges at the expense of the weak Indian world. Actually, these two Greek kingdoms not only kept Hellenistic culture alive but also contributed to its spread. The Indians were forced to regard the yavanas (the Greeks from India and Bactria) as warriors in decline in order to accept them into their caste-conscious world and to remain in contact with them. Probably many yavanas and some Greek and Graeco-Bactrian kings converted to Buddhism. Menander, the Indo-Greek sovereign protagonist of the *Milindapanha*, was a faithful Buddhist or, at least, a man whose spirit welcomed the Good Law. *Milindapanha* is the Buddhist text which relates in dialogue form the questions Menander

86

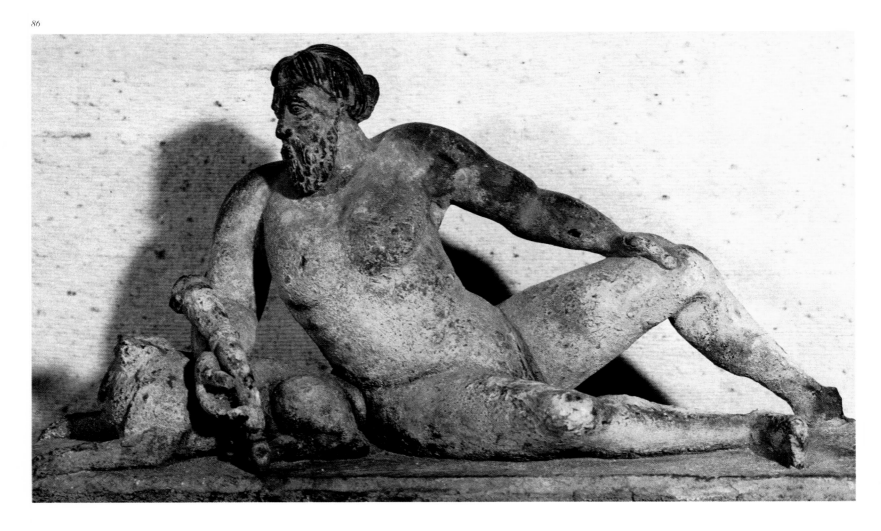

87. *Female statue with helmet and spear of which only a part of the hilt shaft remains. Possibly the goddess Rome. Second century* A.D. *Central Museum, Lahore*
This work is generally considered to be the goddess Athena or a yavani, one of the Western girls who formed the bodyguard of the Indian sovereigns. The statue, about 2 feet 2 inches tall, is one of the clearest examples of the pursuit of perspective effects through distortion. The eyes are not aligned, the ears are brought forward, the asymmetric helmet is larger on the right side. The body is flat. The illustration shows how all these distortions disappear when the angle of focus corresponds to the axis of the chosen viewpoint (from a distance and from below). If it were seen from below, the figure would be completely realistic from all sides.

87

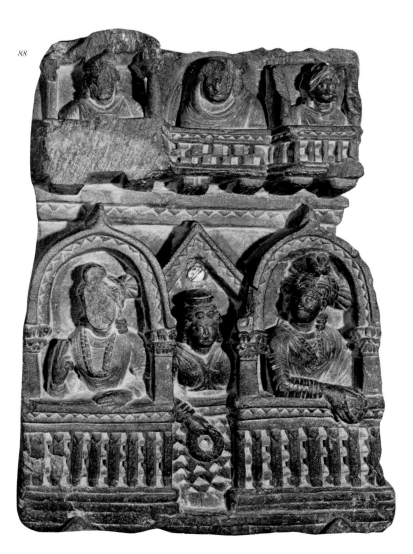

88

86. *River-god. Green phyllite (?). From Taxila, perhaps second century* A.D. *National Museum, Karachi*
The image is unquestionably of Western inspiration, even though similar Roman figures have their legs turned to the left. The grave-looking god is holding a stylized cornucopia in his right hand and is leaning on an acephalous animal that may be a sphinx. If this is the case, the figure can be definitely identified as the Nile, especially since a coin from Alexandria, which was assuredly in contact with the world of Gandhara, shows an identical representation of the Nile. Probably a work commissioned by a Westerner residing in Taxila, it was executed in a pseudo-Hellenistic style.

88. *Figures on a balcony. Panel of bluish schist. Third century* A.D. *National Museum, Karachi*
Under the arches in the foreground, two female figures stand on either side of a pseudo-Nike, with characteristic headdress, who is throwing a garland of flowers to the Buddha. Above are three men; the one in the center is draped in a kind of Roman toga thrown over his head.

put to the wise monk Nagasena, and the dialogue is another sign of the Hellenistic cultural influence; in fact, Milinda is the Prakritic form for Menander. Obviously, it is very likely that the encounter between Classical art and Buddhist thought and legend occurred in this markedly Hellenized area where a group of adventurers and also of yavana artists and philosophers kept Greek culture and tradition alive. There, Asoka's teachings, transforming the doctrines of Buddhism into political doctrines and rules for congregational living, must have borne some fruit, despite the characteristic skepticism of the yavanas, who certainly relied more on their willpower and courage than on the brotherhood preached by Asoka.

Bactrian coins with their artistic qualities are an obvious product of the Greek influence. Portraits on coins had a new development, as they reflected the real life of the sovereign, portraying him as a young man while he was young and as a middle-aged, elderly, or old man as he grew older. Graeco-Bactrian and Indo-Greek coins also are perhaps the most beautiful examples of Hellenistic coinage because of the great skill of the engravers and the humanization of the royal images. The religious symbols (divinities, attributes, and so on) on the reverse of the coins, though inspired by Classical tradition, show adaptations to the local requirements, revealing that the sovereigns' thinking was torn between the attraction of the Indo-Iranian religious speculation and the need to do justice to the local religious belief. The persistence of Greek taste and techniques in coins, however, does not permit us to jump to the conclusion that a proto-Gandharan art developed in Bactria. The few remaining examples of metalwork seem to indicate

89. The Buddha showing his
Kasyapa kinsmen the terrific
Naga (king of snakes) known
as the Black Naga. Fragment of
a panel. Green phyllite. Third or
fourth century A.D. National
Museum, Karachi
The markedly elongated figures
belong to a particular period in
the Gandharan production.

90. Panel with a Buddha in the
center. Bluish schist, third or
fourth century A.D. National
Museum, Karachi
The Buddha is stepping forward,
emitting flames from his shoulders
and torrents of water from his feet.
The interpretation of this panel,
which some think represents the
great miracle of Sravasti, is partic-
ularly difficult. Probably, as
Harald Ingholt believes (Gan-
dharan Art in Pakistan, New
York, 1957, no. 116, p. 82), it
represents the intervention of the

Buddha in defense of Sumaghada,
the pious sister of the merchant
Anathapindika, the protector of
the Buddhist community. The
maiden, who married a follower of
the Nirgrantha sect, the naked
ascetics of the Jain faith, found the
constant presence of these people
in her new home not only un-
pleasant but intolerable. She,
therefore, vehemently expressed
her resentment, but in the fight
that followed, her clothes were
torn and only the miraculous in-
tervention of the Buddha saved
her from being accused of
adultery.

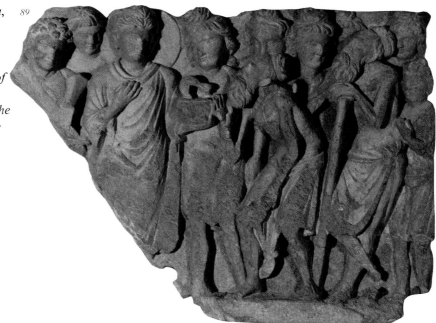

89

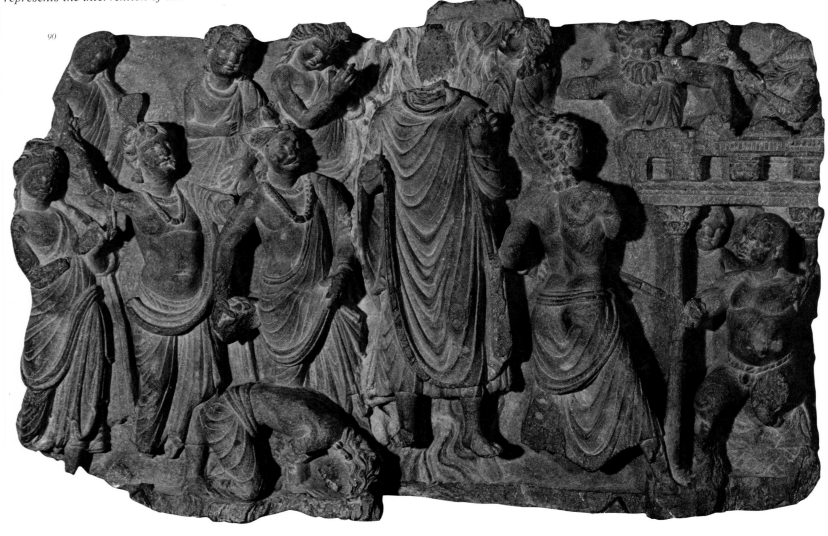

90

the existence of a Graeco-Indian style particularly evident in the silver plates, on which there appear warriors wearing the characteristic *kausia* (the Greek colonial helmet), and in the silver cups, on the outer surface of which are embossed scenes from Greek tragedies and tales rendered with stylistic details that are, however, certainly not Hellenic. Moreover, the peripheral walls surrounding the citadel of Bactria—which, by the way, enabled King Eutidemos to resist for over two years the epic siege of the city by the Seleucid king Antiochos III—though Hellenistic in both plan and technique, have false loopholes in the shape of arrowheads that are of Iranian origin and can be found in Gandharan military architecture as well as in sculptural and pictorial reproductions. Thus, the defensive walls of Bactria appear to be both Hellenistic and Parthian (the latter in its Central Asian form). In short, despite the presence of stone sculptures very closely resembling those of the Gandharan style, such as those of the hermitage of Airtam Termez (old Tarmita of the Sanskrit sources), the date of which is unknown, it is wiser to regard Bactria as just one of the main centers where the Hellenistic elements that were to constitute the Western component of the art of Gandhara survived. Apart from the decidedly Hellenistic character of the coins, the Bactrian artistic traits foreshadowing the Gandharan florescence are above all Graeco-Iranian. Perhaps it was the same elsewhere, as is suggested by the green phyllite statuettes found at Taxila (see fig. 81), whose rigidity and transformation of Classical features show them to be the product of a Graeco-Parthian encounter which is not, however, free from Indian interaction, apparent both in the costumes and in the symbolic meaning.

The stylistic and iconographic Iranian component did not fade with time. Originating from the premises we have mentioned, the art of Gandhara became the national art of the different peoples that ruled over the northwestern regions of the Indian peninsula and eastern Pakistan: the Saka groups (of Scythian or Sarmatian type), the Indo-Parthians, and the mysterious Kushans, who created the huge empire that dominated a great deal of India and, for a few years, almost the whole of western Central Asia. We shall not embark here on the complex problem of their chronology; let us just remember that they were probably a mixture of Iranian nomad groups and people from Bactria. Their origin, far removed in terms of both time and distance, is to be found among the peoples who between 174 and 160 B.C. moved away from Kansu after being attacked by other nomadic populations, in this case of paleo-Asian stock. Stopping on the banks of the Amu Darya, they gradually began to settle down, slowly assimilating the local Bactrian culture, which, as has been said, though strongly influenced by Greece, was rich in Iranian elements that were certainly the most congenial to the taste of the nomads. It is therefore no wonder that, during the Kushan empire, the official art of the court fused Hellenistic elements together with Central Asian and Iranian ones in a perfect blend. The colossal fire temple of Surkh Kotal, devoted to the dynastic cult, and the dynastic statues of the Kushan emperors from the shrine at Mat, near Mathura, are alone proof enough of both a Kushan taste that is only partly reflected in Gandharan art and a definite anti-Classical figural trend of the Iranian–Central Asian type that became grafted onto the persisting Hellenistic traits of the conquered regions and responded to the Gandharan phenomenon while remaining independent. In fact, the Buddhist-bound Gandharan production only desultorily shows these anti-Classical components, which, however, seem to have prevailed in some regions owing to the taste of the ruling Kushans in the second and third centuries of our era.

The Gandharan production must be divided into two phases. In the

91. Stele with the Buddha sitting on a throne and working the miracle of filling the space with hypostases of himself. Bluish-gray schist. Third or fourth century A.D. *National Museum, Karachi*
The panel, of remarkable aesthetic value in part for its bold spatial treatment, indicates that the Buddha and his Law are one with cosmic space. The Buddha is therefore the essence of the universe, for Buddhism recognizes space as the only reality, whereas time is annulled in the cyclic spinning of existence and the world.

91

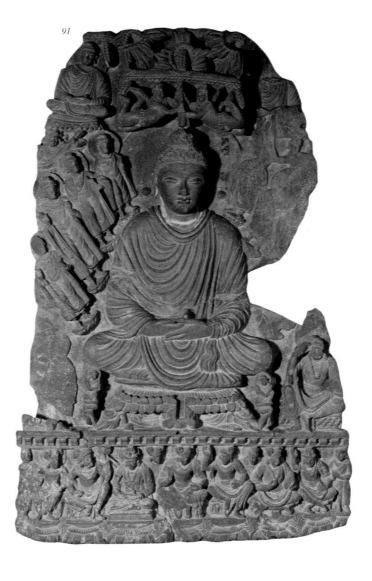

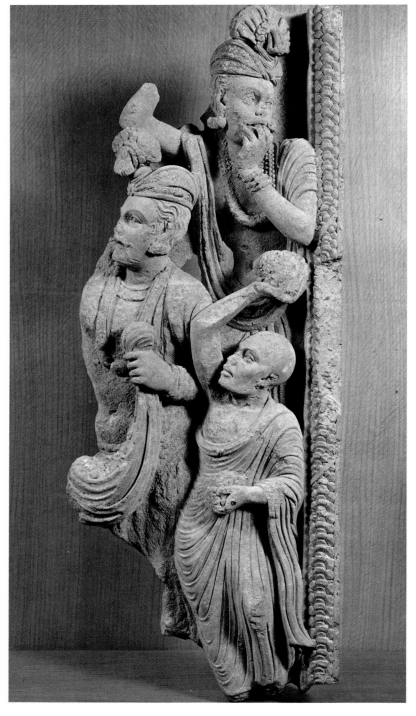

first phase edifying sculptures were made of stone—an easily modeled
blue schist (see fig. 81). The second began after the end of the third
century as a result of major political upsets involving, among other
things, the decadence of the so-called great Kushans (eliminated from
the world scene or, rather, reduced to a very minor role by the eastward
advance of the Sassanian empire). Stucco, which had already been used
on a lesser scale, became the medium most widely employed for rep-
resentation (see fig. 20). Exhausted schist quarries, economic affairs,
and a strong tendency toward repetitious and therefore industrialized
production contributed to the success of stucco, which, on the other
hand, was instrumental in the return of the Classical and especially the
'impressionistic' forms. The stucco phase, which lasted until very late,
saw the revival of Hellenism partly because the circumstances favorable
to figural anti-Classicism—namely, the support of the Kushan rulers—
had ceased to exist. Admittedly, also, this revival occurred not only
because the old influence endured but because it was nurtured by brisk
trade with the Roman and Byzantine area. The contacts between the
two worlds, which were already very extensive at the time of the apogee
of the Roman empire, remained wide until a very late date—in fact,
wider than was thought. In any case, the art of Gandhara is enlivened
by a perpetual contrast between the illusionary, realistic forms of
Classicism and those rigid, frontal, hieratic patterns arising from a
different taste (Iranian and Central Asian) and demanded by the
aspiration to mysticism and the unreal which permeates many Gan-
dharan works, especially of the late stone phase. The stucco phase also
brought an accentuation of emotional and sentimental values among
the Gandharan artists due to the fact that this art was essentially
narrative and edifying and the first ever to represent on a large scale the
episodes and miracles of the final, historical life of the Buddha (see figs.
98–100). The previous Buddhist schools had not dared represent the
Teacher as a human being. They had expressed his presence by the use
of universally comprehensible and acceptable symbols but, complying
with a prohibition which was perhaps a mere convention, had limited
their repertory to those episodes in which the Buddha could be rep-
resented as motionless. All the other episodes were figurally interpreted
for the first time by the school of Gandhara, and the Gandharan real-
izations, which adhered admirably to the texts, inevitably became ac-
cepted by the rest of the Buddhist world. The rich figural background
of Classicism also helped the Gandharan artists to attain conciseness
and clarity in their renderings of these subjects. Thus, the vast diffusion
of Gandharan art and its success in the ambience of the Buddhist world
were determined by its creation of an image of the Teacher that had the
same value as the symbols and by the fact that, through this creation, it
could illustrate a great many legendary episodes, rich in doctrinal im-
plications, which had been inaccessible to the previous schools.

Although it has not been ascertained whether the first anthropomorphic
image of the Buddha was a Gandharan or an Indo-Kushan creation of
the school of Mathura, there can be no question but that the Gandharan
image was far more frequently employed and more widespread, even
though the Mathuran image aroused significant echoes. It seems highly
probable, however, that a Hellenized artist of Gandhara was the first to
achieve the anthropomorphic image of the Teacher. This possibility is
strongly supported by the anthropomorphic character of the whole of
the Classical tradition, whereas it appears less plausible if applied to the
school of Mathura, which, despite the evident presence of a foreign
component, followed more closely the line of Indian tradition—precisely
that tradition which, for sometimes inexplicable reasons, had forbidden
the human representation of the Teacher. The images of the two schools

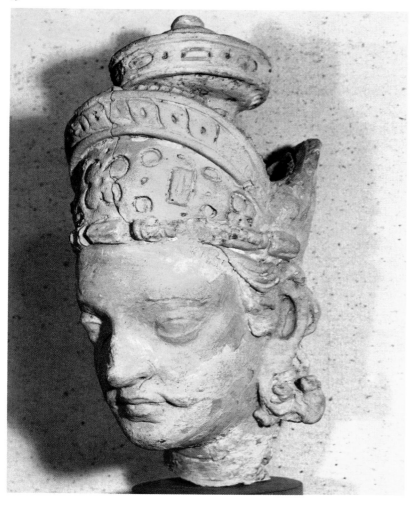

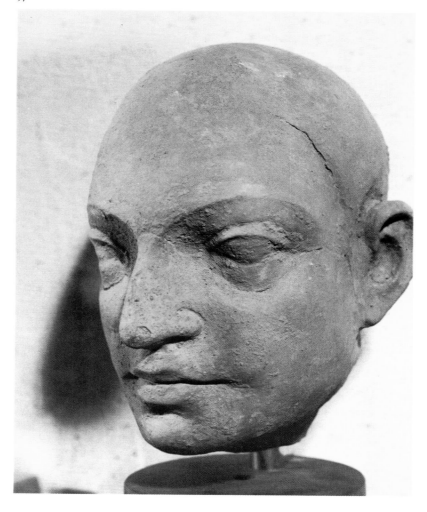

93. *Head of a Bodhisattva. Terra-cotta. From courtyard B of the Monastery of Kalawan in Taxila. Fourth century* A.D. *(other dating:* A.D. *396–415). National Museum, Karachi*
The elaborate headdress in the shape of a crown is rather unusual. The Bodhisattva, who is staring into the void, has the typical side moustaches with the middle of the upper lip shaven.

94. *Head of a monk. Terra-cotta. From courtyard B of the Monastery of Kalawan in Taxila. Fourth century* A.D. *National Museum, Karachi*
The thoughtful expression of this monk is a good example of the skill and sensitivity of the Taxila artists.

must have been created almost contemporaneously, but by entirely different means. That of Gandhara was based on the Hellenistic Apollo (see fig. 20), a divinity with strong solar associations, which had already become identified with other gods of the neighboring East. The Gandharan artists added to this model attributes that by ancient tradition the Indian texts described as the Mahapurusha's own. This imaginary figure, which Buddhism had derived from Vedic descriptions, was of a bivalent nature. It embodied the height to which a human being could rise in the fields of religion and philosophy (thus becoming an Enlightened One, a Buddha) and, at the same time, represented the utmost of worldly power, for if the Mahapurusha (the Superior Man) chose to remain in the world he was destined to attain universal sovereignty, becoming King of the Wheel (Chakravartin) owing to his quality of combining political and military power with the strength of enlightened wisdom. The detailed textual descriptions attributed to the Buddha—as Mahapurusha—thirty-two major signs and eighty-four lesser ones. The Gandharan artists chose the visible unequivocal ones and rendered them elegantly. Thus, the ushnisha, the skull protuberance that indicates wisdom, was covered with hair, whereas historical truth demanded that the head of the Buddha be shaven. Sometimes aesthetic reasons even prompted the artists to transform the hair into a characteristic chignon of Greek inspiration, while at other times it was turned into an Iranian headdress of Parthian type. The monk's habit, draped in Classical Greek fashion so as to follow the line of the body, with pleats modeled according to the tension of the fabric, was the last touch to this composite image, almost always provided with a nimbus to emphasize its divine or,

95. *Pair of gold earrings of Indian style, with granulated gold pendants. From Parthian Taxila (Sirkap). National Museum, New Delhi*
The decoration of the clasps consists of heart-shaped motifs meant to enclose colored semiprecious stones. Heart-shaped motifs are typical of Parthian and Kushan decoration.

96. *Head of a satyr. Stucco. Decidedly Hellenistic, it was found in the apsidal temple of Sirkap, the Parthian Taxila. National Museum, Karachi*
Note the movement of the hair, the flat pug nose, and the slightly parted lips. Its sharp ears are evidence that the figure is of Western inspiration, not only in style but also as a mythological subject. Some of the demons of Gandhara were derived from the type of the satyr.

97. *Fragmentary head of Vajrapani. From Butkara I in the Swat Valley. Museo Nazionale d'Arte Orientale, Rome*
The type is the same as that of the Sirkap satyr, even though the treatment of the hair, beard, and moustaches is much more descriptive and the sad look of this satyr has none of the bestiality of the other one. This is one of the finest works uncovered by the Italian archaeologists.

96

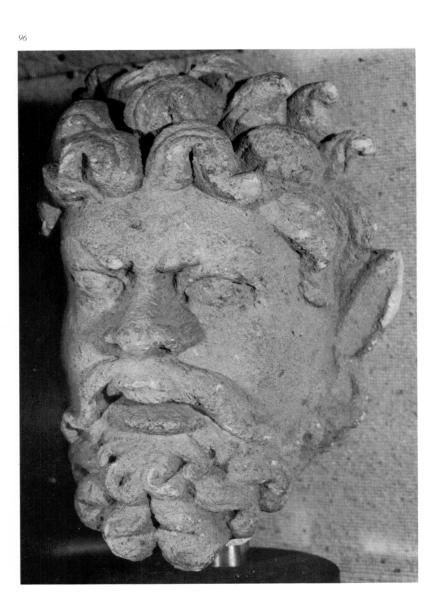

97

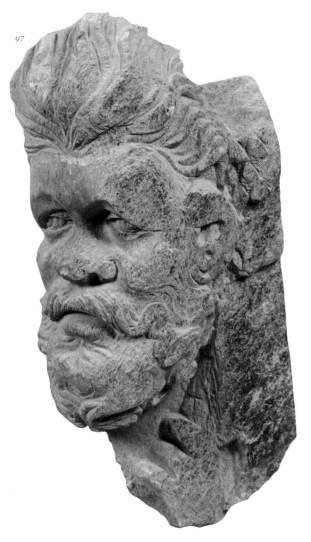

rather, supernatural character (see fig. 80). This value contrasted with the original teachings of the Buddha, who had constantly reminded his disciples that he was merely a man. It suited, however, the new nearly theistic orientation of the Buddhism of the Great Vehicle (Mahayana), which maintained the salvationist, or soteriological, quality of the Buddha on both the personal and the utilitarian level.

Mathura, instead, utilized the body and aspect of the yaksha, a lesser divinity, conferring on it the signs of the Mahapurusha, but in a different form. Thus was originated the type of the kapardin Buddha that has a coil-shaped protuberance (the derivation of the name) at the top of the skull where the texts say the ushnisha was. The artists of Mathura also adopted the nimbus and even made it larger—which shows that to them, too, the Buddha was much more than a mere human being. However, the values of the image of Mathura are very different from those of the image of Gandhara. In the latter the divine, Greek aspect together with the Indian signs of predestination permitted the artists to express both the increasing metaphysical value of the Buddha (gradually identified with the Law he had preached, which had consequently become transformed into the essence of the universe) and his human nature in a synthesis that was perfect and easily comprehensible to all who were even slightly aware of Greek culture and of the basic principles of Buddhism. In the Buddhas of Mathura, however, this conception is confusedly expressed because the stress is laid mainly on the aesthetic values that gratified the Indian taste. This is another reason why it can be inferred that the decisive turn toward anthropomorphism taken by Buddhist iconography was brought about by the anthropomorphic Hellenistic Greek tradition and the possibilities the yavanas had of creating an image that reflected the values expressed by the meaningful symbols, employing means offered by a tradition alien to the Indian one within a composite culture. In the days of the victorious Kanishka, the most famous Kushan king, who ascended the throne in A.D. 128— or, at least, in the first half of the second century—the anthropomorphic image of the Buddha was already widespread, as is evident from the coins of this sovereign; on the reverse side of these coins the clearly Gandharan image appears with the Greek letters *BOΔΔO*.

Once the aniconic tradition was discontinued, the narrative tendency burst forth. It drew its sustenance from Hellenistic Roman elements, as Hellenistic sculpture first and Roman sculpture later, and to a much wider extent, developed the same tendency, though for different purposes. Yet, unexpectedly it is the stone phase, in which the historical and legendary narrative is predominant, that most clearly shows the contrast between the Classical and anti-Classical forms. Originating with Parthian or Kushan taste, the anti-Classical forms finally prevailed in the cult steles where there was no narrative element (see fig. 91). Their stocky, powerful images of exceptional expressiveness are rigidly frontal and must therefore have been appreciated by the ruling classes of the Kushan empire. There can be no doubt that the Kushan aristocracy contributed a great deal to the development of that quality of heaviness and somewhat grim uniformity (even with the original polychromy) that characterizes much of the early production. There are, indeed, stylistic variations due not only to chronology but also to the development of individual 'workshops' and smaller centers, but on the whole the Gandharan production evolved uniformly with canons that rebounded—except for a few minor variations—throughout its area of expansion. Yet the most beautiful and least Classical steles are those of Kapisa, one of the largest Kushan centers. On the evidence of these cult images, we are in a position to say that around Kapisa (a region corresponding to that around modern Kabul) there developed a local, in-

98. Fragment of a stucco composition from Hadda. Perhaps fifth century A.D. *Kabul Museum A group of princes, or gods, and monks is adoring the Buddha. Note the position of the headless monk at the left, who is clutching his habit like the so-called Lateran Sophocles. The postures of the other figures and the drapery resemble those of Roman figures of the Trajan epoch, particularly the figures on sarcophagi.*

98

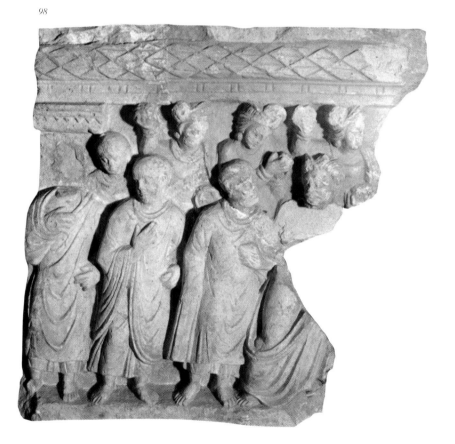

dependent trend; likewise we can say that the school of the upper Swat river valley, which also tended to rigid forms in some of its phases, may be considered a marginal, provincial branch of Gandharan art (see figs. 92 and 97).

The Classical component, anthropomorphic iconography, and the historical narrative tendency borrowed from a religion in which man was the center brought about the absolute predominance of the human image in Gandharan art, but not to the exclusion of touches suggestive of setting and landscape and indicative of perspective. The artists of Gandhara were always forced to create particular spatial effects and compositional structures, which, besides revealing remarkable inventiveness, are proof of a surprising ability to vary the conception of space. Many of the sculptural panels were meant to decorate stupas—solid domed monuments which were at once architectural projections of the universe and reliquaries or, rather, cenotaphs made sacred by small relics of the Buddha or, for lack of these, by sacred texts magically identified with his essence. Charged with symbolic values, the stupas

were honored by the faithful with the rite of clockwise circumambulation, or pradakshina, performed along an appropriate path, with meditation on the various panels representing episodes in the life of the Buddha or edifying scenes that were erected along the route. For this reason, the perspective and illusionistic effects elaborated by Greece in order to preserve the 'validity' of the images or architectural structures (very tall columns, for example), and consisting in corrections of the visual distortions caused by height or by being viewed from a distance, were utilized and perfected to create narrative compositions that would counteract the movement of the viewer. Thus was originated a particular perspective, based on trompe l'oeil and inexistent elsewhere, that may be conventionally defined as 'rotating' perspective. Because of the one way direction of the viewer performing his pradakshina, the Gandharan artists studied a series of devices through which it was possible to attain an illusionistic rotation of the scene, which consequently always appeared lively and valid to the circumambulating faithful. The images were made so that a side view brought to the fore details and

99

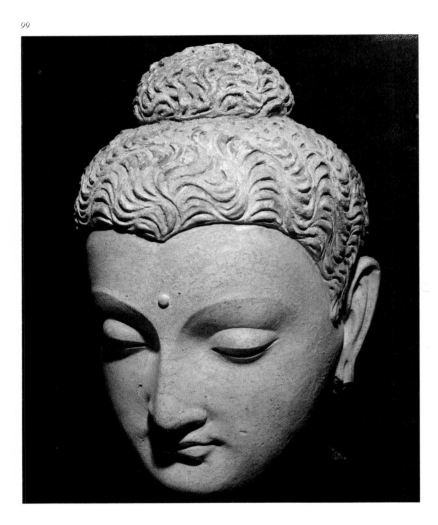

100

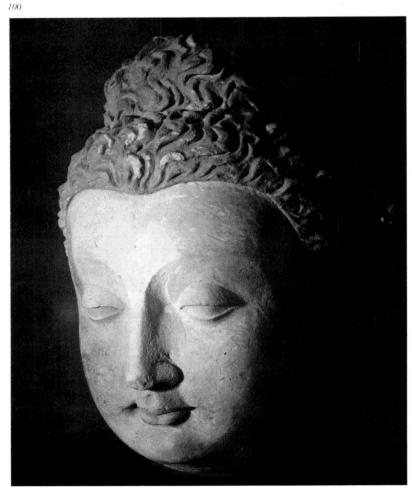

99. Head of the Buddha. Stucco. From Hadda, fourth or fifth century A.D. Kabul Museum This extraordinarily pleasing head conveys both the Buddha's serenity and the intimacy of his reflection.

100. Head of the Buddha. Terracotta. From Hadda, fourth or fifth century A.D. Kabul Museum A variant of the preceding figure with fewer Classical characteristics, despite the Greek profile.

figures which, if seen from the front, seemed secondary or, at least, different and which became transformed with the believer's progress, although the scene remained consistent and plausible from all standpoints in an angle of 160 degrees. Obviously, since they were panels rather than images in the round, the devices necessary to obtain this effect required careful—though empirical—study of the relationship between the figures and the background and of the angle of certain details (the Buddha's nimbus is no longer flat but forms a dihedral angle whose bisectrix is slightly oblique in relation to the background surface). They also demanded a calculated deformation of the facial profiles so that they would present a different vision as the faithful walked on. These characteristic effects, which can also be seen in a series of photographs, are neither frequent nor infrequent in Gandharan art and demonstrate the exceptional technical ability of the sculptors and the originality of their achievements, revealing, besides, a determination to make the best of all the means at their disposal in order to render their creations as suggestive as possible. Perhaps something similar was developed in embryo by the artists of Bharhut in some of their compositions. The merit of fully developing this technique belongs, however, to the sculptors of Gandhara, who interpreted their art as a powerful medium of religious edification and formed a true 'civilization of images' within the limitations of the technical, psychological, and circumstantial conditions of the time. The presence of isolated statues, strangely flattened and asymmetrical in facial structure, such as the so-called Athena that Harald Ingholt believes to be the goddess Rome (fig. 87), attests to a similar pursuit, as these images were no doubt meant to be viewed from a distance and from below. Ingholt bases his opinion on the similarity to a figure of a divinity inscribed with the Greek letters *PIOM*, the Iranian form for *PΩM*, and represented on the reverse of a coin of a Kushan king, Havishka *(Gandharan Art in Pakistan*, New York, 1957, no. 443, p. 168). The strong deformation and conspicuous asymmetry of such statues served partially to rectify the perspective distortion consequent upon the elevated positions in which they were situated. Scientific notions of optics were extremely limited at the time

101

101. Head of a man. Terra-cotta. From Ushkar (Kashmir), seventh or eighth century A.D.
A very expressive barbarian type. The moustaches of this head show the partition that leaves the central part of the upper lip hairless. Vaguely reminiscent of the Gallic Hellenistic Roman types, it proves that in a minor school, such as that of Ushkar, the Hellenistic influence survived to a very late date.

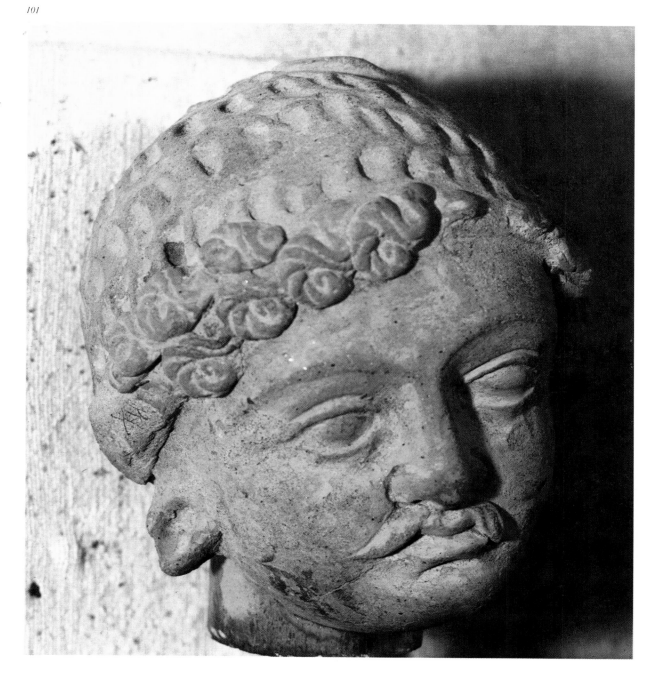

(as they were in the West also) and were, furthermore, marred by many misconceptions; Gandharan art is, therefore, all the more noteworthy, despite its empiricism.

The artists of Gandhara had their own precise and strong will in terms of art, which—as far as the stone phase goes—is manifest in part in the constant contrast between Classical and anti-Classical forms. Thanks to these characteristics the Gandharan phenomenon is valuable also as a term of comparison for a whole series of problems bearing on the artistic evolution of the Classical world. After anticipating some solutions that the West was to adopt in the late antique and Byzantine phases, the art of Gandhara once more turned to the Classical illusionistic forms, marching in the opposite direction from the West,

where, for all its glory, the old but by now exhausted tradition was finally rejected. Industrialization and the depletion of the schist and phyllite quarries cannot alone account for the return, with the stucco phase, of the classicizing Hellenistic Roman forms. Notwithstanding inevitable alterations, a taste borrowed from the West and fully accepted persisted, even though various direct and indirect components—Hellenistic, Graeco-Parthian, and Graeco-Bactrian influences, as well as that which had been brought by trade with Rome—intervened in its formation. Obviously, not all the elements stemming from the Hellenistic background of the region or suggested by the diffusing Mediterranean area that contributed to keeping the Classical component alive were welcomed. The immense figural wealth of Hellenistic Greek and Roman

102

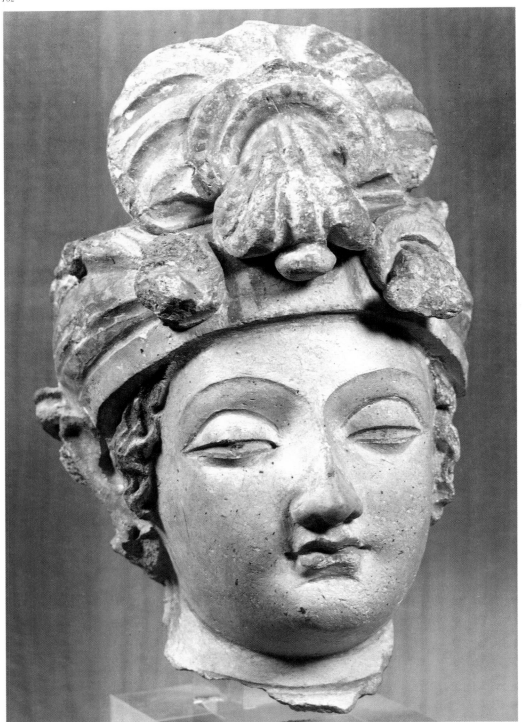

102. Head of a deva or perhaps a Bodhisattva. Polychrome stucco. Place of origin unknown (possibly Taxila). Fourth or fifth century A.D. Museo Nazionale d'Arte Orientale, Rome
One of the finest works of the coroplasts of Gandhara, this head preserves the purity of the Classical profile, despite the typical exophthalmos and the treatment of the arched eyebrows. The crown-shaped turban, though rich, is rendered with great restraint.

art did not overwhelm the artists of Gandhara, who were ready to accept only some elements or principal aspects, immediately adapting them to the local demands. The presence of Classical compositional patterns is evident, and the well-known *exemplaria* of the treasure of Begram (Kapisa) show that the sculptors (see figs. 114 and 115) and coroplasts of northwestern India and eastern Afghanistan could draw directly from valuable Alexandrian sources. Figures typical of the Graeco-Roman iconography in Gandharan works of art reflect a series of transformations in their original meanings, and sometimes surprising and clever adaptations. Each Classical figure underwent a radical change when it reappeared in Gandhara, even if it was absorbed for its original characteristics (whether religious or iconographic), which accounted

103

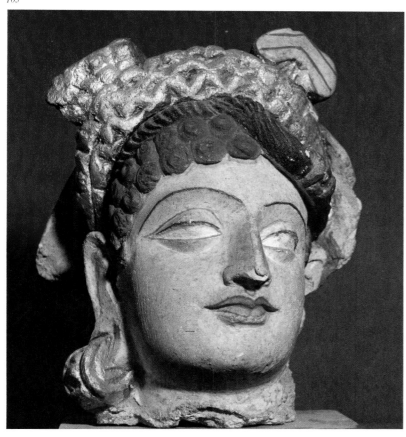

103. Head of a donor or a deva. Painted stucco. Fourth or fifth century A.D. *Central Museum, Lahore*
The well-preserved vivid colors make this head especially interesting as a clue to what stucco works really looked like. Though Classical in style, especially in its profile, the predominant colors (gold, black, red) make it unusual. It is evident that vivid colors were used in the decoration of the stupas to enliven and brighten the dull, standardized architectural structures.

for its presence in a world completely different from the one that it was meant for. Although the artists must have been well aware of Classical mythology and the iconography pertaining to it, these characteristics finally supported or expressed new religious and symbolic meanings. Thus, the Buddha took up the aspect of Apollo for the purposes and under the circumstances already mentioned, while his companion Vajrapani (see fig. 97), the bearer of the thunderbolt which symbolizes the magic power of the Teacher, sometimes looked like Zeus and at other times like Herakles, because the thunderbolt had been stylized into a rod. Sometimes he even wore the skin of the Nemean lion. Occasionally, for being the guardian and the 'secular arm' of the Teacher, he was represented in the guise of a Roman lictor.

Thus Gandharan art is not a dully eclectic figurative trend but a varied one that involved choices in style and composition and also in iconography. Different courses of thinking, contrasting interpretations, and complex choices rule out the possibility that the sculptors and coroplasts of Gandhara were all mere artisans. And this is precisely the point that must be made in order to pass an objective judgment on the artistic phenomenon in which they shared. Practically the sum total of the data at our disposal seems to demonstrate that the Gandharan current differed—despite its duration and extent—from any other similar phenomenon of non-Mediterranean Hellenism and that, for all its classicistic component, it was a trend in its own right, rich in original creativeness. Gandharan art may be called eclectic and semi-Classical, especially in terms of sculpture, but, first and foremost, it is art. As such it must be regarded and evaluated.

In terms of architecture, the problem of the Classical suggestions and of their adaptation must be viewed in a different light. The remaining architecture is almost exclusively religious and almost all Buddhist. Consequently, the Classical elements—technical or otherwise—had to be adjusted to a fundamentally different social structure and to satisfy requirements which involved a thorough transformation of the architectural values, rather than a mere adaptation. The most important exigency of Gandharan architecture was to satisfy the demands of the cult. Its formal evolution occurred, not because of dissension between Classicism and anti-Classicism, but along the lines of the changing religious sentiment. Thus the stupa grew more vertical with increasing mysticism—as did the European Gothic style—even though the various techniques did not keep pace with the new necessities. On the other hand, there was not a constant preoccupation with the durability of the structures, which were very often votive objects. This indifference is demonstrated, among other things, by the frequent reuse of materials belonging to other, crumbled constructions and especially by the habit of cutting out and reversing panels that had already been carved on one side, reemploying them for restoration or brand-new constructions. The economic preoccupation is apparent—saving on the materials, speeding up the work with materials available on the spot, and eliminating the costs of transport; but also evident is the frailty of the buildings, for reemployment occurred after a very brief lapse of time. Indeed, the scenes represented on the two sides of a panel are sometimes by the same hand. Therefore, apart from exceptional cases, the architectural structures were not made to last or to become landmarks of artistic evolution, nor even to stand forever within a natural ambience. Once the votive structure had been completed it had served its religious purpose, and that it crumbled or was demolished did not matter. As for the colossal works, more carefully built but equally frail because of inadequacy of technique, they were constantly exposed to the overflowing of streams and rivers and to frequent earthquakes, to say nothing of the

damage they suffered at the hand of man. Under the circumstances, it is possible that the Classical component caused rock-carved architecture, of which the Indians were very fond, to be set aside in favor of 'built' architecture, which, however, never became predominant. In the creation of particular structures, such as stupas, which have no interior space, the Classical component, if it survived at all, was of necessity deeply altered. Octagonal motifs and round towers at the corners of large civic buildings may be signs of Western influence of the Roman epoch. They are not, however, of basic significance in Gandharan architecture nor in the leanings that prompted it. The Classical component is more evident in the non-Buddhist, heterodox monuments, which are in practice adaptations, Iranian in type, of Hellenistic Greek structures. In any case, any really typical Roman feature was adopted with great difficulty by Gandharan artists owing to the stress Roman architecture laid on interior space. Thus the temple of Jandial, at Taxila, is distyle *in antis*, modified to meet the needs of a non-Greek cult. Surkh Kotal, the dynastic temple of fire, which has already been mentioned, recalls Hellenic models, but in structure and in the gigantic dimensions of the access staircase seems altogether anti-Classical. Instead, Hellenistic derivation is manifest, at least in terms of ground plan, in some large Buddhist complexes, such as Takht-i-Bahi, Mokhra Moradu, Jaulian, and Loriyan-Tangai, where the main stupa stands out between two detached side structures, one containing the chapels and votive objects and the other the dwellings of the monks. From this framework develops the Greek sense of volume and the particular spatial treatment which reduces the stupa itself to a massive element enclosing an intangible space and, with its rounded dome, emphasizing the surrounding buildings.

On the whole, however, Gandharan architecture is solely Gandharan, that is, autonomous and independent of foreign influence, bound to the demands of the cult and a deeply religious society which had nothing to do with the traditional Hellenistic world. Unlike Greek architecture, it tended upward, as in the gradual evolution of the stupa, which from a round plan changed to rectangular or cruciform plans two or three stories high and surmounted by cleverly built wooden structures that have disappeared with time. The stupa founded by Kanishka at Shaji-ki-Dheri, near Peshawar, had a cruciform plan with a maximum width of about 280 feet; its stone structure was about 250 feet tall, but the wooden superstructures that formed thirteen ambulatory terraces made it reach a height of about 625 feet. Fa-hsien, one of the great Chinese pilgrims who went to India, the Holy Land of Buddhism, described the stupa of Kanishka as the tallest tower in the whole of the Jambudvipa, that is, in the whole Indian subcontinent. This gradual verticalization, however, occurred alongside rather heavy ornamental elements adorning the exterior surfaces in a manner comparable to the Baroque and probably borrowed from Parthian Iran. The use of acroteria in the shape of step pinnacles, of undulating festoons, and of diverse moldings, besides revealing a mixed component that could be generically termed 'Western,' shows that the artists had no interest in accentuating the verticalization of the buildings by optical devices. The upward thrust is never as evident as in the European Gothic style, not only because of inadequate technical knowledge but also because the artists chose to use the ornamental repertory at their disposal in their own fashion.

As for painting, the remaining traces in the geographical area of the Gandharan current are too scarce to permit judgment. Side by side with a Buddha from Hadda, which might seem to be derived directly from the Roman and Byzantine West, but which is, in

104. Head of the Buddha. Painted stucco. Fourth or fifth century A.D. *Central Museum, Lahore The deep black hair, bright red lips, the urna between the brows, and the red lines around the eyelids that emphasize the glance are further proof of the pursuit of expressiveness of the Gandharan coroplasts.*

fact, a painted repetition of the frontal images already existing at the time of Kanishka and later developed in the Kapisa steles, are winged eroses, also from Hadda, which are the most Classical imaginable, despite allowances for the local taste. Similarly, the Buddha figures in the vestibule of Group G at Bamiyan belong to the same stylistic vein and bear the same figural conventions as the painted Buddha of Hadda and the corresponding images produced by the stone-phase sculptors. This fact shows the prolonged duration and the success of anti-Classical images and stylizations, for the paintings of Bamiyan are comparatively late. The only substantial series of paintings that can be attributed to the school of Gandhara, but that were for the most part destroyed by accident, is that of Miran (see figs. 157–161), a Buddhist center on the southern branch of the silk route, about 150 miles from the Chinese imperial boundary. Thus to find extensive documentation of the pictorial activity of the school, one must leave the Gandharan area and penetrate deep into Central Asia. The Miran paintings, signed with the name Tita, a Prakritic variant of the Latin name Titus, were probably executed by an artist trained in a 'workshop' or artistic milieu responsible for some of the most beautiful known 'rotating' perspectives. Above all, however, the paintings of Miran are the unequivocal indication of the Gandharan diffusion in Central Asia, and they will therefore be dealt with under that heading.

The minor arts, goldwork in particular, offer several pieces of remarkable archaeological interest. Some, such as the golden reliquary of Bimaran and the gilded bronze one from the stupa of Kanishka, have helped to establish a possible internal chronology for the school of Gandhara; but jewelry proper, such as that of Taxila (see fig. 95), belongs to a mixed Graeco–Indo–Iranian production, in which diverse components are fused into a new style, at least within the limitations of a minor art the purpose and essence of which is its use. A better and more complete understanding comes from the examination of the jewelry reproduced in sculpture (see fig. 83), for the jewelry of Gandhara is not linked only to Indian typology, Iranian models, and other sources of inspiration which may pass as Hellenistic Greek and are very rare in sculptural representations (decidedly not imaginary). The evidence of the stone and stucco images shows also a Scytho-Sarmatian component linking this production to the remote original Central Asian birthplace of the Kushans, the uninterrupted relationship that all the powers ruling over the area of Gandhara kept with Central Asia, and a more frequent and extensive commercial exchange than the stylistic and evolutional autonomy of Gandharan art might suggest. On the other hand, the small metal sculptural production that is the very essence of the art of

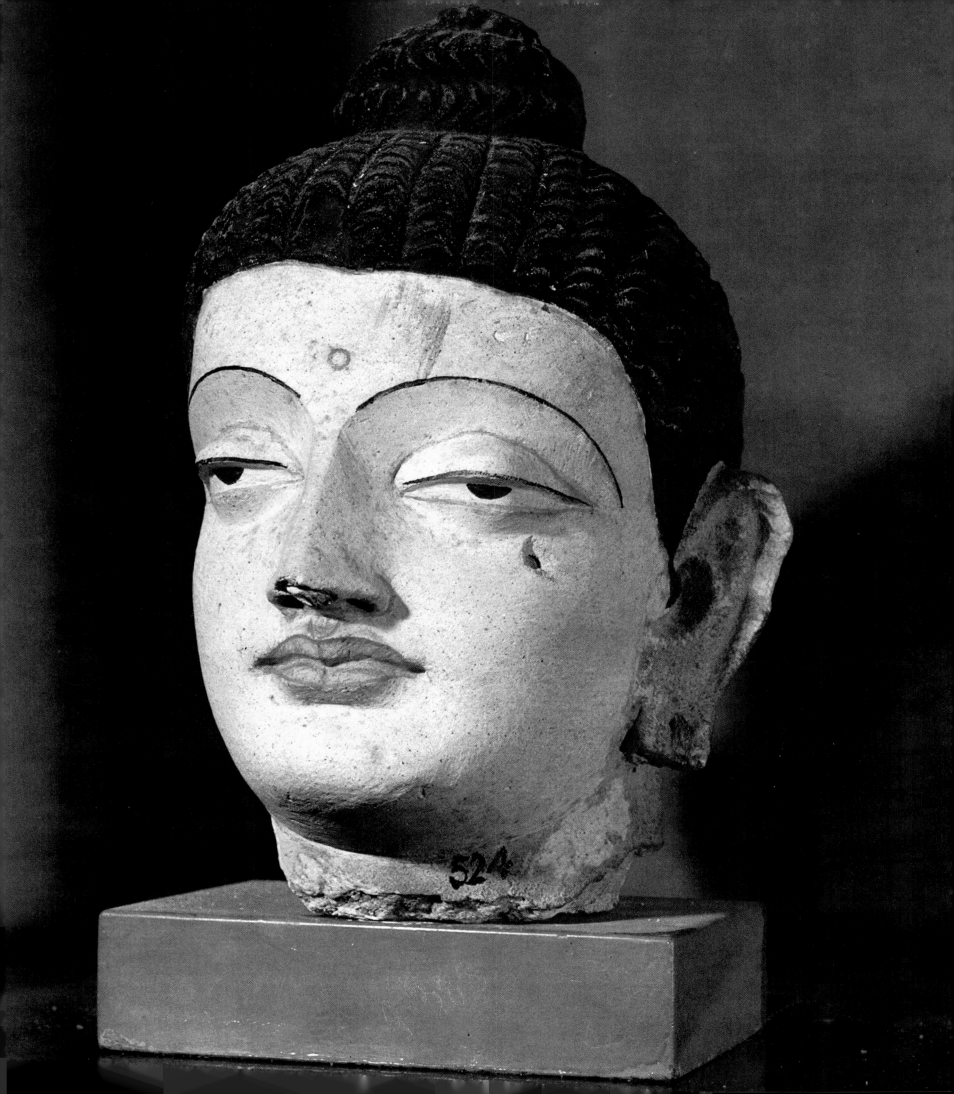

105. Two statuettes, one of the war god Karttikeya and the other of the four-armed Vishnu with his four attributes. National Museum, Karachi
The figure of Karttikeya can be identified by the spear and by the bird he is holding in his left hand; it is the prototype of Vishnu and of a production that was to develop later. Found in the Dar-nika Rajika of Taxila, it belongs to the period when the influence of Kashmir was predominant and can be dated in the fourth century A.D.
The statuette of Vishnu, also from Taxila, can be dated in the eighth century. It shows the god's four characteristic attributes—the lotus (padma) in his right upper hand, the shell (sankha) in his left upper hand, and the staff (gada) and the wheel (chakra) in his two lower hands. In The Development of Hindu Iconography *(Calcutta, 1956, p. 9), J. N. Banerjee notes that the staff is similar to that of a rather classic character on a seal, believed to be Ephthalite, and to the images on the coins of Manes. He also remarks that, apart from the staff, the figure reechoes Gandharan iconography. The style, however, is very different. As is evident, the persistence of the Gandharan influence was far more enduring than might be expected. On the contrary, the preparation for the medieval Hindu style was extremely remote in time. The half figure emerging from the base probably represents the goddess consort of Vishnu assimilated to the earth.*

105

the northern nomads (in other words, of the art of the steppes) always had such a force of expansion and penetration that, for a long time, it influenced the sculpture and the symbolic and decorative motifs of entirely different artistic milieus pursuing discordant ideals. The fact that its influence on the better Gandharan work was limited to jewelry and otherwise shows only in the minor details of some rare sculptural compositions reveals how unreceptive the Gandharan current in stone and stucco was to the figural emanations of the steppes. This is another sign of the vitality and stylistic consistency of this school. It also attests to the difference between the so-to-speak minor production and that

permeated by the Buddhist doctrine or, at any rate, associated with religion, which was an entirely different matter in taste and worth. In a sense, the Graeco-Buddhist—or, rather, Indo-Greek—culture of Gandhara assumes the aspect of a hegemonic culture dominating over a still active cultural sedimentation partly derived from the ancient traditions of the nomads. Originally, in fact, the creators of the Kushan empire were nomads—Indo-Europeans of Scytho-Sarmatian stock—who assimilated the Graeco-Iranian culture of Bactria, mixed with the local population, and re-created an independent civilization of which the so-called art of Gandhara is the artistic expression.

6. The School of Mathura

by Calembus Sivaramamurti

The Kushan empire was huge, extending from beyond the northwestern frontier to near Pataliputra. Just as Gandharan art marked a phase of Kushan in the Gandhara region, the school that developed the indigenous style in the area of Mathura was distinctive. A seat of great artistic activity, Mathura produced numerous sculptures, which have been found in several places; some of them are very famous. The early Bodhisattva type of the Mathura school, which is particularly thickset and heavy and forms a contrast to the Gupta Buddha, has a clean-shaven head, lacking the protuberance of the ushnisha which is so characteristic in all later representations. In Gandharan sculpture the ushnisha is of two types, the bundled-up knot and the bump on the head covered with curls as over all the rest of the head, but when it appears somewhat later at Mathura, the ushnisha is at first a single dextral curl twisted on top of the head almost like a cone; the most famous example of this type is the Buddha from Katra, flanked by two Bodhisattvas. This important type has other examples from Ahich-chhatra almost identical in form, one of which is inscribed.

While in Gandharan sculpture the Buddha has only a simple circular halo without decoration, the halo in Kushan sculpture, though simple, has a scalloped edge. The treatment of the drapery, however, is nearer the Gandharan mode, with a stress on folds which are arranged in a set pattern. In later Gupta sculpture, the treatment of drapery sometimes continues, or resorts to, the simpler method of suggesting the garment by the hem of the robe, avoiding the folds.

In this early phase of Kushan art, the Bodhisattva, as the Buddha is styled, is somewhat stiff and straight with the left hand on his waist and the right raised in the abhaya mudra, or the protective gesture. Even in the case of conventional Bodhisattva figures like Maitreya and others, the disposition of the hands is similar. In the treatment of the legs the sculptors have felt a vacuum and tried to fill the space between them by introducing the motif of a lion or something of the sort. The famous images of the Bodhisattva dedicated by Friar Bala in Sravasti, Mathura, Sarnath, Maholi, and other places, each with an inscription on the pedestal describing the dedication of the image, are typical of the early type of Mathura Buddha.

In the case of Jain Tirthankara images, the chest being bare, the srivatsa mark is prominently incised. This auspicious symbol, which changed its form over the centuries, appears in its early type in these Kushan Tirthankara figures.

Apart from individual representations of single Tirthankaras, there are composite types, or Chaumukhas, four Tirthankaras facing the cardinal directions on the four sides of a slab. Invariably the aesthetic quality in the representation of a Tirthankara is definitely low.

On the other hand, the treatment of yakshis, like the famous ones from Bhutesar (see figs. 106 and 107), or the damsel carrying a platter and pitcher suggesting food and water carved in the round in the Bharat Kala Bhavan at Banaras, or those in relief in the Mathura Museum, is extremely beautiful.

The Bhutesar yakshis, which are the most elegant, are on rail pillars recovered from the site after which they are known. Two of these are in the Mathura Museum, while the other three are in the Indian Museum, in Calcutta. Of the former, one holds up a jar full of wine with a cup covering the mouth of the vessel, and the other hand holds a bunch of green mangoes (fig. 106). The wine jar suggests a moonlit night when the drink is enjoyed, offered by the lover or to the lover on the terrace, with the lunar disk mirrored in the liquor. The fruit symbolizes spring, the season when mangoes blossom and set. The connotations are extremely poetic and charming. In the other carving in the Mathura Museum (fig. 107), the yakshi emerges from the bath with her apparel half revealing and half covering the lovely contours of her body, recalling the poetic idea that feminine charm is heightened by only a partial revelation of beauty.

The three rail pillars with yakshis from Bhutesar in the Indian Museum in Calcutta include one with a dryad conversing with a parrot (fig. 108), her face lighting up with a smile as she inquires whether the bird, her lover's favorite, remembers him. The caged bird is taken out and perched on the shoulder to whisper its reply in her ear. The other two figures show the damsel adjusting her necklace (fig. 109), in one case, and tugging at her dress, in the other. In both cases they cross their legs in a restless attitude, awaiting the lover as a longing love (utkhanthita). In all these rail pillars, a loving couple, a dampati, each in a different attitude, is shown on top, the lover always appreciative of his beloved's charm and helping her by holding the mirror while she adorns herself as described by Asvaghosha in a poem, *Saundarananda*, in the context of Nanda's help to Sundari at her toilet, and in several other similar lovely situations.

Invariably the yakshi is draped in diaphanous apparel that almost creates the impression of nudity. The jewelry (see fig. 108), somewhat heavy but elegant, is characteristic of Kushan art; the broad necklace, the heavy earrings, the multiple bracelets, the elaborate girdle, and the heavy anklets jingle as the wearer moves.

The outstanding Kushan sculpture in the National Museum in New Delhi presents a Bacchanalian scene on one side and a more interesting episode on the other. The drunken revelry depicted (fig. 111) is intended to introduce a courtesan in a courtesan's mansion (vesavasa), where a charming damsel, a danseuse, is plied with wine by a girl attendant,

106, 107. *Yakshis. Rail pillars*
from a Jain stupa. From Bhutesar,
Mathura (Uttar Pradesh).
Kushan, second century A.D.
Museum of Archaeology, Mathura

108. Yakshi talking to her pet
parrot. Rail pillar from Bhutesar,
Mathura. Kushan, second century
A.D. *Indian Museum, Calcutta*

and as she drops down drunk, she is supported by a youth, one of the many rich patrons of the house. Close to the distressed figure is an elderly courtesan, a Kuttani, a clear picture of old age, who once possessed the charms and wiles usual with girls of the vesavasas.

The reverse shows a scene of a lovely damsel moving away from a couple of youths who are following her (fig. 112). That she is rich is suggested by the umbrella held for her by her female attendant. The significant details of this sculpture are that the damsel's anklets are pulled up to prevent their jingling and that her upper garment is pulled over her head to cover her flower-decked coiffure. The scene vividly recalls the first act of the *Mrichchhakatika*, where the courtesan Vasantasena, the famous beauty of Ujjayini, hurried home at dusk hotly pursued by the fool Sakara, the brother of the king's wife, and his friend the Vita, a man of taste, a nagaraka. Out of pity for her the Vita suggests that she throw away her anklets and flowers as the sound of the former and the perfume of the latter betray her even in the darkness of the evening as she tries to escape from her wicked friend: kamam pradoshatimirena na drisyase tvam, saudaminiva jaladodarasandhilina, tvam suchayishyati tu malyasamudbhavoyam gandhas cha bhiru mukharani cha nupurani. The position of the anklets and her attempt to cover her braid as if to conceal the perfume, as she hurries away from Sakara, depicted following her, clearly suggest that the damsel is the courtesan Vasantasena; this impression is strengthened by the vesavasa portrayed on the reverse.

The most important early representation of Sri Lakshmi, now in the National Museum in New Delhi, is of the Kushan period from Mathura (fig. 110). She stands amid lotuses issuing from a brimming vase (purnaghata), pressing her breasts to assure plenty and prosperity, by the provision of payas, meaning both milk and water, both as a mother goddess and as a river-goddess personified. There are peacocks on the back to suggest joy. Her happy mood betokens prosperity, and her pearly teeth, peeping between her vermilion lips, remind one of Kalidasa's description of the charm of the yakshi with teeth like jasmine buds.

The carving of Isisinga on a rail pillar in the Mathura Museum expresses a pensive mood. It illustrates the story of the ascetic boy who was completely unaware of the fundamentals of life and never knew about even the existence of women. Furthermore, it captures a mood rarely effectively depicted, as in the smile of the *Mona Lisa*. Of equal interest is the Yaksha Kubera, the lord of wealth, now in the National Museum in New Delhi, especially for the treatment of the hair in lovely wig-shaped curls, well-trimmed moustaches, sleepy eyes, and a peeping row of teeth suggesting an indifferent smile.

108

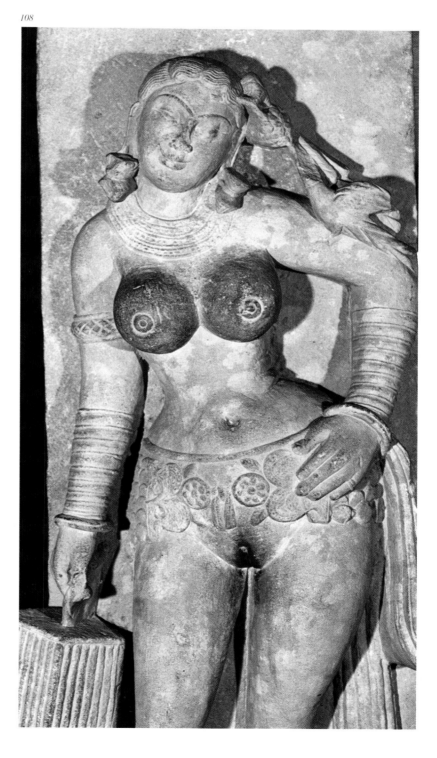

109. *Yakshi adorning herself. Rail pillar from Bhutesar, Mathura. Kushan, second century* A.D. *Indian Museum, Calcutta*

110. *Sri Lakshmi. From Mathura (Uttar Pradesh). Kushan, first– second century* A.D. *National Museum, New Delhi Standing amid lotuses and pressing her breasts, the figure suggests the mother nourishing the children of the soil with payas, meaning both water and milk. The concept also includes the river-goddess as a mother.*

109

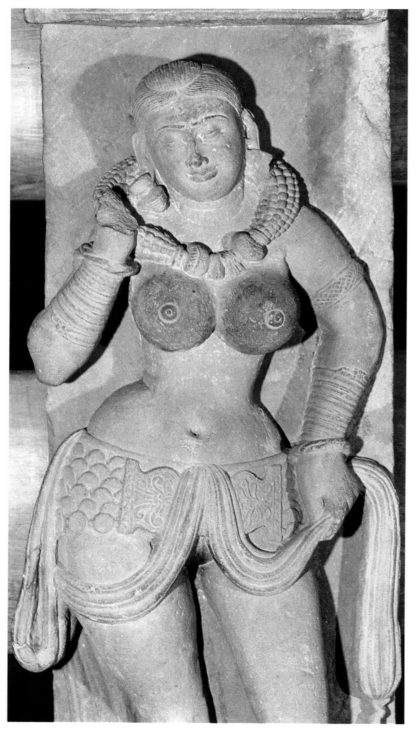

110

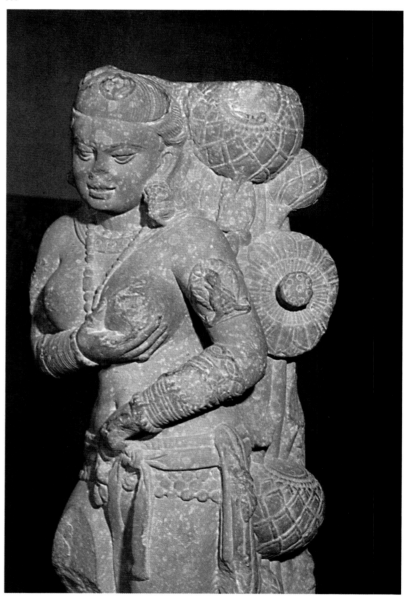

There are several Jain Avagapatas from Mathura of this period. The inscribed Avagapata dedicated by Lonasobhika is especially noteworthy for the representation of a Jain stupa which in all its details closely resembles the Buddhist type. The Avagapata representing Aryabhagavati has for its principal figure the typical goddess of this period. The Jain auspicious symbols are prominently shown on another Avagapata with the Tirthankara centrally composed in a circle which is the common limb of four Nandipada symbols.

Western influence is occasionally seen in the Gandharan school, as in the sculpture of Hariti in the Mathura Museum. But usually Kushan sculpture from Mathura is free from it. Some Kushan Bacchanalian scenes, however, and the Herakles and the Nemean lion now in the Indian Museum in Calcutta clearly show the influence of Gandhara. In the portrait statues, however, the long coat and top boots and other details reflect a different foreign influence, probably Turkoman. Kanishka's portrait statue is an instance for study, as is also the seated figure of Wima Kadphises, both in the Mathura Museum. Fortunately the inscription incised on Kanishka's coat clearly reveals his identity, although the head is lost. A complete figure of the ruler can, however, be visualized by a look at his portrait coins, which abound and which closely resemble every detail in the sculpture.

The coinage of the Kushans is particularly important for the artistic treatment of several deities such as the Buddha, the four-armed Siva standing in front of his bull, Vayu (the wind god), the Moon, and the

111

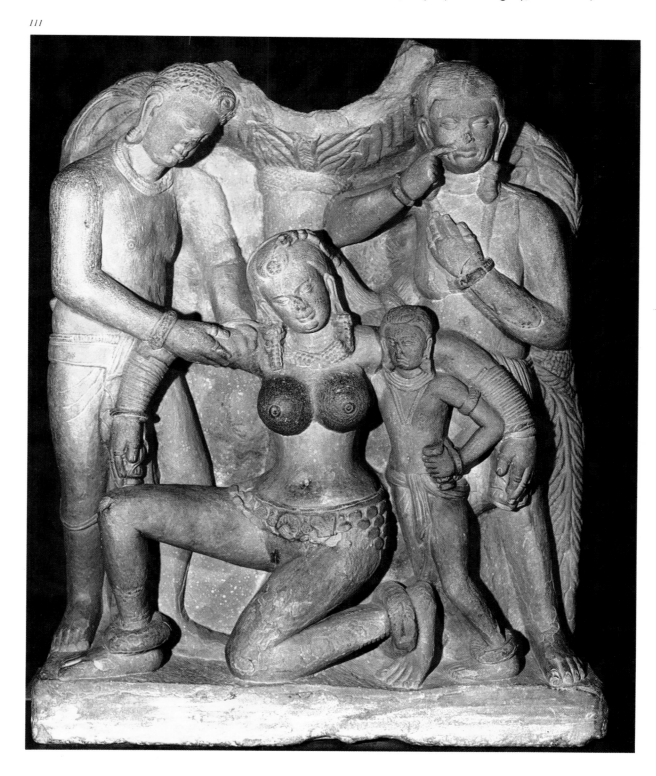

111. Drunken courtesan, helped by a youth and attended by a young female servant and an elderly courtesan. Back of a panel from Mathura. Kushan, first–second century A.D. *National Museum, New Delhi*
The subject of the scene may be the courtesan Vasantasena, an episode from whose story is represented on the front of the panel (fig. 112).

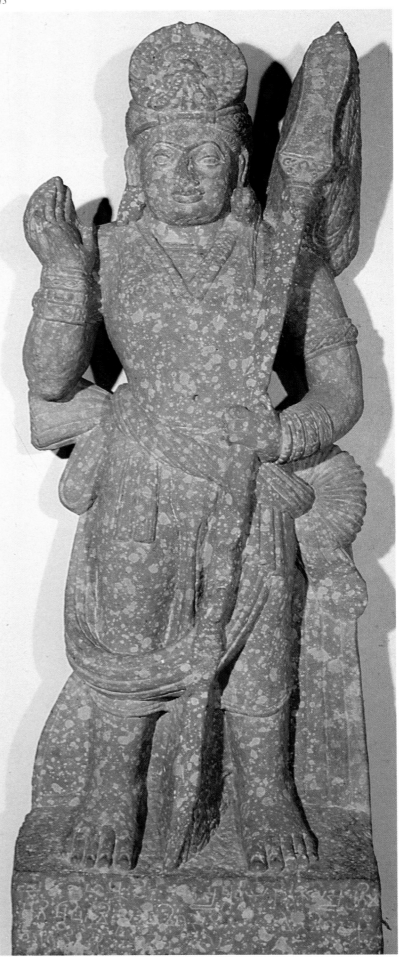

113. *Skanda as Saktidhara holding the spear. From Mathura. Kushan, second century* A.D. *National Museum, New Delhi*

112. *Front of a sculpture carved on both sides showing graphically the first act of the* Mrichchhaka-tika. *From Mathura. Kushan, first-second century* A.D. *National Museum, New Delhi*
A beautiful courtesan, pursued by an admirer, at the suggestion of a friend removes the flowers from her braid and the anklets from her feet, because they betray her by their perfume and jingling in the darkness.

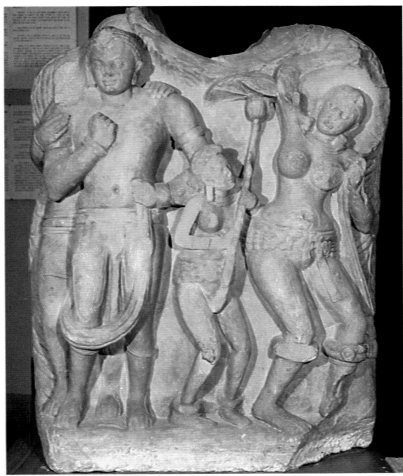

114. Princesses at an entrance.
Ivory carving. From Begram.
Kushan, second century A.D.
Kabul Museum

goddess of prosperity. The royal portrait and the goddess of prosperity in this coin type have served as models for successive coinages, for example, the Gupta, and they are of great aesthetic quality. It is important that these examples should be studied from the point of view of the traditions of Kushan art.

The architraves from Mathura in the National Museum in New Delhi not only depict groups of worshipers and imaginary animals like the dragon (makara) or Garuda, the latter with a peculiar human ear decked with rings, but are especially interesting for details representing vehicles such as the horse and bullock carriages of this period, provided with windows on the sides with adjustable blinds. These architraves are from a derelict Buddhist monument, but others came from Jain structures.

The Jataka scenes represented in Mathura sculpture are sometimes as interesting as they are humorous. The story of the deposed sovereign of the birds, *Utuka Jataka*, in a rare representation, and the talkative tortoise that paid with its life for being garrulous, *Kachchapa Jataka*, cannot but provoke a smile, just as the monkey as a doctor recalls a similar sculpture cartoon of a dentist at Bharhut.

In Kushan iconography, of Brahmanical subjects in particular, there are some very interesting features to be observed. Ganesa not only is depicted with a single pair of arms and lacks a crown, but is nude like a baby. It is noteworthy that here we have, along with a representation at Amaravati, the earliest form of the deity Surya, almost like a king wearing a kavacha, or armor, and top boots, seated on his haunches but with no lotuses in his hand. His standing figure appears only much later in the Gupta period. Combinations of deities in a row, usually three or four, are common in this period at Mathura. They may be the earliest forms of Ganesa, Gajalakshmi, and Kubera, all three deities of prosperity, or Sankarshana, Vasudeva, and Ardhanarisvara, or the more common group of Matrikas, or Mothers. The standing Vishnu has his right upper hand just resting on but not holding the club, which in this case is an enormous pestle rather than a shorter club, while the lower left hand, thrust into the mouth of the conch, holds it down horizontally. Karttikeya or Manmatha, or any deity for that matter, wears a turban with an elaborate circular jewel (moulimani) rather than a crown, except in the case of Sakra, Indra who visits the Buddha in the Indrasailaguha. The Ekamukhalinga of Siva has the face of the deity with the eye along the forehead horizontally, which makes it look weird. The youthful Kama, or Cupid, sugarcane bow in hand, looks a princely dandy. One of the most charming Kushan heads is that of Ardhanarisvara in the Mathura Museum.

The Naga type of figures from Mathura, with wine cup in hand, some-

115. *Ivory casket. From Begram.*
Kushan, second century A.D.
Kabul Museum
The delicate carving illustrates
scenes of the feminine toilet.

times represent Baladeva, who is described in the *Mahabharata* as having snakes on his head and being addicted to drink; excellent examples of this figure occur both in the Mathura Museum and in the Musée Guimet. The Sankarshana-Vasudeva worship and the chatur vyuha concept were very popular in the Kushan age, and Visvarupa forms of Vishnu closely answering the description in the *Bhagavadgita* also occur.

As the Kushan empire was extensive, the style of a school in one locality could travel to a distant place where a different tradition had evolved and developed. Thus it is that the Begram ivories (see figs. 114 and 115) clearly show the Mathura type and style of workmanship, just as similar figures are available from Taxila, like the carved ivory comb and the bone handle of a mirror, or some of the works of art from Central Asia of this period.

The ivory carving of a damsel with an attendant, recovered from Pompeii, is an eloquent example of the Kushan carvers' dexterity in workmanship. It also bespeaks an appreciative market abroad for such elegant works of Indian art.

The small reliquary of the Kushan king Kanishka, recovered from the Manikyala stupa at Shaji-ki-Dheri, is a fine example of metalwork of the Kushan age. It is a mixture of Indian and European styles of workmanship. The inscription it bears mentions the names of Kanishka and the Greek craftsman Agisila who made it. The lid of this casket shows the seated haloed Buddha flanked by two Bodhisattvas, while on the cylinder there is a meandering garland roll supported at intervals by eroses. Figures of the Buddha and Kanishka are introduced at intervals, with a long frieze of geese with outstretched necks and extended wings, recalling a similar theme on Asokan pillars from Rampurva.

7. The Classical Art of India: From Amaravati to Gupta Times

by Calembus Sivaramamurti

The Satavahana sovereigns, who ruled from Pratishthana, concentrated especially on the east, with their capital at Amaravati, when their power was to some extent weakened by the inroad of the Kshatrapas, in particular by Rudradaman.

Rudradaman was the greatest monarch of the Kshatrapas who came into conflict with the Satavahanas. He is eulogized eloquently in the Girnar inscription (see F. Kielhorn, ed., in *Epigraphica Indica*, VIII, 1905, pp. 36–49) as having twice defeated Satakarni, the lord of the Deccan. The Kshatrapas ruled from Ujjain and issued coins with most artistic portraits of each sovereign. The aesthetic quality of the Kshatrapa coins speaks highly for this people's taste. They even inspired the only portrait coin of the Satavahana ruler Sri Yajnasatakarni. As characterized in his inscription at Girnar, Rudradaman was well versed in several arts and was a patron of art and literature.

Fortunately, a few monuments that bespeak the artistic activity in the Kshatrapa realm are preserved for us. The facade of one of a group of five caves at Kumbhalidha in Saurashtra is rich in sculpture. On either side of the gateway there are guardians surrounded by attendants and in the background a garden of asoka or kadamba trees laden with flowers. The caryatid figures in the form of dwarfs that support the structure recall similar figures from the Nasik cave. This brings to mind the caryatids that hold up the Pushpaka palace described by Valmiki in the *Ramayana*.

Art centers abound in the Krishna Valley, as at Bhattiprolu, Jaggayyapeta, Gummididurru, Gudivada, Ghantasala, Goli, and Kondapur, to mention a few.

The most important monument for the study of Satavahana art in the region of the Krishna Valley is, however, the Amaravati stupa. The rail around it represents the perfection of the art of sculpture. But the magnificent rail reached perfection in this art during the time of the later monarchs in the fourth, or Rail, period. At that time both sides of the rail were richly embellished with scenes illustrating Jataka stories, Avadanas, and scenes from the Buddha's life (see fig. 116). Here one can observe an advance from the achievement at Sanchi, as the simple forms utilized there were elaborated and perfected in this phase. The motif of the garland-bearer occurs at Mathura and in Gandhara, but it is only at Amaravati that this motif attains the highest quality. It is interesting, also, to compare with the garland-bearers of Amaravati a similar portrayal of this period, but of Kushan workmanship, found even in Central Asia in some of the murals recovered by Sir Aurel Stein and now preserved in the National Museum in New Delhi. This pleasing motif of garland-bearers perfected at Amaravati continued to inspire later sculptors; as late as the ninth century A.D. and even later, the motif is continued in Pallava monuments, whence it has traveled beyond India, and occurs even in Javanese art.

There are four sculptural periods which can be distinguished at Amaravati. The earliest phase is contemporaneous with Bharhut sculpture. The second phase, which can be dated about A.D. 100, is exemplified by a series of casing slabs representing purnaghatas and the adoration of the Tree and the Stupa. The purnaghata suggests the Buddha's birth and bath. The lotuses issuing from the large decorated vase suggest water from a brimming vessel, and the nearby bath. The tree and the stupa stand for the Enlightenment and the death of the Buddha. The rows of lions and triratnas symbolize Sakya Simha, the lion among the Sakyas, as the Buddha was known, and the Buddhist Trinity (the Buddha; Dharma, the Law; and Samgha, respectively). Some of the slabs of the second phase present the human figure of the Buddha for the first time. This is about A.D. 100. Perfection in depicting the form of the Buddha is, however, yet to come.

The rail from Amaravati, which was carved mainly through the efforts of the Buddhist sage Nagarjuna, dates from about A.D. 150. It is here that the plastic art of the Satavahanas reaches perfection. The themes are as many, the decorative element is as diverse, as are the different technical methods adopted by the Rail artist to render the scenes effectively. Here for the first time lighter and deeper etching, differentiated planes, perspective and distance, and foreshortening are successfully introduced.

Greater delicacy of carving and somewhat elongated figures appear in the last period at Amaravati. Chaitya slabs dating from this period and depicting the typical stupa of the Krishna Valley abound (see fig. 118); a whole series of them was used to encase the drum of the main stupa at Amaravati.

Amaravati sculpture from the rail is not only pleasing but most revealing. Some of the Jatakas and Avadanas here depicted illustrate certain early texts, now lost, which formed the source of inspiration for the carvers. The story of Sibi depicted at Amaravati is based, not on the *Sibi Jataka*, but on an early text, now lost, preserved for us in a late version in Sanskrit, that of Kshemendra's *Avadanakalpalata*. Yet another instance in which the early version of a text inspired the Amaravati sculptors is the legend of Paduma Kumara, preserved in one of the Avadanas of Kshemendra.

Some of the Jatakas depicted at Amaravati, the *Chhaddanta*, *Hamsa*, *Champeya*, *Mandhata*, and *Vidhurapandita*, for example, are well known. But there are others (and interesting ones) which are less familiar and never portrayed elsewhere; an instance is the *Lossa Jataka*. Among the scenes at Amaravati depicting the life of the Buddha there are again some rare ones such as the episode in which Angulimala, Sumana, and Jivaka counsel Ajatasatru to visit the Buddha, and the touching story of the devotion of Samavati, the saintly queen of Udayana, who suffered at the hands of her jealous co-wife, Magandiya. Some

116. *The subjugation of the elephant Nalagiri. Medallion on a crossbar of the rail from the stupa at Amaravati (Andhra Pradesh). Satavahana, second century* A.D. *(fourth, or Rail, period). Government Museum, Madras*

116

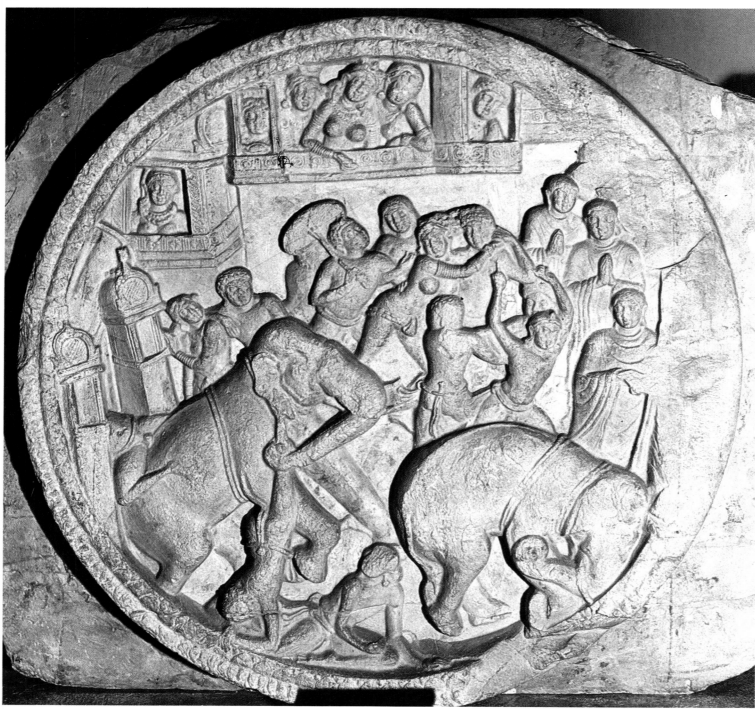

of these appealing, rare incidents have been repeated; one such scene occurs on two medallions, in the British Museum and in the Madras Museum. The most elaborate and pleasing portrayal of the Sakyas welcoming home the Buddha at Kapilavastu is from Amaravati.

Several Gandharan sculptures depict the attempts of Devadatta, the Buddha's wicked cousin, to destroy the Buddha, but no better carving of this theme exists than the world-famous medallion from Amaravati showing the subjugation of the wild elephant Nalagiri whom Devadatta caused to be let loose (fig. 116). A synoptic method for the presentation of events was used in the medallion. The right half shows the furious elephant driving terror into the minds of those caught unawares in the royal highway and even of those safe in their balconies above, while the other half shows the animal calm and subdued, kneeling reverently at the feet of the Buddha.

One of the great masterpieces of Satavahana art of the last period at Amaravati is the group of four women adoring the feet of the Buddha. In this pleasing composition, the body contours of the women and the disposition of their limbs suggest a mood of intense devotion combined with natural feminine bashfulness.

The Satavahanas were of the Brahmanical faith and performed various Vedic sacrifices, but they were tolerant sovereigns who paid equal attention to other faiths. It is this that accounts for the flourishing state of Buddhism. But the great artistic output of the mid-second century, observed mainly in Buddhist monuments, should not be construed as a neglect of Brahmanical institutions. The famous image of Siva on the lingam at Gudimallam is an example of very early Satavahana art representing a Brahmanical deity. It combines the Vedic concepts of Agni and Rudra (Fire and Fear)—the latter as Ushnishin according to the Rudradhyaya of the *Yajurveda*—and the Yajamana, or Sacrificer, from the ashtamurti concept. Allied to the early yaksha figures, this image of Siva, along with the Sivalinga from Bhita, throws great light on the earliest phase of Saivism.

The Ikshvaku rulers who succeeded the Satavahanas in power continued the earlier traditions. Yet the slim and slender figures which characterize this period are adorned with some new forms of jewelry such as the long and pleasing yajnopavita, or sacred thread, entirely made up of pearls, and the crocodile pattern (makari) used as a decoration for the feminine coiffure. Like the Satavahana monarchs, the Ikshvakus belonged to the Brahmanical faith, but some of the princesses of this tolerant royal house were worshipers of the Buddha. The lenience and munificence of the royal donors assured an efflorescence of art in the Sriparvata era.

The sculptures of Nagarjunakonda, Gummididurru, Goli, and Ghantasala are in the style of the fourth period of Amaravati.

Not only familiar scenes but several of the rare depictions at Amaravati are repeated at Nagarjunakonda. The arrangement and composition of the figures is almost identical. Though by A.D. 100, depiction of the Buddha in human form had become accepted at Amaravati, the symbolic representation continued alongside it. The flaming pillar, surmounted by a wheel and trident, or trisula, as a symbol of the standing Buddha which occurs at Amaravati is repeated at Nagarjunakonda, sometimes even in identical scenes like the subjugation of Nalagiri. This significant symbol, it is interesting to note, has traveled far beyond the present Indian border into the northernmost parts of Kanishka's empire, and in a Central Asian wall painting the flaming pillar symbol is portrayed on the Buddha's physical body itself, a curious combination. Maya's dream and its interpretation, the birth of Siddhartha, the prince divesting himself of his ornaments, the overcoming of Mara, the meet-

117. *Yakshi or personified Sri adorning herself under a celestial tree in a kudu arch. From Amaravati. Satavahana, second century* A.D. *(fourth period). Government Museum, Madras The tree and the feminine figure identify the subject as Siri and Vachcha, here representing the Srivatsa as a symbol of Sri.*

119. *Siddhartha kept amid pleasures in the harem. Panel from a frieze from Nagarjuna-konda. Ikshvaku, second–third century* A.D. *National Museum, New Delhi*
Note the women, in particular the damsel gliding, boatlike, along the pellucid stream of love.

118. *Stupa of the Krishna Valley type. Stone slab from Nagarjunakonda (Andhra Pradesh). Ikshvaku, second–third century* A.D. *National Museum, New Delhi*
The scenes from Jatakas and the life of the Buddha, in particular the prominent depiction of the story of Mandhata in the center, the lion-guarded gateways, the five pillars of the avaka type (each group of five faces one of the cardinal points), the adoring celestials above, and the devotees on earth providing floral offerings, are noteworthy.

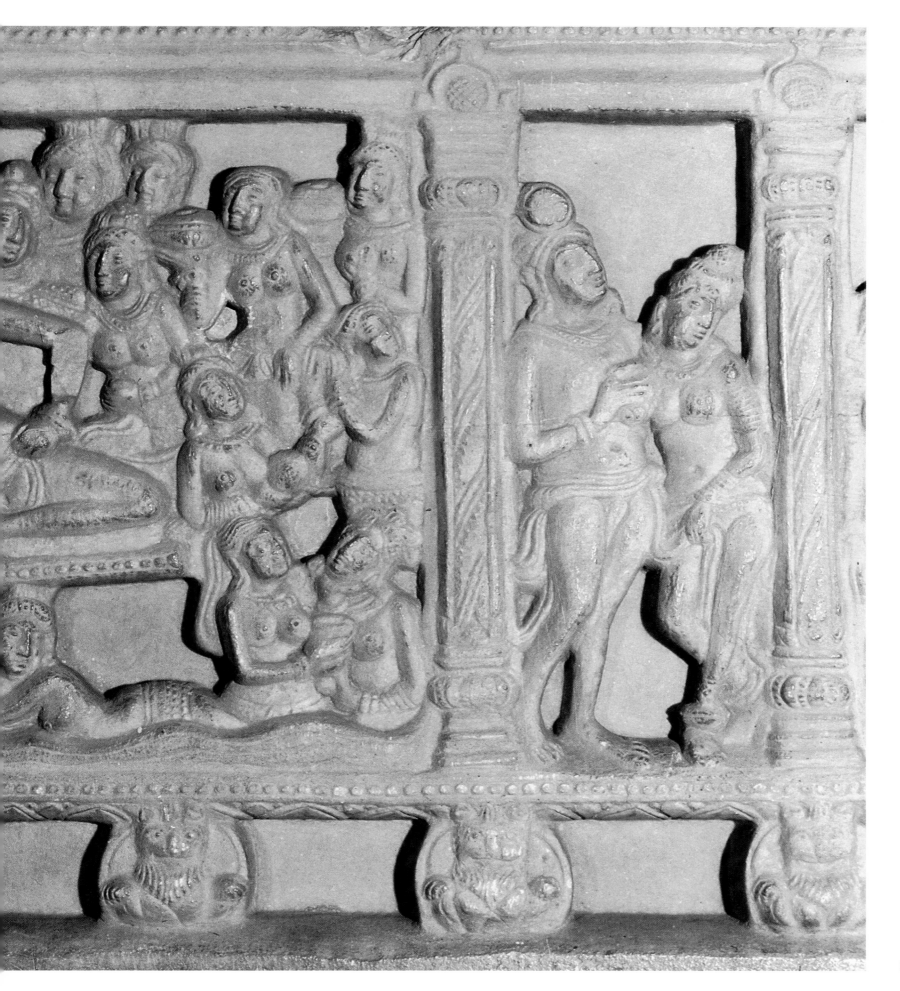

ing of Rahula, the Buddha's visit to Yasodhara, are depicted almost identically at Amaravati, Nagarjunakonda, and Goli. The original text of Kshemendra's *Sarvamdadavadana* is the version followed by both the Satavahana and the Ikshvaku sculptors for narrating the story of Sibi. It is only in the depiction at Ajanta that the Jataka story of Sibi is followed. A very popular theme at Nagarjunakonda, as at Amaravati, is Asvaghosha's *Saundarananda*. This no doubt occurs also in Gandharan art but the most effective representation is at Nagarjunakonda, where the ephemeral nature of beauty and its attraction is clearly indicated by contrasting Sundari or Janapadakalyani with the ugly one-eyed monkey on the stump of a tree, and this beauty herself with the pink-footed nymphs. It is only at Nagarjunakonda that the moral of the story of Mandhata is clearly depicted through the episode of the emperor's fall and his repentance (fig. 118), a subject treated nowhere else. Ajatasatru's visit to the Buddha, which is depicted at Bharhut and Amaravati, is more effectively represented at Nagarjunakonda. The most telling series of panels depicting Vessantara's story is probably

120. The noble Naga prince of the Champeya Jataka. *Another panel from the frieze mentioned in figure 119. Ikshvaku, second–third century* A.D. *National Museum, New Delhi*

120

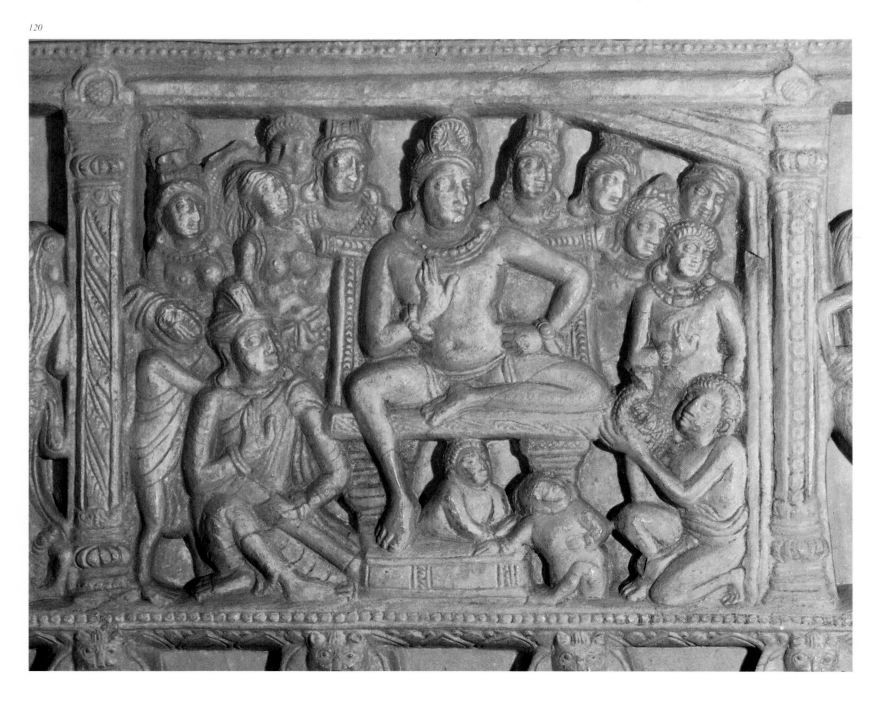

by the Ikshvaku sculptors who sometimes excelled their Amaravati predecessors in narration. Similar elaborate representation is observed in the story of Chhaddanta. It is no wonder that these stories appealed immensely to the painters of Ajanta, and similar elaborate narration marks the genius of those Vakataka painters.

The Ikshvaku sculptors, like their predecessors who carved the Amaravati rail, had great aesthetic taste and a wide knowledge of literature. This is easily observed in the numerous mithuna panels with their rich import. The coquetry, the feigned frown on the brow, the full embrace (gadhalingana), the loving hand on the neck (kanthaslesha), the lover's help in gathering flowers for the braid of the beloved, are instances. A damsel from one of the mithuna, engaged in stopping a parrot's beak with her ruby-set ear ornament, on the pretext of offering it pomegranate seeds, in a vain attempt to avert the bird's indiscreet utterances, recalls lines from the *Amarusataka:* karnalambitapadmaragasakalam vinyasya chanchupute vridarta vidadhati dadimaphalavyajena vagbandhanam.

The lover shown behind his beloved, whom he has approached softly and watches as she examines her marks of enjoyment, or nail marks (nakshashata), in the mirror she holds in her hand, makes her abashed when she notices his reflection and his enjoyment of the situation; this immediately recalls a comment of Kalidasa's on a similar situation: darpanesu paribhogadarsinir narmapurvam anupristhasamsthitah, chayaya smitamanojnaya vadhur hrinimilitamukhis chakara sah *(Raghuvamsa* XIX, 28).

Another mithuna sculpture, showing the lover with his hand on the heavy hip of the damsel, brings to mind a line from Magha: sronisu priyakarah prithulasu sparsam apa sakalena talena *(Sisupalavadha* X, 65).

Indeed a masterpiece by a sculptor of Nagarjunakonda, now in the National Museum in New Delhi, is the scene showing Siddhartha immersed in a stream of love in the royal harem (fig. 119). A passage from the *Mrichchhakatika* is the inspiration for the representation of love. Here the Vidusaka, or court jester, remarks that no other vessels on love's ocean need be required of a vesavasa, or courtesan's house, like Vasantasena's, as the stana, or breast, and nitamba, or hip, are yanas, or conveyance, enough on the smooth-gliding waters of sringara, or poetry: kim tatra prichchyate, yushmakam khalu premanirmalajale madanasamudre stananitambajaghananyeva yanapatrani manoharani.

Both at Amaravati and at Nagarjunakonda Scythian and Roman influence can be noted. The great trade with Rome in pearls and muslin from India brought with it not only Roman gold, but Roman figures of aesthetic interest, which the sculptor has not been slow in welcoming. Some of the feminine figures draped like Roman matrons, the boy with a horn to drink wine from, the soldier in Roman armor, are all telling instances of a foreign note. Another detail, the semicircular 'moon stones' with rows of animals, recalls similar carvings from Ceylon.

The Satavahana sculptor was at home not only in stone carving but in ivory carving also, as can be seen from the beautiful feminine figure in ivory from Ter; he was also adept at modeling lovely figures in wax and casting them in metal according to the *cire-perdue* process. Excellent examples of Satavahana metalwork include the royal elephant rider with queens on the back of the animal found in Kolhapur and preserved in the museum there, and the bronzes representing the Buddha found at Amaravati, Buddham, and other places in the Krishna Valley and now preserved in the Madras Museum and the British Museum. Ikshvaku metal workmanship is well exemplified in the tiny image of a prince holding a bow, excavated at Nagarjunakonda.

121

121. Siva, the lord of music, as the seven musical notes personified (Saptasvaramaya), with ganas playing the four musical instruments that compose the Indian orchestra. At Parel (western India). Vakataka, fourth century A.D.

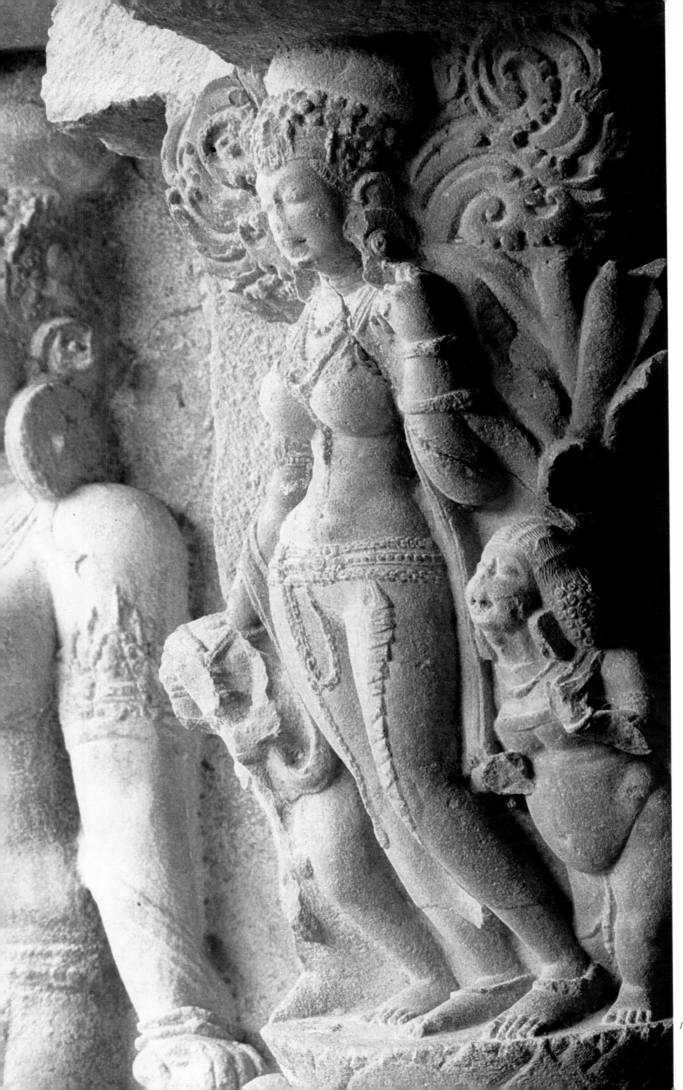

122. *Goddess flanked by dwarf
attendants. Bracket projection of
a pillar in Cave 21 (Ramesvara)
at Ellora (Deccan). Vakataka,
fifth–sixth century* A.D.

The Satavahana modeler fashioned deftly a number of terra-cottas of human and animal figures, most of which have been recovered at Kondapur. The turbans and the feminine coiffures of some of these heads are beautifully decorated; the animals likewise—the elephant, the bull, and the horse—are modeled with a rare discernment of their anatomy. The few but very important early terra-cottas discovered by Professor Jouveau-Dubruil at Pondicherry also represent Satavahana art.

The single portrait of a Satavahana king, Yajna Satakarni, on a coin following the numismatic portrait tradition of the Kushans and Kshatrapas illustrates not only the skill in portraiture of the Satavahana sculptor but also his effective use of symbolism. The last may be seen on the reverse of the coin where the expanding fame of the monarch is taken beyond the mythical mountains at the border of the world to the four oceans, the nether world, the abode of snakes, and the heaven, suggested by the stars or the solar disc. This symbolism so appealed to successive rulers that a whole Kshatrapa and Traikutaka series adopted it.

Satavahana painting has very few fragments left in Caves 9 and 10 at Ajanta. But these represent the earlier phase. In these paintings, the forms, features, poses, ornamentation, dress, furniture, architectural setting, and other details closely resemble those shown in sculpture. The colorful depiction of jewels and decorations on garments is particularly noteworthy; so also is the chatula-tilaka gem that runs over the parting of the hair to rest on the forehead: lalatalasakasya simantachumbinas chatulatilakamaneh.

Though the phalakahara (see fig. 67) is a jewel that occurs only in the second to first century B.C., the simple single strand of pearls (ekavali) continues into the early centuries of our era. The mekhala, or girdle, is elaborate. The fan-shaped coiffure occurring at both Sanchi and Amaravati appears also in the paintings in Caves 9 and 10 at Ajanta. The queen in the *Chhaddanta Jataka* in Cave 10 is almost entirely a painted version, though somewhat earlier in date than the sculptural representation from Goli toward the end of the second century A.D. The Vakataka painting of the princess at Ajanta (fig. 134), depicted in almost identical fashion, illustrates the persistence of traditions.

Professor Jouveau-Dubruil discovered fragments of painting in the Bedsa cave. These resemble the early Satavahana examples but represent a late phase toward the end of the second century A.D. The female figure here is delicately painted and resembles Amaravati sculpture of the fourth period. With the ekavali she wears as she stands in a beautifully flexed pose, she recalls carvings from Amaravati and Karla. A look at this figure also brings to mind at once the maiden in the lotus pool from Dandan-uilik in Chinese Turkistan.

The Salankayanas, who were devout worshipers of Surya in the form of Chitrarathasvami, ruled from Vengi in the fourth and fifth centuries A.D. The famous temple erected by them for their tutelary deity has now disappeared. But a few antiquities still lying scattered at Pedavegi near Ellora give us some idea of the art of the period. A mutilated Ganesa image with a single pair of arms shows how closely it is related

123

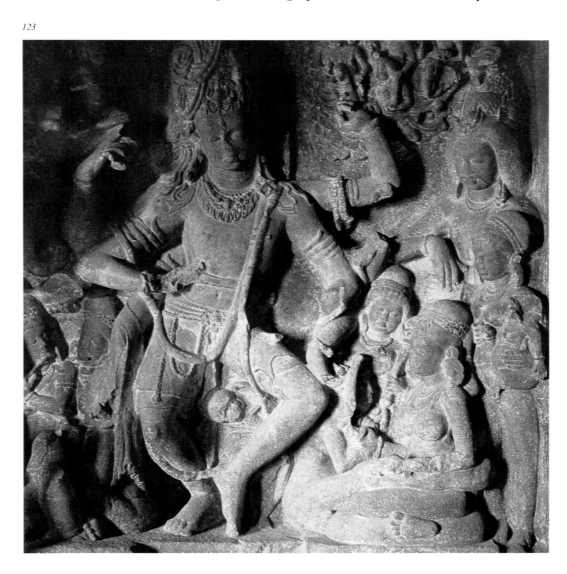

123. Siva as the Supreme Dancer in Cave 21 (Ramesvara) at Ellora. Vakataka, fifth–sixth century A.D.

to the earliest phase of Pallava art of the same period in the Krishna Valley.

The early Pallavas lived very close to the Salankayanas, the Vakatakas, and the Vishnukundins; since their territory abutted the Krishna Valley, their closest connections were the Vishnukundins, with whom they were related by matrimony. The famous Peddamudiyam plaque from the Cuddapah district has one of the most interesting groups of deities for the study of the earliest phase of iconography in South India. Except for Mahishamardini, the other deities—among them, Ganesa, Brahma, Narasimha, Sivalinga, Vishnu, Devi, and Umamahesvara—have only a single pair of arms, and Lakshmi is a peculiar srivatsa symbol. A sculpture from Madugula in the Guntur district has a very lively early representation and a very natural one of Siva with his consort and two children and gana attendants. A carving of Brahma also at Madugula, with three heads, has only a single pair of arms, very much like his prototype in Gupta sculpture from Deogarh. The early image of Siva, carved of the same marble used for the sculptures at Amaravati, with an ax in one of his single pair of arms and with his mount seated at his feet, shows by its style and execution how close it is to the Ikshvaku period. The carvings in the Bhairavunikonda caves near Vellore, which should be dated in the time of Simhavishnu, the father of Mahendravarman and son-in-law of the Vishnukundin king Vikramahendra, indicate that the Pallavas continued to draw inspiration from the Krishna Valley even in the sixth century.

The Vishnukundins, who ruled the Vengi territory in the fifth and sixth centuries A.D., continued the traditions of the Ikshvakus. The best preserved of their monuments are the Mogalrajapuram caves, where the facade has a magnificent figure of the eight-armed Nataraja dancing on the Apasmara, a demon. Here one sees a combination of the northern and southern modes: a number of arms according to the north, and the Apasmara under the foot according to the south. The idea of a triple cell for the Trinity, with the facade showing Brahma, Siva, and Vishnu, which we find later in Pallava monuments, already occurs at Mogalrajapuram. The themes carved on the pillars of these caves, such as the lifting of Govardhana by Krishna, the rescuing of the earth from the ocean by Varaha, the destruction of the demon Hiranyakasipu by Narasimha, Bali overcome by Trivikrama, the incomprehensible flaming pillar baffling Brahma and Vishnu as Lingodbhava, have inspired seventh- and eighth-century carvings at Mahabalipuram and Ellora. It should not, however, be forgotten that it is the famous Varaha of the Gupta period at Udayagiri that gave an impetus to this theme of the boar avatar of Vishnu as it occurs at Badami and Mogalrajapuram. The simple Govardhana scene at Mogalrajapuram has Krishna with four hands, in his divine aspect, unlike the representation at Mahabalipuram, where his single pair of arms stresses his human aspect, but at Ellora in the eighth century the divine aspect is reiterated. A very interesting detail of gopis carrying a pile of pots, as it occurs at Mahabalipuram, has its source in the Mogalrajapuram caves. The horned dvarapalas, or door guardians, in the Pallava caves are certainly inspired by similar figures, but earlier, at Mogalrajapuram.

Already in the second century A.D., there is mention of the Vakatakas in inscriptions from Amaravati which clearly reveal that they migrated from the Krishna Valley to establish a kingdom that gradually gathered strength in the Deccan. The Vakatakas were the imperial successors of the Satavahanas in the Deccan, with matrimonial connections with the Guptas, the Bharasivas, and the Vishnukundins. Two branches of the Vakataka family are known. The main branch was from Gautamiputra, and the other, the Vatsagulma branch, from Sarvasena. Rudrasena, of

124. Interior view of the cave temple at Elephanta (western India). Vakataka, fifth–sixth century A.D.

125. *Siva as Gangadhara receiving the triple stream on his locks. Panel adjacent to the famous three-faced colossal Trimurti at Elephanta. Vakataka, fifth–sixth century* A.D.

125

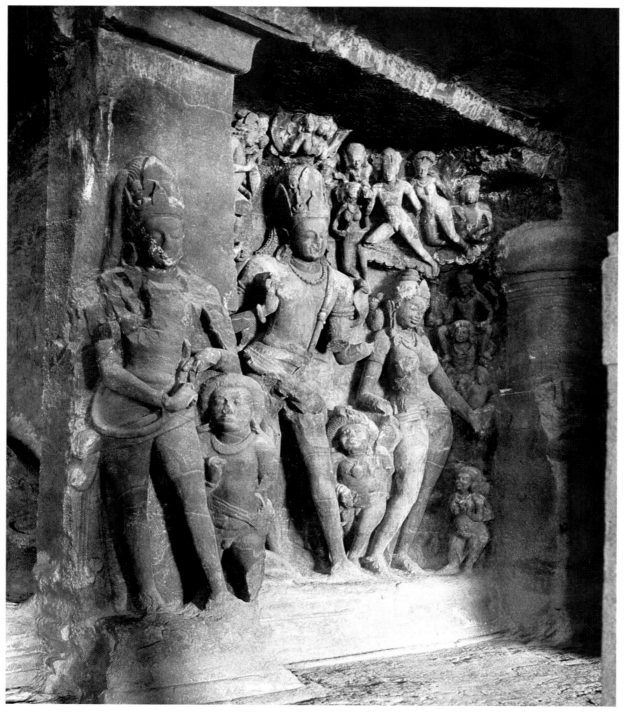

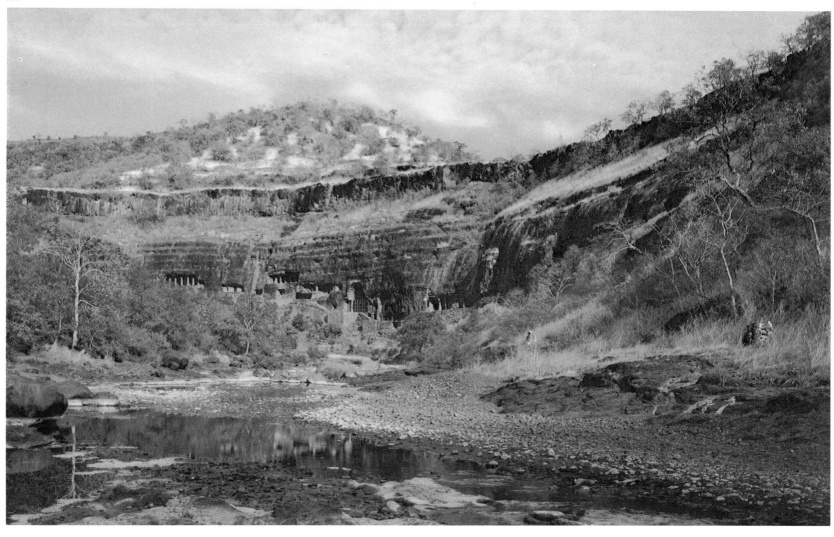

the main branch, married Prabhavati Gupta, the daughter of Chandra-
gupta II. Harishena, the most important sovereign of the Vatsagulma
branch, was the contemporary of Narendrasena of the main line.
Pravarasena II of the main line is famous for his interest in literature,
for Bana sings of his poetic skill. He was also a patron of art. However,
it is under the collateral branch of the Vakatakas, which had no Gupta
influence—especially under the powerful Harishena—that the paintings
at Ajanta were created. To see here the influence of the Gupta painters,
unknown except for the fragments of paintings at Bagh, is fantastic, for
Vakataka sculpture and painting are only a continuation of the earlier
Satavahana tradition.

An inscription in Cave 16 at Ajanta records its dedication to the monks
by Varahadeva, the minister of the Vakataka king Harishena, in the
fifth century A.D. Another inscription in Cave 26 mentions its gift by
Bhaviraja, the minister of Asmaka. These inscriptions being clearly in
the box-headed type of Vakataka script, there can be no doubt as to
who created these Ajanta caves, their sculptures and paintings. It is a
distinct Vakataka phase of art.

The later caves at Ajanta, of the fifth and sixth centuries A.D. (see figs.
16–19 and 126–137), the early ones at Ellora (see figs. 122 and 123),
and those at Aurangabad and Elephanta (see figs. 124 and 125) form a
magnificent group for the study of Vakataka art in the Deccan, which is
contemporaneous with Gupta art in the north.

It is generally the paintings at Ajanta that are better known and studied,
but sculpture here merits equal attention. On the doorjambs of the
shrines in the Ajanta caves are lovely carvings of mithunas; the flanking
figures of Ganga (see fig. 132) and Yamuna at the top, as in Gupta
sculpture at Udayagiri in Bhilsa, recall the earlier tradition in which the
personified rivers were depicted at the bottom instead of at the top. In
Cave 16 the Vidyadhara celestial couples below the capitals of the pilas-
ters arrest attention (fig. 14). No one who has visited Ajanta can forget
the panel of the seated Nagaraja and Nagini with attendant chauri-bearer
in Cave 19 or the elaborate Maradharshana scene, or temptation of the
Buddha by Mara, in Cave 26 where the charm of the Maravadhus,
damsels of ravishing beauty, and Mara, rather like a charming Brah-
manical Cupid with sugarcane bow, point to individual thinking and
execution on the part of the sculptors of Ajanta.

In the early caves at Ellora there are famous panels representing various
aspects of Siva as Ravananugraha, Gajantaka, Kalyanasundara, in-
cluding the story of Parvati's penance, Siva's dance (see fig. 123) in
various modes—lalita, chatura, katisama, and others—Vishnu as Varaha,
Trivikrama, Narasimha, fighting with Hiranyakasipu, and seated gaily
with his consorts, as Padmanabha with the lotus springing from his navel,
each one with a special elegance. A distinctive panel shows Siva ab-
sorbed in a game of dice with Parvati; the pearl-bedecked coiffure of the
goddess is so exquisitely carved that words cannot describe it.

In one of the Aurangabad caves a bevy of musicians and dancers, all of
them women, is depicted; the complete orchestra and a great dance

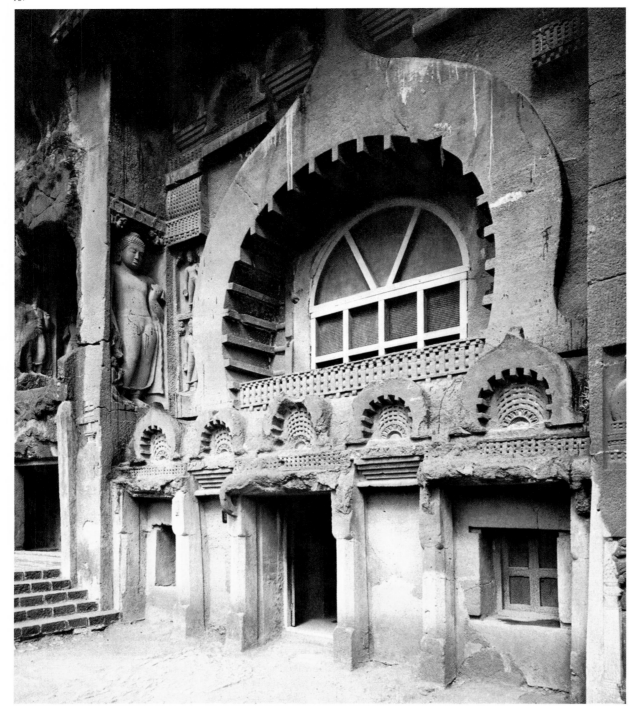

127. *Facade and courtyard of Cave 19 at Ajanta. Vakataka, fifth–sixth century* A.D.

128. *Detail of the facade of Cave 19 at Ajanta, showing the rich decorative carving. Vakataka, fifth–sixth century* A.D.

moment have been immortalized by a Vakataka sculptor.

In the great panels at Elephanta there is a repetition of the motif of Brahma on a flight of swans which recalls Bana's colorful pen picture in his *Harshacharita*. The triple stream of Ganga as tripathaga portrayed at Elephanta (fig. 125), racing in heaven, flowing on earth, and descending to the nether world, has no parallel in the Gangadhara representations elsewhere. The mountain king's bashful daughter, who was given away to Siva, is depicted again at Elephanta in the most noteworthy version of the subject. The panel of Ardhanarisvara, the Hermaphrodite, with the dropped shoulder, attenuated waist, and broad hip of the feminine side, contrasting with the broad shoulder and the masculine torso on the other, as part of a well-composed group reveals the Vakataka sculptor as a master craftsman.

To a Vakataka sculptor we owe also a significant sculpture found at Parel (fig. 121). It is the earliest form of Siva as the god of Music, Vinadhara Dakshinamurti, as he is known in later sculpture. Here he is represented in a rare form composed of seven figures which are the seven musical notes personified—Saptasvaramaya and Nadatanu. Siva is lord not only of dance but also of music. He is fond of the musical chant the Sama. As Kalidasa has it, his glory is sung in seven Samans: saptasamopagitam tvam. In the Vedas he is the seven notes of the Sama: vedanam samavedosmi.

The roots of Vakataka art can be seen in the many echoes of Amaravati carvings both in paintings and in sculpture at Ajanta and at Ellora. In the Maradharshana scene at Amaravati and in a contemporary sculpture on the same theme from Ghantasala, the motif of a head on a

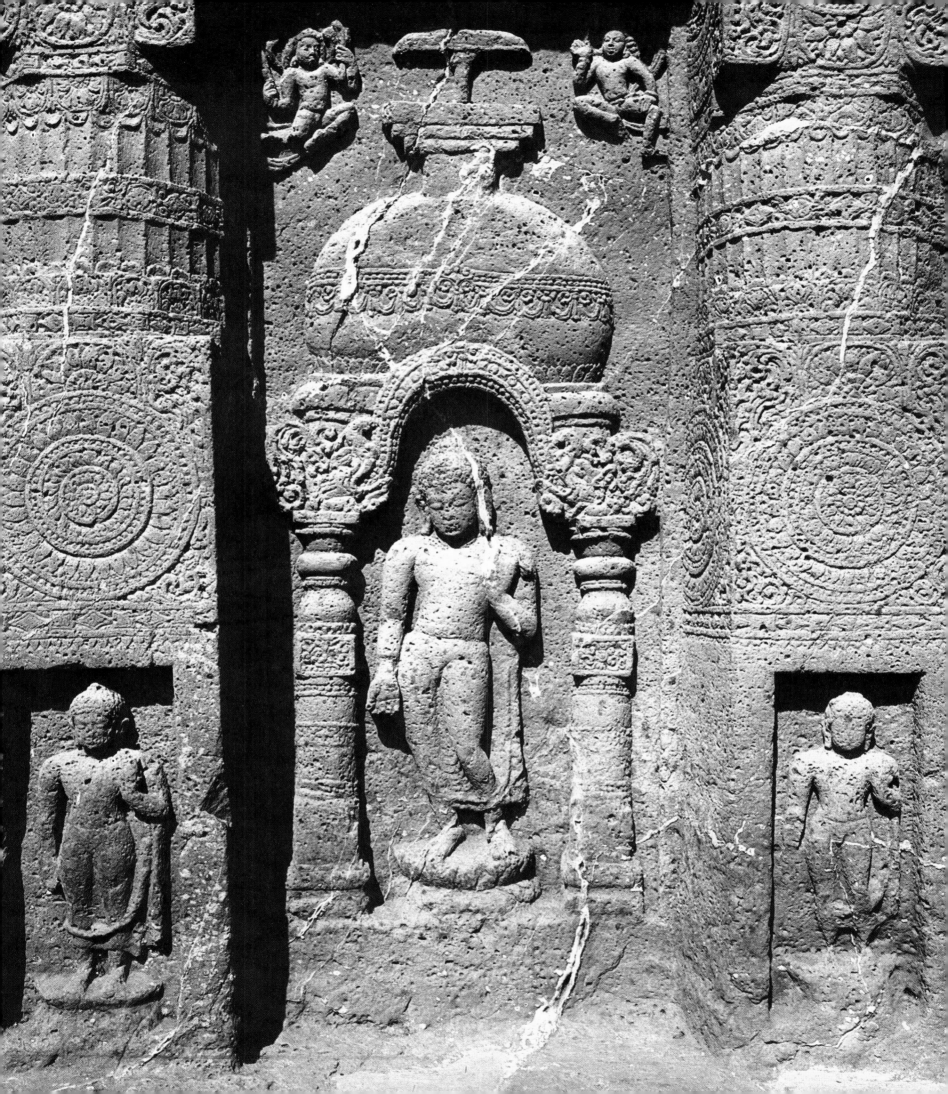

stomach for a gnome, the motif of udaremukha, as in the case of Kabandha in the *Ramayana*, is introduced. In an identical context this last motif is used at Ajanta also. The udaremukha motif continued in popularity in all late sculpture inspired by the Vakatakas, for example, in early Western Chalukya, Pallava, and so forth. It even traveled far beyond the ocean and occurs in proper context in the *Ramayana* panel at Prambanam in Java.

Both the inspiration of Amaravati in the Vakataka art of Ajanta and its echo in the later art of the Pallavas at Mahabalipuram cannot but be a striking illustration of the persistence of art traditions. The identical twist of the right leg put forward in an identical pose at Ajanta and at Mahabalipuram is not just a coincidence.

By their rich color, the beautiful Vakataka paintings help us to comprehend the glory of earlier Amaravati sculpture, for it is only in color that the gem-set jewelry and glamorous drapery, rich furniture, im-

posing architecture, and natural scenery can stand out.

In the Ajanta caves there are excellent illustrations of the six branches of painting, the shadanga: variety of form (rupabheda), correct proportion (pramana), depiction of emotion (bhava), infusion of grace (lavanya-yojana), verisimilitude (sadrisya), and mixing colors to produce an effect of modeling (varnika bhanga). The painter's mastery of the complexity of human, animal, and plant form has helped him not only to train his imagination to create designs but also to group figures and create masterly compositions. Emotion at its best can be seen in several important narrations of stories at Ajanta. Masterpieces such as the princess at her toilet (fig. 134), the so-called Black Princess, or the flying celestials (figs. 135 and 136), revealing the grace of human form, clearly indicate the power of the painter in lavanya-yojana. In the *Vessantara Jataka*, the figure of Jujuka, the wicked Brahmin, repeated in panels identical in form, clearly indicates mastery of portraiture. All

129

129. *Veranda of Cave 2 at Ajanta. Vakataka, fifth–sixth century* A.D.

130. *The king listening to the exposition of dharma by the golden goose* (Hamsa Jataka). *Mural painting in Cave 2 at Ajanta. Vakataka, fifth–sixth century* A.D.

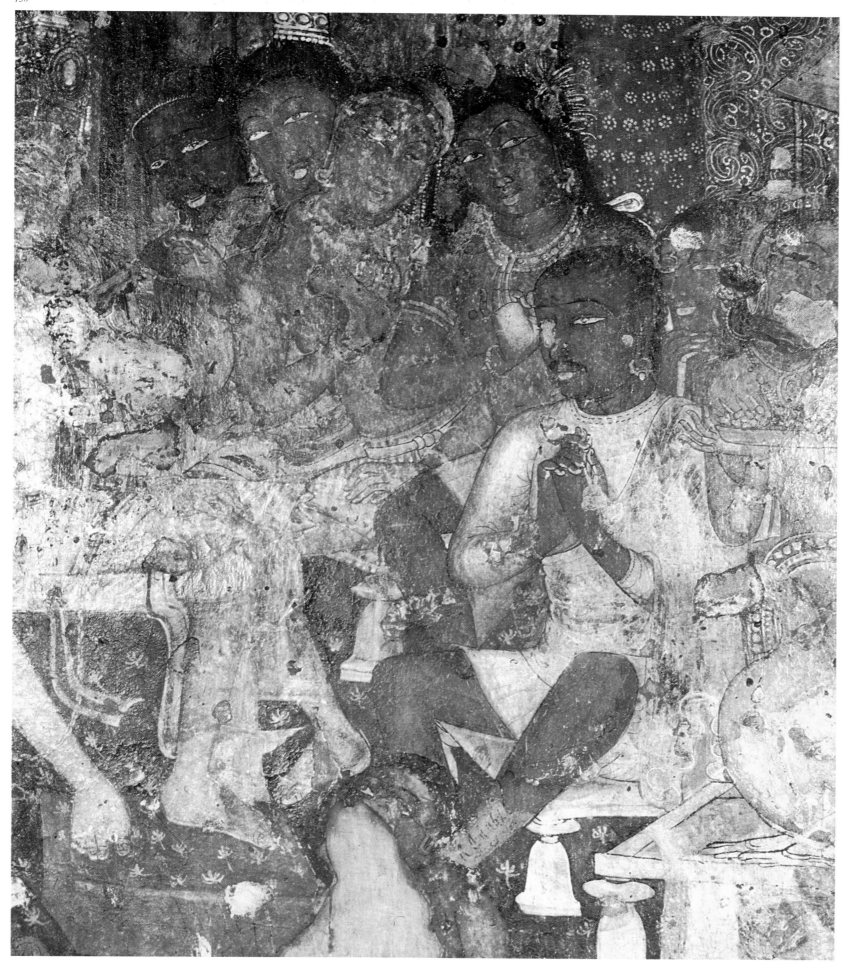

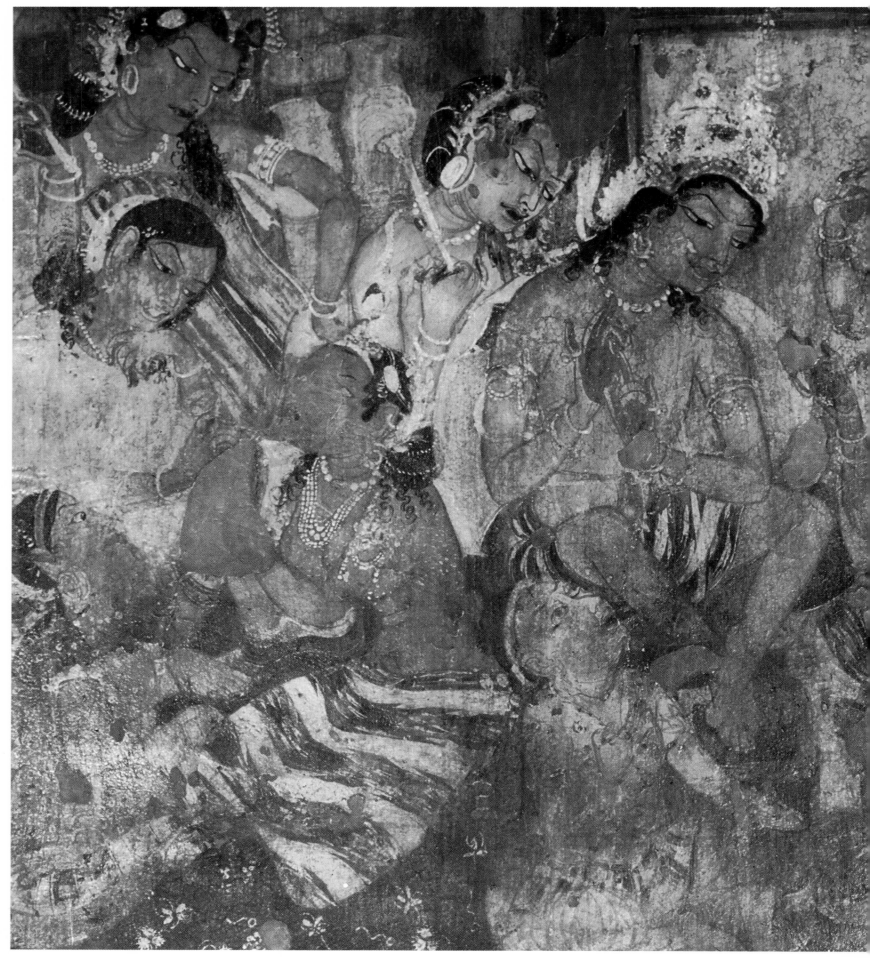

131. King Mahajanaka listening to Queen Sivali (Mahajanaka Jataka). *Mural painting in Cave 1 at Ajanta. Vakataka, fifth–sixth century* A.D.

132. *Ganga, one of two such figures flanking the entrance of Cave 17 at Ajanta, with a painted mithuna motif decorating the lintel. Vakataka, fifth century* A.D.

132

the paintings at Ajanta plainly bespeak the painter's skill in the mixing of colors.

The Vakataka painter was an adept in his art, with both creative instinct and great literary taste, and that accounts for several splendid lyrical creations. The style of feminine hairdress in the paintings of Ajanta, decked with pearls, its charm heightened by the interspersal of lovely ringlets of hair, inevitably brings to mind Kalidasa's description of a pearl-bedecked coiffure: muktajala-grathitam alakam. Similarly, the tender flower sprays at the ear of a damsel in one of the paintings recalls Kalidasa's line describing how this decoration at the ear of the beloved maddens the lover: kisalayaprasavopi vilasinam madayita dayitasravanarpitah.

It is only in a picture in color that a pearl necklace with a large central sapphire can be appreciated: sthula madhyendranilam. At Ajanta there are the most beautiful pearl yajnopavitas, or sacred threads, recalling Kalidasa's muktayajnopavitani.

The spectacular musical scene from the *Mahajanaka Jataka* in Cave 1 at Ajanta (fig. 131) recalls the description in the *Meghaduta*, as do also the flying Vidyadharas in Cave 17 (figs. 135 and 136). The elaborate de-

133. Close-up of two painted mithuna panels on the lintel of the entrance of Cave 17 at Ajanta. Vakataka, fifth century A.D.

133

134. Toilet of the princess. Mural painting in Cave 17 at Ajanta. Vakataka, fifth century A.D.

135. The flying celestials. Mural painting in the veranda of Cave 17 at Ajanta. Vakataka, fifth century A.D.

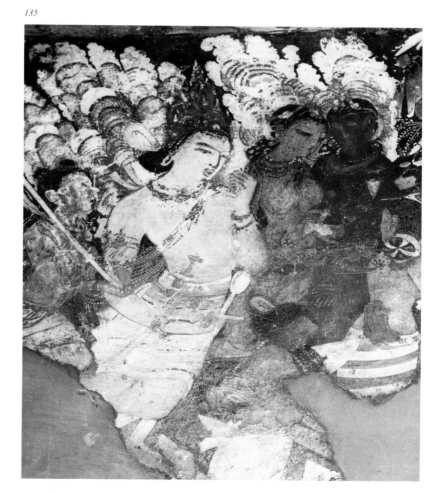

scription of the king's bath in Bana's *Kadambari* has a pictorial version in Cave 1.

The representation of Irandati in a swing, in a pictorial series from the *Vidhurapandita Jataka*, not only reflects but enhances the charm of the Naga princess whose beauty attracted Yaksha Punnaka to do all he did to win her. Thus this painting is more effective than even the sculptural representations at Bharhut or Amaravati.

It is the painters at Ajanta who excelled in presenting Jataka episodes effectively. The *Hamsa Jataka* here (fig. 130) is more vivid than at Amaravati, reverently portraying the golden bird preaching the Law from a golden throne to the attentive royal devotee. The *Vessantara Jataka* is narrated in Ajanta painting with such effect that it excels the narration everywhere else, even the depictions at Goli and Sanchi. The *Matiposaka Jataka* is touchingly depicted and differs from the tame representation at Goli. The *Valahassa Jataka* painted at Ajanta follows the story of the *Divyavadana* and is more detailed than the representation on the Kushan rail pillar. The *Sibi Jataka* at Ajanta is unlike the story of Sibi at Amaravati and Nagarjunakonda, for it presents a different version. The subjugation of Nalagiri is among the most elaborate of the Ajanta scenes from the Buddha's life, even excelling the version at Goli.

In Cave 16, a monastery, or vihara, beautifully painted, an inscription mentions its dedication by Varahadeva, Harishena's minister, and describes it as adorned with windows, doors, beautiful picture galleries (vithis), carvings of celestial nymphs, ornamental pillars, stairs, a shrine (chaitya mandira), and a large reservoir: gavakshaniryuhasuvithivedika surendrakanyapratimadyalamkritam,/ manoharastambhavibhanga... rachaitya mandiram,/ ma... talasannivishtam visa... namanobhiramam,/ va... nchambu mahanidhanam nagendra vesmadibhirapyalankritam.

The contemporaries of the Vakatakas in North India were the Guptas, who were great patrons of art, literature, and science. It was this period that became the golden age of literature. Gupta art, the peak of perfection of indigenous Indian art, continued Kushan tradition, but flowered into something nobler and aesthetically more appealing. Gupta sculptures are unsurpassed for grace and soft manipulation of contour in human and animal forms.

Among the numerous Buddha figures of the Gupta period, three stand

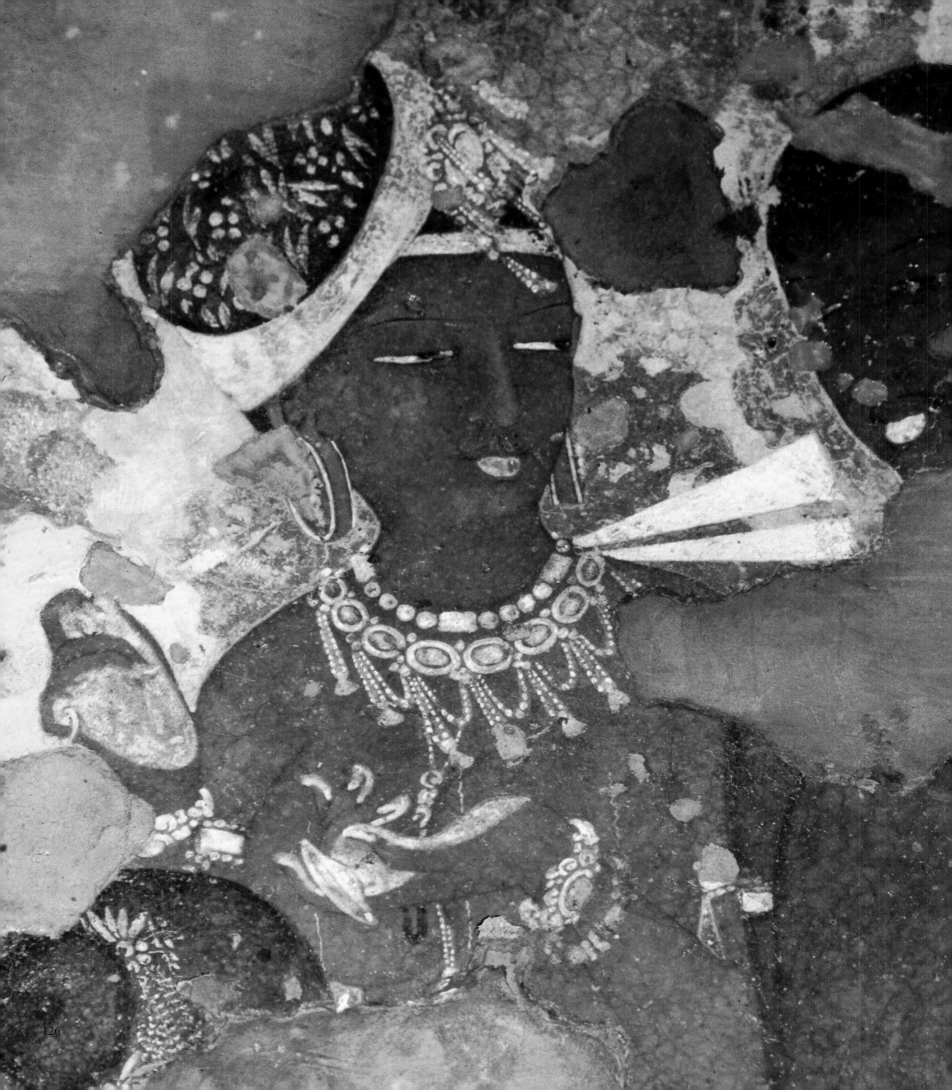

136. Close-up of a nymph playing the cymbals. Detail from figure 135

138. The Buddha with the right hand in the gesture of reassurance (abhaya mudra) and the left holding the hem of his garment; above, umbrella and flying cherubs. Bronze image. From Pophnar (Madhya Pradesh). Vakataka, fifth century A.D. National Museum, New Delhi This is one of a fine series of bronzes, some of them inscribed, found in a treasure trove.

137. Scene in the harem. Mural painting in the veranda of Cave 17 at Ajanta. Vakataka, fifth century A.D.

139. The Buddha with a decorated halo. From Sarnath (Uttar Pradesh). Gupta, fifth century A.D. Indian Museum, Calcutta

137

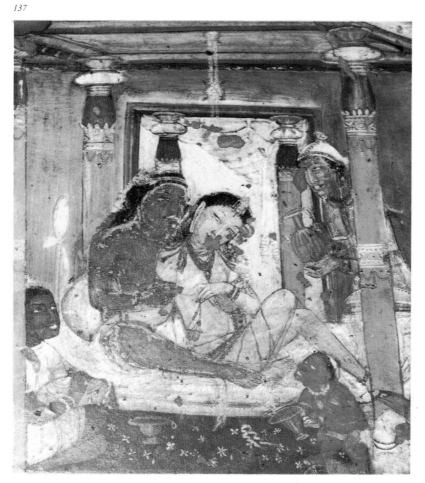

139

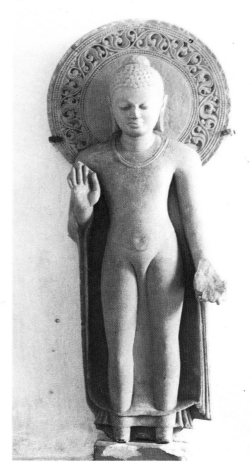

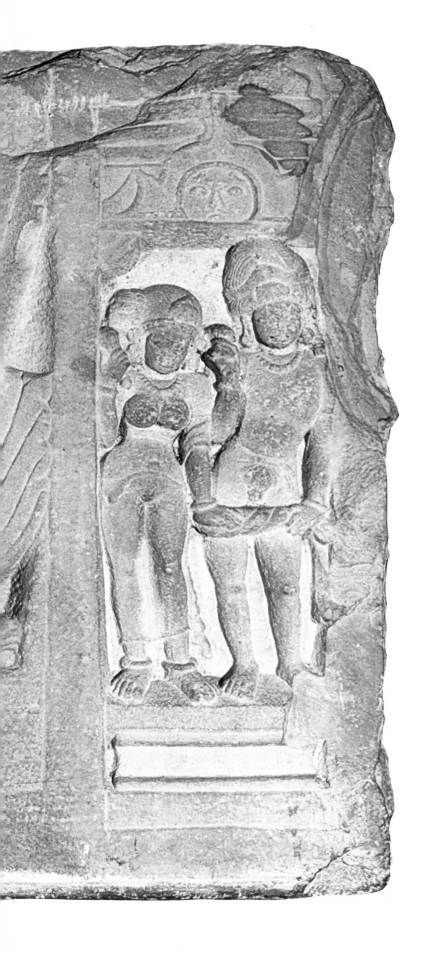

out as masterpieces with all the grace of the period stamped on them. This Buddha type is a model for all later creations of the kind. Two standing Buddhas, both with elaborate halos, in the Mathura Museum and in the National Museum in New Delhi, are exceptionally fine Gupta carvings. The Buddha turning the Wheel of the Law, from Sarnath (fig. 139), is unsurpassed for the serenity of its countenance, the simple robe draping the figure, of which only the fringe remains, and the elaborately decorated, large circular halo, itself a great creation of art. While the arrangement of the folds of the standing Buddha's robe still echoes the Gandharan style, it is the seated Buddha at Sarnath that is completely free of any trace of Western influence. The rounded limbs, the eyes suggestive of meditation, the arched brows, the arrangement of the curls on the cranial protuberance, the indication of the waist cord for the robe, suggesting its transparency, all articulate the delicacy of Gupta workmanship.

The arrangement of the locks of hair flowing upon the shoulders, the long and characteristic yajnopavita, the ananta type of armlet, the charm of the face, the arrangement of the hair (jatas), the artistic flexion of the image, all suggest the Padmapani from Sarnath to be another distinct type of sculpture of the period. For sheer delicacy of treatment and charm of face, the Ekamukhalinga is unsurpassed in Gupta art. It is exemplified in figures from near Khoh and from Bhita. The latter is among the treasures of the Allahabad Museum.

The great temple of Vishnu at Deogarh has three magnificent carved panels around the cell, the Seshasayi, Gajendramokshada, and Naranarayana, each one of which arrests attention. The serene figure of Vishnu, lying on the serpent couch, contrasts with the fighting attitude of Madhu and Kaitabha, who were received in battle by Vishnu's personified weapons. The principal deities of the Brahmanical pantheon—Brahma, Haragauri on the bull, Skanda on the peacock, and Indra on the elephant—are composed at the top of the panel with great artistry. The panel of Naranarayana shows his divine and human aspects, whose strength from asceticism overcomes all failings of the flesh, enabling him sportively to create the most beautiful celestial nymph, depicted rising from the thigh of Narayana, to tempt Indra; the lion and the deer appear in amity and peace without the least taint of hatred. Several other Gupta panels from Deogarh illustrate the *Ramayana* and the sports of the infant Krishna. The punishment of Surpanakha by Lakshmana and the redemption of Ahalya from a sage's curse, both of which are now in the National Museum in New Delhi (figs. 141 and 142), are interesting examples of the narrative spirit of the Gupta sculptors.

Earlier than the developed temple of Deogarh are the caves of Udayagiri in Central India, where the most magnificent panel is undoubtedly the huge Varaha raising the earth goddess from the ocean. Here also is one of the earliest representations of Ganesa in the Gupta period, when the lack of the crown, the urdhvalinga, like that of his father, and the single pair of arms make the figure a primitive example of Ganesa iconography. Among other important sculptures in the Udayagiri caves are Durga Mahishamardini, Seshasayi, and Vishnu. An inscription in an Udayagiri cave mentions its construction during the time of Chandragupta II in the fifth century (dated A.D. 401). A never-to-be-for-

gotten, somewhat worn carving is the amritamanthana scene on the lintel of a Gupta cave here. This theme became such a great favorite that it was repeated in successive centuries by different schools in the territories of the Pratiharas, Gahadavalas, Western Chalukyas, Rashtrakutas, Kakatiyas, and others. It is no wonder that this great and inspiring theme traveled outside the borders of India and found new expression in imposing amritamanthana scenes with even greater suggestive power at Angkor Thom in Cambodia.

Gupta art spread from east to west, and the temple doorway from Dah Parvatiya in Assam showing the motif of the personified river-goddesses Ganga and Yamuna on the jambs conveys forcefully indeed the geographical extent of the Gupta idiom.

One of the finest Gupta monumental pillars, now preserved in the Gwalior Museum, was found in Central India. On this, the Navagrahas and dvadasarasis, most skillfully combined and portrayed, suggest the age of great astronomical studies, when Varahamihira held sway in the field. In the same museum are the famous Matrikas, noted for their simplicity and delicacy of workmanship. From the region of Malwa in Mandasor great Gupta masterpieces have been recovered, like the well-known standing Siva, with trisula, flanked by attendants.

The Lucknow Museum possesses some of the most beautiful architectural fragments and architraves of the Gupta period. One of these, from Garhwa, details the activities of human beings on earth as the celestial luminaries rise and continue their course to form the hours of day and night, midday being emphasized as the supreme hour of the blazing sun, the Visvarupa or the Omnigenous form of the Supreme Being. Among the themes depicted on other architraves and pillars is the kalpavalli, the creeper that satisfies all desires, from the meanders of which peep out heavenly nymphs, jewelry, apparel, and other attractions. Literary descriptions of this plant abound in the *Ramayana* and the *Mahabharata*, and Kalidasa's *Meghaduta* refers to it in a telling line: ekas sute sakalam abalamandanam kalpavrikshah.

141

141. Surpanakha punished by Lakshmana, a scene from the Ramayana. *From Deogarh (Uttar Pradesh). Gupta, fifth century* A.D. *National Museum, New Delhi*
This and other panels from Deogarh are among the earlier illustrations of the epic.

142. Rama releasing Ahalya from the curse of the sage Gautama, a scene from the Ramayana. *From Deogarh. Gupta, fifth century* A.D. *National Museum, New Delhi*

142

*143. The amours of Vikrama
and Urvasi, the latter as a cen-
tauress. Terra-cotta panel from
the Siva temple at Ahichchhatra.
Gupta, fifth century A.D. National
Museum, New Delhi*

144

132

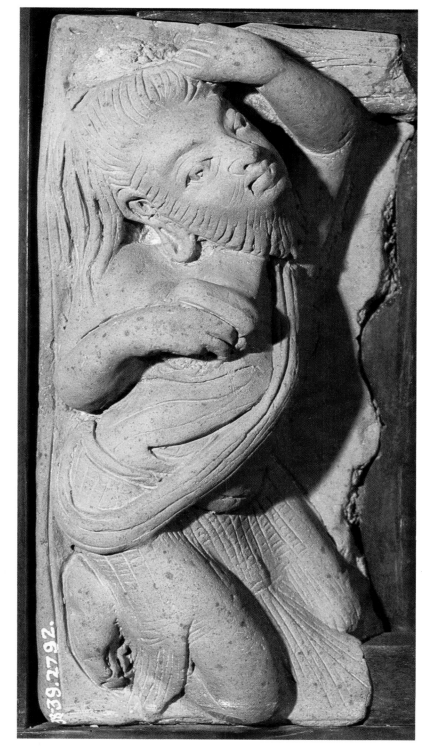

146. *Figure of a Bodhisattva or a donor prince. Stucco. From Mirpur Khas (Sind). Gupta, fifth century* A.D. *Prince of Wales Museum of Western India, Bombay*

145. *Hermit. Terra-cotta panel. Gupta, fifth century* A.D. *Museum of Archaeology, Mathura*

145

146

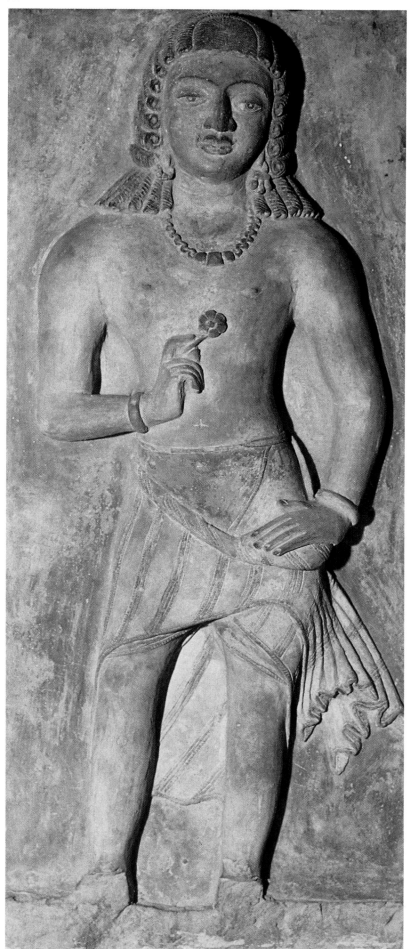

147. *Four coins. From the Bayana hoard (Bharatpur district). Gupta, fourth century* A.D. *National Museum, New Delhi*
(a) Obverse of Samudragupta's coin of the Asvamedha (horse sacrifice) type, showing the sacrificial horse in front of the sacrificial post (yupa).
(b) Obverse of the lion-slayer type of coin of Chandragupta II, showing the king shooting a lion.
(c) Obverse of the couch type of coin of Chandragupta II, showing the king seated at ease on a couch with a lotus in his hand, a portrayal suggesting love of the fine arts.
(d) Obverse of Samudragupta's chhatra (umbrella) type of coin, showing the umbrella held over the emperor by a dwarf attendant to suggest the majestic personality of the tall ruler and his un-challenged sway over a mighty empire.

148. *Four coins. From the Bayana hoard. Gupta, (a) and (b) fourth century* A.D., *(c) and (d) fifth century* A.D. *National Museum, New Delhi*
(a) Obverse of the battle-ax type of coin of Samudragupta, showing the king holding a battle ax, a portrayal that makes the coin's legend 'the battle ax of the god of death' (Kritantaparasu) signifi-cant.
(b) Obverse of the lyrist type of coin of Samudragupta, showing the king playing the lyre, a por-trayal that corroborates the descrip-tion in the Allahabad prasasti.
(c) Obverse of the elephant-rider–lion-slayer type of coin of Kumaragupta I, showing the emperor seated on the state elephant that tramples the lion as it is slain.
(d) Obverse of the rhinoceros type of coin, showing the emperor hunting the rhinoceros, a sugges-tion that the Gupta empire extended up to Assam, the home of the animal.

149. *Four coins. From the Bayana hoard. Gupta, (a) and (b) fourth century* A.D., *(c) and (d) fifth century* A.D. *National Museum, New Delhi*
(a) Reverse of the battle-ax type of coin (Kritantaparasu) of Samudragupta, showing the goddess of royal prosperity seated on a lion and facing the onlooker, her feet resting on a lotus, carrying a noose and a cornucopia in her hands to suggest military strength and treasure (danda and kosa).
(b) Reverse of Samudragupta's lyrist type of coin, showing the goddess of royal prosperity seated on a wicker seat, facing left, holding a cornucopia and a noose.
(c) Reverse of the horseman type of coin of Kumaragupta I, showing him playing with a joyous, dancing peacock with tail outspread.
(d) Reverse of the rhinoceros type of coin of Kumaragupta I, showing the river-goddess Ganga standing on her crocodile (makara) vehicle under an um-brella held by an attendant, a composition suggesting the sovereignty of the emperor over the entire region of the river's course.

150. *Mother and child. From Samalaji (Gujarat). Maitraka, fifth century* A.D. *National Museum, New Delhi*
Note the beaming smile on the face of both figures. The sprig of leaves is a sign of fertility.

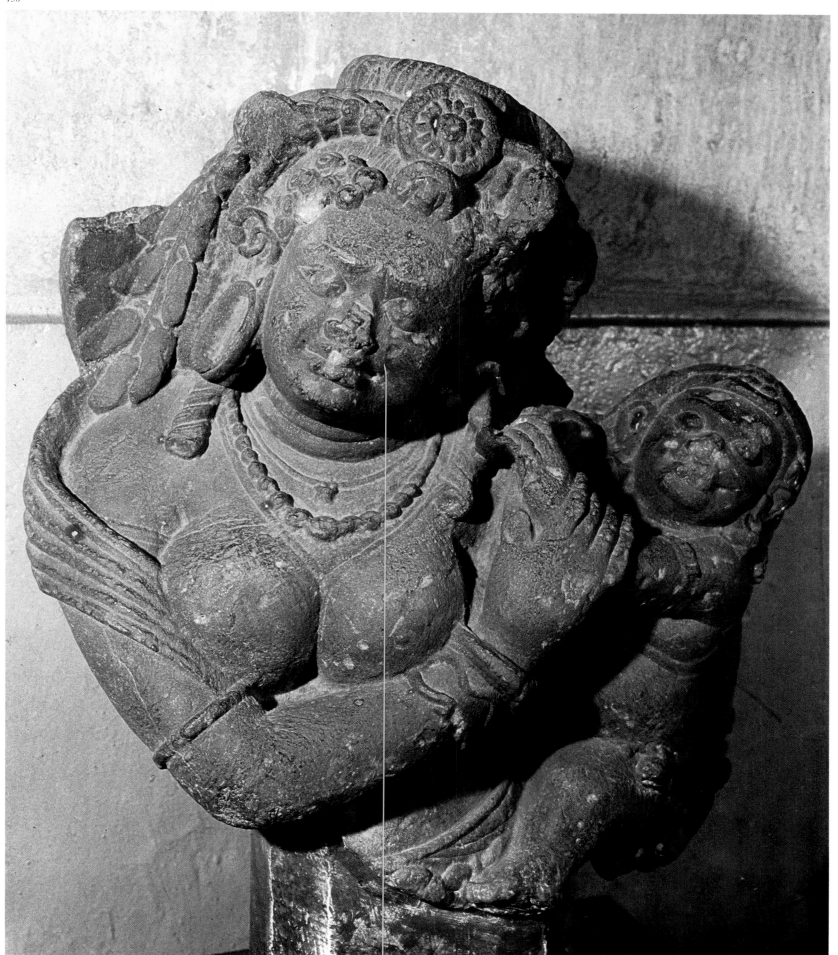

151. *Ganesa with a gana attend-
ant. From Samalaji. Maitraka,
fifth century* A.D. *Baroda Museum*
*The single pair of arms and the
natural elephant head, without a
crown, of this deity of success
indicate the early date of the
workmanship.*

152. *Siva beside the bull. From
Samalaji. Maitraka, fifth century*
A.D. *Baroda Museum*
*Note the elegant arrangement of
Siva's hair (jatas) and the sug-
gestive treatment of the urdhva-
retas, a hermaphroditic feature
indicated by the difference in the
ornaments on the ear lobes.*

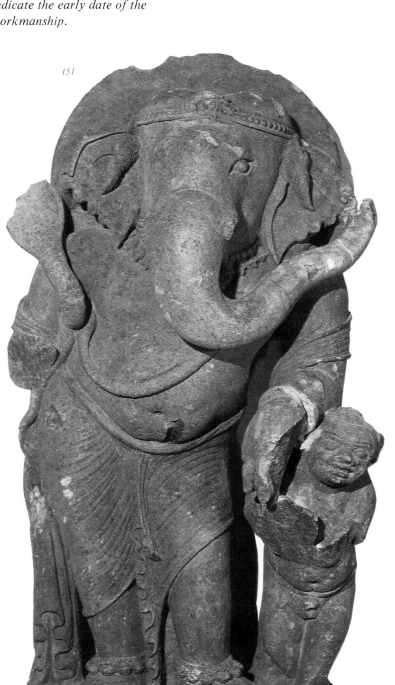

151

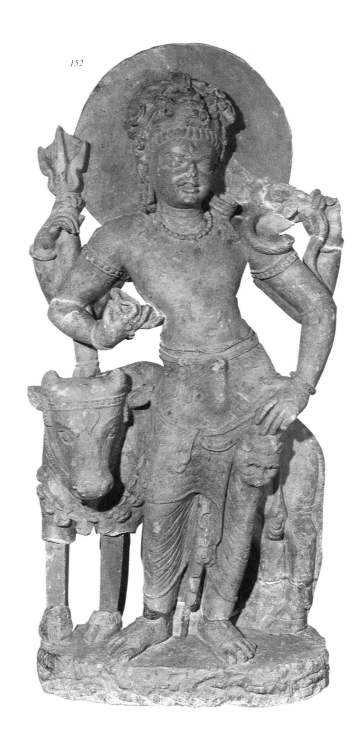

152

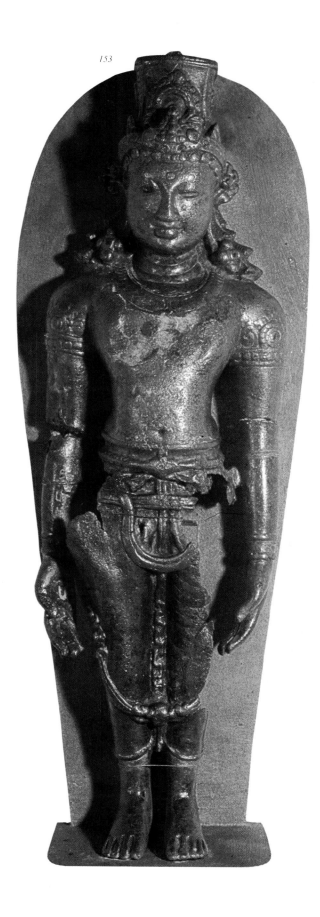

153. Jivantasvami, that is, Mahavira, as a prince before his renunciation of his rank. From Akota (Gujarat). Maitraka, sixth century A.D. Baroda Museum

A number of beautiful sculptures from Bhumara, rescued by R. D. Banerji, now adorn the Gupta gallery of the Indian Museum at Calcutta. The Allahabad Museum also owns exquisite carvings from the same monuments. The Sivaganas depicted here in fantastic and weird forms have never been surpassed; in fact the carvings from Bhumara constitute a veritable treasure house of iconography. The Indian Museum also has an excellent example of sculpture from Buxar, in Bihar, showing Ganga and Yamuna flanking a gateway.

Probably the most original conception and presentation of the Kiratarjuniya and Gangaparinaya theme by a Gupta sculptor appears on pillars from Rajauna now preserved in the Indian Museum at Calcutta. In the Bharat Kala Bhavan in Banaras, there is a simple but attractive juvenile figure of Skanda with his peacock. The Gupta sculptors excelled not only in stone carving but also in fashioning large and beautiful terra-cotta panels with which whole temples were decorated. Once seen, the famous terra-cotta shrines from Bhita, Bhitargaon, Ahichchhatra, and Rajgir can never be forgotten. In the Maniarmath at Rajgir were such splendid works as the Nagini with hoods over her heads and Vishnu flanked by a personified wheel and club. Some of the large terracotta panels from Ahichchhatra, now in the National Museum in New Delhi (figs. 143 and 144), as well as the Ganga and Yamuna, almost life size, illustrate this phase of Gupta art. Particularly noteworthy are the kinnari and her lover the prince, on her back, and the lord of learning, Dakshinamurti. Bhitargaon in Uttar Pradesh has a magnificent temple still *in situ*, terra-cotta panels from which are preserved in the Lucknow Museum and in the Indian Museum at Calcutta. The Seshanarayana panel in terra-cotta from Bhitargaon is very famous not only for its simplicity but also for its effective treatment of the subject.

The theme of the eternal Buddha, which was such a favorite in Gupta sculpture, is represented in a fine example, with the folds of the robe tastefully arranged in relief, in a panel from Sahet Mahet, now in the National Museum in New Delhi. The Mathura Museum has a very effective sculpture in clay representing a hermit (fig. 145).

The ramifications of Gupta art, as already observed, are very great, and in distant Sind a number of stuccos were created in the Gupta style, of which the Padmapani in the Prince of Wales Museum in Bombay is typical.

It is said that the Gupta period was a golden age. This is almost literally true, as the finest coins in gold ever issued in India are of the Gupta period. These are especially noteworthy for the utmost delicacy of their treatment and the fine molding of the details of the figures on both the obverse and the reverse of all of them, the legends also being in the most artistic lettering of the age. The Asvamedha coin showing the horse

standing beside the sacrificial post (fig. 147a) is a fine example of the rendering of this subject in Indian art. The lion-slayer type presents with the utmost animation and spirit the might of the prince who could fight the fierce king of the beasts (fig. 147b). The couch type represents the king as a connoisseur of art and learning (fig. 147c). The sculptor has placed a lilakamala, or sportive lotus, in his hand, suggesting both his leisure and his taste. The legend Rupakriti on this coin appropriately styles him 'prince charming.' The chhatra type presents a prince with an umbrella held by a dwarf attendant (fig. 147d) to emphasize the personality of the prince, tall like a tree (salapramsuh), the parasol suggestive of his supreme sovereignty and quite significant. In the Kritantaparasu type, the warrior spirit of the prince holding a battle-ax is striking (fig. 148a). The prince, seated on a couch, playing the lyre, the subject of the lyrist type, shows Samudragupta as a master musician (fig. 148b), presenting a visual commentary on the line of the inscription on the Allahabad pillar that describes him as putting to shame, by his proficiency in music, even the divine musicians Tumburu and Narada. The

elephant-rider–lion-slayer type, a rare coin from the Bayana hoard (fig. 148c), shows Kumaragupta as the most beloved prince riding the state elephant, with the umbrella held over him to ward off the rays of the sun from his beautiful face, almost in accordance with the account of the stately elephant ride of Rama, the darling of the people of Ayodhya, as related by Valmiki in the *Ramayana:* ichhamo hi mahabahum raghuviram mahabalam gajena mahata yantam ramam chhatravritananam. The prince as a hunter cutting off the horn of the rhinoceros, on a rare gold coin from the Bayana hoard (fig. 148d), is one of the greatest artistic creations by a Gupta sculptor. The reverse of these coins, showing the goddess of prosperity, Sri, holding the noose and the cornucopia (fig. 149a), signifying military strength and royal treasure (danda and kosa); the goddess of prosperity with the peacock, Ganga on the crocodile, or makara (fig. 149d), and so forth, is very impressive. The king-and-queen type of coin is another mode of representing the dampati theme in royal portraits as great connoisseurs of art and literature, for every branch of art was patronized by the sovereigns.

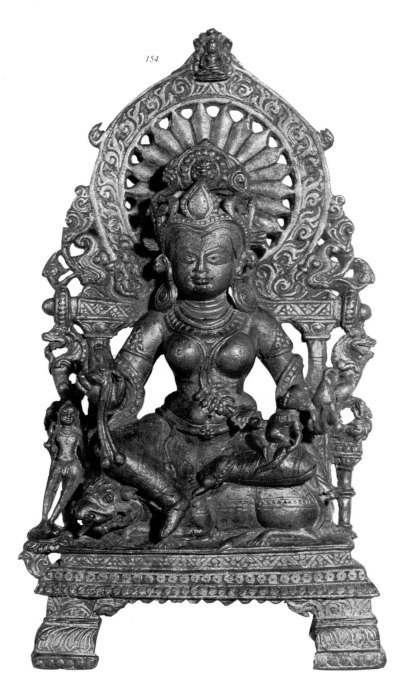

154. Yakshi Ambika. From Akota. Maitraka, sixth century A.D. *Baroda Museum*

155

155. *Tritirtha image of Parsva-*
natha with an inscription men-
tioning the donor, arjika (re-
vered) Khambhili. From Akota.
Maitraka, seventh century A.D.
Baroda Museum

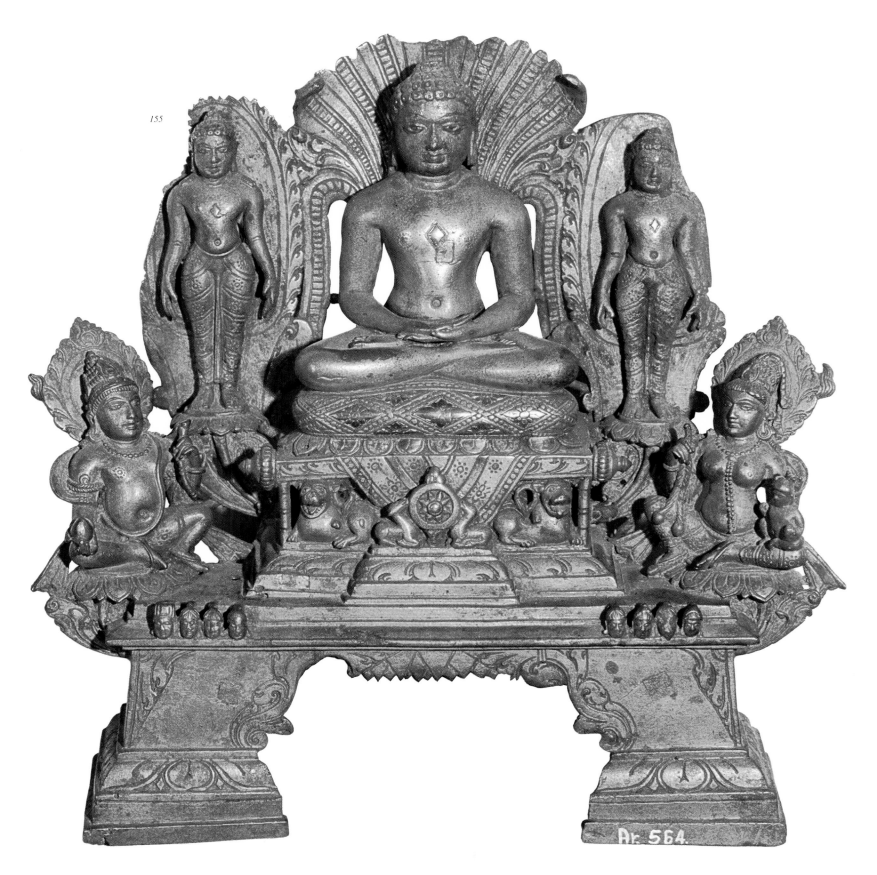

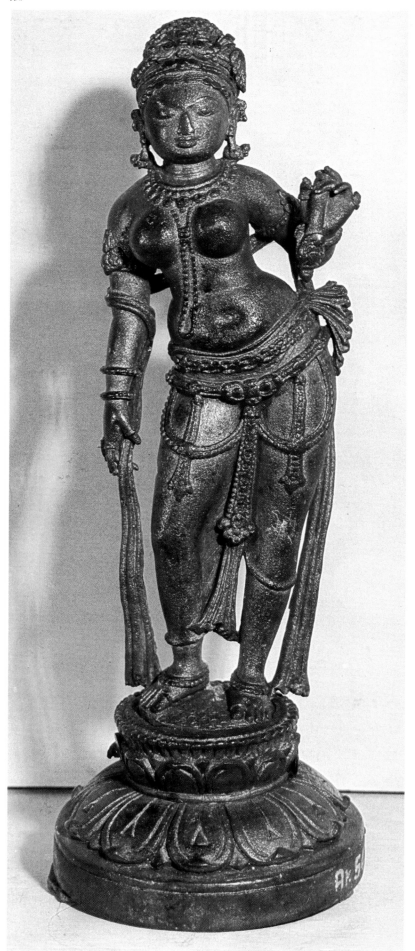

156. Fly-whisk bearer (chamara-dharini). From Akota. Maitraka, seventh century A.D. Baroda Museum

The Maitrakas of Valabhi, who ruled in the area of Gujarat, were feudatories of the Guptas and followed Gupta traditions. The famous Gop temple is a monument of this age and from their realm. Some of the most beautiful carvings from Gujarat come from such places as Idar, Samalaji, Mahudi, Roda, and the like. Exquisite examples of Maitraka art include two figures from Samalaji, the simple but charming two-armed Ganesa with a halo, accompanied by a gana (fig. 151), and the Siva, with an aureole around his head and with his hair (jatas) tastefully arranged, holding the trident, or trisula (fig. 152). The Ganesa and the Siva now have honored places in the Baroda Museum. Of the same school and exceedingly graceful is the mother and child from Samalaji (fig. 150), the mother beaming with the joy of maternity, a work now preserved in the National Museum in New Delhi. The Skandamata from Mahudi shows the mother fondling the child on the shoulder of a girl attendant.

The workmanship in metal of the Gupta period from this area is exemplified in bronzes from Akota, and excellent examples exist in the Baroda Museum. The Santinatha with attendants from Akota is a fine work now in the National Museum in New Delhi.

A Buddha formerly in the Boman Baram collection is undoubtedly the finest expression of the Indian sculptor's art in metal. Another fine example of Gupta work is the Brahma from Mirpur Khas in Sind, now preserved in the Lahore Museum in Pakistan.

Examples of the art of painting of the Gupta period have almost disappeared except for the few remains in the Bagh caves, in the former Gwalior State, excavated on the slope of the Vindhya hills in the vicinity of the river Bagh. Of the nine caves, nos. 2, 4, and 5 are the most important. Cave 2 contains excellent sculptures, the most important of which is the Buddha flanked by Bodhisattvas, all carved in the best tradition of Gupta plastic art. The remains of paintings in the Bagh caves are on the outer wall of the continuous veranda of Caves 4 and 5. The subject illustrated is probably a Jataka or Avadana. The first scene shows a princess in great grief consoled by her companion, the second a group of princely figures, among them Saka, distinguished by his crown, the third some monks and female lay devotees and a scene depicting the playing of several musical instruments, the fourth a group folk dance, Hallisalasya, the dancers in a ring keeping time with little wooden sticks; all are most interesting. The feminine coiffure and the colorful dress and long-sleeved shirt of one of the dancers are especially noteworthy as giving a vivid picture of the age. A procession of elephants, tuskers with royal riders, are all now almost vanished paintings from a great age. These works, along with the paintings of the Vakatakas in the Deccan at Ajanta, proclaim the greatest period of the art of painting in ancient India.

8. Indian Influence in Central Asia

by Mario Bussagli

Since the beginning of our era, the largely arid and desertic lands lying between the basin of the Amu Darya and the eastern boundary of modern Chinese Sinkiang were exposed to a vast cultural diffusion coming mostly from the Indian peninsula. The ancient merchant civilizations which bloomed on those lands and formed an essential page in the history of Eurasia created a great wealth of figural, stylistic, and iconographic phenomena in which the Indian component plays an important role. There, through old Kashgaria—which is sometimes still called Serindia: a misinterpretation of the name Serinda, evocative of the encounter between the fabled Seres and the Indian civilization—ran the two-branch transcontinental route of silk and gold that linked China to India and, through modern Soviet Turkistan, reached Iran and, beyond that, the great eastern ports of the Mediterranean. It was the shortest way from the Mediterranean to the Far East, and the volume of trade along this route regulated the political and economic equilibrium of both continents in the first few centuries of our era. For ages the small feudal monarchies and city-states that flowered in the shadow of the larger oases suffered the anguish of nomad invasions from the north and northeast and fell prey to the covetous sedentary civilizations of the south and the east, whose crescentlike borders, strewn with formidable mountain ranges, encircled the world of Central Asia. The economic riches and strategic importance of these lands stimulated all the neighboring great powers (nomadic empires as well as settled states) to try to conquer them; not to destroy, however, but to preserve their riches. Bactrian Greeks, Kushans, Chinese, Arabs, Turks, Tibetans, Altaic nomads, and other Indo-European peoples, all strove with different degrees of success to gain political and military supremacy over these areas, so that, once they were in command of international trade, they might control the Eurasian economy. Despite this unsettled condition and the Chinese rule to which they were twice subjected (under the later Han dynasty and under the Tang), the western Central Asian monarchies and city-states managed, at the cost of much blood and travail, to preserve a certain amount of independence, thus engendering a historical phenomenon of great complexity. Trade, constant contacts with diverse civilizations, and the political interest that the Central Asian regions aroused in their powerful neighbors caused the preeminent products and ideas of the more advanced civilizations of Eurasia to converge in this area up to the time of its complete Islamization. With the advent of Islam, Central Asia was almost completely shut off and isolated until, under Mongol rule, it resumed its natural role of intermediary in the contacts between East and West. At the time of Marco Polo, however, the characteristic nature of Central Asia had already undergone a deep change. Among the reasons for this was the fact that Turkish peoples of different stocks had for a time taken the place of the eastern Indo-European popula-

tions, whose civilizations they had at first adopted but later ignored to develop a varied and composite culture of their own, which lacked the creative impact of the original ones.

At the time of the Indian figural diffusion, the whole of Central Asia was populated by peoples of Indo-European stock. The languages spoken in the areas dominated by Kucha and Agni—two of the major city-states of eastern Central Asia—belonged to the western Indo-European group and were, curiously enough, much closer to Latin and Celtic than to either Sanskrit or Iranian. It must be noted, however, that the documents and the literary and religious works found in large numbers by archaeological expeditions in Transoxiana and in the Taklamakan Desert attest the extensive use in this area of eastern Iranian languages which are sometimes rather puzzling in syntax, grammar, and lexicon. In any case, it is not easy to account for the misleading existence of western Indo-European languages in a world that was preeminently Iranian in character and lying at the farthest eastern reach of the Aryan languages. It is possible that, at the beginning of the first millennium B.C., a massive but not very clear ancient migration, referred to as 'Pontic,' led groups of Thraco-Cimmerian people to populate the northeastern regions of the Taklamakan after they had been driven out of southeastern Europe by the increasing pressure of the Scythians. The Iranian languages of Central Asia, including the newly discovered one of Bactria, were very widespread. At first the *lingua franca* of trade was Khotanese—that is, the language of Khotan, one of the largest caravan cities on the southern silk route and the capital of a small kingdom. Later, owing to the extraordinary aptitude for commerce of the merchants of Sogdiana, Sogdian became the international language of trade. The effects of the Sogdian cultural diffusion were really astonishing. The propagation of Nestorianism and Manichaeism was largely performed by Sogdian lay missionaries, whom the necessities of trade sent traveling all over the Far East. Sogdian writing, a derivative of Aramaic, served as a model for the alphabet that the Uigur Turks adopted, which, appropriately modified and improved, originated Mongol writing. In the field of the figural arts, however, there is no evidence of similar or related phenomena of unification. Yet all the settled civilizations of Central Asia reveal, on examination, a singular unity, despite the clear-cut division between the western stretches (where people of Iranian stock, a mainly agricultural economy integrated with trade, and governmental structures covering vast regions prevailed) and the almost desertic lands on the east, where caravan city-states had grown around the oases. A common geographical situation and shared historical events were at the bottom of this unity, which does not, however, apply to politics, language, and culture. Among the principal unifying elements were the diffusion and establishment of Buddhism, as is shown in both the figural arts and the literature—in the

latter by the number of translations of Buddhist texts of various types and degrees of importance. Also in this field the local heritage was by no means lifeless; this is why there exists a 'Central Asian Buddhism' distinguished from Indian Buddhism. The divergence lay in the stressed concept of the Buddha's universal sovereignty rather than in the doctrinal tenets and in the obvious tendency to theism, and in the increased importance of the great Bodhisattvas, who were regarded as the heirs to a cosmic sovereignty or, better, crown princes of a realm that extended to the farthest end of the universe. To express this metaphysical concept, the artists of Central Asia understandably resorted to human royalty, reproducing the distinctive signs of the small local potentates or those of the western Iranian sovereigns in the representations of the Buddhas in glory (in Buddhist terminology, literally 'in their glorious bodies') and of the Bodhisattvas. Local trends of thought, not always very carefully examined but unquestionably very interesting, are evidenced also by the preference for certain deities, the emphasis on particular aspects of the doctrine, and the free translations. The fact alone that the cultural, pre-Buddhist background of Central Asia was unaware of the doctrine of constant rebirth and of the law of reward and punishment (kharma) makes the Buddhism of this area a completely different matter from the triumph of the Good Law that it was in the Indian world. This distinguishing element suffices to explain the differing development and value of Buddhism in the regions that concern us, while their iconography clearly reflects the introduction, in the tolerant Buddhist orthodoxy, of local contributions and Iranian influences, which were sometimes very important for the Buddhist exegesis and Buddhology.

Politically, too, India took part in the historical development of Central Asia through the powers that ruled over the northwestern regions of the peninsula. The Buddhist expansion in Central Asia can be ascribed

157. Heads of two figures praying. From Miran, second half of the third century A.D. National Museum, New Delhi
The heads represent two long-necked maidens with elegant hairdress. F. H. Andrews suggests that they may portray the daughters of Prince Vessantara, the protagonist of the* Vessantara Jataka *(Wall Paintings from Ancient Shrines in Central Asia, London, 1948). Though the two faces bear similarities to each other, especially in the large eyes and slightly hooked noses, their expressions are different. The one on the left seems to be younger and enthusiastically involved in what she is doing; the other, a little older, appears more austere and restrained.*

158. Royal figure praying. Fragment of an adoration scene. From Miran, second half of the third century A.D. National Museum, New Delhi
This fragmentary composition, which shows a man sitting on a *throne and resting his bare feet on a stool, is unquestionably a scene of adoration of the Buddha, though it has not been exactly identified. The royal personage, shown with his hands joined and in a Gandharan garment with roughly rendered drapery, may be Prince Vessantara adoring the Buddha of his time. In this event, however, the Jatakas would be enriched by an episode which is not recorded in the texts. The composition shows a series of schematic perspective solutions, which are Gandharan reelaborations of Classical patterns for the distribution of volumes, for differing viewpoints, and for vanishing lines. Akin to Gandharan art also in the garment, the drapery, the position of the bodies, and even in the cut of the moustaches that leave the central upper lip uncovered, this work can be considered a painted version of the sculptural compositions of Gandhara.*

157

158

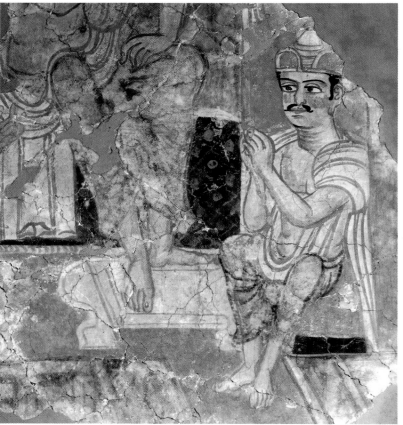

mainly to the Kushans and their epigones, to whom Central Asia is also almost totally indebted for the propagation of the Iranian culture. As B. A. Litvinsky has pointed out in his *Outline History of Buddhism in Central Asia* (Dushamba, 1968), western Turkistan also received the Buddhist diffusion through the Kushans, whose empire, at the time of its greatest expansion, must have included a large section of Central Asia. Furthermore, bearers of it were not only the Kidarits, but possibly also the Ephthalites—the terrible White Huns, whose attitude toward the Buddhist community and the Good Law varied in time and from place to place. Thus, some inexact differentiations between western and eastern Central Asia and groundless traditional beliefs concerning the destructive and persecutory activity against the Buddhist world by groups of people living and active in Central Asia and deemed to have been constitutionally opposed to Buddhism are proved wrong. On the other hand, it is well established that the diffusion in Afghanistan of the Good Law and of its political version, which Asoka called simply the Law (dharma), was performed by that great Mauryan emperor; while the case of Menander, the Greek king protagonist of the *Milindapanha*, is obvious proof that the skeptical yavanas (Greeks or Westerners, generally speaking) also felt the fascination of the Buddhist preaching. Today we are in a position to add that in Bactria as well as in Margiana, in the first centuries of our era, there were numerous followers both of the Vaibhasikas (a branch of the school of the Sarvastivadins) and of the Mahasanghikas. This means that the two most important currents of Buddhist thought—the current of the Lesser Vehicle (Hinayana) and that of the Great Vehicle (Mahayana)—were both to be found in these areas where, with particular inflections, they coexisted more or less peacefully. We cannot tell what the situation of the Buddhist currents was in western Turkistan, but we know that farther east–that is, in today's Chinese Sinkiang—the various Buddhist schools and sects had a precise geographical distribution and were—within certain limits—responsible for the spread and character of the iconographic and stylistic trends in that region.

Kucha and Kashgar, on the northern stretch of the silk route, were centers of the Lesser Vehicle, a fact that surely opened the way to contacts with Bamiyan and to its influence. Bamiyan was a large caravan city in Afghanistan of great religious importance for being a stronghold of this tendency and of equally great artistic importance as the meeting place of Iranian and Buddhist art. On the contrary, in Yarkand and Khotan, on the southern branch of the same route, Mahayana Buddhism—that is, the Buddhism of the Great Vehicle—prevailed, probably because of the proximity of Kashmir and the Swat Valley. On this point the testimony of the Chinese Buddhist pilgrims is explicit. It covers a fairly long period of time and also shows that the inevitable consequence of the predominance of this current, accentuated and established by elements unrelated to the specific belief—which, by the way, had been altered by the psychological and spiritual attitude of the local population—was that the iconography and taste of Yarkand and Khotan were remarkably different from those of the northern cities.

The expansion of Buddhism in Central Asia was performed by missionaries of different nationalities. Some were certainly Parthian and perhaps of royal blood—An Fa-Chin, An Hsuan, and especially An Shih-Kao, to use their Chinese names. According to the official biographies, the last, an outstanding translator of Buddhist texts into Chinese, was the eldest son of the king and queen of A-hsi (Parthia). However, it is not impossible that he may simply have been the son of one of the most prominent Parthian feudal lords or the heir to a royal family from a country under Iranian influence, which might even have

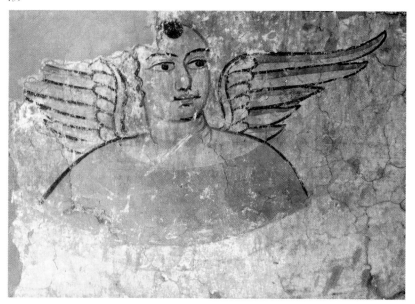

159

159. *Winged figure, the only remaining detail from a festoon in Shrine 3 at Miran. Second half of the third century* A.D. *National Museum, New Delhi The image, derived from the winged eroses of the Classical world, is frontally and heavily rendered after the Parthian or the Kushan taste. The styling of the hair, consisting of a lock on the top of the shaven skull, has also been found at Kucha, one of the largest caravan towns.*

143

160. *Female figure of the Par-*
thian-Kushan type. From the
festooned frieze of Shrine 5 at
Miran. Second half of the third
century A.D. *National Museum,*
New Delhi
The image with the large staring
eyes expresses, in its own strange
figural idiom, a flowering, mature
beauty. The hair style is Indian,
and its general effect, including
the crown-shaped headdress, is
strongly reminiscent of the
Gandharan style.

161. *Fragment with Buddhist*
monks' heads. From Miran,
second half of the third century
A.D. *National Museum, New Delhi*
The shaven heads, the pronounced
features, the abundant use of
chiaroscuro attenuated by spots
of color, the choice of colors, and
the red stripe on the nimbus of a
Buddha, now disappeared, all
belong to the personal style of the
Master of Miran.

been Margiana. This old supposition of H. Maspéro was reconsidered with greater precision and on the basis of newly uncovered archaeological documents by the Soviet scholar M. E. Masson in 1963. Others were Kushans, such as Chih Lou-chia-chion, known as the Yuch-chin (Kushan) Bodhisattva, Chi-chien, the son or grandson of a Kushan ambassador, Chi-wao, Chih Liang, and the monk Dharmaraksa, known as the Bodhisattva of Tun-huang. Some of the missionaries and translators were from Sogdiana, for example, K'ang Meng-hsiang and K'ang-chu; the latter's characteristically regional name unmistakably gives him away as a Sogdian. In Central Asia also members of royal families and the upper classes contributed to the spreading of the Word, sometimes even renouncing the world and becoming among the most outstanding Buddhist translators and exegetes of all times. Many rich but historically unknown people commissioned religious buildings to secure renown and eternal salvation.

The fact that the missionary work and the translating were largely the undertakings of Iranians and Central Asians was not without consequences. As to the enormous quantity of translations, the choice and popularity of some texts in the long run affected Buddhist speculation. Interpolations, changes, and the liberties translators took with the texts facilitated the slow transformation of Buddhism from the rigid Lesser Vehicle to the decisively soteriological Great Vehicle. The innumerable Central Asian art works—especially those of the eastern area —offer ample documentation of the evolution of Buddhology and of the new attitudes of commentators and exegetes. The historical Buddha

tended to fade as the Supreme Buddhas, symbolic exteriorizations of an immobile and immutable principle from which all things are derived, prevailed. Accentuated theism; the newly conceived, complex doctrine of the 'Pure Lands' and Paradises; and the overcoming of the law of kharma (which regulated punishment and reward in the perpetual series of rebirths) by a deeply felt act of faith are all perfectly legible in the murals of Serindia—an area of eastern Central Asia—to whoever is able to detect the minor details of their iconography. These were new, profoundly compassionate, soteriological conceptions, indulging the desire for divine protection of human life which only complicated speculation and clever dialectics could reconcile—at least up to a certain point—with the original attitudes of Buddhist thinking. This tendency is to be found wherever people were converted to the Good Law, but in Central Asia it shows unusual aspects, if for no other reason than the persistence of the Lesser Vehicle in some places. Even more evident is the attitude toward the universal sovereignty of the Buddha. An issue of the doctrine of the three bodies through which the Buddha's essence becomes manifest, it resulted in the prevalence of the 'body of glory' over the 'body of Law,' the metaphysical essence of every Buddha, and of the 'apparent body' (nirmanakaya), which is the Buddha's human aspect—or, rather, that which involves natural perceptions. The historical Buddha, as the Teacher, appeared in this last body, which, according to the Law he preached, was no more valuable than that of any other human being. The only difference consisted in the intuition of the supreme truth, which was at the same time the essence of the universe, permeating the mind and spirit of the one-time prince who, by virtue of his intelligence, had now become the savior of the world. It may be added that many of the magical elements in local interpretations of Buddhism—particularly those of Udayana and, even more noticeably those of the upper Swat Valley—also flowed into Central Asia, where they acquired different values and nuances. Vajrapani, who is probably the personification of the magic power of the Buddha—rarely used but always there as a potential reserve of superhuman and, in a sense, ultradivine power—is seldom to be found in Central Asia and, when it is, it shows very different aspects from those of the traditional Indian iconography, with a tendency to completely new demoniacal values.

In view of the important role of the Kushans in spreading Buddhism throughout Central Asia, it is not surprising that Gandharan art—which reached its peak under their rule—should have been for a time very successful in all the eastern regions of Central Asia and in most of the western ones as well. While admitting that Gandharan art must be included in Indian art for its Buddhist content and because it flourished on Indian soil (today politically a part of Pakistan), it must be remembered that this art was virtually a propagation of the Hellenistic Roman current in form and style. The actual area of its diffusion bordered on the north with the region of Airtam, near Termez (old Tarmita) on the Oxus. However, in Tumshuk, one of the main archaeological centers on the northern stretch of the caravan route, west of Kucha, there are traces of Gandharan diffusion of such magnitude that, in taste and iconography, the earliest artistic phase of this site looks like a peripheral rather than a provincial interpretation of the art of Gandhara. On the southern stretch of the caravan route, about two-thirds of the way eastward, the paintings of Miran (see figs. 157–161) show obvious similarities with a particular trend of Gandharan art. They form a painted rendition of some special stone sculptures with striking 'rotating' perspectives. The artist who created and signed them with the name Tita (obviously a Prakrit adaptation of the Latin name Titus)

162. Figure praying. Fragment of a mural painting, perhaps from Balawaste. Seventh century A.D. National Museum, New Delhi The image, which must originally have been enclosed between two Buddhas (neither of which is extant), though less accurate and less powerfully drawn (cf. fig. 158), shows remarkable similarities with the paintings of Ajanta, including the use of color. Iranian reminiscences in the golden crown and symbols derived from the Kushan royalty, such as the two triangular flames coming out of the shoulders, demonstrate that, though basically Gupta in style, it recalls Iranian and Kushan art, besides reelaborating Indian elements. The image belongs to Tantric Buddhism, as is apparent from the eye drawn on the back of the right hand below the forefinger.

It is unquestionably one of the best Central Asian creations.

163

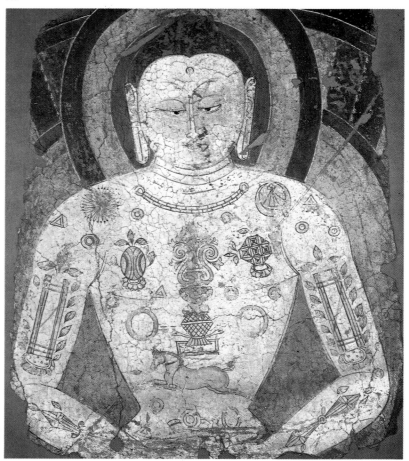

164

163. The Buddha meditating. Probably from Balawaste, mid-sixth century A.D. National Museum, New Delhi
The Buddha, covered with symbolic motifs associated with Tantric doctrines, is represented frontally. In this work, both the front view and the stiffness characteristic of the cult steles of Gandhara seem to survive in painting. The symbols are undoubtedly Tantric, as is evident from the two books, surrounded by flames and resting on two lotus corollas, adorning the arms of the figure and the two stylized thunderbolts (vajra) on the forearms. The sun, the moon, the two jewels, the horse, and the ornamental motif in the middle of the chest (the two-headed snake alluding to the vital energy of the Buddha) complete the meaning of this composition, which is stylistically a product of Central Asian taste already tending toward forms in the Chinese manner.

164. Hariti with children. Mural painting from Shrine 12 at Farhad Beg-yailaki, mid-sixth century A.D. National Museum, New Delhi Derivation from the rigid frontal representations of Gandhara is here especially evident, for the sculptors of northwestern India were familiar with the subject and interpreted it in a similar manner both in composition and in comparative proportion between the main figure and the children. However, this painting is much more markedly frontal and relies far more on circular and elliptical lines than does Gandharan statuary.

must have had links with the Gandharan workshop or school that produced the panels with especially noticeable perspective and 'rotating' effects. Special 'genre' details, the 'paratactic' distribution of the images to suggest a crowd, and the particular aspect of the Buddha with his enormous bun of hair (ushnisha) further prove that there existed a close bond between these paintings and the school of Gandhara or, better, with a particular tendency within this school. For this reason the paintings of Miran, all by the same hand and unfortunately mostly destroyed, might be regarded as the largest cycle of Gandharan paintings to have come down to us, even though in terms of geography they stand far outside the area of this school. This occurrence is by no means extraordinary. Apart from the incised gems with Classical or classicizing motifs scattered all over eastern Central Asia, the enormous importance of the school of Gandhara throughout Central Asia is attested by the Gandhara-inspired works at Turfan, at Karashahr, and elsewhere; similar ones mentioned in Chinese texts and well known also in China; and the sculptural or pictorial reproductions of famous cult images—among which are some of the Graeco-Buddhist school. Gandharan art was so popular that it became one of the principal elements of unification from Chorasmia all the way to the western boundaries of China.

The works of Miran are of uncertain date. Most likely they belong to the period at the end of the third and the beginning of the fourth century, as archaeological data and paleographic inscriptions seem to confirm. Analysis of their iconography and style also points more or less to this dating, though there is no precise and decisive element to go by. The use of a special chiaroscuro, which often consists of white lines running along the black lines of the drawing to lighten the colors where

146

the light strikes most, was a device familiar to mosaicists of the Hellenistic period, to those of the school of Damascus, and to those of Ravenna and Byzantium. In perspective effects—particularly notable in the pictorial fragment representing a partly destroyed large figure to whom a worshiper in princely, or perhaps even kingly, attire is paying homage (fig. 158)—the recurrence of special technical devices is apparent. The vanishing point, purposely introduced with geometrical elements in the floor, is consistent throughout the fragment, and so is the chiaroscuro which presupposes the source of light to be in the upper right corner. The stool on which the main figure rests his feet, however, is drawn according to a completely different perspective, realistic in terms of the resting surface (obviously geometric), but unrealistic in that its left leg is rendered by the decomposition of the masses (a mere graphic sign, actually), so that it looks as if it were standing beside the stool's top. If not entirely impressionistic, this effect is certainly compendiary or sketchy, for, rather than providing an illusionistic vision, it plays on the psychology of the viewer. In any case, the stylistic data available unmistakably link the paintings of Miran to the Classical and Byzantine world, even though the large eyes of the figures recall the paintings of the Fayyum and Iran—or Palmyra—which in terms of style are somewhat similar to those of the Kushans. The fundamental observation, however, is that the pictorial production of Miran belongs without a doubt to the Gandharan current and, consequently, that the figural background of Central Asia sprang from Graeco-Buddhist inspiration. This source was to constitute a determinant of later evolution.

One of the most important consequences of the Gandharan influence, especially of its Classical component, was the predominance of the human figure in all the paintings of Central Asia. The representation of the human figure was fostered by the edifying and narrative purposes of Buddhist art, was continued for a long time, and was not dropped even after the most complicated symbolic images of Paradises and miracles had taken the place of the fantastic but still human portrayals of the last life of the Buddha. Its latest echo is to be found in the votive portraits of the Manichaean or Buddhist Uigurs. Not even the influence of Chinese art—which, however, during the first millennium of our era had not yet fully turned to landscape—could diminish the effect of this first strain which, as has already been said, was in agreement with the general lines of Buddhist thinking.

On the other hand, this ancient semi-Classical background limited the acceptance and expansion of the ornamental value of the human couple (mithuna) typical of India. Other values prevailed, which were for the most part derived from the Iranian world and dictated by mystical impulses of different kinds.

The characteristic aspects of the works of Miran are generally to be found also in the art of Chorasmia, though in less evident form. In short, because of the tendency to industrialization, iconographic and stylistic motifs of various types spread over far-flung areas and into different milieus of Central Asia, originating—within certain limits—its artistic unity. Local interpretations of the same motifs, however, varied greatly. For example, despite the widespread and persistent influence of the Kushans and the resounding echo of Gandharan art, in Chorasmia one would look in vain for any strain of that current, which rationally and consistently developed the illusionistic effects of 'rotating' perspectives, in many respects comparable to anamorphosis or, better, trompe l'oeil.

Thus is raised the problem of the creative autonomy of Central Asia both in the western area (western Turkistan, as it is now called by the Soviets) and in the caravan cities of today's Chinese Sinkiang. That the

165

165. *The figure of the Buddha meditating and the top part of a stupa. Decorative composition (fragment). From Cave 1 at Bezeklik, perhaps seventh century* A.D. *National Museum, New Delhi The highly stylized Buddha is sitting on a lotus flower inside an architectural structure, which is a simplified Gandharan aedicola. The top of the stupa with the cone-shaped series of superimposed umbrellas is unquestionably Indian, but the silk 'flags' are a clear indication of Chinese influence. The execution of this schematized work is certainly based on a technique meant for easy and quick repetitions.*

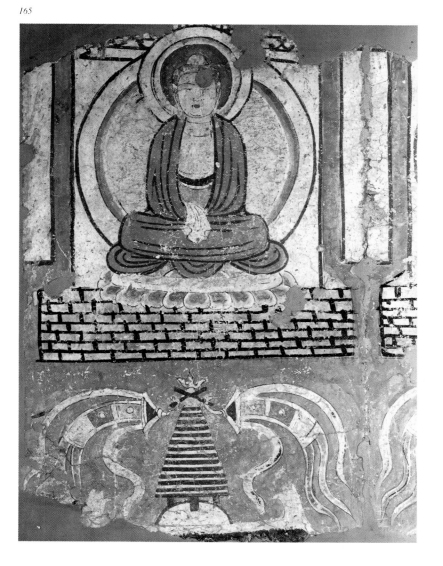

168. *The Buddha sitting on a lotus throne, possibly on an octagonal base. From the gorges of Sengim (Turfan), eighth or ninth century* A.D. *National Museum, New Delhi*
In its lower part the composition includes two praying figures: a markedly Sinified layman and a person in a monk's habit. At the top are two divinities, one of which is recognizable as Vajrapani from the thunderbolt he is holding in his left hand. Despite Sinification, stylistic and iconographic traces, mostly of the northwestern Indian schools, are clearly detectable.

166. *Two devas (divinities) praying. Mural painting from Cave 1 at Bezeklik, eighth or ninth century* A.D. *National Museum, New Delhi*
The unmistakable stylization reveals a strong Chinese influence, especially in the faces; but the drapery still echoes the Indian and Gandharan styles. From the local viewpoint, the jewels, the clothes, and the headdresses are exotic elements adapted to the taste of the Sinified Turks.

167. *People of different nationalities lamenting the death of the Buddha. Detail from a fragment of a mural painting. From Cave 9 at Bezeklik, eighth century* A.D. *National Museum, New Delhi*
The figures reproduced in the picture (among whom a Far Easterner and a Persian are recognizable) are Sinified interpretations of the racial characterization found in the stuccos of Hadda and in the terra-cottas of Ushkar. Obviously, this Sinified interpretation is also the result of the influence of the Tang funerary figurines (ming-ch'i).

166

167

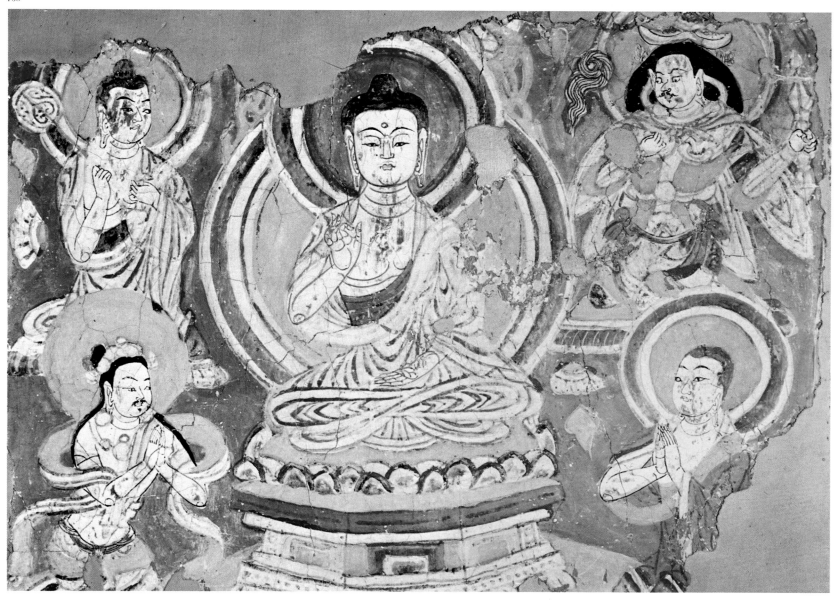

figural arts of Central Asia were autonomous is an unquestionable fact partly resulting from environmental and technical circumstances. The sculpture provides proof of this. Because of the lack of workable stones, the sculptors resorted to second-best techniques and used fabrics impregnated with stucco, chalk, clay, terra-cotta, and even lacquer as sculptural materials. While, however, the school of Gandhara produced, starting from the fourth century, markedly Classical forms in its by now all-stucco production and introduced a sentimental—almost pathetic—element into its narrative compositions, the sculptors of Central Asia went their own different way. They gradually dropped the Classical or classicizing elements in favor of the Gupta style and of a component, generally referred to as Iranian because of its resemblance to Sassanian art, which is actually not only original but even, to a large extent, local. The new aggressive and expansive impulse of Iran under the Sassanids resulted in the conquest of a great deal of western Central Asia and, consequently, in the propagation of the Sassanian culture, particularly evident in some manifestations. For all this deep and extensive diffusion, however, it is also possible that the influence of Central Asia spread into Iran by a reverse phenomenon of no lesser extent, which may have conditioned the artistic evolution of the Sassa-

nian period, especially in the minor arts. On the other hand, it is certain that in the areas disputed by India and Iran, where Central Asian influence reached, there originated a special figural trend that might be called 'Irano-Buddhist.' Aside from an isolated occurrence at Dukhtar-i-Nushiwar, where some painters of Buddhist tradition treated, perhaps for the first time, secular subjects to honor a local prince, evidence of this tendency to follow Iranian styles is to be found in some works of nearby Bamiyan. A large caravan and religious center famous to this day for its colossal statues of the Buddha (see fig. 171), Bamiyan shows a remarkable variety of contemporaneous styles. Undoubtedly because of the proximity of the Sassanian realm and, generally speaking, of the location and economic importance of the city, some of its images are decidedly Sassanian in style. Others, however, have the schematic frontal view of the 'anti-Classical' images of the school of Gandhara and recall the Byzantine creations, while small groups of paintings and especially of sculptures are Indian in character. It cannot be ruled out that Bamiyan also responded to the tendencies that were to prevail in Balalik Tepe, as its few works in the Iranian manner seem to show. Unfortunately, the date of Balalik Tepe, generally believed to be about the fifth or sixth century of our era, is uncertain—it may be earlier or

169. Harp player. Probably
Indra's messenger in the episode
of the visit of the king of gods to
the Buddha meditating in the
cavern of Indrasala. Fragment of
a mural painting, perhaps from
Balawaste, seventh century A.D.
National Museum, New Delhi
The image is a local interpretation
of the Indian schemes found in the
paintings of Ajanta, with the ad-
dition of iconographic elements of
the northern schools.

170. Head of a Bodhisattva in an
almond-shaped nimbus bordered
with plantlike, or phytomorphic,
motifs. Fragment of a mural
painting. From Kara Khoja, on
the site of the old Idikut-shehri,
the Uigur capital, ninth century
A.D. National Museum, New Delhi
The Bodhisattva, with strongly
Sinified face, but with eyes that
recall the stylizations of the images
more closely related to the Indian
Gupta production and to that of
the northwestern schools, is un-
questionably one of the finest
pictorial decorative works of the
Turfan region.

later. If it is earlier, the murals uncovered in the only frescoed room
of the castle there would have been reflected in a stylistic tendency in
Bamiyan. This is an extremely interesting possibility, especially since
the pictorial style of Balalik Tepe is original, though comparable in
some respects with the Sassanian figural tendencies and those of Kucha
and Tumshuk and is, furthermore, unaffected by the Indian influence.
All the other cities of western Turkistan, instead, display iconographic
and stylistic reminiscences of India.

Bamiyan constitutes a problem of fundamental importance for various
reasons. The city flowered in the fourth century at the time when, after
the accession of the Guptas, the influence of India was diffusing with
greater force than ever. It had the typical cosmopolitan aspect of
caravan towns, which is reflected also in the artistic activity. In fact,
Bamiyan was the seat of a great school of painting in which it is said
that Mani, the founder of Manichaeism, had his training as a miniature
painter. At the same time, because of the religious importance of this
center, located on a vital crossroad of the silk route, Buddhist artists of
different origins and schools assembled there. Some must have been
priests, some itinerant artists who offered their services to the large
communities. This objective situation alone can account for the variety
of the tendencies and the coexistence of different styles, which, in turn,
show that, after the Gandharan expansion, the Indian influence often
met and fused with Iranian and originally Central Asian currents,
giving rise to other tendencies and currents that can be called 'Indo-
Iranian' or—to use the terminology of the French school of archaeolo-
gy—'Sassano-Gupta.'

What counts is that the Indian component, constantly tied to Buddhist
symbolism and iconography, always remained vital, though it varied in
time, acquiring different values in different places. The appearance of the
Gupta style—uniform in its variety—started a period of extraordinary
equilibrium in the evolution of art in India; it is therefore only logical
that this time of splendor should leave most conspicuous traces on the
evolution of art in Central Asia also. In its western area, however, the
Indian reminiscences are shallow and mostly iconographic. Though
undeniably apparent, they do not pervade the works. Among the
wooden caryatids of Pendzikent, which were carbonized in a fire at the

171

171. *The colossal Buddha of Bamiyan (approximately 175 feet tall). Fourth or fifth century* A.D. *National Museum, New Delhi This enormous, rock-carved statue, though damaged by Muslim artillery, still shows signs of being stylistically derived from Buddhas of the Gandharan, Mathuran, and archaic Gupta styles.*

172. *King Naga coming out of the water. Fragmentary polychrome stucco group. From Fondukistan, seventh century* A.D. *Archaeological Museum, Kabul*
What is left of this image, which presumably represents the King of Snakes, is exceptionally beautiful and elegant, not only because of the elongated figure and its anatomical accuracy but also because of the sinuous attitude of the body and the enigmatic *expression of the face. The work of Fondukistan, consisting of Central Asian and post-Gupta Indian elements, is hard to evaluate, for it has completely lost its polychromy, especially in the faces. The way we know it, it suits the modern Western European taste and is, thererefore, easily appreciated.*

172

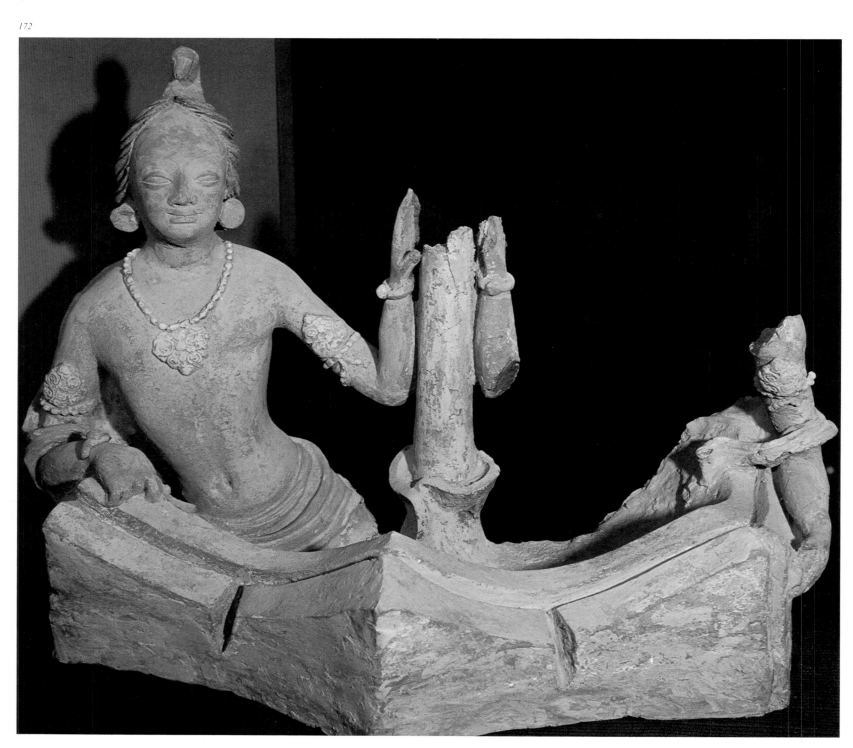

castle and are therefore still extant, there is indeed at least one clearly reminiscent of post-Gupta Indian sculpture and, furthermore, adorned with clothes and jewelry of Indian taste and make. Also among the murals of Pendzikent there are types and figures that can be traced back to the traditional Indian iconography. We do not know whether they include Buddhist subjects, but it is possible that some of the compositions in the later style are particular iconographic renditions of the Buddha's Jataka. In any case, in a group showing two players one of the figures is manifestly a descendant of the typical Gandharan ascetic and the other is a king with wings of flame at the shoulders. This symbol of legitimate royalty was used by the Kushans; it was a sign of one of the Buddha's most famous miracles and, in Gandharan art, was always the symbol of Dipamkara, one of the Buddhas of the past associated with light and flame. The Gupta influence was responsible for the pursuit of pictorial relief in the first phase of the Kucha production, and the Kuchean palette reechoes the favorite chromatic consonances of the painters of the caves of Ajanta of the same period. In sculpture the reminiscences of the art of Gandhara do not vanish but fade somewhat as an effect of the Gupta influence, especially in the images of Buddhas and Bodhisattvas. In other cases, when the figures represent typical, ethnic, or class characters, the Gandharan echo, though modified, is more evident. Perhaps this persistence is partly the consequence of using the same materials and techniques—a necessity that conditioned the sculptural production of the whole of Central Asia, including Chorasmia under the 'Great Shahs.' The Indian diffusion, however, only occasionally influenced style. Rather, it is the wealth of compositional solutions and iconographic materials together with the strictly logical, sometimes even magical, symbols that testifies to the magnitude of the Indian influence, which persisted also in the post-Gupta period, as is evident in the region of Khotan where there is an abundance of figures associated with the Tantric mystical current (see figs. 176 and 177). The Khotan figural production was patterned on the styles of the Pala and Sena dynasties transmitted through the large Buddhist universities, for example, that of Nalanda. In the heritage of Khotan, however, again there looms the Graeco-Buddhist influence, particularly noticeable in architecture. Suggestions of the Gupta style show especially in the stucco figures, in their oval faces, and in the treatment of the drapery. Yotkan, which also belongs in the region of Khotan, seems, instead, to have been more exposed to the influence from the north, namely, from Sogdiana and Chorasmia. The colossal Buddhas of Ravak may have been inspired by the figural structures of Bamiyan; all in all, however, in none of the art centers of Khotan is there to be found a real prevalence of purely Indian elements. Iranian, local or imported Central Asian, Chinese-derived, and originally Chinese elements, all stemmed the Indian influence, which continued to prevail, instead, where proportions were not involved in symbolism and iconography.

Farther east the problem of the Indian component is more complicated. Though its history is not dissimilar from that of Kucha, the Turfan area shows a completely different set of artistic phenomena (see figs. 168 and 174–176). Three circumstances were responsible for the difference. First of all, the Chinese influence was stronger there than elsewhere because Turfan was the main cultural center of the Sinified Uigur Turks. Then there were its proximity to the territory of China proper and, last, the prolonged survival of Buddhism and of the active figural production associated with it. Even here, however, there are considerable traces of the Indian component, so that René Grousset detected in some minor figures of Sengim-agiz "the most felicitous synthesis of Indian supple-

173. Figure of a seated Bodhisattva Maitreya. Polychromed stucco mixed with earth. From Fondukistan, seventh century A.D. Archaeological Museum, Kabul
The elegant, blithe figurine with its thick hair and serene face is a marvelous example of the expressive ability of the Fondukistan school, which was capable of reelaborating the teachings of the most varied currents through clever stylization. Note the ease *and movement in this position of rest, which in Buddhist iconography is called labitasana. The Fondukistan school excelled in the rendering of movement.*

173

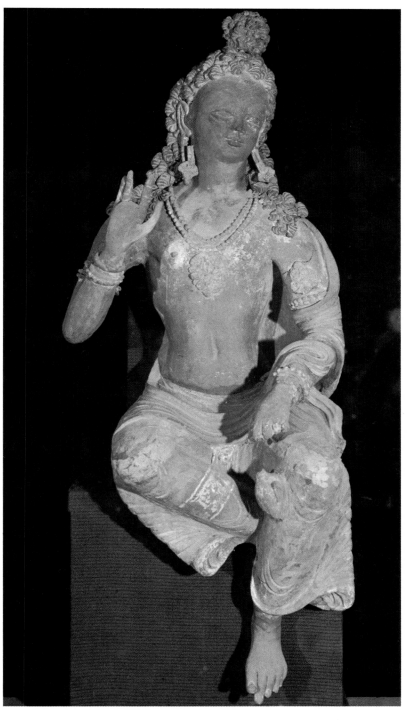

174. *Head of a Buddha. Fragment of a mural painting from the region of Turfan, eighth century* A.D. *National Museum, New Delhi*
Executed in the technique of the double line, it shows the strong Sinification that suited the taste of the Uigurs. However, the proportions of the face and the thin moustaches are typically Indian (also of the Pala schools) and characteristic of northwestern work.

175. *Head of a deva or Bodhisattva. Fragment of a mural painting from the region of Turfan, eighth century* A.D. *National Museum, New Delhi*
The single-line drawing makes this image especially Chinese-looking. Note the folds of the neck and the flylike motif under the lower lip.

174

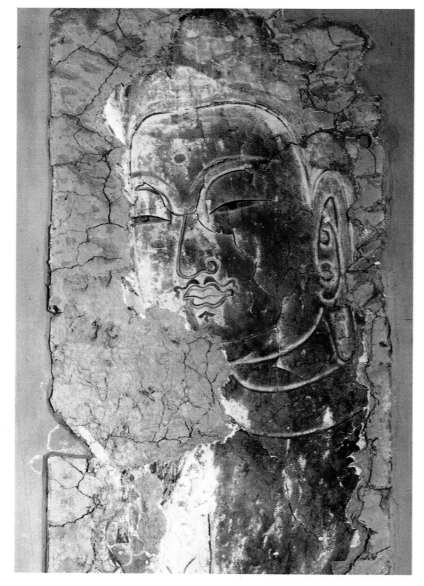

175

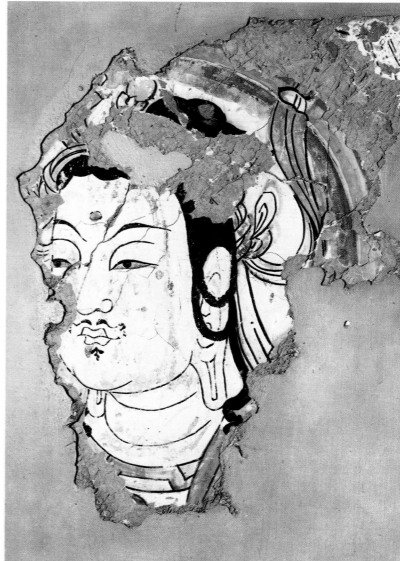

176. *Head of a Bodhisattva. Fragment of a painting. From the region of Turfan, eighth or perhaps ninth century* A.D. *National Museum, New Delhi The heavy lower part of the face and the slanted eyes reveal a pronounced Chinese influence. The unusual attitude and the flamelike urna between the brows are proof that the image belongs to a mystical trend, Tantrism.*

177. Terrifying divinity. Fragment of a four-armed dakini. From Bezeklik, eighth or perhaps ninth century A.D. National Museum, New Delhi
A Tantric divinity with floral forms on her face and three heads (one is damaged and is hardly visible above the headdress of the main head). The two well-preserved right hands hold, respectively, the skull and the knife (khadga) for blood sacrifices. The remaining left hand rests on the hip; the lost left hand held a cord for strangling the victims. This fragment belongs to a frieze in which floral and fluttering scarflike motifs filled the space between the figures. It is connected with a Saivite-influenced Tantric current derived from the cult of Kali.

177

ness, Hellenistic elegance, and Chinese gracefulness." Some images of the Turfan area are decidedly Indian, especially those of Buddhas or Bodhisattvas (see figs. 168 and 174). Though rare and, in a sense, isolated, they indicate an iconographic tradition that could not be fully asserted but left its imprint on figures in which the exotic and religious character of Indian images reflects the world and ambience in which the Buddha's word was preached. It must also be noted that the Sinified Turfan images of Buddhas and Bodhisattvas—though rendered in a markedly Chinese manner—also reflect a faint Indian component that reached there, as a backlash, through Chinese art (see figs. 168 and 174–176). For Chinese iconography appropriated the Indian creations, adapted, modified, and transformed them, but often reveals to a trained eye the images that are of Graeco-Buddhist origin and those that are inspired by the school of Mathura or by Gupta work.

In conclusion, Indian art left a conspicuous trace in the whole of Central Asia—deeper and more continuous in the eastern area (especially in Kucha), less extensive but not negligible in its western part from Sogdiana to Chorasmia. Furthermore, the artistic background of Central Asia was mainly Graeco-Buddhist and had been originated by the acceptance and expansion of Buddhism even in those lands that lacked the appropriate social and economic structures to appreciate the full purport of the original innovatory spirit, but had, nevertheless, adopted it for its metaphysical implications arising from the encounter with other religious currents.

Despite the backlash from China, which affected the more Sinified regions of Central Asia, India exercised its influence on the whole Buddhist world. Even in China, Korea, and Japan the Indian influence from Central Asia is recognizable in iconography, iconology, and composition, as well as in lesser figural conventions concerning landscape and minor details.

We are not in a position to know the extent and nature of the Indian component in the production of the great Khotan painters active in China between the end of the Sui dynasty and the beginning of the Tang epoch. One of the two Wei-ch'ih painters, Po-chih-na, known as Wei-ch'ih the elder, was famous for his imaginative Buddhist paintings, whereas the other, I-seng, was a specialist in murals, flower paintings, exotic images, and also Buddhist figures. It is well established, however, that Khotan painting influenced the school of Tibet in its formative stage and perhaps also that of Kashmir. But its contribution in Tibet, despite the Indian component in the art of Khotan, was by no means the main source of Indian influence, for the Khotanese school had a definite character of its own. In this instance there is no question of multiple contributions but of a definite Central Asian influence. Central Asia also inspired the works of Fondukistan in Afghanistan (see figs. 172 and 173) and, in many respects, even Islamic art.

9. Indian Influence in Southeast Asia

by Mario Bussagli

The expansion of Indian civilization over the lands of so-called Farther India—including the whole of southeastern Asia from Burma to Vietnam and from Malaya to insular India—is an important cultural phenomenon from many aspects, notably for having raised peoples ethnically and culturally very different from one another to a high level of civilization. In the field of the figurative arts the consequences of this phenomenon are deep and vast. In the process of becoming adapted to the taste of foreign populations living in very different areas, the Indian influence gave rise to entirely new artistic currents, schools, stylistic trends, and experiences rich in implications and potential developments. Thus were originated great works of art capable of standing comparison in both quality and expressiveness with the best creations of the Indian genius. The encounter of this rich and mature figural civilization with the fresh imagination of fast-ascending peoples understandably produced a vast range of iconographic and stylistic phenomena. In some cases, changes, adaptations, and a different approach caused a minor architectural detail to become a major structural feature; in other instances, a decorative motif of India's imaginative sculptors became a recurrent and differentiating element. Later, the encounter of the Indian and the Chinese approaches to aesthetics originated another set of complex figural phenomena, different from those which occurred in Central Asia but no less rich and important.

The geographical area of Farther India is, as has already been said, vast and consequently inhabited by a variety of populations which for historical or environmental reasons reacted in diverse ways to the diffusion of Indian culture, however deeply felt. The element in common lies in the fact that everywhere this cultural influence prevailed absolutely. In fact, some specialists maintain that the masterpieces of the Indian artistic genius are to be found in this 'Magna India'—to use a designation favored by scholars and obviously copied from 'Magna Graecia,' which, if for no other merit, is commendable for the emphasis it lays on the extent and depth of the Indian contribution. Because of a different social and historical evolution from that of Magna Graecia, however, the Indian acculturation of southeastern Asia was not limited to a mere parallel development of forms and styles. Once rooted, it activated innovatory currents, which, without denying their origin, ran their own courses with styles and attitudes of taste quite unlike those of the large peninsula. Yet the spread of Indian culture in those lands was the result neither of a definite policy nor, by any means, of armed conquest. It was, instead, a rare instance in human history of pacific colonization springing from sporadic immigration. Trade no doubt acted as an important spur to this migratory movement and India's superiority in the fields of medicine and religious speculation made the settlers welcome to the local populations. Indeed, this random penetration and the subsequent fusion between the immigrants and the natives, which gave rise to

the so-called Indianized States of southeastern Asia, generally produced effects more useful to the indigenous populations than to the bearers of the Indian culture. The systematic exploitation of the immense and until then unused local riches made possible by Indian knowledge and techniques became essential to the economic equilibrium of the Eastern world. As for the religious aspect of the Indian diffusion, in time common spiritual values established a basis for continued exchange between India proper and Farther India. Mutual understanding was immensely facilitated and, since Indian art was preeminently religious—being the reflection of a world in which opposition between the secular and the spiritual was nonexistent—the religious diffusion encouraged the diffusion of the Indian figural arts.

It should be noted at this point that the area of southeastern Asia influenced by Indian culture can be divided into two sections. The section consisting of 'Insulinde' (modern Indonesia) and the southern Malay Peninsula was open only to the cultural influence that came by sea. The rest of the area lay open to influences that, instead, came overland via Assam, a region that both geographically and culturally belongs to the Indian subcontinent. The diffusion that came over the better-known and more frequented sea routes, however, was equally powerful. After asserting itself in the port towns and their immediate surroundings, it penetrated inland by a slow process of expansion connected with historical events in the 'Indianized States.' The background onto which Indian culture was grafted was not a void. Throughout southeastern Asia, including insular India, there had developed for a long time different cultures emanating from the direction of China. The local bronze cultures reflect those of Ordos and northwestern China, in turn no doubt related to the Eurasian continental evolution, which thus descended south all the way to the heart of the Indonesian archipelago. Other aspects suggest contacts or relationships—or perhaps mere evolutional analogies—with the insular regions of the Far East. The characteristic bronze bells of Cambodia, Tonkin, the local cultural area of Dong-so'n, and even of Malaya may easily be related to the Japanese *dotaku*, despite the different decoration. In any case, it is an unquestionable fact that, even though its evolution appears to have lagged behind that of the originating areas, the cultural background of the zone that concerns us depended, before the success of Indian culture, on a series of influences coming from China and Ordos.

As for Indian religious expansion, apart from the occasion on which the Emperor Asoka sent two Buddhist priests to the 'land of gold' (Suvarnabhumi; perhaps the Burmese region of Mon), the first known state to turn Hindu was that which Chinese sources call Funan. Centered on the lower course of the Mekong in the third century of our era, Funan was already on diplomatic terms with China and remained until the middle of the sixth century the protagonist of Indochinese history. Another

state, Lin-yi, consisting perhaps of barbarian groups of Cham stock, suddenly came into existence in A.D. 192 as an effect of a rebellion against—or, better, by an act of independence from—the Chinese empire of the Han dynasty. Lin-yi sprang from the courage of a local imperial official who, having grown tired of serving a foreign dynasty, rebelled and proclaimed himself an independent sovereign. In the Indonesian Archipelago, Kalinga (Chinese, Ho-ling), an Indianized state, was named after the Indian region of the same name, perhaps as a consequence of the migratory movement from East India. The process of Indianization shows, however, in the mass conversions, rather than in the forming of these states. The desultory Chinese expansion produced limited effects in the field of culture, whereas the Indian religious penetration was continuous and lasting. While Sinified groups in Vietnam tended to break away from China in their pursuit of independence, on the ruins of Funan there developed the first Khmer kingdom, with a marked tendency toward Indianization. It was the time when the Mon and the Pyu (the latter of Tibetan-Burmese stock) embraced the Buddhist Law. The Mon became followers of the Theravadin sect; the Pyu accepted

Tantric Buddhism. In Indonesia governmental structures based on the Indian concept of regality, on adherence to the *Dharmasastra* (the treatises of religious and social law), and on the use of Sanskrit as the liturgical as well as the official language triumphed. The spread of Sanskrit, a sophisticated language rich in vocabulary and particularly suitable for expressing philosophical and abstract concepts, brought about a quick transformation in the abilities of the people of Farther India to think and express themselves verbally, a change somewhat similar to that which was to take place in the field of the figural arts. In fact, the two processes of evolution—or, if you prefer, of transformation—ran parallel courses, at least in terms of the expressive ability of the Southeast Asian people in religious figuration and religious literature.

Unfortunately, we are not in a position to follow the artistic evolution of Farther India from earlier than the end of the sixth century of our era. At that time durable materials instead of perishable wood came into use, thus enabling us now to observe the evolution of architecture and of the ornamentation applied to structures, and revealing an interesting decorative taste, as well as the general lines along which ornamen-

178

178. *Apsaras with her maidservant. Fragment of a mural painting. From Sigiriya (Ceylon), end of the fifth century* A.D. *(479–97). National Museum, Colombo*
In the mural painting from Sigiriya the effects of the Ajanta style can be felt, but reelaborated in the Ceylonese manner. The palette is different; moreover, the images are detached from each other and 'immersed' in a space which has nothing to do with the psychological perspective and the thickly peopled compositions of continental India. For this reason the two figures reproduced here are portrayed in profile and three-quarter face, respectively. The features of the faces also are different from those of the main Indian tradition.

179. *The Bodhisattva Avalokite-svara. Stone sculpture standing out from a frame in the form of a niche, placed as an ornament on the left side of the stairway of Lankatilaka, one of the buildings of the Jetavana Monastery, Polonnaruva (Ceylon). Twelfth century* A.D.
In spite of the delicacy of the modeling and the suppleness of the pose, of continental origin, this clearly Ceylonese image is a classical product of a culture which is peripheral but not provincial in a disparaging sense.

180. *The king Parakramabahu I. Colossal statue carved in rock at Potgul Vehera, near Polonnaruva. Twelfth century* A.D.

The image shows an attempt at the portrayal of individuality, and can certainly be said to represent the 'regal' aspect of the sovereign, since he is holding in his hands the yoke which is the symbol of regal power. The grave majesty of the image confirms the belief that it was sculpted to exalt the sovereign not as a man but as a being invested with more than human dignity.

181. *The Parinirvana (the death of the Buddha). Detail of the so-called Gal Vihara near Polonnaruva. The work was commissioned by King Parakramabahu in the twelfth century* A.D.

The colossal figure lying on its right side is typically Ceylonese in the treatment of the face and the muscle masses of the body. The drapery, which is highly stylized and does not correspond to the realistic elements, recalls the solutions adopted at Bamiyan and in the Gupta school.

182. *Loro Jongrang, Prambanam
(Java). Eighth century* A.D.

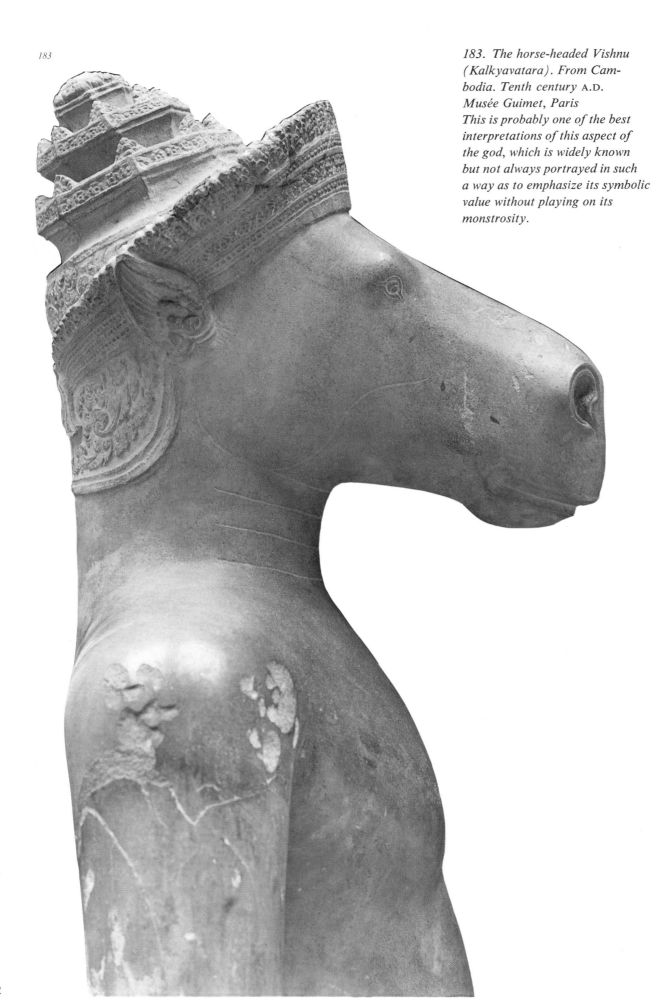

183

183. The horse-headed Vishnu (Kalkyavatara). From Cambodia. Tenth century A.D. Musée Guimet, Paris
This is probably one of the best interpretations of this aspect of the god, which is widely known but not always portrayed in such a way as to emphasize its symbolic value without playing on its monstrosity.

184. Apsaras. Bronze. Khmer, twelfth century A.D. Musée Guimet, Paris
This heavenly nymph is represented in a dance position, portrayed in a dynamic but rigid manner. The face is almost monstrous (as if it were covered by a mask), to indicate that the nymph belongs to a superhuman world. The diadem in the form of a crown connects her with sacred and royal values. All traces of Indian tradition, except in the gestures and dance movements, have been attenuated almost to the point of disappearance.

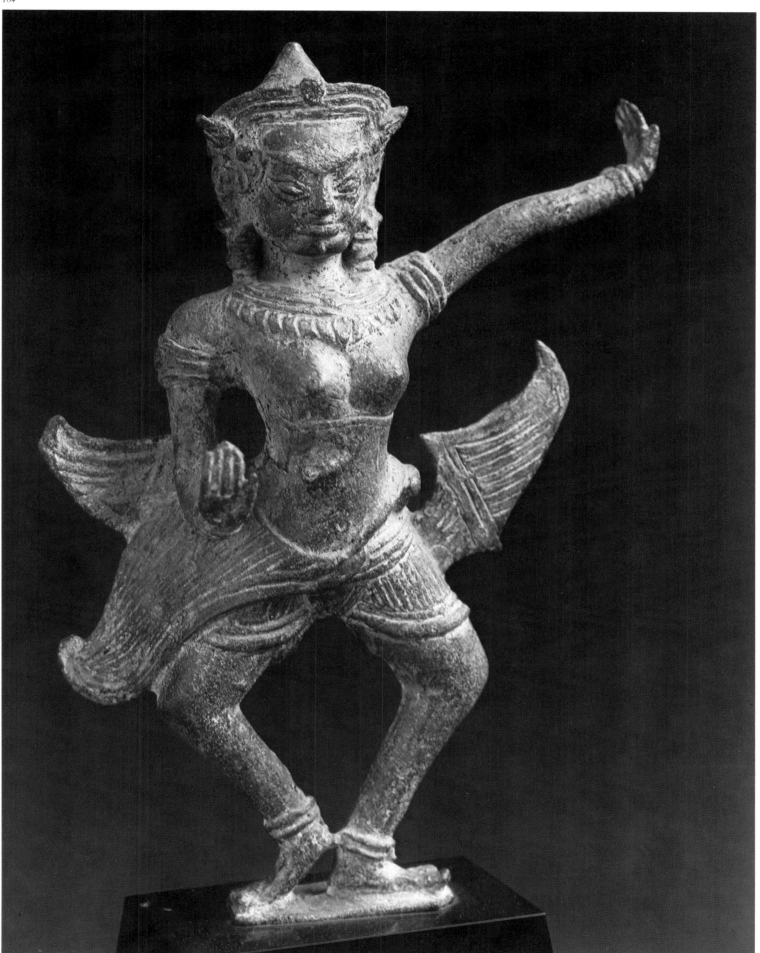

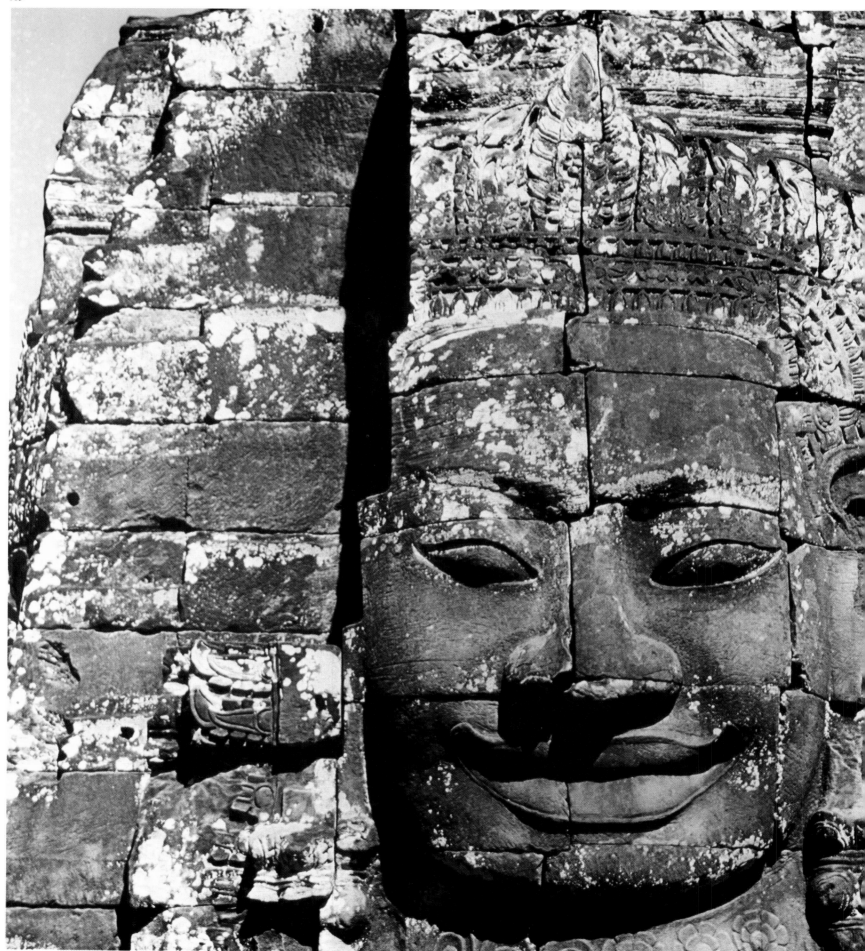

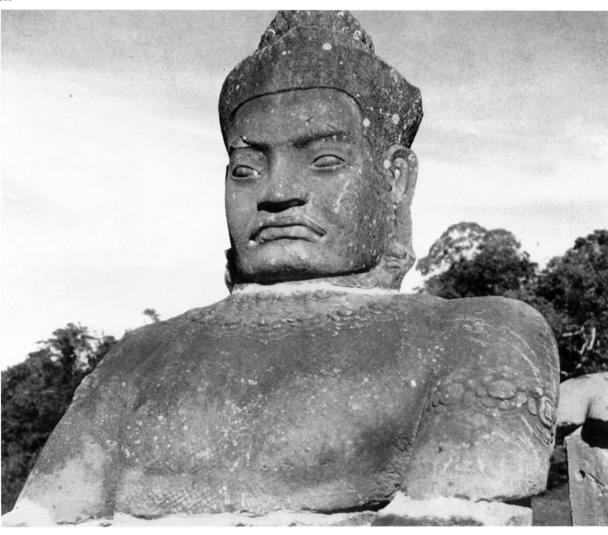

185. One of the faces of the
towers with human faces in the
Bayon of Angkor Thom (Cam-
bodia). Twelfth century A.D.
Enormous faces such as these,
repeated in the four cardinal
directions, appeared on the towers
which overlook the approaches to
the city and on those of the temples
of the Bayon and of Banteay
Chmar. They probably represent
divine royalty in its aspect of
Bodhisattva Lokesvara, that is,
of the most compassionate being
imagined by Buddhist thought.
They signify that the royal pro-
tection extended its authority and
its farseeing beneficence over the
whole of the kingdom. The Khmer
conception of royalty is clearly of
Indian derivation.

186. One of the colossal statues
which flank the Avenue of Victory
at Angkor Thom. First half of the
twelfth century A.D.
These statues are important from
the iconographical and historical
points of view on account of the
effort made in them to obtain an
impression of massiveness and
power without departing from
reality, that is, without excessive
stylization. There can be no
doubt that these figures, which
represent Nagas, portray im-
pressively the demonic force of
the protectors of the earth and the
waters.

187. *An army on the march. Detail of a panel at Angkor Thom. Datable between the middle of the twelfth and the beginning of the thirteenth century* A.D.
The style is that of the Bayon, and the bas-relief, which shows no sign of the flattening typical of Angkor Vat, is closer in form to the narrative scenes of ancient India. The crowded images, the rhythm of the dance, the excited but elegant movements of the figures, *make this a work of considerable artistic value.*

tal sculpture developed. From the previous epoch, however, there remain archaeological traces testifying to the existence and vastness of the contacts with India and even with the Roman West. What matters to us, in any case, is the knowledge that in the second century of our era bronze cult statues were already being exported from India to southeastern Asia. This is proved by the Buddha of Dong-duong, which belongs to the Indian school of Amaravati, as well as by a great many other bronze statues, some of which were found even beyond the borders of the more intensely Indianized areas. The place where the Buddha was found belonged to the kingdom of Lin-yi and was called Amaravati owing to a toponymic transposition which can probably be accounted for by the brisk trade existing between this area and the Indian artistic and religious center of the same name. Starting in the sixth century, when Gupta art was still blooming in India, the figural evolution of

187

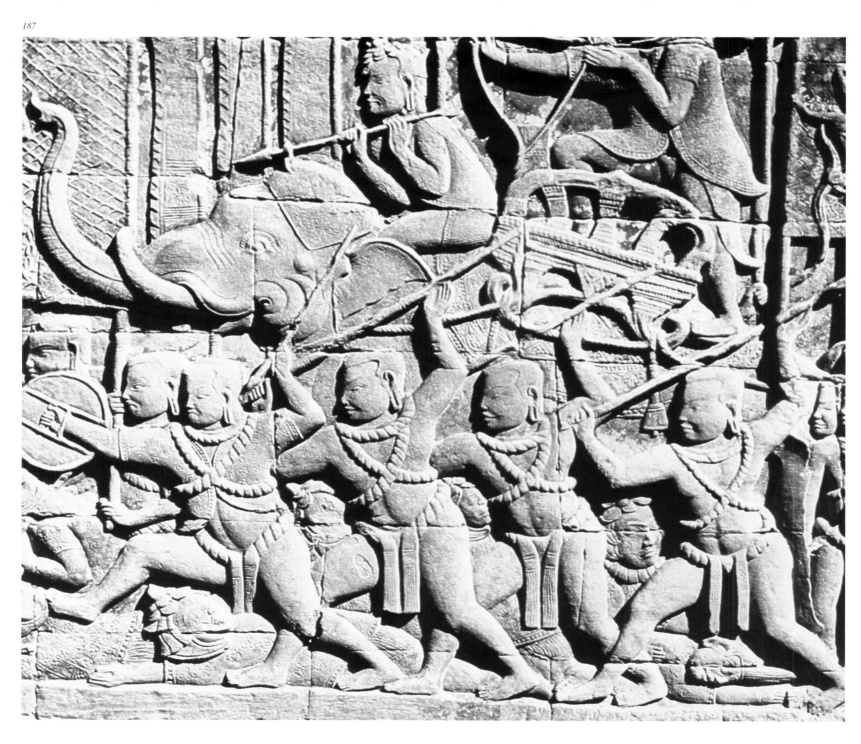

Farther India can be followed with a certain amount of precision in all its various phases. This is a period of which it can be said that the Gupta current had a real colonial expansion (with the understanding that the word 'colonial' has no derogatory implication, but merely hints at the limited allowances made to the local taste). At the same time, it must be noted that, while the eastward Indian figural diffusion came from the whole of the east coast of India, the chief sources were the south-central and southern regions. This preponderance probably had different causes, including the facilities and locations of certain southern ports; however, in view of the fact that the Gupta style did not develop uniformly throughout India, it is not impossible that it was also the result of preference, if not downright choice, for the figural production of the south-central regions. In any event, the stylistic differentiation of the various schools of Farther India unquestionably came later.

188. *Elephant. Detail of the decoration of the Terrace of the Elephants at Angkor Thom. Thirteenth century* A.D.
The terrace, which lies to the east of the royal palace of Angkor Thom, is adorned with bas-reliefs representing scenes from the working life of elephants. Indian interest in the life of animals is reflected, with the same religious basis, in Khmer art.

188

167

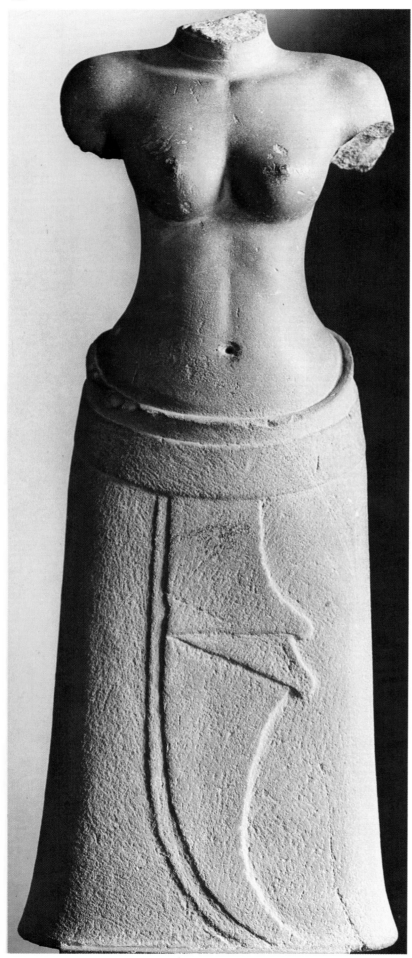

189. *Female figure of stone; head and arms lost. Datable at the end of the twelfth century* A.D. *Musée Guimet, Paris*
This statue, in spite of its poor state of preservation, is remarkably expressive and powerful, thanks to the contrast between the rigidity of the drapery and the sensuality of the nude torso, which obeys in part the Indian laws of female beauty, though revised according to Khmer mentality and taste.

190. *Head of a Prajnaparamita from the Bayon, II/III phase, twelfth–thirteenth century* A.D. *Musée Guimet, Paris*
The almost completely closed eyes, the slight smile, and the treatment of the hair suggest a probable date at the beginning of the thirteenth century. The image of the Bodhisattva on the cranial protuberance, or ushnisha, should be noted.

One of the mainsprings of the Indian figural expansion was the island of Ceylon, which belonged to the cultural world of Buddhism and shows an independent evolution that, however, resembles very closely that of the peninsula. Characteristic monuments and original forms are not lacking (see figs. 178–181), but their origin can often be traced back to the continent. Converted to Buddhism since the middle of the third century B.C., Ceylon developed its Buddhist art more or less from the beginning of our era. Its stupas, called dagobas by the Singhalese, differ from the Indian examples in both their gigantic size and their characteristic bell shape. The almost hemispherical dome resting on three downward-sloping circular drums like superimposed rings and with a pointed top suggests the bell shape that was to be fully developed in the stupas of the upper terraces of Borobudur, the large Javanese Buddhist complex. This type of bell-shaped structure, however, is not limited to Indonesia. In Thai (Siamese) art it was preserved until the time of that art's incipient decadence. Other incidental details, such as large staircases and lines of elephants half-emerging from the base walls of stupas or from the top drums of the larger examples, also became favorite features with the world of Farther India (see fig. 188). The Ceylonese production of sculptural bronzes has left no notable traces, especially since it conformed to a taste which showed hardly any difference from that of India itself. At the time of maximum activity, the predominant figural trend in Ceylon very closely resembled the Pala currents.

As to the entire territorial expanse of Farther India, it can be stated that, apart from the Ceylonese components, the Indian influence always became manifest and survived not only in the conception and structure of the Buddhist stupa but also in the sanctuary towers, which underwent independent evolution and transformations. For example, urged by a sense of order and symmetry which they needed to express supernatural values, the Khmer architects tended to transform and emphasize the *prasat* (the local name of the tower) into a prominent architectural feature to satisfy the requirements of religious syncretism. During the last Khmer phase—that is, under the reign of the Khmer king Jayavarman VII (1181–1218)—because of new symbolic values, the *prasat* acquired a most unusual shape, and huge human faces with royal crowns made their appearance in the superstructures of the towers. Facing the cardinal points, these faces, enlivened by enigmatic smiles, represented the king as the Bodhisattva Lokesvara, the symbol of universal compassion. Consequently, they expressed the protective power of the sovereign and his benevolence, extending in all directions, toward the kingdom over which he ruled. Variants of this architectural structure (practically turned into a gigantic piece of sculpture fragmented into panels so as to afford a frontal view of the face on all sides) are to be found in the

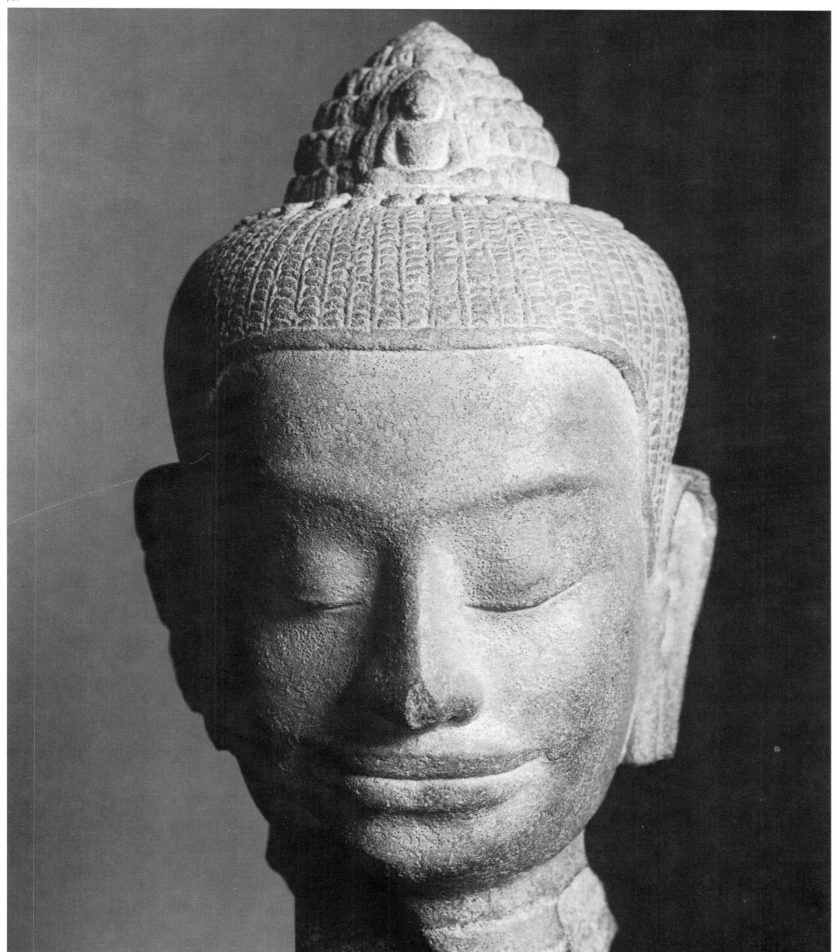

temple of the Bayon (see fig. 185) and on the gates of Angkor Thom. This sculptural value given to an architectural structure is fundamentally a consequence of the lack of interior space in the towers, as is apparent also from similar buildings in India.

Other elements of obviously Indian derivation are the widely used corbeled vaults, the choice of subjects, postures, and gestures of the images (derived from the traditional Indian symbolism connected with the attitudes of the dance and the yoga technique), and the attributes of the divinities, which are understandably those of the traditional Indian iconography. Along with the great gods, there also passed into the world of Farther India the immense host of supernatural and semidivine beings and the 'vehicles' and paraphernalia of the gods and the celestial or demonical mythical beings, the gandharvas and the Apsarases, the ganas and the Asuras, in more or less the same forms that had been created by the imagination of Indian artists. The fact that the Indian figural diffusion came largely as a consequence of the religious expansion accounts, as was previously noted, for the recurrence throughout southeastern Asia of the same symbolic and iconographic motifs as were originally connected with identical religious subjects and beings in India. Yet, despite the rigid iconographic and iconometric rules set forth in

191

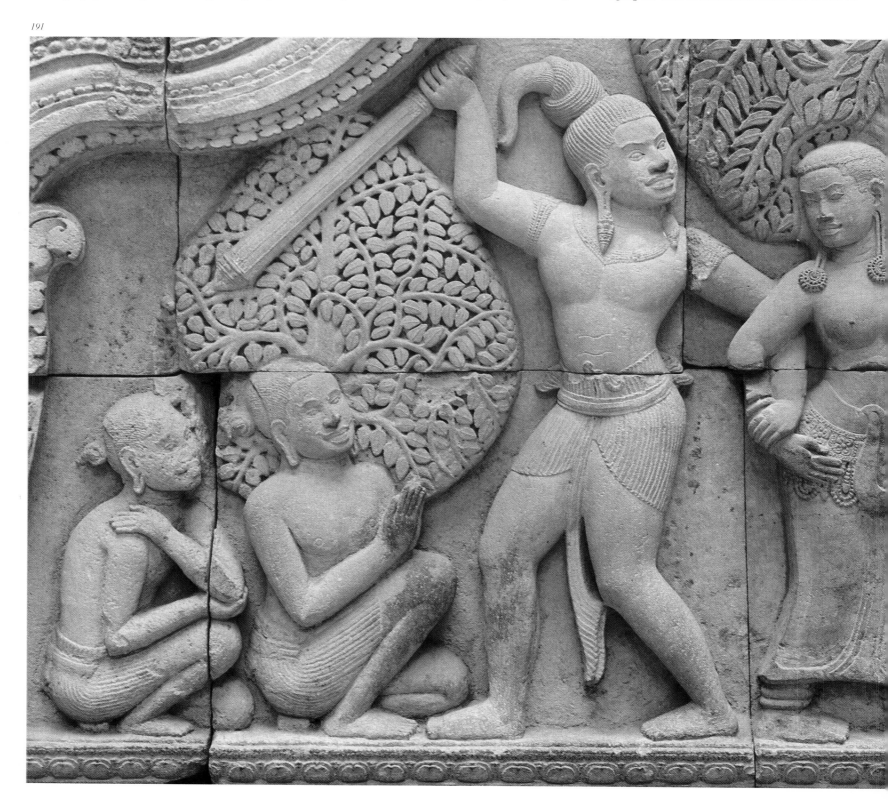

the Indian technical texts, the stylistic interpretation soon became transformed.

The credit for the blossoming of art in Java goes to the realm of Srivijaya, a kingdom whose principal center was located near Palambang on Sumatra, but which exercised hegemony as far out as central Java and even the continent. The Srivijaya phase was one of preparation (see fig. 200); the subsequent phase of the Sailendras (a Buddhist dynasty ruling from the center of the island) was a time of achievement, so much so that the early period of the Indonesian artistic evolution, extending from the seventh century to the middle of the ninth century of our era (or perhaps even to the beginning of the tenth century) is known as Indo-Javanese or Central Javanese. Forms borrowed from India predominate, but are treated with especial sweetness and harmony. The temples bear great similarities to the minor ones of Mahabalipuram. The stupas, however, were already bell-shaped, and balustraded staircases were important elements at this time. In the human figure, though attenuated, the triple bend was preserved in all its suppleness. The canon of feminine beauty was the first to change (for obvious reasons), and the breasts and hips lost their heaviness as the figures became slenderer and more youthful. All in all, greater restraint and a better sense of balance

192

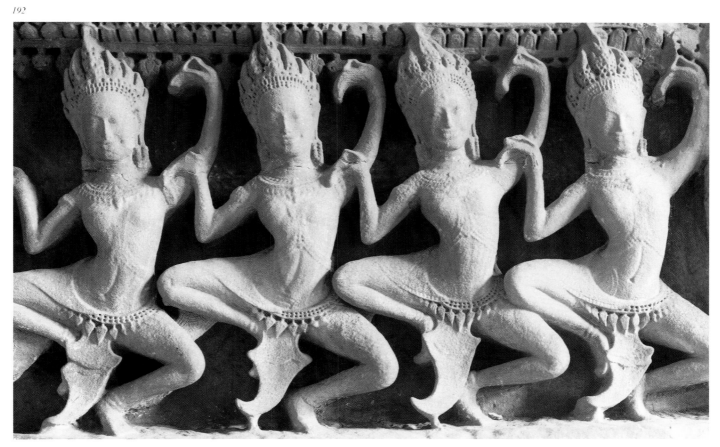

191. The beginning of the struggle between two Asuras (demonic beings). Detail from a fronton in the form of an acroterion from Banteay Srey. Datable between the tenth and the fourteenth century A.D. *Musée Guimet, Paris These Asuras were brothers who terrorized the world and whom even the gods could not conquer, but who killed each other for love of the nymph Tilottama, created by the gods themselves to sow discord between the demons. The legend is obviously Indian; the representation, both in style and in costume, is typically Khmer.*

192. Dancing Apsarases. Detail from a frieze with nine such figures, which was part of a fronton of the temple of the Bayon. End of the twelfth century A.D. *Musée Guimet, Paris The rhythm of the dance is expressed in a contained and subtle dynamism, derived from Indian tradition, but used according to Khmer vision.*

193. *The Buddha sitting on the coils of a Naga, which protects him with its seven-headed hood. The work belongs perhaps to a transitional style. Datable between the eleventh and the twelfth century* A.D. *Musée Guimet, Paris*

194. *The Buddha standing on a double lotus. Stone. From the Monastery of the Great Relic at LopBuri (Thailand). Dvaravati style, seventh–eighth century* A.D. *National Museum, Ayudhya The hands, now missing, were probably held in the gesture of certainty, or in the characteristic gesture which in Thailand indicates the decision of the Buddha to be born again for the last time (descent from the heaven of the Tushita gods).*

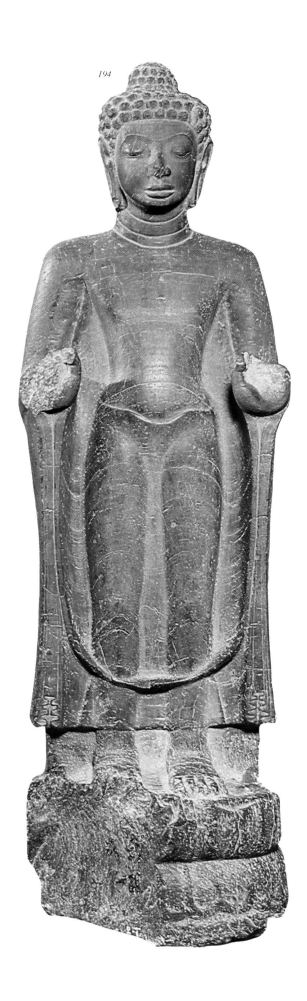

194

prevailed. In Java, the so-called kalamakara arch, a motif to be found also in Indian art, became a predominant element. The face of the monster looks out from the center of the arch, at the base of which—sometimes at the foot of the jambs—two fantastic sea monsters (makara) emit from the mouth or support on the back the decorated cornices that frame the opening. A typical instance of the passage to the fore (in aesthetic vision) of an originally secondary element.

Sculptural composition is very different from that of India because of a different sense of space. A classic example is provided by the sculptural decoration of Borobudur, a mountain stupa of really colossal size (it was built so as to cover a hill), where the narrative images are not only clear and well composed but bear notable suggestions of landscape and in some cases show intentional rhythms meant to emphasize the vehemence and violence of the movements in a manner absolutely alien to Indian art. It must be remembered that the complex of Borobudur includes at least thirteen hundred panels (each a complete subject) and a great many statues by different hands and of different schools (or, better, work-shops). Consequently, this tendency to lightness, clarity, and better-balanced rhythm was evidently a requirement of the local taste. Never-theless, despite a better sense of volume and roundness in the bodies and faces, the Buddha statues of the upper terraces are very close to the Indian taste of the Gupta period.

At Prambanam, in the instances where Hindu subjects from the same period prevail, the sculptures, mostly inspired by the *Ramayana* and the legend of Krishna, cover the inner surface of the balustrades delimiting the terraces. The compositions, thicker and less serene than the Buddhist ones, render the fantasies of India in a manner suited to the Javanese taste. Also at Prambanam are to be found attempts at rendering the landscape and sometimes the masses of fighting warriors, especially if the subjects are drawn from the *Ramayana*, and an interest in the animal world (also shared, however, by India). If Borobudur is the greatest monument of Mahayana Buddhism in Java, Loro Jongrang near Pram-banam is its Hindu counterpart (see fig. 182). At Loro Jongrang, six temples—of which the larger three are dedicated to Brahma, Siva, and Vishnu, respectively—stand within a square enclosed with gates at the four points of the compass and are further encircled by a triple row of shrines (156 in all), distributed so as to emphasize the square cross plan of the access ways to the central enclosure. The whole stands on a huge man-made platform. Here, aside from the apparent Khmer influence evidenced in the temple of Siva, dating from the end of the ninth or the beginning of the tenth century, the manifest teaching of India takes on a different aspect. It might seem as if the sculptors and, to a certain extent, the architects serving the Hindu religious currents enjoyed greater freedom than those serving the Buddhist current. The truth of the matter is, instead, that Buddhist thought, centered on man and therefore really universal, was true to itself even when it was translated into figural terms, and equalized taste more than other subjects could. Other Buddhist temples in the same place (sometimes consisting of hundreds of individual but close-lying buildings, as is the case with Candi Sewu) confirm this view. They do not appear very different from the Indian works even though their dating is as late as the end of the Indo-Javanese period.

The following phase, known as the Eastern Javanese, marks the end of the Sailendra period. In the tenth century a local sovereign, Airlangga, succeeded in unifying the whole island under his rule for a short time; however, for reasons that remain unclear, the central part of the island was gradually abandoned in favor of its eastern region. The Indian in-fluence is evidenced in the square or Greek-cross plan of the temples,

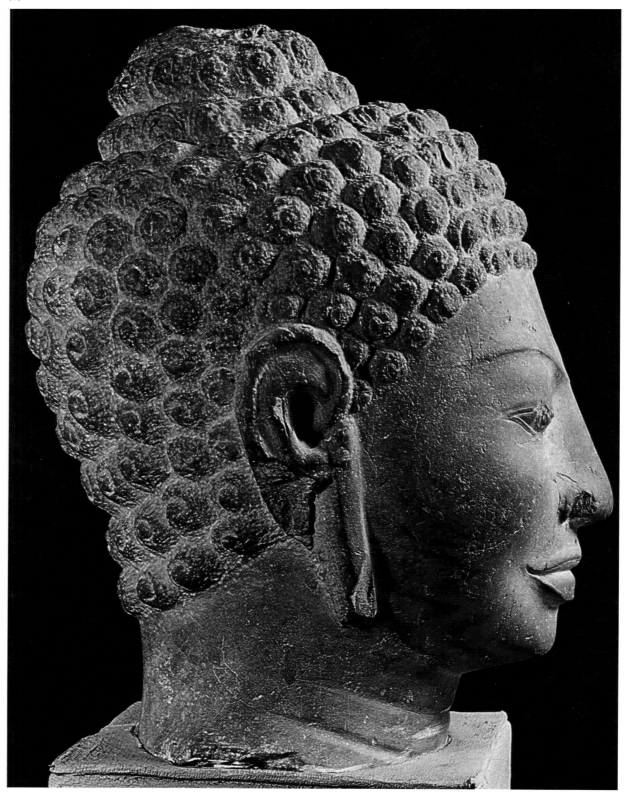

195. *Head of the Buddha. Sandstone. Datable about the eighth century* A.D. *National Museum, Bangkok*
This is one of the works which best express the essence of the Thai style called Dvaravati. The iris and pupil incised to give strength to the gaze, and the hair curled in a clockwise direction as at Mathura, should be noted.

196

197

196. *Head of a divinity. Stucco.*
Highly stylized in the Dvaravati
style in its decorative aspect.
Datable between the seventh and
the tenth century A.D. *National*
Museum, Nak'on Pathom
The remaining characteristic
earring, in the form of a triple
disk, confirms the attribution to
the style and iconography of
Dvaravati.

197. *The Buddha. Stone. From*
Vieng Sra (Thailand). Datable
between the eighth and the tenth
century A.D., *probably about the*
eighth century. National Museum,
Bangkok
The image has a characteristic
cylindrical headdress (mukuta)
and four arms, two of which are
broken off at the elbow. In the
two remaining hands are the at-
tributes characteristic of the god
(club and shell). The work is
either Dvaravati or possibly pre-
Angkorean in style. It is slightly
stiff in comparison with Indian
prototypes, and the anatomical
study is more complete and de-
tailed than it would have been in
India.

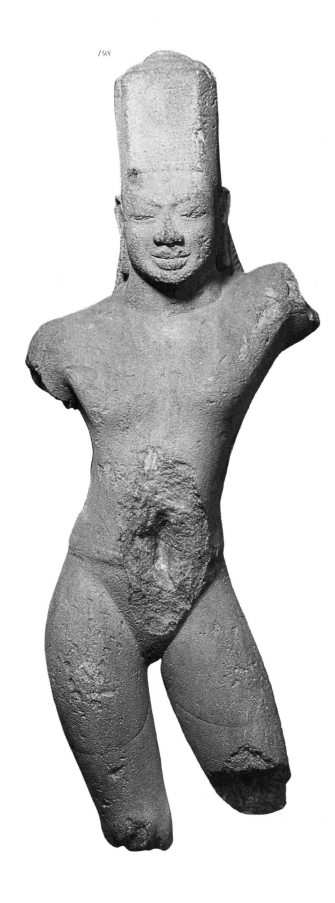

198

198. *Vishnu. Stone. From Si T'ep, province of Bejapurna (Thailand). Dvaravati style. National Museum, Bangkok*
The standing figure is represented according to the canon of triple flexion (the characteristic Indian tribhanga), which demonstrates how tenacious the persistence of Indian influence was. The region where the Dvaravati style flourished was dominated by the Khmer from the seventh *to the tenth century A.D.; and the image of Vishnu presented here, to judge from the contrast between the heavy oval of the face and the lively agility of the body, should be dated between the eighth and the tenth century.*

199. *Male head in terra-cotta, probably to be identified as a Bodhisattva on account of the strange and rich headdress. It is one of the most expressive and beautiful works of all the terra-cottas discovered at Ku Bua. Dvaravati style, ninth–tenth century A.D. National Museum, Bangkok*

199

*200. The Avalokitesvara Bodhi-
sattva with four arms, unfor-
tunately broken off. Bronze.
From Java, perhaps Borobudur.
Srivijaya style, ninth–tenth
century* A.D.
*The rich jewels evoke the art of
South India and of Java. On the
very elaborate headdress is the
Buddha Amitabha, of whom the
Bodhisattva is an emanation.
The treatment of the eyes recalls
the Indian schools of the north.
As can be seen here, Indian in-
fluence persists for an extremely
long time.*

which were mostly Hindu, although phenomena of syncretism between Buddhism and Saivism occurred, as is apparent, for instance, in the temple of Candi Jawi. Sculpture became more and more decorative and in some cases shows cultural—actually, religious—values, too. The relief continues to be remarkable, but the movement lacks its earlier impulse, becoming intensely restrained, as if the gestures were suddenly inter- rupted. A differentiating characteristic is the use of sacred pools as temples. To conclude, the phase of Eastern Java, characterized also by the upward thrust of the markedly vertical lines of the architectural structures, which ended, however, in truncated tops, shows a noticeable continuity with the previous period. The Indian influence lost its impact as the artists continued to pursue independent forms and solutions un- til, in the epochs known as Singhasari and Mojopahit (corresponding to the thirteenth and fourteenth centuries), entirely new architectural and decorative forms began to appear; these changed along the evolution- ary line indicated by the verticalizing tendency. The complex elevations of the buildings of this epoch recall in this form a gigantic lamp, and in some monuments the resemblance is made more striking by seemingly supporting but actually applied 'paws,' consciously designed to suggest the spiritual illuminating function of the temple by the evident resem- blance to the usual lamps (for example, Candi Kidal).

Thus Indonesian art had become independent but still bore traces of the Indian inspiration which emerged noticeably when this art, as it spread for political or commercial reasons, came across other figural trends also charged with Indian reminiscences.

Among the art styles of Farther India, the one that is best known and most appreciated by the Western world is the art of Khmer, praised in the travel books of famous writers and considered a really impressive figural phenomenon. Developing approximately between the end of the sixth and the middle of the thirteenth century on the territory of present- day Cambodia, its evolution was fragmentary. The different periods are indicated by the names of the different Khmer capitals. Extremely rich in monuments, it is famous above all for the sacred and royal city of Angkor. The building of the large temple of Angkor Vat marks the apogee of the Khmer figural civilization, corresponding to the reign of Suryavarman II in the first half of the twelfth century (see fig. 186). The invasion by the Cham, the fall of the Khmer, and the pillages that fol-

lowed the invasion and conquest spelled a period of decadence, which was later overcome under the rule of Sayavarman VII, when the damaged and pillaged city of Angkor was rebuilt and embellished as Angkor Thom (see figs. 185, 187, 188, 190, and 192).

Khmer sculpture, from the seventh century onward, developed an original trend, departing from the sense of volume, the attenuated contours, and the typical bent poses of Indian art. The ideals it pursued, dictated by a very different taste from the one that had provided inspiration, are partly connected with the religious quality attributed to the Khmer sovereigns. The sovereign's temple was a magic center identifiable with Mount Meru, which was the axis of the universe. It reproduced that mountain's structure by man-made devices such as the step pyramid supporting the sanctuary. In architecture, order and logic were predominant, producing effects of symmetry and grandeur that the wealth of ornaments could not stifle. Concern with order shows, first of all, in the plan of the buildings, their grouping, and the concentric distribution of the square galleries. In fact, the standard pattern consists of the tower *(prasat)*, the step pyramid constituting the base of the temple, and the galleries which are corridors open on one side and sometimes in

201

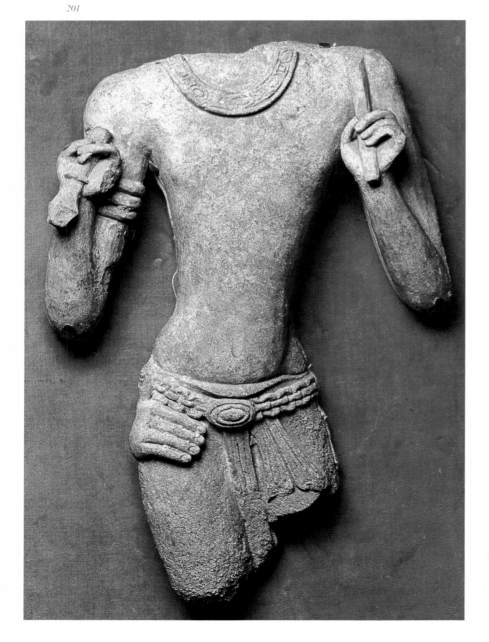

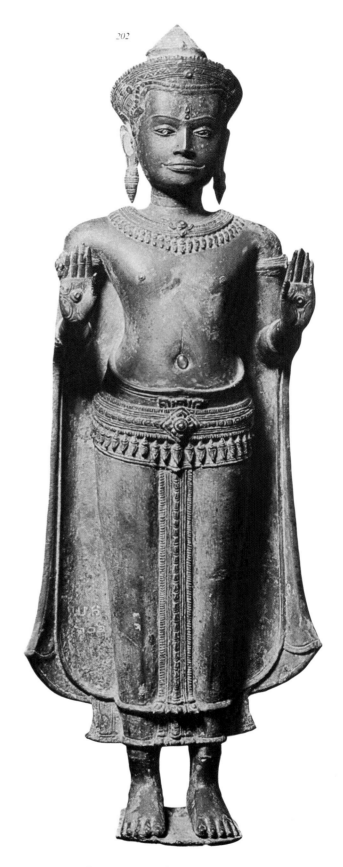

202

201. *Fragmentary torso of a divinity, in the attitude of triple flexion of the body (tribhanga). Stucco. Dvaravati style (late phase?), tenth century* A.D. *(?). National Museum, Bangkok*

The anatomy is clearly of Indian derivation, but the proportions are considerably modified in accordance with local Thai taste, while the costume recalls more strongly than many other works that of Indian prototypes.

202. The Buddha standing, wearing royal vestments. Bronze. From LopBuri, twelfth–thirteenth century A.D. National Museum, Bangkok
Both hands are decorated with the lotus, and are posed in the abhaya mudra, the gesture of protection. Such symmetry would have been almost heretical for India.

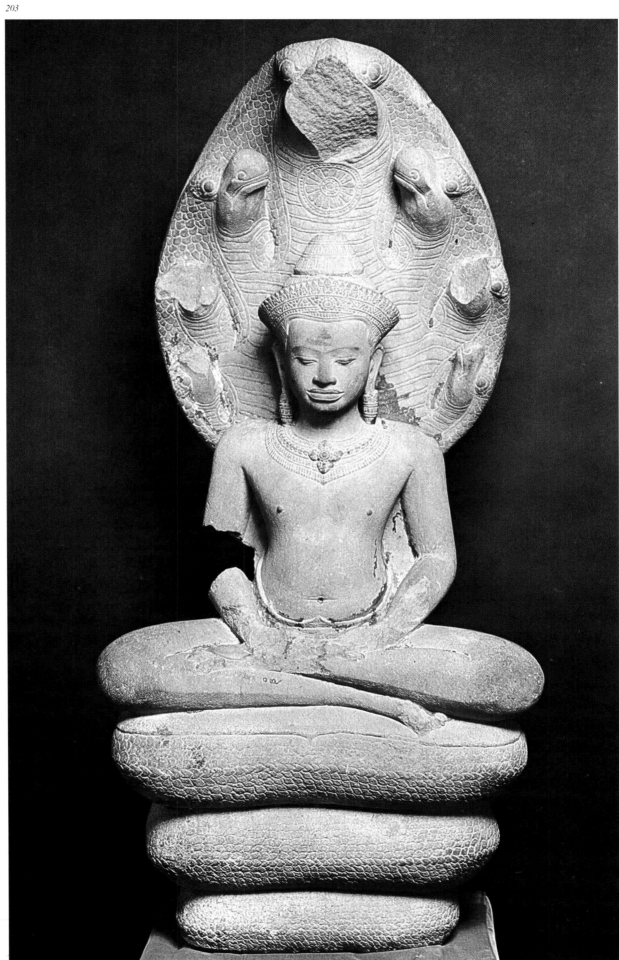

203. The Buddha meditating, protected by the Naga Mucilinda. Sandstone statue. Style of Lop-Buri, with strong influences from Angkor. Thirteenth century A.D. National Museum, Ayudhya
The Buddha, attired in his royal vestments (necklace, diadem, and muskata, a sort of tiara), is presented here in a classical situation, protected by the King of Snakes, who is sheltering him from a terrifying hurricane.

205. Votive stupa in bronze, sustained by atlantes and lions. Style of LopBuri, thirteenth–fourteenth century A.D. *National Museum, Bangkok*
The Buddhas adorning the drum are seated in the yogi position with their right hands held in the gesture called the bhumisparsa mudra, which calls upon the Earth to be a witness to the realization of Enlightenment.

204. Head of the Buddha. Style of LopBuri. Thirteenth century A.D. *National Museum,. Bangkok*

204

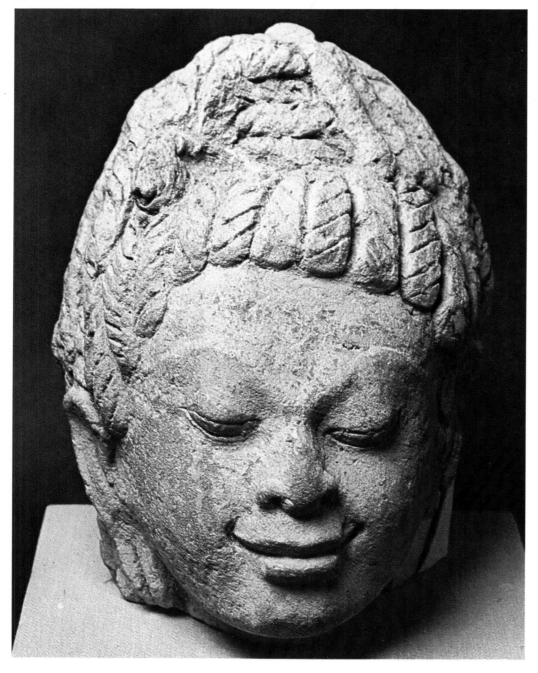

180

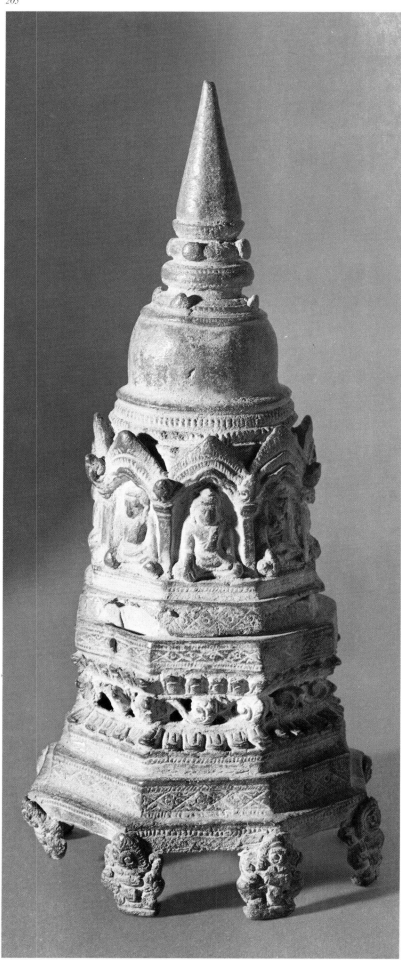

tiers. It must be remembered that Angkor Vat, the masterpiece of Khmer architecture, was also a funerary monument. Possibly that is why it was built to face the west. Its function, however, does not make it any less magnificent or less carefully planned. In fact, its makers even exploited the light effects that would enhance the pronounced relief of the sculptures. Low relief is limited to the ornamental panels meant to emphasize the amplitude and imposing massiveness of the monumental walls, as was not always the case in India.

Closely bound to architecture, Khmer sculpture modified the Indian standards of feminine beauty (see fig. 189); the greater rigidity of the bodies is emphasized by restrained gestures, angular, stiff, and always ornamental. Khmer artists complied with the Indian rule demanding that the clothes and jewels adorning the divinities and characters in sacred scenes reflect the current local fashion (see fig. 184), but the faces of Khmer images, cleverly stylized, radically transformed the original Indian suggestions to express that detached and infinitely compassionate benevolence which, speaking of the Buddha, Pierre Loti defined as "le sourire de la Grande Paix obtenue par le Grand Renoncement et la Grande Pitié" (the smile of the Great Peace obtained by the Great Renunciation and the Great Compassion).

The Champa current, which developed between the eighth and the seventeenth centuries in southeastern Vietnam, reflects the Khmer and Javanese currents and further modifies their Indian component. Champa art repeats the sanctuary tower feature while neglecting galleries and temples. In the twelfth century (with the Binh-dinh style) the Khmer *prasat* became an extremely elegant structure as is apparent from the 'Jade tower' (on the outskirts of modern Quinhon), reminiscent of Angkor Vat, and even more obviously from the so-called Ivory towers of the end of the twelfth century. The Cham tower, called *kalan*, despite its wealth of ornamentation, consisting of moldings, fillets, and so on, is a sober structure of vertical lines. Lancet arches, which sometimes occur in pairs one on top of the other, reveal their distant origin from the Indian kudu only on accurate anlysis. Still, in Champa ornamentation there survived some really Indian elements along with others borrowed from Java and Khmer.

Thai art, instead, has its roots in the Gupta style. It originated in the kingdom of Dvaravati, from which it derived its earliest name (see figs. 196–198 and 201). The Gupta models copied in the region of the lower Mekong differ from the Indian prototypes only in the ethnic characteristics of the Buddha's face (see fig. 195). The temporary conquest of this region by the Khmer introduced a Khmer influence. In any case, the preference of the powerful western neighbors of Dvaravati fostered the development, on the lower course of the Mekong and the surrounding areas, of a mode known as the style of LopBuri (see figs. 194 and 202–205), which is no more than a provincial variant of Khmer art, even though it shows originality in some minor traits. The advance of Thai populations from Yunnan down the Menam seems to have brought about a deep change and actually originated Thai art proper. Its peculiar quality, also seen in large cities such as Chieng-sen and Sukhodaya (see figs. 206–209), which bloomed from the middle of the thirteenth to the fifteenth century, is a result of the prolonged contacts with Buddhist Burma (and through it with northeastern India) and, by sea, with Buddhist Ceylon. From both places came models and suggestions that were soon modified to suit the Thai taste. In Chieng-sen there was a strong Pala influence, while in Sukhodaya that of Ceylon prevailed (see fig. 209). This is why the Buddha images of Sukhodaya are clad in Ceylonese clothes and their legs are bent in the Ceylonese version of the yoga pose (crossed legs and exposed feet). The Buddha images of Chieng-

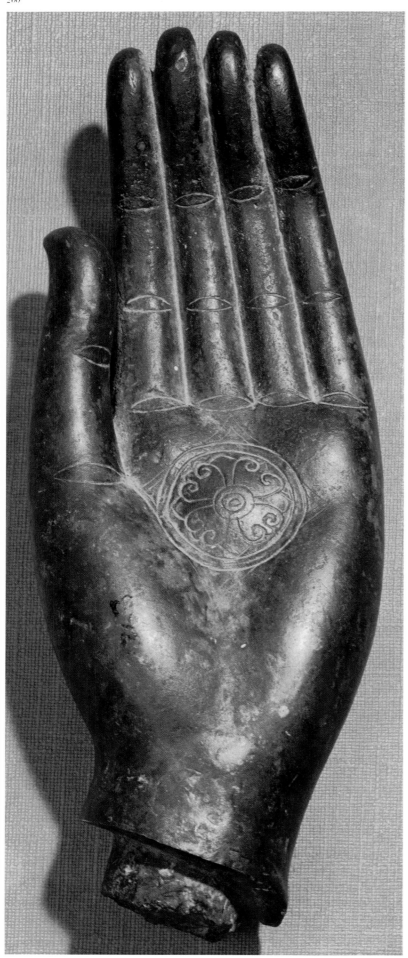

206. Stylized hand of a Buddha in gilt bronze. Style of Sukhodaya. Fourteenth century A.D. National Museum, Bangkok
The hand is held in the gesture of protection, and has carved on the palm the symbol of the lotus, which is also the Wheel of the Law.

207. The Buddha walking. Gilt bronze. Vat Benchamabop'it (Monastery of the Fifth Kingdom), Bangkok. Datable in the fourteenth century A.D.
From the protuberance on the cranium, or ushnisha, issues a tongue of flame. The image is highly stylized and decorative, and belongs to the Sukhodaya style.

208. The Buddha welcoming. Votive tablet made of lead. Style of Sukhodaya, fourteenth century A.D. National Museum, Bangkok
Under an archway, which has vases of flowers standing before it and two umbrellas above, the Buddha advances holding his left hand in the posture of argumentation (vitarka).

sen have the skull protuberance of the Pala school Buddhas; in those of Sukhodaya the protuberance is turned into a pointed motif, which soon became a stylized flame (see fig. 207). The original Indian iconography had become a thing of the past, and yet evidence of it was still there, even though Thai art is a great art in its own right.

The extent and manner of the Indian figural expansion in southeastern Asia—or Farther India—can be retraced and evaluated with a fair amount of precision because of the religious conservatism and resistance to change that characterize outlying, provincial (the term is used in the sense that we have been trying to define) areas. Unlike that of China, which amounted to colonization in the real sense of the word, the influence of India asserted itself for its superiority and the particular spell it cast on the peoples of Farther India. Accepted by free choice and ranging so far and wide that it limited the Chinese figural diffusion to very small areas, the Indian influence brought about a consistent and gradual evolution which was different in the various regions and partly conditioned by the political and social structures within the immense area it affected. It might be said that the peoples of Farther India, recognizing the superiority of Indian culture, strove to make it their own, altering it according to their creative genius. Unlike what happened in Central Asia, where Indian art met with other equally vigorous currents and fused with them, from Burma to Indonesia the art of India was undisputed in its rule and proved both its vitality and its charm even as it became transformed. Everywhere in this area it activated new currents, each to become in time an art in its own right and an important page in the history of world art.

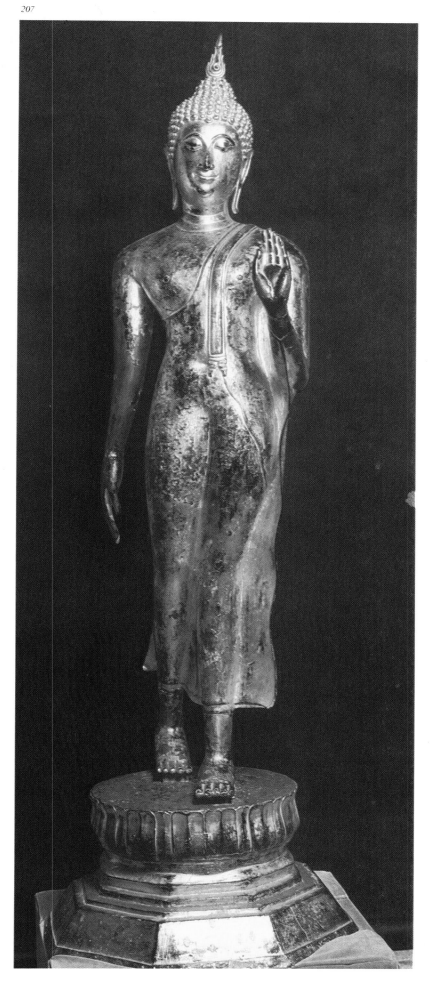

207

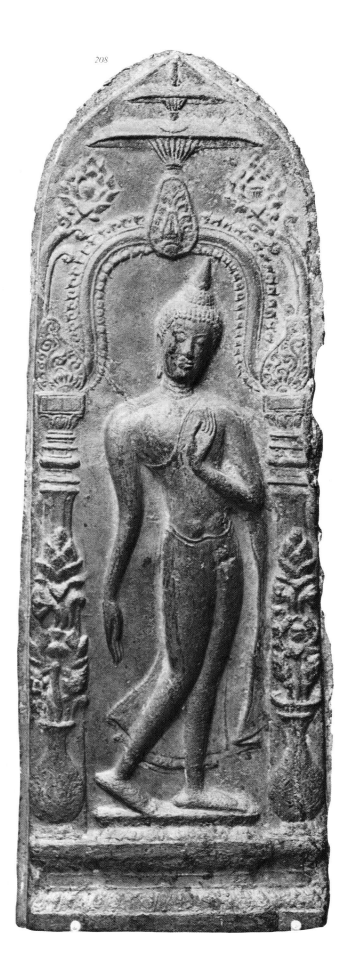

208

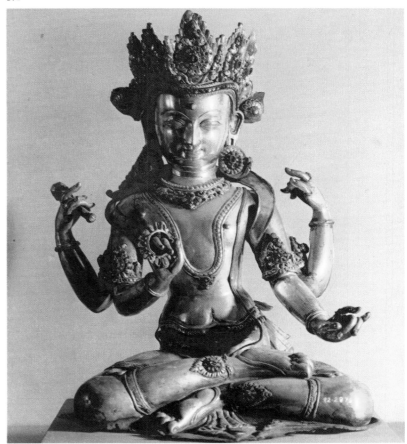

210. Vishnu. Gilt bronze. Fifteenth century A.D. (?). Prince of Wales Museum of Western India, Bombay
In the two right hands are the chief attributes of the god, while the two left hands are held in characteristic and distinctive poses (mudra). Strong analogies with Tibetan iconography and iconometry are evident.

209. The Parinirvana. Bronze. Thai, school of Sukhodaya, datable in the fourteenth century A.D. National Museum, Bangkok
The portrayal of the death of the Buddha, first developed by the Gandharan school, is here given strength and at the same time refined. Images of this sort, which are rather rare, bear witness to the process of stylistic transformation undergone by an Indian iconographic motif that passes from its original dramatic form to an elegant and almost affected interpretation.

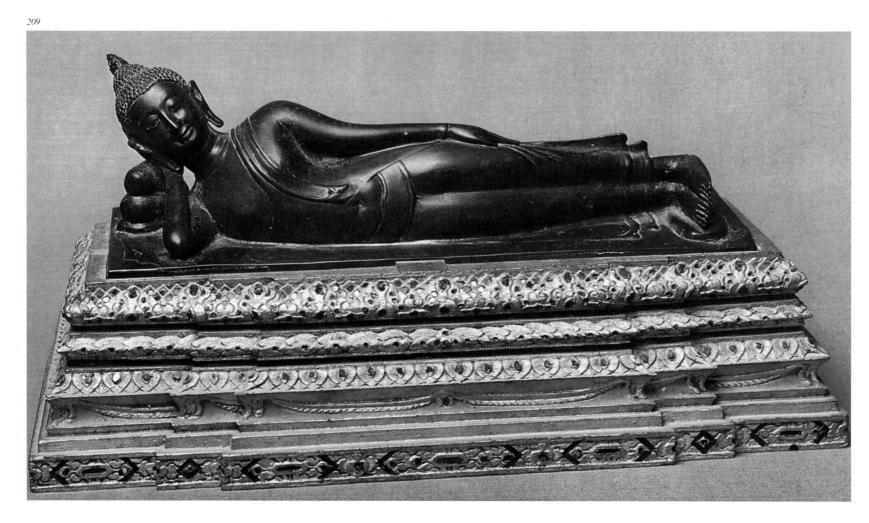

211. *The goddess of earth evoked as a witness by the Buddha to confound his opponent, Mara. Bronze. Style of Bangkok, first half of the nineteenth century* A.D. *National Museum, Bangkok The goddess is wringing her hair, which is soaked by the libations made in his previous lives by the Buddha himself. In this way she causes a flood which puts Mara and his army to flight.*

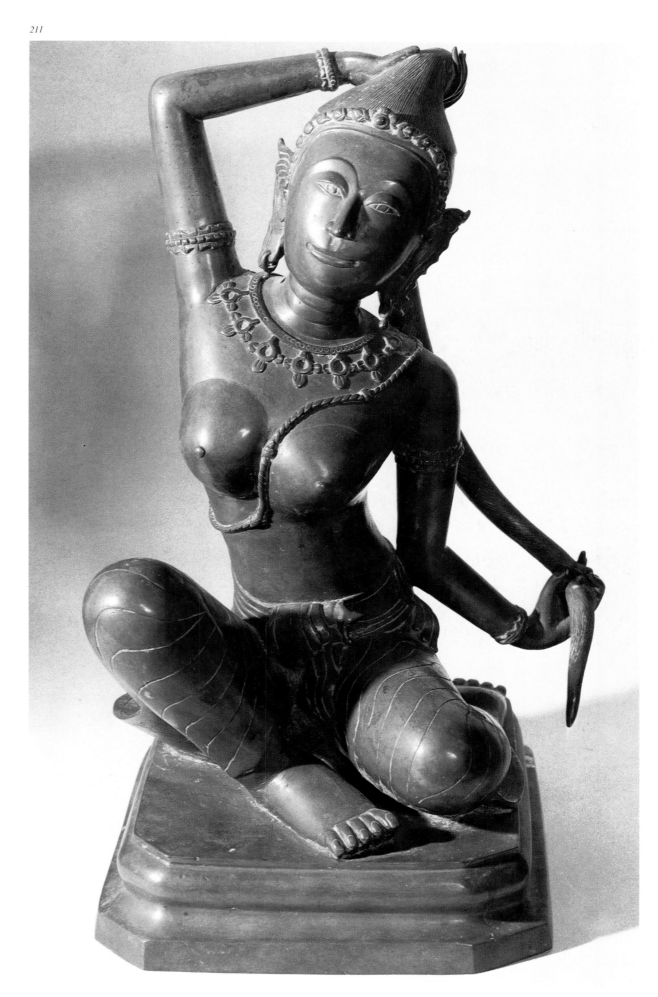

211

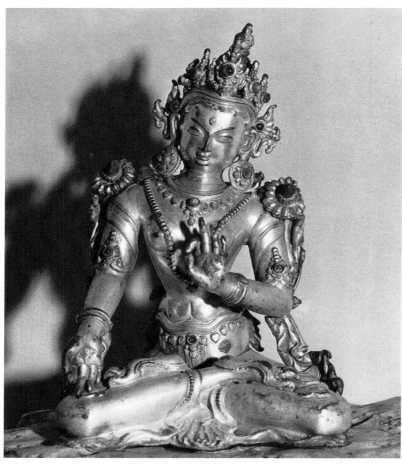

212

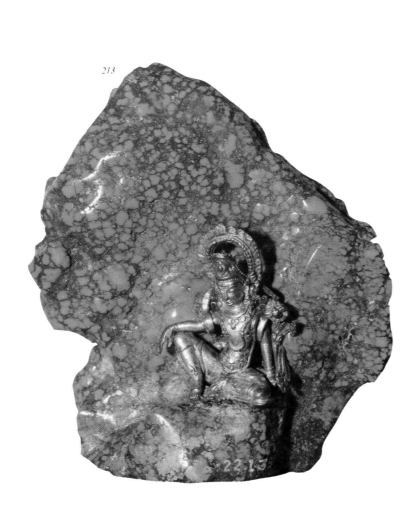

213

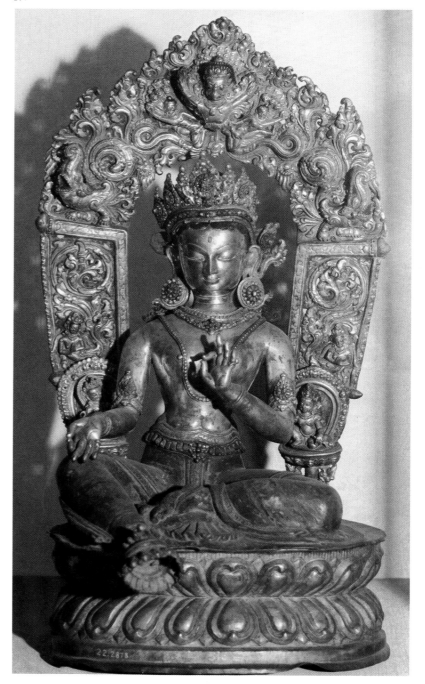

214

212. *Tara, a Buddhist divinity. Gilt bronze. Nepalese, seventeenth century* A.D. *Prince of Wales Museum of Western India, Bombay*
The style is characteristic of the peripheral works which passed from Nepal to Tibet.

213. *Avalokitesvara. Image in gilt bronze, set in a large fragment of veined turquoise. Nepalese, eighteenth century* A.D. *Prince of Wales Museum of Western India, Bombay*

214. *Tara, seated on a lotus, with a halo worked all around the figure. Bronze. Eighteenth century* A.D. *Prince of Wales Museum of Western India, Bombay*
Excellent example of provincial art undergoing transformation.

10. The Art of Medieval Hindu India

by Calembus Sivaramamurti

After the Guptas, for a brief period sovereignty passed to the Vardhanas, of whom Harshavardhana, a remarkable emperor and himself a poet and patron of letters, was also a patron of art. This was in the seventh century A.D. Under this emperor, the prosperous kingdom of the Maukharis, ruled by Grahavarman, the prince who married Harshavardhana's charming sister, was also united to the Vardhanas on the death of Grahavarman at the treacherous hand of a common enemy.

A few examples of the exquisite sculptures of this period exist. An outstanding one is the beautiful female bust from Gwalior now in the National Museum in New Delhi (fig. 215). The pearl-bedecked coiffure (muktajalagrathitam alakam) and the transparent dress with its neat embroidery make it one of the finest creations of the Indian sculptor's chisel.

In the eighth, ninth, and tenth centuries, the Gurjara Pratiharas came to power. They had a vast empire extending over the Ganga-Jamuna Doab, Gujarat, and Rajasthan. The greatest of the Gurjara Pratihara monarchs was Mihira Bhoja, who ruled in the tenth century. Their empire was so great and their power so overwhelming that they could not but come into conflict with the great power in the east, Pala, and in the Deccan, Rashtrakuta. It is therefore in this period that sculptural similarities occurred in geographically separated areas in Central India, bringing together the styles of the regions of Bundelkhand, Kanauj, Osia, Abaneri, Bikaner, etc. Some exquisite examples of Gurjara Pratihara work have been found at Kanauj. The already popular theme of Visvarupa Vishnu, noted in the Mathura sculpture of the Kushan and Gupta periods (pp. 104, 130), is represented in a magnificent example in which the principal Avatara forms of Vishnu, fish, tortoise, boar, and lion, are shown as four faces; the rest are distributed over the crown. Brahma, the eleven Rudras and the twelve Suryas, Indra, Sarasvati on the swan, Karttikeya on the peacock, and a host of other deities, including the eight Bhairavas, make up a large encircling background for the figure. It is a telling visual version of a passage in the *Bhagavadgita:* pasyadityan vasun rudran asvinau marutas tatha bahunyadrishtarupani pasyascharyani bharata.

In another example (fig. 222), the marriage of Siva and Parvati, the grouping of the deities above, closely following the earlier Gupta tradition, shows Varuna, Yama, Indra, Vayu, Ganesa, and other gods on their respective mounts.

A charming sculpture of a mother and child, the young mother provided with a halo suggestive of divinity, in this case, Parvati, with the baby Skanda, is another exquisite example of the same school from Udaipur in Rajasthan, dating about the eighth or ninth century. A Kubera, also from Udaipur, is yet another early work. In the Gwalior Museum there is a sculpture representing a divine nymph, or Surasun-

dari; the body, in lovely flexion, is modeled with exquisite grace and draped very tastefully in a garment with an artistic border and scattered patterns—undoubtedly a supremely charming creation of feminine beauty by a Gurjara Pratihara sculptor about the tenth century A.D.

An idea of the sculptural metalwork of this school can be had from two fine examples recently acquired by the National Museum in New Delhi, both of the tenth century and representing Vishnu, one with an inscription mentioning Mahipaladeva (fig. 223) and the other with a more elaborate background showing in characteristic Pratihara fashion the ten avatars set all around it, a feature often noted in lithic sculpture.

Contemporary Kashmir sculpture was under the patronage of the Karkota dynasty, of whom Lalitaditya Muktapida is famous as a great patron of art and literature and as the creator of monuments at Lalitapura and Parihasapura, with the temple at Martand as a tribute to his art-mindedness. Later under the Utpala dynasty, under the distinguished Avantivarman who built the Avantisvami temple at Avantipura, medieval Kashmir established great traditions in art. Here was a meeting place for Greek, Gupta, and Sassanian styles. There is a tinge here of influence not only from Gandhara but from the Central Asian area also. The crown of Surya from the eighth-century temple at Martand strangely survives in Kangra paintings. The arrangement of the hair recalls the Gupta style at Masrur, on the hills near Chamba, where in the rock-cut temples there are some lovely carvings; a noteworthy one shows Varuna on the makara, or crocodile.

In the Avantisvami temple at Avantipura, one can never forget the important panel showing the king, accompanied by the queen and attendants, approaching the shrine as an humble devotee. It is certainly the portrait of Avantivarman, who, like Rajendra Chola later in the eleventh century at Gangaikondacholapuram, immortalized himself supplicating the deity whom he has honored in a temple built by him. The panel of Manmatha flanked by Rati and Priti with the parrots, so closely associated with Cupid, typifies medieval Kashmir sculpture.

Here, again, the ancient tradition in India of the versatility of the Indian carver is perceptibly seen in magnificent ivory carvings recovered from this area and now preserved in the Prince of Wales Museum of Western India in Bombay. One of them shows the Maradharshana (fig. 229), a vivid portrayal of the Buddha overcoming the importunities of Mara, the Satan of Buddhism. The great care and perfection of detail with which the uncouth forms of the weird hosts of Mara are rendered make the work the most outstanding in carved ivory yet recovered in India. Equally important is the Avalokitesvara Bodhisattva with attendants (fig. 230); the delicacy of the work is beyond praise. These pieces toise, boar, and lion, are shown as four faces; the rest are distributed the eighth century.

A very early example of metalwork from Kashmir near the Gandhara

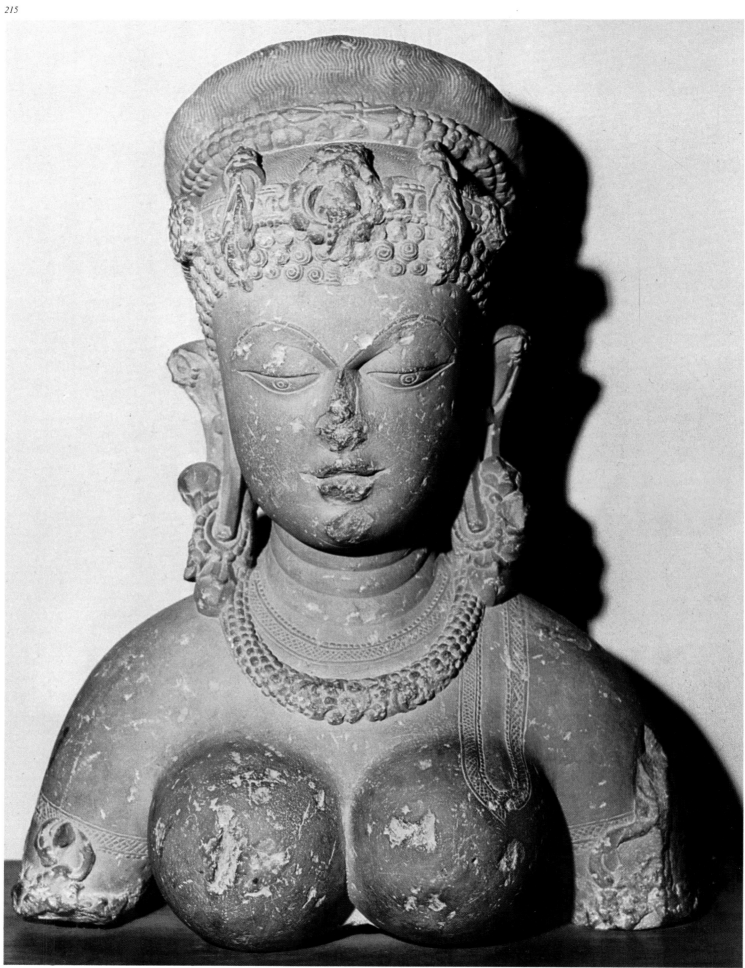

215. *Feminine bust. From Gwalior (Madhya Pradesh). Vardhana, seventh century* A.D. *National Museum, New Delhi*
Note the dreamy eyes, the elegantly dressed braid decorated with pearls, flowers, and tender sprigs, the curls nestling on the forehead, and the diaphanous bodice.

216

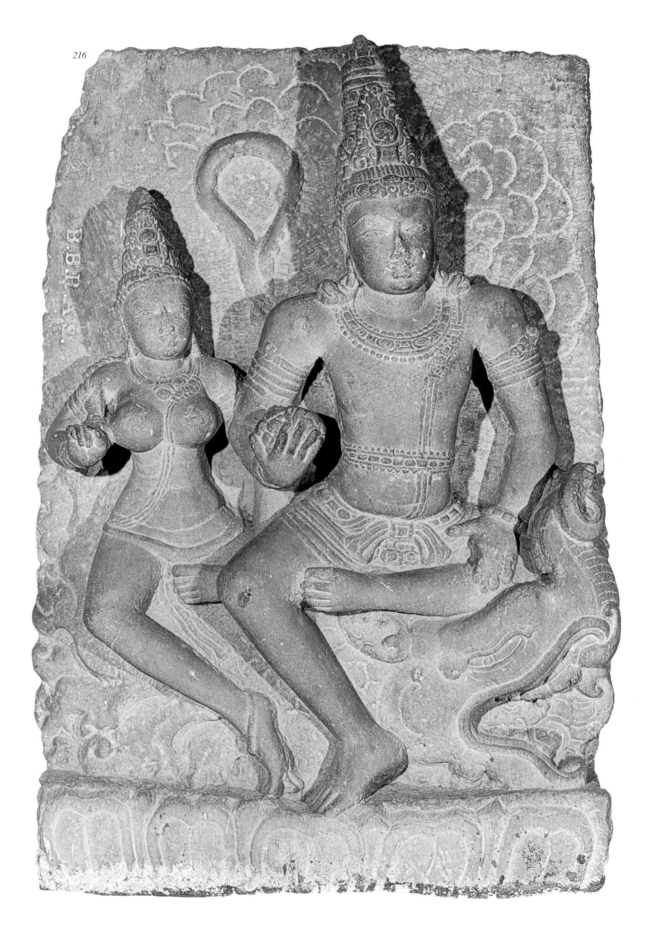

216. *Varuna, lord of the waters, with his consort Varunani on his mount, a monster, or makara. Gurjara Pratihara, eighth century* A.D. *Prince of Wales Museum of Western India, Bombay*
Note the elegant treatment of the figures, the clouds in the background, and the pasa, or noose, suggestive of Varuna.

189

area, a Vishnu with personified weapons on either side, the wheel and the club in male and female forms respectively (of which only one is intact), is in the Staatliche Museen, Berlin. This work presents a well-modeled torso based on Greek or Roman traditions and is at once suggestive of Gandharan art, though it is rather late for Gandhara. Clearly of later date, it has inspired still later creations of the early medieval school in Kashmir. This points to continuation of metalwork from the early centuries in Kashmir; fine examples like Vaikuntha Vishnu (see fig. 217), with additional heads of the lion and boar, are of frequent occurrence.

The Mahishamardini image with an inscription stating that it was fashioned by Gugga, and the seated Narasimha, Kaumari, and other similar bronzes, somewhat elongated in form and with pleasing countenances, from Barmaur and Chhatarhi in Chamba illustrate eighth-century Kashmir craftsmanship.

In eastern India, the powerful Pala dynasty built up an empire founded by Gopala and continued by Dharmapala and Devapala, his successors. The Pala kings, being great patrons of learning and art, encouraged universities at Nalanda, Vikramsila, and Uddandapura. They were devout worshipers of the Buddha. This accounts for the variety of sculptural theme, Brahmanical and Buddhist, of the Pala period. The sculptors were equally at home working in stone and in clay. The terra-cotta tradition, to which magnificent examples of the early period from Paharpur and Mahasthan bear testimony, continues in the very late temples like those at Birbhum. The dream of Trisala representing a Jain theme and a medallion showing the mithuna motif are expressions

in the medium of terra-cotta from Mahasthan. These works can be compared very favorably with such fine examples as Seshanarayana fighting Madhu and Kaitabha from Bhitargaon.

A trace of Gupta sculpture can still be seen in famous examples of Paharpur work like Radha and Krishna or Krishna and Balarama fighting Chanura and Mushtika. The earliest dated Pala sculpture of the time of Dharmapala, a lintel representing Surya, Siva, and Vishnu, in the Indian Museum in Calcutta, is of poor aesthetic quality. An outstanding large sculpture of the Pala school, now in the Rajshahi Museum, is the famous Ganga, or the heavenly stream personified, with especially noteworthy perfection of decorative and anatomical detail. There are two modes of Pala work that can be distinguished, one from Bihar and the other from Bengal, for the large empire of the Palas extended to the areas of both Magadha and Banga. The figures in the former are a little heavy and thickset. In the eastern region, however, the treatment is lighter and the figures are more vivacious. Of the early sculptures from Bihar, the large image of Vishnu on Garuda, still recalling Gupta features, is a noteworthy example from the Broadley Collection preserved in the Indian Museum in Calcutta. To the same phase belong the Vishnu with consorts and the Tirthankara Parsvanatha recovered by J. C. French and preserved in the Indian Museum. A sculptural work of this early phase from Nalanda that arrests attention by its grace and dignity is the Kumarabhuta Avalokitesvara in the National Museum in New Delhi (fig. 231).

The Bengal sculptors' delicacy of treatment is seen in such magnificent creations of the Pala school as the Nartesvara dancing on a bull,

217

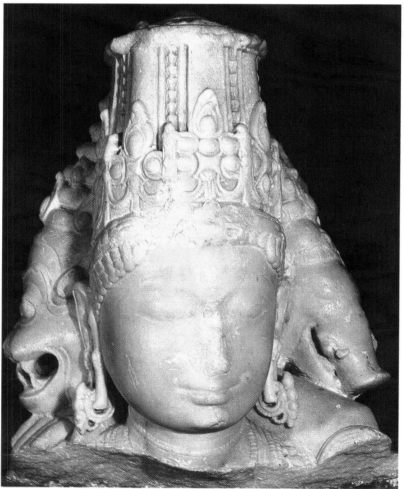

217. Head of Vishnu as Vaikuntha with a lion face and a boar face on either side. Gurjara Pratihara, eighth century A.D. *Prince of Wales Museum of Western India, Bombay*

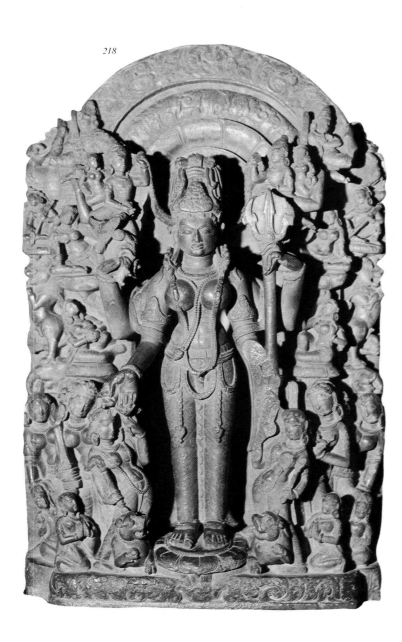

218

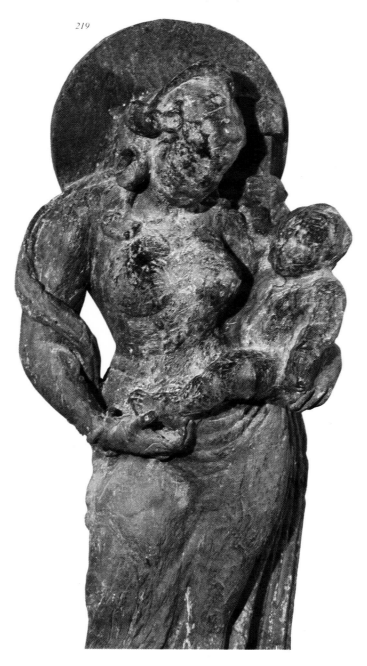

219

219. Mother and child. Maitraka,
sixth century A.D. Udaipur
Museum (Rajasthan)
Delicately modeled and very
natural in treatment. The halo
suggests that the subject is a
Skandamata (mother of the god
of war).

218. Mahesvari with attendants.
From Chamba. Gurjara Pratihara,
eighth century A.D. National
Museum, New Delhi
A typical example of the delicacy
of workmanship in the Chamba
area in the early medieval period.

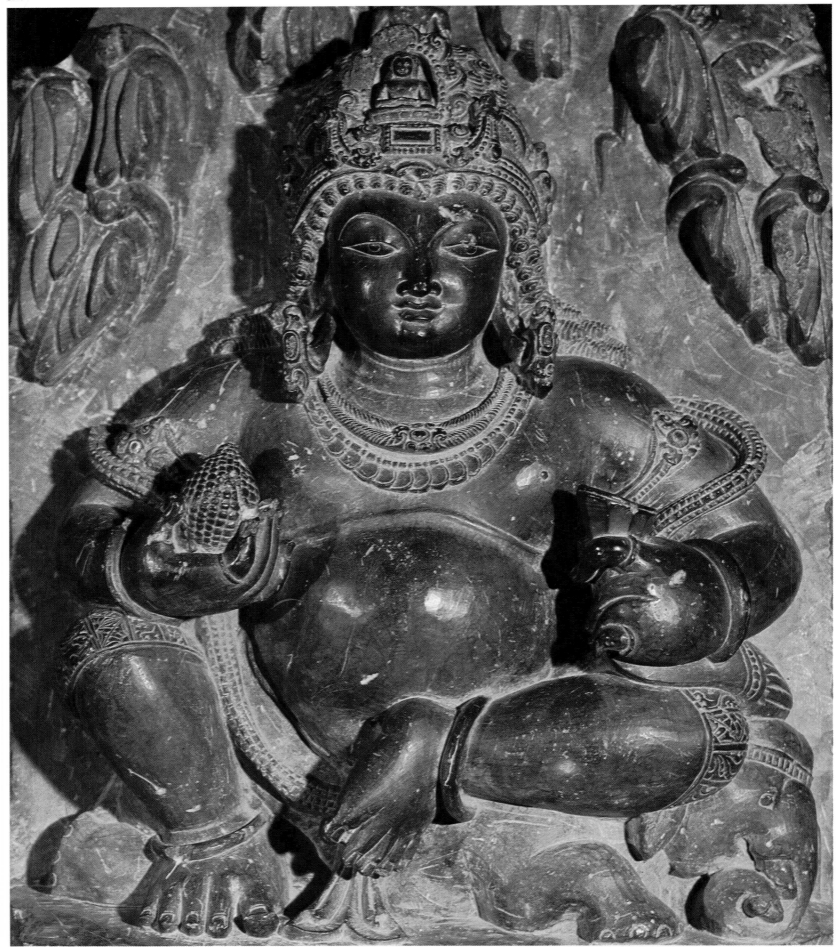

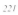221

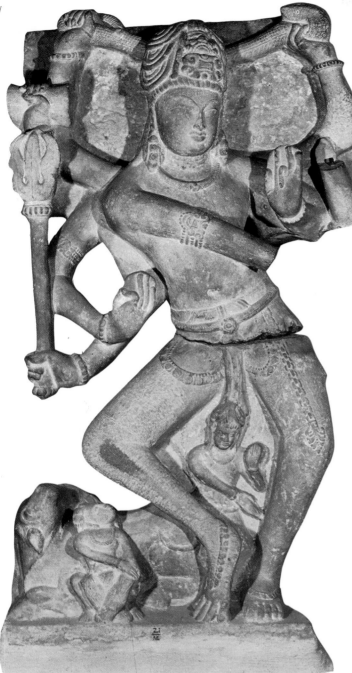

221. The ten-armed Nataraja
dancing in the lalita mode with
ganas holding musical instruments.
Gurjara Pratihara, ninth century
A.D. Gwalior Museum, Ujjain
(Madhya Pradesh)

222. The marriage of Siva and
Parvati. Gurjara Pratihara,
eighth century A.D. National
Museum, New Delhi
An effective sculptural represen-
tation of this theme. The treatment
of the clouds with celestials above
is reminiscent of earlier traditions
of the Guptas and Vakatakas.

222

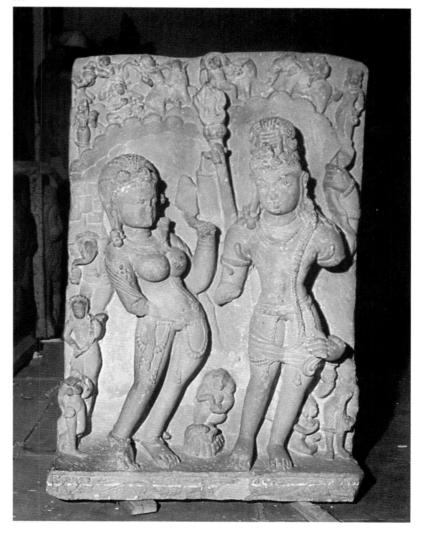

220. Yaksha Sarvanubhuti.
Gurjara Pratihara, eighth century
A.D. Udaipur Museum
The fulsome face and corpulent
body and the excellent modeling
of the elephant, his mount, are to
be noted.

from Sankarbandha, in the Dacca Museum. It is the Pala counterpart of the famous Chola images representing Siva dancing. The Ardhanarisvara, the hermaphrodite form of Siva, in the Dacca Museum is another important sculpture. A very early Pala carving, with the still harp-shaped vina in the hands of Sarasvati, itself suggestive of the early date of the image, is from Lakshmankati. This work and the Nartesvara, are the most important examples of sculpture of the Pala school.

The Pala metalworker has created some of the most charming bronzes of India. These date from the eighth to the twelfth century. Although the Rangpur bronzes of Vishnu with consorts in the Indian Museum in Calcutta and the Rajshahi Museum are later than some other early ones in the Rajshahi Museum, like the Sarvani from Deulvadi, which

has an inscription mentioning its dedication by a princess, they are very fine examples of their kind. The Sarvani is of the seventh century, is pre-Pala, and shows the continuity of the craft of metal casting in eastern India. Exquisite early examples of Pala metalwork from East Bengal are the Sitatapatra from Tipperah preserved in the Dacca Museum and the Hrishikesa from Sagardighi in the Bangiya Sahitya Parishad Museum in Calcutta.

From Nalanda come a host of lovely bronzes of both Buddhist and Brahmanical inspiration. Sankarshana, Sarasvati with the harp-shaped vina, and the group of Matrikas and Vishnu with personified weapons are not in any way less important than the Jambhala, Tara, Arapachana, and other Buddhist icons from this source. The lion and elephant motif cast in a very large size, as a support for a seat (fig. 233), and a

223

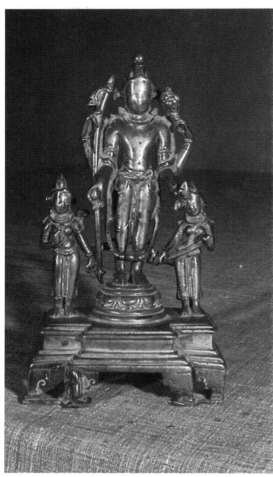

224

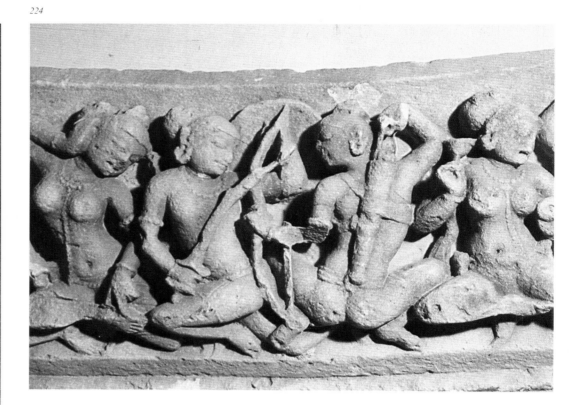

224. A row of musicians, danseuses, and warriors. Detail from a long frieze from the top of a mandapa, or pillared hall, of a temple at Sikar (Rajasthan). Gurjara Pratihara, tenth century A.D. *National Museum, New Delhi The frieze is an exquisite example of the delicacy and charm of early medieval sculpture from Rajasthan.*

223. Vishnu, flanked by Sri and Sarasvati. Bronze. Provenance unknown. Gurjara Pratihara, tenth century A.D. *National Museum, New Delhi This bronze figure is extremely important not only for its simple and effective workmanship, but also because it is inscribed in the reign of the Gurjara Pratihara ruler Mahipaladeva.*

225. Close-up of the wall of a temple at Jagat (Rajasthan). Chandella, tenth century A.D. *The delicate figure carving includes alasakanyas (celestial nymphs), mithunas, and other deities conventionally portrayed as to iconography.*

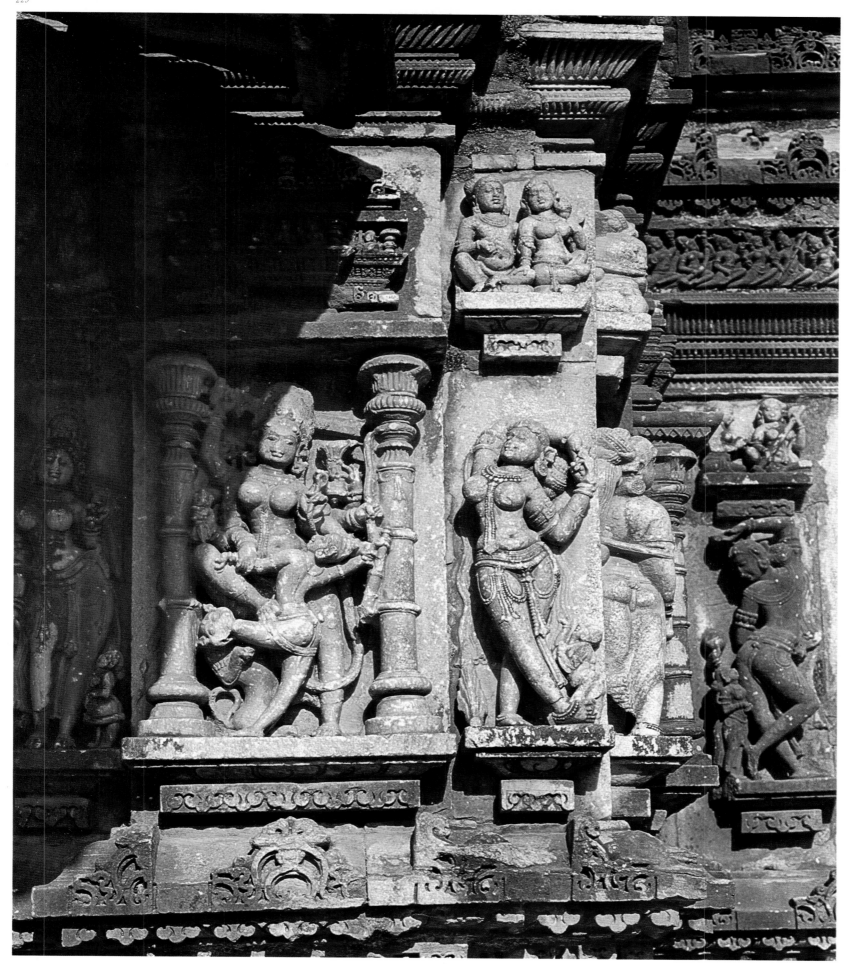

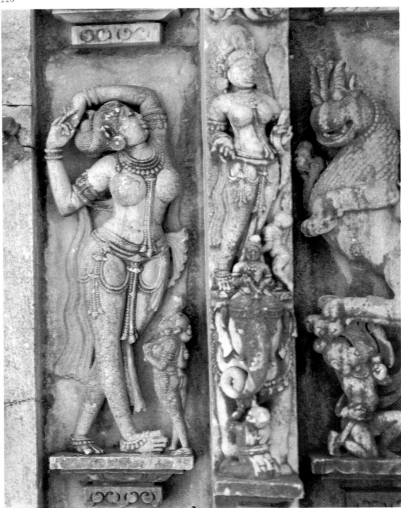

226. *Alasakanya, a celestial nymph, on the wall of the Ambika temple in Jagat. Chandella, tenth century* A.D.

227. *Teli-ka-Mandir, Gwalior. Gurjara Pratihara, ninth century* A.D.
This is the only temple of the north, apart from Vaital Deul in Orissa, that superficially resembles the towers of temple gates, or gopuras, of South India with their sala-shaped roofs.

227

fine votive stupa are important examples of the early Nalanda school. A large number of bronzes from Kurkihar, some very large in size, now preserved in the Patna Museum, including such examples as the Buddha's descent from heaven by the jeweled ladder flanked by Indra and Brahma, his turning of the Wheel of the Law, his overcoming Mara, and figures of Tara, Parnasavari, Jambhala, and other deities show the dexterity of the hand of the Pala sculptor in metal.

The painter of the Pala period was in no way behind his other companions in art, the sculptor and the smith. Illustrations in early Buddhist manuscripts such as the *Prajnaparamita* depicting such scenes as the birth of the Buddha, his overcoming Nalagiri, his Parinirvana, the Bodhisattva, and Tara are masterpieces of Indian painting of the eleventh and twelfth centuries. The illustrations in the manuscripts of the Asiatic Society and in the collections of S. K. Sarasvati and O. C. Gangali are of exceptional interest.

The Senas, who succeeded the Palas, continued the tradition of their predecessors. Lakshmanasena, the famous monarch of this dynasty and also the last, was the patron of Jayadeva, Dhoyi, and other poets. Some of the most important sculptural creations of the Sena school are worthy of especial note, in particular the inscribed Sadasiva in the Indian Museum in Calcutta, since the motif was, for the first time, introduced into Bengal by the Senas, a southern family. Another is an exquisite Ganga image now in the National Museum in New Delhi (fig. 234). Interesting works of this school include a mother and child, a theme which became a great favorite; there are several examples, one

228. *Devi as Bhuvanesvari.*
Gurjara Pratihara, tenth century
A.D. *Gwalior Museum (Madhya*
Pradesh)

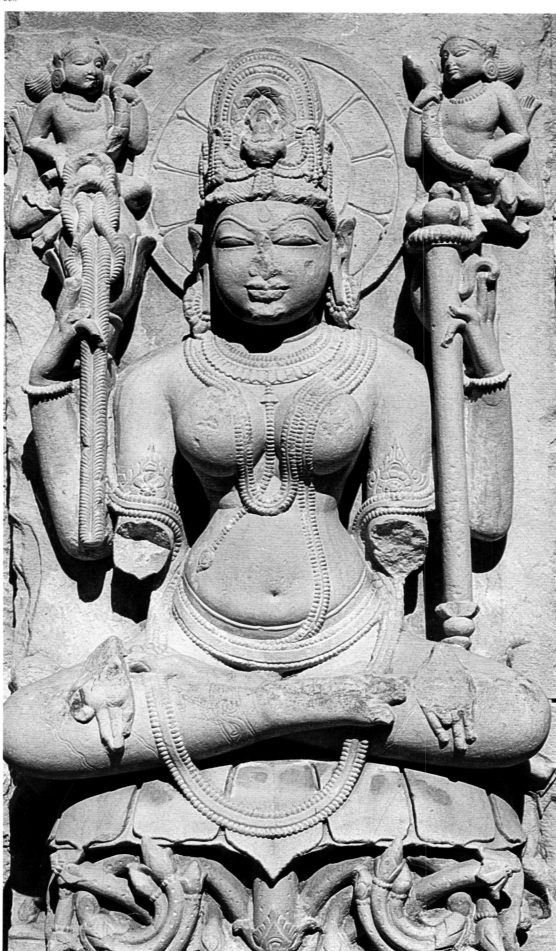

*229. The temptation of the
Buddha. Karkota, seventh century
A.D. Prince of Wales Museum
of Western India, Bombay
This is a rare example of delicate
ivory work that recalls the nuances
of the late Gupta style in the early
medieval period. Including a
trace of Gandharan influence, it
is typical of the best examples of
the Kashmir style in the seventh
and eighth centuries.*

*230. The Bodhisattva Avaloki-
tesvara with flanking attendants.
Karkota, seventh century A.D.
Prince of Wales Museum of
Western India, Bombay
Note the delicate treatment of
the locks of hair, ornaments,
and drapery, and the elegance of
the body flexion. A fine example
of ivory work from Kashmir.*

*231. Avalokitesvara. From
Nalanda (Bihar). Pala, ninth
century A.D. National Museum,
New Delhi
One of the finest early carvings
of the Pala school from that great
center of art.*

229

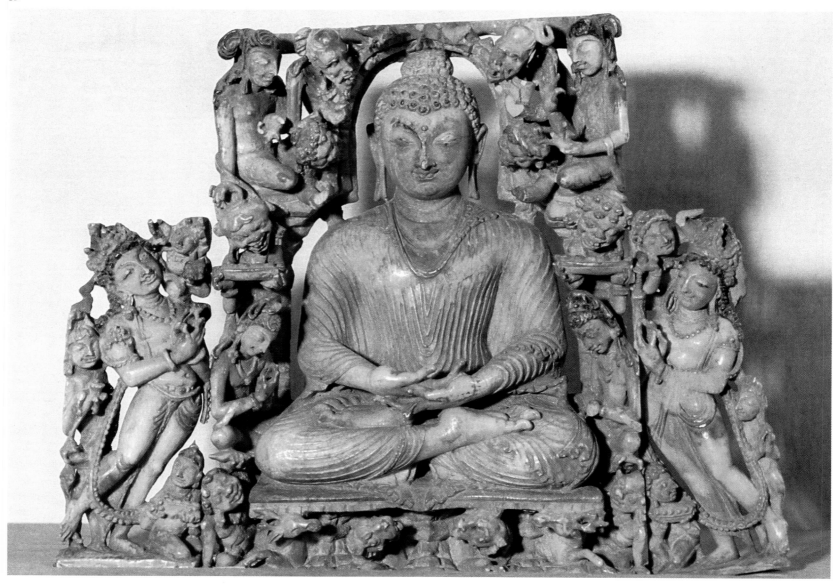

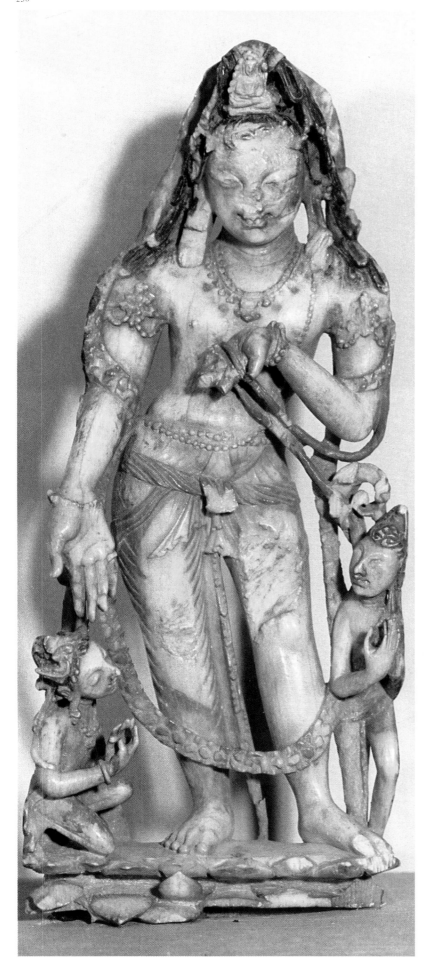

230

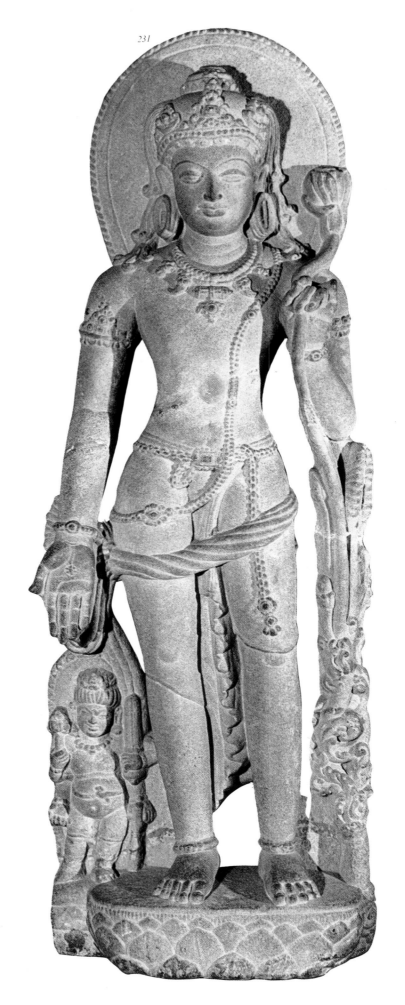

231

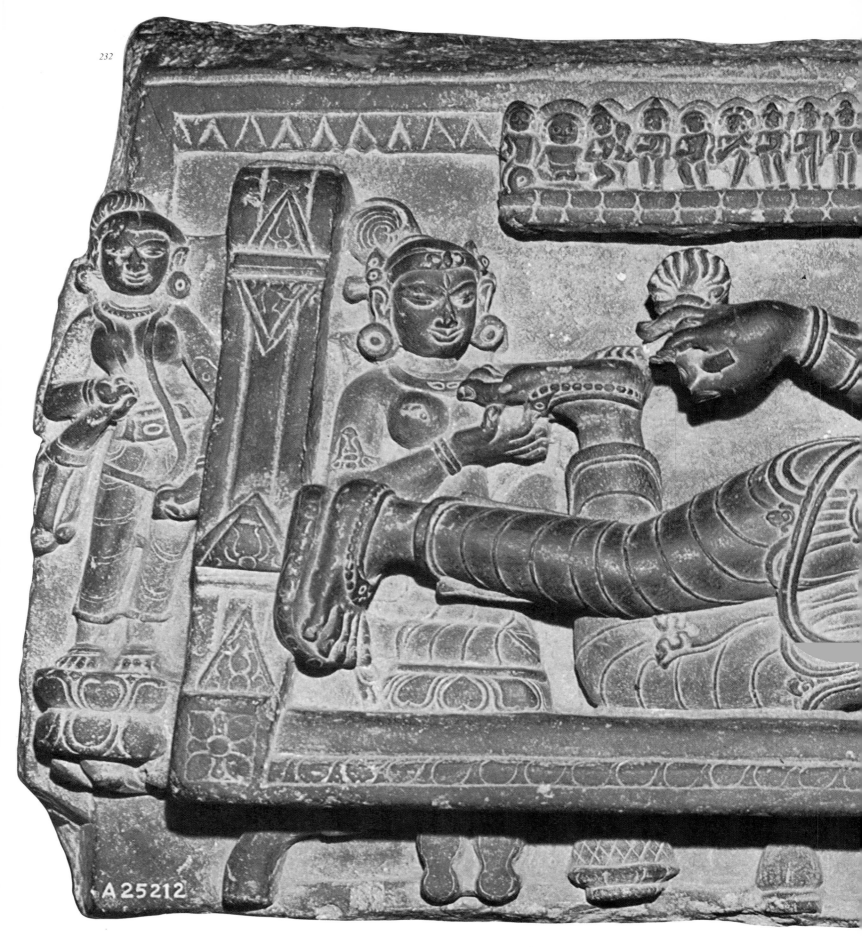

232

A 25212

232. *Mother and child. From Bengal. Sena, twelfth century* A.D. *Indian Museum, Calcutta*

The theme of this work appears to be a newborn child who is destined to be outstanding in life.

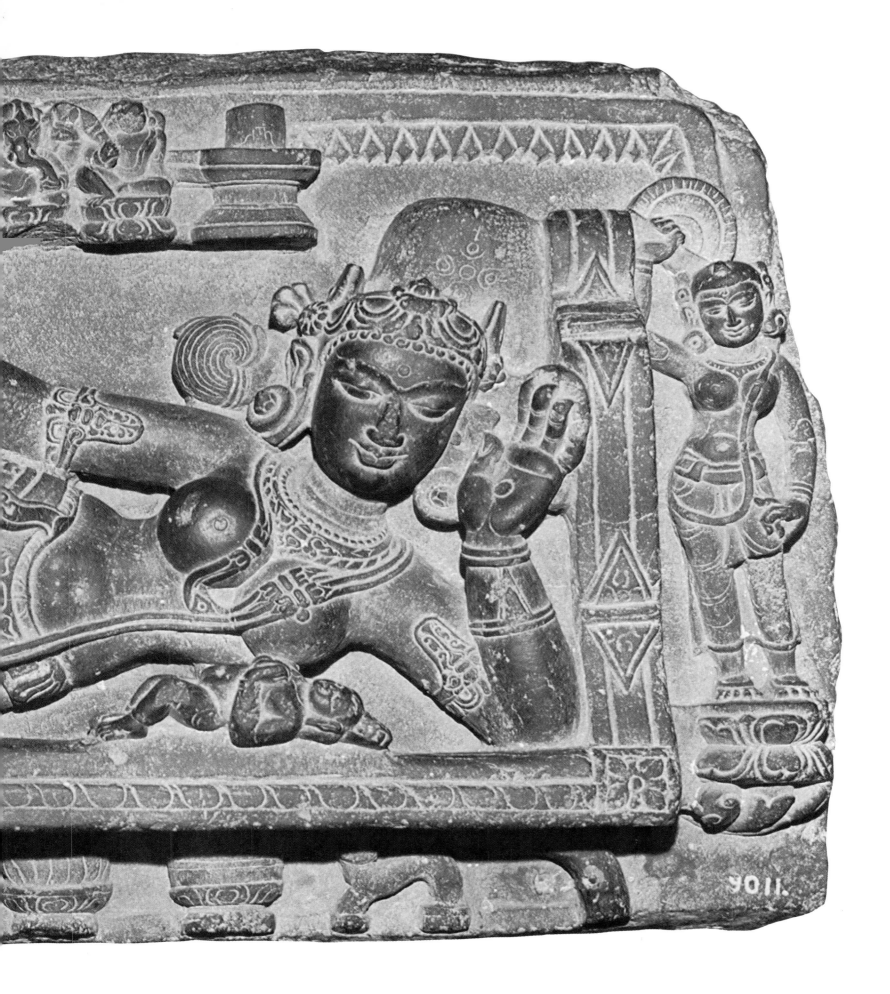

234. *Ganga. From Bengal. Sena,*
twelfth century A.D. *National*
Museum, New Delhi
The jar in Ganga's hand and the
tree behind her suggest the river
and the celestial sphere where she
flows amid wish-fulfilling trees.

234

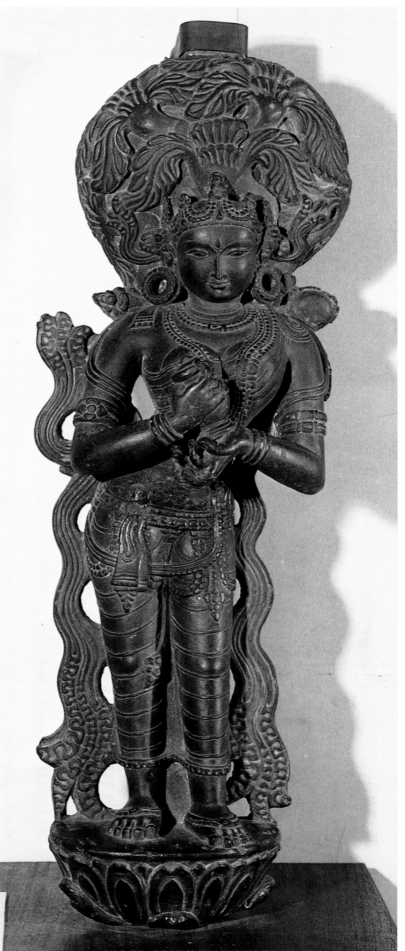

233. *Lion attacking an elephant*
and overpowering it. One of the
metal finials of a seat. From
Nalanda. Pala, ninth century
A.D. *National Museum, New Delhi*

233

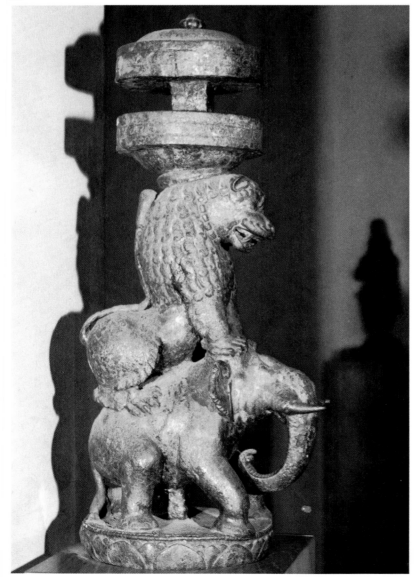

of which, in the Indian Museum in Calcutta (fig. 232), is a typical carving of this period.

To the south of the empire of the Palas was that of the Eastern Gangas, who ruled originally from Dantapura near Mukhalingam. One of their very early temples is the Parasuramesvara of the seventh century at Bhubanesvar. The temple's carved screen showing a group of musicians and dancers is famous; in it still there are traces of Gupta charm. Also at Bhubanesvar is the temple of Muktesvara, a miniature shrine of great beauty. It is almost a sculptor's dream realized. The pierced windows of this shrine are intricately worked with narrations of fables. The impatient bride, Vasakasajjika, awaiting her lord, peeping through the door and inquiring of her parrot when he will arrive, is indeed a lovely presentation of a poetic theme. The central shrine (deul) with its porch (jagamohana), the arched gateway (makara torana), and the neat little bathing pool make this charming temple one of the most important in Eastern Ganga art.

The Rajarani temple at Bhubanesvar, of slightly later date, is a magnificent work (see figs. 235–237). Here the Dikpalas, presented in their respective directions, are well conceived and neatly executed. There are several wonderful poetic themes here, like a damsel slipping her jingling anklet on her foot (fig. 237), and another sounding the cymbals to

235. The Rajarani temple, Bhubanesvar (Orissa). Eastern Ganga, tenth century A.D.
This temple is the only one of its kind in the region of Orissa to have a cluster of diminutive towers, or sikharas, in tiers composing the main tower. Both the jagamohana, or porch, and the deul, or central shrine, are richly decorated.

235

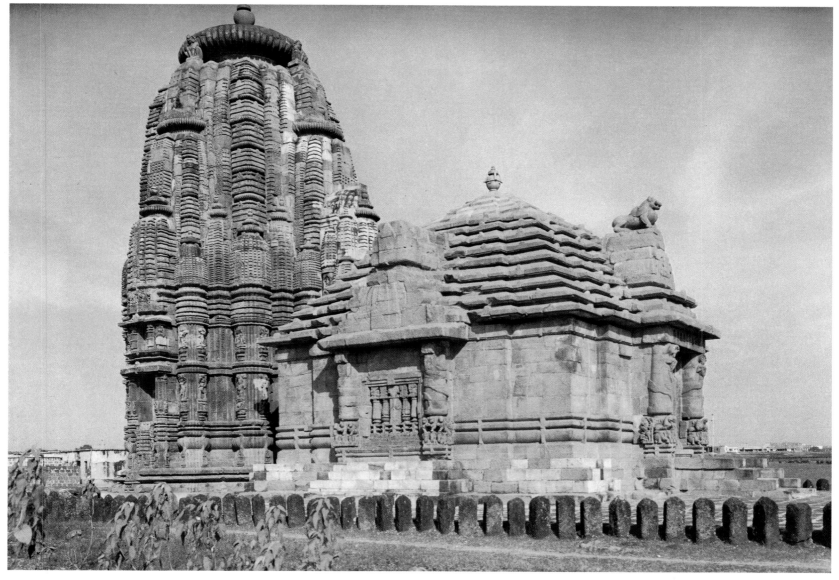

237. Damsel slipping a jingling anklet on her foot. Detail of the deul of the Rajarani temple in Bhubanesvar. Eastern Ganga, tenth century A.D.

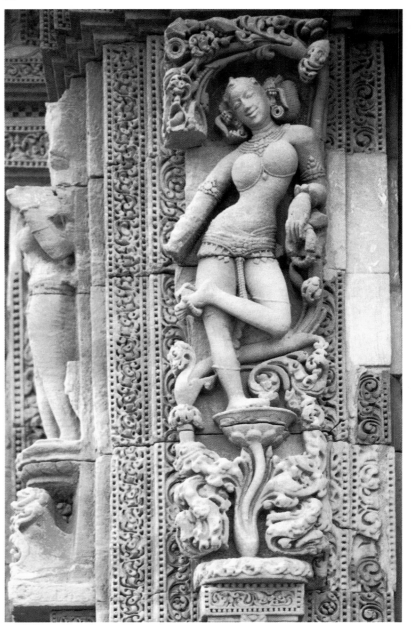

236. Detail of the deul of the Rajarani temple, Bhubanesvar. Eastern Ganga, tenth century A.D.

236

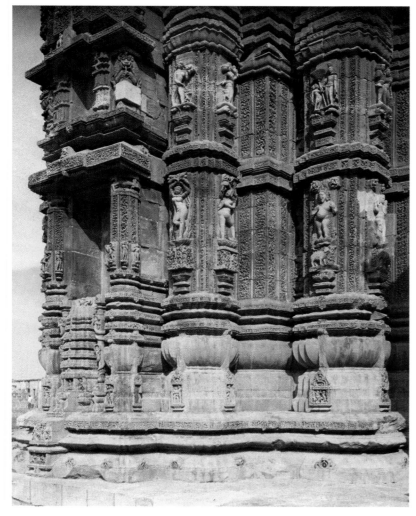

dance her pet peacock, recalling a description in Kalidasa's *Meghaduta:* talais sinjavalayasubhagaih kantaya nartito me yam adhyaste divasavigame nilakanthas suhrid vah.

The Lingaraja, a stupendous monument at Bhubanesvar, abounds in masterpieces of sculptural decoration. One of these, the Nayika awaiting her lover with her finger on her chin, a pose suggesting impatience and wonder, is a sculpture never to be forgotten.

Indeed, the most imposing monument ever raised by the Eastern Gangas is the Sun temple at Konarak. It is the creation of Narasimha, a descendant of the Chola princess Rajasundari, who was married into the house of the Eastern Gangas. This accounts for the introduction of a Chola motif, the horse and wheel, to convert the huge Sun temple into a lithic solar car, drawn by seven horses. Only the porch, or jagamohana, is left (fig. 238), which itself inspires awe in the visitor. The rich and elaborate decoration of this temple and its wealth of design and theme are unparalleled. Some of the carvings here are as much miniatures as many are monumental. The rough-hewn pink-colored larger carvings vie in beauty with the delicately worked details of the miniatures, which surpass the jeweler's art. Scenes from Narasimha's life with portraits of him abounded in this temple, and some of them are now preserved in the National Museum in New Delhi. The king is portrayed in various attitudes, as a poet appreciating contemporary poetry in an assembly of poets, as a devotee worshiping at the shrines built by his ancestors, as a warrior displaying feats of archery, and as a happy prince enjoying life seated on a swing in his harem (fig. 240), all narrations from his life, reflecting his versatility.

An earlier and especially charming phase of Orissan sculpture is seen at Mayurbhanj and Jajpur, and also at Lalitagiri. There are exquisite carvings from Mayurbhanj, in particular of Nagas, Naginis, and Siva in his various forms, where delicacy of treatment and detail of ornamentation surpass every other local school in Orissa. The Khiching Museum has some excellent examples of this school; of these a mother and child takes precedence over the rest.

The Gurjara Pratiharas were succeeded by the Gahadavalas. Gahadavala sculpture has much in common with contemporary sculpture from the regions of the Chandellas, the Paramaras, and the Chedis. A very important sculpture of the Gahadavala school is an inscribed Vishnu, recently unearthed near Kutab Minar and now preserved in the National Museum in New Delhi (fig. 256). A lovely female head from Rajorgarh in Bikaner, with a coiffure bedecked with flowers, is a masterpiece carved with utmost elegance (fig. 242).

Of the rulers in Central India in the region of Bundelkhand in the tenth to twelfth centuries, it is the Chandellas or the Chandratreyas, with their capital at Khajuraho or Kharjuravaha, who will be remembered forever for the innumerable magnificent temples raised by them in their capital and elsewhere. These temples are Brahmanical, Jain, and Buddhist.

The best known, the Kandariya Mahadeva temple (see fig. 243) on a

238

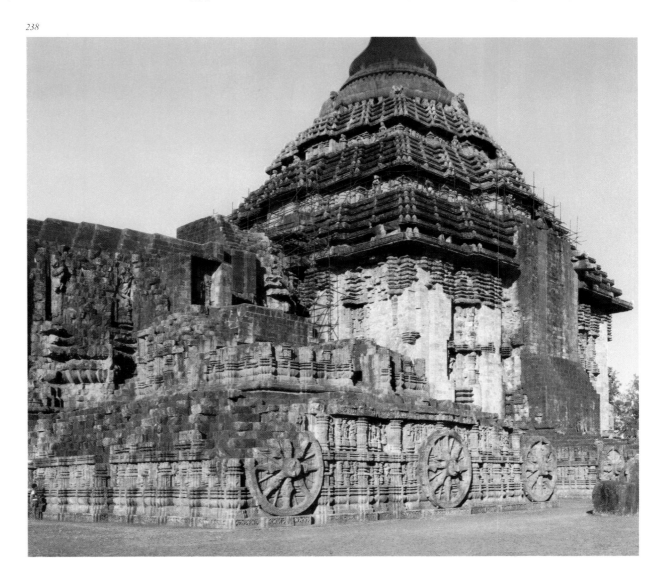

238. The colossal jagamohana of the Konarak temple in Konarak (Orissa). Eastern Ganga, thirteenth century A.D.
The wheels suggest that the whole edifice of stone is a moving chariot of the Sun-god.

239

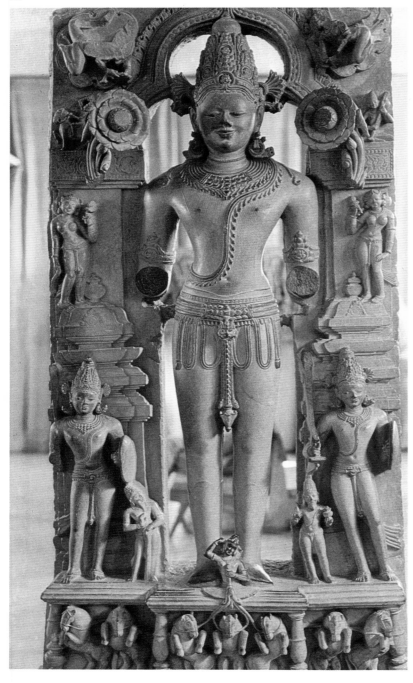

240

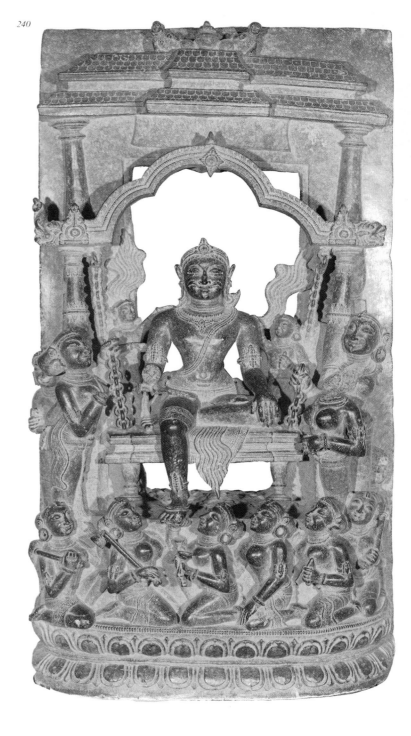

239. *Surya, the god of light, flanked by attendants such as Danda and Pingala and his consorts, Chhaya and Suvarchasa. From Konarak. Eastern Ganga, thirteenth century* A.D. *National Museum, New Delhi*
The blooming lotuses symbolize the rising sun.

240. *Narasimha enjoying a ride in a swing in the harem. From Konarak. Eastern Ganga, thirteenth century* A.D. *National Museum, New Delhi*
The gay prince, the sovereign who built the Sun temple at Konarak, was pious, learned, and heroic, as other similar portrait panels indicate.

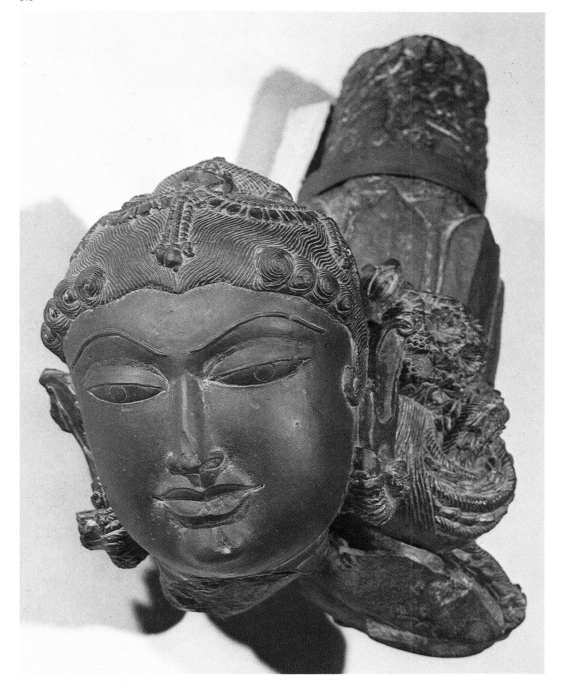

241. *Varunani, a noose in her hand, seated on a maraka. From Konarak. Eastern Ganga, thirteenth century* A.D. *National Museum, New Delhi*
An exquisite carving of a goddess whose representation is very rare.

241

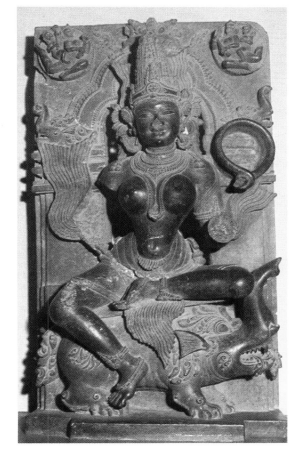

242. *Feminine head showing a tastefully decked coiffure. From Rajorgarh (Bikaner). Gahadavala, twelfth century* A.D. *National Museum, New Delhi*
Note the ringlets of hair, the strings of pearls as decoration, and the flowers tucked in the braid

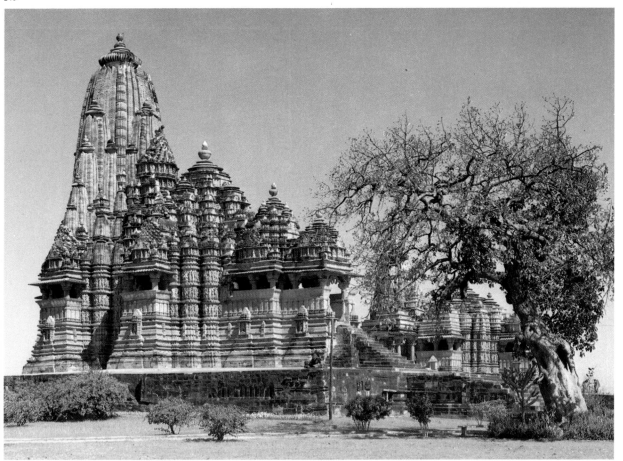

243. The Kandariya Mahadeva temple, the most elegant and famous of the group of temples at Khajuraho (Madhya Pradesh). Chandella, c. A.D. 1000

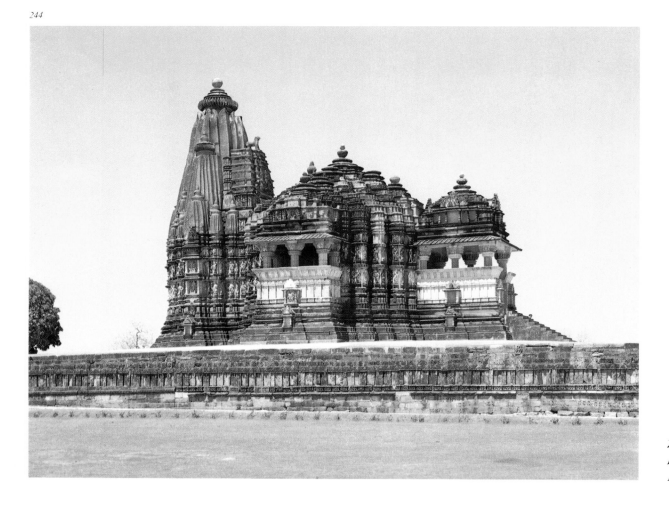

244

244. The Chitragupta temple at Khajuraho. Chandella, c. A.D. 1000

high plinth, has richly embellished walls all around, with niches and screens, pillars with bracket figures, and pavilions and courtyards, dazzling the eyes of the visitor by the wealth of sculpture and design. Here, the history of the monarchs of the line, the royal processions, the rich wealth of iconography, the Surasundaris, or divine nymphs, in diverse amorous attitudes, the figures of musicians and dancers, the lovelorn damsel sporting with a bird, adjusting a braid before a mirror (fig. 247), applying collyrium to her eye, or pulling out a thorn from her tender foot, are all brilliant creations of literary-minded artists.

It is indeed interesting to find that some of the sculptors from Mahoba, the Chandella capital, are known by name for their great sculptural triumphs. Sri Satana is mentioned as a great chitrakara, whose son Chitanaka, who carved the Bodhisattva found at Mahoba, describes himself as born into a family of painters well versed in the fine arts: chitrakara sri satanas tat putras sakalasilpavidyakusalas chitanakas tasyeyam. Even Sri Satana's daughter-in-law, who out of modesty refrained from giving her name here, carved a sculpture of Tara, as the inscription states: chitrakara sri satanas tasva vadhukasya iyam.

At Khajuraho itself, the lovely sculpture of a girl playing a flute is by the sculptor Sri Kana, whose name is inscribed.

A Chandella sculptor was so imbued with literary taste that he could chisel nail marks appropriately on the charming figure of a damsel writing a love letter (fig. 249), recalling the description of Magha. The application of a tilaka, an ornamental mark, to the forehead, the mother and child (fig. 248), and the loving mithunas (fig. 251) are themes excellently handled by Khajuraho sculptors. Especially charming is the delineation of the Buddha by a Chandella sculptor (fig. 252), with his robes so different from yet so near the indigenous Gupta type,

but with the folds depicted in a special way unlike anything that is known in early sculpture where the Western influence is easily perceptible.

The seated king and queen in the museum at Khajuraho (fig. 254) is an exquisite example of the portrait sculpture of donors; it can take rank with any of the finest portrait carvings of any school and of any date. It is interesting to compare with this pair another similar representation of a monarch seated with his queen, Hoysala Vishnuvardhana with his queen Santala, on one of the lithic screens in the temple at Belur.

The Paramaras, who ruled from Malwa, were responsible for some of the finest temples in their realm; particularly noteworthy is the Udayesvara temple at Udaipur built by Udayaditya in the middle of the eleventh century. But Bhoja is the most outstanding of the monarchs of this line. He was versatile. He was at once an engineer, a poet, a philosopher, a literateur, and a patron of learning and art. He established a great university in his capital, Dhara, where he enshrined a likeness of the goddess of learning, Sarasvati, with an inscription mentioning its installation. A line of the inscription: srimadbhojanarendrachandranagari vagdevi pratima vidhaya..., confirms how truly Bhoja, as a patron of learning, has remained a darling of poets in the memory of a grateful people. This magnificent sculpture, the most famous of its school, is now in the British Museum. The dancing figure of Nataraja on the Udayesvara temple itself is an equally interesting piece.

Just as the Paramaras ruled to the west of the Chandellas, the Chedis ruled to the east in the area of the former Rewa state in Bundelkhand. Karna, who was a contemporary of Bhoja of Malwa, was a great king of this dynasty. It is very interesting that a common source of inspiration, the Gurjara Pratiharas, has brought together the following

245. The Jagadamba temple at Khajuraho. Chandella, c. A.D. *1000*

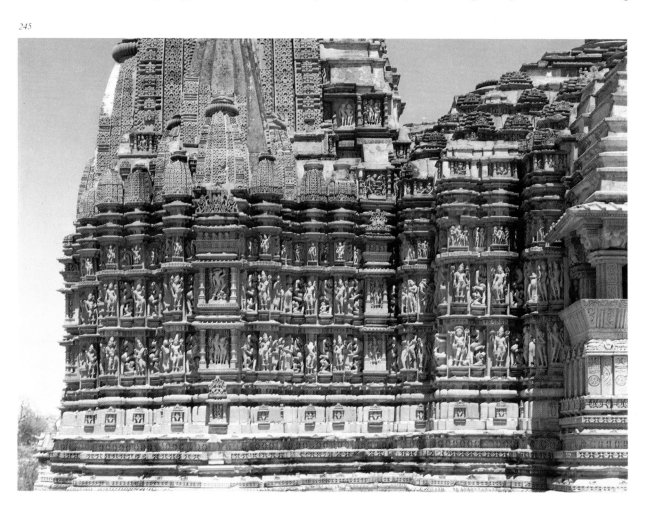

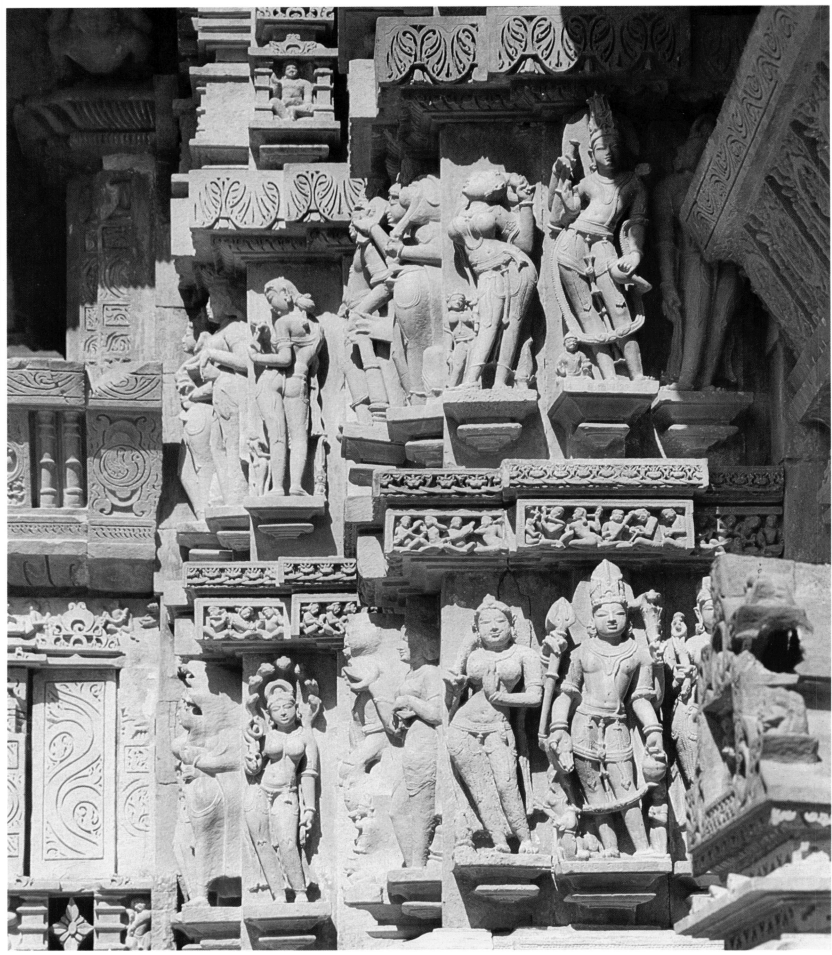

246. *The Lakshmana temple, Khajuraho. Detail showing the excellent figures. Chandella, c.* A.D. *1000*

247. *Damsel adjusting a braid before a mirror. From the region of Khajuraho. Chandella, tenth century* A.D. *Indian Museum, Calcutta*

248. *Mother and child. From the region of Khajuraho. Chandella, tenth century* A.D. *Indian Museum, Calcutta*
Note the natural treatment of the fondling of the child.

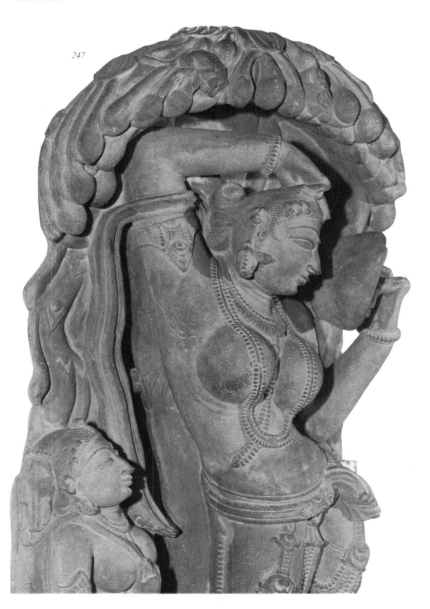

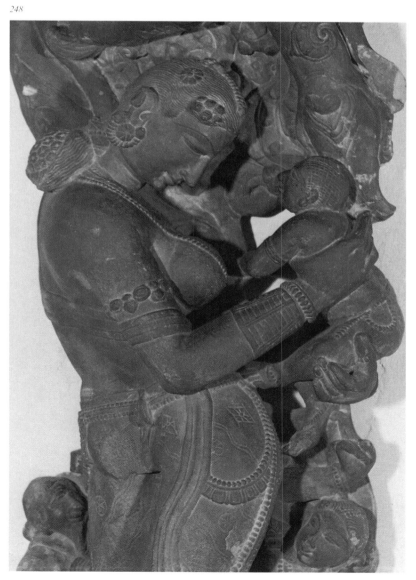

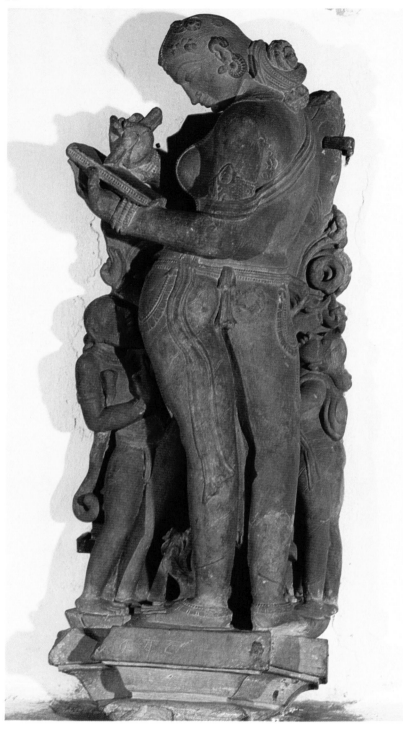

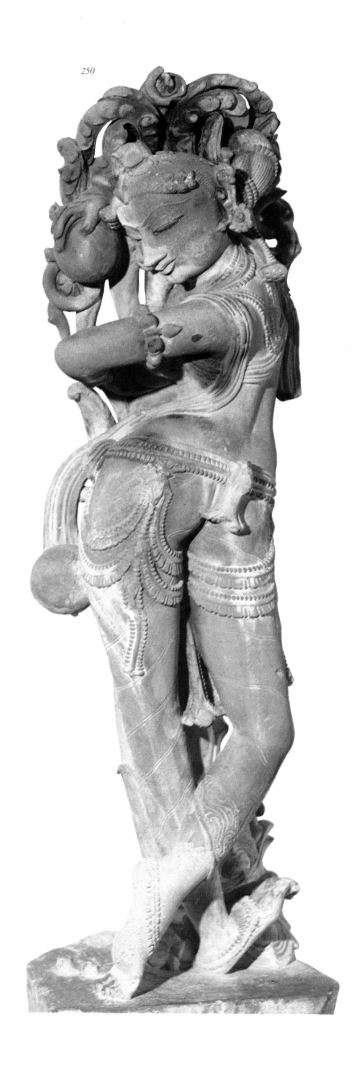

*249. Damsel writing a letter to
her beloved. From the region of
Khajuraho. Chandella, tenth
century A.D. Indian Museum,
Calcutta*
*An expressive sculpture. The nail
marks on the body naively recall
the lover's frenzy and are almost
the alphabet of love.*

*250. Damsel playing with a ball.
Chandella, tenth century A.D.
Khajuraho Museum*
*The ball springs up as if to chal-
lenge the figure's youthful breasts.*

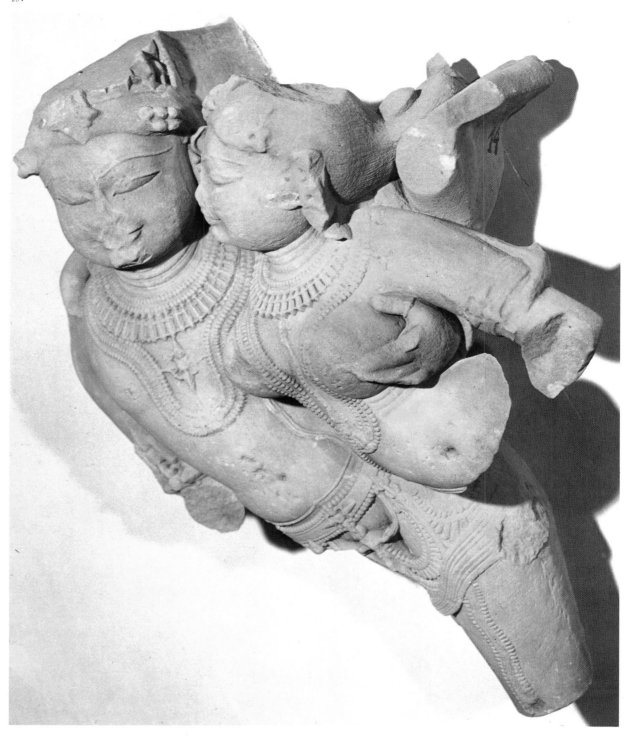

*251. The lovers. Chandella, tenth
century* A.D. *Khajuraho Museum
Note the beaming faces, the close
embrace, and the spirit of union.*

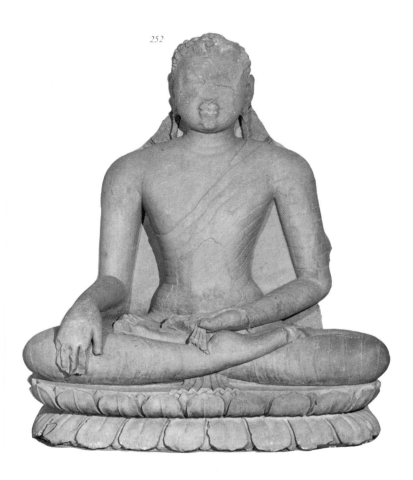

252

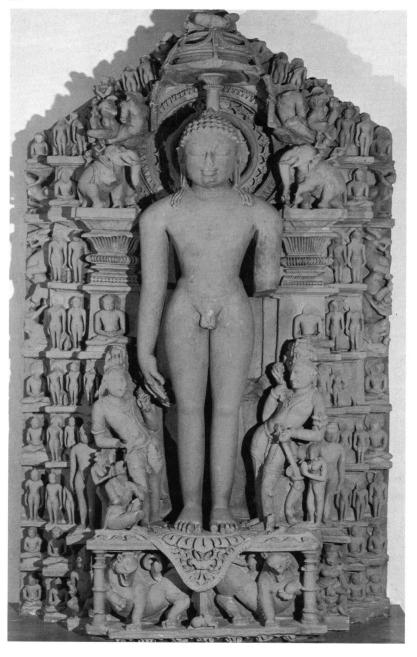

253. *Tirthankara Mahavira with attendants and the other earlier Tirthankaras in the background. Chandella, tenth century* A.D. *Khajuraho Museum*
Note the pleasing treatment of a theme that affords little scope for the sculptor's play on stance, drapery, and ornamental detail.

253

252. *The Buddha seated with one hand in the bhumisparsa mudra, or the earth-touching gesture. Chandella, tenth century* A.D. *Khajuraho Museum*
A rare and charming carving with diaphanous drapery arranged delicately.

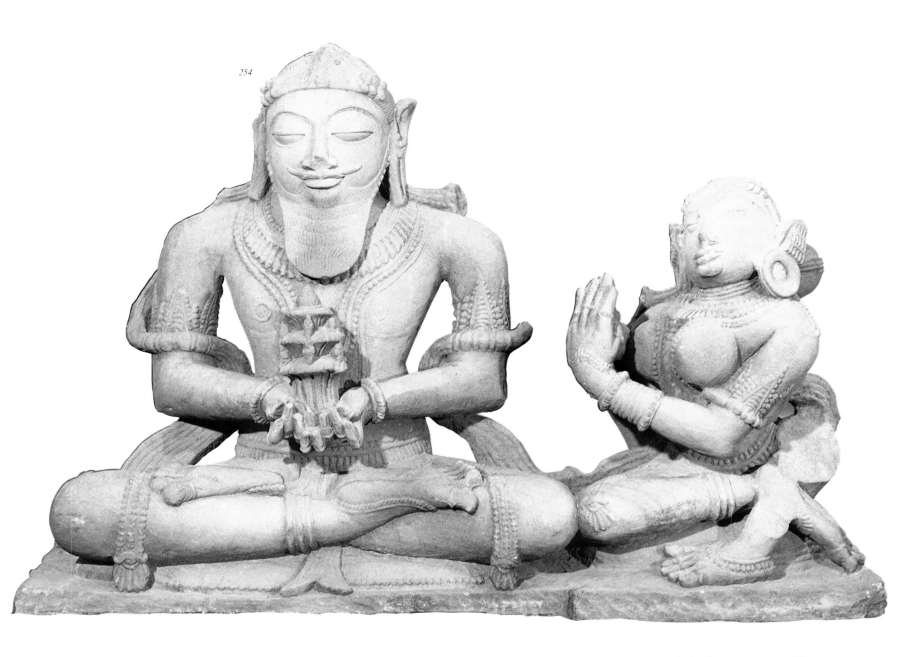

254

254. *Royal donor and his queen
with a votive offering. Chandella,
tenth century* A.D. *Khajuraho
Museum
A characteristic portrait of
its time.*

255. *Avalokitesvara. From Sirpur (Madhya Pradesh). Chedi, ninth century* A.D. *National Museum, New Delhi*
An exquisite bronze of the early medieval period from Central India. An inscription in Nagari on the pedestal gives the name of the sculptor as Dronaditya.

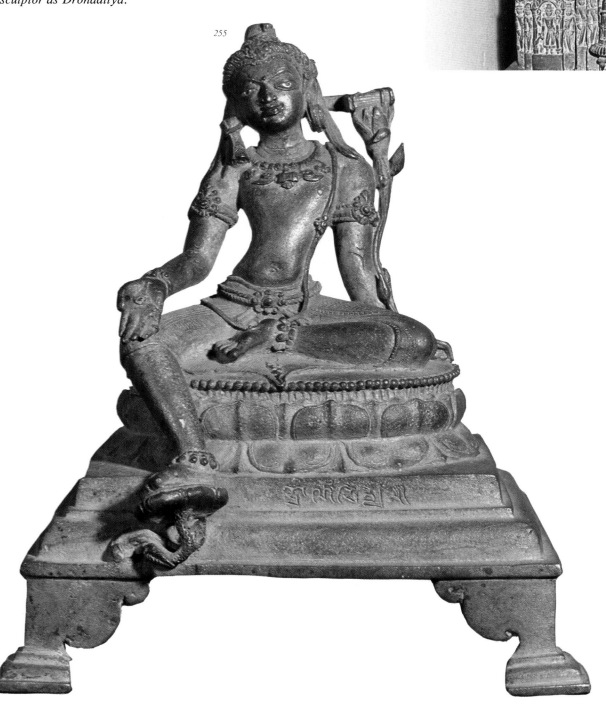

256. *Vishnu with his avatars arranged as decorative details on the background of the nimbus, or prabhavali. From Mehrauli. Gahadavala, twelfth century* A.D. *National Museum, New Delhi*
The inscription on the pedestal mentions the sculpture's dedication by an affluent merchant in the vicinity of the present Kutab, then known as Vishnugiri, where a temple of Vishnu existed; its remains can still be seen.

257. *Pillared hall, or mandapa, of the Sun temple, Modhera (Gujarat). Chalukya, twelfth century* A.D.
Note the richly carved stone pillars with a wealth of iconographic detail.

schools: Chedi, Gahadavala, Chandella, and Paramara. Ganga and Yamuna, fashioned on the doorway of the temple at Chandrahi, represent the early phase of Chedi sculpture. At Sohagpur in the Viratesvara temple, the theme of Surasundaris is cleverly handled by the sculptor. Similar bracket figures also abound on the pillar capitals of the mandapa. The famous temple of the sixty-four Yoginis at Bheraghat has examples of the tenth or eleventh century. The Chedi carvings here, with the names inscribed, give us a wealth of iconographic detail and present as it were a visual textbook of forms of deity. There are rare names like Gumbtali, Bhishani, Darpahari, Uttala, Rikshamala, Phanendri, etc. The magnificent torana, or carved gateway, of the medieval period of the temple of Siva at Gurgi is rivaled only by the Chalukya torana at Dabhoi.

There are beautiful metal images from Sirpur (see fig. 255), some of them inscribed, representing Buddhas and Bodhisattvas, easily dated by the palaeography of their inscriptions which clearly corroborates the style of workmanship of the period; they come close to the Chedi carvings from Sutna and point to the sculpture of this area. A bronze in the National Museum in New Delhi mentions the name of the sculptor Dronaditya.

In Gujarat, the descendants of Mularaja were reigning when Mahamud of Ghazni sacked Somanath. Bhima, a nephew of Durlabha, was the ruling sovereign of the time. Jayasimha, also known as Siddharaja, added a portion of Rajasthan to his kingdom. Being an art lover, he constructed several temples. His son Kumarapala was a staunch Jain. Later, Lavana Prasada, of a branch line, became a powerful king, and his son Viradhavala had as his minister Vastupala, whose brother Tejahpala was the richest merchant of Dholka.

The Sun temple at Modhera (see fig. 257) and the Vimala temple at Mount Abu are very important early structures in this area; the Somanath, Navalakha, and Tejahpala temples at Shatranjaya and Mount Abu are twelfth-century work, as are also the richly carved toranas from Gujarat. Those from Dabhoi, Modhera, and Vadnagar should be especially mentioned. The amritamanthana scene on the Dabhoi torana is the finest representation of a theme often repeated in sculpture through the centuries, although the mithuna motif, the Sura-

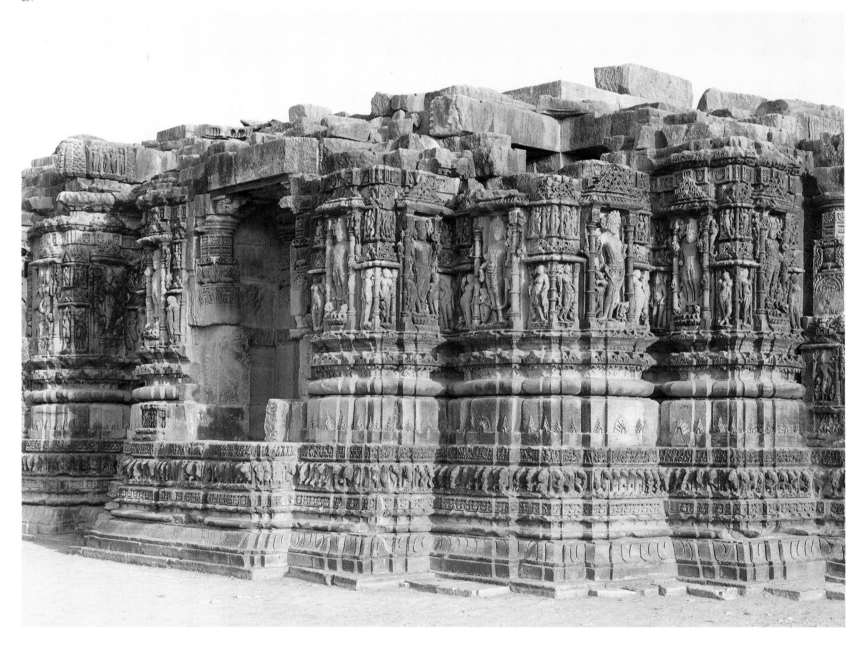

257

217

sundaris, and innumerable carvings of subjects both real and imaginary are also genuinely pleasing. There are groups of musicians and, in different courses, friezes of elephants, horses, and troops (gajaratha, asvaratha, nararatha), in the temple of Modhera.

The liberality of the art-minded wife of Tejahpala, who helped Sobhanadeva and other architects on the Satrunjaya hill, and the similar spirit of her husband in trying to reward the skilled architects, have borne fruit as it were in the miraculous works of art created by them and in the portraits of the donors carved by the grateful recipients of this unstinted encouragement.

Though there are no murals to illustrate the painting of this period, there are illustrated manuscripts from western India (see fig. 261), palm-leaf ones from the eleventh and twelfth centuries, and rich and colorful paper manuscripts with gold and silver lettering from the next two or three centuries on, with profuse painted decoration to illustrate such texts as the *Kalpasutra*, *Kumarapalacharita*, *Kalakacharyakatha*, which are Jain, and others such as the *Vasantavilasa* and *Balagopalastuti*. The simplicity of color and stylized form, the peculiar bulge of the eyes (one of them appearing outside the contour of the face), and other characteristics make these paintings distinctive. Some of these features, noted in the latest series of paintings at Ellora, point to a continuity of tradition in Gujarat and Rajasthan.

The later Rajasthani schools of art are a continuation of the earlier style. Particularly interesting are the large murals from Udaipur that demonstrate how completely the artist was at home in painting both walls and miniatures. The Rajasthani painter continued a conservative fashion in painting for quite a long time (see fig. 380), unaffected by Mogul influence, which, however, inevitably came to be felt at a later stage, as in the Bundi school. The Rajput painting (see fig. 393), unlike the Mogul (see fig. 381), which was aristocratic and individualistic and strong in portraiture, was in tune with the simple life of the folk, sublime in theme, universal in appeal, religious and mystical, with a love of nature in all its manifestations, animate and inanimate, bird and beast, man and woman, streams and brooks, hills and valleys, trees and creepers. The Pahari schools of the hilly region show the least trace of foreign influence and the strongest throb of life (see fig. 394). Hindu religious fervor and love of nature are abundantly present. While a strong folk element is obvious in the virile Kulu (see fig. 389) and Basohli schools, the Kangra and Guler schools (see, respectively, figs. 264 and 386–388, 390) exhibit the most graceful contours of form and suitable handling of color. The themes are the sports of Krishna, the story of Rama, the Raga-raginis, Nayika-Nayakas, months and seasons personified, among several others.

In the Deccan, on the decline of the great power of the Vakatakas, the

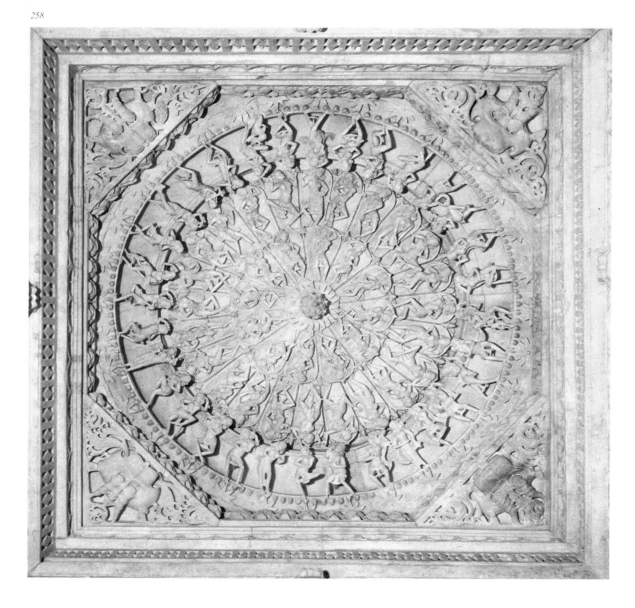

258

258. Ceiling of a Jain temple, Mount Abu (Rajasthan). Chalukya, eleventh century A.D. An elaborate pattern of concentric circles composed of dancers and musicians forms the decoration.

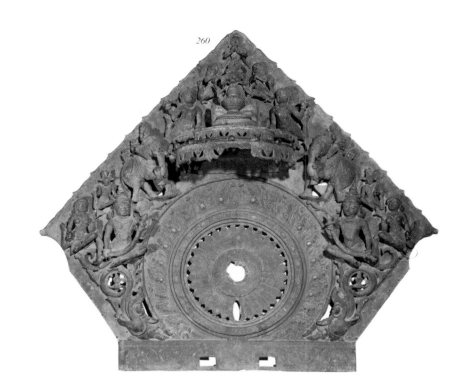

259. Dancing figures. Detail of a carved pillar, Dilwara, Mount Abu. Chalukya, thirteenth century A.D.

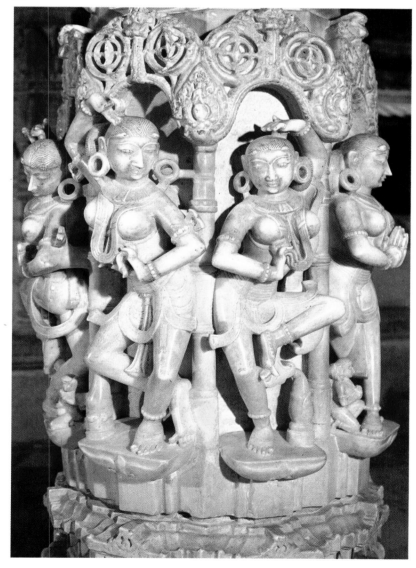

260. Circular halo and the richly carved metal back frame for a seated Tirthankara, now missing. From the region of Dilwara. Chalukya, eleventh century A.D. National Museum, New Delhi Note the delicacy of the workmanship and the fine grouping of flying celestials, elephants, the triple umbrella, and ornamental patterns.

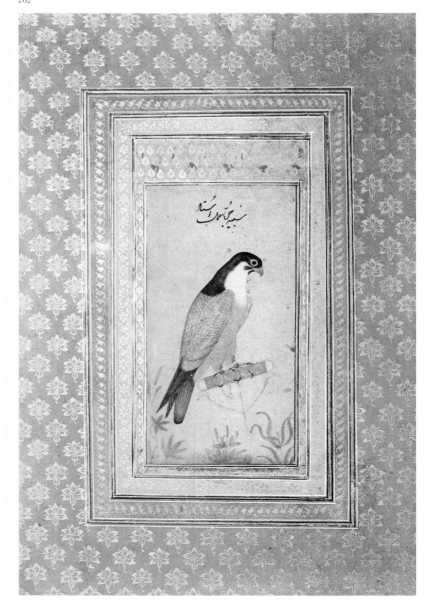

261. The dance of the Apsarases. Illustrated page from a Jain manuscript of the Kalpasutra. *From western India, fifteenth century* A.D. *National Museum, New Delhi*

262. Mogul painting

263. Mewar or Malwa painting

Western Chalukyas of Badami rose to prominence. Mangalesa, the brother of Kirtivarman, was a powerful king and a great connoisseur of art. To beautify his capital, he excavated in the rock magnificent cave temples, of which Cave 3 (see figs. 269 and 271), the Vaishnava cave as it is called, is as spacious as it is well embellished and as aesthetically elegant, for it bespeaks the religious fervor of the sovereign, who has an inscription describing in detail the carving and dedication of this rock-cut temple.

The earliest examples of this phase of art are from Mahakutesvara, Aihole, Badami, and Pattadakal. The pillar inscription from Mahaku-tesvara, of the sixth century A.D., shows how close the Western Chalukyas are to the Guptas and the Vakatakas. It is no wonder that the earliest examples of Western Chalukyan sculpture closely resemble the earlier Vakatakan.

The apsidal temple of Durga at Aihole is very early in date. Some of the finest panels representing deities, such as the Mahishasuramardini, Narasimha, Siva, Vishnu, Varaha, embellish the apse which encloses the central shrine. The pillars of the front mandapa have some very fine carvings (fig. 266). The ceiling originally had a number of lovely Vidyadhara panels, two of which are now in the National Museum in New Delhi (see fig. 265). This theme of flying celestials (Vidyadhara) is a great favorite from the early centuries of the Christian era, but the perfected figures occur mostly in Gupta-Vakataka and Chalukya-Pallava carvings.

The Ladkhan temple, also at Aihole, has a very early symbolic representation of river-goddesses flanking the entrance. The purnakumbha, or vessel filled with water, is repeated on either side, and among the mithuna motifs here, one is of a kinnara and a kinnari, the latter with an equine head, recalling the asvamukhi so often mentioned in literature. Such noteworthy sculptures as Seshasayi, Haragauri, and Brahma (fig. 268) now preserved in the Prince of Wales Museum of Western India in Bombay closely resemble the panels in the Kunti temple at Aihole. The adoration of Brahma by Rishis, the swan looking up to him, the krishnajina worn by the deity as uttariya and yajnopavita, the attributes closely related to sacrifice that he holds, the pleasing bearing of the figure itself, even the attitude of the swan looking at his master, all bespeak the dexterity of the early Western Chalukyan sculptor.

Equally important is the lovely Haragauri panel, where the charm of Parvati, who looks longingly toward her spouse, is praiseworthy. A

263

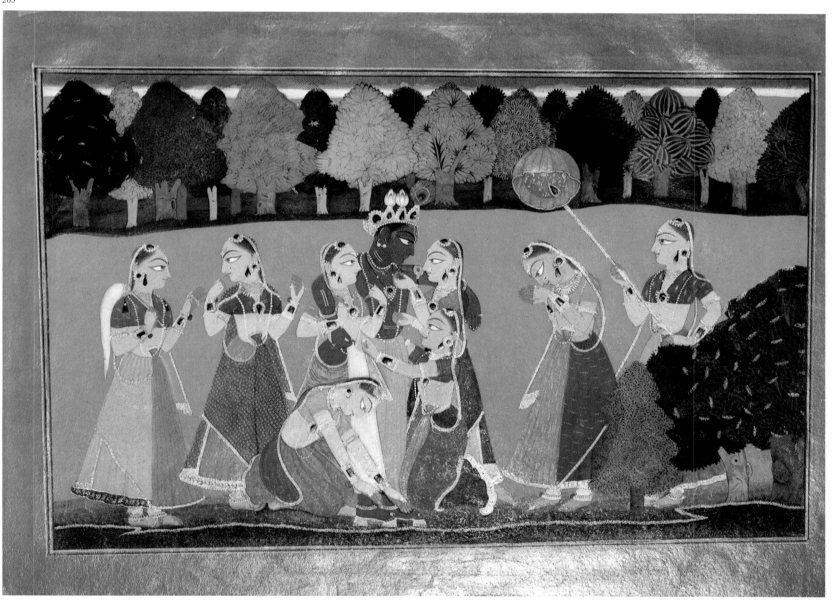

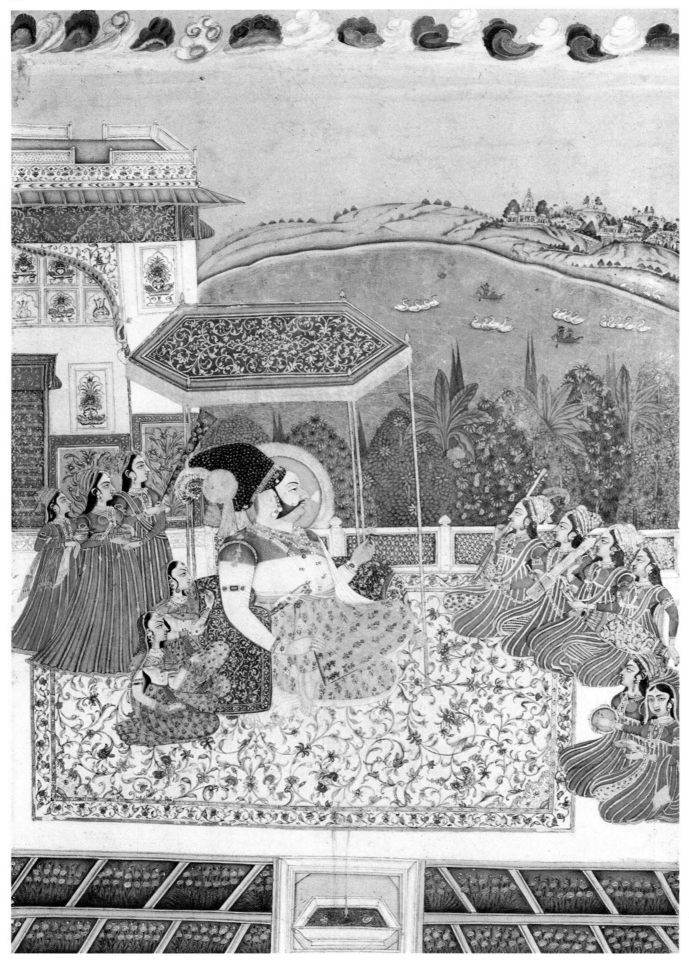

most effective Vidyadhara couple is also from Aihole; there is movement in the disposition of the limbs of the loving pair, flying amid clouds, with fluttering garments, suggesting speed of movement.

The Vaishnava cave at Badami is probably the most important of the cave group. Here there are imposing panels representing Vishnu seated on a snake (fig. 269), Varaha, Trivikrama, and Narasimha, each one of which arrests attention. There are equally beautiful groups of figures against the capitals of the pillars which are as significant as they are aesthetically attractive (see fig. 271). The ceiling of this cave is executed with no less dexterity. It is interesting that the inscription, dated A.D. 578, describes the cave temple as "exceeding the height of two men and of wonderful workmanship, extensive in its major and minor parts,

ceiling, and sides, all extremely beautiful to behold": layanamahavishnugriham ati dvaimanushyakam atyadbhutakarmavirachitam bhumibhagopabhagopariparyantatisayadarsanoyatamam. (See J. Eggeling, ed., 'An Inscription from Badami,' *Indian Antiquary*, III, 1874, pp. 305–6; J. Burgess, 'Rock Cut Temples at Badami,' *ibid.*, VI, 1877, pp. 363–64; for correction of the reading and translation, see C. Sivaramamurti, 'Indian Epigraphy and South Indian Scripts,' *Bulletin of the Madras Government Museum*, N.S. IV, No. 4, 1948.)

Pattadakal is another place in the vicinity where the fecundity of early Chalukya art can be seen. Here the inspiration of Pallava art from Kanchi has greatly enriched and ennobled Chalukya art. An inscription in the Virupaksha temple at Pattadakal proclaims the proficiency of the

265

265. *Flying Vidyadharas, or celestials. From Aihole (Deccan). Western Chalukya, sixth century* A.D. *National Museum, New Delhi The swift but soft movement of the loving celestial couple is indicated by the lines of their body contours, their fluttering garments, and the clouds.*

266. *Pillared hall of an apsidal temple at Aihole. Early Western Chalukya, sixth century* A.D.

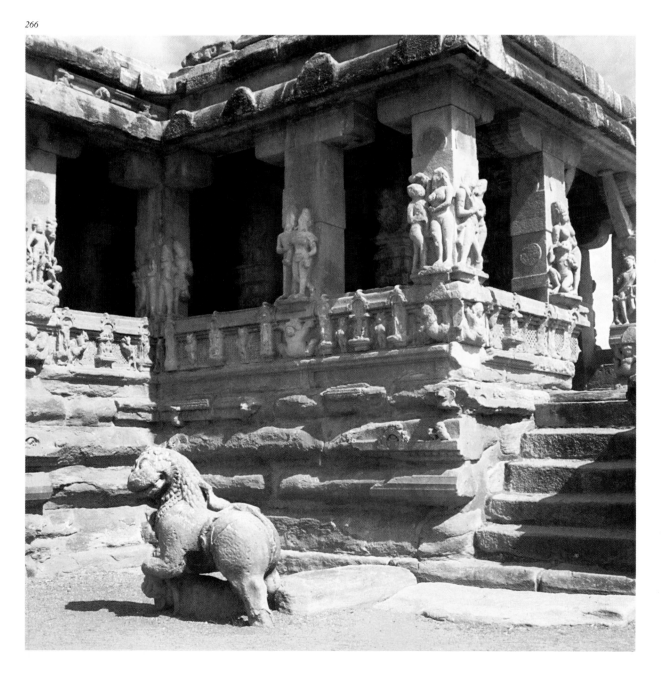

267. *Umamahesvara. From Ai-
hole. Western Chalukya, sixth
century* A.D. *Prince of Wales
Museum of Western India,
Bombay*
*This is a simple but effective
portrayal of the family of Siva
with Uma, Ganesa, Skanda, the
prancing ganas, and adoring
sages.*

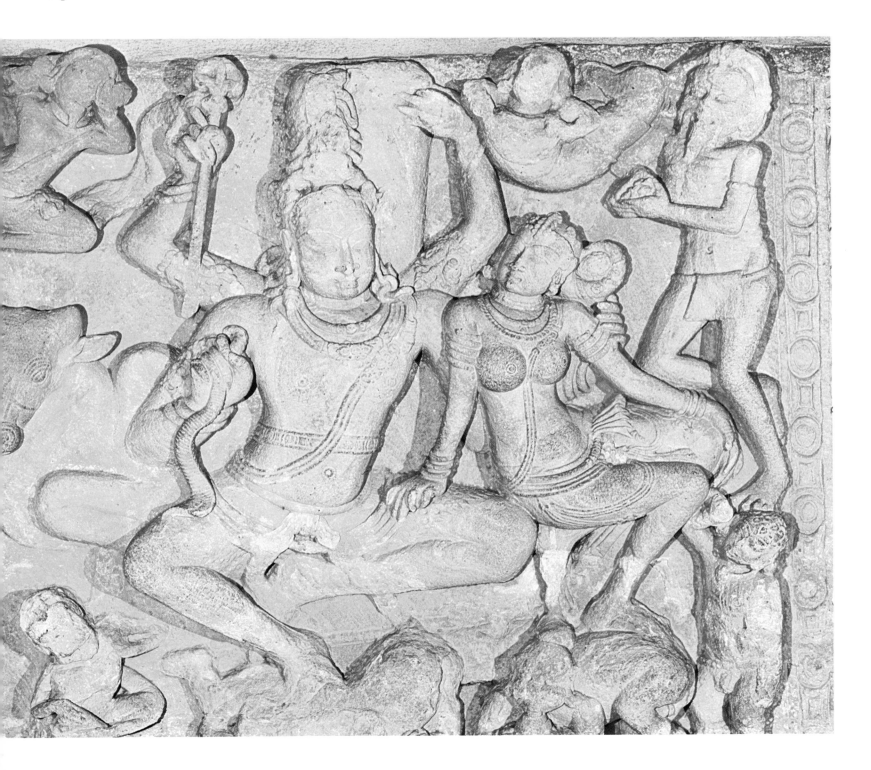

architect Sarvasiddhi who erected it. Sarvasiddhi, who was from the south, was exceptionally qualified to fashion innumerable types of monuments. The connoisseurship of the great victor Vikramaditya accounts for his bringing sculptors from the south to build and embellish the Virupaksha temple at Pattadakal, and an inscription at Kanchi in the Pallava temple of Rajasimhesvara mentions Vikramaditya's appreciation of the works of art created there. Fortunately he had as his helpmate an equally art-minded consort, Trailokyamahadevi, who helped him in his undertakings in the arts.

A danseuse and a lovely lamp chain with a prince on an elephant attended by a chauri-bearer are decorations in metalwork in the best tradition of early Western Chalukyan art and show the trends in this craft; they come from near Jogiswara in the vicinity of Bombay and the ninth-century Bahubali, and are both in the Prince of Wales Museum, Bombay.

The discovery of paintings in the heavily vaulted roof of the front mandapa of the Vaishnava cave by Stella Kramrisch has given to the world what little there is of painting of the early Western Chalukyan school (see fig. 270). These paintings are among the earliest from Brahmanical temples. One of the panels represents Indra seated in his palace, witnessing dance and music—the dance of Urvasi—in the presence of the dance master Bharata himself. The next panel in this context depicts the royal personage Kirtivarman, the departed brother of Mangalesa. There Mangalesa, the beloved brother, with great love and respect has depicted his royal elder brother as a great ruler on earth who had reached heaven and become a partner in celestial glory with

268

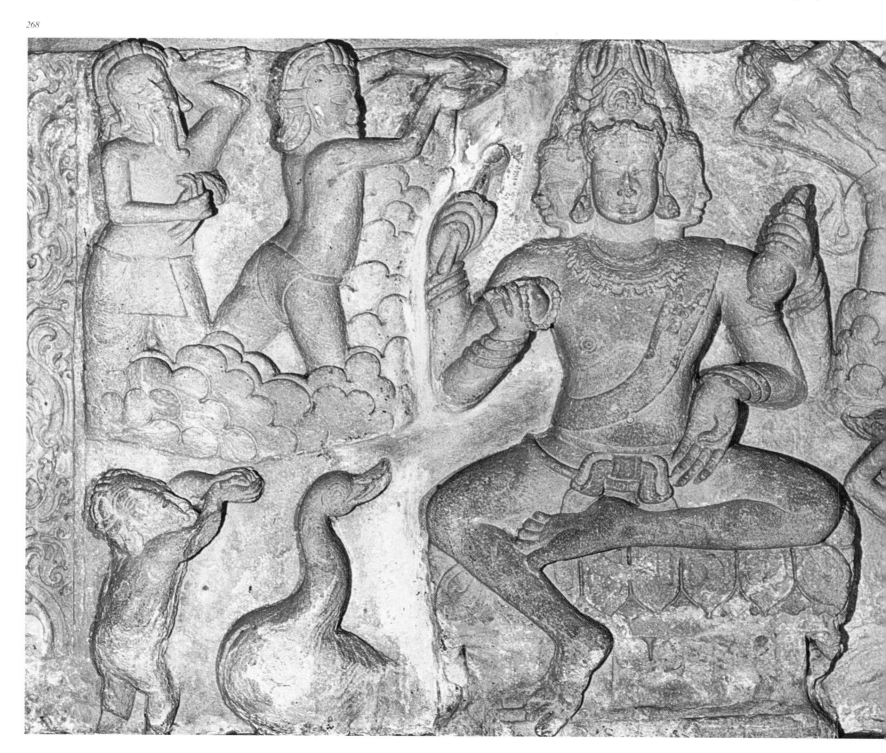

226

268. *Brahma. From Aihole.*
Western Chalukya, sixth century
A.D. *Prince of Wales Museum*
of Western India, Bombay
Brahma, the lord of creation,
is shown receiving the worship
offered by the celestial and
terrestrial sages above the clouds
and on the ground below. The
reverential look of even the swan,
Brahma's mount and the source
of sacred scripture, is interestingly
portrayed.

269. *View of a colonnade with*
the seated Vishnu on Sesha at
the farther end. Vaishnava cave
(No. 3), Badami (Deccan)

269

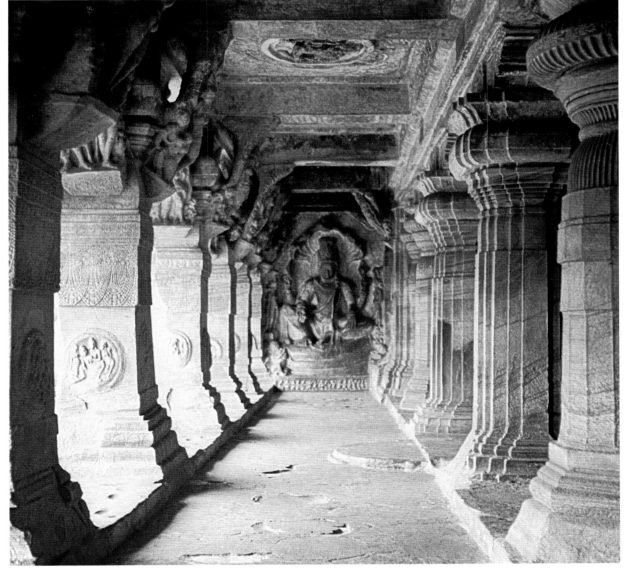

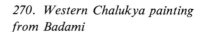

270. *Western Chalukya painting from Badami*

271. *Celestial loving couple, or dampati. Decoration on a pillar bracket. Vaishnava cave (No. 3), Badami*

Indra. Among the extant fragments of painting are pairs of flying Vidyadharas. Even the colors depicting the damsel fair of form and her consort, greenish blue in complexion, recall a description in a poem by Kalidasa: indivarasyamatanur nriposau tvam rochanagaurasarirayashtih (*Raghuvamsa* VI, 65). These few fragments are of great consequence to the study of the early medieval phase of painting in the Deccan.

In the south, with Kanchi as his capital, the great art-minded king Mahendravarman ruled as a contemporary of the Western Chalukyas. Because of his art-mindedness he was called Vichitrachitta and Chitrakarapuli. He was versatile and always curious to create new forms of art and architecture. For the first time in his kingdom, he experimented with excavating temples in the living rock. His famous inscription from the cave at Mandagapattu reveals his own wonder at his creation of such monuments, which were neither of brick, nor of wood, nor of metal, nor of mortar, but something totally different from these: etad anishtakam adruman aloham asudham vichitrachittena/ nirmapitam nripena brahmesvaravishnulakshitayatanam. (On the inscription, see T. A. Gopinatha Rao in *Epigraphica Indica*, XVII, 1923, pp. 14–17.)

The triple cell for Brahma, Vishnu, and Siva is an inspiration that Mahendravarman drew directly from the home of his maternal grandfather, Vikramahendra of the Vishnukundin family. The triple cell was seen earlier at Mogalrajapuram. The dvarapala, or door guardian, in Mahendravarman's cave, with his hair arranged in a large mass on either side of the face and resting on the shoulders, with heavy drapery, and with hands on the waist, or raised in wonder, or in a threatening attitude, which are special characteristics of the period, recalls similar figures, in particular those with the yajnopavita, or sacred thread, running over the right arm, in earlier Western Chalukya and Vishnukundin carvings. Mahendravarman's cave in Tiruchirapalli has a magnificent panel representing Gangadhara, one of the finest creations of early Pallava sculptors. The princely figure in the Mahendravarman cave at Tirukalukundram is an especially noteworthy carving.

Narasimhavarman, Mahendravarman's son and successor, was responsible for several monuments at Mahabalipuram. The heavy pillars of the Mahendravarman period were replaced in the time of Narasimhavarman by slenderer ones, sometimes resting on a seated lion. The group of cowherds and milkmaids in the Govardhana scene is indeed amazing (figs. 272 and 274), but more amazing is the creation, on a great boulder, of the gigantic group depicting Arjuna's penance (figs. 273 and 275).

272. *Govardhana, a mountain raised by Krishna. Govardhana cave, Mahabalipuram (South India). Pallava, seventh century A.D.*
The second most impressive massive composition at Mahabalipuram, representing a sculptor's dream of an ideal group of cowherds, milkmaids, and cattle for whom Krishna created a rock shelter.

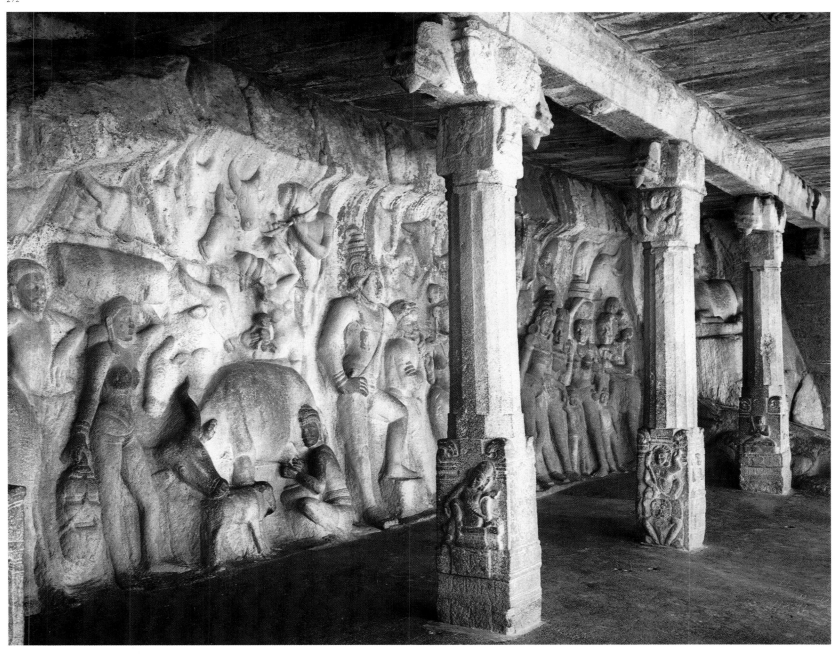

A crevice in the rock has been utilized to represent the river Ganga, on the banks of which Arjuna won, by austerities, the valued Pasupata weapon of Siva, which is the theme of this great artistic creation.

Of the two Varaha caves, one is particularly important for the famous portrait panels representing Mahendravarman and Simhavishnu, both with their names inscribed. Narasimhavarman, with great affection, provided the finest panels for his father and grandfather and for himself only a comparatively unimportant lone portrait figure on the Dharmaraja ratha. No one who has seen the Mahishamardini cave can forget either the Mahishamardini panel (fig. 276) or the Seshasayi in front of it.

Among the various extant monolithic temples at Mahabalipuram, which include the large and imposing Dharmaraja ratha, with a wealth of iconographic detail in the panels; the long barrel-roofed Bhima ratha, as it is known; the simple leaf-roofed, hut-shaped, decorative Daraupadi ratha; and the apsidal Nakulasahadeva ratha, the Arjuna ratha is probably the most elegant and most tastefully decorated with carving. Here, on one side, is a very lovely carving of Siva as Vrishabhantika (fig. 278), resting his hand on the bull and attended by a royal couple on either side, the Pallava kings dedicating themselves in that fashion eternally to the service of the deity whom they glorified.

At Mahabalipuram itself, there are examples of the later, structural variety of temple, the shrine near the lighthouse and the Shore temple (see fig. 281) being the most important here. In these constructed (as opposed to rock-cut) temples, where the main shrine is large and imposing, the entrance tower is very small; it is a tiny gopura, as we know from the Kailasanatha temple at Kanchipuram. Here, for the first time, there are mandapas added to the pillared hall of the temple

275. The Sun, Vidyadharas, kinnaras, or faun musicians, and mithunas, or erotic couples, etc. Close-up of Arjuna's penance (see fig. 273).

273. Arjuna's penance. Mahabalipuram. Pallava, seventh century A.D.
The most impressive massive composition at Mahabalipuram. That the river Ganga flows through the celestial, terrestrial, and nether regions is indicated by the celestials above (including the sun and moon), the sages and hermit boys near a temple, and the elephants of the quarters, respectively, of these three regions.

274. Milking the cow. Detail from figure 272. Govardhana cave, Mahabalipuram. Pallava, seventh century A.D.

273

274

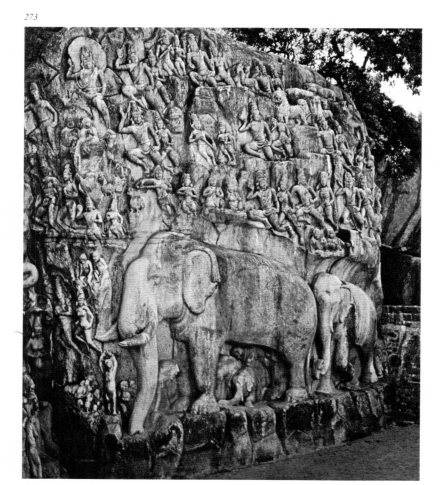

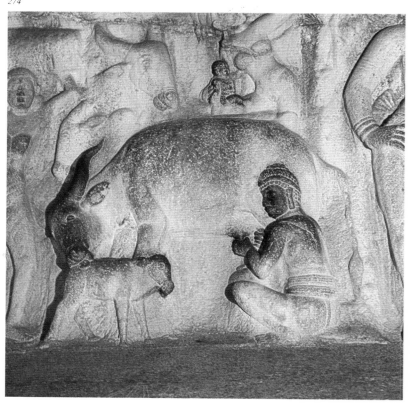

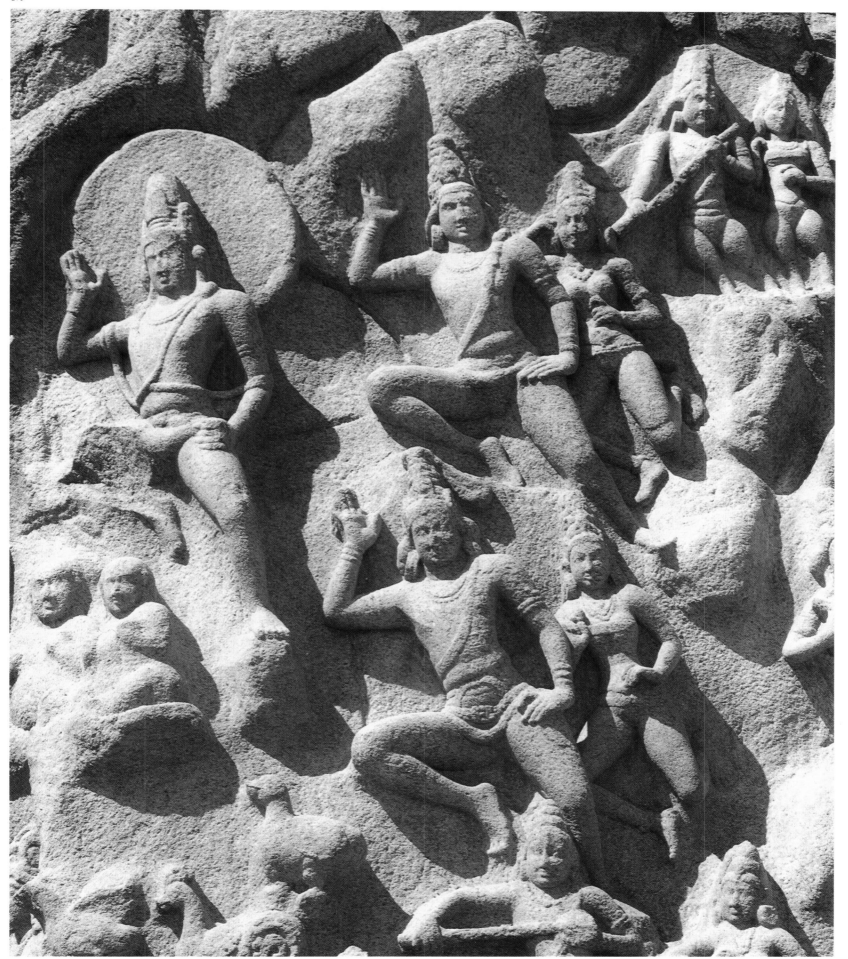

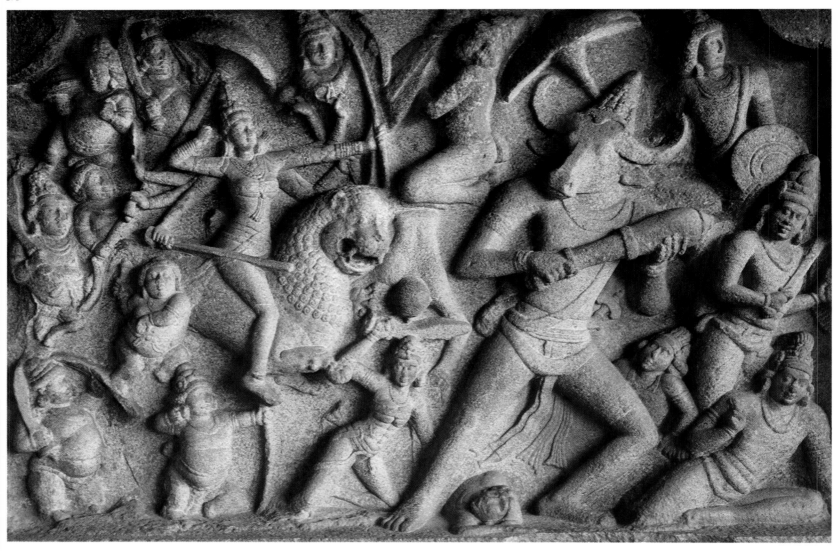

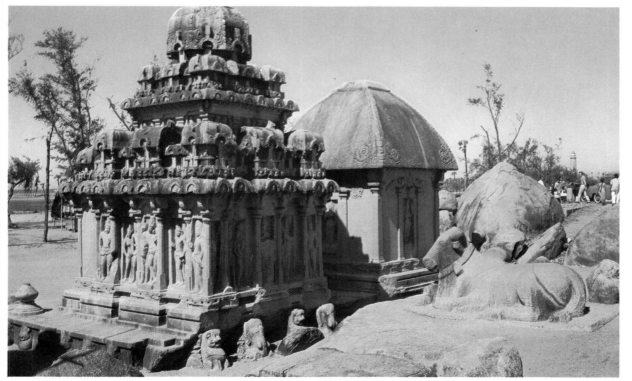

276. Mahishamardini on a lion with his retinue attacking the buffalo demon. Mahabalipuram. Pallava, seventh century A.D.
One of the most famous sculptures of its period. The cave is named after the theme represented.

277. Arjuna and Daraupadi rathas, or temples, at Mahabalipuram. Pallava, seventh century A.D.
Freestanding monolithic temples of supreme importance for the study of the development of Pallava art.

278. *Siva as Vrishabhantika.*
Detail of a carving on the Arjuna
ratha at Mahabalipuram. Pallava,
seventh century A.D.
The subject is exquisitely carved.
The royal couple on either side
and the princely attendants with
fly whisks are most elegantly
portrayed.

and a perambulatory passage in the open courtyard with cloistered cells all around. In their workmanship the later Pallava carvings exhibit greater detail, lighter handling of anatomy, and more developed artistic finish. The temples at Kanchipuram such as the Kailasanatha, Vaikunthaperumal, Avravatesvara, and Muktesvara are splendid works. In all these temples, the central shrine has a carving of Somaskanda (see fig. 282) prominently placed behind the Sivalinga, which is specially fluted. Virabhadra, of the Matrika group in Pallava art, is sometimes represented as Yogadakshinamurti, as in the famous group in the Government Museum in Madras. The Vaikunthaperumal temple is particularly rich in historical carvings depicting in successive panels all around the inner walls of the temple the origin and growth of Pallava sovereignty.

Kaveripakkam, in the North Arcot district, has some especially note-

278

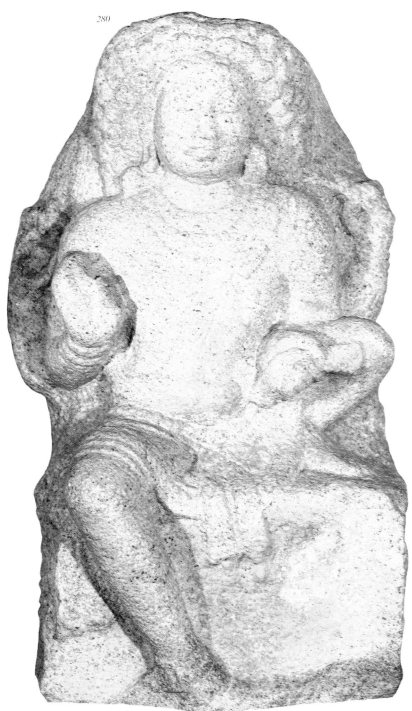

280

279. Somaskanda, or Siva with Uma and the baby Skanda. From Mahabalipuram. Pallava, eighth century A.D. *National Museum, New Delhi*
The unity of the Trinity in early sculpture is here indicated by the presence of Brahma and Vishnu in the background. This, the most popular theme in Pallava art, is always found depicted in the central shrine.

280. Dakshinamurti, or Siva as the Supreme Teacher of the universe. From South India. Pallava, ninth century A.D. *National Museum, New Delhi*
The smile on the face and the hand in the chin mudra, the gesture of explication of the Law, proclaim his mute eloquence.

worthy Pallava sculptures; their Rashtrakuta elegance, fused into Pallava art, recalls the matrimonial relationship between the Rashtra-kutas and the Pallavas, which accounts for even the name Dantivar-man. The Pallava king of this name was so called after his royal Rashtrakuta grandfather on the mother's side.

The Somaskanda in the National Museum in New Delhi (fig. 279) is one of the most elegant works of the Pallava period; equally important is the Bhikshatana and Alidhanritta Siva, a small but elegant panel, in the same museum. A late Pallava representation of Dakshinamurti in the National Museum (fig. 280) is important as showing how the Pallava sculptor continued until the end to create wonderful works of great aesthetic value.

In consonance with the size of the Pallava shrines, their metallic images, used for festival processions, were cast as miniatures. They were, however, fashioned with the utmost elegance, with all the details worked out in the wax itself, so that, when reproduced in metal, they required the least amount of finishing. The Vishapaharana from Kilapuddanur, Natesa from Kuram in the urdhvajanu pose, Tripurantaka with a single pair of arms in the Sarabhai Collection, the miniature Somaskanda from Tiruvalangadu, more Pallava-looking than the transitional work between Pallava and Chola that it is, some Vishnu miniatures, and a few more are among the numerically smaller group of Pallava images in metal. Two or three rare terra-cottas which can be assigned to the Pallava age were discovered by Jouveau-Dubreuil in Pondicherry and are now in the Madras Museum.

Again it is Jouveau-Dubreuil who discovered the early paintings in the temples at Kanchipuram and Panamalai in South India. In the Kaila-sanatha temple at Kanchi, there are several fragments of paintings in the cloister cells, but the most beautiful of all, and also comparatively better preserved, is the Somaskanda (fig. 282), which well illustrates the painter's art of Rajasimha's time toward the end of the seventh century. The painting clearly shows the artistry in the flow of the lines

283

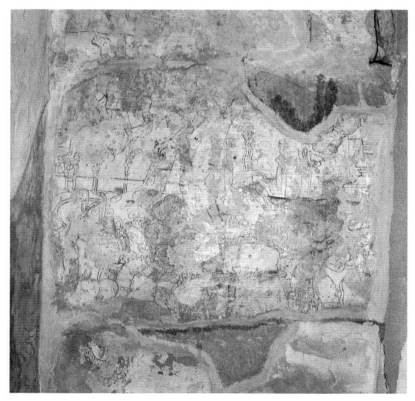

282

282. Somaskanda, a painting depicting Siva with Uma and Skanda seated. In one of the series of cloister cells around the main shrine of the Kailasanatha at Kanchipuram (South India). Pallava, seventh century A.D.

283. Parvati standing. Pallava painting at Panamalai

composing the figures of the seated Siva and Parvati with the baby Skanda in between, with a dwarf gana follower of Siva on one side and a charming female attendant of Parvati beside her on the other. It is the lovely theme of fond parents and a frolicsome child, of ideal mates and the object of their love, of the pleasing affection which, though lavished on offspring, increases a thousandfold: vibhakatam apyekasutena tat tayoh parasparasyopari paryachiyata.

The painting in the Siva temple at Panamalai shows the outline figure of Urdhvatandava Siva and a comparatively better preserved Uma standing close by witnessing the dance of her consort (fig. 283). It is probably the most elegant feminine figure in painting of the Pallava period.

Almost looking like Pallava temples are similar Pandyan ones farther south in peninsular India. We have to understand these temples in the context of the Pandyan king Nindrasir Nedumaran, who was converted by the baby saint Tirujnanasambadha and inspired by a great and sudden zeal for creating Saiva shrines. At Tirumalaipuram, there is an excellent example of an early Pandyan cave. Here there is a dancing figure of Nataraja cut into the rock, a Ganesa, Brahma, and Vishnu, and dvarapalas closely resembling Pallava ones. Similar caves are found at Kunnakudi, Sendamaran, Tirupparankundram, Chokkampatti, and other places. The panel representing Natesa's dance at Tirupparankundram is one of the most beautiful from South India. The orchestra, the dwarf ganas, Parvati and Nandi watching Siva dance are all executed with great skill. The staff Nandidhvaja held by Siva when dancing in the chatura pose cannot but recall a similar staff showing the bull emblem in the hand of Nataraja at Pattadakal.

It is, however, the rock-cut freestanding temple at Kalugumalai, closely

236



284. *Recumbent bulls and Siva as Dakshinamurti playing the drum. South face, top of the vimana, or temple, of the rock-cut shrine of Siva at Kalugumalai (South India). Early Pandya, eighth century* A.D.
This work is exquisitely carved and closely resembles the Kailasa at Ellora (see figs. 289–291).

284

285. *Umamahesvara. Close-up of the vimana of the rock-cut temple at Kalugumalai (fig. 286). Early Pandya, eighth century* A.D.

285

238

286. Front view of the rock-cut temple at Kalugumalai, showing a row of frolicking ganas on the lower tier and Siva and Parvati as Umamahesvara on top. Early Pandya, eighth century A.D.

287. *Standing princess in a niche.*
Nagesvarasvami temple, Kumba-
konam (South India). Chola,
ninth century A.D.
Note the graceful decoration of
the hair and the slim, dainty
feminine form, which are typical
of very early Chola work.

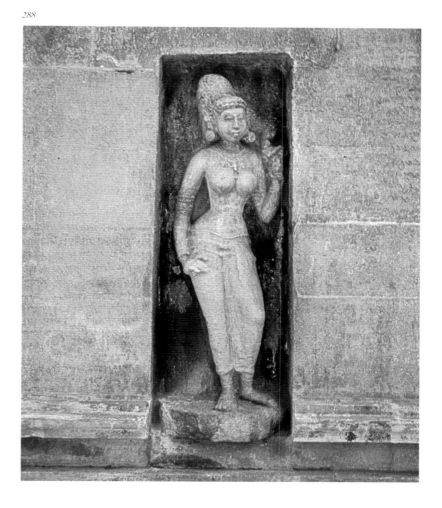
287

288. *Princess standing. Nagesva-*
rasvami temple, Kumbakonam.
Early Chola, ninth century A.D.
Note the beautiful flexion and the
graceful contour of the feminine
form, typical of early Chola
workmanship.

288

resembling the Kailasa temple at Ellora, that should be considered a gem of Pandyan art (see figs. 284–286). It is called the Vattuvankovil. Vattuvan was a sculptor. This is as much as to say that it is the only temple worthy of having for its architect the one great Vattuva or sculptor. The ganas, or dwarf followers of Siva, are here arranged in a large frieze rich in artistry of pose and in animation, their faces wreathed in smiles, beaming with enthusiasm, playing musical instruments or dancing for joy, sharing secrets in whispers or supporting the tiers of the temple, or vimana (see fig. 286). Here themes for the embellishment of the monument are expressed in various iconographic groups, Siva, Umasahitamurti (fig. 285), Dakshinamurti, Vishnu, Brahma, Skanda, Chandra, Surya, and others. There are also nymphs against shallow niches between the tiers in attitudes of toiletry and coquetry.

On an adjacent hillock, there are innumerable panels illustrating the Jain pantheon of about the same period.

The early phase of Pandyan painting is preserved in the lovely dancing figures of nymphs in the cave at Sittannavasal, where in addition the portrait of a Pandyan king and queen appears on a pillar. These paintings also were discovered by Jouveau-Dubreuil, who likewise found paintings at Tirumalaipuram. The paintings at Sittannavasal have an especial charm in that the lotus pool on the ceiling is happily shown with flowers, fishes, ducks, a buffalo, and an elephant. The lotus gatherers here are extremely handsome, and the panel of the royal couple shows the Pandyan painter at his best in portraiture.

Beyond the Pandya area, in the Chera territory, at Kaviyur near Tiruvallara, an early cave has interesting dvarapala figures on the facade. Similar carved figures at the entrance of the Vilinjam cave near Trivandrum are extremely handsome and typical of eighth-century

239

work, closely approaching the Pallava idiom in far off Tondaimandalam. They are unusual forms of Siva, one as Kiratamurti, brandishing his bow and arrow, with his left foot on a dwarf, exactly like the famous, though rare, form of Kiratamurti in metal of early Chola date from the Rajarajesvara temple at Tanjore; and the other, Nataraja dancing with his legs crossed in padasvastika, an attitude of the lalita mode, watched by his consort, a theme already familiar from the Pallava painting at Panamalai (detail, fig. 283). Some Chalukya elements are evident in sculpture from this area, which mainly follows the Pallava style in this early phase. The bells arranged on the yajnopavita, or sacred thread, and on the central tassel of the undergarment, and a certain richness of decoration, cannot but suggest a Chalukya influence.

There are excellent panels of dancers and musicians from Trivikramangalam where on the balustrades of the temple the Kudakuttu dance scenes are extremely handsome and suggest the revelry in music and love of dance of South India: Nityavinoda.

The caves at Namakkal with the famous panels of Lakshminarasimha, Varaha, Vaikunthanatha, and Ranganatha should be dated in the eighth century A.D. and cannot but recall similar Pallava carvings, in particular the Seshasayi at Mahabalipuram. This is the phase of Kongu art in which the Cheras held sway, and the Ay rulers had friendly relations with the Pallavas.

Early Chera metal sculpture, which closely follows the lithic mode, is best studied in such examples of distinct style as the two Vishnus in the Trivandrum Museum.

The Chera painters' art of this period is represented in the fragments of painting that still adorn the Tirunandikkara cave, but the clearest of the extant subjects is a single beautiful face of a celestial.

With the weakening power of the early Western Chalukyas in the eighth century, the Rashtrakutas remained for some time the foremost power in the Deccan. Dantivarman's uncle, Krishna I, built the Kailasa temple at Ellora (see figs. 289–291). It is worth noting of this temple that it follows southern traditions, for it closely resembles the Virupaksha temple at Pattadakal, which is itself inspired by the traditions of Kanchi. The beauty of the Kailasa temple is described in an imaginary conversation of celestials, who pause for a while, during their sojourn in the clouds, to reflect on the nobility of this rock-cut monument and to wonder if anyone could create a temple so exquisite. The celestials' imaginary talk is a ruse for praising the monument in the context of a later Rashtrakuta copperplate grant. It is, however, a fact that the stupendous monolithic monument was cut out of a hill from the top downward to the base by the architect, who, with the entire plan in his mind, carefully accomplished this almost impossible task, creating an architectural wonder.

(For the Baroda grant of Karka Suvarnavarsha, see J. K. Fleet, ed., 'Some Sanskrit and Old Canarese Inscriptions,' *Indian Antiquary*, XII, 1883, pp. 156–65, especially p. 163.)

289

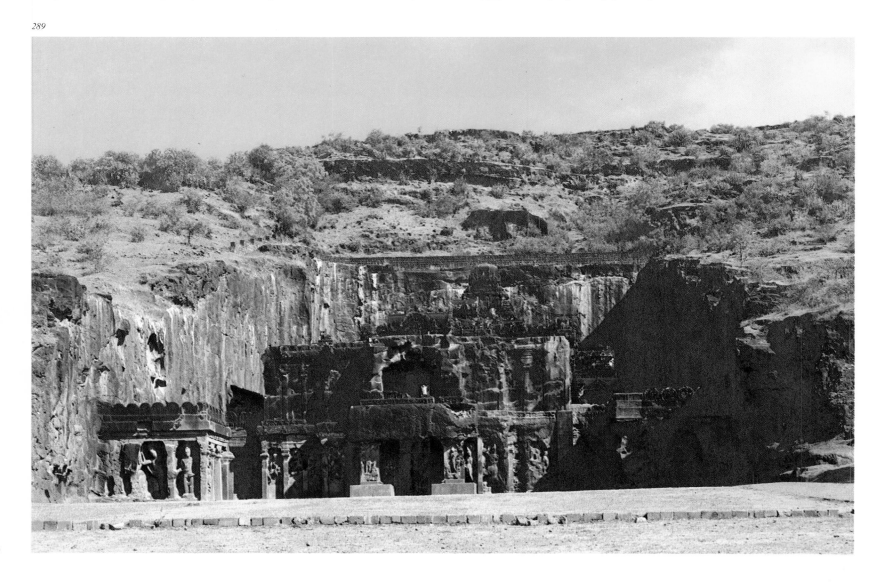

289. *Entrance facade of the Kaila-sanatha temple at Ellora (Deccan). Rashtrakuta, eighth century* A.D. *The treatment of the Dikpalas here is charming and unlike any-where else.*

291. *Lovers. Kailasanatha temple at Ellora. Eighth century* A.D. *Typical of the delicacy of Ra-shtrakuta work.*

290. *Court of the Kailasanatha temple at Ellora, showing the Nandi mandapa, or pillared hall, and the monolithic column. Ra-shtrakuta, eighth century* A.D.

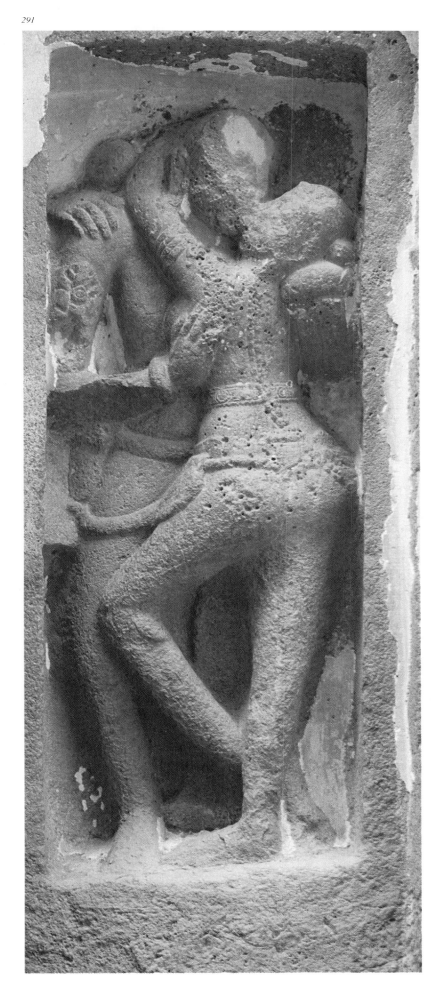

290

291

292. *Rashtrakuta painting at Ellora*

292

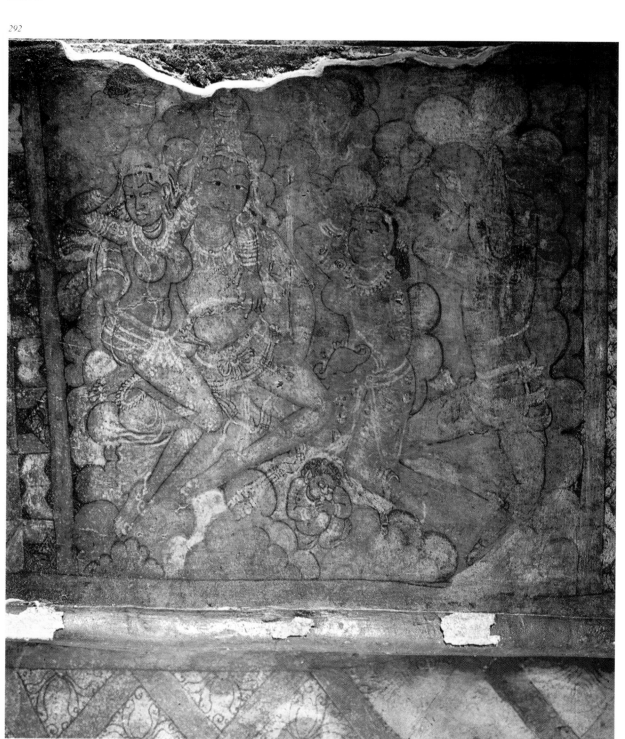

294. *Inscribed Umamahesvara. From Hemavati (Andhra Pradesh). Nolamba, ninth century* A.D. *Government Museum, Madras*
An exquisite sculpture typical of the simple and effective style of the Nolambas. The inscription below, in early Canarese script, mentions the name of the royal donor, a princess named Pasanabbe.

242

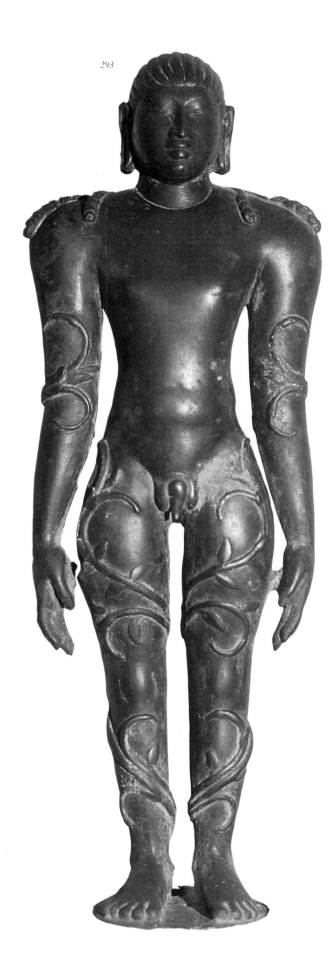

293

In the Kailasa temple are some of the best-known and most admired panels of medieval sculpture; for example, Lakshmi amid lotus flowers; Ravana shaking Kailasa (cf. fig. 28) and worshiping Siva with a garland of his own heads; Rati and Manmatha; the triple stream of Ganga, Yamuna, and Sarasvati; Siva as the greatest warrior, Tripurantaka; and so forth. Among the scenes from the *Ramayana* and the *Mahabharata*, the attack on Ravana by Jatayus is significant.

The Rashtrakuta sculptors continued the Chalukya motifs of cloud patterns, foliage backgrounds, design and canopy, elaborately decorated crowns and elongated halos, features continued by the later Western Chalukyas.

A subschool in the Chalukya style is the Western Ganga. The monarchs of this family—some of them were of the Jain faith—ruled from Talakad on the banks of the river Kaveri. The most important sculpture of the Western Ganga school is undoubtedly the colossal image of Gomatesvara at Sravanabegola. Rachamalla Satyavakya, the Western Ganga king, created it at the instance of his general Chamundaraya. It is dated in the year A.D. 983, and in spite of its colossal size the details of the workmanship show the sculptor's great mastery over his art.

Another subschool of about the same date is the Nolamba. Ruling the kingdom of Nolambavadi from their capital, Hemavati, the dynasty of kings known as the Nolambas, who were mostly feudatories of the Western Chalukyas, Rashtrakutas, and Cholas successively, created some of the most lovely temples in the Chalukya style, with special characteristics that single them out as a distinct subschool. It is a great tribute to the artistic skill of the Nolamba sculptors that a whole series of exquisitely carved pillars was brought from Hemavati to near the Chola capital by Rajendra Chola, a conqueror of this area, as a war

294

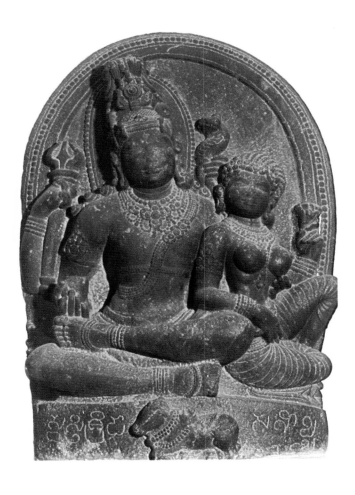

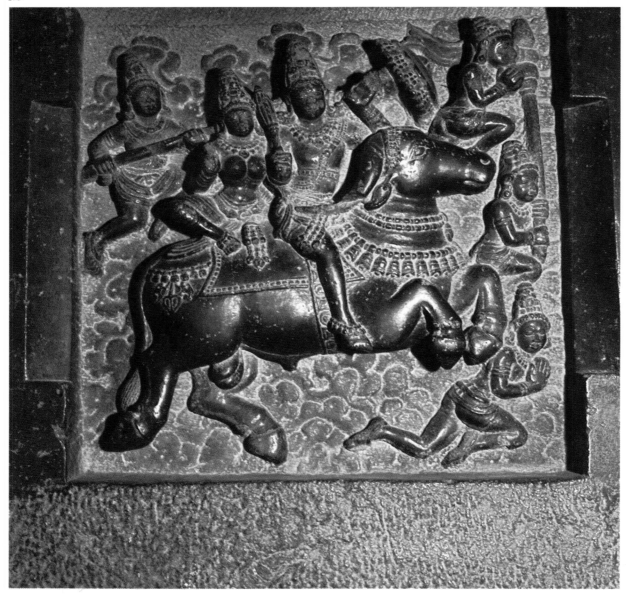

trophy, primarily in a spirit of connoisseurship. They now adorn a mandapa at Tiruvayyar in the Tanjore district. Some Nolamba pieces have also been affixed in the Rajarajesvara temple at Tanjore. A particularly charming pierced window is noteworthy for its fine carvings. The Government Museum in Madras has a fine collection of Nolamba sculptures, of which the inscribed Umamahesvara (fig. 294), a Nataraja dancing with his body twisted in the Prishthasvastika fashion, and a ceiling slab depicting three panels of Dikpalas (see fig. 295), Agni, Yama, and Nirruti, with their consorts, on their respective mounts, show the delicacy of workmanship and high polish of Nolamba sculpture.

The Chalukyas, who came back to power as the succeeding dynasty that ruled from Kalyani, could also boast of a great connoisseur of art and literature in Vikramaditya VI, a king who was as great a warrior as a connoisseur. Some of the most beautiful later Chalukya temples, like those from Kukkanur and Haveri, are of this period. The Kuruvatti temple is particularly noteworthy for its exquisite bracket figures, carved screens, polished pillars, and tiers of friezes showing rows of birds, animals, dwarfs, and figures of musicians and dancers. A great sculptor of this period, Sovarasi, has given a boastful, though justified,

assertion of his skill in design and carving. Vikramaditya, who was the patron of the famous poet Bilhana, was conscious of his duty toward sculptors and architects also.

The Yadavas, who ruled in the North Deccan, were equally zealous patrons of learning and art. Under them rose several temples in a special style named Hemadpanti, like those at Lonar, Mahkar, Satgaon, and other places. The style, though characterized by heaviness of structure and a minimum of sculptural adornment, is only another expression of the main stream, namely, Western Chalukya.

Kubja Vishnuvardhana, the warlike younger brother of Pulakesin, was made the viceroy by his warlike elder brother after his victory in the Vengi area in Andhra. He was responsible for a dynasty of kings that ruled longer than even the main line itself, first from Vengi and later from Rajamahendravaram. Kubja Vishnuvardhana was responsible for some of the most imposing massive monolithic sculptures (see figs. 300 and 301). Some remains of the art of this period are still in Vijayavada (Bezwada). Two great sculptures (figs. 298 and 299), one of them inscribed, mentioning the name of Gundaya, the principal sculptor in the court of the royal Chalukya patron, are now in the Government Museum in Madras. This pair of gigantic dvarapalas, one adorned

296. *Beauty reflected in a mirror.*
From the Deccan. Western
Chalukya, twelfth century A.D.
National Museum, New Delhi
Pleasing decorative sculpture
characteristic of Western Cha-
lukya work of the time.

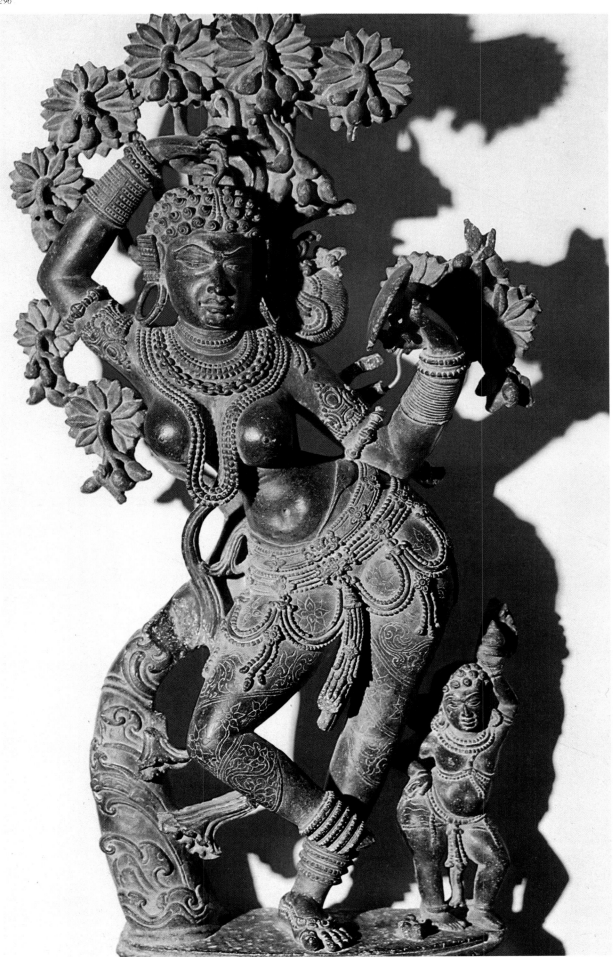

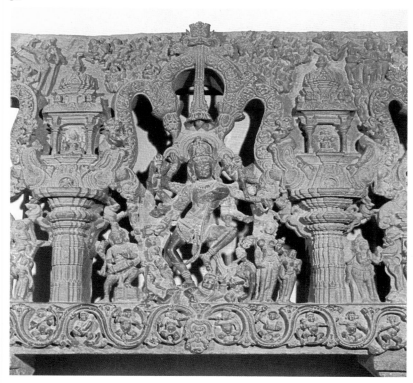

297. *The multiarmed Siva dancing to a musical accompaniment, as Devi, Ganesa, and Skanda watch. Detail from a lintel. From Hampi (Mysore). Late Western Chalukya, twelfth century* A.D. *National Museum, New Delhi*
The delicately carved musical gana figures entwined in a meandering creeper design enhance the general effect of the sensitive carving typical of fine late Chalukya work.

299

298

298. *Monolithic dvarapala, or door guardian. From Bezwada (now Vijayavada, Andhra Pradesh). Early Eastern Chalukya, seventh century* A.D. *Government Museum, Madras*
The figure is carved simply but with dignity, with a long and characteristic sacred thread, or yajnopavita, a heavy club, typical ornamentation and dress, and with a hand raised in wonder and legs crossed.

299. *Monolithic dvarapala. From Bezwada. Early Eastern Chalukya, seventh century* A.D. *Government Museum, Madras*
One of a pair (see fig. 298). On the back is an inscription mentioning the name of the sculptor, Gundaya, the court sculptor of Kubja Vishnuvardhana.

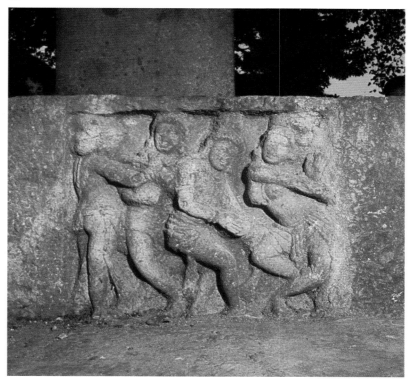

with a yajnopavita of lotuses and lilies, and the other with one decorated with bells suspended from it at intervals, comes very close to similar gigantic carvings in the caves of Badami.

Narendramrigaraja Vijayaditya II, a great warrior, was the victor in 108 battles fought during twelve years in the ninth century. He created as many temples as victories in thanksgiving to Siva. In the Jamidoddi at Vijayavada, some of the carvings, including the beautiful pillar capitals and panels of musicians (see figs. 300 and 301) and dancers, represent this phase of art. The story of Arjuna winning the Pasupata weapon, carved in panels recalling the Kiratarjuniya on a pillar that is a fine example of ninth-century workmanship, with an inscription commemorating the deity, is a fitting tribute to the warrior king who caused it to be made.

Gunaga Vijayaditya III has left important temples at Biccavolu, near Rajamahendravaram, which illustrate in great detail the style and workmanship of the Eastern Chalukya sculptors of his day. For the first time, the motif of Ganga and Yamuna on the doorway of one temple is introduced as a memento of the triumph of the Eastern Chalukyas over the Rashtrakutas on at least one occasion. The Rashtrakutas themselves took pride in this motif as something they had appropriated from the Pratiharas of the north, and we know that the motif occurs from the Gupta period onwards on doorways in northern temples. Now it was the turn of the Eastern Chalukyas to bring the motif down to their own realm.

In the Golingesvara temple at Biccavolu and in the Rajaraja, there are rich sculptures, representing Nataraja, Ganga, Skanda, Ganesa, and other deities.

The Bhimesvara temple at Samalkot, named after Chalukya Bhima, and another by him at Draksharama, are famous shrines.

The Eastern Chalukya metal craftsman was not a bit behind the stone carver. The Chimakurti group from the Venugopala at Belur, the most beautiful of its kind, now in the Government Museum in Madras, is a clear example of the elegance of metalwork in the Eastern Chalukya

300. Musical group with Rishi Mandakarni in the Panchapsara Lake. Jamidoddi, Bezwada (now Vijayavada)
Sculpture of great beauty and grace, typical of early Eastern Chalukya work.

301. Frieze showing dancers and musicians. Jamidoddi, Bezwada. Typical Eastern Chalukya sculpture
The grace of the dancers and the flexion of their bodies is matched only by the vigorous movement of the musicians forming the orchestra.

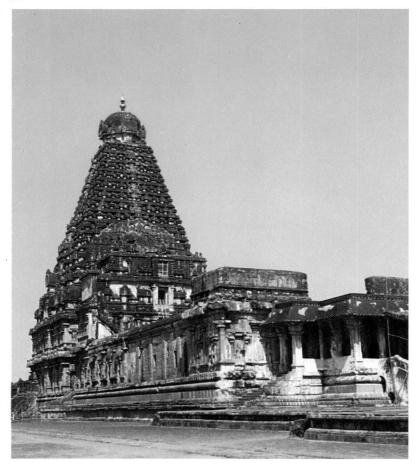

302

303

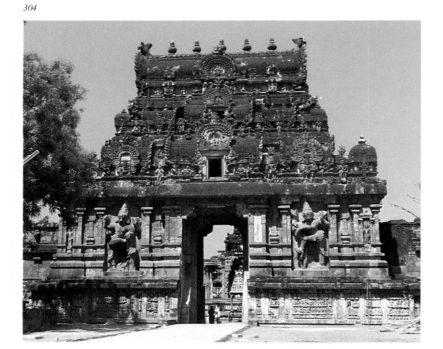

304

302. *General view of the Briha-disvara temple, Tanjore (South India). Early Chola, A.D. 1000*
Note the imposing vimana, which is the mightiest temple con-struction in the south. Built about A.D. 1000 by Rajaraja.

303. *Detail of the Brihadisvara temple, Tanjore. Early Chola, A.D. 1000*
Note the imposing and powerful figure of the dvarapala, which seems to suggest the aggressive power of the Cholas.

304. *Gopura, or tower, entrance of the Brihadisvara temple, Tan-jore. Early Chola, A.D. 1000*
Note the comparatively dwarfish appearance of this imposing gopura, which gradually developed into the gigantic entrance of the late Chola and Vijayanagara periods.

territory. A point to be noted in connection with Eastern Chalukya sculpture is that in it Chedi, Chola, Western Chalukya, Eastern Ganga, and Pala art met. The traditions and motifs of these styles are here intertwined. Thus, Vishnu, in Eastern Chalukya sculpture, carries the gada and sankha in the southern fashion, though Surya has top boots as in Pala or Eastern Ganga sculpture.

The Cholas were undoubtedly the greatest builders of monuments and have contributed largely to the vast wealth of metallic images in which India is so rich. The small kingdom founded by Vijayalaya grew under Aditya and Parantaka and attained monumental proportions under Rajaraja and Rajendra. Its growth was more than spectacular. Sombianmadevi, queen of Gandaraditya and great-aunt of Rajaraja, was the most generous donor of temples and shrines all over the Chola empire. She built and richly endowed a number of them.

The early Pallava traditions were continued. There is always a lingering

305. Somaskanda. From Tiruva-langadu. Well-known early Chola bronze. Tenth century A.D. *National Museum, New Delhi*

305

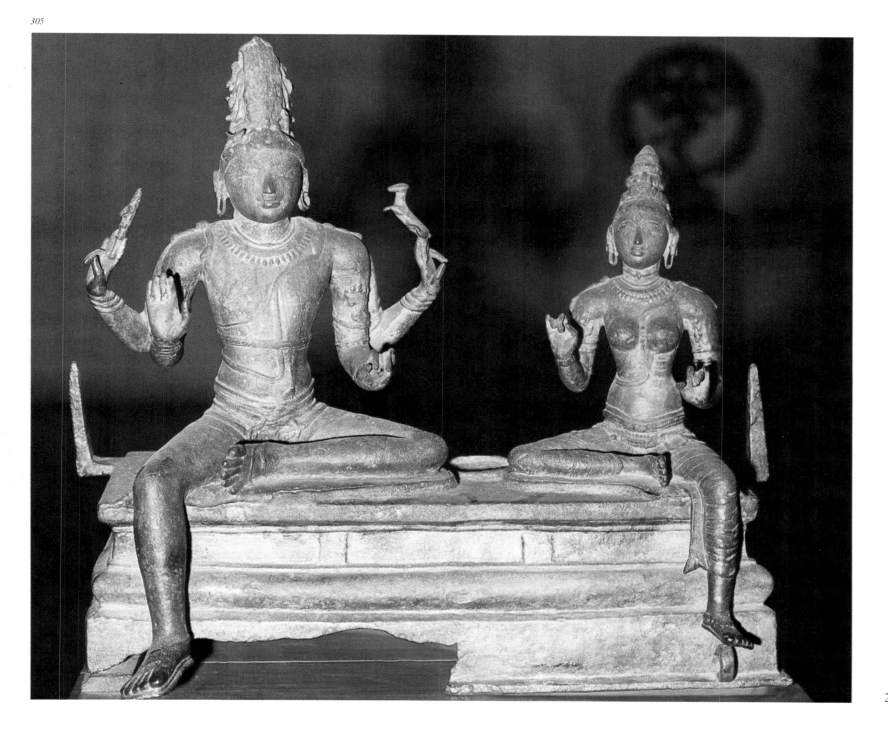

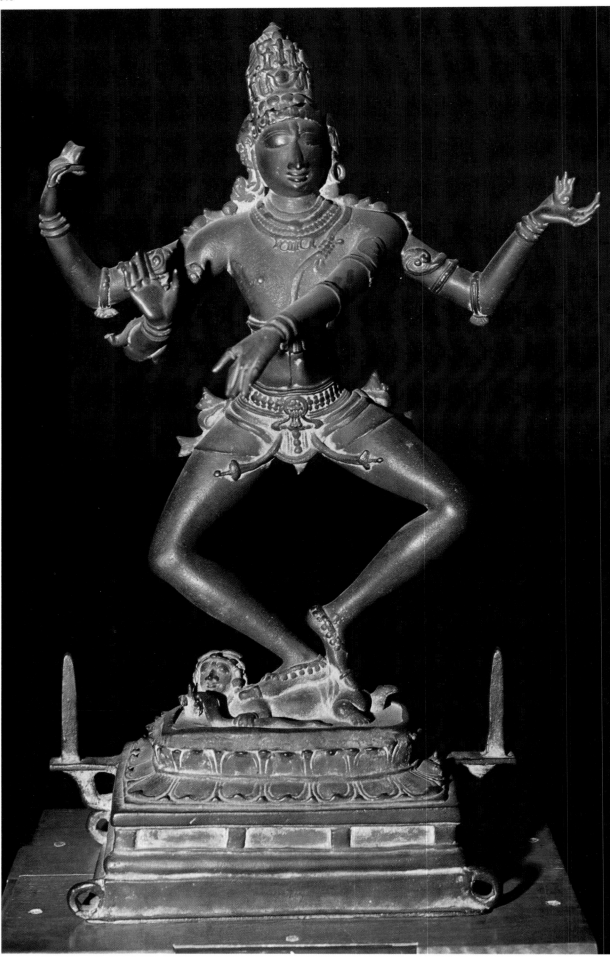

306. Nataraja dancing in the chatura pose. From Tiruvarangulam (South India). Chola, tenth century A.D. National Museum, New Delhi
Aesthetically and iconographically the most important bronze in the collection.

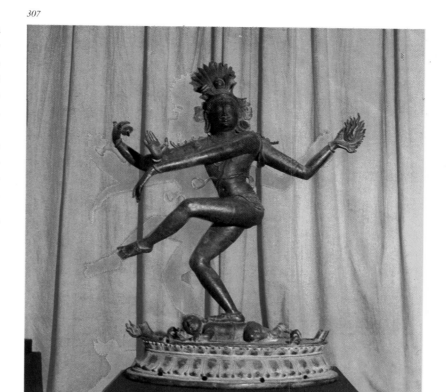

grace in the carvings of the Pallava-Chola transition period, of which the most noteworthy are temples like the Nagesvarasvami at Kumbakonam (see figs. 287 and 288), and the Kuranganatha at Srinivasanallur. Sometimes Rashtrakuta influence in Chola monuments is due to the people's contacts with a conquering power in warfare or in any temporary occupation, even if only for short periods. This is easily observed at Kaveripakkam.

Undoubtedly, the most honored place among the Chola monuments should be given to the Rajarajesvara temple at Tanjore, which is a veritable treasure house of early Chola art, built in heroic proportions about A.D. 1000. It has a most stately vimana that rears its head high above everything that surrounds it, including the gopuras that are still dwarfish. Here, there is a stress on the warlike and heroic aspects of Siva, for example, as Tripurantaka, Kalantaka, and Kirata.

In a new capital that he founded at Gangaikondacholapuram, Rajendra, the great warrior son of Rajaraja, not only created an irrigation tank twelve miles long, filled with Ganges water, which he got as a tribute from the kings he overcame in the north, but also raised an edifice for Siva, worthy of his conquest, closely following the pattern set by his father at Tanjore. In one of the outstanding panels at Gangaikondacholapuram, representing Chandeanugrahamurti, the devout emperor as Chandesa has almost seated himself humbly at the feet of the divine pair and claimed the flower wreath wound round the head of the devotee as his own as laurels of victory and the blessings of Siva. This is one of the great masterpieces of early Chola art.

The temple at Darasuram is the most evocative in Chola art. It suggests Nityavinoda, eternal music and dance. The abundance of the sculpture illustrating this theme and the lives of Saiva saints carved in several panels make it one of the richest of the smaller Chola temples of the medieval period both in artistry and in iconography. Here, for the first time, as also simultaneously at Chidambaram, the wheel and horse motifs are introduced, to convert a mandapa into a ratha. This so appealed to connoisseurs of art that the motif traveled to Eastern Ganga territory in Orissa, and the ratha temple at Konarak is only an

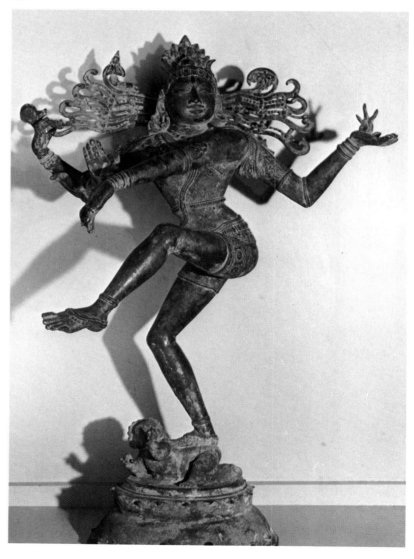

307. Nataraja, in metal. From Tiruvalangam (South India). Early Chola, A.D. 1000. Government Museum, Madras
Said by Rodin to be the most perfect representation of rhythmic movement in the world.

308. Nataraja without a halo, or prabha. From Punganuru (South India). Early Chola, eleventh century A.D. Government Museum, Madras
Considered to be one of the best without the flaming arch (see fig. 317); very simple, effective, and elegant.

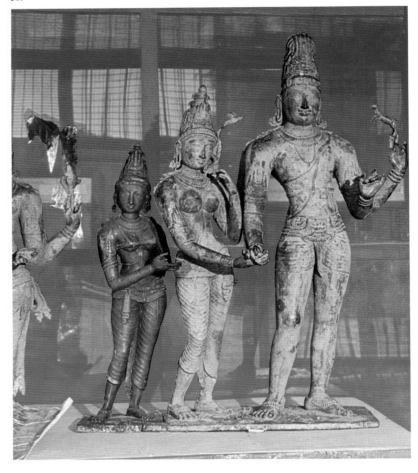

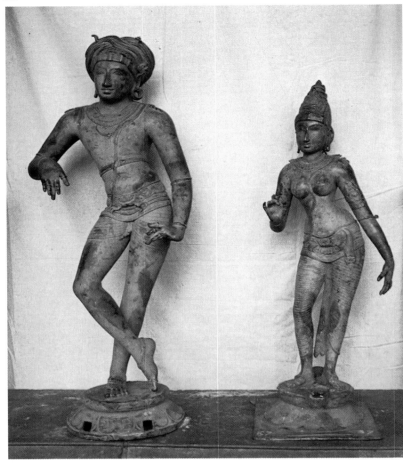

elaboration of this earlier Chola motif. The marriage of Princess Rajasundari of the Chola house into that of the Gangas made the easy diffusion of these motifs possible.

In the late Chola gopuras of Chidambaram, the skill of the sculptor, combined with his knowledge of literature, dance, music, and other arts, is clearly exhibited in a series of panels describing dance modes visually (see fig. 318). The text below each in Chola Grantha letters provides a lithic version of Bharata's treatise on dance. When we recall that the inscription from the Tiruvottiyur temple mentions the appreciation of a performance by a danseuse by the royal witness, Rajendra Chola, it is clear that all the fine arts were equally patronized, and there was a great feeling for art and architecture.

The two outstanding sculptures of Surasundaris from the Kampaharesvara temple at Tribhuvanam, which are gems of late Chola art, show that the high quality of aesthetic achievement by Chola craftsmen persisted until the end.

The metal craftsmen of the Chola age were undoubtedly the greatest in India. The famous Nataraja from Tiruvarangulam (fig. 306) is as important as the Pallava image of Vishapaharana in metal. The Somaskanda from Tiruvalangadu (fig. 305) is a beautiful little bronze of the transitional period from Pallava to Chola, with a peculiar trait unknown in other examples, that of Siva carrying the trident, or trisula, in one of his hands. If the Siva as Tripurantaka with a single pair of arms and the Nataraja from Kuram are outstanding examples of Pallava work, the Rama, Sita, Lakshmana, and Hanuman groups from Vadakkupanayur and Paruttiyur, the marriage of Siva from Tiruvelirkkudi, now in the Tanjore Art Gallery (fig. 309), Ardhanarisvara from Tiruvenkadu in the Government Museum in Madras (figs. 313 and 314),

309. Kalyanasundara, an exquisite group illustrating the marriage of Siva and Parvati, the latter being given away in marriage by Vishnu and Lakshmi. From Tiruvelirkkudi (South India). Early Chola, A.D. 1000. Tanjore Art Gallery

310. Vrishabhavahanamurti with Devi. From Tiruvenkadu (South India). Early Chola, A.D. 1011. Tanjore Art Gallery
This is one of the most effective Chola bronzes yet discovered. For sheer grace and beauty of form, there is rarely another to match it. The locks arranged in the jatabhara fashion are not easily distinguished from the snake that is wound up in them, but their treatment is very skillful.

311. Detail from figure 310

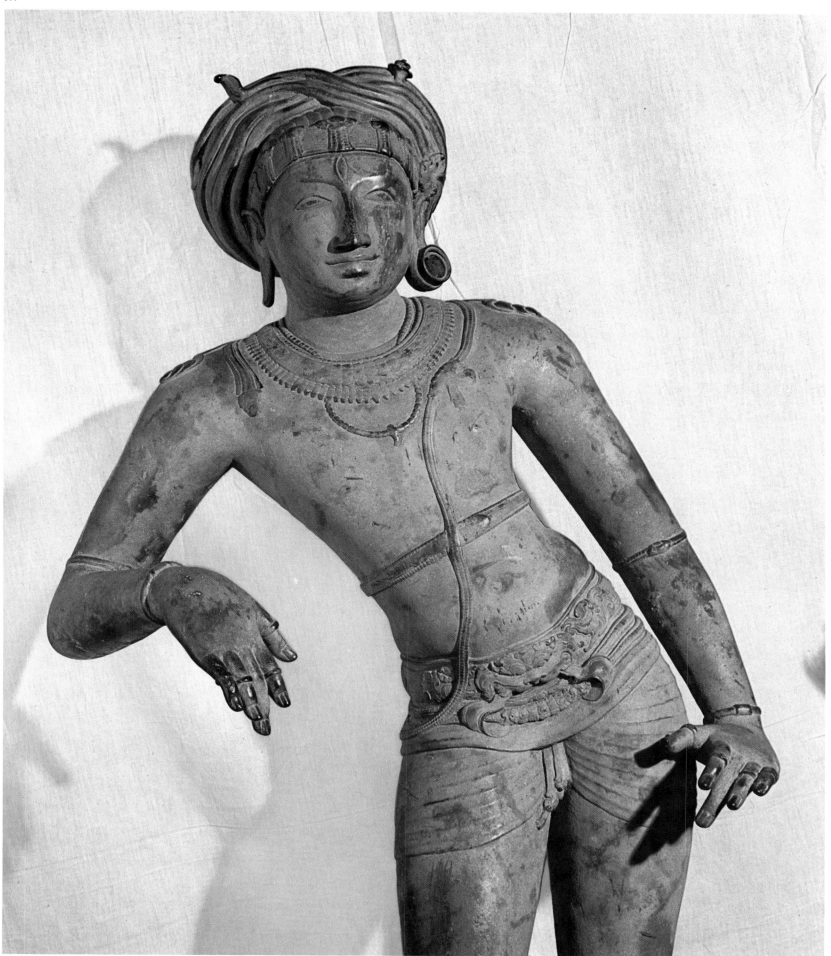

312

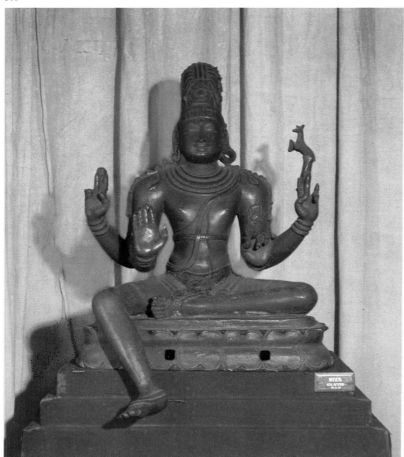

313

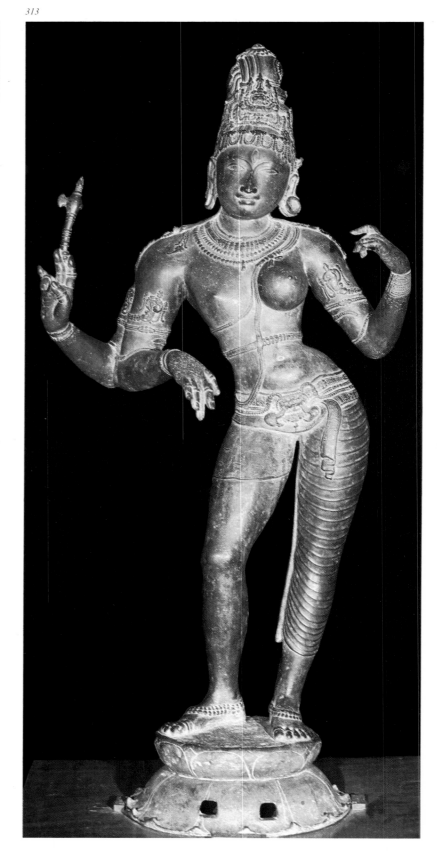

312. Sukhasana Siva seated at ease. From Kilayur in Tirukkovilur (South India). Government Museum, Madras
Typical of the most elegant images of the late Chola phase, the twelfth century A.D.

313. Ardhanarisvara, the hermaphrodite form of Siva. From Tiruvenkadu. Chola, eleventh century A.D. *Government Museum, Madras*
This is a rare image. The metal sculptor has with great taste fashioned the masculine and feminine halves of the body in true proportions. The droop in the left shoulder, the slim waist, and the broad hip contrast with the broad shoulder and masculine torso to the right.

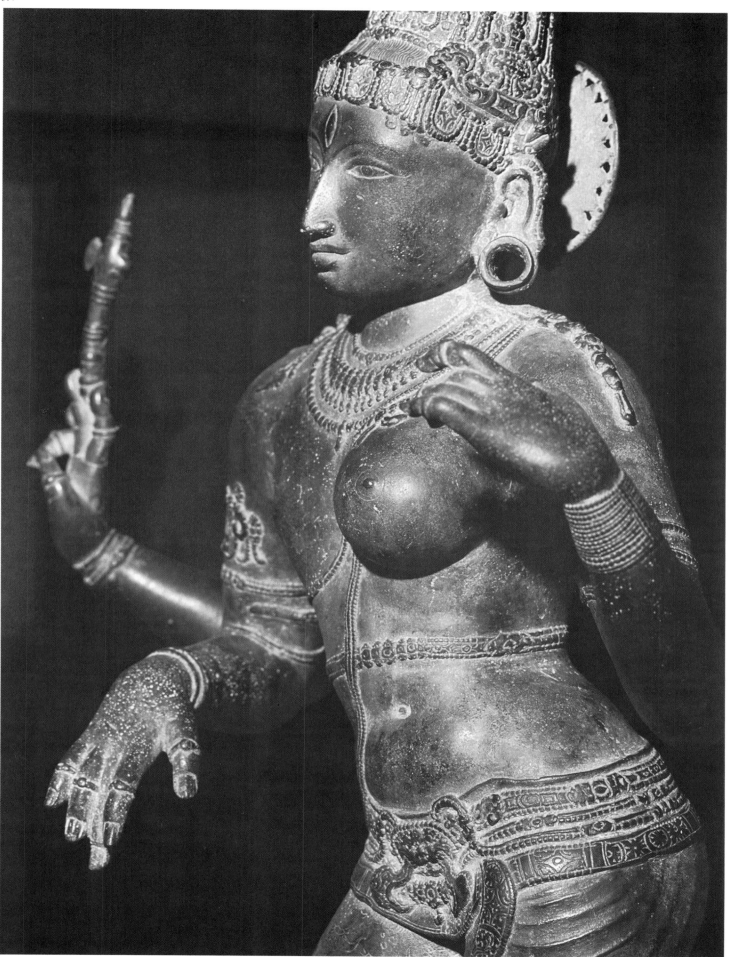

315. *Nataraja (close-up view).*
From Velankanni (South India).
Chola, eleventh century A.D.
Government Museum, Madras
One of the famous bronzes in this
rich collection.

315

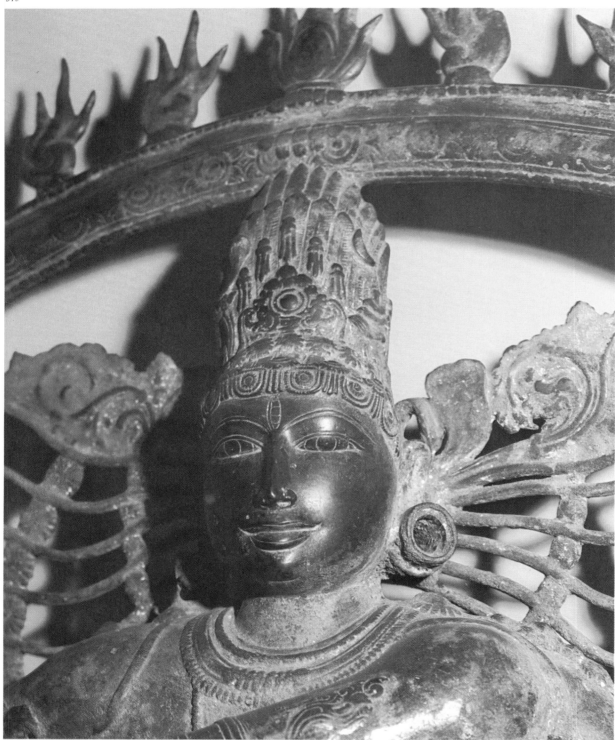

are exquisite examples that have to be ranked among the greatest Chola creations of art in metal.

Among paintings of the Chola period, there are none more important than those of A.D. 1000, the earlier layer, in the dark pradakshina passage round the main cell of the Rajarajesvara temple at Tanjore. Here, scenes from the lives of saints, like Sundara, are beautifully and impressively narrated. A Tripurantaka fighting the Asuras is, alone, the largest single subject portrayed anywhere in India. Siva, seated in the alidha position on his strange earth chariot, is the very personification of heroism. The giants of the three brazen cities, Tripurasuras, fighting the impossible battle, with their consorts clinging to them in despair, teary-eyed, clearly convey the artist's intention to commingle the moods of heroism (vira), pity (karuna), fear (raudra), and anger (bhavanaka). Rajaraja, the greatest warrior of his time, could not have chosen a better ideal than the great Warrior Lord Tripurantaka whom he often emulated and never tired of depicting both in sculpture and in painting.

The representations of Rajaraja with his dancing master Karuvurar and as a devotee of the favorite deity Nataraja from Chidambaram show the ability of the Chola sculptor in portraiture.

With the decay of Chola and Chalukya power, the Hoysala rulers from Dorasumudra in the Mysore area, on the one hand, and the Kakatiyas who ruled from Warangal in eastern Andhra territory, on the other, asserted themselves. Bittiga, the Jain Hoysala king, was converted to Vaishnavism by Ramanuja in the twelfth century. With the zeal of a convert, he studded his kingdom with monuments that he built; those of Belur and Halebid (see fig. 322) are very famous. There are others, like the temples at Doddagaddavalli, Arsikere, Nuggihalli, and Somanathpur (see fig. 323); all of these monuments portray the highly decorative style of the Hoysalas. The high plinth of the last has

316. Ganesa with his trunk curled up in the fashion called Pranava (the mystic symbol Om). From South India. Chola, eleventh century A.D. National Museum, New Delhi

317. *Nataraja. From Kankodutta-vanitam (South India). Chola, eleventh century* A.D. *Government Museum, Madras*

One of the important large bronzes in the collection. The arrangement of the jatas, or hair, is noteworthy.

317

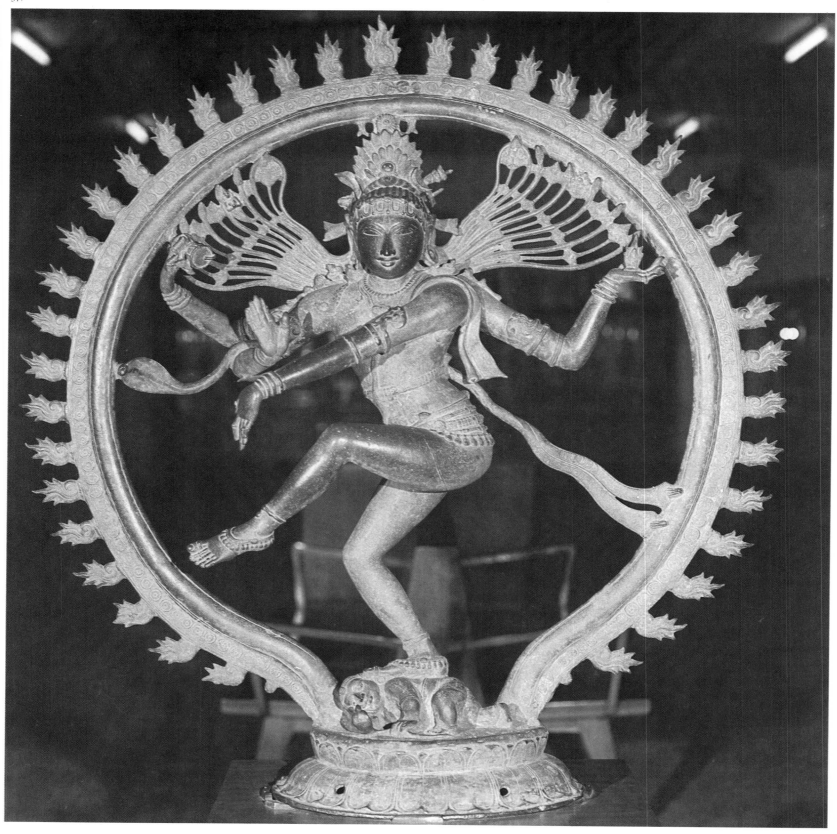

318. *Dance panels illustrating the karanas, according to the text of Bharata's* Natyasastra *inscribed beside each on the eastern gopura at Chidambaram (South India). Late Chola, twelfth–thirteenth century* A.D.

an elaborate carving of rows of lotuses, swans, makaras, elephant riders, and the like. The pillar-bracket figures are exquisite (see figs. 324 and 325). The intricate workmanship of the pierced windows and lattice screens is striking (see fig. 322). The dancing figures of Ganesa and Sarasvati at Halebid, like those of the Venugopala at Belur, are magnificent. At Belur an elaborate makara torana and monolithic dvarapalas present an imposing sight. Here we have the portrait of King Vishnuvardhana in his court with his learned queen, Santala, beside him. Though a Jain, the queen was of a catholic outlook and actively supported her husband in building shrines for deities of the Brahmanical and other faiths.

Though no murals of the Hoysalas have yet been found, excellent illustrations in color on palm-leaf manuscripts of this period are fortunately preserved in Mudbidri (see fig. 328); they give an insight into the painter's art, which closely follows the sculptural style. A rare manuscript of the *Dhavala*, a commentary on the Jain text *Shatkhan-*

dagama, is extremely valuable for an understanding of Hoysala painting of the twelfth century A.D.

Kakatiya sculpture, which is also in the Chalukya style but more ornamental than Hoysala, has exquisite examples in the temples at Palampet, Hanamkonda, Pillalamarri, and other places. The richly carved monumental lintel from Warangal (fig. 326), now in the National Museum at New Delhi, is one of the outstanding creations of the Kakatiya sculptors. The dancing figures of the Hindu Trinity are extremely interesting, as all three are known from literature and the text of Bharata as lords of dance. The Hyderabad Museum has several carved panels from the ceiling of a mandapa at Warangal; they are typical of the best that the Kakatiya sculptors could create. A delicately carved Mahishamardini Durga from Tripurantakam in the Government Museum in Madras illustrates Kakatiya art by a very fine example.

The Siva temple on the hillock at Tripurantakam in the Kurnool district in Andhra Pradesh has a fine series of paintings of the Kakatiya school,

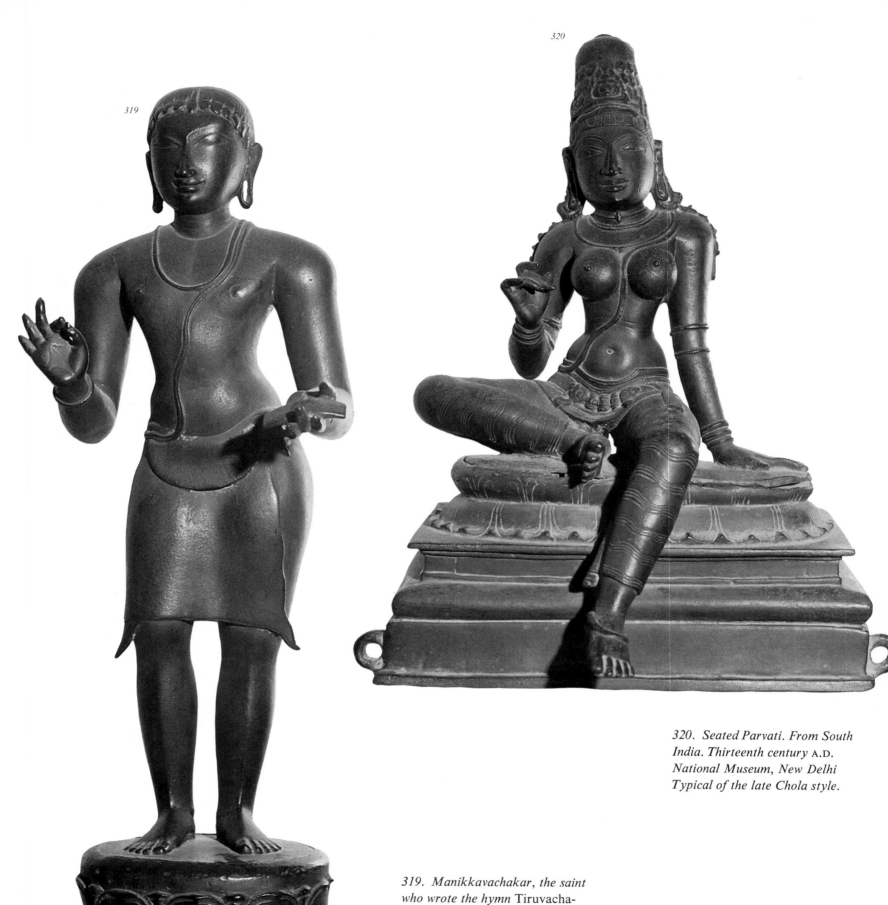

320. Seated Parvati. From South India. Thirteenth century A.D. *National Museum, New Delhi Typical of the late Chola style.*

319. Manikkavachakar, the saint who wrote the hymn Tiruvacha-kam, *with the book in his hand. From South India. Chola style. National Museum, New Delhi The image has a short inscription in Tamil letters of the twelfth century that corroborates the style of the figure.*

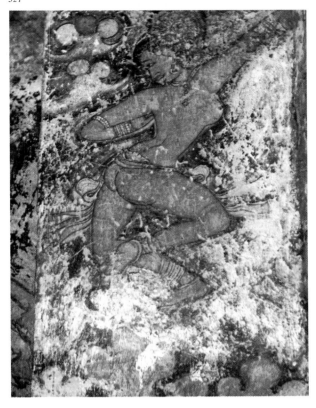

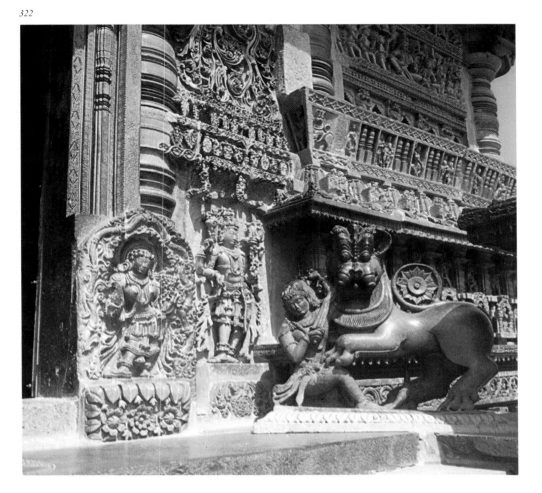

321. Celestial dancer. Chola painting in the Brihadisvara temple, Tanjore

322. Sala fighting the tiger, and other subjects. Close-up of the Hoysalesvara temple, Halebid (Mysore), showing carved screens typical of Hoysala art of the twelfth century A.D.

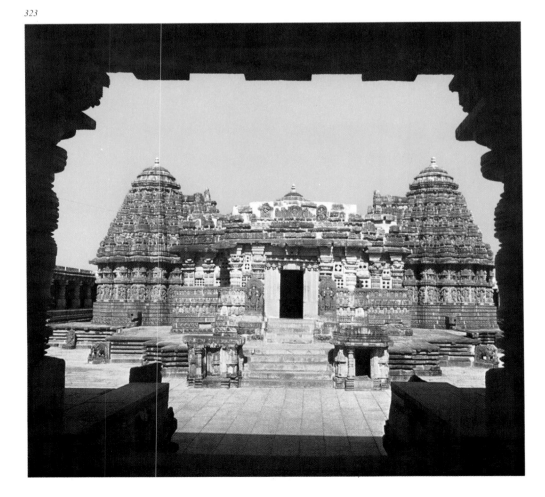

323. View of the Somanathpur temple, Somanathpur (Mysore). Twelfth century A.D. *This temple is one of the gems in the miniature work of the Hoysalas.*

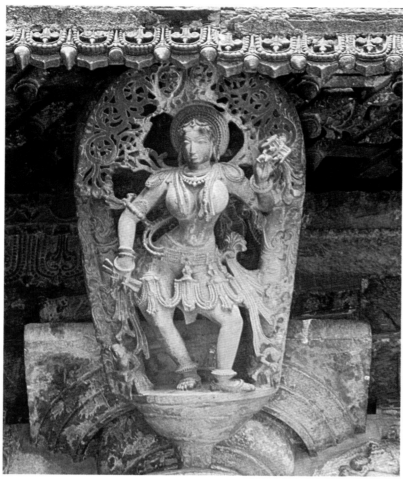

324. *Feminine dance. Delicately carved bracket figure. Belur (Mysore). Hoysala, twelfth century* A.D.
The bracket is placed between the eaves and the pillar, a placement typical of Hoysala work.

325

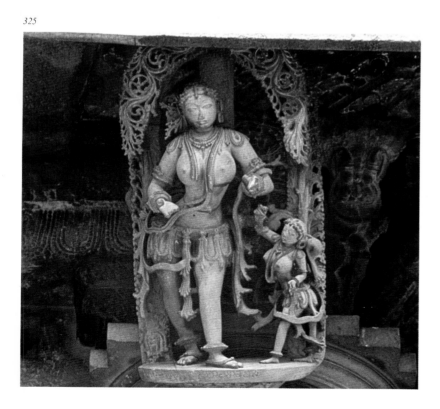

325. *Pause after a dance. Belur. Hoysala, twelfth century* A.D.
An exquisite sculpture, typical of the Hoysala treatment of ornamentation, dress, canopy of foliage, etc.

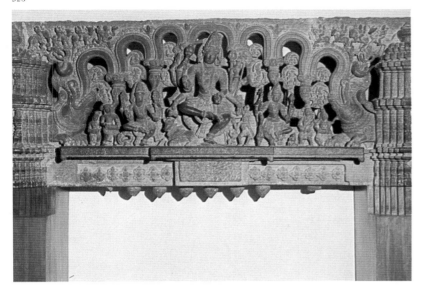

327. *Bharata carrying the palukas of Rama on his head. From Tiruchirapalli (South India). Vijayanagara, fifteenth century* A.D. *National Museum, New Delhi This rare metal sculpture illustrates an equally rare theme, Bharata as the ideal brother returning home without Rama but with only his sandals, to rule the empire in their name. Bharata dressed as a gentle hermit like his elder brother, living so in the forest, is full of pathos, and the sculpture is a masterpiece.*

326. *Siva, Brahma, and Vishnu dancing, all three as masters of this great art that they revealed to the world. Lintel with an exquisite decorative pattern as a background for the three principal figures. From Warangal. Kakatiya, twelfth century* A.D. *National Museum, New Delhi*

328. *Jain manuscript painting. In Mudbidri. Hoysala, twelfth century* A.D.

yet to be studied. The amritamanthana scene, which continued to be a favorite theme over the centuries, has been painted in a very lively way by the Kakatiya painter in the temple at Pillalamarri.

In the Srisailam temple in the Kurnool district in Andhra Pradesh, there are several carvings which give us an idea of the aesthetic taste in sculpture under the Reddis, who ruled in this area for a while in the fourteenth century.

Similarly, work in sculpture was given a great stimulus under the powerful king Jatavarman Sundara Pandya. Both in Srirangam and Madurai courts were added, and several powerful sculptures stand out as the precursors of a great tradition, to culminate at a later date in the monolithic carving of the Nayaks.

In the fourteenth century, the great spiritual leader Vidyaranya laid the foundations of an empire under Harihara and Bukka. The Vijaya-nagara dynasty continued unabated and gained great prominence in South India and the Deccan, including within its vast territory practically all the area south of the Godavari.

Hampi, the capital of the Vijayanagara emperors, after continued devastation for six months by the combined forces of the five sultanates of the Deccan, still has so much left that one is baffled in imagining how it looked in its heyday. It is no wonder that Portuguese travelers like Domingo Paes have left glowing accounts of the empire of Krishnade-varaya and his achievements. This monarch was himself a poet, a patron of letters, and a greater patron of art. It is believed that Krishna-devaraya was responsible for almost all the rayala gopuras that abound in South India. Some of the finest carvings of the late Vijayanagara period are on the gopura of the Ramasvami temple at Tadpatri. The Hazara Ramasvami temple at Hampi (Vijayanagar) and the Krishna

329

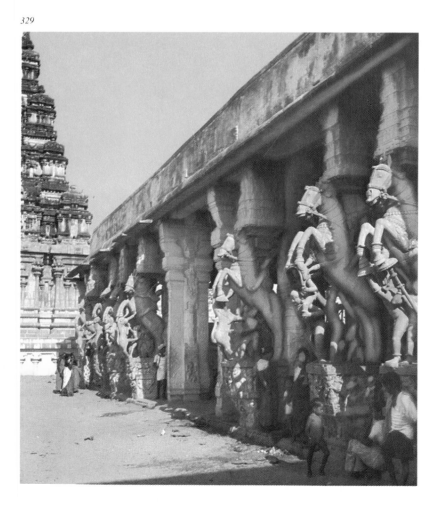

329. Pillared hall, with prancing horses as decoration on the columns, at Srirangam (South India). Sixteenth century A.D. *A favorite device exquisitely fashioned in the Vijayanagara period.*

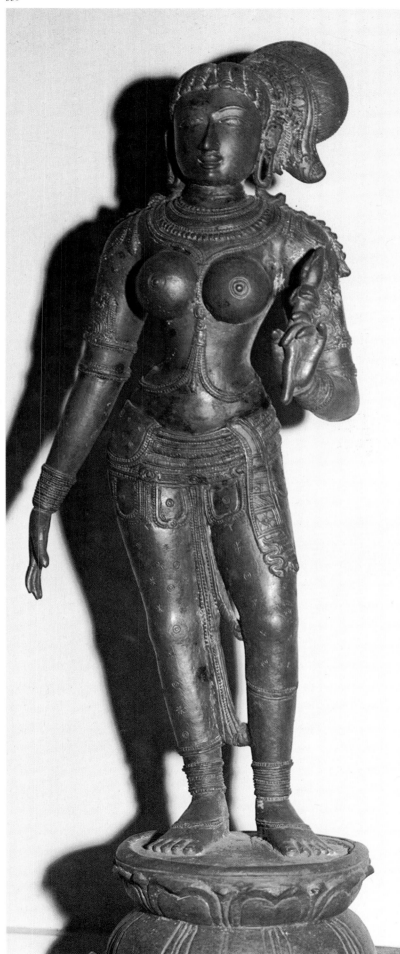

330. *Rukmini. A very well-fash-*
ioned Vijayanagara piece, of the
fourteenth century A.D.
Note the handsome braid.

331. *Portrait of Tirumala Nayak*
and his queen. Lowermost piece
of a metal cover for a huge door-
way to the temple sanctum. From
the neighborhood of Madurai
(South India). Seventeenth
century A.D. *National Museum,*
New Delhi
When the lamp pans were filled
with oil and lit in the evening, the
doorway presented a colorful
sight.

331

temple at Penukonda depict the *Ramayana* and the *Bhagavata Purana* in a long series of panels.

Lepakshi has a magnificent Natya mandapa, but probably the most noteworthy is the Kalyana mandapa in the Jalakanthesvara temple at Vellore with exquisite carvings on the pillars. The almost lifelike monkeys running after doves on the mandapa roof of the Varadaraja temple at Kanchipuram are especially noteworthy. The temple of Venkatesvara is another important Vijayanagara monument in Tirupati. The Vijayanagara emperors associated themselves with the temple by making renovations and additions to it. It is here that there are exquisite examples of metalwork representing portraiture. The almost life-size group of Krishnadevaraja and his queens, Tirumalamba and Chinnadevi, is a magnificent work in metal.

The pretty little Lotus Mahall at Hampi and the beautiful palace of the emperors at Chandragiri, like the well-planned and neatly executed fort at Vellore, are excellent examples of secular buildings of high aesthetic quality.

The last flicker of the work of the Vijayanagara sculptors is to be seen

332. Tirumala Nayak and his queen. Ivory. Nayak, seventeenth century A.D. *Temple Museum, Srirangam*
Ivory carving flourished in India over the centuries, and the art-minded ruler of Madurai encouraged the ivory carver. Several examples of this royal patronage are preserved in the museum of the temple at Srirangam.

333. Tirumala Nayak and his queen. Seventeenth century A.D. *Temple Museum, Srirangam*
Several portraits of this king are known at Madurai and Srirangam.

332

333

334

334. *A Vijayanagara prince.
From South India. Sixteenth–
seventeenth century* A.D. *National
Museum, New Delhi
This is a fine example in ivory of
the portrait sculpture in different
mediums of the Vijayanagara
period.*

335. *The story of the Emperor Muchukunda, a very devout man. Painting on the ceiling of a pillared hall of the Nagaraja temple, Tiruvarur (South India). Nayak, seventeenth century* A.D.

336. *The story of Bhikshatana and Mohini. Painting on the ceiling of the pillared hall of the shrine of Sivakamasundari in the Nataraja temple, Chidambaram (South India). Nayak, seventeenth century* A.D.

in the Pudu mandapa, the large gopura, and the courts of the Minakshi temple at Madurai (see fig. 331) for which Tirumala Nayak was responsible. During the reign of this great king the ivory carvers excelled in their craft and produced some of the most outstanding examples, including not only portraits of the sovereign with his queens (see figs. 332 and 333), but contemporary European visitors to India and groups well balanced in composition representing episodes from the epics.

In the sixteenth century the Vijayanagara painter at Lepakshi made not only the largest picture ever drawn, that of Virabhadra, with Viranna and Virupanna, the two chieftain brothers responsible for the temple, as devotees near the deity's feet, but also several panels representing various aspects of Siva, all of which are extremely interesting in iconography and sometimes very descriptive because of their departures from the accepted norms.

A century earlier, the entire ceiling of the imposing pillared hall, or mandapa, in the temple of Virupaksha in Hampi was covered with many spectacularly rendered paintings. Among them was the most impressive procession of the period, that of Vidyaranya, the preceptor of the emperor, borne in a palanquin and preceded and followed by troops mounted on elephants, camels, and horses. A distinctive rendering of Siva as Tripurantaka and as Madanantaka and the archery competition for the hand of Draupadi, which Arjuna won, are other notable subjects. There are also paintings in the temples at Somapalayam and Tadpatri; a large series from the latter await detailed study.

Similarly, paintings exist also in other temples at Tiruvalanjuli, Tiruvarur (see fig. 335), Chidambaram (see fig. 336), Tiruparattikunram, and other sites of the somewhat later Nayaka period.

In Malabar, the Vijayanagara phase had a different form, for the Chalukya and Hoysala influence was very strong there. At Ettumanur, Satankalangara, Payur, and Padmanabhapuram and at Suchindram the temples and their sculptural work—and also paintings wherever they exist, as at Tiruvanjikulam, Triprayar, Padmanabhapuram, Mattancheri (see figs. 338–341), Trichur—have a peculiar commingling of Hoysala and Chola traditions. Here were created rich, embellished, and colorful groups of figures, most interesting and charmingly decorative, their general appearance closely resembling the dress and mode of Kathakali dancers, whose activity found expression in the Kuttambalam, or dance halls, of the temples of this region.

337

337. The coronation of Yudhisthira. Cuddapah (Andhra Pradesh). Nayak, seventeenth century A.D.

338. Krishna lifting Mount Go-
vardhana. Painting in the Mat-
tancheri Palace, Cochin (Kerala).
Late Chera, eighteenth century
A.D.
Note the typical Kerala style and
workmanship recalling the
Kathakali costume and life
surviving still on the west coast.

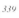

339

339. Krishna as Gopala amid
milkmaids, or gopis. Painting in
the Mattancheri Palace, Cochin.
Late Chera, eighteenth century
A.D.

340. Celestial devotees with crowns, ornamentation, and dress recalling Kathakali costume. Painting in the Mattancheri Palace, Cochin. Late Chera, eighteenth century A.D.

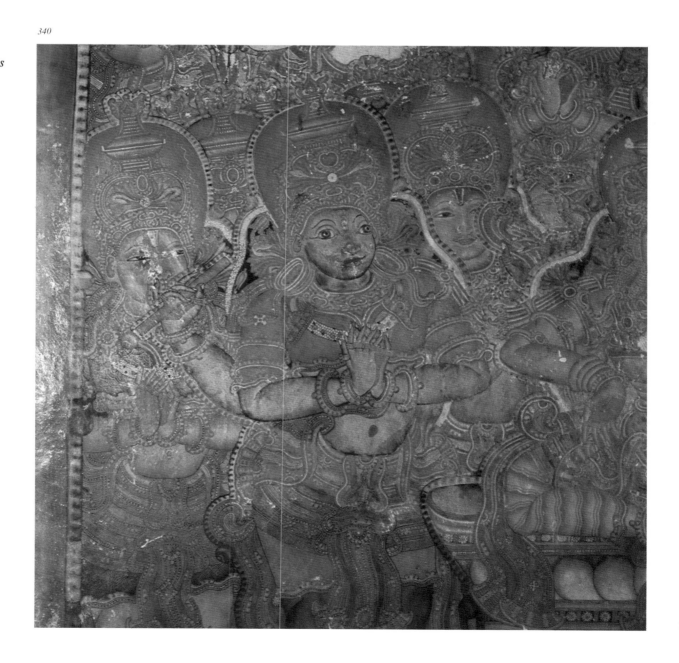

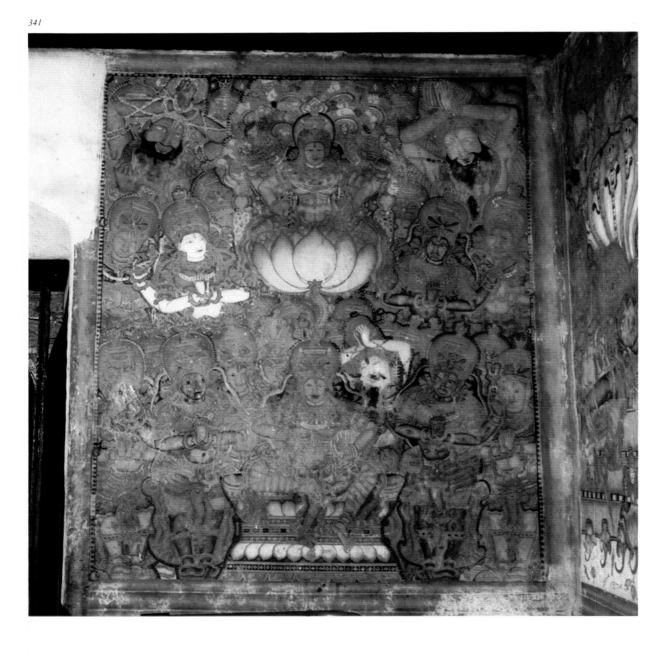

341. *Lakshmi on a lotus amid other celestials and devotees. Painting in the Mattancheri Palace, Cochin. Late Chera, eighteenth century* A.D.

11. Muslim Art in India, and the Indo-Islamic School

by Mario Bussagli

India clashed with the world of Islam for the first time in the middle of the eleventh century. The Muslim conquest of a large part of the peninsula and the subsequent penetration of these foreign peoples, the bearers of an intolerant religious ideology, overturned India's figural evolution and civilization in general. Traditional Indian training was not altogether erased but, being forced into contact with an alien mentality, it gradually changed, so slowly, however, that the Indians were hardly aware of it. This was a period of transition and adaptation, at the end of which the Muslim art of India was to bloom into a luxuriant life of its own, worthy of the name 'Indo-Islamic art.' As H. Goetz noted, the Muslims were a minority who dominated vast regions; it was therefore inevitable that their artistic expressions should reecho the world with which they were in constant touch even to the extent of transforming Hindu techniques, forms, and decoration into local styles. On the other hand, the latter-day Muslim art of India assumed a characteristic attitude not very unlike the typical Indian one, though with some inevitable and appropriate alterations. In its turn, Islamic art challenged classical Indian art and the latter was renovated without, however, departing from its essence, which was in opposition to that of the traditional Islamic trends. A book by Hasan Nisami says that at first, when the clash was at its fiercest, the unrelenting, desecrating fanaticism of the conquerors made them destroy each individual Indian fortification so that not a single stone would be left standing, but all would be turned into dust as if crushed "under the feet of a fierce and gigantic elephant." This first phase, when cities were ruthlessly sacked, innumerable human lives were destroyed, and all the Indian temples and monuments in the areas exposed to the destructive fury of the Muslims were razed to the ground, was followed shortly afterward by a destructive method of a different kind. The Buddhist and Hindu buildings in the conquered regions were torn down to provide materials for the construction of other—Islamic, of course—architectural works. This second phase involved the reuse of materials—at times of whole elements—from the demolished structures, and reuse was often conditioned by the shape, nature, and configuration of the materials recovered. Consequently, the Muslim constructions built by this economic method often had a nondescript aspect—half Indian, half Muslim. It was the worst phase of Buddhist and Hindu monuments, but also that which paved the way for the subsequent artistic flowering, for it was then that the two apparently irreconcilable figural currents were brought together.

In fact, Islamic art is antithetical to Indian art not only in terms of space and time, which are basic for the development of a taste, but also in so far as the conceptions of the religious building and of the value of the anthropomorphic figure go, for the Muslims believe that the human figure must never be represented. The mosque *(masjid,* that is,

literally, the place where one prostrates oneself) was not only the Muslims' cult center but also the determinant of Muslim style. Simple, linear, open to the light and to all who came to pray, it contrasted with the enormous structure of the typical Hindu temple, which enclosed a small cell, reflected a longing for darkness and mystery, and kept the faithful out, leaving room only for the priest. Hindu architecture symbolically reproduces a cosmic structure (the mountain); it is introspective, complex, and indeterminate, at the same time extending to and reflecting on the vital rhythm of the individual, as well as of the community, the mystery of sacredness. The structure of the mosque, instead, merely points to a direction—that of Mecca; it is fully visible and comprehensible, it does not involve the mystery of being but constitutes an abstract element and the imprint stamped by human faith on the natural ambience. It expresses a transcendency through inventiveness and bold building techniques. It is a real work of architecture, whereas the Indian temple may well be defined as "a phantasma of massive darkness." More important still, the Indian architects coped with their problems in a completely different manner, often solving those related to statics by means of incised or carved rocks (monolithic temples and cave structures), enormously thick walls, and massive, weighty parts.

Conversely, since all was mystery to the Hindu, in his thinking, human life flowed along the course of natural rhythms: no cause to hide anything, no limitations and fears, but everything disclosed. The Muslim, instead, tended to be reserved, isolated, protective. As Goetz observed, life was the harem—secretive, sacred, "like the garden, love, woman." This interpretation of life, springing from the original desert ambience of the Arabs and from the necessity to protect themselves against a hostile nature, influenced their whole attitude toward architecture and artistic activity in general. Consequently, whereas Indian painting is a reflective interpretation of nature in the wider sense, that of Islam, when it does not pursue abstract aims, is an attempt at transforming painting into calligraphy. For the same reason, in purely Indian tradition there is a preference for subdued, mellow colors, whereas Islamic colors tend to be vivid and loud, except in Mogul miniatures as a result of the Western and Indian influences.

The strongest contrast was therefore in architecture for historical as well as social and psychological reasons. This is why we have chosen to examine first and separately the evolution of this art.

Although the world of Islam established no precedence in the arts, conferring only a theoretical primacy on calligraphy, which materialized the word of God, the importance of architecture was predominant owing to the fact that it required technical ability as well as theoretical preparation and because it was the stamp of Islam on the lands won to

273

343. *The Qutb Minar at Delhi.*
Gate of entry to the compound.
Detail of the building

342. *The Qutb Minar at Delhi.*
Thirteenth century A.D., *begun in*
1199
Built beside the Quwwat-ul-
Islam, this gigantic minaret (238
feet high) is typical of the Muslim
construction, but it uses orna-
mental elements developed by
Indian craftsmen and brought
into the Indian repertory of
decoration.

342

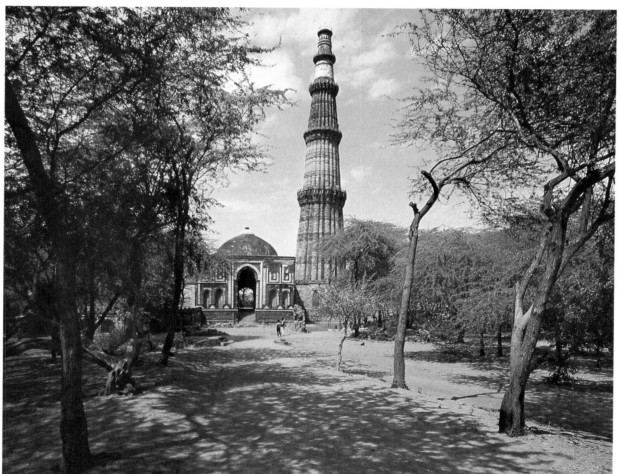

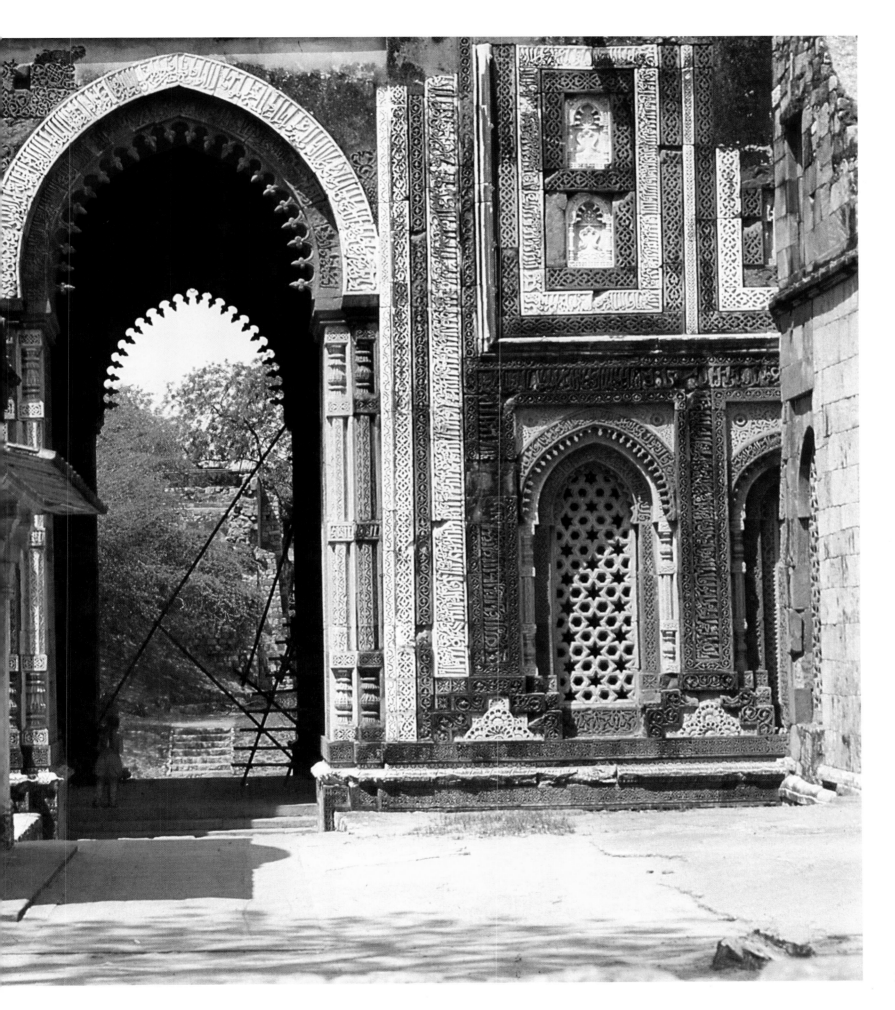

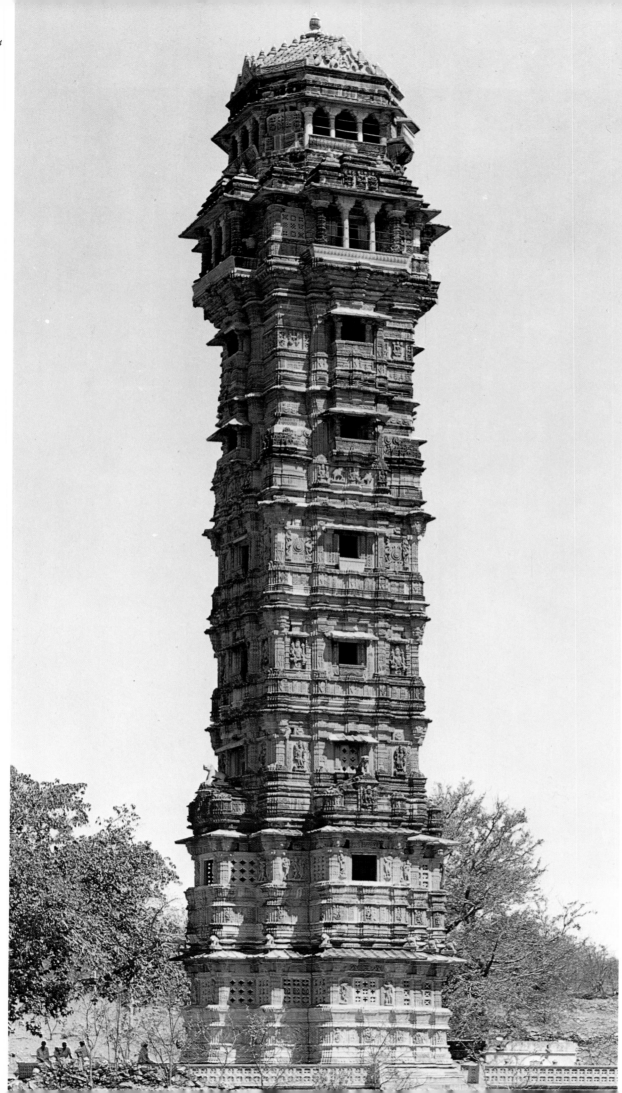

344. The Gaurav stambha, or pillar, at Chitor, the Rajput stronghold. Thirteenth century A.D.
The tower construction, perhaps of Islamic origin, involves Indian elements and others, attenuated.

345. *Mausoleum of the Emperor Humayun at Delhi. Begun in 1564, eight years after the death of the emperor*
One of the most important works of Mogul architecture, it presents an exceptional harmony of lines and balance of masses, especially if one considers the difficulty of correlating the exterior with the interior, where every room is octagonal.

the word of Allah. Architecture was not, however, exclusively religious, but was also military and civic. Always distinctive—if for no other reason than for its basic dome and pillared hall—it underwent a long evolution resulting in varied manifestations. Among these, the architecture of India is one of the most important and valid.

In India traces of Islamic architecture are to be found in the ruins of the small mosques, built after the style of the Samarra mosques, which emerged from excavations at Brahmanabad Mansura in lower Sind. These mosques are, however, the only ones from the phase of the first contacts. Real Indo-Muslim art can be traced back only to the end of the twelfth century. Delhi, which used to be a fortified town and capital of the Rajput Chauhans, after its conquest became the capital of the sultanate of Qut-ud-Din Aibak, the first of the Slave, or Turki dynasty, of sultans. In 1193 Aibak had the first mosque built here. The base of a large temple was aggrandized with the materials recovered from its demolition so as to make it spacious enough to house both the mosque and a congregation hall. Native craftsmen must have worked at it, perhaps under the direction of foreign architects. They responded better than one might expect to the new demands. A series of pillars from a destroyed Jain temple was also employed in the construction, giving rise to some improvised solutions to the many problems posed by the inexperience of the builders and the limitations set by the reused materials. Percy Brown thought the building had more the character of an archaeological miscellany than a considered work of architecture (*Indian Architecture*, Bombay, 1951). Nevertheless, because it was impressive and social and political life flowed toward it, it became the town center. Before the mosque there was placed the famous 'Iron Pillar,' deprived of its crowning figure of Garuda, a gift of Heliodorus removed from its original site after about six hundred years. It was in those days that the saying 'he who possesses Delhi possesses India' was beginning to circulate; that is why its tall minaret was erected. Begun in 1199, after the additions of 1368 and 1503, the Qutb Minar now measures 238 feet (figs. 322 and 323). It was to be at once a symbol of Aibak's great

victory and power, a watchtower, and, obviously, a minaret. Its construction shows none of the uncertainties and errors that appear in the mosque—a sign that the local workers had by now become accustomed to the taste and techniques of their new overlords. Copied from the Jam minaret built by the Chorid sovereigns, the Qutb Minar consists of four superimposed Seljuk funerary towers in the shape of tents (the Seljuks were Turks who had not forgotten their nomadic origins). The tapered and fluted towers are provided with projecting balconies resting on fine 'muqarna,' the characteristic Muslim stalactites. Pseudo-Indian friezes are combined with Koranic inscriptions and arabesques. The work is perfectly valid and remarkably beautiful in appearance. The tomb of Aibak, situated behind the mosque and built in the shape of a cube (originally surmounted by a dome), also has very fine arabesques consisting of Indian and Islamic elements. Of the civic architecture of the time no trace is left, for the large palaces were completely razed by the subsequent kings to be used as quarries for building materials. The conquest of Gujarat and the Deccan followed, in time, the terror that the hordes of Genghis Khan had spread over India when, shortly after the death of Aibak in a polo accident in 1210, they had reached Peshawar and marched westward.

Under the Khilji and the Tughlaq dynasties (from 1290 to 1414), Indo-Muslim architecture departed from the Seljuk models, favoring huge buildings, so colossal in fact that they could never be completed; extremely pronounced military features, even where there was no need for them; and more elements of the Indian tradition. Thus, the A'lai Darwaza, a large cubic construction with a low dome, four doorways, and real and sham windows covered with Indian and Islamic decorations, which was to have been part of a gigantic complex, presents chromatic effects derived from Gujarat Hindu architecture, obtained by the juxtaposition of blue schist, red and yellow sandstone, and black and white marble with streaks of different colors. The Tughlaq defensive structures of Tughlakabad and Adilabad—the latter protecting the dam of the man-made lake on which Tughlakabad depended for its

345

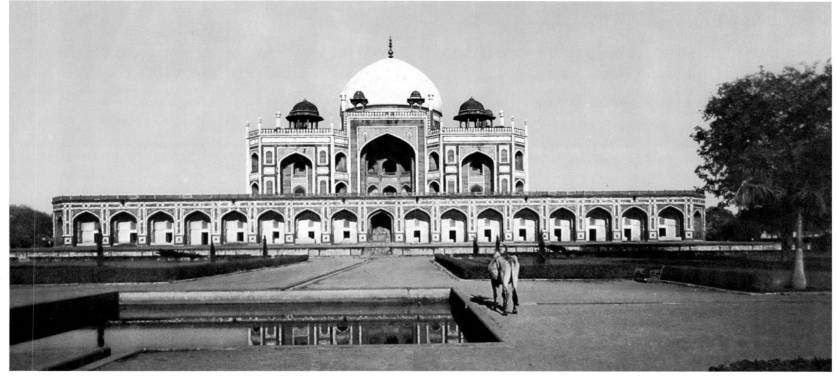

346. *Coins of the Mogul emperors Akbar (a) and Jahangir (b and c), with Indian symbols (gibbous bull) or with portraits (one of Akbar was struck) which bear official witness to the very relative Islamic orthodoxy of the first Moguls. National Museum, New Delhi*

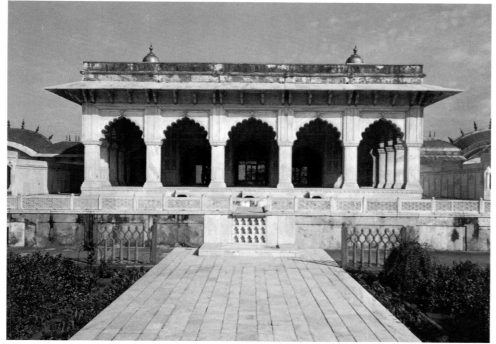

347. *The Fort, Agra. Khas Mahall. Front of the central building*
Rebuilt between 1563 and 1573, this grandiose construction uses elements derived from the Rajput style. It obeys Indian taste in a lesser upward impulse and in the solid massiveness of its elements, which remain at the same time undoubtedly harmonious.

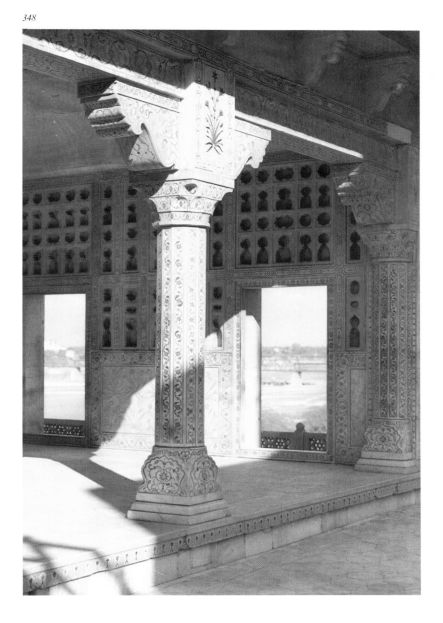

348. The Fort, Agra. Inside the octagonal tower, with a polygonal pillar; its capital is reminiscent of the pre-Islamic world
The octagonal plan of the tower and the form of the pillar belong to a taste originally external to the tendencies which were dominant under the Moguls; but they found wide use during the classical phase of Mogul architecture, to the point of becoming one of the characteristic elements of the architecture of that period.

water supply—are the best examples of Indo-Muslim military style. Made of red sandstone and embellished with elegant ornamentation, these buildings are at once formidable defensive structures and paragons of refined decorative taste. Another example is Deogiri (Daulatabad), which was built by order of Muhammad ibn Tughlaq, like Adilabad, as a new capital. This enormous, impregnable fortress, perched on a rocky cone-shaped mountain on the northern boundaries of the Deccan, dominated the passes that join the northern and the southern portions. Later, Muhammad ibn Tughlaq brought the capital back to Delhi and enlarged the city. His fortified and strongly armed palace is still standing as an example of unusual functional and defensive devices (for instance, zigzag passages). Despite its military power, however, the sultanate of Delhi actually began to decline under Muhammad. Governors and nobles from the provinces became more powerful than the sultans, and if the art of the Tughlaq period continued to thrive under Muhammad's successor—the pious and intelligent Firuz Shah—the Tughlaq phase was quickly beginning to wane. The innovations it had brought, aside from a more complete fusion of the Islamic and Indian attitudes toward aesthetics, were the octagonal ground-plan mausoleum, the long niche at the center of the facades of mosques, the pyramidal roof, and the comparatively rare use of glazed-tile decoration. The

combination of a pointed arch with an underlying corbel architrave, which appears in fourteenth-century Tughlaq architecture, is the exact contrary of a scientific approach to the construction of an arch, but it was a step toward the attainment of the four-centered arch that was to be largely employed by the Moguls. It is relevant to observe that the Indian architecture of the Tughlaq phase felt the influence of Ilkhan Iran—that is, of the Persian Mongols—though in a feeble and discontinuous fashion. Thus, the large Begampur Khirki mosque built for one of Firuz Shah's ministers has a Persian-type iwan behind the main entrance. Beside this mosque, a very fine smaller one, for women only, indicates a change in the women's worship of the divine.

The kings of the Sayyid dynasty (1414–51) and the early sultans of the Lodi dynasty of Delhi (1440–1520) were vassals of the Timurid power of Central Asia. The architecture of the Lodi kings, who conquered all the northern Indian plains as far as the borders of Bengal, the Punjab, and the whole of Central Asia, continued the trend of Tughlaq architecture, incorporating elements from Central Asia and Iran, especially noticeable in the decorative quotations. High domes reappeared, and the lines of the buildings became more vertical. Polychrome stucco ornaments, encaustic tiles, niches, and ornate moldings give these buildings a heavy, baroque aspect, which, though

279

it was the result of an approach to ornamentation recurrent throughout Eurasia, seems to have arisen from the impact of Islamic taste upon that of Hindu India (rather than from their encounter). The octagonal ground-plan mausoleum, surrounded by an open colonnade with domes fluted on the inside and crowning pavilions (inspired by the Indian chattris) supported by slim columns, is also very common. This type of construction was to become typical of later Indo-Muslim architecture. The Lodi style survived the first Muslim conquest of northern India by the Mogul emperors. Not a meager survival, it produced some wonderful buildings (for example, Jamali Masjid and the beautiful small mausoleum of Maulana Jamal Khan, at Mehrauli, of 1530), and originated the architectural tendency that bloomed under the emperors of the Sur dynasty of Afghanistan and particularly under Sher Shah Sur, who reigned in Delhi from 1540 to 1545. This phenomenal builder had made Solomon's seal his insigne and had it carved on all the works he commissioned. Sher Shah Sur ordered the building of many palaces and fortresses, such as Patna and Kanauj. At Delhi, he built the imperial citadel (Purana Qila) with the fine mosque called Qila-i-Kohna Masjid, and his architects, mindful of the Tughlaq experience, which shows in the multicolored decoration of the Purana Qila, strove to synthesize all the styles that had formed in northern India. Possibly the fall of the Mameluke empire of Egypt (1517) had brought exiled artists to India and caused the introduction of Mameluke Egyptian marble mosaics with consequences in technique and style both at the time of Sher Shah and in the subsequent Mogul period.

In any event, the major turning point of imperial Indo-Muslim architecture in Mogul times occurred with the full acceptance of an Iranian style resulting from the adaptations of the Timurid style to Central Asian preferences (Turkistan trends), and its later reelaboration in the Iranian Safavid current (or, better, phase).

So far we have followed the main evolutionary line of Indo-Muslim art, generally referred to as 'imperial,' which is the trend that prevailed in Delhi and in the areas of its influence. Before facing the various problems that Mogul architecture poses, however, it must be pointed out that there existed numerous 'provincial' currents of Indo-Muslim art both in the north and in the Deccan. Some of these schools, such as the Deccan school of the Bahmani dynasty, were closely linked to the artistic evolution of Persia. It is very likely that the cause of their figural choice lay in the dissensions among the Bahmanis in the reign of Vijayanagar—which lasted until the end of the fifteenth century—and the desire of the Bahmanis to oppose their Hindu adversaries. This is not to say, however, that the Deccan style did not include, then and later, numerous Hindu elements in both decoration and—to a lesser extent—construction. The Indian kudu, for instance, reemerged as a freestanding arch at the entrance of the Banda Nawaz (1640). On the other hand, in the middle of the fourteenth century, settled Persian, Mongol, and Turkoman communities had already established exchanges with their various countries of origin and had introduced different figural tendencies, as these people were slowly becoming assimilated in a process that was further complicated by interaction with other Islamic centers, such as Malwa. The resurgence of Vijayanagar, its strong military power, its fall into the hands of the coalition of successors to the Bahmani at Talikot in 1565 facilitated and sped the fusion of Hindu and Muslim elements until the simple and logical Islamic buildings were reduced to a baroque stodginess, so overlaid with plant motifs that the domes of the minarets were shaped like lotus blossoms.

Some of the other tendencies, flowering at different periods, showed the influence of Delhi—for instance, those of Malwa from 1405, of Jaunpur

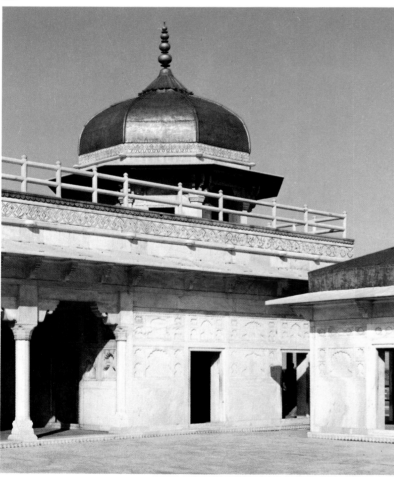

349.

349. *The Fort, Agra. Octagonal tower with the characteristic metal-plated dome and part of the building in front of it*

for a little over a century (1376–1479), and of Nagaur in Rajasthan. Their provincial character is partly due to the reuse of Hindu materials and partly to the persistence of certain modified Timurid elements. In Gujarat, Kashmir, and Bengal the Hindu component is predominant. Though stifled, the echo of Tughlaq art unquestionably recurs in all these trends. Skillful Indian labor kept all the Hindu forms of decoration alive, except for those that could seem idolatrous in the eyes of the Muslims, and helped to enrich them with Islamic arabesques and Koranic inscriptions. Apart from the architectural structures of brick and lime, all the others reflect the traditional patterns and techniques of India. The fusion between these two completely different worlds, though far from complete, was well under way.

With the advent of the Moguls the artistic character of India changed radically. Babur, 'the lion,' who had been the Timurid governor of Ferghana and Samarkand, and later of Kabul, vanquished the two great powers of the north, the Lodi sultanate and that of the Rajput kings of Mewar in the person of Rana. Babur's son Humayun conquered Malwa, Bengal, and Gujarat, and was overthrown by Sher Shah Sur, who forced him to leave India, to which he returned in 1554, where he died in a polo accident in 1556. Both Babur and Humayun resided in Agra, but Humayun undertook some construction in Delhi on the site where Sher Shah was later to erect the Purana Qila. Although they were educated, fond of art, and undoubtedly refined in taste, both Babur and his son remained faithful to the Timurid architectural patterns of Central Asia, favoring octagonal ground-plan pavilions and gardens adorned with tulips, hyacinths, and narcissus, geometrically designed to highlight the schematized plans of the buildings. In painting, they were partial to the Chinese component, which was also

350

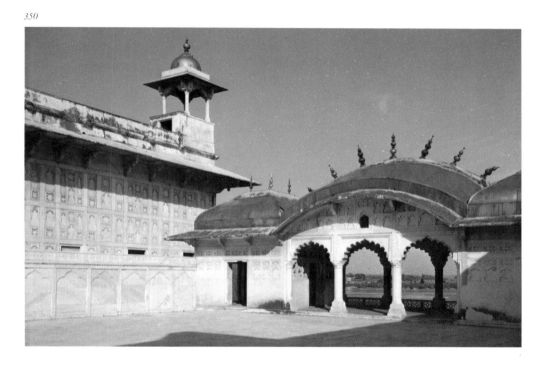

350. The Fort, Agra. One of the gates and a watchtower in the form of a kiosk. Mogul period The corrugated line of the arches over the entrance should be noted.

351

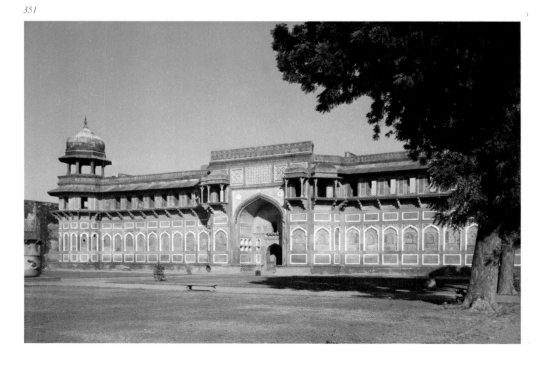

351. The Fort, Agra. Jahangiri Mahall (the palace of Jahangir). End of the sixteenth century A.D. The attempt to give movement to the facade both with projections and indentations and with polychrome effects is noteworthy.

followed by the Safavid Persian painters (see fig. 366). All in all, they remained what they were—Central Asians of mixed culture, to whom Persia was the land of the greatest artistic refinement in both the figural arts and literature.

The imperial style of the Moguls, despite the various works commissioned by the early kings, began to develop only under Akbar, the first of the great Mogul emperors and the first who really regarded India as his homeland rather than as a conquered country. The immediate consequence of this changed cultural and political outlook was the re-emergence of the Lodi style. The Mogul architects of the days of Akbar employed local craftsmen and the skillful Indian master builders. The few architects who continued in the Timurid and Safavid traditions were soon joined by other Indian architects, to whom the polychrome glazed tiles characteristic of Persia and Central Asia were completely foreign. Other factors, such as the difficulty of securing and applying tiles, also made such decoration less popular. For these reasons, the techniques involving the use of sandstone; of marble and schist slabs; of marble intarsia, sometimes with spectacular decorative effects and wondrous skill; and of mosaic soon prevailed. The predominant stylistic component was Safavid art—that is, Persian—but mixed with Hindu elements and other features derived from the encounter of Islamic and Indian aesthetics and the consequent deformations that had occurred in the Lodi period and at the time of Sher Shah. Generally speaking, the first Mogul phase, despite the great architectural activity, is not very original. The following phase, instead (that of Akbar and of his son Jahangir), is an eclectic phase that actually gave rise to a new

352

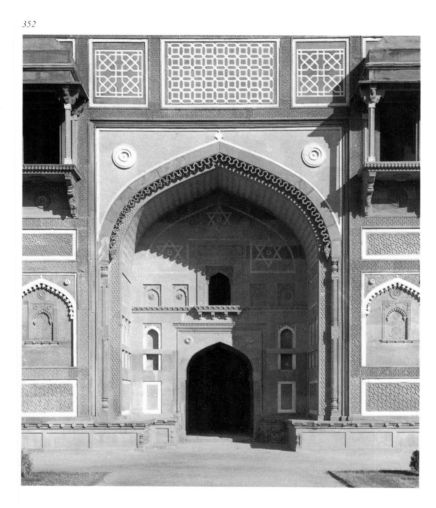

352. Central gate to the palace of Jahangir with the two verandas projecting at the sides
Inside the niche can be seen the hexagram (the six-pointed star formed from two equilateral triangles) with the circle, or ring, inside it, the sign of the magic power of the Mogul emperors.

353

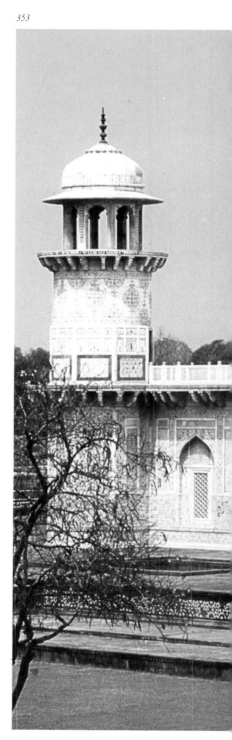

353. Tomb of Iʻtimad-ud-Daulah at Agra
This small but elegant construction belongs to a transitional phase in which the exquisite finishings assume a predominant importance. Besides the four octagonal towers which rise at the corners like minarets incorporated into the building, the tomb is crowned by a sort of pavilion, with wide openings in the sides, in the middle of the roof. The openings to allow access and to provide light, which are surrounded by arched niches, give movement to the facade. The construction is elegant and harmonious, worthy of the official to whom it was dedicated. Iʻtimad-ud-Daulah was the father of Nur Jahan (born Nur Mahall), the beloved wife of Jahangir.

style (see fig. 355). The empire had become a supernational state in which attempts were being made to give Muslim and Hindu subjects equal rights. Furthermore, because of Akbar's interest in religious problems, he departed from Islamic orthodoxy with consequences also in the field of architecture.

Among his other merits as a builder, Akbar was the founder of Fatehpur Sikri (1573; see fig. 358), in which the combination of different styles is a precise indication of his political attitude, evidenced also by the fact that the city was erected around an Islamic hermitage where the prayers of the empress (who was a Rajput) for an heir to the throne had been granted. The city was not fortified, its buildings were of red sandstone reinforced by a framework of pillars and architraves grooved to allow the insertion of slabs of the same material, and its roofs were derived

from the Hindu tradition. Ornamentation was far from the traditional Islamic kind—in fact, so different that in at least one instance the human figure was used for ornamental purposes. Possibly this figure, represented in the act of picking fruit off a tree, was inspired by the figures on the Islamic silver cups on which the labors of the different months were illustrated, a motif derived, in turn, from Italian Romanesque decoration. In any case, this unique image was unquestionably used in an Indian spirit. The Indo-Muslim architecture of Akbar's reign reflects a desire to meld the traditional elements of Indian Islam with the characteristic architecture of the Rajputs, who were the most unrelenting and bold opponents of the Muslim power in India. The attempt is particularly evident in the fortresses, among the most important of which is the Fort at Agra (see figs. 347–351). The plan of this

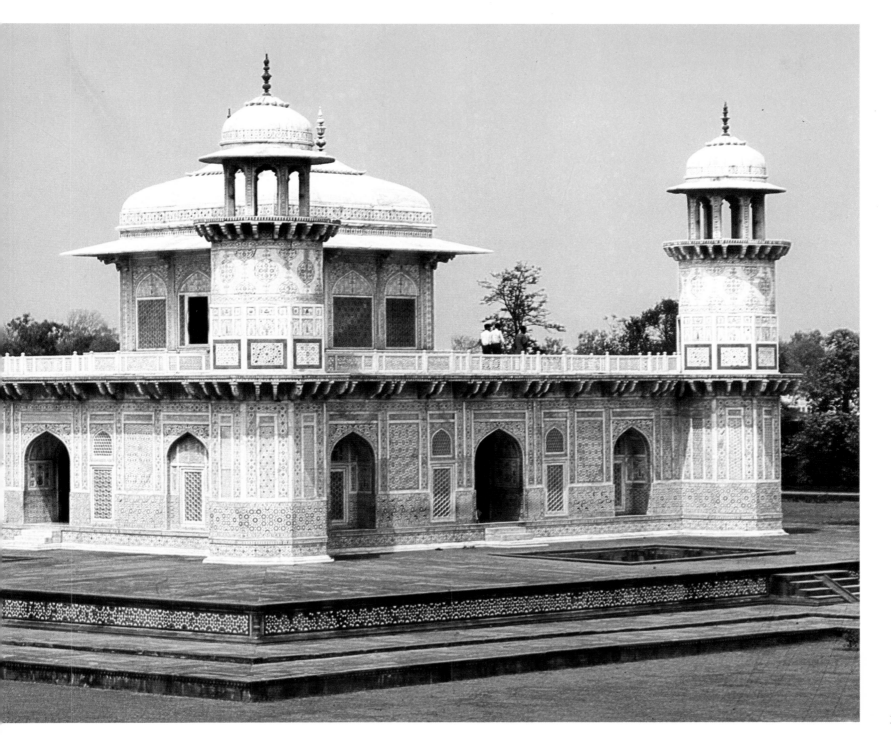

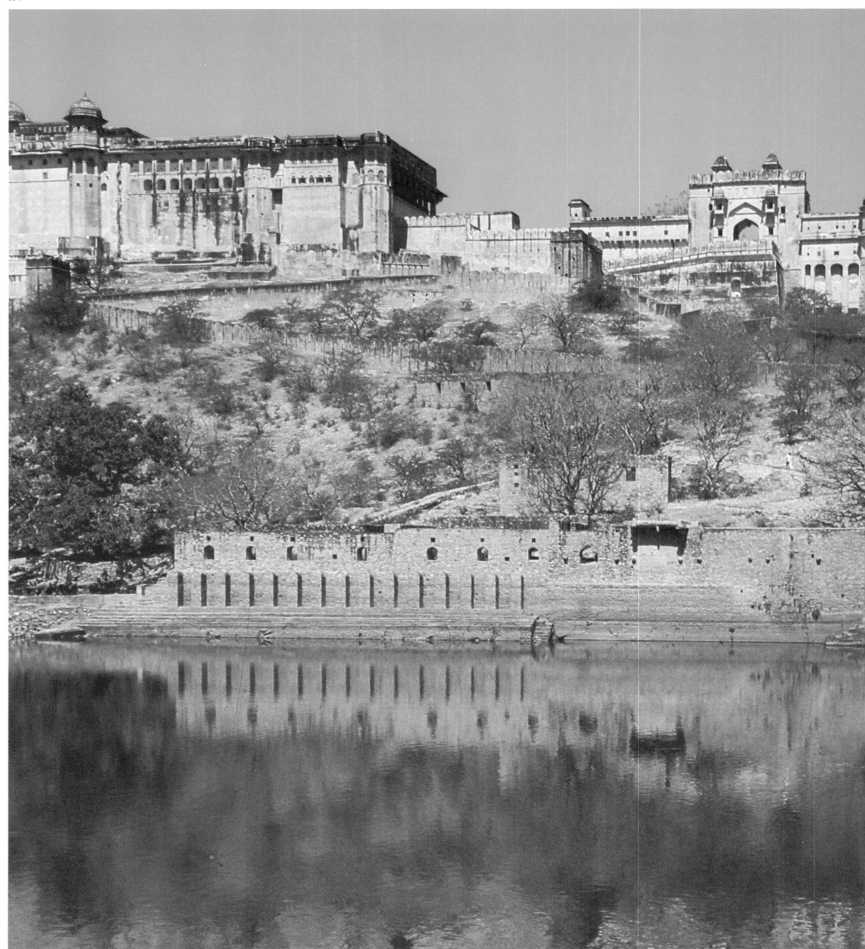

*354. The fortified city of Amber
(Rajasthan)
Most of the monuments of Amber
belong to the reign of the Maha-
raja Man Singh (1592–1615)
and to that of the Raja Jai Singh
(d. 1668). The city was a cere-
monial residence as well as the
capital of the state. The bastions
in the form of towers should be
noted.*

fort is a maze of cellars, storerooms, wells, passages, communication trenches, and so on. A frieze with elephants adorns the exterior; pavilionlike structures, low and sloping for obvious functional reasons but also domed, supplement the main building. This admixture of Rajput and Islamic elements was not only the result of circumstances arising from the clash of the two sides but also an intentional device to demonstrate on the political level that understanding and coexistence were possible. It must be remembered that a curious aspect of the conciliatory policy of the Moguls toward the non-Muslim Indians is the fact that human figures appeared on coins (in other words, on official government documents in wide circulation; see fig. 346c) and that both Akbar and Jahangir commissioned statues after the stylistic motifs dear to the Rajputs. The statues were later either destroyed or damaged. The human figure was therefore no longer confined to the so-called minor arts and the interior decoration of living quarters. It became a fully accepted feature of decoration, breaking forever the traditional, though not always strictly observed, aniconic prejudice of Islamic art. Although the phenomenon of 'Indianization' occurred very soon in architecture, it was slower in the other figural arts. It can be said that the advent of the really classical Mogul style was a result of this transformation in architectural taste, which formed the basis of all later developments.

When Shah Jahan ascended the throne in 1628, the Mogul style changed. The effort to fuse the Islamic tendencies with those of the Rajputs—Hindu tendencies simplified to suit a semifeudal society—slackened as preference was given to marble, a material until then very little used. The color of the great architectural works, and particularly of mausoleums, changed from red to white and rose-white (see figs. 353, 359, and 355), while intarsia and carved decoration became extremely naturalistic, rich, and often multicolored. In fact, there are even examples of inlay in gold and in semiprecious stone sometimes mixed with gems. This lavish display of wealth was unheard of in Muslim orthodoxy. Marble was matched with white muslin curtains. Ornamental openwork panels of marble had been used before, but never in such quantities, except in the mausoleum of Hushang Shah at Mandu, dating from 1430–35. The mausoleums of Jahangir and Nur Jahan, near Lahore, are among the best examples of the new style derived from Safavid Persia and introduced into the Mogul court partly because of the presence of Nur Jahan (born Nur Mahall), the beautiful and enchanting Persian poetess whom Jahangir had fought to marry and for whose love he had given up control of state affairs. The mausoleums, of which only the part devoted to Jahangir with his cenotaph is standing, were characterized by, among other features, fine openwork grilles. All its decoration in marble and semiprecious stone was later removed by order of Ranjit Singh of Lahore, who used it to adorn the golden temple of Amritsar.

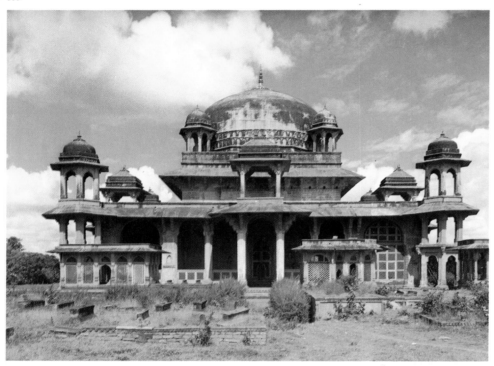

355

355. *Tomb of Muhammad Ghaus at Gwalior*
Built in 1564, the monument uses elements derived from the architectural style of Gujarat and others from the sultanate of Lodi. It is a fine example of eclectic architecture.

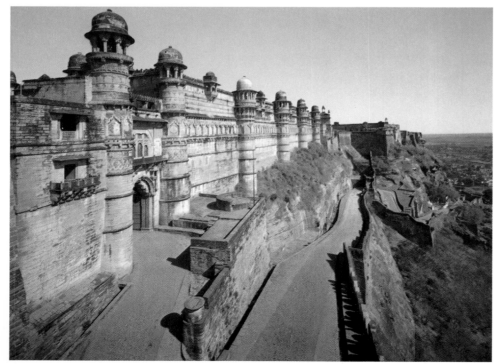

356

356. *Gwalior Fort, seventeenth century* A.D. *The Man Mandir in the Gwalior Fort, built by the Maharaja Man Singh (1486–1516)*
A fine example of Hindu civic architecture (with strong military elements), previous to and contemporary with the Moguls. Babur was struck by the shining domes of gilt copper. Although ingenuous in its exterior decoration, in its repeated arches, and in its heavy structure, it is a clear expression of a typically Indian taste. Touched up several times.

The masterpiece of the classical Mogul style is the Taj Mahall, at Agra (figs. 359–365), begun in 1632 and completed in 1648; H. Goetz considers this work the most Oriental and best of the Persian current as opposed to a definitely Hinduized, inferior current that he believes to have been the more genuine expression of the Moguls' taste. This interpretation, in which there is some truth, must be accepted with reservations. As all scholars agree, the Taj Mahall, the mausoleum that Shah Jahan commissioned for his beloved wife Mumtaz Mahall, embodies the purest Indian spirit in Muslim architecture. There is, however, the problem of its attribution. The available documents are not in accord. Some say that 'the author of the plan' was Ustad Ahmad, also called Ustad 'Isa, who worked at the Taj together with his brother Ustad Hamid. A very authoritative text on the Taj Mahall *(Risala-i-Rauda-i Taj Mahall)* reveals, instead, that the architect of the Taj was a Christian, "a rare designer and artist." Still other documents say that among those working at the Taj was 'Isa Muhammad Effendi, a pupil of the great Sinan, the best-known Turkish architect of the time. On the other hand, Father Sebastiano Manrique *(Itinerario de las Missiones del India Oriental)* states that "the architect of these buildings was a

Venetian by the name of Geronimo Veroneo, who came to these lands under Portuguese sail and died in the city of Lahore shortly before my arrival"—a fact directly and indirectly confirmed by various data. Possibly collaborating in the construction of the Taj Mahall were architects from Persia, Turkey, and the West—Geronimo Veroneo, for one, and, perhaps working at the tentative plans, Austin of Bordeaux, who had received the prestigious title 'inventor of the arts' from Shah Jahan's father, Jahangir—all under the supervision of the emperor, the passionate coordinator of the designs and suggestions that his artists submitted. The only concern of Shah Jahan after his wife's death was to honor his beloved with the wonderful monument that perpetuates her memory to this day.

Although decidedly Indian, the Taj, 'the pearl of India,' stands in an unusual scenographic setting. If viewed from the gate of the enclosure surrounding the whole architectural complex, it appears diminutive, more like a block of carved marble than a building. As the viewer comes closer, however, its size increases until it seems to loom and soar. The soaring effect is actually illusionistic, as the height of the Taj from the ground to the top of the exterior dome is the same as its breadth. The

357. The so-called Elephant Gateway of the Man Mandir, Gwalior Fort
Attached to the main building as a continuation of it is the boundary wall of the fort, with its watchtowers and defense towers. Its appearance is characteristic, both on account of the reinforcing bastions, consisting of round towers, and the design as a structure in itself, complete with balcony, moldings, blind arches, and cornices of decorative function. The fort of Gwalior, which became practically the center of the city, was the capital of an autonomous Maratha kingdom in the eighteenth century.

357

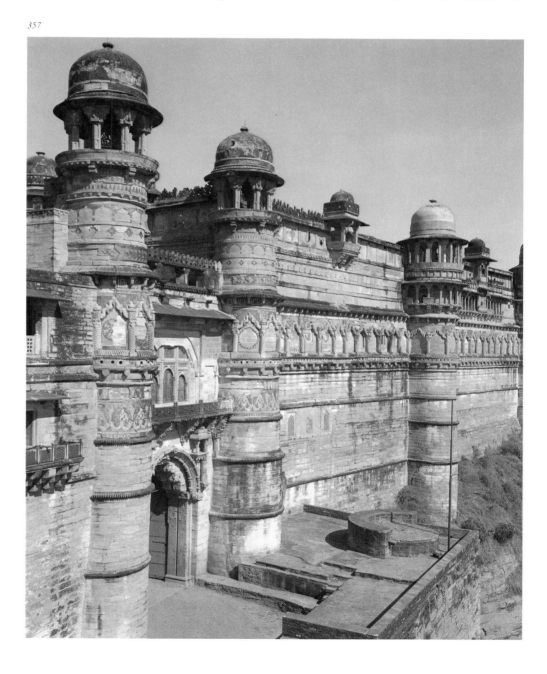

effect, however, is undeniable, owing to its glistening white marble facing and the dark shadows of its arches and loggias, to say nothing of the four corner minarets, each about 140 feet high. These impressions caused by optical illusions are further heightened by the crystal-clear water in the central lagoon and the white curbs on either bank, which form a straight line running up to the lower terrace at the bottom of the garden. Cypresses and evergreens arranged in rows accentuate this effect of infinite perspective. The garden is designed like those of the contemporary villas of the Veneto, where houses and front gardens are interrelated and the square or rectangular gardens seem like carpets aligned with the fronts of the houses. On the other hand, the mausoleum is reminiscent of the evanescent, fairy-tale Persian (Timurid and Safavid) miniatures and some of the Mogul type. In these paintings based on a limited perspective (they are practically two-dimensional), the buildings, incorporeal for lack of depth and volume, are nevertheless suggestive. It is therefore possible that an artist who could master scenographic effects should so conceive as to impart to the main building of such an imposing architectural complex as the Taj the same immateriality that is to be found in the buildings reproduced in the miniatures. To be able to conceive such a thing, however, he must have been very well acquainted with scientific perspective, accustomed to a totally different—Western—taste, and, above all, in a position to compare the two-dimensional pictorial idealizations of the miniatures with much more realistic representations and, therefore, able to appreciate their fairy-tale nature. The contribution of Geronimo Veroneo must have been really remarkable, even though the other architects who worked at the Taj played important roles in its construction and were sensitive enough to cooperate with their Italian colleague's pursuit of scenographic and illusionistic effects. On the whole, the Taj is in keeping with the other mausoleums of the time, such as those of Jahangir, Nur Jahan, and I'timad-ud-Daulah (fig. 353). Its central pavilion (fig. 359), however, is an octagon, as if the corners of the basic rectangle were cut by slanting planes. The resulting vertical planes contribute to the scenographic effect. Decoration is strikingly subdued, consisting for the most part of Koranic verses carved in black marble with very fine calligraphic effects, geometric motifs, and exquisite arabesques (see fig. 360). It was executed by a Persian, Amanat Khan Shirazi, known as the best calligrapher of the empire. As has been said, the decoration, which

358

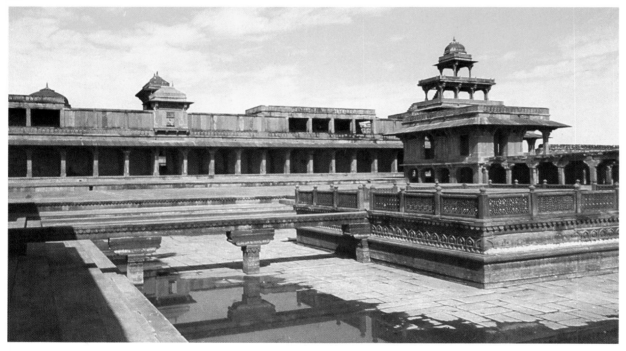

358. Fatehpur Sikri. The characteristic rational and functional style found in most of the buildings of the city, grouped approximately according to their intended purpose and their use, can be seen in this view.

359. The Taj Mahall (central building with the great dome and part of the canal in front of it), Agra, 1632–48
The name given to the monument as a whole is that of the princess who is buried there, and who was called Taj Mahall, which means 'pearl of the palace,' also an official title. The proportions of the central structure are studied in such a way that the dome, from its base to the metal pinnacle which surmounts it, has the same height as the structure that frames the enormous niche around the entrance. Although derived from similar constructions, this building is distinguished from them both in the harmony of its proportions and in the polychrome effect of the gilt marble and inlaid decorations.

shows in itself extraordinary chromatic effects, was further brightened by precious stones (diamonds and sapphires), and the huge gates were solid silver. The openwork marble grilles enclosing the two cenotaphs (the emperor's and his wife's; see fig. 365) are substitutes for the original ones of gold, which were thought too precious to be left there. All these treasures were removed or looted during the wars that followed the most splendid phase of Mogul rule.

It has been mentioned before that a large part of the empire was more exposed than the rest to Persian influence—perhaps also as a consequence of the importance that the family of Nur Jahan had acquired—and that the Taj Mahall at Agra, according to some critics, marks the height of this influence (mixed with other components) as well as the easternmost limit of the Safavid diffusion. It must be observed, however, that every Persian suggestion was immediately transformed; for example, whereas in Persia external glazed-tile decoration covered the whole surface of a building, in the Mogul area, it consisted of panels framed by thin ledges of unglazed bricks. This is why the Persians—who, by the way, were arming for more bloody clashes with their powerful eastern neighbor—considered the Moguls to be provincial. The gap in style

became wider when Mogul designers began to combine red sandstone and marble in the same building.

Distinctive contributions from Bengal, Kashmir, and the Deccan sped the transformation of Mogul architecture and the insurgence of new features, such as ogival and cusped arches, capitals inlaid with semi-precious stones, and underground living quarters where people could escape the stifling heat of the Indian hot season. The best example of civic architecture—the Taj is actually a religious building—is the Red Fort at Delhi, built between 1639 and 1648 under the supervision of two of the architects who had worked at the Taj, Ustad Ahmad and Ustad Hamid. Though much larger, its ground plan resembles those of the forts of Agra and Lahore. Altered several times, also in the days of British rule, and stripped of some interior structures, it looks even now a formidable instrument of war and domination with its low buttresses, battlements, and corner turrets covered with bulbous domes. The keep is built into the uninterrupted line of its interior walls with octagonal bastions and two symmetrical watchtowers in the form of stout minarets. Its characteristic battlements, shaped like large shields with rounded tops, answer functional requirements in a very practical

359

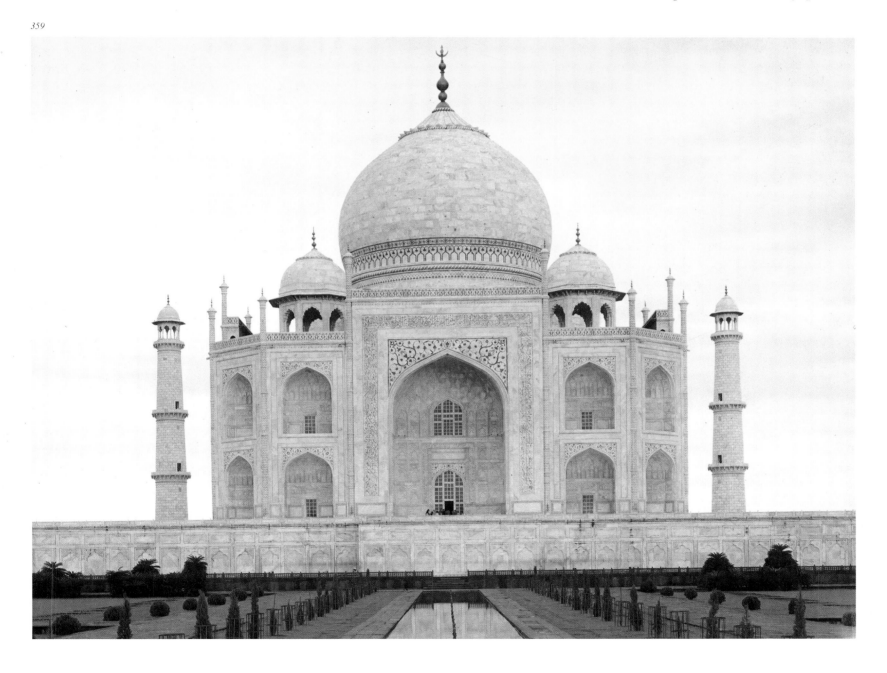

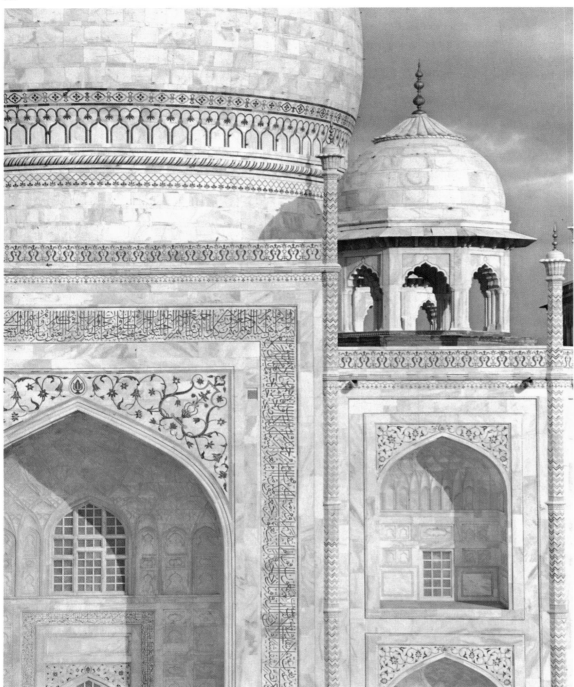

360. *The Taj Mahall. Detail of
the exterior decoration of cal-
ligraphic inscriptions (supervised
by Amanat Khan Shirazi) and
floral and geometric motifs*

manner. Under Shah Jahan and at the beginning of the reign of his successor, Aurangzeb, palaces, administration buildings, gardens, bridges, and caravansaries were erected. The civic architecture of this Mogul phase has not been systematically studied. It is possible to observe, however, that decoration consisted of marblelike stucco coatings and a more extensive use of painting. The ground plans that had previously been developed continued to be employed.

Muslim orthodoxy, which had greatly slackened in the reign of the unprejudiced Akbar, was restored under the reign of Shah Jahan and became preponderant and intolerant under Aurangzeb. Consequently, both sultans were ardent builders of mosques. These had high central arches (pishtag) and false niches intended to animate the facades. Red sandstone, the favorite material, was inlaid with marble—a fusion, so to speak, of the two more common techniques. The importance of mausoleums decreased: the personality of the individual, even of the representative of the empire, was redimensioned to the scale of man as a creature of God, unprivileged and valueless. This, however, did not diminish the emperor's sway, for he continued to be the sole ruler of a highly centralized form of government, which was actually indicative of the serious crisis that was afflicting the empire. Under the successors of Aurangzeb, who had depleted his strength in the fights against the Marathas while the Europeans were seizing the key positions on the peninsula under pretense of submission to the Moguls, it became practically impossible to secure marble or even the more common and less valuable red sandstone. Construction was continued with second-best materials, suggestions from the European baroque style, over-elaboration, stucco to cover underlying worthless materials, and exaggerated polychromy. The great phase of Indo-Islamic architecture was spent, despite the attempt at revival at Hyderabad in the first half of the eighteenth century, in Mysore in the second half of the same century, and in Kashmir. Practically speaking, the effort of the sullen Aurangzeb to restore balance among the contrasting and dispersive forces of the empire by enforcing strict orthodoxy had not only failed but also attained the opposite effect. It had accelerated fragmentation and political decadence with the inevitable consequences on culture in a civilization dying of overrefinement.

Apart from the painting and miniature tradition existing before the Mogul period, it was the impression that the works of the great Persian miniaturists made on Babur, the founder of the Mogul empire, that prepared the success of this genre. Struck with the expressive power of Bihzad while visiting at Herat, Babur transmitted his admiration to his son. Humayun brought back with him from Persia two of the best artists of the time, Mir Sayyid 'Ali of Tabriz and Abd al-Shamad of Shiraz, whom he appointed to different honorary and administrative posts, but whose task was actually to lay the foundations for that Indo-Persian school that was soon to achieve topmost quantitative and qualitative levels of production. The output of miniatures of the Mogul phase, which also was embellished by famous names, was an organized, almost industrialized undertaking dictated by the taste of the emperor and his court. The Persian painters in the service of Humayun set up large workshops where 'teams' undertook and carried out the illustration of not only monumental, rich works, such as the famous *Dastan-i-Amir Hamzah* (the legendary stories of Emir Hamzah), but also less extensive and simpler pictorial cycles (see fig. 366). Two or more artists often worked at the same miniature–a designer, a colorist, sometimes a portraiture specialist, and a minor detail painter. Obviously, the purpose of this teamwork was to speed and increase pro-

361. The Taj Mahall. One of the little kiosks which flank the great central dome of the main building Note the many-lobed arches and the double false pillars which sustain them.

361

362

363

362. *The Taj Mahall. Detail of the balustrade surrounding the cenotaph of the princess (upper register)*
The alternation of the flat, pink-and-white inlaid surfaces with more elaborate elements creates an admirable decorative effect.

364. *The Taj Mahall. Detail of the floral decoration inlaid in the balustrade which surrounds the cenotaph of Taj Mahall*
The almost geometrical stylization of the stems, in contrast with the naturalism of the flowers and leaves, is very far from classical Islamic arabesque forms, and accentuates the ascending rhythm of the supports of the balustrade.

363. *The Taj Mahall. Detail of the decoration of the supports of the balustrade of the cenotaph*

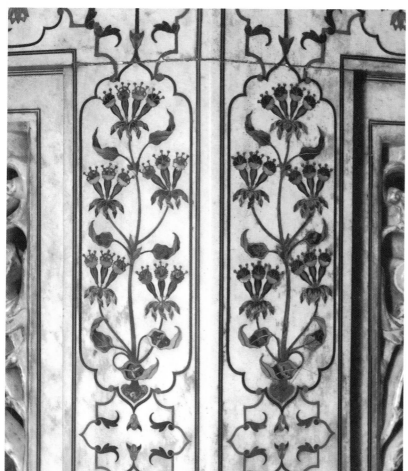

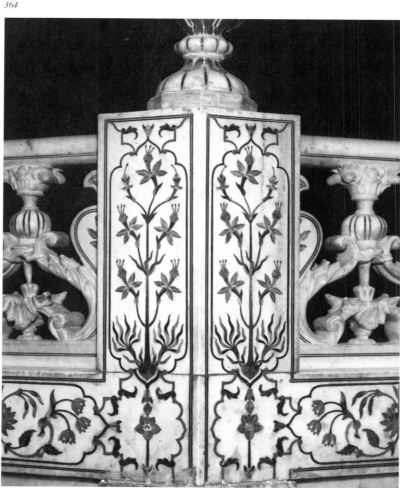

364

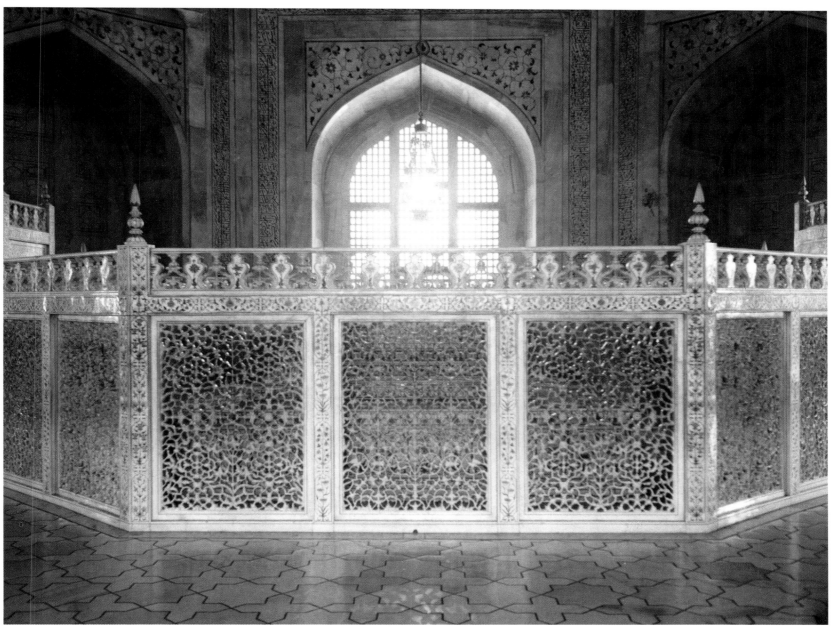

365. Interior of the Taj Mahall
The tomb of the princess, which is
in fact a cenotaph, with the great
balustrade in filigree marble
surrounding it. The tomb is empty,
because the remains of the princess
are preserved in the underground
part of the building. The present
balustrade replaces the original
one in gold, removed after a short
time because it was too valuable.

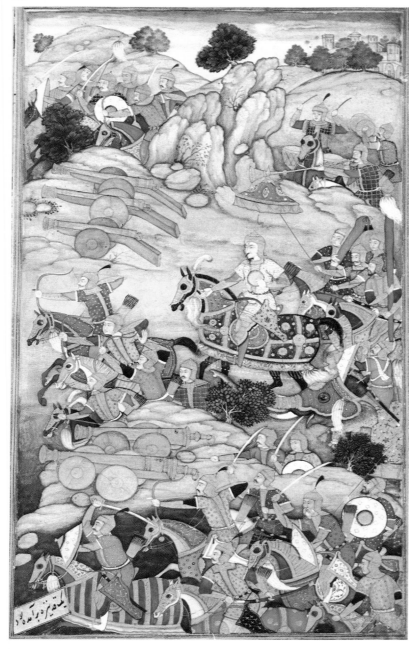

366. *Miniature painting for 'The History of Babur' (Babur Namah), representing a martial episode. Date uncertain (1530?). National Museum, New Delhi The miniature is predominantly Persian in style, with a few Western elements.*

367. *Ragmala. Miniature representing one of the modes of Indian music. Ahmadnagar, 1580–90. National Museum, New Delhi This isolated page, related to the graphic styles of North India,* portrays a couple on a swing. The subject alludes to the name of a musical mode, 'Hindola,' meaning swinging.

368. *Episode in the life of Jahangir. Miniature. Mogul, end of the sixteenth century* A.D. *Prince of Wales Museum of Western India, Bombay Certain iconographic and stylistic details reveal a Western element, especially in the structures of city and garden in the background, which are not always perfectly understood.*

369. The final episode of the siege to which Akbar subjected Chitor in 1567, that is, the 'Janhar.' Miniature. Mogul, seventeenth century A.D. Victoria and Albert Museum, London
The Rajput women throw themselves into the fire which they themselves have started. The composition is still based on Persian tradition. Extremely descriptive, it uses a palette relying chiefly on red and related tones, as is suitable to the description of the horrors of a pitiless war.

duction by a sort of industrialization. There are works executed by a single, great artist, but as a rule a work is attributed to the designer, who also took care of the finances involved. Though there were no 'academies' as in China and in the West, the Mogul phase of pictorial production was the outcome of imperial patronage of a unique kind. Large workshops were organized, work was distributed on precise orders, and fashions were dictated by the preferences of the court. Thus, during Akbar's reign, a pronounced interest in Persian miniatures gave way to the imitation of Western works, known directly or seen in reproductions and prints. The Mogul emperors—especially Akbar and Jahangir—were taken with the artful perspective effects of European works and had them studied and imitated (see fig. 372), though they were foreign to Islamic taste. For this reason, Mogul miniature painting has been considered a spurious production, half Persian and half Westernizing, whereas, instead, it is an important page in the history of Indian art. True, the changes of fashion in architecture had repercussions in miniature painting and the minor arts, but the personalities of great artists such as Basawan, Daswanth, and Miskina, in no way inferior to the topmost Persian miniaturists, gave miniature painting a stature of its own. In the early Mogul period, in the reigns of Humayun, Akbar (see figs. 370 and 371), and Jahangir, the interest in painting was keen. Shah Jahan appreciated the art, no doubt, but as one of the minor artistic activities at his court, despite the fact that Muhammad Faqirullah and Mir Hashim, heads of his painting studios, were miniaturists and calligraphers fully equal to the best of their predecessors. The time of Shah Jahan, however, lacked the creative impulse and zest for life of the days of Akbar and the quiet and careful attention to detail to be found in the works of Jahangir's time. The effort toward serial production and industrialization of the first large Mogul workshops had drained the original creative vein. Moreover, the interest in Western works and their perspective effects, introduced by Jesuit fathers at the court of Akbar, had stirred up many problems.

One of the greatest interpreters of the new manner was Basawan, who became an expert at finding a perspective that would combine the Iranian and Indian traditions with the illusionistic tendencies of the West. His great, unfortunate rival, Daswanth (certainly an Indian, as his real name was Dasvanta), who committed suicide for reasons unknown, though responsive to novelty of whatever origin, remained more firmly attached to tradition. On the other hand, in an effort to give the characters the proper setting and, so to speak, attune the human image to the surroundings, early Mogul miniaturists copied in an Indian fashion the Persian way of representing landscape, even transferring Persian flora, rendered in the traditional Persian manner, into Indian

landscapes. The lack of depth, which in the Gujarat school produced a particular type of perspective generally referred to as 'verticalized,' engendered representations in which, despite the minute proportions, nature was carefully and realistically rendered in detail and the figures were almost still or in slow motion. The naturalistic tendency reached its peak in both quality and popularity at the time of Jahangir. The accurate and clever studies of animals, birds, and flowers belong with the best creations of the Mogul period (see figs. 262 and 379). They were prompted by interest in natural sciences but also satisfied an urge to study unusual forms and the life which, in Indo-Muslim thinking, flows in every element of nature. At the same time, Persian bird's-eye perspective (see fig. 368) gave way to pseudo-Rajput, naturalistic compositions in tiers with horizontal, three-quarter views (see fig. 369),

which posed the difficult problem of the background (generally indefinite). The paintings of political events, ceremonies, audiences, and so on are a lavish display of gold and rich ornaments.

With Aurangzeb the painting activity at the court dwindled. Many artists who were dismissed from the imperial workshops went to the courts of the Hindu kings and offered their services to the nobles. The crisis, however, was so deep that it affected the spiritual aspects of Mogul life also. With his intolerant puritanism and his useless, bloody wars, Aurangzeb stifled every creative impulse. The country donned a mask of austerity and pessimism and, apart from a few genuinely religious works, paintings became exercises in calligraphy and pretense to that mysticism that the desperate—but sincere—will of the emperor forced upon the country. If the early miniatures of Humayun and Akbar

370

370. Scene from life at court: a prince receiving fruit as a sign of homage and well-wishing. Mogul school, Akbar period or shortly after. National Museum, New Delhi

371. The Emperor Akbar watching the capture of a wild elephant near Malwa, an episode of 1564. Illustration from the Akbar Namah, *edited by L'al and Sanwlah. Akbar school. Victoria and Albert Museum, London*
The traditional Indian element can be seen in the treatment of the elephants, which dominate the scene, and of the horse of the emperor, who advances calmly among his dismayed servants.

372. The Madonna and Child. Mogul miniature of the period of Jahangir; elaboration of an engraving by Bernaert van Orley (1492–1542). British Museum, London
The miniature, signed Chulam-i Shah Salim, interprets in its own way the carefully drawn drapery of the robe. The possibility that the artist was inspired by the drapery in ancient Buddhist works, but only as a visual reminiscence, cannot be ruled out. His difficulty in the execution of the hands stems from their *position and the movement of the fingers, which is unusual for an Indian work. The face of the Madonna reveals the painter's Mogul background, showing through in spite of his desire to adhere completely to the European model.*

373. The Madonna and Child with St. Joseph dressed as a Jesuit missionary. Miniature. British Museum, London
Behind the tree is portrayed, as in the West, a young girl holding her dress in her left hand so as to form a fold suggestive of maternity.

374

374. The elephant's feeding time.
Miniature. Mogul school, datable
about 1620
The enormous image of the ele-
phant being fed faces that of the
man who tends him affectionately.
The sense of brotherhood with
animals, and the interest in their
anatomy, are typically Indian
elements preserved in this mini-
ature.

375. Miniature painted on a page
from a manuscript of the Razm
Namah. Mogul school, beginning
of the seventeenth century A.D.
National Museum, New Delhi
A legendary scene divided into two
distinct planes, the upper and
divine and the lower and human.

375

extolled the sultans' war enterprises, their hunts, and the salient
episodes of lives full of adventures and surprises, now the only subject
left was sterile devotion, contrasted, on a completely different level, by
pronouncedly erotic, and sometimes manifestly obscene, represen-
tations. It was as if the free spirit of the Hindus was emerging through
the dullness of this epoch in which a different and languishing sense of
religion was being pressed upon the people.

Despite these ups and downs, however, Mogul painting was a remark-
able phenomenon. Aside from its portraits (and their characteristic
pursuit of psychological traits [see figs. 375–377], sometimes stretched
beyond credibility), Mogul painting presents an interest of its own and
a novel approach, which intrigued and fascinated even Rembrandt, who
tried to imitate it. Willem Schellinks, a Dutch painter and a follower of
Rembrandt's, also reelaborated in European fashion the technique of
Mogul miniature painting, creating two works with magic implications,
in which he reproduced not only exotic subjects and motifs, but also the
'caprices'—composite, irrational compositions of, for instance, figures
part human and part animal—that had flowed into Mogul art from
Persia. Conversely, the Mogul imitations of Western works were
innumerable; so plentiful were they that the Portuguese Jesuit father
Fernando Guerreiro was amazed at seeing in the palace of Jahangir at
Agra enormous murals of Christian subjects executed by local artists—
Christ in Glory, the Madonna, scenes from the Passion, St. Luke, and
so on. It was the time when religious problems were disturbing the
minds of the more learned Moguls after Akbar had attempted to unify
Islam, Christianity, and Hinduism. Of course, this strange occurrence
of Christian paintings in a different and distant world was not limited
only to the murals of a sumptuous palace. Christian subjects were
comparatively frequent also in miniatures and were executed both in
the Western manner (see figs. 372 and 373) and, more infrequently,
in the traditional manner of Iran and India. Abu'l Hasan, one of the
best artists at Jahangir's court, copied Dürer's St. John of the *Crucifixion*
when he was only thirteen years old. Engravings by Dürer, Maarten van
Heemskerck, and the Van der Heydens served as models and, in a sense,
as ability tests for the Mogul artists; and the works of the Italian

299

376. *Portrait of Ibrahim II, Shah Adil of Bijapur (1580–1626). Painted about 1616. British Museum, London*
The composition places the sovereign in the frame of a shady garden. In his right hand he is holding the Kurtar and in his left the castanets in two colors which amateurs and musicians used as primitive metronomes. The minute detail in the clothes, ornaments, and flowers is characteristic of the school of Bijapur; but the great palace in the background, a proof of the opulence of royal seats, is drawn in almost scientific perspective and is obviously of European inspiration.

377. *Royal portrait. Miniature painted on a manuscript page. Mogul, sixteenth–seventeenth century* A.D. *National Museum, New Delhi*

376

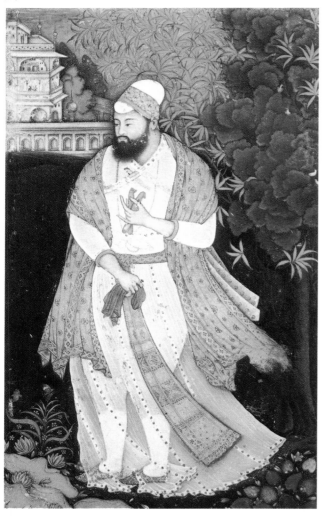

377

painters and engravers, seen in the original or in excellent reproductions, also left visible traces in Mogul miniatures.

The influence of the imperial art spread far and wide, surmounting diverse local tendencies and foreign influences of varying intensity and different degrees of adaptability. The Deccanese current of the states of Ahmadnagar, Bijapur, and Golconda is not noticeably different from the Mogul current, though it shows a preference for stiff, stylized, decorative forms and gold backgrounds. It constitutes an intermediary tradition between the Islamizing aesthetics of the early Mogul phases and the ever-reemerging Hindu Indian tradition. The fondness for music of some of the emperors also was reflected in the figural arts, giving rise to a particular type of 'musical' painting; in other words, to transpositions into painting of the values contained in melodic themes and in the poetry they had inspired. To this type belong the Ragmala, or 'garlands of Raga' (see figs. 368 and 384), raga meaning melodic mood (sometimes connected with the seasons). The interest in music, which equaled the Moguls' interest in architecture, distinguished the two cultural spheres, which were different not in rank but in the favor given to either one of these contrasting, though complementary, artistic expressions. Portraits, also, which at the Mogul court were often celebrative and official (see figs. 368 and 370), in the Deccan remained on a more human level (see fig. 376), despite the artists' liking for imaginative (though not imaginary) settings with exotic trees and unrealistic light effects, and their excessive concern with clothes and costumes. The Mogul conquest brought destruction to many art works at both Golconda and Hyderabad (the cultural center of a former state of the same name), but did not hinder the influence on the Rajput production in the areas neighboring on the southern borders of the Mogul empire (before Aurangzeb's conquest).

The Rajput pictorial current is a vast movement with markedly Indian characteristics, in a sense in contrast with Muslim Indian art. It flowered under the Rajput princes, tenacious and brave opponents of the Muslims, organized into a feudal society, who withstood practically single-handedly that triumphant and, to them, insufferable civilization. The subjects that the Rajput painters favored (see fig. 393) were obviously very different from those the Moguls chose, for Rajput art was not a court art. The Rajput painter belonged to a guild; he was free and independent. Fully equipped, he could try his hand at miniatures as well as murals. If work was scarce, he was prepared to decorate rooms and halls, zealously keeping the secrets of his art, which were passed on from father to son. The legends of Krishna, the hero and god and the eighth incarnation of Vishnu, were his main sources of inspiration. But his representations also included daily life, festivals, religious ceremonies, and mythological episodes. Since Krishna was worshiped as Krishna Gopala, the youthful shepherd surrounded by shepherdesses (his lovers, who symbolize souls yearning to be reunited with the divinity), many of the miniatures have an erotic character often refined by a genuine sentimental impulse, which may occasionally appear mannered or overdone. In these works, seemingly so contradictory to the hard nature of the warlike Rajputs, there shows, however, a fully valid, innovatory, and mildly spiritualized vein. Divided into two major trends—the Rajasthani trend of Rajputana (see fig. 380) and all the Pahari (mountain) schools that developed in the areas of the Himalayas (see figs. 378 and 394)—Rajput painting was a complex figural phenomenon, which cannot be regarded as a variant of Mogul art. It is impossible, in fact, to evaluate the Rajput production on the basis of its content and choice of subjects. Its refreshingly candid form and style differ from the courtly style of the Moguls in palette, in the use of

378

378. Ragini Todi. Miniature representing one of the modes of Indian music. Pahari school, end of the eighteenth century A.D. *National Museum, New Delhi The theme is that of the young girl who tames wild animals, which come running toward her.*

color—sometimes splashy—and in design, where hardly any trace of the scientific perspectives to be found in the works of the Westernizing Mogul current are visible. Stemming from the bidimensional tendency prevalent in Gujarat, it adhered throughout to this figural convention. Minor details of technique, drawing, and costume emphasize the differences.

The Rajasthani branch was further divided into several schools. The Mewar school could boast of some great artists but generally remained on the level of high-quality artisanship (see fig. 263), favoring contrasting, sensational colors. In some of its works, however, the colors are inexplicably mellow and soft. The Malwa school produced rhythmical, glowing, and spacious compositions and figures hard and determined in look. The Bikaner school, whose greatest representative is Shahadin (end of the seventeenth century), created splendidly powerful, imaginative works, whereas those of the Amber school were flatter and at perpetual variance from, but also in constant contact with, Mogul miniature painting. The lesser schools, such as those of Bundelkhand, Marwar, and Bundi, adapted diverse motifs characteristic of the Rajput current to a variety of intermediate taste, partly conditioned by the Mogul production and partly original and unrelated to either the imperial school or the other Rajput trends. As for the school of the

upper Punjab—that is, of the diminutive Rajput states lying at the foot of the western Himalayas—it felt the Mogul influence much less. Its tendency was to resort to the ancient indigenous (but not provincial) heritage, which had remained alive in the whole area and counteracted the overpowering, courtly, imperial style.

It is not an easy task to trace a coherent evolutionary line for the Pahari schools. It is, instead, very easy to pick out the differences between them. The most important center was Basohli, then Guler and Nurpur, Jammu, and Kangra (see fig. 264). The graceful and innocently romantic Guler style lent new freshness to old schemes (see figs. 384 and 386–388), as did also the school of Basohli with its elegant shades of color. No doubt the latent opposition to the hegemonical style of Islamized India stimulated the Pahari production, which, though seemingly contradictory and indefinite because of the multiplicity of its aspects, created great works that it would be unfair to brush off as folk art. The heritage of the Kangra school, consisting mainly of a predilection for calligraphy, was appropriated by the Sikhs, a religious sect believing in reformed Hinduism, who rebelled against the Moguls and the Afghans and became a strong military power in northwestern India throughout most of the nineteenth century. Adoption of this art form by a preeminently military people resulted in

380. Miniature. Rajasthani
school. Prince of Wales Museum
of Western India, Bombay
The simplification and stylization
of the subject are particularly
obvious in the flatness of the
modeling.

381. Portrait of the Emperor
Jahangir (?). Miniature painted
on a manuscript page. Mogul,
seventeenth century A.D. Prince
of Wales Museum of Western
India, Bombay
The halo signifies royal splendor
and supreme power.

380

381

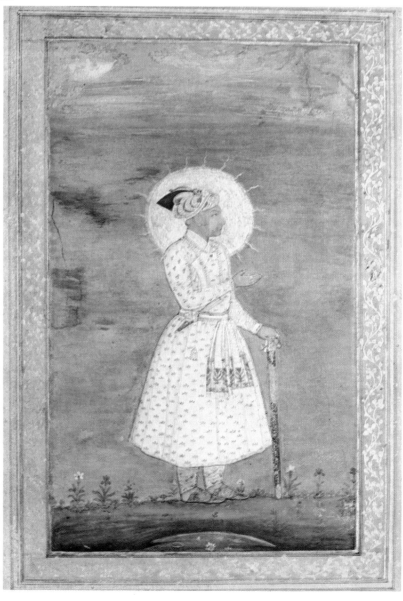

increased but simplified and popular stylization (see fig. 392), as if easier compositions and more vigorous expressiveness were conducive to better and more complete enjoyment of the works.

As has been pointed out, the inlay, mosaics, and glazed and majolica tile work used to decorate architectural structures originated a trend in ornamentation which was reflected also in the minor and applied arts of the Mogul phase and in the contemporary neighboring production. The ornamentation on glazed tiles and especially the often calligraphic intarsia in marble and sandstone were generally of undeniably fine technical and aesthetic quality. The same motifs, slightly altered and often improved by a more rhythmical and better sense of ornamental effect, are to be found also in metal and even in semiprecious stone inlays. Iron and steel arms were particularly lavish, with gold—more-infrequently silver—inlays, and very fine hilts, sometimes of jade inlaid with gold or enormously valuable precious stones. Gold- and silver-work included, besides jewelry, vases, plates, etc., metal ornaments embossed in mezzo-relievo. The basic metal was brightened by enamel, inlays, studs, and so on. The lavishness of some of these creations is evidenced by the 'Peacock Throne' of Persia, which was looted from the Moguls during the Persian campaigns in India. The fact that the gates of the Taj Mahall were of silver and the grilles that once surrounded its two cenotaphs were of gold helps to give an idea of the magnificence of the imperial court and of its imitators—the semi-independent or independent kings of the peninsula. Jewelry became richer than in the past, displaying greater imagination and variety of forms than it

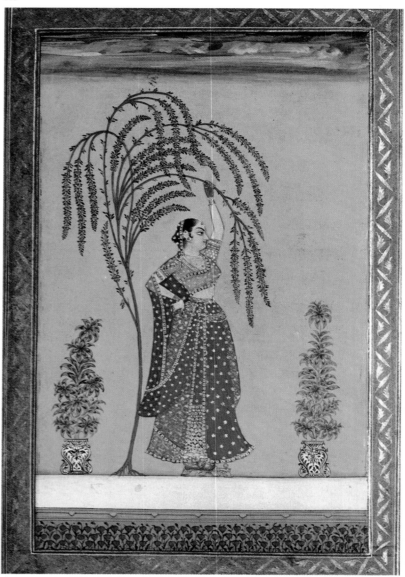

383

383. Kanada Ragini. A melody as pleasing as a beautiful woman in a garden, represented by the motif a 'Lady in a Garden.' Highly stylized miniature, in the Deccan style. Seventeenth or eighteenth century A.D. *Prince of Wales Museum of Western India, Bombay*
The setting is suggested by the tree, which seems to wrap the female figure round in its foliage, and by the two ornamental plants at the sides.

382

382. Krishna in a boat. Miniature. Guler school, eighteenth century A.D. *National Museum, New Delhi*
In the foreground, a garland being offered. In the background, a city.

304

had ever done in previous times, in which it had already reached very high levels.

Glass imported from Persia had a tremendous flowering. Cups and drinking glasses, vases and pitchers were carved out of rock crystal. Even wooden furniture testifies to the fad for inlay. Ebony and mother-of-pearl were cut into very small pieces fitted, glued, and finally nailed together by means of minute pins. The technique of enameling was completely renovated on Persian and Western suggestions. The finest enamel work belongs to the seventeenth and eighteenth centuries. Later, this genre seems to have declined.

The blooming of the minor arts in Mogul times was not only the result of prosperity, and of the splendor of the court and the nobility, but also the consequence of a definite mental attitude. Islam conceived of no gradation of the various figural arts, even though in point of fact it held architecture and calligraphy in greater consideration. The latter, in fact, was regarded as the materialization of the Lord's word. Because of the aniconic tendency that still underlay the more orthodox Muslim thinking, every creation, even if sheerly ornamental, mirrored the omnipotence of God. Consequently, the small ceramic cup, the jewel, the decorative motif—all could be appreciated as complete works in their own right, in no way inferior to rich mosques and mausoleums, regardless of function, material, or size; only the craftsmanship, the creative impulse, and the artistic ingenuity counted. (This is why many of the minor works of the Mogul phase are a source of amazement to the Western critic for their accuracy of detail and for their precision and elegance of execution. That is also why new techniques for enamel, inlay, and glasswork were sought.) The splendor of the courts was enriched by this point of view, owing to which an everyday object could be regarded as a masterpiece of technique and refined elegance comparable with a miniature or a fine architectural structure. This was all the more true since the original Islamic prejudice against precious materials was a distant recollection of almost legendary primeval times when the Arab cavaliers, lords of the desert, animated by an incredible expansive thrust, had bravely carried the word of Allah as far as Central Asia in one direction and as far as the Pyrenees in the other. To us

384. Royal couple with female attendants. Guler style, middle of the eighteenth century A.D. National Museum, New Delhi Part of a Ragmala, and therefore connected with a melody which expressed the royal dignity of the lovers and their love.

385. The interrupted concert. Seventeenth–eighteenth century A.D. Prince of Wales Museum of Western India, Bombay In this rather late miniature the subject, which is almost a genre scene, is less interesting than the perspective effects of obviously Western derivation. Limited to the details of the architecture, they can be observed in the foreshortening of the arches of the big building on the right, and have no real scientific foundation. They are in fact consistent only piece by piece. It is clear here that Indian taste is trying to use perspective without giving up its own sense of composition.

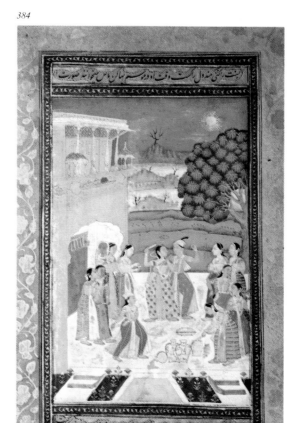

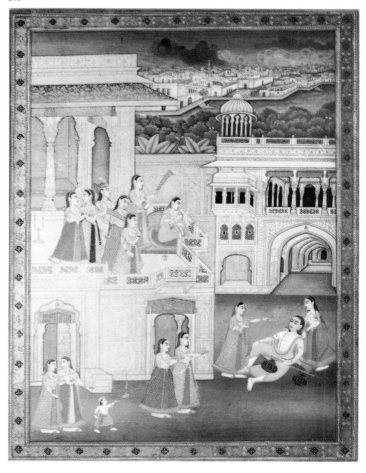

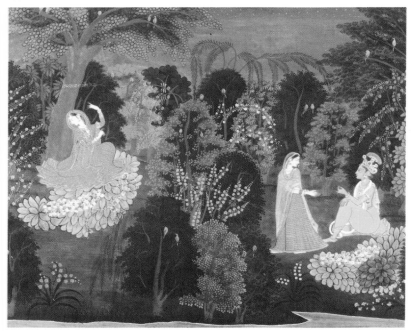

386. Radha discovers the infidelity of Krishna by hiding among the bushes in a wood. Miniature. Guler school, second half of the eighteenth century A.D. *Prince of Wales Museum of Western India, Bombay*

Westerners, of course, the products of the minor arts do not come up to the level of architectural and pictorial masterpieces. Though inevitably biased by this approach, we cannot help feeling unreserved admiration for certain works, if only we take the trouble to observe them with the necessary attention, bearing in mind the fact that our prejudices are completely alien to the civilization that created these objects.

It is Mogul art, even in its slow decline (see fig. 396), and the Rajput and Sikh schools (see figs. 392 and 393), rather than surviving Hindu art, that constitute the last outburst of Indian creativity. With British rule and the introduction of foreign fashions, techniques, and schemes, the whole of India seems to have forgotten her glorious past. In fact, she seems to have given up competition with the fermenting Western world and, for a time, to have followed the European currents, indulging the taste of the new overlords without even attempting to remold it on her tradition. E. B. Havell, the principal of the Calcutta art school and one of the best and most ardent students of Indian art, must be credited with laying the foundations for its renaissance. Events in the West, such as the smashing of the classic ideal of beauty, the insurgence of the Impressionists, the appreciation of Japanese prints, and the almost general interest in Gandharan art and its semi-Classical aspects, spurred the revival, it is true, but it is also true that the dedicated work of Havell was paramount to a reassessment of the traditional values, not very unlike the reestimation that caused the values of medieval art to be recaptured in Europe. Under Havell's influence, the Tagores (Abinindranath and the poet Rabindranath) together with Nandalal Bose, their cousin and an excellent painter, tried to link themselves to the Mogul tradition, sometimes experimenting with new techniques borrowed from the West or from China. Though misconceived, the attempt stirred the dormant and resigned milieu of the artists. Thus

387. Episode connected with the cult of Krishna, taken from the Bhagavata Purana. *Miniature. Guler school, last quarter of the eighteenth century* A.D. *National Museum, New Delhi The composition of the scene, for clarity, is divided into two parts, the chief of which is closed off by the vegetation. The other appears to be merely an added detail.*

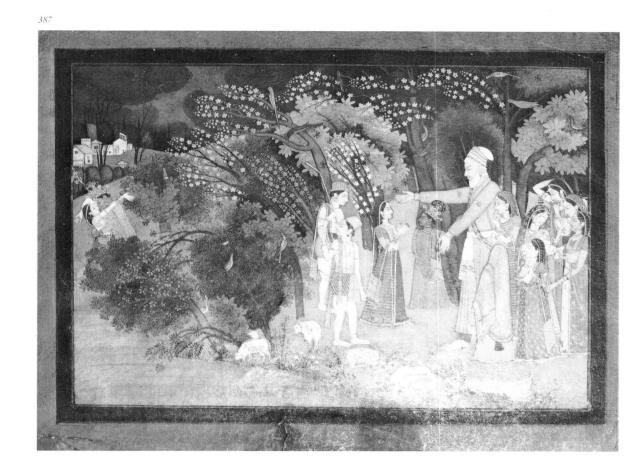

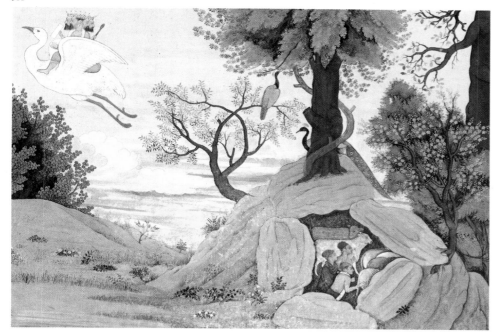

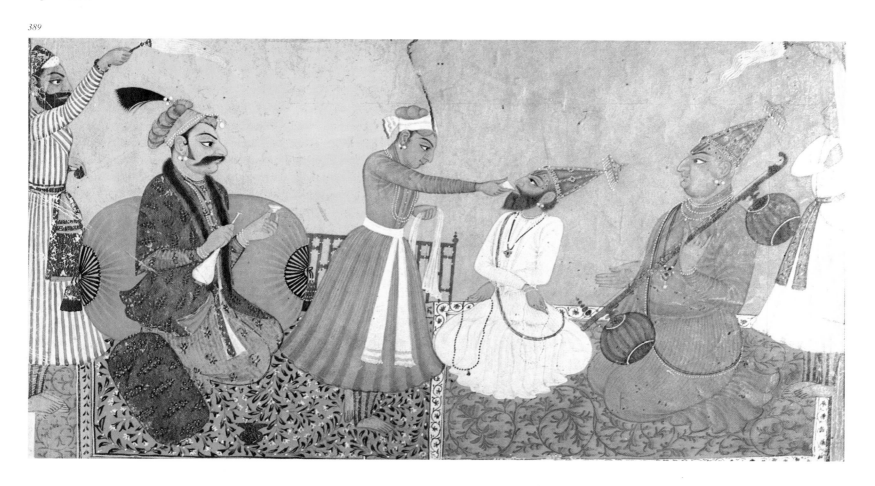

388. *Fantastic episode from the* Bhagavata Purana, *a collection of legends celebrating the power and the deeds of Vishnu. Miniature. Guler school, last quarter of the eighteenth century* A.D. *National Museum, New Delhi In this episode the four-headed Brahma is flying away on the bird that represents the Hamsa (supposed to be a swan), symbol of the 'high point,' or the supreme power of the universe. Occasionally, the swan is replaced by a white crane. The miniature is very important on account of the attempt made to construct a landscape which is unreal but at the same time composed of naturalistic elements.*

389. *The poisoning of the captive Raja. Kulu school, end of the eighteenth century* A.D. *An historical episode illustrated with ingenuous violence; the portrayal is as impressive as it is improbable.*

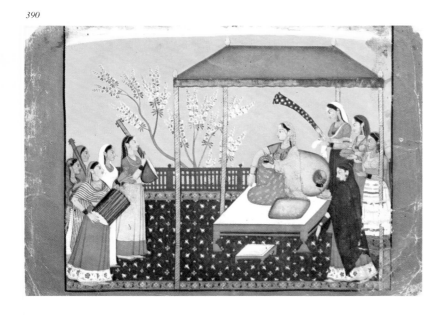

390. Lady listening to a concert.
Miniature. Guler school, 1750.
British Museum, London
The taste of the high Punjab can
be seen in the variety of the
colors, in the accentuated styliza-
tion, in the closed-up faces of the
people, and in the spacious and
chromatically harmonious com-
position.

391. The god Siva in his terrible
aspect. Miniature. Mandi school,
datable around 1740. Victoria
and Albert Museum, London
The divinity is represented with
ten arms and three heads, and
with the attributes of his power.

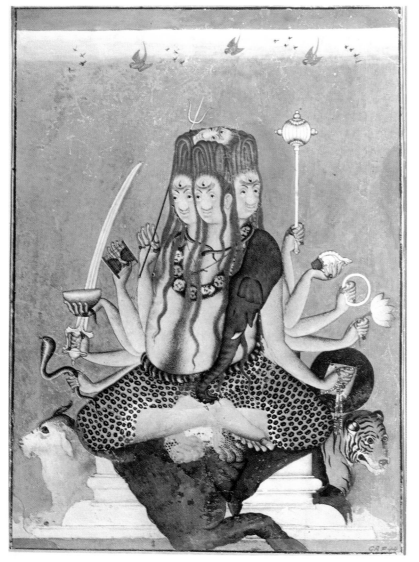

originated the Bengal school (with centers in Calcutta and the University of Shantiniketan), which was welcome as a hope and initiated numerous different currents. With standardized attempts, these currents promoted a rapid transformation of the criteria for renewal. The so-called Bombay group, started by Gladstone Solomon, eventually became integrated into or, at least, associated with the Bengal school. Apart from the absurdity of wanting to interpret an entirely new reality in the spirit of a long-vanished world, the sentimentality of these pioneers, who persuaded themselves into thinking they could face the future by a return to the past, nevertheless paved the way for the next generation, more sensitive to international tendencies, to social problems, and to contacts with the masses. While official academicism tried to elaborate composite styles based on tradition, the new artist took a novel approach to the problem of the Indian renaissance. Sailoz Mookherjee and especially Jamini Roy modernized and revalued neglected aspects of Indian folk art. Their inspiration, however, did not follow the models unimaginatively. Instead, they modified, reelaborated, and enlivened them with a taste and style that were by now unconnected with tradition. George Keyt (the Indian 'Picasso') and especially Amrita Sher (who died in 1942), whose style recalls those of Modigliani, Gauguin, and certain Japanese masters, also helped to reinstate India among the great nations and to make her appreciated not only for her glorious past but also for her fervor of renewal. Actually, the effort of the Indian nations to extenuate the old structures and to modify them to the requirements of a truly modern life is still hindering the expressive ability of the figural artists. The uncertainties of the way, the difficulty of the choices, the almost complete impossibility of interpreting in an effectual manner the needs of a population of five hundred million people on all different cultural levels make the task of contemporary and future artists very hard, especially if, as is to be hoped, they are trying to make their Indian voice heard among those of the internationalizing tendencies—a veritably Indian voice that may turn out to be the voice of mankind.

393. Late miniature of the Rajput school. National Museum, New Delhi
The composition is obviously inspired by a desire to portray a simplified scene, made impressive by color.

393

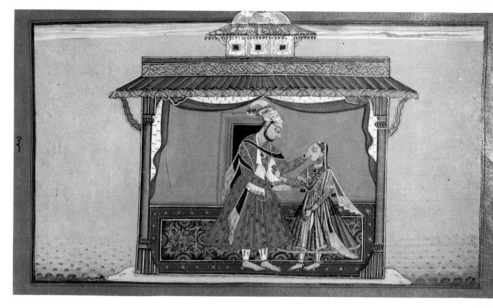

392. Two Sikh nobles. Miniature illustrating a visit, with an evident intention to make true portraits. End of the eighteenth century–beginning of the nineteenth century A.D. British Museum, London
The mellow lines of the drawing are typical of the Sikh school.

394. Pair of lovers. Miniature. Pahari school, end of the eighteenth century A.D. National Museum, New Delhi

392

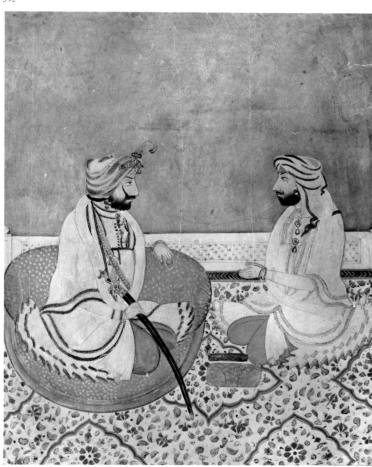

394

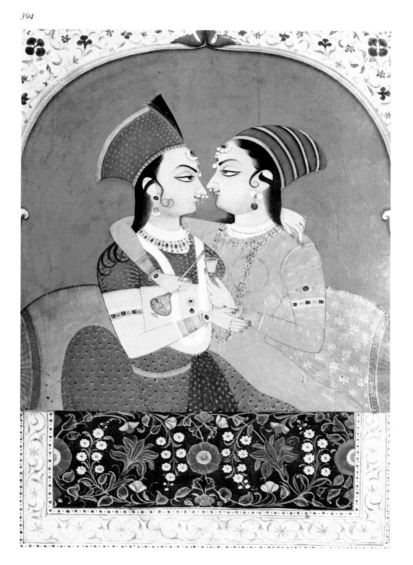

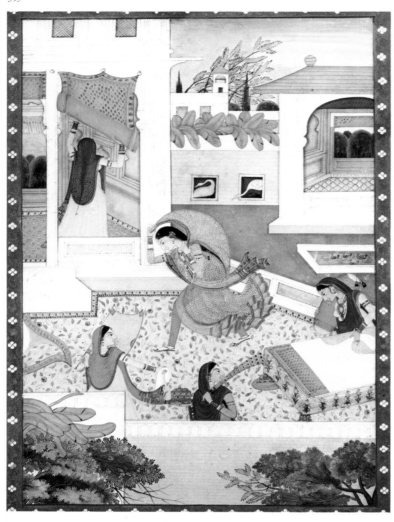

395

396. Dance company gathered in the porch in front of a dwelling of Anglo-Indian type. Miniature. Late Mogul school of Delhi, datable around 1820. Victoria and Albert Museum, London

The perspective and the architecture are clearly of Western inspiration, while the arrangement of the figures is derived from a photographic realism of English Neo-Raphaelite type.

396

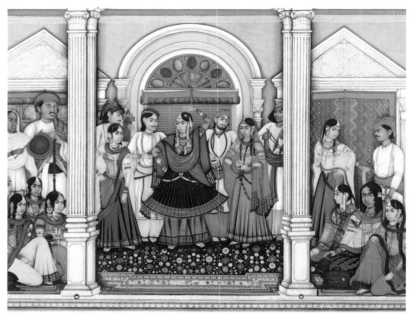

397

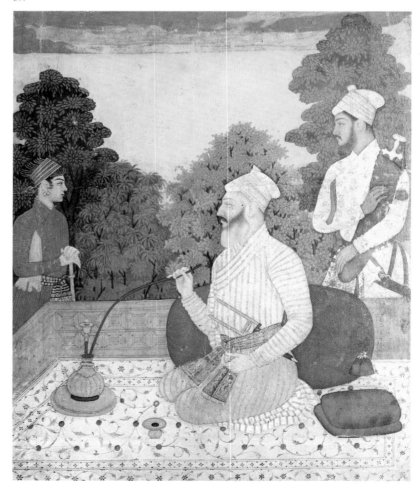

395. The Gate of Love. Miniature. Beginning of the nineteenth century A.D. Victoria and Albert Museum, London
Miniatures with an erotic theme are very frequent, especially in the provincial schools. This one, most interesting for the excited movements of the central figure, belongs to the style of Saynu, and comes from the region of Mandi, a state of the Punjab.

397. Court scene. Mogul ruler smoking a water pipe, or nargileh, attended by a young prince and a dignitary. Miniature. About the middle of the seventeenth century A.D.

12. Conclusion

by Mario Bussagli

The figural art of India is the reflection of an extremely well-defined, consistent civilization, in a sense unique and inimitable. Concerned with conciliating the demands of individuals and communities engaged in a continuous, sincere pursuit of the sacred, this civilization is, on the whole, essentially religious. The profane is either nonexistent or stifled, and even when it does occasionally emerge in limited areas, it cannot shake the dominant system that rests on fixed and universally accepted (though nondogmatic) premises, with which the life of the individual is unfailingly connected. Theoretically, this pursuit of the sacred allows people unlimited personal freedom, dissipating metaphysical anguishes, eliminating the fear of death, enhancing physical and mental powers which attend on a conception of life involving no final choice and no sense of tragedy, but promising all who have will and intelligence that their lives will be merged with the cosmic flux that regulates the existence of the universe. The almost superhuman effort that this pursuit implies is made possible by paranormal techniques and a complex philosophy; and despite its shortcomings and failures, it has shaped a civilization thousands of years old, which has survived complete and has remained appreciative of all the values of life. The main aspect of the pursuit of the sacred in India is that it guarantees each person unrestrained spiritual freedom. The fact that it creates other ties and limitations unconceivable in other cultures is unimportant—a mere consequence of popular ritualism and religious feeling. What counts is the endeavor to do away with fear of death and to enhance moral freedom, which sometimes, however, borders on indifference among people aware of republican government and, since remote times, tendentially democratic, but actually always ruled by centralized and despotic forms of administration. Indeed, only the fact that the population was dispersed in isolated villages and towns with inadequate systems of communication reduced the hardship inherent in its despotic institutions. These people have, however, a strong sense of individuality and, at the same time, a sense of society at large, which enables them to think in terms of the common interests of groups and classes. The caste and guild systems—the nightmare of all governments for their clannishness and economic power—stem from this ability to congregate. Spread over a huge geographical area, Indianism—that is, the essence of a polymorphous culture, hard to define, even if characteristic—acquires different aspects according to the tastes, attitudes, and mental sets of different groups and peoples united by a typical acceptance of certain constant social and cultural factors, such as the caste system and the belief in a cycle of successive lives. Non-Muslim India must be credited with taking man closest to the Absolute, with recognizing the validity of all means to this end, including that of eroticism, and with rejecting dogmatism and relying, instead, entirely on intelligence and the habit of meditative techniques for the development of paranormal powers.

These were, however, always regarded as mere techniques without preternatural intervention. Although here the sacred and the profane are not in opposition and the pantheon includes thousands of deities—they, too, bound to the wheel of life and therefore destined to fall from their supremacy—India never developed, but rather ignored, the Western conception of God. Thus, to judge India as a solely religious world is at once right and wrong. It is right in so far as the pursuit of the sacred is the main concern of individuals and communities, and it is wrong in that there is no definite boundary line between religion and life in its fullest sense. The religion that looms on India's background throughout her history is Hinduism. Even when Buddhism and Jainism rebelled against it—mainly because it tended to turn man into an ephemeral monad incapable of a gesture of compassion or charity that would lighten the burden of living—the Hindu line of thinking continued to dominate the scene, if only by being the enemy. And when India suffered the violent invasion of Islam with its entirely different approach to life in every respect, she receded into her tradition. Thus, for the first and only time in its history Islam could not eradicate the religion of the subjected country, and the conquerors and the conquered lived together without melding or ever understanding each other.

The art of non-Muslim India is one of the consistent and unifying elements of Indianism. Even though it accepted, reelaborated, and adapted foreign suggestions and originated numerous schools and styles, the continuity of Indian art is exceptional. It responded with changes in iconography and symbolism to the needs of the various trends of religious thinking, but never underwent a revolution or upheaval, for it was tied to that strange, almost atheistic, religious practice that relied on preternatural experiences to which the aid of images was indispensable. In a sense, it is a complex, self-regulating process, animated by a life of its own and rooted in sociological and religious constants, but also upheld by the permanence of traditional techniques and the recurrent use of symbols. By means new and elsewhere unknown, it strove to express the inexpressible, while the more or less deified human figure became predominant. No attempt at representing individual identities is evident, however; instead of emphasizing anatomical details, Indian art concentrated on the psychological and social values of the figures represented, concerned as it was only with rendering the spiritual and moral energy (in a world unaware of the concept of sin, of course) that underlies the life of the body. Only Buddhism—after it became a Pan-Asian religion—tended to affirm its universality with images reproducing the typical facial traits of the most varied peoples among those that had come in touch with the Word. This is especially true of the works of the schools at the northern boundaries and of the Central Asian ones, more or less distantly influenced by India. To the truly Indian artist it mattered little whether

the person represented became known as a human being; his real concern was that the figure should render the category to which the person belonged and, above all, the idea or value that it embodied. This attitude accounts for the comparative disinterest in traditional portraiture, which flowered only under the influence of foreign currents —the Kushan, Indo-Muslim, and Mogul schools—and shows occasionally in medieval bronze portraits of kings and princesses, markedly stylized and modeled after cult images. On the other hand, because of the strange symbolism, the anthropomorphic images of deities are turned into dehumanized and fantastic creations with multiple arms and heads that serve the purpose of suggesting visually the immense power of the god or goddess (see figs. 27 and 23). Tied to this peculiar language when it deals with the human figure, Indian art presents either intensely human (see fig. 68), and sometimes even sensuous images —though idealized in a compendiary form (see fig. 33)—or symbolic humanoid freaks (see figs. 313 and 314), removed from reality but neither surreal nor abstract. Thus, Indian art is the only one that can express itself in truly dehumanized forms even when erotic motifs are used to symbolize, on the divine plane, the unity and fusion of contraries (see fig. 36). Yet the canon of feminine beauty, always adhered to, makes all female figures, without exception, paragons of sensuality and voluptuousness (see fig. 108)—if only potentially—and consequently transforms them into 'character' figures deprived of individuality. Putting the biological life of man on the same level with all other forms of animal life, from which man is distinguished only because he can attain Liberation and the Absolute through willpower and intelligence, India has used, as was said before, the human couple as an ornamental motif, not hesitating to represent extremely vivid erotic scenes even on the exterior walls of temples, as if coupling—involving magic, religious, or sometimes symbolic values—were just another way of expressing life. The spirit in which these erotic scenes are represented is, however, altogether different from that of similar compositions produced in other countries.

The entire art of India, including the Indo-Muslim and Mogul currents, shows a comparative disinterest in all that is not 'life'; its favorite subjects are, in this order, man, animals, plants, and flowers. Consequently, compositional space does not offer interesting environmental notations, especially if they are inanimate. Representations of deities are, instead, almost unfailingly combined with some hint of nature, whether it be a flower, a bird, or an animal. This attitude obviously influenced the characteristic organization of space in Indian figural art—Buddhist as well as Hindu—regardless of the differences and alterations that distinguish schools, styles, and antagonistic religions. Buddhist and Jain stupas are solid constructions without interior space. Articulated as architectural structures at least on the outside since they are based on elements characteristic of 'constructed' architecture, they are actually, as was said in the Introduction, much closer to monuments; they look like sculptures assembled piece by piece rather than works of architecture proper. Akin to obelisks and commemorative columns, they may in future times and civilizations become the core of large, planned town sections, in much the same manner as obelisks and columns are. In any event, the stupa, which is almost always at the center of a more or less open but always precisely delimited consecrated area, is the symbolic projection of cosmic space. It is a vision of the cosmos which we have already defined 'in the negative' because it is seen from the outside, as if the spirit of the beholder could extract itself from space and stand looking at it in its entirety the way he can observe any other object. Symbolic language lends itself to these acrobatics; space per se, however, has always been a very real element to the Indian spirit and one that neither artists nor designers, no matter how steeped in magic experiences and values, could ever suppress. And the carved (not excavated) cliff temple is an enormous piece of freestanding sculpture with an architectural function and values akin to those of the stupa (see fig. 289). This aptitude for abstraction enabled India to visualize religious architecture in a manner all her own, except perhaps for some analogies with certain monuments of ancient Egypt. Hard cliffs were carved as if to obtain an eternal token of unknown space—of this world in which the being that today is man and tomorrow may be god or insect, animal or prostitute, lives and dies to be reborn. If it is true that architecture is, of all the figural arts, the one most closely bound to the cultural and social ambience that produces it, undoubtedly the uniqueness of Indian culture and social order is reflected in the way architectural and symbolic space is conceived.

'Constructed' architecture, more or less functional and symbolic; excavated architecture, consisting of grottoes and caves with internal space only and relying on the compactness of the material for immobility; and carved architecture, similar to gigantic sculpture but provided with both interior and exterior space as 'constructed' architecture is, testify to a ductility and a variety of purposes and of meanings attached to space that have no counterpart anywhere else. Even the complicated philosophy of India cannot account for them, though they are indicative of the spiritual attitude and mental patterns that pervade Indian culture at all levels. Obviously, this manner of conceiving space—the outcome of autonomous thinking that was capable of producing a logic divergent from that of the West—extends also to the sculptural and pictorial production, whose 'secret,' determining the style and distinctive character of the works, does not lie solely in the fact that cult images and edifying narrative compositions invite the beholder to meditation. It is not even identifiable with the sum total of all the symbolic meanings that tend to transform—sometimes by means of dance rhythms—cult images into 'contemplative' diagrams. The true essence of Indian art resides in its conception of space, expressed also by indications of movement.

The creations of this art are not enclosed within polygons and prisms nor do they show any preference—as the Chinese production does—for elliptical lines and volumes. They are also devoid of the pursuit of illusionism, as can be seen from their rudimentary scientific perspectives. The organization of space springs from an inner, intuitive vision and is simplified through a representational method as unrealistic as a dim dream. On this premise it is no wonder that, especially in the

representation of deities, painters should use statues as refined mannequins instead of concentrating directly on the human body. Single images are characterized by tensions, rounded, smooth surfaces, and connecting lines. They can be circumscribed within simple geometrical shapes. In the narrative field, sculptural and pictorial perspectives often rely on psychology and intuition and are supported by a fairly good knowledge of optical effects. In conclusion, although it is difficult to give a precise definition of the complex set of phenomena of Indian art through the centuries, it can be stated that the figural space of Hindu India springs from a dynamico-psychological conception which reduces the inertia of the material through movement—either clearly and even realistically rendered or simply suggested to the imagination of the beholder—and the lively tension and energy of the still body. The preference for rounded surfaces and lack of angularity (angularity is to be found only in Gandharan art and in the production of Mathura at the time of the Kushans) are a consequence of this attitude to space and of the manner in which the image is visualized in it.

Islamic Indian art has an entirely different approach, originating from the attempt to adapt the local taste and materials to a system of life and a religion completely alien to the mentality of India. In simpler words, the Islamic schools, Mogul art, and the Indo-Muslim currents, which sometimes show Hindu contents, departed from the age-old traditions of Buddhist, Jain, and Hindu India to seek new values. The Islamic civilization was preeminently urban, whereas the nucleus of the Indian civilization was the village. Artistic activity per se was regarded in a different manner; also different was the hierarchy of the arts and the images that the imagination of the artists created, which belonged to a thoroughly fantastic 'perfect world.' The two civilizations were often in opposition, sometimes at odds, and rarely complementary. Muslim architecture, which had by now spread very far from its birthplace, became adapted to the new world, creating slightly different forms from those which can be found in the rest of the Islamic area and, above all, introducing an approach to the world and to art almost opposite to that which the Indian tradition had engendered. No more carved or excavated or freestanding but solid structures; no more important sculpture; no more murals for all the temple visitors to see, but paintings restricted to the courts and the large workshops (huge collective ateliers), which the patronage of the emperors created here and there to comply with the cultural inclinations of the more refined Muslims. The miniature predominated. It was almost abstractly unrealistic —except when the illusionistic schemes of European scientific perspective, of a different kind of unrealism, were resorted to under the Moguls. The human dimension, the measure suggested by everyday life and history—which Hindu India despised—took on a new value, surviving contradictions and inconsistencies. The Muslim art of India is a separate page in the evolution of Islamic art; even though it is derived to a large extent from Islamic Iran, its characteristics are very personal and arise from the fact that it asserted itself in a different and hostile ambience. The function and purpose of monuments changed. Domes, unconceivable in a world where the heavy and molded sikhara

was the rule, made their appearance, but, despite the suppression of human and animal figures, ornamentation recalled the Jain decorative motifs. Better balanced and harmonious proportions attenuated the massiveness of the Hindu temples; the mosque stood as the antithesis of the temple—or, better, group of temples—that constituted the sacred city.

With the Moguls there occurred a change in direction, a fusion of different currents with a strong Western component, whereas with the Rajput schools there emerged a popular vein and chromatic and stylistic tendencies unrelated either to the classical tradition of Hindu painting or to the aesthetics of Islamic painting, even though the influence of both is manifest. This coexistence of diverse currents is a sign of the vitality and genius of Hindu and Islamic Indian art, which accounts for its wide diffusion, so vast that it gave rise to peripheral—not provincial —artistic trends such as Nepalese art, to new figural experiences such as those of Farther India, and to extensive phenomena of interaction, for instance, those of Central Asia. The expansion of Indian art was felt even in the Far East, where entirely different aesthetic concepts and figural conventions had always prevailed, at least in religion-engendered iconography and symbolism. Actually, despite the undeniable importance of the religious factor, it would be a mistake to give Buddhism full credit for the expansion of Indian art. Close examination of the Indian artistic activity reveals that it includes every aspect of creativity, not only because it ranges from the simplest forms of artisan work to extremely bold and skillful works worthy of standing comparison with the world's masterpieces, but also because in its own original and unique way it is invested with all the aspects that characterize the evolution of both Western and Chinese art. Apart from the influence of the West all possible figural phenomena are to be found in the artistic activity of Hindu India and, to some extent, of Muslim India as well. Proof of this is the development of philosophical theories of art extremely similar to those elaborated by Hegel and his followers in the first half of our century, but antedating them by a thousand years. The relationship between the figural arts, music, literature, and even the theater (which contributed a great deal to the development of sculptural and pictorial space in narrative compositions) confirms the fact that in the arts Indian civilization mirrors a complete, complex, and profoundly human world—one that was engrossed in religious and metaphysical speculations, but was unconcerned with transcendency and consequently interested in all the worldly aspects of life. Meditative techniques and paranormal notions opened the way to infinite serenity and detached wisdom and also formed the basis for the philosophico-religious speculations that served as a guideline for individual and associated life, even in the Muslim phase. India, or, better, Indianism, always knew how to laugh, observe, love, and suffer with the same intensity as any other people. Her anonymous artists transfused their ever-fresh enthusiasm to stone and bronze, murals, and lacelike marble in different styles but with unabated zest for life, enjoyment of elegance, and appreciation of unfathomable beauty.

List of Indic Proper Names and Words

Place names well known in English are omitted.

Abaneri
abhaya mudrā
Abhinavagupta
Ābū
adbhuta
Āditya
Agni
Ahalyā
Ahichchhatrā
Aihole
Airāvata
Ajātaśatru
ājyapatra
Akoṭa
alasakanya(s)
ālīḍha
Ālīḍhanṛitta Śiva
āmalaka
Amaruśataka
Ambikā
Amri
amṛitamanthana
ananta
Ananta Gumpha
Anāthapiṇḍika
Angulimāla
antarīya
Apasmāra
Apsaras(es)
Ārāmadūsaka Jātaka
Āraṇyaka(s)
Arapachana
Ardhanārīśvara
Arjuna
Arjuna ratha
Arsikere
Arthaśāstra
Āryabhagavatī
ashṭa bhauma
ashṭamūrti
Aśmaka
Aśoka
aśoka
Asura(s)
Aśvaghosha

Aśvamedha
aśvamukhī
aśvaratha
aśvattha
Atthasālinī
Avadāna(s)
Avadānakalpalatā
Āvāgapaṭa(s)
Avalokiteśvara
Avantipura
Avantisvāmi
Avantivarman
Avatāra
Avrāvateśvara
Āy
Ayodhyā
Ayudhyā

Bādāmī
Bāgh
Bahmani
Bāhubali
bakula
Bala
Baladeva
Bālagopālastuti
Balarāma
Bali
Bāṇa
Banāras
Baṅga
Bāṇgaṅgā
Bangiya Sāhitya Parishad
Barābar
Barmaur
Basohli
Bayana
Beḍsā
Begrām
Belūr
Bhagavadgītā
Bhāgavata
Bhāgavata Purāṇa
Bhairava(s)

Bhairavunikoṇḍa
Bhājā
Bhāraśiva(s)
Bharata
Bhārat Kalā Bhavan
Bhārhūt
Bhāsa
Bhaṭṭiprolu
bhāva
bhavānaka
Bhāvirāja
bhayānaka
Bherāghāṭ
bhībhatsa
Bhikshāṭana
Bhilsa
Bhīma ratha
Bhīmeśvara
Bhīshaṇī
Bhīṭā
Bhītargaon
Bhoja
Bhubaneśvar
Bhumarā
bhūmiśparsa mudrā
Bhūteśar
Bhuvaneśvarī
Biccavolu
Bilhaṇa
Bimaran
Bimbisāra
Bīrbhūm
Bisauli
Bittiga
Bodhgayā
bodhi
Bodhisattva(s)
Boman Baram
Brahmā
Brāhman
Brahmanabad Mansura
Brāhmī
Brāhuī
Bṛihadīśvara
Bṛihadratha

Buddha
Buddhacharita
Buddhagosha
Buddham
Bukka
Butkara

Chaitraratha
chaitya
chaitya mandira
chaitya vṛiksha
chakra
Chakravartin
Chālukya(s)
Chālukya Bhīma
chamaradharini
Chammasataka Jātaka
Champeya Jātaka
Chāmuṇḍaraya
Chaṇḍeānughrahamūrti
Chandella(s)
Chaṇḍeśa
Chandra
Chandragiri
Chandragupta Maurya
Chandragupta II
Chandrahi
Chandramukha, Yaksha
Chandrātreya(s)
Chanhu-daro
Chāṇūra
Charidamaha
chattrīs
chatula-tilaka
chatura
chatur vyuha
Chaumukha(s)
chaurī
Cheḍi(s)
Cheṛa(s)
Cheṭa
Chhaddanta
Chhaddanta Jātaka
Chhatarhī

Kambujika
Kampahareśvara
Kanada Rāginī
Kanakamuni
Kañchuki
Kaṇḍāriya Mahādeva
Kanhadāsa
Kanishka
Kankoduttavanitam
kaṇṭhāślesha
Kapardin Buddha
Kapilavastu
Kāpiśā
Kara Khoja
karanas
Karka Suvarṇavarsha
Karkoṭa(s)
Kārlā
Karṇa
Karṇa Kauphar
karnaveshatana
Kārttikeya
karuṇā
Karuvūrār
kastūrī
Kaśyapa
Kaṭahādi
Kathakali
kaṭisama
Katra
Kaumārī
Kauṇḍinya
Kauśāmbī
kavacha
Kaveripākkam
Kaviyūr
Kerala
Khajurāho
Khambhili, arjika
Khaṇḍagiri
Khāravela
Kharjuravāha
kharma
Kharoshṭhī
Khiching
Khoh
Kidarit(s)
Kīlapuddanur
Kilayur
kinnara(s)
kinnarī
Kirāta
Kirātamūrti
Kirātārjunīya
Kīrtivarman
Koṇārak
Koṇḍane
Koṇḍapūr

Koṅgu
kośa
Kot-Diji
Krakuchanda
Kṛishṇa
Kṛishṇa I
Kṛishṇā
Kṛishṇadevarāja
Kṛishṇadevarāya
Kṛishṇa Gopāla
kṛishṇājina
Kṛitāntaparaśu
Kshatrapa(s)/kshatrapa
Kshemendra
Kubera, Yaksha
Kubja Vishṇuvardhana
Kuḍakūttu
kuḍu
Kukkanūr
Kukkuṭa Jātaka
Kulli
Kumāra, Paduma
Kumārabhūta Avalokiteśvara
Kumāragupta
Kumārapāla
Kumārapālacharita
Kumbhalidha
Kunnakuḍi
Kuntī
Kūram
Kuraṅganātha
Kurkihār
Kurtar
Kuruid(s)
Kurukshetra
Kuruvaṭṭi
Kushāṇ(s)
kūṭa
Kutab
Kutab Minar
kūṭāgāra
Kūttambalam
Kuttanī

Lāḍkhān
Lakshmaṇa
Lakshmaṇasena
Lakshmaṇkaṭi
Lakshmī
Lakshmīnarasimha
lalita
Lalitāditya Muktāpīḍa
Lalitagiri
Lalitapura
Laṅkā
Lankatilaka
lāṭ(s)

Lavaṇa Prasāda
lāvaṇya-yojana
Lepākshī
līlakamala
liṅgam
Liṅgarāja
Liṅgodbhava
Lokeśvara, Bodhisattva
Lollaṭa, Bhaṭṭa
Lomas Ṛishi
Lonar
Loṇaśobhikā
Lossa Jātaka
Lothal

Machchhavalaka
Madanāntaka
Madhu
Māḍugula
Māgadhī
Māgandiya
Māghā
Mahābalipuram
Mahābhārata
Mahādeva Jātaka
Mahājanaka
Mahājanaka Jātaka
Mahākapi Jātaka
Mahākūṭeśvara
Mahamud
Mahāpurusha
Mahāsanghika(s)
Mahāsthān
Mahāvira
Mahāyāna
Mahendravarman
Maheśvarī
Mahīpāladeva
Mahishamardinī
Mahishamardinī Dūrga
Mahishāsuramardinī
Mahkar
Mahobā
Maholī
Mahudi
Maitraka(s)
Maitreya
makara(s)
makara toraṇa
makarī
Mālavikāgnimitra
Mañchapuri Gumpha
Maṇḍagapaṭṭu
Māṇḍakarṇi, Ṛishi
maṇḍapa(s)
Mandasor
Mandhata

Mandhata Jātaka
Maṅgaleśa
Maniārmaṭh
Mānikkavāchakar
Māṇikyāla
Manmatha
Māra
Māradharshaṇa
Maratha(s)
Māravadhū(s)
Mārtāṇḍ
Masrūr
Māt
Mātanganakkra
Mātiposaka Jātaka
Mātṛikā(s)
Maukhaṛi(s)
Maurya(s)
Māyā
Meghadūta
Mehrauli
mekhalā
Mihira Bhoja
Milinda
Milindapañha
Mīnākshī
mīnavāji
Mirān
Mirath Aśoka
Miskīna
mithuna(s)
Modhera
Mogulrajapuram
Mohinī
Mojopahit
Mokhra Morādu
moulimani
Mṛichchhakaṭika
Muchukunda
Mucilinda, Nāga
Mudbidri
mudrā
Mūgapakka Jātaka
Mukhaliṅgam
muktayajñopavītāni
Mukteśvara
mukuta
Mūlarāja
Mushṭika

Nādatanu
Nāga(s)
nāgadanta
Nāgarāja
nāgaraka
Nagari
Nāgārjuna

P. 61 ēkas sute sakalam abalāmaṇḍanam kalpavriksha (Kālidāsa, *Meghadūta*).

P. 66 akusumitam aśokam dohadāpekshayā vā vinamitaśirasam vā kāntam ārdrāparādham (Kālidāsa, *Mālavikāgnimitra* III, 12).

P. 72 avalambya gavākshapārśvam anyā rachitā toraṇasālabhañ-jikeva (Aśvagosha, *Buddhacharita* V, 52).

P. 99 kāmam pradoshatimireṇa na drisyase tvam, saudaminīva jaladodarasandhilīna, tvam sūchayishyati tu mālyasamudbhavoyam gandhaś cha bhīru mukharāṇi cha nūpurāṇi (*Mrichchhakaṭika*).

P. 111 karṇālambitapadmarāgaśakalam vinyasya chañchūpuṭe vrī-ḍartā vidadhāte dāḍimaphalavyājena vagbandhanam (*Amaruśataka*).

P. 111 darpaṇesu paribhogadarśinīr narmapūrvam anuprishṭha-saṁsthitaḥ, chāyayā smitamañojnayā vadhūr hrīnimīlitamukhīś cha-kāra saḥ (Kālidāsa, *Raghuvamśa* XIX, 28).

P. 111 śroṇisu priyakaraḥ prithulāsu sparśam āpa sakalena talena (*Śiśupālavadha* X, 65).

P. 111 kim tatra prichchyate, yushmakam khalu premanirmalajale madanasamudre stananitambajaghanānyeva yānapātraṇi manoharāṇi (*Mrichchhakaṭika*).

P. 113 lalāṭalāsakasya sīmantachumbinaś chatulātilakamaneḥ.

P. 118 saptasāmopagītam tvām.

P. 118 vedānām sāmavedosmi.

P. 124 muktājala-grathitam alakam.

P. 124 kisalayaprasavopi vilāsinām nadayitā dayitāśravanārpitah (Kālidāsa).

P. 125 gavākshaniryūhasuvīthivedikā surendrakanyāpratimādya-lamkritam, / manoharastambhavibhaṅga . . . rachaitya mandiram, /

ma . . . talasannivishṭam visa . . . namanobhirāmam, / va . . . nchāmbu mahānidhānam nāgendra veśmādibhirapyalaṅkritam (inscription in Cave 16, Ajaṇṭā).

P. 130 ēkas sute sakalam abalāmaṇḍanam kalpavrikshaḥ (Kāli-dāsa, *Meghadūta*).

P. 138 ichhāmo hi mahābāhum raghuvīram mahābalam gajena mahatā yānta rāmam chhatrāvritānanam (Vālmīki, *Rāmāyana*).

P. 187 pasyādityān vasūn rudrān aśvinau marutas tathā bahūnya-drishtarūpāṇi paśyāścharyāṇi bhārata (*Bhagavadgītā*).

P. 205 talaiś śiñjāvaḷayasubhagaiḥ kāntayā nartito me yām ad-hyāste divasavigame nīlakaṇṭhas suhrid vaḥ (Kālidāsa, *Meghadūta*).

P. 209 chitrakara śrī sātanas tat putras sakalaśilpavidyākuśalas chi-tanakas təsyeyam.

P. 209 chitrakara śrī sātanas tasva vadhūkasya iyam.

P. 209 śrīmadbhojanarendrachandranagarī vagdevi pratimā vidhāya . . . (inscription for the likeness of Sarasvatī at Dhara).

P. 223 layanamahāvishṇugriham ati dvaimānushyakam atyadbhu-takarmavirachitam bhumibhāgopabhāgoparif paryantātiśayadarśanō-yatamam (from a ceiling inscription in the Vaishṇava cave at Bādāmī)·

P. 228 indivaraśyamatanur nriposau tvam rochanagauraśirayashṭiḥ (Kālidāsa, *Raghu vamśa* VI, 65).

P. 228 etad anishṭakam adruman aloham asudham vichitrachittena / nirmāpitam nripena brahmeśvaravishṇulakshitāyatanam (from Ma-hendravarman's inscription in the cave at Maṇḍagapaṭṭu).

P. 236 vibhakatam apyekasutena tat tayoḥ parasparasyopari pa-ryachiyata.

Index

All numbers refer to pages. Numbers in *italics* refer to pages on which legends for illustrations appear.

Farther India, 157, 166, 168, *162* (Khmer), *177* (Srivijaya), *179, 180, 182, 184-86;* Gurjara Pratihara, 187, *194;* Indus Valley, 49, *8;* Kashmir, 197; Ordos, 157; Pala, 194, 196, *202;* Vakataka, *127; see also* metalwork
Brown, Percy, 277
Buddha: 32, 72, 87, 89, 107, 142, 145, 173; relics preserved, 32; REPRESENTATIONS: 94, 97, 101, 111, 125, 140, 181-82, 217, *144;* adoration scenes, 107, *12, 89, 142;* anthropomorphism in, 86-87, 89, 107, 147, *20, 81;* figures: meditating, *146, 147, 179,* seated or enthroned, 104, 129, 156, 181, 209, *24, 27, 85, 148, 172, 214,* or standing, 107, 129, 149, *78, 127, 151, 172, 175, 179,* and heads: *23, 90, 94, 154, 174, 180, 182;* his Jataka, 153; life in previous births, 61, *172, 185;* Parinirvana (death), 68, *160, 184;* partition of relics, 61, *65;* scenes from his life, 61-66, 68, 71, 105, 107, 110, 125, 196, *20, 67, 68, 84, 106, 108,* and notable events: with Mara (Maradharshana), 71, 107, 187, 196, *183, 198,* Nalagiri (elephant), 107, 125, *106,* and Yasa, *23;* as Siddhartha, 61, 66, 107, 111, *108;* by symbols, 86, 107, 153, *12, 24, 62;* types: as eternal (in glory), 137, 142, kapardin, 89, as Mahapurusha, 87, 89; Stupa and Tree, 72, 105, *67, 68; see also* Buddhas; Buddhism; Buddhists; Law; Wheel of the Law
Buddhagosha: *Atthasalini,* 26, 28
Buddham: bronzes, 111
Buddhas: *145;* previous representations, 66, 153; Supreme, 34, 145
Buddhism: 7, 32, 66, 72, 77, 87, 89, 107, 142, 153, 311; aesthetics, 7, 15, 17, 26, 28; aniconic schools, 26; Asoka and, 58, 82, 83, 143; Great Vehicle (Mahayana), 89, 143, 144, 173; kharma (doctrine), 142, 145; Lesser Vehicle (Hinayana), 143, 144, 145; spread of, outside India, 32, 34, 78, 80, 94, 141-45, 153, 156, 157, 158, 168, 173, 177, 313; Tantric, 153, 158, *145, 146, 155, 156;* texts translated, 142, 144; *see also* Buddha; Jatakas; Law
Buddhists: representations of, 140, *144, 145, 148*
Bundelkhand school: miniature painting, 302
Bundi school: miniature painting, 302
Burma, 157, 158, 181
Butkara (Swat Valley): sculpture, 90, *86, 88*
Buxar: sculpture, 137
Byzantium: art, 77, 92; Central Asian art influenced by, 147, 149; mosaicists, 147; trade, 86

calligraphy: Indo-Muslim, 288, 296, 304, *290;* Islamic, 273; Kangra, 302; Sikh, 302
Cambodia: 158 (Khmer), 177-78; architecture, 32, 168, 170, 177, 178, 181; sculpture, 32, 130, 157, 168, 170, 178, 181, *162, 165-68, 171*
Candi Jawi (Java): temple, 177
Candi Kidal (Java): temple, 177
Candi Sewu (Java): temples, 173
Central Asia, art of: architecture, 153, 279-80, 281, 282; autonomy of, 149; and Byzantium, 147, 149; Chinese influence on, 141, 147, 153, 156, *146-48, 150, 154, 155;* and Classical art, 34, 147, 149, *143;* exerted influence on: Afghanistan, 156, Bamiyan, 149, Gandhara, 85, 86, Indo-Muslim architecture, 279, 280, Iran, 149, Kashmir, 187, Tibet, 156; Gandharan influence on, 78, 94, 145-46, 147, 149, 150, 153, 156 (Hellenistic), *142, 144, 146, 148, 151;* Gupta influence on, 149, 150, 151, 153, 156, *150, 151;* human figure, treatment of, 147, 311, *152;* iconography, 142, 143, 145, 146, 147, 150, 153, 156, *153;* Indian influence on, 34,

141-47, 149, 150, 153, 156, *148, 152;* and Indus Valley, 47; interaction with Hindu art, 313; Iranian influence on, 34, 141-42, 143, 144, 147, 149, 150, 153, *143-45;* Irano-Buddhist trend in, 149; Kushan influence on, 105, 107, 143, 144, 145, 147, 153, *143-45;* Mathuran influence on, 156, *151;* mural painting, 94, 145-47, 149-50, 153, 156, *142-48, 150, 154-56;* and Parthia, *143, 144;* sculpture, 149, 150, 153, *151-53*
ceramics: Indus Valley, 43, 44, 47, 53, *44-46, 49, 51;* other protohistoric cultures, 43, 44-45, 47, 51, 53, 57, *44, 45*
Ceylon: 168, 181; architecture, 168; bronzes, 168; mural painting, *159;* sculpture, 111, *159, 160; see also* Lanka
Chakravartin, 87
Chalukya: 243, 244; architecture, 217, 244, *216;* exerted influence on: Chera, 240, Rashtrakuta, 243, Vijayanagara, 267; metalwork, *219;* Pallava influence on, 223; sculpture, architectural, 244, *218, 219; see also* Ganga, Western; Nolamba
Chalukya, Eastern: architecture, 247; metalwork, 247; sculpture, 244, 247, 249, *246, 247;* and Western Chalukya, 249
Chalukya, Western: 130, 221, 228, 240; architecture, 221, 223, 226, 244, *224, 227;* and Eastern Chalukya, 249; metalwork, 226; mural painting, 226, 228, *228;* sculpture, 120, 221, 223, 243, 244, *223, 225, 227, 228, 245, 246*
Cham: 158, 177; tower, 181
Chamba: 187; bronzes, 190; sculpture, 187, *191*
Chamba school: miniature painting, *40*
Chammasataka Jataka, 74
Champeya Jataka, 105, *110*
Chandella (Chandratreya): 217; bronzes, 217, *216;* iconography, 209; sculpture, 20, 209, *211-15;* temples, 205, *208, 209*
Chandragiri: palace, 266
Chandragupta II: 129; coins, 138, *134*
Chandrahi: temple, sculpture, 217
Chandramukha, Yaksha, 72
Chandratreya, *see* Chandella
Chanhu-daro, 47, 54
chariots, 72, 73-74; rathas, temples in the shape of, 32, 205, 251, *27, 39, 205*
Chaumukhas (Tirthankara types), 97
Chedi: 205, 209, 217; bronzes, 217, *216;* and Eastern Chalukya sculpture, 249; and Gahadavala sculpture, 205, 217; and Gurjara Pratihara art, 209; sculpture, 205, 217
Chellean culture, 43
Chera: caves, sculpture, 239-40; metalwork, 240; mural painting, 240, 269, *270-72*
Cheta: cave, sculpture, 61, *62*
Chhaddanta/*Chhaddanta Jataka,* 66, 71, 73, 76, 105, 111, 113
Chhatarhi: bronzes, 190
Chidambaram: gopuras, sculpture, 252, 257, *259;* Nataraja temple, mural painting, 269, *268;* ratha temple, 251
Chieng-sen (Thailand): 181; sculpture, 181-82
China: 43, 141, 143, 147, 158, 295; aesthetics, 157; architecture, 32; arts, figural, 80, 113, 141, 147, 153, 156, 312, *148;* bronzes, 157; Buddhism, 143; and Central Asia, 141, 147, 153, 156, *146-48, 150, 154, 155;* and Farther India, 157, 158, 182; and Gandharan art, 78, 80, 146; iconography, 143 (Sinkiang), 156; Indian influence on, 156; Khotanese art, 141, 143, 153, 156; modern Indian painting influenced by, 306; Mogul painting influenced by, 281

324

Malaya: bronze, 157
Malwa: 130, 209; architecture, 280
Malwa school: painting, 302, *220*
Mamelukes, 280
Manchapuri Gumpha cave, 61
Mandagapattu cave, 228
Mandhata, 73, 110, *108*
Mandhata Jataka, 105
Mandi: miniature painting, *308, 310*
Mandu: mausoleum of Hushang Shah, 285
Mangalesa, 221, 226
Manichaeism, 141, 147, 150
Manikkavachakar, *40, 260*
Manmatha, 103, 187
Manrique, Father Sebastiano, 287
Man Singh, *285, 286*
manuscript painting, *see* miniature and manuscript painting
Mara, 71, 76, 107, 117, 187, *81, 185*
Maradharshana, 71, 76, 107, 117, 118, 120, 187, *198*
Maratha: 291; architecture, 7, 37, *287*
Maravadhus, 117
Margiana, 143-44
Martand: temple, 187
Marwar: painting, 302
Maspéro, H., 144
Masrur: temple, sculpture, 187
Masson, M. E., 144
Mat: sculpture, 85
Mathura: 156; Central Asia influenced by, 156, *151;* Kushan metal reliquary, 104; sculpture: 66, 105, 313, *19, 174,* early anthropomorphic images of Buddha and Boddhisattvas, 86-87, 89, 97, iconography, 103-4, Jain works (Kushan period), 101, 103, *99, 100,* Kushan ivories, 104, *103, 104,* other Kushan works, 86, 89, 97, 99, 101, 103, 187, 313, *100, 101, 102,* Sunga terra-cottas, 67, Western influence, 78, 101, *79*
Matiposaka Jataka, 125
Matrikas, 103, 130
Mattancheri: palace, mural painting, 269, *270-72*
Maukharis, 187
Mauryan art: 57-61, 82, 143; architecture, 57, 59, 60, 74 (caves); Iranian influence on, 57, 58, 60; pillars and capitals, 57-58, 59, 60, *58, 59;* sculpture, 59, 60, 74, *10, 60*
Maya, 66, 107, *62*
Mayurbhanj: sculpture, 205
Megasthenes, 57
Mehrauli: Jamali Masjid, 280; mausoleum of Maulana Jamal Khan, 279; sculpture, 66
Menander, 82-83, 143
Meru, Mount, 178
Mesopotamia: and Afghanistan and Pakistan, 80; and India, 20, 45; and Indus Valley civilization, 47, 51; protohistoric cultures, 43, 44, 47; sculpture, 49
metalwork, 187; Chalukya, 223, *219;* Chalukya, Eastern, 247; Chalukya, Western, 226; Chera, 240; *cire-perdue* (lost-wax) process, 53, 111; Gupta, 140; Ikshvaku, 111; Indus Valley, 45; Kushan, 104; Pallava, 235, 252; protohistoric, 45, 56; Rashtrakuta, *242;* Satavahana, 111; Vijayanagara, 266, *263, 265; see also* bronzes; gold and goldwork; silverwork

Mewar school: painting, 302, *220*
Mihira Bhoja, 187
Milindapanha, 82-83, 143
miniature and manuscript painting: Chamba school, *40;* Deccan style (Ahmadnagar, Bijapur, Golconda), 37, 301, *295, 300, 304;* Gujarat school, 296, 302; Hoysala, 259, *263;* Indo-Muslim, 37, *40, 300;*
 Mogul: 40, 218, 273, 288, 306, components and traits of style, 37, 218, 281-82, 291, 295-96, 299, 301, 302, 313, court and historical scenes, *294-96, 319,* imperial patronage, 291, 295, manuscript illustrations, 291, *294, 297, 299, 300,* nature, treatment of, 295-96, *220, 297, 299, 302,* painters, 291, 295, 299, 298, portraits, 218, 299, *300, 303,* subjects relating to music (Ragmala, etc.), 301, *295, 301, 304, 305,* Western (European) influence, 37, 295, 302, 313, *294, 298, 305,* workshop production, 291, 295;
 Rajput school: 218, 301, 306, *309,* Himalaya (Pahari) branch, 37, 218, 302, *301, 309*—Basohli, 218, 302, Guler, 218, 302, *304-8,* Jammu, 302, Kangra, 187, 218, 302, *222,* Kulu, 218, *307,* Mandi, *308, 310,* and Sikh schools, 302, 304, 306, *309*—Rajputana (Rajasthani) branch, 37, 218, 301-2, *303*—Amber, 302, Bikaner, 302, Bundelkhand, 302, Bundi, 218, 302, Malwa, 302, *220,* Marwar, 302, and Mewar schools, 302, *220*—
 western Indian painted manuscripts, 218, *220; see also* painting; perspective
Miran (Serindia): mural painting, 94, 145-47, *142-44;* Shrine 3, *143;* Shrine 5, *144*
Mirath Asoka pillar, 59, *59*
Mir Hashim, 295
Mirpur Khas: sculpture, 140, *133*
Mir Sayyid 'Ali, 37, 291
Miskina, 37, 295
mithunas, 24-25, 111, *123, 124*
Modhera: Sun temple, 217, 218, *216;* torana, 217-18
Mogalrajapuram caves: 228; sculpture, 114
Mogul art: 7, 34, 305, 312, 313; architecture, 37, 279, 280, 281, 282-83, 285, 291, 313, *285,* Fatehpur Sikri, 283, *288,* Fort, Agra, 283, 285, 289, *278-81, 282,* Fort, Gwalior, *286, 287,* funerary monuments, *276, 282, 286,* Taj Mahall, 37, 287-89, 304, *288, 290-93, see also* Delhi, Lahore; Chinese influence on, 281; coins, 285, *278;* enamel, 305; figural representation, 283, 285, *278;* glass, 305; goldwork and silverwork, 289, 304; Gujarat influence on, *286;* Hindu influence on, 282, 283, 285, 287; inlay, 304, 305; Iranian influence on, 37, 280, 281-82, 285, 287, 289, 291, 295, 296, 299, *294, 295;* Lodi influence on, 282, *286;* miniature painting, *see under* miniature and manuscript painting; modern Indian art influenced by, 40, 306; perspective, 288, 295, 296, 302, 313; and Rajput art, 218, 285, 296, 301-2, *278;* Safavid influence on, 280, 282, 285, 289; sculpture, 285; Timurid influence on, 280, 281, 282; Turkish influence on, 37; Western influence on, 37, 273, 295, 299, 301, 302, 313, *294, 298, 310;* Western painting influenced by, 299
Moguls, 34, 280, 281, 282
Mohenjo-daro: 43, 47, 48, 53, 54; bronze, 49, *8;* ceramics, 44, *45;* jewelry, *56;* sculpture, 20, 51, *46, 49, 51, 53-55*
Mohini, *266, 268*
Mojopahit, 177
Mokhra Moradu: architecture, 94
Mookherjee, Sailoz, 308